DATE DUE

DEMCO 38-296

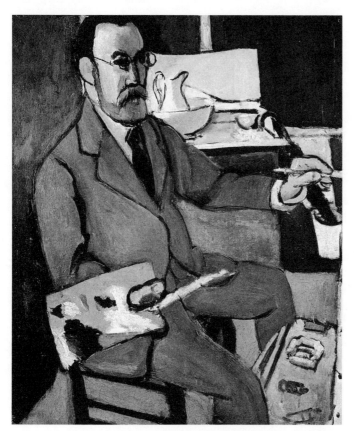

Matisse, *Self-Portrait*, 1918

ALSO BY HILARY SPURLING

~

Ivy: The Life of Ivy Compton-Burnett

Invitation to the Dance: A Guide to Anthony Powell's "Dance to the Music of Time"

Elinor Fettiplace's Receipt Book

Paul Scott: A Life of the Author of the Raj Quartet

Paper Spirits: Collage Portraits by Vladimir Sulyagin

The Unknown Matisse: A Life of Henri Matisse: The Early Years, 1869–1908

La Grande Thérèse: The Scandal of the Century

The Girl from the Fiction Department: A Portrait of Sonia Orwell

MATISSE THE MASTER

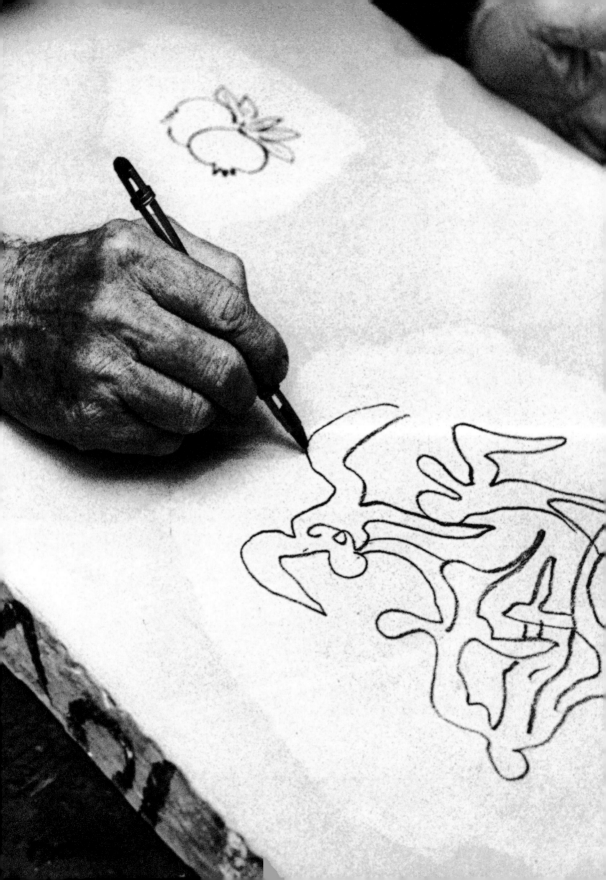

MATISSE THE MASTER

A LIFE OF HENRI MATISSE: THE CONQUEST OF COLOUR, 1909–1954

Hilary Spurling

Alfred A. Knopf New York 2005

THIS IS A BORZOI BOOK
PUBLISHED BY ALFRED A. KNOPF

Published in Great Britain by Hamish Hamilton, Ltd., London, in 2005.

www.aaknopf.com

Library of Congress Cataloging-in-Publication Data
Spurling, Hilary.
Matisse the master : a life of Henri Matisse, the conquest of colour, 1909–1954 / Hilary Spurling.—1st ed.
p. cm.
Companion volume to the author's: The unknown Matisse.
Includes bibliographical references and index.
ISBN 0-679-43429-1
1. Matisse, Henri, 1869–1954. 2. Artists—France—Biography. I. Title: Life of Henri Matisse, the conquest of
colour, 1909–1954. II. Spurling, Hilary. Unknown Matisse. III. Title.
N6853.M33S678 2005
759.4—dc22
[B] 2004051074

Manufactured in the United States of America
FIRST AMERICAN EDITION

CONTENTS

~

Illustrations *vii*
Preface *xvii*

CHAPTER ONE · *1909: Paris, Cassis and Cavalière 3*

CHAPTER TWO · *1910: Issy-les-Moulineaux, Collioure and Spain 34*

CHAPTER THREE · *1911: Seville, Paris, Collioure and Moscow 65*

CHAPTER FOUR · *1912–1913: Tangier and Paris 98*

CHAPTER FIVE · *1913–1915: Paris and Tangier 135*

CHAPTER SIX · *1916–1918: Paris and Nice 173*

CHAPTER SEVEN · *1919–1922: Nice, Paris, London and Etretat 216*

CHAPTER EIGHT · *1923–1928: Nice and Paris 254*

CHAPTER NINE · *1929–1933: Nice, Paris, America and Tahiti 296*

CHAPTER TEN · *1933–1939: Nice and Paris 340*

CHAPTER ELEVEN · *1939–1945: Paris, Nice, Ciboure, St-Gaudens and Vence 387*

CHAPTER TWELVE · *1945–1954: Vence, Paris and Nice 426*

Key to Notes *467*
Notes *469*
Index *497*

ILLUSTRATIONS

∾

All images by Henri Matisse are Copyright © Succession Henri Matisse.
AMP: Archives Matisse, Paris
RMN: Agence photographique de la Réunion des Musées Nationaux, Paris
Frontispiece: Matisse, *Self-Portrait*, oil on canvas, 1918 (Dépôt du Musée du Louvre, Musée Matisse, Le Cateau-Cambrésis. Photograph: Claude Gaspari)
Title page: "The Hands of Matisse"—Matisse drawing on a lithography stone, photograph, 1953, Ina Bandy (Copyright © Ina Bandy/RAPHO, Paris)

CHAPTER ONE

page 3 Matisse, *Composition No. 1*, watercolour, 1909 (Copyright © The State Pushkin Museum of Fine Arts, Moscow)

4 Matisse, *Nymph & Satyr*, central panel of triptych made for Haus Hohenhof, Hagen, ceramic mural, spring 1908 (Karl-Ernst Osthaus Museum der Stadt Hagen. Photograph: Achim Kukulies, Düsseldorf)

5 Paul Cézanne, *The Rape (The Abduction)*, oil on canvas, 1867 (By kind permission of the Provost and Fellows of King's College, Cambridge, on loan to the Fitzwilliam Museum, Cambridge. Photograph: Copyright © the Fitzwilliam Museum)

7 Maurice Denis, *Cupid Bearing Psyche Upward* (panel 7), oil on canvas, 1909 (Copyright © The State Hermitage Museum, St. Petersburg)

11 Matisse, *Woman with Closed Eyes*, ink on paper, 1910 (Photo courtesy AMP)

12 Arvid Fougstedt, *Matisse Teaching Scandinavian Artists in His Studio*, India ink, 1910 (Boras Kunstmuseum, Sweden)

15 Marie Vassilieff, *La Bohème du XXe siècle*, self-portrait, pen, ink, gouache, 1929 (Collection Claude Bernès, Paris)

16 Olga Meerson in a fur-trimmed robe, photograph, c. 1908–11 (Private collection/ photo: Nicholas Spurling)

18 *Phalanx Class (Kandinsky's Class in the Phalanx School, Munich)*, 1902, including Olga Meerson and Wassily Kandinsky, photographer unknown (Gabriele Münter und Johannes Eichner Stiftung, Städtische Galerie im Lenbachhaus, Munich)

20 Matisse, *Girl with Black Cat (Marguerite Matisse)*, oil on canvas, 1910 (Photographer: Peter Willi/Artothek)

28 Matisse, *Bonjour Mlle Levy*, ink on paper, 18 August 1909 (San Francisco Museum of Modern Art, Bequest of Harriet Lane Levy)

29 Matisse, sketch of himself with nude model on beach, in a letter to Manguin, 11 August 1909 (Archives Jean-Pierre Manguin)

CHAPTER TWO

34 Edward Steichen, *Henri Matisse Working on "La Serpentine,"* platinum print, 1909 (Photo courtesy AMP)

36 House at Issy-les-Moulineaux, photograph, c. 1910 (Photo courtesy AMP)

40 Camoin and Marquet in the studio at Issy, c. 1910 (Photo courtesy AMP)

41 Floods, rue Bara and boulevard du Point du Jour, Issy-les-Moulineaux postcard, ed.: MCFL—Issy (Seine), 1910 (Collection and photograph: Issy-les-Moulineaux, Musée Français de la carte à Jouer)

44 Matisse, *Matthew Prichard,* etching, 1914 (Photograph © Institut national d'histoire de l'art, bibliothèque [collections Jacques Doucet], Paris)

53 Jules Leon Flandrin, sketch of *Dance* and *Music* at the Autumn Salon, in a letter to his brother, Dr. Joseph Flandrin, dated 2.11.10 (Private Collection)

60 Postcard of the Sala de las Camas in the Alhambra, c. 1911 (Photo courtesy AMP)

63 Matisse, *Joaquina,* oil on canvas, 1910 (National Gallery, Prague)

CHAPTER THREE

65 Matisse, *Seated Nude (Olga),* bronze, 1910 (cast c. 1947–55) (Hirshhorn Museum and Sculpture Garden, Smithsonian Institution, Washington, D.C. Gift of Joseph H. Hirshhorn, 1966. Photographer: Lee Stalsworth)

70 Auguste Bréal, *Courtyard of the Painter's House in Seville,* oil on canvas (Collection K. and M. Brunt)

72 Matisse, *The Manila Shawl,* oil on canvas, winter-spring 1911 (Private collection, USA/ Photograph: Hans Hinz/Artothek)

84 Matisse's studio at Collioure, photograph, summer 1911 (Musée Terrus, Elne, France)

85 Group in Etienne Terrus's studio at Elne, photograph, 1911 (Musée Terrus, Elne, France)

86 Matisse, *Portrait of Olga Meerson,* oil on canvas, 1911 (The Museum of Fine Arts, Houston. Museum purchase with funds provided by the Agnes Cullen Arnold Endowment Fund)

90 Page from a Moscow newspaper, *Zerkalo,* November 1911 (N. Semenova Archive, Moscow)

91 Matisse, Adoration du Grand Henri, from his letter to Mme Matisse, 16 November 1911 (Photo courtesy AMP)

CHAPTER FOUR

98 Matisse, *Moroccan in Green (Standing Riffian),* oil on canvas, 1912 (Copyright © The State Hermitage Museum, St. Petersburg)

99 Matisse, *Portrait of Sergei Shchukin,* charcoal on paper, 1912 (Private collection. Photograph: The Bridgeman Art Library, London)

100 *The Archangel Michael,* icon, Novgorod School, c. 1475 (State Tretiakov Gallery, Moscow. Photo: Private archive, Moscow)

101 Matisse, *The Moroccan Amido,* oil on canvas, 1912 (Copyright © The State Hermitage Museum, St. Petersburg)

103 Matisse, *The Bay of Tangier,* oil on canvas, 1912 (Musée de Grenoble. Bequest Agutte-Sembat, 1923. Photograph © Musée de Grenoble)

105 Matisse and Mme Matisse during the second trip to Morocco, photograph, winter 1912–13 (Photo courtesy AMP)

108 Matisse on muleback, sketch on a postcard to Manguin, 1913 (Archives Jean-Pierre Manguin)

110 Matisse, *Three Studies of Zorah,* pen and ink on paper, 1912 (Isabella Stewart Gardner Museum, Boston. Photograph: The Bridgeman Art Library, London)

111 *Porteuses de Charbon, Tangier, Morocco,* postcard from Matisse to Gertrude Stein, 22 Feb-

ruary 1912 (Yale Collection of American Literature, Beinecke Rare Book and Manuscript Library, Yale University, New Haven, Connecticut. Permission granted by Estate of Gertrude Stein/Literary Executor—Mr. Stanford Gann, Jr., of Levin and Gann, P.A., and David Higham Associates, London)

115 Matisse on horseback, photograph, 1912 (Photo courtesy AMP)

116 Matisse, *Zorah Standing*, oil on canvas, 1912 (Copyright © The State Hermitage Museum, St. Petersburg)

126 Postcard from Matisse and Mme Matisse to Camoin showing a chastity belt, 11 July 1912 (Archives Camoin, Paris)

128 Postcard from Tangier showing Matisse's studio, 1913 (Photo courtesy AMP)

129 Matisse, Tangier, sketch with horseman in tribute to Delacroix, 1912 (Photo courtesy AMP)

130 Eugène Delacroix, *Women of Algiers*, oil on canvas, 1834 (Musée du Louvre, Paris. Photograph © RMN/Le Mage)

132 Matisse, letter to Mme Matisse with sketches of his favorite Arab café and customers, 25 September 1912 (Photo courtesy AMP)

133 Shchukin's drawing room rehung to incorporate paintings from Morocco, photograph, 1913 (Photo courtesy AMP)

CHAPTER FIVE

135 Alvin Langdon Coburn, *Henri and Amélie Matisse in the Studio at Issy-les-Moulineaux with the Unfinished "Bathers by a River,"* photograph, May 1913 (Courtesy George Eastman House, Rochester, New York)

138 Matisse, *Back II*, bronze, 1913 (Centre Georges Pompidou–MNAM–CCI, Paris. Photo © CNAC/MNAM Dist. RMN/Service de documentation)

139 Matisse, *Jeannette (V)* (Jeanne Vaderin, 5th State), bronze, 1916 (The Museum of Modern Art, New York (MoMA). Acquired through the Lillie P. Bliss Bequest, 10.1952. Digital Image © 2003 The Museum of Modern Art/Licensed by SCALA, Florence)

142 Matisse, *Portrait of Mme Matisse*, oil on canvas, summer/early autumn 1913 (Copyright © The State Hermitage Museum, St. Petersburg)

143 Matisse, *Portrait of Madame Matisse*, crayon, graphite on paper, 1915 (Musée Matisse, Nice. Photograph: Ville de Nice, Service Photographique)

146 Van Dongen's ball, Paris, photograph, 1912 (© Harlingue/Roger–Viollet/REX FEATURES, London)

147 Matisse, sketch of Van Dongen's *Tableau*, in a letter to Camoin, November 1913 (Archives Camoin, Paris)

150 Matisse, *Portrait of Mrs. Samuel Dennis Warren (Mabel Bayard)*, graphite pencil on white paper, 1913 (Courtesy Museum of Fine Arts, Boston. Gift of Mrs. J. Gardner Bradley, Mrs. Warren Thayer and Miss Sylvia Warren. Photograph © 2004 Museum of Fine Arts, Boston)

152 Matisse, *Woman on a High Stool (Germaine Raynal)*, oil on canvas, early 1914 (The Museum of Modern Art, New York [MoMA]. Gift and Bequest of Florene M. Schoenborn and Samuel Marx, 1964. Digital image © 2003 The Museum of Modern Art, New York/Licensed by SCALA/Art Resource, New York)

154 Matisse, *Yvonne Landsberg*, pen and ink on paper, July 1914 (The Museum of Modern Art, New York [MoMA]. Alva Gimbel Fund. Photograph: courtesy AMP)

155 Matisse, *Portrait of Mlle Yvonne Landsberg*, oil on canvas, spring/early summer 1914 (Philadelphia Museum of Art. The Louise and Walter Arensberg Collection. Photograph: Graydon Wood, 1992)

157 Matisse family at table with Berthe and Armand Parayre, photograph, 1914 (Photo courtesy AMP)

159 Louis Joseph Guillaume, photo of German troops marching past the Matisse house in Bohain, 1914 (Collection Georges Bourgeois)

161 Matisse, *French Window at Collioure*, oil on canvas, 1914 (Centre Georges Pompidou-MNAM-CCI, Paris. Photograph © CNAC/MNAM Dist. RMN/Philippe Migeat)

171 Matisse, *Still Life after Jan Davidsz de Heem's "La Desserte,"* oil on canvas, late 1915 (The Museum of Modern Art, New York [MoMA]. Gift and Bequest of Florene M. Schoenborn and Samuel A. Marx, 508.64. Digital image © 2003 The Museum of Modern Art, New York/Licensed by SCALA, Florence)

CHAPTER SIX

173 Matisse, *Study for "The Studio, Quai Saint-Michel,"* pencil on paper, 1915–16 (Private collection)

174 Matisse, sketch for *The Moroccans* in a letter to Mme Matisse, 25 October 1912 (Photo courtesy AMP)

179 Jean and Marguerite Matisse on the steps of the studio at Issy, photograph, c. 1916 (Photo courtesy AMP)

181 Pierre Matisse playing the violin, photograph, c. 1915 (Photo courtesy AMP)

183 Matisse, *The Piano Lesson*, oil on canvas, late summer 1916 (The Museum of Modern Art, New York [MoMA]. Mrs. Simon Guggenheim Fund. 125.1946. Digital image © 2003 The Museum of Modern Art, New York/Licensed by SCALA, Florence)

185 Matisse, *Composition No. 2*, ink, pen, watercolour on paper, 1909 (Copyright © The State Pushkin Museum of Fine Arts, Moscow)

188 Matisse family on studio steps with Walter Halvorsen and Greta Prozor, photograph, c. 1915 (Photo courtesy AMP)

191 Arvid Fougstedt, *The Opening of the Lyre and Palette*, drawing, 1916 (Moderna Museet, Stockholm)

192 Marie Vassilieff, *The Braque Banquet*, drawing, 1916 (Collection Claude Bernès, Paris)

193 Matisse, *Auguste Pellerin (II)*, oil on canvas, winter/spring 1917 (Centre Georges Pompidou–CCI, Paris. Photograph © CNAC/MNAM Dist. RMN/Philippe Migeat)

194 Matisse, *Study for the Portrait of Greta Prozor*, crayon, 1916 (Centre Georges Pompidou–MNAM–CCI, Paris. Photograph © CNAC/MNAM Dist. RMN/Philippe Migeat)

195 Matisse, *Portrait of Greta Prozor*, oil on canvas, 1916 (Centre Georges Pompidou–MNAM–CCI, Paris. Photograph © CNAC/MNAM Dist. RMN/Philippe Migeat)

196 Matisse, *The Italian Woman*, oil on canvas, 1916 (Solomon R. Guggenheim Museum, New York. By exchange, 1982. 82.2946. Photograph © David Heald/The Solomon R. Guggenheim Foundation, New York)

197 Matisse, *The Studio, Quai Saint-Michel*, oil on canvas, autumn 1916–17 (The Phillips Collection, Washington, D.C.)

197 Gustave Courbet, *The Sleeping Blonde*, oil on canvas, 1849 (Private collection, Paris. Photograph © 1990 SCALA, Florence)

198 Jean-Baptiste-Camille Corot, *Forest of Fontainebleau* (detail), oil on canvas, 1834 (Chester Dale Collection. Image © 2004 Board of Trustees, National Gallery of Art, Washington)

199 Matisse, *Lorette Reclining (Sleeping Nude)*, oil on canvas, 1917 (Private collection. Photograph © The Bridgeman Art Library, London)

200 Matisse, *Woman in a Turban (Lorette)*, oil on canvas, early 1917 (The Baltimore Museum of Art; Cone Collection, formed by Dr. Claribel Cone and Miss Etta Cone of Baltimore, Maryland. BMA 1950.229)

203 Matisse, *The Windshield, on the Road to Villacoublay*, oil on canvas, 1917 (The Cleveland Museum of Art/Bequest of Lucia McCurdy McBride in memory of John Harris McBride II, 1972.255)

210 Matisse, sketch of himself asleep under an olive tree on Mont Boron, in a letter to Camoin, 23 May 1918 (Archives Camoin, Paris)

ILLUSTRATIONS

211 Matisse, sketch of himself kissing his wife's cheek, in margin of a letter to Mme Matisse, 8 May 1918 (Photo courtesy AMP)

213 Louis Joseph Guillaume, Bohain in ruins, photograph, 1918 (Collection Georges Bourgeois)

214 Matisse, *Violinist at the Window*, oil on canvas, spring 1918 (Centre Georges Pompidou–MNAM–CCI, Paris. Photograph © CNAC/MNAM Dist. RMN/Adam Rzepka)

CHAPTER SEVEN

216 Matisse, *Odalisque in Red Culottes*, oil on canvas, 1921 (Centre Georges Pompidou–MNAM–CCI, Paris. Photograph © CNAC/MNAM Dist. RMN/Philippe Migeat)

219 In Renoir's studio at Cagnes-sur-Mer (seated: Greta Prozor and Auguste Renoir; standing: Claude Renoir, Henri Matisse and Jean Renoir), 1917, photographer Walter Halvorsen (Musée départemental Matisse, Le Cateau-Cambrésis)

221 Matisse, *Interior with a Violin Case*, oil on canvas, winter 1918–19 (The Museum of Modern Art, New York [MoMA]. Lillie P. Bliss Collection. 86.1934. Digital image © 2003 The Museum of Modern Art, New York/Licensed by SCALA, Florence)

224 Pierre Auguste Renoir, *Gabrielle in an Open Blouse*, oil on canvas, 1907 (Private collection)

225 Matisse, *Antoinette with Long Hair*, graphite, 1919 (The Minneapolis Institute of Arts/The Putnam Dana McMillan Fund. The Richard Lewis Hillstrom Fund and Gifts of Funds from Ruth and Bruce Dayton and Gifts of Funds from the Print and Drawing Council)

226 Matisse, *The Plumed Hat*, graphite on paper, winter/spring 1919 (The Baltimore Museum of Art; Cone Collection, formed by Dr. Claribel Cone and Miss Etta Cone of Baltimore, Maryland. BMA 1950.12.58)

228 Matisse, *Tea in the Garden*, oil on canvas, summer 1919 (Los Angeles County Museum of Art. Bequest of David L. Loew in memory of his father, Marcus Loew. Photograph © 2004 Museum Associates/LACMA. M.74.52.2)

232 Matisse, costume for a Mandarin in the ballet *Le Rossignol*, silk, cotton, metallic fabric, ink, bakelite, 1920 (National Gallery of Australia, Canberra)

236 Matisse, *Marguerite Asleep*, oil on canvas, 1920 (Photo courtesy AMP)

237 Pierre Matisse, *Portrait of Amélie Matisse*, oil on canvas, 1921 (Private collection)

240 Matisse, *The Painter and His Model*, oil on canvas, 1921 (Private collection/Artothek)

244 Matisse, caricature of himself on his knees in prayer, in a letter to Mme Matisse, 9 May 1921 (Photo courtesy AMP)

247 Matisse, sketch of a film set, in an undated letter (c. 1921–23) to Mme Matisse (Photo courtesy AMP)

250 Matisse, sketch of himself, in a letter to Marguerite Matisse, 9 May 1921 (Photo courtesy AMP)

252 Marguerite Matisse, diagram of the family's picture show, including paintings by Matisse, Cézanne and Renoir, in a letter to Matisse dated Easter Monday, 1923 (Photo courtesy AMP)

CHAPTER EIGHT

254 Silhouette of Matisse painting at his studio window in Nice, photograph (Photo courtesy AMP)

257 Matisse, *Georges Duthuit*, drawing, 1924 (Private collection. Photo courtesy AMP)

263 Clorinde Peretti as Spanish dancer, photograph (Courtesy C. Peretti)

269 Matisse, *Odalisque with a Bowl of Fruit*, lithograph, 1925 (Musée Matisse, Nice. Photograph: Ville de Nice, Service Photographique)

270 Matisse, *Pianist and Checker Players*, oil on canvas, 1924 (Collection of Mr. and Mrs. Paul Mellon. Image © 2004 Board of Trustees, National Gallery of Art, Washington)

280 Matisse and Georges Duthuit, photograph, c. 1926 (Photo courtesy AMP)

281 Michelangelo, *Tomb of Giuliano, Duke of Nemours,* detail *(Night)* (Florence, Medici Chapels. Photograph © 1992 SCALA, Florence. Courtesy of the Ministero Beni e Att. Culturali)

281 Matisse, *Large Seated Nude,* bronze, 1922–29 (Raymond and Patsy Nasher Collection, Dallas, Texas. Photographer: David Heald/The Solomon R. Guggenheim Museum)

283 Matisse at work in his Nice studio, photograph (Photo courtesy AMP)

286 Pablo Picasso, *Large Nude in Red Armchair,* oil on canvas, 1929 (Paris, Musée Picasso, Photograph © RMN/J. G. Berizzi)

287 Henri and Amélie Matisse in the garden, last photograph at Issy (Photo courtesy AMP)

290 Matisse, *Woman with a Veil,* oil on canvas, 1927 (The Museum of Modern Art, New York [MoMA]. The William S. Paley Collection. WP22.90. Digital image © 2003 The Museum of Modern Art, New York/Licensed by SCALA, Florence)

291 Matisse and Zita, c. 1928, photograph (Photo courtesy AMP)

293 Henri and Amélie Matisse in their dining room in Nice, photograph, c. 1925 (Photo courtesy AMP)

294 Matisse, sketch of himself alone at table, in a letter to Mme Matisse dated 15 July 1928 (Photo courtesy AMP)

CHAPTER NINE

296 Matisse, *Brise marine* (figure at the prow of a Tahitian schooner), etching printed in black, 1930–32, from the illustrated edition of *Poésies de Stéphane Mallarmé,* published by Albert Skira & Cie, Lausanne, 1932 (The Baltimore Museum of Art. The Cone Collection, formed by Dr. Claribel Cone and Miss Etta Cone of Baltimore, Maryland. BMA 1950.12.693XI)

301 Matisse, *Back IV,* bronze, 1929–30 (The Tate Gallery, London. © 2004 Tate, London)

308 Matisse, *Trees in Tahiti,* pen and ink on paper, 1930 (Courtesy of the Pierre and Maria-Gaetana Matisse Foundation. All Rights Reserved. Photograph: Christopher Burke, New York)

312 Matisse, photograph of Pauline and Etienne Schyle, 1930 (Photo courtesy AMP)

313 Matisse, *Pauline Chadourne (Schyle),* ink on paper, 1930 (Photo courtesy AMP)

314 Matisse, *Tahitiennes,* pen and ink on paper, c. 1930 (Musée des Arts d'Afrique et d'Océanie, Paris. Photograph © RMN/Daniel Arnaudet)

317 Matisse, sketch of himself as a castaway, in a letter to Mme Matisse, 4 May 1930 (Photo courtesy AMP)

317 Matisse and Friedrich Wilhelm Murnau in Tahiti, photograph, 1930 (Filmmuseum Berlin–Stiftung Deutsche Kinemathek)

319 Matisse, sketch of himself swimming under water, in a letter to Mme Matisse, 29 May 1930 (Photo courtesy AMP)

325 Matisse on the cover of *Time,* 20 October 1930 (Photograph: Time Inc./Time Life Pictures/Getty Images)

327 Matisse in Etta Cone's dining room at The Marlborough Apartments, Baltimore, photograph, 17–18 December, 1930 (The Baltimore Museum of Art: The Cone Archives)

329 Matisse drawing *The Dance* with a bamboo stick, photograph, 1931 (© The Barnes Foundation, Merion, Pennsylvania/The Bridgeman Art Library, London)

336–7 Matisse, *The Dance,* oil on canvas, 1932–33 (Photograph © 1994. Reproduced with the permission of The Barnes Foundation, Merion, Pennsylvania. All Rights Reserved)

338 Matisse, *Le Pitre chatié,* etching and letterpress, 1930–32, from the illustrated edition of *Poésies,* by Stéphane Mallarmé, published by Albert Skira & Cie, Lausanne, 1932 (The Baltimore Museum of Art; Cone Collection, formed by Dr. Claribel Cone and Miss Etta Cone of Baltimore, Maryland. BMA 1950.12.691)

CHAPTER TEN

340 Lydia Delectorskaya, *Henri Matisse*, photograph, 1935 (Photo courtesy AMP)

341 Matisse, *Lydia Delectorskaya*, photograph 1935 (Photo courtesy AMP)

354 Antonio Pollaiuolo, *Hercules and Antaeus* (Florence, Galleria degli Uffizi. Photo-
 graph © 1990, SCALA, Florence. Courtesy of the Ministero Beni e Att. Cult-
 urali)

355 Matisse, *Hercules and Antaeus*, charcoal, 15 March 1935 (Photo courtesy AMP)

356 Matisse, *The Blue Eyes*, oil on canvas, 1935 (The Baltimore Museum of Art; Cone Col-
 lection, formed by Dr. Claribel Cone and Miss Etta Cone of Baltimore, Mary-
 land. BMA 1950.259)

357 Matisse, *Lydia*, stump drawing, 1933 (Photo courtesy AMP)

359 Matisse, *Large Reclining Nude (The Pink Nude)*, 1935 (State XIII, 4 September 1935) (The
 Baltimore Museum of Art: The Cone Collection, formed by Dr. Claribel Cone
 and Miss Etta Cone of Baltimore, Maryland. BMA 1971.54.13)

359 Matisse, *Large Reclining Nude (The Pink Nude)*, 1935 (State XVII, 14 September 1935)
 (The Baltimore Museum of Art: The Cone Collection, formed by Dr. Claribel
 Cone and Miss Etta Cone of Baltimore, Maryland. BMA 1971.54.17)

359 Matisse, *Large Reclining Nude (The Pink Nude)*, 1935 (State XIX, 17 September
 1935) (The Baltimore Museum of Art: The Cone Collection, formed by
 Dr. Claribel Cone and Miss Etta Cone of Baltimore, Maryland. BMA 1971.
 54.19)

360 Matisse, *Large Reclining Nude (The Pink Nude)*, oil on canvas, 1935 (Baltimore Museum of
 Art; Cone Collection, formed by Dr. Claribel Cone and Miss Etta Cone of Balti-
 more, Maryland. BMA 1950.258)

361 Matisse with Claude Duthuit in his arms, photograph, 1935 (Photo courtesy
 AMP)

365 Matisse, *Faun Charming a Sleeping Nymph*, drawing, 1935 (Centre Georges Pompidou–
 MNAM–CCI, Paris. Photograph © CNAC/MNAM Dist. RMN/Georges
 Meguerditchian)

368 Simon Bussy, *Portrait of Jane Bussy at 20*, pastel on paper, 1926 (Musée des Beaux-Arts
 et d'Archéologie, Besançon. All Rights Reserved. Photograph: Charles Choffet,
 Besançon, France)

376 Matisse in his studio with a portrait of Etta Cone on the easel and *Interior with Dog*
 on the wall, photograph, 1934 (Photo courtesy AMP)

381 Henri and Amélie Matisse with their children and grandchildren at their home on
 the boulevard Montparnasse, photograph, 1936 (Photo courtesy AMP)

CHAPTER ELEVEN

387 Matisse's studio, photographed by Lydia Delectorskaya, with a selection of "girls in
 chairs" paintings on the wall (Photo courtesy AMP)

388 Matisse, *Lydia Delectorskaya in a Hooded Cape*, oil on canvas, 1939 (Photo courtesy
 AMP)

397 Matisse, *The Dream*, oil on canvas, 1940 (Private collection. Photograph: Peter Willi/
 Artothek)

406 Matisse, *Louis Aragon*, drawing, 1942 (Centre Georges Pompidou–MNAM–CCI,
 Paris. Photograph © CNAC/MNAM Dist. RMN/Philippe Migeat)

410 Matisse, *Cusin, monstre à double aile*, lithograph printed in color (pp. 90–91) in the illus-
 trated edition of *Florilège des amours de Ronsard*, published by Albert Skira, Paris, 1948
 (Beinecke Rare Book and Manuscript Library, Yale University, New Haven, Con-
 necticut)

418 Matisse, *L'angoisse qui s'amasse...*, linoleum cut from the illustrated edition of
 Pasiphaë/Le Chant de Minos, by Henry de Montherlant, published by Martin Fabiani,
 Paris, 1944 (Beinecke Rare Book and Manuscript Library, Yale University, New
 Haven, Connecticut)

CHAPTER TWELVE

426 Henri Matisse barefoot in wheelchair at Cimiez surrounded by cut-outs, photo-graph, 1953 (© Fonds Hélène Adant, Paris. Centre Georges Pompidou, Biblio-thèque Kandinsky)

430 Matisse's studio in Vence: wall decoration with "Papiers découpés" (cut-out, painted and pasted paper forms created by Matisse), 1948 (Photograph: akg-images, London/Bianconero)

432 Matisse, *Young Woman in Blue Blouse (Portrait of Lydia Delectorskaya)*, oil on canvas, 1939 (Copyright © The State Hermitage Museum, St. Petersburg)

433 Matisse, *Portrait of Lydia Delectorskaya*, oil on canvas, 1947 (Copyright © The State Hermitage Museum, St. Petersburg)

436 Matisse, *Red Interior, Still Life on a Blue Table*, oil on canvas, 1947 (Kunstsammlung Nordrhein-Westfalen, Düsseldorf. Photograph: Walter Klein, Düsseldorf)

446 Matisse, *Oceania, the Sea*, silkscreen, 1946 (Centre Georges Pompidou–MNAM–CCI, Paris. Photograph © CNAC/MNAM Dist. RMN/Jacqueline Hyde)

463 Matisse's studio at the Hotel Régina, Nice-Cimiez, 1952 (© Fonds Hélène Adant, Paris. Centre Georges Pompidou, Bibliothèque Kandinsky)

465 Alberto Giacometti, *Drawing V, July 5, 1954*, drawing from *Six Studies of Henri Matisse* (Collection Mme A. Giacometti)

COLOUR PLATES

1. Matisse, *Nymph and Satyr*, oil on canvas, 1908–9 (Copyright © The State Hermitage Museum, St. Petersburg)

2. Matisse, *The Girl with Green Eyes*, oil on canvas, 1908 (San Francisco Museum of Modern Art. Bequest of Harriet Lane Levy. Photograph: Don Myer)

3. Matisse, *Seated Nude*, oil on canvas, 1909 (Musée de Grenoble. Bequest Agutte Sembat, 1923. Photograph © Musée de Grenoble)

4. Matisse, *Dance (II)*, oil on canvas, 1910 (Copyright © The State Hermitage Museum, St. Petersburg)

5. Matisse, *Music*, oil on canvas, 1910 (Copyright © The State Hermitage Museum, St. Petersburg)

6. Matisse, *Seville Still Life*, oil on canvas, 1910–11 (Copyright © The State Hermitage Museum, St. Petersburg)

7. Olga Meerson, *Henri Matisse*, oil on canvas, 1911 (Private collection/Photograph: Nicholas Spurling)

8. Matisse, *The Pink Studio*, oil on canvas, 1911 (Copyright © The State Pushkin Museum of Fine Arts, Moscow/The Bridgeman Art Library, London)

9. Matisse, *The Painter's Family*, oil on canvas, 1911 (Copyright © The State Hermitage Museum, St. Petersburg)

10. Matisse, *The Red Studio*, oil on canvas, 1911 (The Museum of Modern Art, New York [MoMA]. Mrs. Simon Guggenheim Fund. 8.1949. Digital image © 2003 The Museum of Modern Art, New York/Licensed by SCALA, Florence)

11. Matisse, *Interior with Aubergines*, distemper on canvas, 1911 (Musée de Grenoble. Donated by artist, 1922. Photograph © Musée de Grenoble)

12. Matisse, *The Conversation*, oil on canvas, 1908–12 (Copyright © The State Hermitage Museum, St. Petersburg)

13. Matisse, *Palm Leaf, Tangier*, oil on canvas, 1912 (Chester Dale Fund, Image © 2004 Board of Trustees, National Gallery of Art, Washington, D.C. Photograph: Lyle Peterzell)

14. Matisse, *Goldfish*, oil on canvas, 1912 (Copyright © The State Pushkin Museum of Fine Arts, Moscow/The Bridgeman Art Library, London)

15. Matisse, *Moroccan Café*, distemper on canvas, 1912–13 (Copyright © The State Hermitage Museum, St. Petersburg)

16. Matisse, *Interior with a Goldfish Bowl*, oil on canvas, 1914 (Centre Georges Pompidou–MNAM–CCI, Paris. Photograph © CNAC/MNAM Dist. RMN/Jean-Claude Planchet)

17. Matisse, *Goldfish and Palette*, oil on canvas, 1914 (The Museum of Modern Art, New York [MoMA]. Gift and Bequest of Florene M. Schoenborn and Samuel A. Marx. 507.1964. Digital image © 2003 The Museum of Modern Art, New York/Licensed by SCALA, Florence)

18. Matisse, *The Moroccans*, oil on canvas, 1915–1916 (The Museum of Modern Art, New York [MoMA]. Gift and Bequest of Florene M. Schoenborn and Samuel A. Marx. 386.1955. Digital image © 2003 The Museum of Modern Art, New York/Licensed by SCALA, Florence)

19. Matisse, *Bathers by a River*, oil on canvas, 1909, 1913 and 1916 (Charles H. and Mary F. S. Worcester Collection, 1953.158. Image © The Art Institute of Chicago)

20. Matisse, *French Window at Nice*, oil on canvas, 1919 (© The Barnes Foundation, Merion, Pennsylvania/The Bridgeman Art Library, London)

21. Matisse, *The Moorish Screen*, oil on canvas, 1921 (Philadelphia Museum of Art. Bequest of Lisa Norris Elkins, 1950)

22. Matisse, *Nude with Goldfish*, oil on canvas, 1922 (Courtesy of Mr. and Mrs. Thomas Gibson)

23. Matisse, *Decorative Figure on an Ornamental Ground*, oil on canvas, 1925–26 (Centre Georges Pompidou–MNAM–CCI, Paris. Photograph © CNAC/MNAM Dist. RMN/Adam Rzepka)

24. Matisse, *The Fall of Icarus*, cut-paper collage, frontispiece to *Verve*, no. 13, E. Tériade Editeur, Paris, 1945 (© Fonds Malraux, Paris. Centre Georges Pompidou, Bibliothèque Kandinsky)

25. Matisse, *Tristesse du roi*, cut-paper collage, 1952 (Centre Georges Pompidou–MNAM–CCI, Paris. Photograph © CNAC/MNAM Dist. RMN)

PREFACE

~

One of the oddest things about Henri Matisse is that he has had no biography until now, fifty years after his death. The work has been left to speak for itself, which should have meant that the life recedes into the background, remaining insignificant and largely unknown. In practice, something more like the opposite has happened. The blank pages of Matisse's life have been filled in over the past half century with half-truths, misconceptions and downright fabrications, many of them now so deeply embedded in art-historical culture that they seriously distort the ways in which people look at his paintings.

"If my story were ever to be written down truthfully from start to finish...," Matisse wrote in retrospect, "it would amaze everyone." It has certainly amazed me. The popular image of Matisse bears little relation to the character who slowly emerged from my ten years' research. Key facts about the life confidently accepted as self-evident in previous accounts have frequently turned out to be nothing of the sort. Interpretations of the work based on these supposed facts need to be reexamined. This biography attempts to realign Matisse's life and work within a more accurate framework that contradicts at crucial points the myths too often uncritically accepted as historical reality.

Biography has long been rated a poor relation of art history, but, in this case, a strict application of the rules of evidence is long overdue. I will instance two standard assumptions, both false, both of which have restricted or undermined understanding of Matisse's work. The first concerns his supposedly exploitative relationship with the women he painted. The proposition that the painter automatically slept with his models has become an unquestioned tenet of Matisse scholarship, taken for granted long before it was first explicitly stated (by J. D. Flam in his groundbreaking *Matisse: The Man and His Art* in 1986). I began by taking it for granted

myself, but no first-hand testimony or documentation has ever been produced to back up this notion, nor have I been able to find a shred of evidence to support it. On the contrary, rigorous biographical scrutiny points to very different conclusions. It is not my role to deal with the sexual, moral and political theories posthumously erected on this basic misconception, only to point out how strongly it has coloured attitudes to Matisse's work, especially to the paintings he produced in Nice in the 1920s and '30s, which remain to this day largely misrepresented and neglected.

My second example concerns a further set of baseless but damaging allegations about Matisse's behaviour in World War II. The popular image of the painter indulging himself among the fleshpots of Nice in wartime will not stand up to even cursory inspection. For one thing, the whole area lay under imminent threat of invasion from Italian forces in 1940, and again from Allied armies in 1943–44. Matisse spent many months under bombardment in or just behind a military zone on pre-alert. His situation was complicated in January 1941 (a few weeks after his seventy-first birthday) by an emergency operation he was not expected to survive, which put him at grave risk for the next twelve months, and left him an invalid for the rest of his life. Rumours that he had dealings with the Nazi regime in France are based on a misreading both of the historical context and of the painter's personal circumstances. These and many comparable blurrings or falsifications are documented in detail in the relevant sections of my text and endnotes. All of them crucially modified reactions to Matisse as a painter. The longstanding, at one time almost universal, dismissal of one of the greatest artists of the twentieth century as essentially decorative and superficial is based, at any rate in part, on a simplistic response to the poise, clarity and radiant colour of Matisse's work that fails to take account of the apprehensive and at times anguished emotional sensibility from which it sprang.

My attempt to clear away prejudice and preconception could not have been fully documented without drawing on the extraordinarily rich and revealing correspondence preserved in the Matisse Archive in Paris. Matisse himself was a vivid, frank and lucid correspondent, who for the greater part of his long life set aside an hour or more each day for keeping in contact by post with family and friends. Only a minute portion of these letters (principally those to and from three fellow artists, Pierre Bonnard, Charles Camoin and André Rouveyre; the collector Sergei Shchukin; and the Dominicans, Father M. A. Couturier and Brother L. B. Rayssiguier, during the construction of the chapel in Vence) has so far been published.

The family correspondence remains an unrivalled and as yet largely untapped resource. Matisse wrote regularly to his wife, sending letters that amounted to a detailed daily journal whenever the couple was separated for any length of time, up to and including his visits to Tahiti and the United States in the early 1930s. The Paris Archive also includes his letters to and from other members of the family, principally his daughter Marguerite Matisse Duthuit, as well as the many letters exchanged by members of the family. A further thirty years of intimate and moving correspondence between Matisse and his son Pierre has recently been lodged with the Pierre Matisse Papers in the Pierpont Morgan Library in New York.

I owe an immeasurable debt to Matisse's heirs—Claude Duthuit, Gérard Matisse, Jacqueline Matisse Monnier, Paul Matisse and Peter-Noel Matisse—who allowed me unprecedented and unrestricted access to these letters, and permitted me to quote freely from them. I am profoundly grateful for their generosity and confidence. Where my interpretation differs from theirs, they left me at liberty to disagree, and the responsibility for any consequent errors, large or small, in proportion, emphasis or detail, is mine alone.

My deepest thanks go also to the late Gaetana Matisse, and the late Marie Matisse, both of whom helped me unreservedly. For longstanding moral as well as practical support, I thank especially Claude and Barbara Duthuit, Jacqueline Matisse and Paul and Mimi Matisse. My next great debt is to Georges Matisse, who presided over my long labours in the Matisse Archive with inexhaustible patience, kindness and efficiency. Wanda de Guébriant has been for me, as for all other users of that archive, an incomparable source of insight, advice and information.

I was also fortunate enough to work regularly with the late Lydia Delectorskaya in Paris in the last five years before she died in 1998. She put her knowledge, memory and meticulous records at the disposal of writers and scholars over three or four decades, enriching key books from the two volumes of Louis Aragon's *Matisse: A Novel* in 1968 to Hanne Finsen's magisterial edition of the *Matisse Rouveyre Correspondance* in 2001. My book is the last in a long line to benefit from the collaboration of Mme Lydia, and I am truly grateful.

I have recorded elsewhere how much I owe to the unfailing support of Matisse scholars, but I should like to renew here my thanks to J. D. Flam and Dominique Fourcade, and to record a special debt to John Elderfield, who put at my disposal the prodigious research archive amassed by the late Judith Cousins for the Museum of Modern Art in New York. In Paris, my thanks go above all to Rémi Labrusse and Paule Laudon; in le Cateau-

Cambrésis to Dominique Szymusiak, director of the northern Matisse Museum; and in Nice, to Marie-Thérèse de Pulvenis, director of the Matisse Museum in the South at Cimiez. I am also grateful to Catherine C. Bock-Weiss, Olive Bragazzi, Alessandra Carnielli, Lily Farkas and Margaret Loudon of the Pierre Matisse Foundation, John Caumann, Jack Cowart, John Klein, Isabelle Monod-Fontaine and Claude Laugier of the Musée Nationale d'art moderne in Paris, Kaspar Monrad of the Statens Museum fur Kunst in Copenhagen and Robert Parkes of the Pierpont Morgan Library in New York. I thank most particularly Doreen Bolger and Jay M. Fisher, respectively director and curator of drawings at the Baltimore Museum of Art; and Agnès Barbier, director of the Musée de la carte à jouer, Issy-les-Moulineaux, together with the archivist, Catherine Stouls-Nicolas, and Florian Goutagneux.

Among those who knew Matisse or their descendants, I have had inestimable help from Tamara Estermann, Paule Caen-Martin, the late Mme Clorinde Landard and Edward T. Cone. I renew my gratitude for continuous unstinting help to Natalya Semenova in Moscow, and to Georges Bourgeois in Bohain-en-Vermandois. I should also like to thank Isabelle Alonso, the late Quentin Bell, Claude Bernès, Cornelia Bernini of the Thomas Mann Archive, Zurich, Dr. Stanley Blaugrund, Professor Ashley Brown, Dr. William Chapman, Aldo Crommelynck, Sharon Dec, Philip French, Angelica Garnett, John Golding, Catherine Graham, Marie-José Gransard, Irus Hansma, Steven Harvey, Peter Kropmanns, Jacques Poncin, Karl Pringsheim, Brenda Richardson, Kathy Robbins, Rona Roob, Dorothy Rowe, the Lady Pauline Rumbold, John and Rosamond Russell, Richard Shone and David Thompson.

My best thanks go to all those who sheltered me during the research for or writing of these pages: Dame Drue Heinz, under whose wing I wrote the first two chapters of volume one at Hawthornden Castle, and the final chapter of volume two at Casa Ecco; Sarah and Robert Mackenzie, Jean-Jacques and Catherine Germond, and Marie-José Donche-Gay for taking me under their respective roofs in Paris; John and Janet Hale in Nice; Richard and Anne Rempel in Canada; Ian and Lydia Wright in Islington; and above all, for princely hospitality over ten years in New York, to the inimitable Ellen and Arthur Wagner. Rachel Packer and Nat Spurling provided essential maintenance and technical support. I acknowledge once again with delight and admiration the expertise of my long-suffering editor at Knopf, Susan Ralston, my designer, Iris Weinstein, my indomitable picture researcher, Grainne Kelly and Juliette Mitchell at Penguin. Lastly, I thank those who gave comfort and courage along the way,

especially Carole Angier, Richard Cohen, Michael Holroyd, Bruce Hunter, Diane Middlebrook and—for inexhaustible support over longer than I could have imagined possible when I started out fourteen years ago—John Spurling.

Hilary Spurling
Holloway, London
June 2004

MATISSE THE MASTER

CHAPTER ONE

~

1909: Paris, Cassis and Cavalière

Matisse, *Composition No. 1*, 1909: first sketch of *Dance*, commissioned for Sergei Shchukin's house in Moscow

Returning from Berlin to Paris in January 1909, Henri Matisse got off the train partway to visit one of his few German supporters. He had just said good-bye to his majestic *Harmony in Red*, leaving it behind in a gallery in Berlin, where people said his latest paintings were senseless, shameless, infantile monstrosities or sick and dangerous mes-

3

sages from a madhouse. The French felt much the same. Harmony—the goal Matisse desired more passionately than any other—was the last thing his art conveyed to his contemporaries.

His host at Hagen, a few miles along the Ruhr from Essen, was the collector Karl Ernst Osthaus, who had already bought five works from Matisse and was about to commission a sixth.[1] Osthaus insisted on showing off his latest acquisition, a mosaic design installed in a modern crematorium newly built on an industrial waste site. When they entered the building on a cold, grey, rainy Sunday afternoon they found an organ playing softly in the gloom and a coffin sinking into the ground in front of them. Tired, depressed and deeply shaken by what had happened in Berlin, Matisse lost his usual composure and let out a scream: "My God, a dead body!"[2]

Osthaus explained that the body was a fake, part of a public relations exercise put on to counter the local workers' instinctive mistrust of cremation. But Matisse could not forget it, and often marvelled afterwards at the strange way Germans chose to amuse themselves on a Sunday afternoon. He had a second shock when he got home and received a parcel from Germany containing what looked like a gigantic funeral wreath. In fact, it was a wreath of bays posted by a young American admirer, Thomas Whittemore of Tufts College, to console Matisse for the failure of his Berlin show. Trying to lighten her husband's nervous tension, Mme Matisse tasted a bay leaf ("Think how good it will be in soup"), and said brightly that the wreath's red bow would make a hair ribbon for their fourteen-

Matisse, *Nymph & Satyr*, 1907–08: a relatively tame early version of a theme that preoccupied Matisse at this point

Paul Cézanne,
The Rape
(*The Abduction*), 1867

year-old daughter, Marguerite. "But I'm not dead yet," Matisse said grimly.[3]

The work Matisse stopped off to see in Hagen was his own *Nymph & Satyr*. It was a relatively conventional set of three ceramic panels showing a stocky muscular nymph doing a stamping dance, then falling asleep and being tentatively approached by a hairy, hopeful satyr enclosed in a frieze of grapes and vine leaves. In January 1909, Matisse had recently completed an oil painting of the same subject (colour fig. 1).[4] This time the satyr (who had been more of a tame faun on Osthaus's glazed tiles) started out with a little beard and pointy ears, but turned into something far more violent and raw. Matisse's final version is unequivocally human: a clumsy, graceless, lustful male advancing purposefully on a naked female huddled with her back turned at his feet. The man's pink, thinly painted flesh is outlined in red, the colour of arousal. So is the woman's, but every line of her expressive body—bent head, drooping breasts, collapsing limbs—suggests exhaustion, helpless weakness and enforced surrender.

This is the mood of Paul Cézanne's *The Abduction* (or *The Rape*), where another masterful naked man carries off another pale, limp, fleshy female.[5] The fierce erotic charge in both paintings is reinforced by harsh colour and rough handling. In Matisse's case, the texture of the paint was itself an outrage. The choppy stabbing brushstrokes, the landscape's crude contours filled with flat scrubby green, the blurry patches round the man's head, crotch, left hand and right knee, all convey extreme disturbance. His picture, like Cézanne's, is both personal and symbolic. Both suggest an image spurting up from some deep, probably unconscious level of the

imagination on a tide of bitterness and rage. Matisse's satyr looks as if he means to strangle his victim with his outsize red hands. Matisse himself said that this was how he always felt before he began a painting.[6]

For him each painting was a rape. "Whose rape?" he asked, startling his questioner (perhaps also himself) with the brutal image that surfaced in his mind during an interview that took place more than three decades after he painted *Nymph and Satyr:* "A rape of myself, of a certain tenderness or weakening in face of a sympathetic object."[7] He seems to have meant that he relied on his female models to arouse feelings that he could convert to fuel the work in hand. He confronted whatever underlay that process head on in *Nymph and Satyr.* The displaced emotion here is at least in part aesthetic. The last time Matisse put classical nymphs into a picture was in 1904 in *Luxe, calme et volupté,* an uneasy experimental composition that led directly to the explosive canvases dismissed by most people the year after as the work of a wild beast, or Fauve. In the winter of 1908–9, Matisse was once again grappling with, and violating, the ancient canons of a debased classical tradition in a canvas that commits pictorial and depicts sexual rape.

This coarse, powerful, primitive painting was earmarked for the Russian collector Sergei Ivanovich Shchukin, a man in process of committing himself as unreservedly as Matisse to liberating painting from the academic tyranny of Beaux-Arts aesthetics. Shchukin was an inordinately successful textile manufacturer with a patchy education and no academic training. People dismissed him, in both Paris and Moscow, as gullible and uncouth, an ignorant boyar who made no attempt to cultivate the refinement that enabled other Moscow merchants to build up more serious art collections. It was Shchukin who had commissioned the *Harmony in Red* currently hanging in Paul Cassirer's gallery in Berlin. Shchukin went to see it there and, unlike the German art world, was powerfully impressed. On 9 January he followed Matisse to Paris to inspect work in hand in the studio, including the *Nymph and Satyr.*[8]

Shchukin took delivery of six Matisse paintings in the month after he got back to Moscow. The painter said that in some ways he came to dread the visits of this particular collector because of his unerring knack for picking out the latest breakthrough canvas and carrying it off, sometimes with the paint still wet. Shchukin grasped at once that *Nymph and Satyr* was an affront to decency and morals, which only increased his impatience to possess it. This new canvas could not easily be displayed in mixed company, let alone in public. It was quite different from the sexy pictures other men kept behind locked doors in their private rooms and cabinets. Its

Maurice Denis,
*Cupid Bearing Psyche
Upward,* 1909: The
only competition
Matisse faced in
Moscow was
Denis's version of
seduction with any
hint of desire or
danger airbrushed
out.

secret kick for a subversive like Shchukin was precisely that it violated every sacred Beaux-Arts precept enshrined in the flawless public nudes that filled the Paris salons.

The contemporary French incarnation of those precepts in the eyes of fashionable Moscow was Maurice Denis. Shchukin himself owned several pictures by Denis, who had once embodied the last word in sophistication for him, too. In January 1909, Denis was making waves in Moscow. He had come to install his latest work in the home of another Moscow merchant, Ivan Abramovich Morozov (who had also made a fortune out of textiles). Morozov, who was Shchukin's close friend and only Russian rival in the field of modern art, had ordered seven huge painted panels telling the story of Cupid and Psyche for his music room.

Denis pictured Cupid as a plump, life-size, naked youth wearing wings to match his predominant colour scheme of pink, green and blue. His Psyche is a solid girl with cushiony breasts, buttocks and hips. The couple's sturdy build adds to the absurdity of their chaste embrace as they dangle cheek to cheek in midair with nothing touching below the waist. The décor of Cupid's palace with its garden ornaments, mauve silk drapes and floral sprays is more reminiscent of an expensive modern florist than of ancient Greece. This is seduction with any hint of desire or danger airbrushed out. It went down well on its first showing at the Paris Autumn Salon, and it made an even bigger splash in Moscow. So much so that Morozov, who was thinking of hiring Matisse to decorate his dining room, dropped the idea in favour of commissioning six more panels from Denis.[9]

It was Shchukin instead who commissioned wall paintings from

Matisse. The painter never forgot the lunch at the Restaurant Larue in Paris where the pair of them together hatched a plan to end all blue-pink-and-green decorative schemes peopled with dancing nymphs and piping fauns. Matisse's *Dance* and *Music* grew from their conversation at this lunch. "I hope that when they see your decorations, the tumult of admiring cries to be heard at present will die down a little," Shchukin wrote in May, describing the fuss over Denis's *Psyche.* "At present they talk of it as a great masterpiece. They laugh at me a little, but I always say, 'He who laughs last, laughs best.' I trust you always."[10]

Nymph and Satyr, one of the starting points for the new scheme, was finished, crated up and posted off to Moscow in early February.[11] By this time, Matisse had left Paris for the Mediterranean coast. He planned to spend a month at the little Hotel Cendrillon in Cassis, replenishing the stocks of energy depleted by the gloom and strain of a Parisian winter. Walking along the steeply shelving shore at Cassis and in the chestnut woods on the cliff top, he studied air, water, light, sun glinting on spray, waves pounding on rocks as he had done further along the coast at Collioure four years earlier. "There is . . . a cove near Cassis," wrote Marcel Sembat, who spent a day with Matisse in early March, "where the green of the open sea on the horizon brings out the deep blues and foamy whites of the tide trapped between cliffs, which you can see jostling and throwing up little blade-like crests in the full sun."[12]

Movement preoccupied the painter in the run-up to *Dance.* Sembat was struck by the intensity and accuracy of Matisse's response to the violent swirling currents, "the clash of creative contrasts we talked about together." Sembat, seven years older than Matisse, married to a painter and himself a passionate art enthusiast, was an exceptionally acute and attentive witness. By his own account he was living out a dream that day in Cassis, having brought with him one of his lifelong heroes, the great reforming architect of the Third Republic, Jean Jaurès. The Socialist leader and his two companions walked and talked beside the sea, delighted with one another, with the brilliant spring sunshine, and with the infectious visual excitement emanating from Matisse at the end of his month in the country. They rounded off their morning over lunch at the hospitable little village inn. Sembat wrote the day up in his diary and returned to it again a decade later, leaving no doubt that, for him at least, there was something magical about this unlikely encounter between two great French stars, one rising fast, the other soon due to set forever.

Sembat's writings provide some of the sharpest and most lucid testimony to Matisse's progress in the decade leading up to the First World

War. The two first met, probably, through Georgette Agutte, Sembat's wife, who had belonged loosely to the same little knot of painters as Matisse in their student days. But they had an even earlier point of contact through Matisse's wife, Amélie, whose father, Armand Parayre, knew Sembat from the start of his career. As a newly elected Socialist deputy writing leaders for Parayre's radical campaigning newspaper, Sembat had belonged to the generation of up-and-coming Republican politicians who, unlike many of their elders, managed to leap clear of the sensational Humbert scandal which all but destroyed Matisse's in-laws in 1902. Parayre himself survived public ignominy, imprisonment and a dramatic trial with the help of his young son-in-law (this was the first if not the last time Matisse had reason to be thankful for the brief training as a lawyer forced on him by his own father).[13]

Amélie Matisse emerged, like her father, apparently unscathed from her family's terrifying ordeal. (Her mother, who never got over it, died prematurely in 1908.) But the affair left Amélie with a deep-seated horror of any kind of exposure, and a lasting suspicion of the outside world. It reinforced her self-reliance, her stubborn pride and her almost reckless indifference to what other people thought. Beneath the demure and unassertive manner that was all she showed to those who didn't know her, Amélie was, by the standards of her class and age, profoundly unconventional. Her marriage had been a gamble in which money, security, social advantage played no part. She became her husband's eager partner in a high-risk enterprise neither ever truly doubted would one day succeed. She had recognised what was in him at sight, and backed her instinct unreservedly ever after.

At times, when Matisse found himself disowned not only by the professional art world but by most of his fellow artists too, his wife remained virtually his only backer. Mutual trust was the core of their relationship. "The basis of our happiness . . . was that we built up this confidence quite naturally from the first day," Amélie wrote long afterwards to Marguerite. "It has been for us the greatest good and the envy of all our friends, it meant we could get through the worst of times."[14] The two did everything together. Almost from the day they met, they were known as the Inseparables.[15] The four weeks Henri spent in Cassis was probably the longest time they had been parted since their marriage eleven years before. The studio was the centre of their world, and it was her province as much as his. Henri and his painting gave Amélie's life its shape and meaning. Hardship and privation hardly mattered by comparison; nor did the rising tide of mockery and abuse that accompanied Matisse's growing fame.

Even the arrival of their children hadn't greatly changed their way of life. When it came to a choice, work took precedence over child care. Their elder son, Jean, grew up as much at home with his Matisse grandparents in the north of France as with his parents in Paris. The younger boy, Pierre, spent so much time in the south with his Parayre grandfather and Amélie's only sister, Berthe, that his aunt became his second mother. Amélie herself was closer to the boys' older half sister, Marguerite (or Margot), who was Henri's child by an earlier liaison, and who became in some ways a second self to her adoptive mother. It was Marguerite who stayed at home, sharing the life of the studio that meant life itself to the Matisses.

The family dynamics began to shift a little when they finally moved out of Henri's cramped bachelor flat in a block opposite Notre Dame into a disused convent at 33 boulevard des Invalides on the far side of Montparnasse. Money was still tight. After a decade of penury, it was too soon to count on the income beginning to come in at last from enterprising collectors headed by Shchukin (who would in fact continue to buy steadily until his trips to Paris abruptly ceased on the outbreak of war in 1914). But at least they seized their chance to reunite the family. The former convent of the Sacré Coeur, split up into studios that could be rented cheaply on a temporary basis to hard-up painters and poets, was still only half full. There was ample space for all of them, and a large overgrown garden full of fruit trees for the Matisse boys to play in.

By the spring of 1909 the couple had spent twelve or fourteen months with all three of their children gathered under the same roof for the first time. Amélie was a strict mother. Living for years in two tiny rooms, one of which was Henri's studio, she knew how to make sure that whichever child happened to be at home remained quiet, polite and unobtrusive. All three were a credit to her training. She was a good cook and an excellent needlewoman, but the role of fulltime housewife was not a part she ever envisaged for herself, or felt comfortable playing. She had been born for higher things.

In just over a decade since she first tentatively posed for her husband on their honeymoon, Amélie had become a capable and experienced studio manager. She saw to everything from keeping the models happy to the ritual washing of the brushes every evening. She made records and organised paperwork. She coped with the distractions that encroached on Henri's time by day, and read to him night after night when the tormenting pressures of his work bore down and stopped him sleeping. She still modelled for him, although other jobs left her less time than in the early

days when he had painted her sewing, sleeping, having her hair done, dressed up in fancy outfits in his Paris studio or naked in the foothills of the Pyrenees behind Collioure (a mountain glade was the only place his wife could take her clothes off for him without intruders popping out from behind the bushes). Amélie had sat for or watched over every one of the paintings that had stunned and confounded almost all who saw them in the four years since the Fauve explosion of 1905.

She could not have done it without help from Margot, who had grown up from birth in her father's studio. Her education had consisted largely of the kind of schooling he would most have liked to have had himself: looking at and thinking about painting. At fourteen, she was already a practised model, and an increasingly efficient housekeeper. From a small girl she had helped with shopping, cooking, cleaning and minding the boys. By the time she reached her teens, she was indispensable. Her parents kept her at home with them partly because they would have found it hard to do without her, but partly also as a precaution. Her health had been a worry ever since she was six years old, when an emergency tracheotomy saved her life but left her at greater risk than her brothers or her more robust contemporaries. She had had to learn to breathe through a tube inserted in her neck with an opening concealed by high-necked blouses or a black velvet ribbon. Margot needed looking after. Meanwhile Jean and Pierre, ten and nine years old in 1909, were fast approaching the age when something would have to be done about finding them a lycée.

Matisse's time at home had other claims on it besides his children. Once his family was settled in what had once been the nuns' parlour at the Sacré Coeur, his school followed six months later. The students occupied a bare, high-ceilinged former refectory divided by a partition from the studio where he worked. In theory he taught only two mornings a week, but

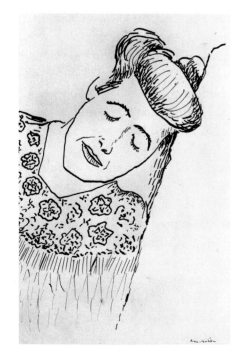

Matisse, *Woman with Closed Eyes*, 1910: Amélie Matisse

his powerful presence behind the screen exerted a pull nobody could ignore.[16] Although Matisse dealt patiently with the students' needs and queries, his wife was not so keen on interference from the crowd next door, who could not be relied on to observe the same discipline as her own children.

Matisse now found himself surrounded by followers only too eager to sit at his feet and hang on his every word. His American contemporary, Sarah Stein—sister-in-law to the collectors Leo and Gertrude—acted as unofficial class president, seeming sometimes in her unconditional devotion and proselytising enthusiasm more like a high priestess. Mrs. Stein wrote down everything Matisse said. She was one of a handful of older students trusted to work alongside him in the afternoons, but the studio itself was vulnerable to intruders who assumed a teacher to be on tap at all times. In their early years together, Henri and Amélie had lived and worked on a subsistence income in a mood of exhilarating, stern and serious dedication. Those days were gone for good, and with them the old heroic simplicity and certainty that had been the initial basis of their marriage.

Matisse's school had begun as a painting class for a few friends, and friends of friends, whose admiration for their teacher was fond, protective and tinged with awe. But word that tuition was free soon got round the foreign colonies of Montparnasse. In 1908, at the beginning of the school's second season, numbers exploded. Students poured in that

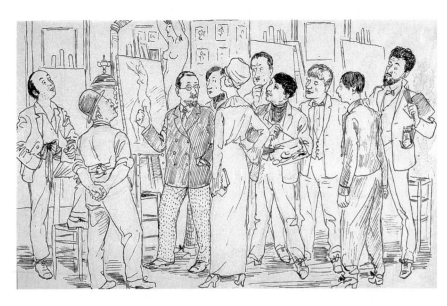

Arvid Fougstedt,
*Matisse Teaching
Scandinavian Artists in
His Studio,* 1910

autumn from all over Europe and America. Scandinavians were quickest off the mark, accounting for roughly half Matisse's pupils by the end of 1909. Most of them had been alerted, directly or indirectly, by Birger Simonsson, the first Swede to bring news of Matisse's paintings back from Paris three years earlier. The impact on the art schools and summer painting camps of Stockholm, Oslo and Copenhagen was described by a contemporary, who made Simonsson's summons to cross the sea sound like the start of a Norse fairy tale:

> His "fulmer calls" amazed us. We were annoyed. We were bewildered and enchanted. Strange new names buzzed in our ears: Greco, Cézanne, van Gogh, Matisse.... One after the other, gradually more and more, we went out to see the unknown which tempted and attracted us.[17]

Newcomers were often taken aback to find Matisse exhibiting none of the symptoms of a visionary, let alone a wild beast. He no longer loped about the streets, as he had done a little earlier, in a black sheepskin coat worn shaggy side out. As his paintings grew bolder and more disturbing, his dress and manner became quieter and more restrained (Hans Purrmann, the class monitor, who knew Matisse better than the others—and who had been thoroughly embarrassed by the sheepskin coat—correctly diagnosed his sober classroom manner as a protective covering).

Matisse's teaching was practical and constructive. He had no set programme or preconceptions. His critical analyses were simple and direct. He could explain the most difficult concepts in terms that made them seem easily intelligible ("As a German I was amazed," wrote Purrmann, who had been used to high levels of obfuscation and specialist art jargon in his own country).[18] The one thing he could not stand was showing off in paint. Anything flashy, meretricious or exaggerated had to be identified and cut out. Matisse came down always on the side of close observation and strict truth to what he called the observer's "first emotion,"[19] or primary response. The students who wrote about the school afterwards all ended up, sometimes to their own surprise, by agreeing with another Swede, Edward Hald: "He personified French clarity and order."[20]

Matisse's classes wore him out. Sometimes, when he came home across the garden afterwards, he could no longer see straight.[21] The trouble was that he treated all his pupils equally, applying himself to sorting out the difficulties of even the least gifted with the same concentration he brought to his own struggles on canvas. His student days were too recent

for him to have forgotten how it felt to be a young painter newly arrived in Paris, cold, hungry, bewildered and desperate for instruction. Some of his students were so short of money they were said to eat the bread balls that the others used instead of rubbers to correct their drawings. Isaac Grunewald spent the evenings of his first Parisian winter dancing in the cheap dance halls of Montmartre sooner than sleep in his own wretched lodgings, where ice formed inside the broken windowpanes. When the nightclubs closed and stragglers were evicted, he would walk the four or five miles back downhill to the Seine and up again to Montparnasse, waiting on the street for a friendly waiter to open the Café Versailles at six o'clock and let him sleep on a banquette for a couple of hours so as to be ready for the start of morning class at eight.[22]

Life was hard for the men but harder on the women, who were outnumbered in the school by five to one. They had less freedom and faced more obstacles than their male contemporaries. No matter how poor they were, female students could not wander the streets alone or sleep on café benches. Decent landladies were suspicious of single women without the protection of male relatives or guardians. Most art schools refused them entry. Older men in general, and artists in particular, were their natural predators. Matisse's school was under constant attack at this point on snobbish, racist and educational grounds (people accused him of peddling pretentious rubbish to a low-grade audience of gullible foreigners), but his harshest detractors never thought of questioning his morals on this score.

His supporters even managed to persuade friends to put their daughters in the school. Shchukin, who introduced Léopold Survage in January 1909, followed this first success by sending along several respectable young women, including one of his own nieces.[23] Matisse's American friend Sarah Stein did the same (American mothers drew the line at letting him paint their daughters' portraits, but that seems to have been because they feared that what he might paint—rather than anything he might do—would compromise their reputations).[24]

The school still had something of its original family atmosphere at the beginning of 1909. One of the American students, Patrick Bruce, had moved into the convent the year before with his wife and baby, whose pram was parked beneath cherry and apple blossoms in the garden. Birds sang outside the school's tall windows. Students painted indoors and out. Several of them settled into studios of their own scattered among the convent buildings. There was a Norwegian painter in the nuns' living

quarters, and a Spanish sculptor in the chapel. The Bruces lived above the Matisse family on the first floor of the old visitors' block, which they shared with Hans Purrmann. On the top floor, tucked away in a large, light, airy space under the roof, were a couple of Russian girls who had arrived separately, unannounced, with no apparent backing and nothing to live on but their wits.

One was the young Maria Ivanovna Vasilieva, who turned up at Matisse's door sometime in the winter of 1908–9 on the strength of having seen his work at the Autumn Salon. She had left behind a solid bourgeois family of teachers, engineers and lawyers in St. Petersburg, making her way to Paris via Munich (where she cropped her hair and handed out revolutionary pamphlets on the street). Vasilieva was extremely small, and as forceful as she was intrepid. Even in those days she had the determination and the battering-ram persistence that powered an impressive subsequent career as Marie Vassilieff, the Mother Courage of the Parisian avant-garde between the wars.

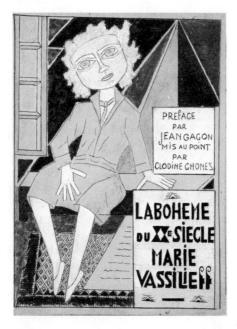

Marie Vassilieff, *La Bohème du XXe siècle,* self-portrait, 1929: Vassilieff ten years after she first entered Matisse's class

But in her own eyes Vassilieff at twenty-five was still innocent, guileless and "beautiful as a Madonna." She took to Matisse at once because of his red-gold beard, his rimless glasses and his firm handshake. " 'He looks Russian,' I thought. 'You could easily take him for a doctor or a teacher from Petersburg.' "[25] She was disconcerted but not cowed by his professional artist's trick of undressing her with his eyes. "He looked me over like a connoisseur, and I sensed he was seeking out 'the nude' in my diminutive young body. Thoroughly intimidated, red as a tomato, I stared back at him."

Matisse fixed her up with a room in the attic for next to nothing ("You come from Russia, you're young, artificial heating is only a habit," he said briskly when she complained that it was unheated). Vassilieff, who supported herself in part with journalistic odd jobs, set about translating his "Notes of a Painter," which had come out in France the previous

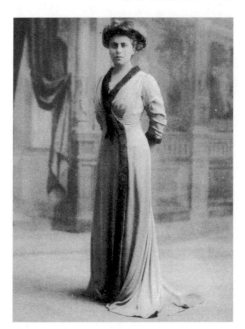

Olga Meerson in
Paris at the time of
her first meeting
with Matisse

December. She peppered
Matisse with questions and
requests for illustrations.
Another student remembered
her hanging on to his coat
buttons when he tried to get
away. When his "Notes"
appeared in Moscow's avant-
garde news sheet, the *Golden
Fleece*, in June, Vassilieff,
according to her own indig-
nant account, found the edi-
tor had passed off her
translation as his own.[26]

The fellow student who
shared the attic with her was
Olga Markusovna Meerson,
six years older than Vassilieff
and already an established
artist.[27] Olga was a Russian Jewess with high cheekbones, a shapely figure,
creamy white skin and a mass of bright, rich auburn hair. Her personality
was as striking as her looks. Pat Bruce and Gertrude Stein, both of whom
resented the stir she caused, nicknamed her "Mlle Russia." She had moved
into the convent at the start of the summer of 1908, staying on in Paris for
most of the school holidays when Matisse was shut up alone in his studio,
working furiously to finish the *Harmony in Red* while his wife tended her
dying mother in the south of France. Their meeting proved a turning
point for Meerson, and faced Matisse with a decision which would come
back to haunt him later.

He was dubious about her to start with. Meerson was a highflier who
had just won warm approval with half a dozen vivid and confident pic-
tures at the official Paris Salon. Matisse said she had a rare gift for por-
traits: "She combined with this ability to catch a likeness, a rich feeling for
colour and a generous sense of design, the kind of manner, derived from
both the English and the Spanish schools, which has made the reputation
of leading painters from the Salon of the Champ de Mars [once a break-
away outfit but now almost as conventional as the original Salon], and
which is much appreciated in fashionable circles."[28] Given the circum-
stances, this was damning with high praise. Matisse himself had been a
few years younger than Meerson when he, too, had his first success at the

Champ de Mars in 1896. A lucrative career would have followed if he hadn't discovered Impressionism and launched himself on a course that broke all the rules of taste and decency. This was precisely what Meerson had in mind for herself: "She wasn't happy, she told me, with her work even though it had many admirers and could have made her a fine portraitist. . . . I pointed out to her how much she already possessed, and how much she stood to lose by leaving the officially approved path in order to work towards creating a means of individual expression of her own."

Meerson insisted that she wished to place her future in his hands. She was thirty-one years old, and the new world Matisse had opened represented for her the end of a ten-year search. He remained unconvinced, dwelling with relish on the public's bottomless appetite for flattery and reassurance that she was perfectly equipped to serve. In the end he agreed to accept her as a pupil only on condition she took a fortnight to reconsider her position. Meerson duly thought about it, and moved in two weeks later.

The academic training she now proposed to discard had been rigorous and thorough. She had been accepted by the prestigious Moscow School of Art at the age of thirteen, which would have been highly unusual for a boy and was virtually unheard of for a girl, let alone a Jewess.[29] Stringent racial laws ensured that few Jews had access to higher education in Russia. Olga's father was a merchant of the second class, one of a limited number of prosperous Jewish businessmen licensed to move in from beyond the pale of Lithuania to Moscow. The Meersons, who were clever, cultivated and highly musical, thrived in the capital. Olga's older brother preceded her at the Moscow art school, her two married sisters respectively sang and played the piano to professional standards. She was the youngest and artistically the most ambitious of them all. In 1899, after eight years' study in Russia, she left at twenty-one to become one of the first wave of pioneering Russians to settle in Munich, then second only to Paris as a modernist art capital.[30]

The Russian colony in Munich congregated round Wassily Kandinsky, whose famous Phalanx Class was run in its first year by Meerson as class monitor. Kandinsky painted her in 1902, and dedicated to her one of the rough vigorous little landscapes that, he said, he dashed down while "drunk on nature."[31] Meerson, when she first reached Munich, was herself a refined and subtle traditionalist. She made tiny touching portraits of her friends, Thomas Mann's wife, Katia, and Katia's brother, Eric Pringsheim:[32] exquisite likenesses of jewel-like brightness and clarity, built up on sections of enamel with minute brushes in strokes so fine as to be barely

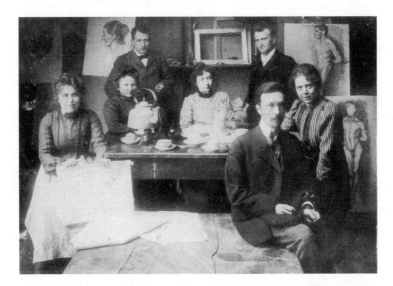

Kandinsky's Class in the Phalanx School, Munich, 1902: Olga Meerson as class monitor on far left with Vassily Kandinsky seated in front at right

visible to the naked eye. She must have been one of the last people to master the art of the Elizabethan miniaturist, which was definitively superseded by photography over roughly the same period.

This kind of outmoded expertise had no place in the art of the future endlessly debated in the Munich circles that revolved round Kandinsky and his closest ally, Alexei Jawlensky. All agreed that the new vision they were seeking could only come from France. In 1905, Meerson set off at the same time as Jawlensky and his companion, Marianne Werefkin, to spend the summer painting in Brittany,[33] reaching Paris just in time to catch up with the Fauve commotion that autumn. When her companions returned to break the news in Munich, Meerson stayed behind, supporting herself (as Matisse had done before her) by selling copies of old masters in the Louvre. She copied Poussin (as he had done), while simultaneously trying to loosen and unravel the academic disciplines that regulated her own style.

Meerson's circle of émigré friends in Paris included the Efrons, a family of exiled revolutionaries whose daughter, Lilia, became her closest friend (Lilia's brother Sergei, whom Meerson also knew, married Marina Tsvetaeva, later one of Soviet Russia's greatest dissident poets).[34] Lilia herself was an actress, part of the theatrical crowd currently overturning standard assumptions about drama and staging at the Moscow Art Theatre. Meerson painted one of MAT's experimental young directors, Feodor Komisarjevsky (who would emigrate after the Revolution to England, where he introduced the work of Anton Chekhov in a season that changed

the face of British theatre). In the first decade of the new century, Meerson and her friends were part of a tidal surge of innovation sweeping Europe in poetry, plays and painting.

Kandinsky himself followed her to France in 1906 to find out what was going on. Meerson visited him in lodgings at Sèvres with another of his Russian students from the Phalanx school, Elisaveta Ivanovna Epstein. Kandinsky's companion, Gabriele Münter (also an ex-Phalanx pupil), joined the other two in Paris, taking a room at 58 rue Madame, directly above the studio belonging to Sarah Stein which was the best place in the capital to see Matisse's paintings.[35] The canvases Kandinsky produced during his year in France showed no overt reaction to the Fauves he had come to see. His dark congested work in progress looked dismally old-fashioned to one of Matisse's pupils, who called on him in Sèvres with Münter. Kandinsky returned to Munich to spend the summer of 1908 painting with Münter, Jawlensky and Werefkin at Murnau (a lakeside retreat discovered two years before by Meerson). It was only after the momentous breakthrough the four of them achieved at Murnau that Kandinsky would come to rank Matisse among the greatest of living painters; and it was through Münter, who first grasped its implications, that Matisse's pictorial revolution reached the other three.

Meerson in Paris meanwhile had finally persuaded Matisse to accept her as his pupil. She personified the pride, courage and resilience that he responded to all his life at the deepest instinctual level in his female models. Meerson's friend Lisaveta Epstein embodied something similar for Thomas Mann. She was the model for Lisaveta Ivanovna, the painter who stands for everything bold, frank and free in *Tonio Kröger*.[36] Hard up, single, self-supporting, having cut loose from her native country in order to find her own way in another without social constraint or family ties, Mann's Lisaveta is the archetypal outsider. Like Epstein and Meerson, she belongs to a new breed of young woman abroad in Europe in increasing numbers at the turn of the twentieth century, the sort of self-reliant single girl whose forerunners figured as heroines in Henry James's novels of the 1880s and '90s, and whose successors would be transposed into a different fictional key in the 1930s by Jean Rhys.

In Paris before the First World War Matisse painted an astonishing sequence of this kind of young woman: *The Girl with Green Eyes, The Algerian Girl, The Spanish Girl with a Tambourine, Girl in Green, Girl with Tulips.* The sitters included professional models, and any young female friend or visitor prepared to let him paint her. The first was his student Greta Moll, in 1908. Two years later he painted his daughter, Margot, wearing a pinafore

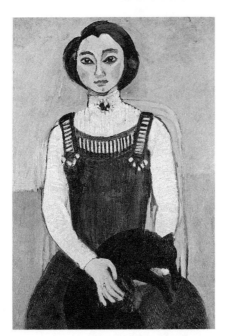

Matisse, *Girl with Black Cat (Marguerite Matisse)*, 1910

dress and stroking a big black cat. In between came a series of extraordinarily varied experiments on the same simple formula. The sitter in each case is portrayed full-face, head-on at three-quarter length against a flat, coloured, sometimes elaborately patterned background. The effect, still brilliant today, was electric then.

These portraits struck contemporaries as uncouth, outlandish and exceedingly offensive. Most people could make no sense of their thick black brushstrokes outlining what appeared to be an ugly jumble of patchy, strident, high-pitched colour. *Girl with a Black Cat* hung in Sarah Stein's apartment and horrified her visitors. *Girl with Tulips*—a soberly dressed young woman in a black skirt and plain shirtwaist, twisting her hands shyly in her lap—looked crazy to the Muscovites who first saw her in Shchukin's house. *The Girl with Green Eyes* (colour fig. 2) became a byword for grotesquerie when shown in Paris in the spring of 1910. It would be the most virulently attacked of all the pictures in the notorious Post-Impressionist show at the end of the same year in London (this was the only one of these Jamesian portraits actually seen by James himself, though he remained obstinately silent when pressed to say what he thought of it).[37]

Roger Fry, who organised the show, energetically defended *The Girl with Green Eyes* in terms of its abstract linear design and effective colour harmony. But even he could make nothing of it as a likeness ("Regarded as representation pure and simple, the figure seems almost ridiculous").[38] It took nerve to sit for Matisse in those days. "Your courage astounds me!" wrote one of Fry's English associates to an American girl Matisse hoped to paint. "Are you able to drink of the double cup—the advice of your friends who would dissuade you before being painted, and their laughter afterwards?"[39] The girl in question turned Matisse's proposal down for fear she might end up looking like his daughter in *Girl with a Black Cat*.

Nice girls did not pose for paintings that would turn them into public

targets to be insulted in the newspapers, sneered at by their friends and pointed out as ridiculous or worse by pitying strangers in the street. Initial fright and shock were universal, whether among art adepts like Fry or comparative innocents like the young New York schoolteacher Inez Haynes Irwin, who never forgot the excitement of what she called "Fauve hunts" on her first trip to Paris in 1908. "It delights me," Irwin wrote on rereading her Paris diary nearly half a century later, "to read now how soon the new school of painters who, at first, irritated, amazed and fairly disgusted me, converted and thrilled me ultimately."[40] Much the same was true of the fashionable sophisticates who responded to Matisse's first New York exhibition by inventing a paint-and-paper game, named after him, in which the players competed to see who could come up with the weirdest combination of coloured sploshes.[41]

Matisse himself was reluctantly obliged to accept that the reactions his pictures provoked in the first people to see them were pretty much the opposite of the feelings he intended to convey. Emotion was his prime test of authenticity in a painting. He taught his students to discard their elaborate formal training and trust their instincts instead, explaining that even a still life involved affection and respect. They were to paint not so much the fruit and bowls in front of them as the response these objects commanded in the painter. He showed them how tenderly he himself felt towards the taut compact volumes of an African wood carving, the generous roundness of a copper pot, the swelling, tear-shaped belly of a slender vase.[42] He advised them how to analyse and render flesh or cloth without ever losing sight of the human qualities of the hired model on the stand before them.

In his own portraits, the young women whose expressions were once so difficult to decipher now seem to gaze back coolly and with striking confidence at the spectator. Nearly all of them were foreigners, unconstrained by the strict rules that governed French bourgeois wives and daughters. Some were themselves prospective artists, operating autonomously in a world where women were not expected to challenge or respond to men on anything like equal terms. It was their toughness, more even than their youth and innocence, that touched Matisse. There is nothing sensual or ingratiating about these portraits. Independence (and the price that had to be paid for it) is implicit in everything about *The Girl with Green Eyes,* from her unconventional clothes to her straight nose, her thick black brows, her resolute red mouth, the steady look in her eyes and the firm set of her head on its uncompromising columnar neck.

Matisse's female sitters at this stage all suggest the kind of frankness

and directness he first caught in *Woman with a Hat*, the notorious 1905 portrait of his wife "with her face as yellow as a lion's ruff and with shadows on her cheek as green as jungle vines."[43] It was this freakish, feral quality that underlay Picasso's joke about the handful of people prepared to buy his own work before the First World War: "They're not women, and they aren't men either: they're Americans."[44] But even Americans were not yet bold enough to pose for Matisse. He himself was well aware of the risks entailed for the sitters as well as for the painter. In the case of his young German student Greta Moll, Matisse said it was her statuesque aspect, the innate force and dignity of her personality, which he tried hardest to convey. When a second student, the Russian Olga Meerson, posed for him three years later, he painted the vulnerability underlying her wary pose, her tensely folded hands and the erect carriage of her head.

Meerson and her younger compatriot Marie Vassilieff had come further and staked more than his other women pupils. Matisse exhibited alongside the pair of them in 1910 in a remarkable Franco-Russian show held in a studio made famous by the sensational murder of its previous occupant, a minor society painter called Adolphe Steinheil. "The murdered artist probably never saw works of such quality in his studio in his lifetime," wrote the Moscow critic Jacob Tugendhold, reviewing the clay busts and bronzes exhibited by Elie Nadelman, Prince Trubetskoy and "the Russian Rodin," Stepan Erzya. The sculptors were headed by Antoine Bourdelle, and the painters by Matisse himself, making an unequivocal public show of confidence in his two Russian protégées.[45]

"Mlle Vassilieff uses her voluptuous skills to compose portraits of young women with subtle eyes and feline gestures to which the acid colouring of the modern palette gives a charm that offsets the brutality of form," wrote Guillaume Apollinaire. "Mme Olga Meerson has great strength."[46] Vassilieff, nothing if not practical, made the most of Matisse's support, advertising herself as his pupil at the Autumn Salon, and persuading him to help with a fundraising lottery for the newly founded Académie Russe in 1911 (when she was accused of embezzling the funds, she promptly resigned as secretary to found an academy of her own).[47]

Meerson's relationship with Matisse was more disinterested and at the same time more intense. He had warned her on the day they met of the dangers implicit in her admiration for him. That first interview was followed over the next three years by many conversations about art and life, all conducted in the loftiest terms ("The aspirations of her soul are of the noblest," Matisse wrote later).[48] Hans Purrmann described the severe and

painful testing endured by Matisse's students once they had committed themselves to the eradication of stylistic tricks and mannerisms: "He would strip each work down to its bare essence, examine what was left for any trace of individual expression, and then devote himself to clarifying and strengthening this residuum."[49] In the months after she became his student, Matisse spent much time helping Meerson unlearn every skill she had acquired since she entered the Moscow School of Art as a brilliantly precocious child.

He himself was working simultaneously on the *Nymph and Satyr*, a picture that aimed to violate the canons of Renaissance art in its most sacred shape, the nude. Perhaps the two images—the actual girl and the generalised nymph of the classical Western tradition—merged into one. Recent art historians have certainly assumed that Meerson modelled for this painting, largely on the strength of the nymph's ginger hair, which seems flimsy evidence given that Meerson's hair was in fact brown with auburn or chestnut lights (no one has ever suggested she had red eyes, like Matisse's nymph, or for that matter that Matisse himself—who was a red-head—had black hair like the man in his picture).[50] But something is clearly going on in this canvas, which is almost the only place where Matisse confronted actual or intended violence in his work.

Vassilieff's memoirs record a suggestive episode that occurred early in 1909, soon after she came to live in the convent. Matisse (who had moved up from the ground floor to sleep next door to her in the attic on the grounds that he needed air) woke her one spring morning by tapping at the glass door of her room in his pyjamas: "Still fast asleep, wearing nothing but a kimono, I opened the door."[51] When he explained that he had brought the illustrations for her translation of "Notes of a Painter," she asked him to wait while she got dressed. "He stood there in the open doorway looking at my still warm bed, and at me, pretty as I was in those days; and then, all of a sudden, he was gone."

Vassilieff was a first-rate fantasist whose testimony is unreliable, self-serving and recklessly selective. Even so this particular memory sounds plausible enough. If it happened at all, the incident must have taken place either before Matisse left Paris for Cassis in early February, or immediately after he got back. This means that when he burst in on Vassilieff he had just finished his *Nymph*, or else was already working on the first version of his *Dance*, painted at top speed in a white heat after his return to Paris. Either way, Vassilieff's account sounds very like the process Matisse himself described long afterwards when he said that for him all painting was a rape. Questioned by Louis Aragon about his relations with his female

models, Matisse explained that he could only achieve the extreme, impersonal, quasi-surgical concentration essential to the act of painting by working through his feelings for the model:

> I reckon I've made progress when I recognise more and more clearly in my work a detachment from the support offered by the model (the presence of the model, who is there not so much to provide possible information about her physical constitution as to keep me in a state of emotion, a sort of flirtation which ends by turning into a rape. Whose rape? A rape of myself, of a certain tenderness or weakening in face of a sympathetic object).[52]

Matisse returned from Cassis in precisely the state of imaginative arousal he seems to be describing here. By the time he got back, the *Nymph and Satyr* had disappeared to Moscow. But the prostrate nymph rose up again in his mind's eye to join four others in a whirling, stamping dance. He found a letter waiting for him from Shchukin, asking for a colour sketch of the large painted panel they had discussed as a decoration for his staircase. Matisse posted off two small sketches on 11 and 12 March, the first showing a ring of naked dancers, the second a group of women bathing. A flurry of correspondence followed between Paris and Moscow.[53]

Shchukin was both delighted and dismayed, explaining that the strict, semi-Oriental codes of polite society in Russia made it impossible for him to hang anything so sexually explicit as a nude above the stairs in his entrance hall. Already treated in Moscow as a butt on account of his crazy paintings, Shchukin shrank from further provocation, begging Matisse to drape his figures or, alternatively, to carry out the original scheme on a smaller canvas that could be kept out of sight in his private quarters. But he swiftly got the better of his hesitations, cancelling all afterthoughts and confirming his original commission for two huge panels in a telegram dated 28 March. "It took nerve to paint them," Matisse said long afterwards, "and it took nerve to buy them too."[54]

All his life Matisse worked on the human figure in two successive stages. The first consisted of close and subtle observation of external reality, which had to be thoroughly explored and absorbed before it could be reshaped by the imagination in images that "rise up from fermentation within, like bubbles in a pond."[55] The sketch of dancers made for Shchukin gave shape to an image that had been maturing or fermenting at Cassis. Perhaps the elements that fed into it included one or other of the

girls who posed for Matisse in Paris. The dance itself went even further back, to a ring of small whirling figures in the background of the *Bonheur de vivre* (a painting Shchukin had first seen surrounded by jeering, howling crowds on its initial showing at the Salon des Indépendants in 1906).

Matisse himself traced this particular motif to a band of Catalan fishermen he had watched dancing on the foreshore during the first summer he spent with his wife and children on the Mediterranean coast at Collioure. The setting for *Bonheur de vivre* came from a sheltered cove called Ouille, where the family went swimming. Matisse peopled it with strange unearthly nymphs, fauns and lovers in an unprecedented harmony of synthetic lemon yellows, purples, greens and acid pinks. It was an extremist version of the process described by his friend Henri Cross, another painter from French Flanders who rendered the impact of the southern sun on an introverted northern sensibility by importing figures from an imaginary Arcadia into a real Mediterranean setting: "On the rocks, on the sand of the beaches, nymphs and nereids appear to me, a whole world born of the beautiful light."[56]

Cross had migrated south to settle in the tiny hamlet of St-Clair, near St-Tropez, where Matisse first met him through their mutual friend Paul Signac in 1904. It was Matisse's encounter with the two of them that led directly to the first of the great, unsettling, exploratory canvases in which he articulated his response to what he called "the revelation of the South." *Luxe, calme et volupté* grew from a first sketch of a picnic at St-Tropez with his wife, who can still be seen in the finished picture, sitting on the rocks in her hat and high-necked, long-sleeved Edwardian walking dress alongside four naked nymphs apparently blown in from the sea.

In the spring of 1909, when nymphs were once more beckoning him to break through to another level of reality, Matisse contacted Cross again. He may even have visited St-Clair with Marcel Sembat from Cassis. Cross certainly arranged the hire of a holiday villa a little further along the coast at Cavalière so that Matisse could return to the Midi that summer with his family to resume studies for *Dance*.[57] The two always stimulated one another, but the serene and joyful nymphs who regularly invaded Cross's paintings were about to turn, on Matisse's canvases, into agents of violent pictorial change.

He painted a first version of *Dance* in Paris in March in two or three days of frenzied concentration. By 11 April, Sarah Stein's friend Matthew Prichard had seen a photograph of "a ring of dancing women, or a ring expressing the rhythm of women dancing," which made him pronounce Matisse "the greatest of the modern men."[58] On 12 April, *Les Nouvelles*

published an interview in which Matisse explained that the invention of photography released painting from any need to copy nature. From now on art was free to condense and synthesise, eliminating surface detail in an attempt to penetrate rather than reproduce reality. He said that the aim of the new art was to "present emotion as directly as possible and by the simplest means," citing his current scheme for decorating a staircase as a case in point.[59] He could hardly have signalled more clearly his intention to use this first major decorative commission as a launchpad for modern art. *Dance* and its companion, *Music,* represented a public declaration of faith from a collector who trusted the painter unconditionally. In Moscow that April, Shchukin told anyone who would listen that Matisse held the future in his hands.[60]

Shchukin's support, material as well as moral, profoundly affected the painter's life and work. The 27,000 francs Shchukin paid for his two decorative panels put the Matisse family's finances on a stable footing for the first time. It transformed their situation when the French state finally decided to sell off the convent of the Sacré Coeur, serving notice on the Matisses to quit the premises in June. Driven to distraction by the needs of his students as well as by his growing notoriety that winter, Matisse set about house hunting as far away as it was possible to get without actually leaving Paris. He found a place to rent almost immediately on the northern outskirts of the city, perched above an industrial suburb still under construction at Issy-les-Moulineaux.

By this time the family had been overtaken by a far worse blow. Marguerite would be fifteen in August, and adolescent changes were placing steadily increasing strain on the damaged windpipe that had not grown properly since childhood.[61] In March her breathing problems reached a crisis point, and her doctors performed a second tracheotomy. Matisse helped hang the exhibits for the Salon des Indépendants but missed the opening on 25 March because of his daughter's operation. "So I have had little taste for anything ever since, especially not for painting," he wrote, reporting to his old friend Albert Marquet on 4 April that she was out of immediate danger. The affair brought back terrible memories of the summer nine years before when Marguerite fought for breath and her father had to hold her down on the kitchen table of their tiny attic flat while the doctor cut into her windpipe.

This time she faced a long convalescence and an uncertain future. She still could not breathe without a cannula inserted in her throat. Matisse's old friends, who knew or feared the implications of this fresh ordeal, sent anxious messages asking after Margot. As soon as it was clear she would

recover, her father plunged into the business of a move, signing a lease for the new house at Issy on 18 May.[62] He had arranged through Cross to rent the Villa Adam at Cavalière from May to August, sub-letting it for the first month so that he and Amélie could attend to the practicalities of packing, shifting furniture, storing work and organising builders to erect a prefabricated studio big enough for him to work on Shchukin's panels when they got back in the autumn.

Both of them saw the move as a solution to their problems. The house and grounds at Issy would provide them with the space and quiet impossible to find in central Paris. The new setting would restore their equilibrium as a couple by freeing Henri from the constant demoralising demands of pupils, critics, dealers and potential buyers, while restoring Amélie to her rightful place at the centre of their joint enterprise in the studio. It would enable the children to lead a more normal domestic life in a peaceful country setting, where Margot could recover and the boys pursue their education at the local lycée. The whole family would flourish. Gertrude Stein was struck by Amélie's reckless happiness, which she celebrated that spring by taking a cab all the way to Issy and making it wait— "Only millionaires kept cabs waiting in those days"—while she picked spring flowers in the big, rambling garden that would be hers by autumn.[63]

As soon as the school broke up for the holidays in early June, Matisse escaped for a week to stay with his oldest childhood friend, Léon Vassaux, now a country doctor at Saint-Saens in Normandy. The occasional few days spent in Vassaux's company provided Matisse in these years with an essential rest cure. The doctor took him for drives (he owned the first motor car in the entire region), saw to it that he ate and slept well, indulged their mutual passion for music at local concerts, and capped his friend's scabrous accounts of the Paris art world with stories about the canny Norman peasants who were his patients. By mid-June Matisse was back in the Midi, settling into the Villa Adam at Cavalière with his wife and their three children.

This time he brought a real nymph with him. Her name was Loulou Brouty. She was a Parisian model with dark hair, neat catlike features, a compact dancer's body and skin so tanned and glowing that, after her summer at Cavalière, Matisse's pupils nicknamed her "the Italian sunset."[64] Amélie got on well with her, as she generally did with her husband's models. Brouty fitted easily into the family, following a pattern set by the two girls who had accompanied them south to Collioure in previous summers (the first was another Paris model, Rosa Arpino, the second a cousin of Matisse). The two women provided company for one another in iso-

lated fishing communities where the only other outsiders were occasional visiting painters.

Cavalière was even more cut off than Collioure had been. Matisse's old friend Henri Manguin, spending the holidays there three years earlier, had been shocked to find himself and his family stranded on a rocky headland with no other houses, no boats, no greenery, no grand views, nothing for miles around but pine trees and dry, scrubby sand dunes. The weather was poor when the Matisses arrived, and stayed unsettled all summer. Jean caught mumps. Henri complained he couldn't work ("Manguin, what frightful weather—the model's freezing and I'm fuming," he wrote in July).[65] But he remained in excellent spirits, bathing, boating and teaching Brouty to swim. "I've made progress," he wrote cheerfully in August. "Now I can dive and swim underwater, I can even pick up a sou from the bottom four metres down. Work hasn't gone as well as I would have wished, but still I'm happy with my stay. My wife is too."

They visited the Crosses at St-Clair, and the poet Jean Nau and his wife at Le Lavandou. Sarah and Michael Stein came over for the day from Le Treyas near St-Raphael with their young son. Matisse posted off a sketch to Sarah's friend Harriet Levy (who had bought his *Girl with Green Eyes*), showing himself in striped bathing pants poised to plunge overboard from an absurdly flimsy dinghy. The painter and his doings always emerge from Matisse's impromptu sketches as intrinsically ludicrous. He pictured himself at Cavalière in letters and cards to Manguin as a cartoon character, tentative, quizzical and myopic, often ducking out of sight, hidden waist deep in water or disappearing beneath the surface with nothing showing but a pair of big bare feet.

His model meanwhile stands, naked and relaxed, on the beach beside his abandoned easel, or sprawls casually on her back in a patch of scrub with legs spread wide and arms folded behind her head. Matisse had exchanged jokey shorthand messages like these—a more

Matisse, *Bonjour Mlle Levy*, 18 August 1909: the painter's greeting to an American collector

Bonjour Mademoiselle Levy
Je vous envoie de Cavalière les
amitiés de la famille
Henri. Matisse
18/8 09.

sophisticated French equivalent of the saucy British seaside postcard—with Manguin and Marquet from student days. In fact, Brouty possessed Matisse's imagination that summer in far less conventional ways than this kind of standard male fantasy. She posed for him standing, sitting or leaning on her hand under the pine trees on the foreshore. His brush swooped and darted round her body with apparently effortless confidence, trapping sunshine and shadow on small luminous canvases organised in pools and patches of unlikely colour. Matisse liberated painting at Cavalière in precisely the way he had described, before he left Paris, to the journalist from *Les Nouvelles*. These nude studies were crucial to "the long process of reflection and amalgamation" he had set himself in the spring when he went into training for the final version of *Dance*.[66]

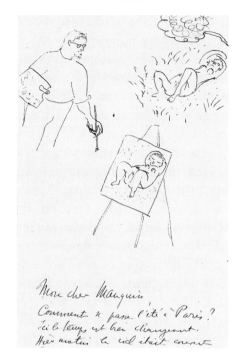

Matisse, self-portrait with model in a letter to Manguin, 11 August 1909

Matisse's comic illustrated letters, showing himself at work with Brouty, diffused tension and relieved the nerve-racking anxiety that always accompanied each fresh attempt to push forward in his painting into unknown territory. One of his bulletins went to Henri Cross, who lay bedridden at St-Clair. "Your letter touched me very much, and your sketches bathed in the light of the Midi amused me exceedingly," Cross wrote on 14 August; "...the fact is that I'm living through such intense and constant suffering that moments of respite are rare."[67] In the summer of 1909, Cross was dying of cancer. His friends were appalled by the agonies he endured. For Matisse, it was a replay of the summer of 1905, when Cross's wife had begged him to send descriptions of his light-filled, radiantly coloured canvases to comfort her husband, whose eyes had grown so weak that he had to be shut up blindfolded in a darkened room for weeks on end.

In 1905, Matisse had broken through a barrier Cross said he dared not leap himself. In 1909, Matisse once again achieved what Cross had

dreamed of doing years before when he, too, had imported a model from Paris to pose for him out of doors in the Mediterranean light. "This nude in sun or shade puts before me unexpected harmonies of form and colour," Cross wrote at the time, explaining sadly to another painter that ingrained timidity and habit prevented him from pursuing the spontaneous sensations of wild enthusiasm, bordering on madness, which the experiment had provoked.[68] Perhaps he said the same thing to Matisse. The two had for years exchanged notes, jokes and cries of terror, consoling and commiserating with one another about their blind, compulsive urge to master what Matisse called "this confounded Painting."[69] Cross was one of the few—possibly the only person apart from Amélie Matisse—who fully understood the state of barely suppressed panic that underlay Matisse's own unremitting experimentation.

The harmonies of form and colour Matisse brought back from Cavalière were so unexpected as to be inconceivable at first even to his boldest admirers. Marcel and Georgette Sembat, leafing through the summer's work one day with the Matisses after lunch at Issy, shrieked aloud when they reached the study of Brouty called *Seated Nude* (colour fig. 3):

> We had come across a strange little canvas, something gripping, unheard of, frighteningly new: something that very nearly frightened its maker himself. On a harsh pink ground, flaming against dark blue shadows reminiscent of Chinese or Japanese masters, was the seated figure of a violet-coloured woman. We stared at her, stupefied, astounded, all four of us, for the master himself seemed as unfamiliar as any of us with his own creation.[70]

At first the picture made no sense, but, as soon as Sembat started sorting out what he saw, he realised that this composition of green, blue, pink and indigo had to be read as a design in its entirety. "You see, I wasn't just trying to paint a woman," Matisse explained: "I wanted to paint my overall impression of the south." Sembat bought the picture, because he recognised it as what he called "an egg": the egg that contained in embryo the great synthetic canvases that would follow over the next decade. Matisse and his family had returned from the south in September to take possession of the new house and studio at Issy where, apart from a brief break the following spring, he remained for the next twelve months, absorbed in work related to the panels for Shchukin. Those who saw the first version of *Dance* described it as pale, delicate, even dreamlike, painted in colours that were heightened—"hitched and hoisted up as it were on

the back of the previous work"—in the second version into a fierce, flat frieze of vermilion figures vibrating against bands of bright green and sky blue.[71] Contemporaries saw the painting as pagan and Dionysian: "A dance that would have pleased Zarathustra," reported the philosophy student Camille Schuwer, who remembered previous versions in which the dancers looped lightly across the canvas like a scarf, "a floating red scarf."[72]

It was the uprush of violence as much as the earthy physicality of the finished work that shocked people. Matisse said he himself took fright, like the Douanier Rousseau, who sometimes had to open a window to let out the elemental force of his own painting.[73] In *Dance* and *Music*, Matisse attempted simultaneously to release and contain that force. "At the precise moment when raging bands were milling about in front of his huge canvases, tearing him to pieces and cursing him," wrote Sembat, "he confessed coolly to us: 'What I want is an art of balance, of purity, an art that won't disturb or trouble people. I want anyone tired, worn down, driven to the limits of endurance, to find calm and repose in my painting.' "[74] Contemporaries responded to this kind of statement by assuming that Matisse was playing tricks if not actually insane. Even his supporters found it hard at the time to credit that he meant exactly what he said. Matisse's vision of Olympian calm was a strategic war plan: he aimed to achieve the great destructive and constructive goals of modernism by imposing the evenhanded clarity and order of the central French tradition inherited from his masters, Nicolas Poussin and Paul Cézanne.

The effort took everything he had to give. It devoured his days, invaded his dreams at night and put increasing strain on his private life. The family's daily round at Issy was driven by it. This was the obsessive passion that had wrecked Matisse's relationship with Marguerite's mother. He had warned Amélie about it when they first met, explaining bluntly as soon as he realised that their affair was serious: "I love you dearly, mademoiselle, but I shall always love painting more."[75] The terms of their marriage were laid out from the start in a pact Amélie accepted with alacrity. He gave her the cause she had been waiting for from girlhood. As an enthusiastic reader of romantic novels, she chose early role models who gave up all for love: heroic women who faced ferocious opposition and endured grinding privation in order to stand shoulder to shoulder with men battling against impossible odds.

Life with Matisse meant austerity, dedication and self-sacrifice. Pablo Picasso talked in the same terms when he, too, went into training in these years for pictorial contests that would test him to the utmost. Piet Mon-

drian vowed himself to chastity ("A drop of sperm spilt is a masterpiece lost").[76] Renunciation was in the air. It was foremost among "the moods and feelings of the time" pinpointed in Thomas Mann's account of the decade before the First World War: "One may not possess. Yearning is giant power, possession unmans."[77] Matisse told a friend long afterwards that sexual abstinence had been his goal ever since the Fauve summer of 1905.[78] He and his wife had even tried to put it into practice on their Corsican honeymoon in 1898, when the inhuman rule of abstinence proved too hard to keep (try as they might, the couple's first child was conceived in Ajaccio). But just over a decade later, Matisse's self-discipline was harsher and the task in hand even more demanding. Some form of abnegation lay behind the painting he called *The Conversation,* (colour fig. 12) which seems to have been begun at the convent of the Sacré Coeur and completed at Issy. On one level it is a formal colour harmony of Byzantine simplicity and splendour. On a more humdrum human level, it depicts Amélie in a green housecoat one spring morning sternly confronting her husband in his pyjamas (the striped pyjamas worn by Matisse in this and other paintings over the next twenty years and more were his standard working gear in the studio, woollen in winter, cotton or later silk in summer).[79] It is a counterpart to that other early-morning scene in spring described by Marie Vassilieff. Matisse would write a frantic note later to Olga Meerson, begging her to overlook what sounds like a similar intrusion.

Meerson's friend Thomas Mann was fascinated by the position of the artist, obliged to choose between sacrificial austerity and the social and domestic happiness of the "comfortably normal" bourgeois human being. He dramatised the choice in *Tonio Kröger,* whose heroine was based on Olga's friend Lisaveta Ivanovna Epstein. "I stand between two worlds," Kröger confesses to Lisaveta. "I am at home in neither, and I suffer in consequence."[80] This was the dilemma Matisse confronted in acute form in his first years at Issy. He described it to journalists, and complained about it to friends. He alerted Olga to it at their first meeting (just as he had once warned Amélie), urging her not to turn aside from the official path that would lead her to fame and fortune in favour of the route he himself had taken. Olga (like Amélie) chose the stony path of hardship and self-denial.

Mann's story ends with Kröger promising Lisaveta to dedicate himself to the modernist quest: "I am looking into a world unborn and formless, that needs to be ordered and shaped; I see into a whirl of shadows of human figures who beckon to me to weave spells to redeem them." Meer-

son visited Matisse regularly in the studio at Issy, where he worked on *Dance*. Together they gazed into the formless void that had beckoned Kröger. The experience absorbed and exhilarated them both. This was a realm where Amélie could not follow, but in the end it wasn't Olga she had to fear, or fresh young girls like Vassilieff, or the long succession of professional models that would fill her husband's studio to the day he died. Amélie had a more powerful rival. She was competing with the seductress who had monopolised Matisse's two great French predecessors: the mistress who obsessed and absorbed Cézanne; the lifelong companion Poussin included in the background of a strange self-portrait he made the year before he died. Poussin identified her as Painting in person, picturing her as a beautiful, fair-skinned, golden-haired young woman embraced by two passionate male arms. This was the confounded tyrant Matisse had grumbled about to Henri Cross. She was jealous, demanding and possessive to the exclusion of all others. It was Painting whose arms closed fast around Matisse—and his round her—in an embrace that would never let him go.

CHAPTER TWO

~

1910: Issy-les-Moulineaux, Collioure and Spain

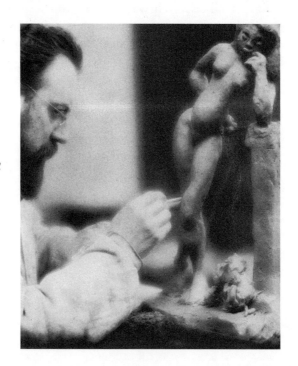

Edward Steichen,
Henri Matisse Working
on "La Serpentine"

*T*he move to Issy-les-Moulineaux in the autumn of 1909 was part of
a larger strategy of disengagement and withdrawal. "If my story
were ever to be told in full ...," Matisse wrote thirty years later,
"it would amaze everyone who reads it. When I was dragged through the
mud, I never protested. As time goes on, I realise more and more how

34

completely I was misunderstood, and how unjustly I was treated."[1] Ostracism and rejection made him stubborn. "The whole world turned its back on him," said Lydia Delectorskaya, the companion to whom Matisse talked more freely than to anyone else in his last years. "Everyone clustered round the Cubists, there was a whole court centred on Picasso. It was a question of pride. He never wanted to make a show of himself, to reveal how much it hurt him."[2]

The incident that confirmed Matisse's outcast status, at any rate in his own mind, came one day when he turned into one of the artists' cafés in Montparnasse for a drink with Picasso and his band, who refused to speak to him. Matisse never forgot sitting alone at the next table in a café full of fellow painters, none of whom returned his greeting. "All my life I've been in quarantine," he said when he recalled the scene.[3] This was how he had felt as a boy in Bohain, when his father first discovered his mad plan to be a painter. He used the same image to describe how it felt, at the age of twenty-five in 1896, to find people treating his work as if it were alive with germs. He was appalled a decade later when press and public once again identified him as a plague-carrier, spreading infection and pollution at the head of the notorious Fauves.

The acclaim that was the obverse side of this abuse brought little consolation. Matisse was more disconcerted than delighted by young followers hoping to pick up the knack of making colour explode on their canvases the way it did on his. The power of crowds or groups meant nothing to him. His closest ally, André Derain, had long since transferred allegiance to Picasso, together with Georges Braque (who had experimented briefly with Fauvism) and various lesser Fauves. Their defection was in some sense a relief to Matisse, who had never seen himself as the leader of a party. Art for him had no political dimension. "He was interested neither in fending off opposition, nor in competing for the favour of wayward friends," wrote Françoise Gilot, contrasting Matisse's behaviour with Picasso's. "His only competition was with himself."[4]

By 1909, the vogue had peaked. Painters all over Montparnasse and Montmartre whose canvases had once turned blue in imitation of Cézanne, and later switched to the rainbow palette of the Fauves, now put aside "the outmoded power of colour" in favour of black grids. Anyone in tune with current trends went out and bought a set-square. "Everyone wielded a brush. Not just those whose calling it was but also poets, schoolboys out for a laugh, retired old people, writers, models of both sexes, even down to the chip-seller on the Place du Tertre who made a fortune out of painting."[5] Of all the competing Parisian factions, Cubism

was the liveliest and most warlike. "Wholesale massacre" was its slogan, "nothing less than total destruction" was its programme. Over the next few years potential rivals ("Fauves, Neo-classicists, Post-Impressionists, Futurists, Simultanists, Realists, Pointillistes") were named and shamed at rumbustious meetings convened by Picasso's camp-followers.

But their favourite target was Matisse, who was busy dismantling his own power base at this point. He decamped to Issy, submitting only two relatively inoffensive flower paintings to the Autumn Salon, resigning from the committee of the Salon des Indépendants the year after, and giving up his school at the same time. "I rolled myself into a ball in my corner as an observer, and waited to see what would happen."[6] Thirty or forty of his works remained behind in Paris, on view in the apartment of Sarah and Michael Stein at 58 rue Madame. "The vast studio was crowded with visitors," reported the English critic Louis Hind. "My first sensation was of dismay, almost of horror."[7] But Hind was struck in spite of himself by the eerie power emanating from the painter's self-portrait: "That head of himself—bearded, brooding, tense, fiercely elemental in colour—seemed as I gazed to be not a portrait but an aspect of the man, the serious Matisse, almost a recluse, indifferent to opinion, whose aim it is to approach each fresh canvas as if there were no past in art, as if he is the first artist who has ever painted."

That aim could not be achieved without some sort of distancing, but Matisse dreaded as much as he needed the isolation Issy gave him. The new house stood on the summit of a hill in an area already parcelled out into speculative building plots.[8] The Matisses occupied a double corner plot surrounded on three sides by high walls and at the front by a metal

House at Issy-les-Moulineaux: the first and only family home the Matisses ever owned

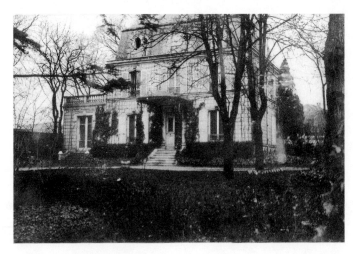

grille. Inside the double gates, the front path curved round a circular lawn before the house with a cypress alley leading off at right angles to the big new studio, a sturdy prefabricated structure put together from metal girders and wood planking in the furthest corner of the property, against the northern boundary wall. Glass doors, huge windows and skylights in the roof made it broiling hot in summer and hard to heat in winter.

The house itself was medium-sized, solid and unpretentious, white-painted and grey-tiled with a central porch and mansard roof: unremarkable except that it was the only one of its kind on the heights above Issy. The rooms were mostly small, but well proportioned. There was a pretty, octagonal dining room on one side of the hall, and a long drawing room at the other, running from front to back with a window at each end. The house had a telephone, a bathroom and central heating, rare luxuries in France in the first decade of the twentieth century. It faced south, looking out over fields and market gardens, halfway along the road joining the town to the railway station at Clamart, itself still a small country village on the edge of woods stretching northwards to Versailles. The old rural communities were being torn up by the roots. Abandoned cottages and outbuildings all over the surrounding farmland were being hastily adapted to house workers from the densely packed industrial development lining the riverbanks at Issy. When the Matisses moved into 92–94 route de Clamart, they were virtually the only inhabitants on their section of the road. Over the next few years a double line of much smaller houses would come snaking up the hill towards them, occupied by bank clerks, railway employees, commercial travellers and office workers taking refuge from the smoke and din of the factories on the plain below.

For the circle Matisse and his wife had left behind in Paris, Issy was well beyond the limits of the known world. He begged old friends to visit, pointing out that fifty-four trains from Montparnasse station ran daily to Clamart. Marcel Sembat proposed ordering four hundred visiting cards incorporating a route map to the Matisses' farflung northern suburb, but it was hard to persuade Parisians to venture out beyond the Porte de Versailles. Matisse's departure fuelled increasingly wild stories. Rumours multiplied about the splendour of his country house, and the luxurious studio in his grounds. People said he was charging crazy prices. Even his old friends believed it. Jules Flandrin complained that his own pictures still fetched only 75 francs each while Matisse had persuaded a tame Russian to shell out 75,000 for a single painted panel.[9] Simon Bussy sent rueful congratulations on the fabulous wealth pouring into the Matisse household at last after twenty years of grinding poverty.[10]

In fact, money was a constant worry in the first years at Issy. The rent of 3,000 francs a year over-stretched the family budget so that it was often hard to scrape up the next instalment at the end of each quarter, or pay for extras like doctors' bills.[11] The lease would scarcely have been feasible if Matisse hadn't signed a contract with Maurice Denis's dealers, the brothers Josse and Gaston Bernheim-Jeune. Safe, prosperous and relatively stuffy, the Bernheims were beginning to expand into modern art under the fastidious and phenomenally successful guidance of Félix Fénéon. Taking on Matisse was Fénéon's riskiest move to date. The contract—dated 18 September 1909, a few months short of the painter's fortieth birthday—offered him a measure of financial stability for the first time in his life. The Bernheims agreed to buy everything he painted, paying on delivery according to a scale which ranged from 1,875 francs for a large wall painting to 450 for the smallest size of canvas, together with a royalty of 25 percent on sales.[12] The deal led to much envious gossip in Paris. Fénéon was said to have preempted potential rivals by intercepting the painter with a contract at the station on his return from the south (legend credited Eugène Druet with having done exactly the same thing three years earlier).[13] But neither side can have gained much from their bargain in the first twelve months, which Matisse spent working on *Dance* and *Music* already contracted to Shchukin.

Still hopeful at this stage of receiving more commissions, Matisse had negotiated special terms for portraits and decorative schemes. But the only prospective taker turned out to be Bernard Berenson, in Paris that autumn in search of a painter to decorate the new library at his villa of I Tatti outside Florence. Berenson was taken aback by the rough-and-ready style of Matisse's studio—"He was still anything but prosperous"—and dubious about his work.[14] He bought the *Copper Beeches* of 1901, which was small and relatively safe (though bold enough for him to enjoy the shocked reactions of connoisseurs drawn to I Tatti by his incomparable collection of Italian primitives).[15] Matisse sent sample drawings for the library, following them up in December with photographs of his *Dance*. This time Berenson's response was unequivocal—"The composition delighted me: I study the blank spaces with my eyes, and feel the rhythm with my whole body"—but it came too late. The commission had already gone to Matisse's old acquaintance René Piot, whose weak sense of design, flashy execution and vapid colouring made even Maurice Denis look daring. Berenson would realise his mistake as soon as he saw the finished murals a year later. "About the frescoes—they are really more horrible than words

can paint," wrote Mary Berenson, describing her husband's shame and fury. "I cannot imagine a more complete fiasco."

The discovery that Berenson had turned him down in favour of Piot added to the deepening gloom that overtook Matisse in his first winter at Issy. The move that was to have provided a fresh start for the whole family sometimes felt more like a disaster. "The time I suffered most was in those first years at Issy, when I felt I had crammed too many sails on my boat," Matisse said, looking back.[16] The change went beyond physical upheaval. It meant a whole new way of life for the Matisses, who had always travelled light, living simply in rented rooms with little in the way of personal belongings beyond Henri's paintings and his working collection of textiles, ceramics and African carvings. At Issy, the household and its responsibilities weighed heavily. A school had to be organised for the boys, a doctor found for Marguerite. The garden had to be dug and planted. The work was too much for Amélie to manage alone, even with the aid of the odd-job man from the school, Marc Antonio César, who came regularly by train from Paris to help out.

Matisse drew up a schedule.[17] Sunday was set aside for private relaxation, Monday for visitors and correspondence. Tuesday, Wednesday and Thursday would be spent in the studio. On Friday and Saturday he taught classes in Paris at the school, which had stayed on at 33 boulevard des Invalides in an unsold convent building. The student body was constantly changing and expanding. Newcomers, turning up for the few weeks or months they happened to be in Paris, grumbled about a teacher who reduced his visits to once a week, and eventually to once a fortnight. Their steady pressure added to the practical problems involved in maintaining a studio so far away from the artists' quarter on the Left Bank, where Matisse had spent his entire professional life until now. Deliveries had to be arranged, materials laid in, and models persuaded to take the train to Clamart. Potential clients and collectors from abroad could not be persuaded to time their visits to suit anyone but themselves.

Even when it ran smoothly, the timetable left less than half the week for work. This was the core of Matisse's trouble. The move to Issy freed him from the daily bulletins of malicious gossip that had tormented him in Paris, but it brought him face-to-face with worse anxieties. He missed the fellow painters who had always surrounded him in the same tenement building, or in studios a few streets away. Even after he left the quai St-Michel, he had never been more than ten minutes' walk from the centre of Montparnasse. Mutual support and consultation were a key part of his

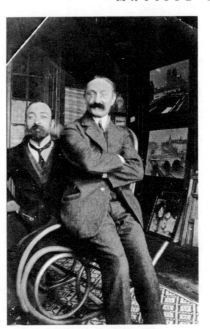

Camoin and
Marquet in
Matisse's studio

working pattern. Old friends recognised the desperation underlying Matisse's pleas to visit him at Issy. Marquet came as often as he could, and so did Manguin. Charles Camoin and Maximilien Luce both set up their easels to paint the view from the riverbank at the foot of the hill below Matisse's house. But none of them could drop in any longer on a daily basis.

The intense, unremitting effort required by *Dance* and *Music* set up a state of tension that gave way to mounting panic. Once again Matisse could not sleep. Prolonged insomnia frightened him, and wore him down. He felt incapable, frustrated, full of foreboding. Shchukin, who might have reassured him, was being treated in Paris for failing eyesight when news came that one of his two surviving sons had killed himself. This was the third suicide of a close relation in less than four years to hit Shchukin, who had not fully got over his wife's sudden death in 1907. "You see how thickly life is strewn with ordeals," Matisse wrote, explaining why the Russian had had to leave for home in January 1910. "Luckily he has great courage."[18]

Snow fell on Issy in the New Year, followed by the worst floods in living memory. The streets disappeared under nearly six feet of water. People evacuated their homes in the town by boat, piling furniture and bedding on the roofs. Rain fell and the river continued rising for ten days. Floodwaters filled the valley beneath the grey leaden skies that always paralysed Matisse. Ten months later, he looked back with horror to the impotence and inertia that had overtaken him. "Think of me at the time of last winter's martyrdom," he told his wife, who had for once been unable to lift his depression. "It would have been better to be far from home and on form, than at your side and so helpless."[19]

One of the inducements held out by the Bernheims for him to join their gallery was the offer of a one-man exhibition in 1910. The show was scheduled to open on 14 February. The two panels on which Matisse had laboured since the autumn were far from ready, and he had done little else

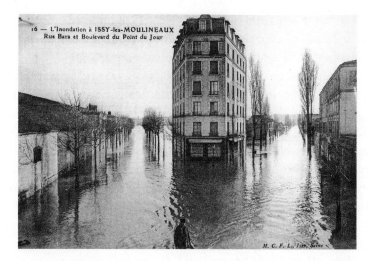

16 — L'Inondation à ISSY-les-MOULINEAUX
Rue Bara et Boulevard du Point du Jour

M. C. F. L., Issy, Seine

Floodwaters rising
in Matisse's first
winter at Issy-les-
Moulineaux

that winter. Instead he planned a retrospective, starting with a traditional
Flemish still life from his student days and plunging swiftly into the
astonishing experiments that followed: the initial eruption of colour trig-
gered by his exposure to the light of the Mediterranean in 1898; the brief
encounter with Divisionism in 1904 that led on to Fauvism itself, inaugu-
rating an unprecedented series of rich, complex, increasingly synthetic
colour harmonies; and ending with the Sembats' *Seated Nude* of 1909.
Hardly any of the sixty-five paintings on show were for sale (most had
been loaned by private collectors, well over a third by the Steins). This was
the most comprehensive showing Matisse's work had ever had, and he
hoped it would demonstrate a steady, logical progression towards a
stripped-down and reinvigorated modern art.

 The critics responded with a dismissive brutality that even Matisse
had scarcely encountered on this scale before. They accused him of vulgar
excess, wilful confusion and gratuitous barbarity. Even the more serious
reviewers found him incapable of following any consistent line, or evolv-
ing a style of his own. One after another they attributed their inability to
make head or tail of what Matisse was doing to his shortcomings rather
than their own. Attacks came from all quarters. The young and progres-
sive were as splenetic as the elderly and conservative. The veteran Octave
Mirbeau, friend and champion of the Impressionists, reported to Claude
Monet at Giverny that the exhibition showed Matisse suffering from gen-
eral paralysis of the insane—"It's been a success. Russians and Germans,
male and female, drooling in front of each picture, drooling with joy and
admiration, naturally."[20]

Ambitious journalists in their twenties competed to outdo one another at Matisse's expense. André Salmon wrote him off in *Paris-Journal* as an incoherent second-rater appreciated only by minor artists from abroad. Roland Dorgelès made his name (he would end up as president of the Académie Goncourt) a fortnight after Matisse's show closed by submitting a canvas to the Salon des Indépendants called *Sunset over the Adriatic* by J. R. Boronali. Dorgelès became famous overnight when he revealed with maximum publicity that Boronali was an ass—none other than the donkey belonging to the owner of Picasso's favourite Montmartre hangout, the Lapin Agile—which had produced the work in question by swishing a loaded paintbrush tied to its tail.[21] He clinched his point with an article at the end of the year accusing Matisse simultaneously, in the crudest racist terms, of pomposity and incompetence ("He paints like a nigger while talking like a Magus").[22] Envy and resentment were blatant in most of these attacks. Much play was made of the vast income Matisse gained from shrewd and cynical exploitation of his credulous foreign followers, and the laurel wreath from Germany (some claimed it was a golden crown) that he was said to wear for teaching.[23]

The show attracted so much attention that its run had to be extended by ten days. When it finally closed on 5 March, Matisse left Paris, travelling south alone to take refuge with Amélie's father and sister at Perpignan. From there he moved on by train along the coast to Collioure, where he was joined by the sculptor Aristide Maillol and the painter Etienne Terrus. These two had been the first to make him feel at home in their native region in 1905. They had worked by his side that summer, and stood by him in the storms that broke over the work he took back to Paris in the autumn. In March 1910, Matisse said he was fleeing from the Parisian cold, but snow fell in Collioure soon after he got there, and it is clear from his daily letters to his wife that the warmth he needed was the reassuring company of old friends.

"Maillol and his wife are being very good to me, and Terrus the same," he wrote. "My dear Amélie, how can I describe my feelings on rediscovering Collioure? Fond and sad. It's a part of our life."[24] He made the rounds of the little town where they knew everyone, exchanging news and catching up on local gossip. The place was wonderfully calm and restful. "I've become a Cocolibrian [native of Collioure] again," he told Amélie, proposing to keep on the rented attic studio on the avenue de la Gare where he stored his painting things so that he could come back to paint next winter. "All I need to be completely happy is to have all of you here with me."[25]

He revisited his old painting sites with Maillol and Terrus, walking along the shore to the bay at Ouille, lunching at the local inn and spending the afternoon in the hills above the town. The Maillols invited him to stay at Banyuls. Terrus—who lived alone all his life in the village where he was born, painting the mountains and the sea, tolerated by his neighbours and ignored by the Parisian art world—was one of Matisse's trustiest confidants. The two had commiserated with one another before on the score of indifference, hostility and neglect. No one could have listened more sympathetically than Terrus to Matisse's account of the "crisis of will" which he feared might get the better of him this time.[26] Between them, his two old allies restored Matisse's confidence. Soon he was sleeping better, and announcing that his father- and sister-in-law wouldn't recognise him as the wreck he had been when he first arrived.[27] The sun shone, peach trees bloomed beneath the snow, and the landscape looked magnificent. Matisse wrote to Gertrude Stein to say that he had grown three years younger.[28]

He returned to Paris in early April to find support already being mobilised. He had sent a single canvas to the Salon des Indépendants, and been energetically defended by Guillaume Apollinaire ("No man is a prophet in his own country and, in applauding him, foreigners applaud that same France who is herself prepared to stone one of the most seductive of all contemporary artists").[29] The writer Michel Puy, whose brother Jean had been Matisse's companion as a student, was preparing a vigorous and carefully reasoned essay in his defence.[30] The Sembats had protested strongly to the Minister for Fine Arts about the state's failure to purchase Matisse's work ("any mention of the name of Matisse is enough to make the Academicians froth at the mouth," the Minister's representative replied frankly).[31]

Reviewers were markedly more respectful in New York than in Paris in March when Alfred Stieglitz's tiny, enterprising 291 Gallery put on the second Matisse show ever mounted in the United States, consisting of drawings and black-and-white reproductions of his most revolutionary recent paintings. In April, Matisse canvases were included in exhibitions in Berlin, Budapest and Florence. The director of the Neue Staatsgalerie in Munich, Baron Hugo von Tschudi, who agreed with Shchukin that Matisse was one of the key artists of the twentieth century, commissioned a painting (this *Still Life with Geraniums,* which powerfully impressed the young Kandinsky, would become the first of Matisse's paintings to enter a museum when the Staatsgalerie bought it after Tschudi's death in 1911).[32]

Much of this activity could be traced back directly or indirectly to the

Steins, and in particular to Sarah Stein, who concentrated her considerable energies on promoting Matisse while her sister-in-law, Gertrude, threw her no less substantial weight behind Picasso. Artistically the most gifted of the family but wholly lacking in Gertrude's genius for self-promotion, Sarah gave up painting at this point (she trained as a Christian Science practitioner instead, on the grounds that she could do it in a year, whereas it would take her fifteen to become a painter). She combined a bold and discriminating visual sense with mesmeric power. Visiting Americans, bamboozled into buying from Matisse rather than spending their money on copies of old masters from the Louvre, often found their confidence draining away once they left the apartment on the rue Madame. "They spoke of this to Mrs. Stein, who smiled as one who could sympathise with their ignorance, but as one who understood things beyond their appreciation."[33]

Her collection was a learning ground for most of Matisse's early admirers, from Shchukin himself to Berenson and the young American photographer Edward Steichen, who had organised the two New York shows, proposing the artist in the first place, picking the works himself, and persuading Matisse to have his picture taken in the studio at Issy. First-time visitors to the Michael Steins' apartment generally fell back in disgust, before discovering to their surprise that they couldn't tear themselves away from the canvases that lined the walls frame to frame three or four deep. "An astonishing sight, glaring and gay, crude but great beauty of line," wrote the English Lady Ottoline Morrell, whose own taste for gaudy colours, barbaric jewellery and stupendous hats made her more receptive than most, although she didn't care for the solemn hush Mrs. Stein also managed to impose: "No one dared to talk, silenced perhaps by the clamour that seemed to shout from the walls."[34]

Matisse, *Matthew Prichard*, 1914: the philosophical English friend who lent a thoroughly Oxonian respectability to Matisse's strange experiments

Lady Ottoline's guide in Paris was her compatriot Matthew Prichard, another of the regulars at 58 rue Madame.

Prichard was a Socratic teacher and thinker who held no official post, avoided the academic world, rarely if ever lectured in public and published virtually nothing. But he possessed, in T. S. Eliot's phrase, "an influence out of all proportion to his public fame,"[35] and exerted it in these years exclusively on Matisse's behalf. Oxford educated, trained as a lawyer and aesthetically self-taught, Prichard had abandoned a promising career as an Oriental specialist at the Boston Museum of Fine Arts in 1908, moving to Paris in his early forties to apply himself to modern art instead.

A visual sophisticate (like Berenson, who had abhorred Matisse until taken in hand by Sarah Stein), Prichard passed through the usual stages of shock, incredulity and conversion at lightning speed, reporting his progress in letters throughout 1909 to a friend in Boston, Isabella Stewart Gardner. Baffled by his initial encounter with Matisse's work in January ("He is . . . coarse, is shortsighted, perhaps has some other optical trouble"),[36] he was admiring, if still faintly dubious, three months later, and by the summer had made Matisse's cause his own, committing himself with all the fervour of a narrow, fastidious and passionate intelligence. He responded with characteristic violence to a London friend who told him John Singer Sargent had dismissed Matisse's painting as worthless: "I replied insolently and hyperbolically that if Mr. S. knew the truth he would commit hara-kiri before one of his own portraits."

From then on Prichard never looked seriously at another contemporary artist. The Bernheim show in 1910 inflamed his imagination. "As soon as I entered the gallery, I was almost dazzled by the splendour and brilliance of your works," he told Matisse.[37] By this time, he was paying regular visits to the studio at Issy, bringing potential collectors, connoisseurs and critics. Prichard's circle divided more or less equally into wealthy middle-aged women on the one hand and young male disciples on the other. Lady Ottoline herself, Mrs. Emily Chadbourne of Chicago and Park Lane in London, Mrs. J. Montgomery Sears and Mrs. Samuel Warren of Boston were all assured of Matisse's towering status, and personally escorted to his studio, by Prichard.

He convinced Mrs. Chadbourne she should buy a bronze and several drawings, failed to persuade Mrs. Sears to let her daughter pose for a portrait (he would succeed later with Yvonne Landsberg's mother) and arranged for Mrs. Warren to sit herself. The Byzantinist Thomas Whittemore, who had caused such trouble by posting a wreath of bays from Berlin, was one of Prichard's protégés. It was Prichard who introduced the young Eliot to Matisse before the First World War,[38] together with many other prospective highfliers, including a future generation of curators like

William King of the Victoria and Albert Museum, and theorists like Camille Schuwer and Georges Duthuit.

Prichard came close to embodying the French stereotype of an eccentric Englishman: handsome and clean-cut with a firm profile and an almost flamboyant indifference to clothes. He moved easily in worldly circles but chose to live alone on vegetables, in a series of rented rooms, with the frugality of a Chinese scholar. His ample network of contacts, and the satisfaction he got from bringing them together, did not stop him remaining (like Matisse himself) in Parisian terms a complete outsider. "One of the aspects of his personality that appealed to Matisse," wrote Rémi Labrusse, the scholar who rescued Prichard singlehanded from oblivion more than half a century after his death, "was precisely that Prichard admired him as a modern painter . . . while at the same time playing no part in the contemporary art world, its fashions, factions and power ploys."[39]

Independence, an ingrained refusal or inability to conform, was the key to Prichard's life and thought. His background in Oriental and Byzantine studies had led him to mistrust the Western classical heritage. He looked to the decorative traditions of the East to release a powerful new vision that would replace the outmoded laws of three-dimensional illusion. Prichard, who had begun exploring possible links between Occidental and Oriental approaches in Boston, found Matisse putting into practice many of the principles he had himself outlined in theory. Over the next five years Prichard's well-stocked, well-cultivated and essentially philosophical mind would lend intellectual weight and brilliance—"a thoroughly Oxonian respectability"—to the strange course Matisse was already taking.

Sarah Stein, too, had experienced little or no difficulty in grasping the import of Matisse's paintings the first time she saw them, having come from a similar direction, through the Chinese art, lacquerwork and ceramics with which she had begun her career as a collector before she left San Francisco for Paris. She inclined naturally to Prichard's belief that the Orient showed the way towards the art of the future. Their company was tonic for Matisse. Whenever he attended an evening gathering at the rue Madame, he would spend much of it talking privately in a back room with Mrs. Stein and Prichard. "The conversations with Prichard, and with the Steins, helped Matisse to get away from the atmosphere of the studio, to escape from his everyday preoccupations," his daughter Marguerite wrote later, "—they opened a perspective on to wider horizons, which troubled him at the time but could only be fruitful in the long run."[40]

Prichard himself recorded many of these conversations, including a relatively early one that took place in front of the Rembrandts in the Long Gallery at the Louvre on the eve of Matisse's opening at Bernheim-Jeune. Prichard's account—allowing for his still imperfect French, and the imperial arrogance that afflicted even the least conventional Englishman in those days—bears out Marguerite's view that Matisse found his ideas initially disturbing:

> My position about art seemed to disconcert him, and he had to wriggle extraordinarily... when I showed him some Byzantine things, he had to adopt an attitude which was v. elaborate, artificial and untenable. He returned to the matter later in the afternoon in a way to show he was uncomfortable still.... To me he quite certainly does not see the bearing of his own work, or that he is an innovator, and an innovator whom others will follow soon. He said to me in the Louvre—"Then you don't like all these pictures in the Long Gallery—and you place oriental art higher than them!"[41]

Matisse told an American interviewer, well before he ever met Prichard, that he relied on Oriental art to help him express abstract ideas through the simplification of form and colour.[42] But the Englishman's invincible certainties, together with the fresh sources he opened up and the discomfort he fermented, came at precisely the right moment. He helped Matisse to analyse and regulate alarming developments on canvas through what would evolve over the next few years into a joint theory of aesthetics. Prichard's rigorous intellectual approach corresponded to the disciplined side of Matisse, the side that struggled, as he said himself, "to get some order into my brain."[43] This was the sober workmanlike character in buttoned-up white overalls photographed by Steichen in the studio at Issy.

But there remained the question of what Matisse was working on in the long hours he spent shut up alone, watching *Dance (II)* (colour fig. 4) grow under his slashing brushstrokes, shaping and reshaping the larger-than-life-size figures with their pointed satyr's ears, muscular red bodies and prehensile feet. Prichard himself held that art was primarily instinctive and emotional. Like many nervous, intense and rigidly controlled ascetics, he needed some sort of tool or strategy to help him break through to a more intuitive level of his being. In his case, it was art. "Much of what Matisse gives us is to be found in our unconscious life,"

he wrote in one of the notebooks devoted to his "Conversations with Matisse." "To find what it is we must plunge there in a state of trance or ecstasy, we must swim along the bottom of the stream of our existence."[44]

Matisse used more violent language to describe his efforts to kick down the door between himself and painting. The struggle was at its most ferocious over the ring of dancers Prichard had first seen in April 1909. Matisse spent that year concentrating successively on one thing at a time: the fierce clashing movement of the elements in the incoming tide whipped by wind and trapped by rocks at Cassis; the vibrating bands of light, heat and colour under the pine trees at Cavalière; the plastic possibilities of the human figure, explored in a series of extraordinary clay figures modelled during the first months at Issy. The attempt to organise and exploit his findings within the framework of his original design began as soon as the first of the two enormous canvases was finally erected in the new studio.

Prichard came regularly with small groups of friends or followers, mustering support and monitoring progress. Both panels went through many stages. Georgette Sembat saw an early stage of *Music* on 30 March 1910, just before Matisse's return from Collioure. She wrote to tell him that she was impressed by the flow of the drawing, but worried that the newly heightened colour of the musicians' bodies would mean repainting the dancers to match.[45] All Matisse's friends knew how much he relied on their critical response. Pierre Bonnard asked why he had eliminated tones and shadows (Matisse, after a sleepless night, decided the answer was that they added nothing to the effect he wanted).[46] Leo Stein described sitting in the studio at Issy talking to Matisse, who constantly jumped up to make drastic changes to *Music* on the wall behind them.[47]

Each of the panels was eight and a half feet high and well over twelve feet long. Matisse painted from stepladders, slapping away with big brushes at figures taller than himself. Hans Purrmann, who sometimes acted as studio assistant, was amazed by the way the alteration of one line could upset the balance of the whole vast composition ("He kept rearranging the limbs of the four figures . . . and manipulated the entire group as if it were one single figure with eight legs and eight arms").[48] Matisse painted intuitively, without thought or premeditation, like a dancer or an athlete. Months of preparation and practice meant that calculation translated directly into spontaneous action. "A picture is like a game of cards," he told Purrmann. "You must figure out from the very beginning what you will have at the end; everything must be worked backwards and always be finished before it is begun."

The process was intensely physical. Matisse hummed dance hall tunes as he worked on the plunging rhythms of *Dance*, which went back before he ever saw the Catalan fishermen on the beach at Collioure to his memories of workmen and soldiers whirling their sweethearts round the floor at the Moulin de la Galette in Montmartre.[49] The figures on his canvas grew beneath his brush into a great elemental surge of release and liberation. At times he seemed to be unleashing forces that, according to Purrmann, "frightened even him." As an image of thrusting, pulsing life being pumped back into a dead classical tradition, the painting could hardly be more graphic. This was the animal uprush of feeling Matisse had experienced as a boy of twenty at the great turning point of his whole life, when his mother gave him his first paint-box: "From the moment I held the box of colours in my hands, I knew this was my life. I threw myself into it like a beast that plunges towards the thing it loves."[50]

Its bestial aspect was the first thing that struck Matisse's contemporaries about *Dance*. They said it was primitive, grotesque, diabolical, barbaric and cannibalistic. He repeated that peace and harmony had been his aim, pointing out that the stillness and absorption of the figures in *Music* (colour fig. 5) were intended to contrast with the delirious abandon of his dancers. He had worked on the two panels alternately, switching from the bodies levering themselves into the air and hurling themselves earthwards on the first canvas to the engrossed and softly rounded shapes strung across the second like notes in music. The contrast once again reflected two sides of his nature. Music had been Matisse's first love, and he always regretted the rejection entailed in choosing painting as a career. He had played the fiddle as a boy, and retained ever afterwards a special feeling for violins and violinists, using them as a kind of stand-in or substitute for the artist in his work. The violin player in *Music*, whose rudimentary body seems no more than a conduit or conductor for the feeling flowing through his instrument, would reappear almost a decade later in *Violinist at the Window*, painted at another pivotal point in Matisse's career.

He explained his intentions in 1910 to the American art critic Charles H. Caffin, who had already published one interview with him. A sympathetic and intelligent observer, Caffin had been disconcerted at their first meeting by the evident sanity of the painter popularly billed as a wild beast or madman. His article, published in *Camera Work* in January 1909, was among the first to try to interpret Matisse's work for American readers. In his second interview, conducted in front of the two more or less finished panels, Caffin catches something of Matisse's own exhaustion and elation in his account of the violinist on the left of *Music*—"the ten-

sion of his body as taut and vibrating as that of the strings"—and even more in his description of the singer in the middle: "His limbs were gathered up close to his body very much in the attitude of a jumper, while through the wide opening of the mouth his whole nature seemed to be draining out."[51]

Matisse described to his old friend Jean Biette how he felt on having brought *Music* to its definitive state towards the end of May. "It's been an immense effort which has exhausted me, so much so that I'm feeling a bit drained at this moment," he wrote, "—and I could do with a good month's rest, which I can't take."[52] Crowds poured in to see the Bernheim show in spite of the critics' response. "If you only knew how I long to get away from here. I'm being made to suffer for the importance I've taken on recently. I'd rather things were simpler." Matisse finally gave up his school in June. ("What a relief!" he told Biette. "I took it far too seriously.") His regular teaching sessions had become more and more of a burden, student numbers unmanageable, the rumours racing round Paris about his military discipline and crackpot tuition steadily more absurd. Matisse confided in Prichard that what most of his students needed was spiritual makeover rather than technical instruction. But the school produced long-term effects, both on individual pupils and on their teacher's reputation. His students went home speaking a new visual language. All the countries represented by sizeable numbers—the Scandinavian nations, the United States, Germany and Russia—acquired substantial holdings of Matisse's work in his lifetime (Germany's would be disposed of under Hitler, Soviet Russia's successively confiscated by Lenin and incarcerated by Stalin), unlike France, England and the rest of Europe, whose citizens stayed away (Matthew Smith, Matisse's lifelong follower and only English pupil, said he had been too shy even to catch the master's eye, let alone speak to him).

Completing *Dance* and *Music* kept Matisse in his studio all through the summer of 1910. At this point, he needed more than ever to know how his work looked to other people. Almost anyone would do. The more innocent the eye, the better. He had always relied for an immediate response on his children and his models. When a girl posing for one of his clay figures remarked on the ugliness of the result, adding that if you looked closer there was something about it that wasn't exactly ugly, Matisse pressed her so hard to tell him more that she came close to tears.[53] To her his insistence may have had bullying overtones, but to him she represented a future for his work, a time when people might come to see that it wasn't so ugly after all. He told Leo Stein that he always hoped, at the beginning of every

picture, "that he could end without any distortion that would offend the public, but that he could not succeed."

Matisse spent much time showing and explaining his two panels to a stream of inquisitive and often discouraging visitors. When the New Yorker Henry McBride was taken along in June by two other critics, all three ended up feeling awkward and embarrassed ("There was great uncertainty in my mind whether the huge canvas . . . was meant as a joke or as a serious attempt at something beautiful").[54] McBride's companions were Bryson Burroughs and Roger Fry, who smoothed things over with characteristic tact, asking questions in his fluent French and saying something noncommittal when asked for an opinion. They waved good-bye to Matisse from Clamart station with considerable relief. "We all agreed that we liked him very much and thought him frank and honest," wrote McBride, "showing that there had been some doubt of his honesty in our minds."

Fry had come to sound Matisse out about the possibility of contributing to a mixed show in London. When he had first proposed bringing over the work of the much talked about French painters ("sometimes called revolutionaries, but more often raving lunatics"), Fry's friend Clive Bell assumed he was out of his mind.[55] Fry himself privately put Matisse's painting on a par with the work of his own seven-year-old daughter.[56] His review of *Dance* and *Music* in October was cold and uncomprehending. He would retain his suspicions about Matisse until well after the opening of what became the first Post-Impressionist show in November. Matisse, who was used to being taken for a conman, must have known he was letting himself in for a double dose of trouble with work going on view for the first time in London immediately after the showing of his decorative panels at the Paris Autumn Salon.

He admitted to Biette that the long solitary haul of the last twelve months had left him mentally exhausted ("This is between the two of us, *mon vieux*, for I've enough troubles already without letting people see my weak points").[57] Matisse had detested his first winter at Issy so much that he resolved never to spend another there if he could help it, but his dream of taking the family with him next winter to the Midi had to be shelved because of the boys' schooling. Jean had settled into the nearby Lycée Michelet, where Pierre would join him in the autumn. A year after her operation, Marguerite's health seemed on the mend at last. Her father reported to Terrus in early June that her throat was cured, and his own crisis of confidence was over.[58] He took a few days off to stay with Léon

Vassaux, and another ten days in August for a painting trip with Marquet.[59] The garden at Issy was a delight to the whole family. High boundary walls enclosed almost exactly an acre of ground with tangled shrubberies, rough lawns at back and front, tall trees, twisting paths, a lilac grove, a fruit orchard, two ornamental pools and a greenhouse where Amélie raised seedlings and grew begonias. It was, as Matisse said "between pride and chagrin" to Gertrude Stein, a smaller, more tousled and unruly version of the Luxembourg Gardens.[60] Amélie planted beds of brilliant flowers on either side of the path leading to Henri's studio. Etienne Terrus offered to send cuttings from his climbing roses. There were steps and a shady porch at the front of the house, a table and garden chairs under the nut trees beside the pond at the back.

The place could hardly have been more sheltered and secluded. In their first two years at 92 route de Clamart, the Matisses had no immediate neighbours except for a railway inspector further down the hill at no. 82 and a local government clerk at no. 62. The other families, arriving later, were either retired or much younger couples with small children. Shut up in her big house set among fields and building sites, Amélie found herself cut off for the first time from the perpetual comings and goings of painters and their wives or girlfriends, who had made up her world until now. At some stage, the family acquired a maid, Marie Danjou, from Amélie's native Roussillon (who must have been lonely too, since there were no other southerners in Issy and few domestic servants).[61] Otherwise, there was often nobody for company except the fifteen-year-old Marguerite, who was beginning to take over more and more of the running of the household.

Removing Henri from the distractions of Montparnasse had unforeseen consequences for Amélie. Instead of retrieving her place at the centre of his life and work, she seemed in danger of losing him altogether. He was away for large parts of the week in Paris on gallery business, coping with his students, drawing from the live model in afternoon sessions at Colarossi's, and attending the Steins' evenings on the rue Madame. At home he spent days on end shut away in his studio at the far side of the garden, desperately trying to make up for lost time. A procession of visitors came by car or train from Paris, many of them foreigners whose languages Amélie didn't speak, and who treated her, when they noticed her at all, as a dim, silent housewife. Society hostesses like Mrs. Chadbourne and Mrs. Sears made her feel defensive. Loud, self-confident intellectuals like Sarah Stein or Ottoline Morrell put her at a disadvantage. Even Gertrude Stein, who approved of Mme Matisse and took her part, relegated her

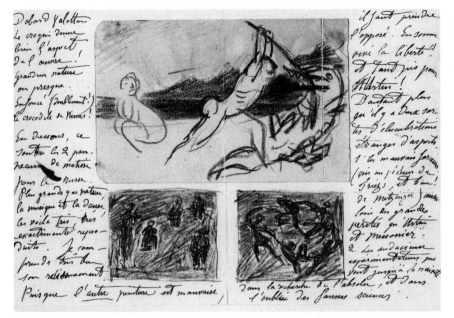

Jules Flandrin, sketch of *Dance* and *Music*, in a letter to his brother, 2 November 1910: Flandrin was one of the few to grasp at once the significance of his old friend's scandalous submission to the Autumn Salon. (Top sketch: Félix Valloton's *Perseus and the Dragon*)

firmly to the sphere of cooking, darning and childrearing. This was the fate Amélie had dreaded from girlhood, and at Issy it threatened to overwhelm her.

His wife's growing tension heightened the pressure on Matisse as he prepared *Dance* and *Music* for their first public showing at the Autumn Salon, which opened on 1 October 1910. The response was immediate and devastating. Crowds collected, jeering, catcalling and shouting insults in front of the two panels as they had done for three years running at the height of the Fauve upheaval. Old friends were dismayed by the new works, fellow artists were outraged. The reviews were so universally damning that Amélie had to hide them from her husband.[62] Even the sympathetic Lewis Hind reported that the figures in *Dance* looked like cavemen ("startling, disconcerting, terrifically ugly in the conventional sense—essential Matisse"), and congratulated himself on being cured at last of an unpleasant addiction, until he realised that the rest of the Salon looked insipid by comparison: "Those two palaeolithic panels came drumming in my inner consciousness.... He will not be denied.... His personality overshadows the other exhibitors.... Death, I fancy, will find me still trying to explain Matisse."[63]

Only Apollinaire stood out in print against the onslaught (Matisse, who had never forgiven him for failing Mécislas Golberg on his deathbed, said he would sooner have him for an enemy).[64] This time Matisse was

53

better prepared than he had been in February. Within a week of the opening, he left Paris for Munich to catch the last ten days of a major exhibition, "Masterpieces of Islamic Art." Marquet travelled with him. Matthew Prichard, who had already spent six weeks studying the show, was waiting for them in Munich, and Purrmann joined them from his home in Speyer. Matisse's friends did their best to distract and entertain him. He went drinking in the beer cellars with Purrmann, and accompanied him and Marquet to inspect the private collection of virtually his only supporter in the museum world, the director of Munich's Staatsgalerie, Baron von Tschudi.[65]

But it was Prichard who supplied the most effective antidote. This was the opportunity he had been waiting for to demonstrate to Matisse the actual and potential power of Oriental art. The exhibition provided an unprecedented display of decoration in all its forms, from carpets, carvings, tiles, ceramics, enamelled glass and illuminated manuscripts to Byzantine metalwork and coins. The most striking thing about it, according to Roger Fry, was the way in which the perfunctory, mechanical formulae of late Graeco-Roman classicism gave way in the middle ages to an Oriental decorative art of astonishing subtlety and strength, "an art in which the smallest piece of pattern-making shows a tense vitality even in its most purely geometrical manifestations, and the figure is used with a new dramatic expressiveness unhindered by the artists' ignorance of actual form."[66]

Matisse was himself attempting to bypass an exhausted classical tradition by similar means. He and Prichard spent hours looking at the exhibition and talking about its implications. They discussed reality and illusion, the possibilities of large-scale public decoration, and the obtuseness of the contemporary art establishment. "A picture by Matisse is like the blast of the trumpet of the last judgement to them," Prichard jotted down in his notebook.[67] Their week together in Munich cemented their alliance as nothing else could have done. It would inform Matisse's work, and direct his travels over the next three years. Asked afterwards what had impressed him most about the Islamic show, he singled out the textiles and the bronzes, which gave him the confirmation and support he could not get from contemporary art or artists. "You have to wait until you're dealing with a dead lion," he told Prichard in Munich. "If it's still alive, it will devour you."[68]

On the evening of 15 October, Matisse's father died suddenly at home of a heart attack. Matisse left Munich immediately for Bohain, arriving in

time to go with his younger brother Auguste to register the death.[69] The family seed-store closed, and bells tolled throughout the town for the funeral on 19 October. Matisse needed courage to walk behind his father's coffin at a moment when his activities had once again brought public shame and ridicule on the family name. His notoriety had soured the last years of his father's life. Matisse said that by the end communication had shrunk to "How's it going?" when his father met him with a trap at the station, and "Come again soon" when he took him back to catch the train to Paris.[70]

But Matisse's father had seen him through years of penury and hunger, enduring derisive comments from the neighbours with a baffled sense that his elder son was neither dishonest nor mad, and certainly not stupid. As Matisse's own two sons grew older, he understood more. He recognised his own unbudgeable determination in his father, and knew that his father had respected the same in him. They were proud, dour, obstinate people, who habitually covered emotion with the dry wit of their native North. When Matisse finally made good—or at any rate felt sufficiently secure at forty to rent his own place in the suburbs—he had shown his parents round the house and garden at Issy, drawing his father's particular attention to the newly planted flowerbeds. "Why not grow something useful, like potatoes?" asked the seed-merchant.[71]

It remained a source of bitterness ever after that Henri Matisse Senior had died too soon to see his son justified, or to admit that a potato crop was not the only one worth growing. At the time, his death was a shatter-ing blow. "I have been completely crushed ever since,"[72] Matisse told a friend the week after the funeral. "I am utterly demolished by it," he wrote to Biette.[73] The family travelled back in deepest mourning to Issy, taking Henri's widowed mother with them. Their return coincided with the Bernheims' last valedictory show of work by Henri Cross, whose suffer-ings had finally ended in death at the beginning of the year. Cross had consoled and encouraged Matisse as his own father never could. "He was a man of the North," wrote Maurice Denis, paying tribute to the passion-ate heart that beat beneath Cross's cool exterior in a passage that might just as well have described Matisse:

He was born amid the mists of Flanders . . . and he settled on the Mediterranean coast. The whole of his artistic life lies between his dark start and his destination in the sun. . . . In his eyes—the pale eyes of a man of the North—shone all the luminosity of the

Midi: it was reflected in his gaze, and its sparkling brilliance together with the emotion it inspired were in turn perpetuated in his work.[74]

Five days after the funeral, Matisse forced himself to look at his reviews. "How much rage they show," he wrote sadly to Biette on 26 October. "Luckily I didn't read them until the day before yesterday, because I'm going to have to show them to Shchukin. How far away it all seems—I only hope this indifference is genuine."[75] Shchukin had been taking a leisurely holiday in the south of France with a party that included his future second wife. By the time he reached Paris on 1 November, a week before the Salon closed, he had read enough about his decorative panels in the French press to be extremely worried.[76] All his original misgivings about hanging nudes in public came back sharper than before. People were already saying in Moscow that his abnormal and degenerate taste in art had driven two of his sons to suicide. Now, as he was about to make a second marriage, he must have known that displaying *Dance* and *Music* on his stairs would expose his new wife and her two teenage children to scandal even worse than anything his first family had endured.

Matisse blamed the Bernheim brothers ever afterwards for what happened next. They came specially to Issy to tell him that Shchukin had rejected *Dance* and *Music* in favour of a work by Puvis de Chavannes which was too large to fit into their gallery. They asked him to lend his studio instead, so that the rival painting could be displayed in all its glory to its prospective owner. Matisse agreed at once. To have Shchukin refuse his panels after nearly two years during which he had thought of little else, at a moment when he was still reeling from the impact of his father's death, was almost more than he could credit. Half a century later, his daughter recalled that day for her brother Pierre. "I remember very well the moment when our father said: 'If Shchukin really looks at my work, I am bound to emerge the winner from this contest.' But it was rather like a man stunned by a blow who gets up again by sheer willpower, using more of it than even he had ever needed to exert before."[77]

Puvis's *The Muses Greeting Genius: The Herald of Light* had been commissioned from one of the most prestigious painters in France to hang above the staircase in the magnificent new entrance hall of the Boston Public Library. The painting (a copy made by the master from his own original) was as much an allegory about art as either of Matisse's panels, but it belonged to another world. Marguerite said that to a child brought up among the Fauves, its ghostly pallor and elegant, etiolated figures were

shocking.[78] But as a young man Shchukin himself had been, by his own account, "infatuated with Puvis." Confronted in Matisse's studio with the full enormity of what he had been about to do, he reverted to the idol of his youth. Puvis emerged the winner.

On 8 November, Shchukin caught the train for Moscow. Two days later he reversed his decision in a telegram dispatched from Warsaw station along the way, writing to explain that during the two days and two nights of his journey he had "come to feel ashamed of my weakness and lack of courage. One should not quit the field of battle without attempting combat."[79] It was a long, brave and extraordinarily honest letter. He confessed his youthful passion for Puvis, adding that the newly purchased painting no longer meant anything to him, that the Moscow Museum had refused to take it as a gift and that, even if Bernheim-Jeune declined to buy it back, he had learned his lesson and would count the money well lost. Matisse's two panels were to be sent immediately.

Purrmann, who came to help roll and pack them, said that Matisse sprang back in panic when the figures on the two huge canvases laid out on the studio floor suddenly seemed to heave and stir beneath the baleful gaze of Puvis's muses.[80] Matisse still couldn't take in what had happened. "If you remember, I didn't fall to pieces," he wrote, recalling the first shock a month later to his wife. "I made myself go rigid."[81] The whole family was deeply shaken by this affair, and by Matisse's inability to absorb it. Gradually he came to see it as a characteristically short-term dealers' ploy to cash in on a client's indecision and bump up the profits that had so far failed to accrue from the Matisse contract, by off-loading an otherwise unsellable Puvis. "You couldn't do that to Maurice Denis," Matisse said long afterwards, remembering the shabby trick the Bernheims played on him.[82] At the time it sickened and unnerved him. Years after her father's death, Marguerite could still vividly recall "the memory of the state of anguish that possessed Matisse night and day from the moment when the Bernheims came to propose putting the Puvis in his studio to the moment when he received the letter written by Shchukin from the train."[83]

The whole sorry business overshadowed the opening on 8 November of the London Post-Impressionist show, which drew fresh floods of startled and aggrieved vituperation from press and public ("Fry is lifting them by the scalp," Prichard reported cheerfully to Mrs. Stewart Gardner).[84] For the third time that year, Matisse fled Paris, boarding a train in the opposite direction as soon as he had seen his panels safely onto the slow goods train for Moscow. He chose Spain, apparently on Prichard's advice ("I'd been so messed about . . . over my decorations, I didn't know if I was

coming or going," he explained to Biette. "It seemed to me the sun would do me good, someone suggested I come here, and I left").[85] He planned to follow up their talks in Munich by visiting the Alhambra, taking in on the way the Moorish palaces and mosques of Cordova, Seville and Granada.

He reached Madrid on Thursday, 17 November, in cold, wet weather, with his head spinning after twenty-six hours on the train. He drew himself huddled over the radiator on his first afternoon for Marquet: "I wanted to go out but here is how—and in what—I saw the Spanish, who aren't always that good-looking," he wrote, sketching a barrel-shaped Spaniard clutching an umbrella in driving rain.[86] He said the people in the streets all looked like curés, or alternatively like lean, dark and handsome Henri Manguins. Two days later he rushed through the Prado, firing off a series of exuberant postcards to old friends. "Goya, Greco, Velasquez, Tintoretto, I'll see the other jokers tomorrow. Why aren't you here?" he asked Marquet. "Magnificent weather—picturesque views—Prado exquisite—hope it keeps up," he told Manguin on 22 November.

On the 24th he moved on via Cordova to Seville, where the sun came out. "It's wonderful, and so is the temperature!"[87] he wrote to Amélie. In Madrid, he had run across an old acquaintance from student days, Francisco Iturrino, a dashing, gaunt, grave Spaniard who had been much painted at the turn of the century by Parisian romantics (including both Picasso and Derain). Iturrino was on his way to Seville, where Matisse found another hospitable old friend, Auguste Bréal, leading an idyllic life in an apartment built round a pillared courtyard with palm trees and a fountain in the middle.[88] Bréal, who showed him round the town and introduced him to flamenco, proved a knowledgeable and enthusiastic guide to Spanish life and culture. Matisse collected old glazed Moorish tiles (including a blue-and-white, seventh-century tile from Iznik which he would draw in 1915), sending a packet of them back to Issy together with two cases of local pottery for the garden. He bought a fine piece of antique glass for Amélie, and a cream-coloured woollen rug with a dark blue design for himself ("It caught my eye in an antique shop in Madrid . . . it's not in a very good state, but I'll be able to work a lot with it, I think. . . . I've never seen anything like it").[89]

After a few days, he moved into Bréal's club on the main square, the only adequately heated quarters in the whole of Seville, according to Matisse, who grumbled mildly to his wife about the lack of stoves and the fact that no one ever dreamed of closing doors or windows. The only snag about this elegant club was that he felt so out of place in his shabby old clothes he had to ask Amélie to post him his one decent coat (taking the

precaution of having it relined first, so that he wouldn't stand out too much among the chic and beautifully groomed Spaniards). He described himself lying late in bed in the mornings with palm fronds waving gently against a blue sky outside his window. "I'm basking in the sun here," he wrote to Charles Camoin on 3 December,[90] and to Manguin, "Long live wine, women and tobacco!"[91]

The reality behind these cards and letters was very different. Matisse was functioning on autopilot. The various accounts he gave at the end of his life describe almost complete physical and emotional breakdown in his first weeks in Spain. He said he had been living on clenched nerves for so long that they could not be unwound. The last straw had been the shock of the Bernheims' treachery, which only began to sink in once he reached Madrid, where, to his surprise, he failed to sleep on his first night. From then on insomnia exacerbated his inner turmoil. He had not slept for more than a week by the time he reached Seville in a state of near collapse. After the first few days, the weather deteriorated into torrential rainstorms fiercer than he had ever seen before. "Seville is a town turned in on itself, where everyone shivers with cold," he told Pierre Courthion in retrospect.[92] The chill that gripped him body and soul made him tremble so violently that his metal bedstead drummed on the tiled floor of his room. "My bed shook, and from my throat came a little high-pitched cry that I could not stop."[93]

He stayed indoors, sick and feverish, dosing himself with laudanum, until rescued by Bréal, who booked an appointment with his own doctor on 6 December, and promptly moved the patient into his house on the Calle Imperial to be nursed according to a strict regime. The doctor prescribed rest, tranquillisers and warm baths three times a day, warning that fear of not sleeping made sleep even more problematic. Amélie had said the same for years. Matisse owed much to this shrewd and sensitive Spanish doctor, who explained that there was nothing clinically wrong with him, that black despair would inevitably follow bouts of such intense nervous pressure and emotional exhilaration, and that all he could do was learn to manage his condition by sticking to a regular work schedule, and by being less exacting towards himself ("All artists have this particular make-up, that's what makes them artists, but with me it's a bit excessive," Matisse told his wife, adding optimistically, "perhaps that's what gives their quality to my pictures").[94] The first part of this advice became Matisse's rule for the rest of his life, but he failed, if he ever tried, to follow the second.

The worst of the crisis was now over. "My dear Mélo," Matisse wrote

Postcard of the
Sala de las Camas
brought back by
Matisse from the
Alhambra

on 8 December, using his wife's pet name and describing his recovery in terms he normally reserved for the great symbolic liberations of his youth, like his first paint-box or his first sight of the southern sun: "Suddenly I understood my case so clearly that it's changed me, it's as if I'd been saved."[95] He felt a familiar surge of energy and release. Free at last to pursue the purpose of his journey, he left for Granada the next day. The train had a special semicircular, glass viewing compartment, where Matisse sat alone from ten in the morning until eight o'clock at night, entranced by the fertile Andalusian plain ("palm trees, eucalyptus, pomegranates and orange trees, the walls of the houses and villas hung with vivid purple morning glories and dark green foliage"), and by the harsh dry mountains of the Sierra Nevada ("a poor country where the poor people in the towns—and there are many of them—swarm around the train to beg whenever it stops"). He reached Granada in another howling downpour, and took a room in a pension, where he spent Saturday waiting for the storm to pass. The pension was outside the town, close to the Alhambra, surrounded by huge elms described by Baedeker as a sacred grove ("Sacred it may be, but I can tell you it's swearing like a heathen at the moment, because the wind is strong enough to de-horn the bulls of Andalusia, and they're pretty solid, those horns").[96] On Sunday, 11 December, he reached his goal. "The Alhambra is a marvel," he wrote to Amélie that evening. "I felt the greatest emotion there."

Amélie had forwarded to Granada an urgent request for a pair of large still lifes from Shchukin (who hoped that something relatively straightforward and easy on the eye might help to lessen the inevitable public outcry over *Dance* and *Music*). Arriving in that place at that moment, the commission affected Matisse like a starting pistol. "Ideas have come to me here . . . ," he wrote on Sunday night to Amélie. "I could see the two of

them already complete, but done here." He allowed himself only one more full day at Granada to continue the exploration begun with Prichard in Munich. The brevity of this encounter if anything intensified its impact. The courts and palaces of the Alhambra, its pierced screens and shuttered spaces, its rhythmic variations on the theme of inside/outside, its counterpoint of form and colour, dark and light, riotous pattern and restful intervals of sky or water, found echoes ever afterwards in Matisse's imagination.

Part fortress, part paradise on earth, constructed at the time of the Crusades when the mediaeval collision between East and West reached its height over a century of almost unimaginable violence and aggression, the Alhambra embodies Islam's dream of harmony, peace and luxury. A parallel vision lies at the core of Matisse's work. He first encapsulated it in the notorious image of an armchair designed to soothe a harassed businessman. Later he would identify for Prichard the particular businessman he had in mind: "He instanced the case of Shchukin, who after his day's work and trouble sat in his drawing-room where he proceeded to forget his worries under the influence of Matisse's pictures, which have a calming tendency."[97]

The letter Matisse dashed off to Amélie from Granada on the night of 11 December makes it clear that the two new works for Shchukin's drawing room were conceived in the Alhambra. He responded with the passionate, instinctive force of his whole being to the inner quietude secreted within a fantastic decorative profusion perfected, in the words of Roger Fry, by "systems of Mohammedan design so skilfully interwoven, so subtly adapted to their purpose, that the supremacy of Mohammedan art in this particular form has been recognised and perpetuated in the word Arabesque."[98] More than forty years later, Matisse acknowledged that he had been possessed at this point by a love of line and of the arabesque—"those givers of life"[99]—which stirred his senses and appeased his spirit.

On Tuesday, 13 December, he caught the train, arriving back in Seville late at night, still cold and wet, still plagued intermittently by sleeplessness, but with his weakness shot through by elation. He found a letter waiting for him from Georgette Sembat, urging him to ignore the critics, whose spleen would turn to admiration in ten years, and comparing him to J. D. Ingres:

> It's his correspondence, where he is thinking aloud, and where
> at every turn it seemed to me it might have been you writing—

especially when he senses his own power and feels sure of himself, knowing he is doing the opposite of his contemporaries, and certain he will succeed in producing something new, and then he receives at Rome the terrible, spiteful, slashing reviews of his work at the Salon, and weeps with rage, suffering all the same and rebelling, crying aloud his misery at the injustice they have done him, it's very vivid and very true—in spite of his confidence in himself, in spite of your confidence in your work, you can't help suffering at seeing yourself judged like that, even if it is by people you despise.[100]

The day after he reached Seville, Matisse hired a studio for a month, laid out a still life (colour fig. 6) (including the cream-and-blue quilt that had captivated him in Madrid), and set to work without waiting for the brushes, palette knife and paints he had sent for from home. The two paintings he produced in quick succession for Shchukin marked a fresh departure. The thinness of the paint and the speed of execution testify, as Alfred Barr noted dryly, to "Matisse's excitement when confronted by the problem of controlling and harmonising such a bedlam of assertive patterns."[101] European and Oriental concepts of decoration confront one another on these canvases. The layout and its components—fruit, flowers, vegetables, a green-glazed local pot and half a dozen newly acquired textiles—represent the standard still-life paraphernalia of Western painting, but the rhythmic overall fluidity of swirling line and brilliant colour belong to another world. "In Eastern friezes the drawing combines with the background in a single ornamental design, a decorative whole, a great vibrating carpet. Such are the arabesques of Tunis, Algeria and the Alhambra palace," wrote the Russian critic Jacob Tugendhold, assessing Shchukin's collection a few years later, "and it is just this lack of distinction between the 'design' and the background that is the characteristic feature of Matisse's work. . . . Matisse's painting has none of the solemnity of High Art, but it has a gaiety of its own that has less to do with the decorative-architectonic Renaissance tradition than with decorative purity in the oriental sense."[102]

Matisse had borrowed paints and brushes from Iturrino, who shared the studio, setting up his easel alongside his French friend's to paint his own two versions of the same still life (Iturrino would make a comeback with Matisse's help at the Autumn Salon that year in Paris). The pair attended a drawing club together in the evenings, and were photographed

beside the river Guadalquivir by
Bréal, who also found them a
live model: a dancer with black
hair, high cheekbones and
strong, expressive features, called
Joaquina.[103] Matisse, whose life
had for so long revolved around
the dance, was fascinated by the
gypsy dancers of Seville. He never
forgot a sixteen-year-old called
Dora—"a miracle of suppleness
and rhythm"—who made the
toast of Paris, Isadora Duncan,
seem brash and unsubtle by com-
parison, more of a gymnast than a
dancer. Dora "revealed to me
what the dance could be. . . . I
compared her to the celebrated

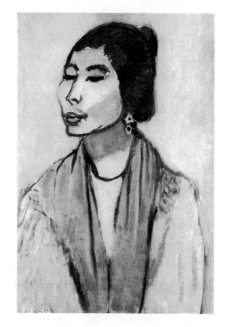

Matisse, *Joaquina*,
1910: the Spanish
dancer who posed
for Matisse and his
two friends in
Seville

Is. Duncan, whose gestures cut across the flow of the music, where Dora
by contrast prolonged the sound with her arabesques."[104]

The three canvases he painted with Iturrino were the only ones
Matisse produced in Spain. Looking back afterwards, he reckoned that his
crisis lasted in the end for a month and a half. Insomnia had dogged him
until the last night of the year, which was his forty-first birthday. Its
approach made him feel old as well as lonely. Missing his friends, thinking
sadly of his mother, he reached out to his wife, begging her to write and
get the children to write too ("The little wretches couldn't care less about
their father, or his forties").[105] He saw everything in Seville through a haze
of exhaustion. Although he reached his studio every morning at ten, pal-
pitations and rising fever forced him to stop work after half an hour, or
forty-five minutes at the most ("All the rest of the time I dragged my
fatigue and revulsion round with me").[106] It was only back in Paris that his
two still lifes surprised him: "I saw they weren't too bad . . . they were the
product of nervous tension."

Matisse marked the new year of 1911 with a long, sombre letter to
Biette, tracing the history of the panels commissioned by Shchukin ("A
commission is more horrible than desirable for certain temperaments"),
for which he said he had moved heaven and earth over two years.[107] He
attributed the assaults that followed to jealousy, intensified by a sense that

Matisse had somehow managed to collar for himself the lavish Russian funding that should by rights have enriched the entire Parisian art market. "So now I ask myself if these panels are really important enough to motivate aggression on a scale that still surprises me, and which maybe I couldn't stand—," he wrote, breaking off in a flurry of crossings-out as he contemplated a possible recurrence. He looked back longingly to his beginnings as an unknown young artist experimenting at Collioure in the summer of 1905. The events of the past year confirmed his resolution to have nothing more to do with the manipulative world of art politics. "Now I have decided to reject the over-importance that has been given me, and that perhaps I let myself be given, and to continue on my way without that sort of complication."

This letter was written a month after the publication of the most vicious of all the attacks of 1910, "The Prince of the Fauves" by Roland Dorgelès, who repeated all the old racist slurs, accusing Matisse of greed and cynicism, and gloating over the graffiti campaign organised by Picasso's band on the walls of Montmartre ("Matisse drives you mad! Matisse is more dangerous than alcohol! Matisse does more harm than war!").[108] The memory of this article stayed with Matisse for the rest of his life. "That he had been terribly wounded in the past was obvious," wrote an English artist, C. R. W. Nevinson, impressed by the philosophical detachment the older painter had achieved by the time they met a decade later: "He told me how his wife used to hide the press cuttings from him, as the dirtiness of the art criticism drove him to distraction."[109] Matisse knew by now that his only hope of survival as an artist lay in stripping down his life as he had stripped down his work, centreing his existence on the studio and establishing a working rhythm that would enable him to live with the hostility of others, above all to endure the ravages of his own unquiet temperament. "The public is against you," Shchukin wrote from Moscow, reporting the arrival of the two panels that winter, "but the future is yours."[110]

CHAPTER THREE

~

1911: Seville, Paris, Collioure and Moscow

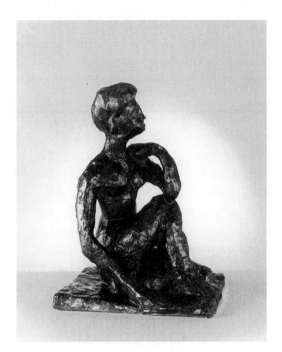

Matisse, *Seated Nude (Olga)*, 1910

Matisse wrote almost daily to his wife from Spain, where fine weather in his first few days in Seville reminded him of the sun shining on their Corsican honeymoon. He said her presence was the one thing missing to make him happy, and begged her to send news once a day, as he did ("The hour you spend writing you'll be with me. . . .

You'll see how it will make our separation easier to bear").[1] He missed her
even more as the turmoil of his nights increasingly spilt over and threat-
ened to engulf his days. Even allowing for the need to reassure her by min-
imising the problem, his letters vividly record one of the worst of the
periodic cycles of panic and collapse when his only hope of relief came
from Amélie. "It gives me immense pleasure to tell you about it," he
wrote, reporting the first faint sign that he was getting the better of his
terror of not sleeping, "for I feel I owe it to you after all the miseries
you've had to put up with during my nights of insomnia."

What clinched his recovery was Shchukin's letter, followed in quick
succession by two more, each containing successively more ambitious pro-
posals.[2] A week after his request for two still lifes, the Russian suggested a
large group portrait of the painter's family. A fortnight later, he offered to
set aside a whole room in his palace, small and dimly lit but big enough to
hold three full-scale wall panels on allegorical themes. Matisse sent
prompt businesslike letters of acceptance in each case. In private, he
responded like a man coming back to life again, or a lover receiving the
advances of an irresistibly seductive mistress.

Initially he had planned to spend a month in the Moorish city of
Seville, or Granada, or nearby Tangier. He said he saw things to inspire
him on all sides, but after two weeks in Spain when he could neither draw
nor paint, he was ready to abandon the scheme altogether ("You know
that if the idea upsets you, I won't think of it any more").[3] A week later
the prospect of being able to sleep again—which meant a renewed capac-
ity to work—filled him with incredulous delight. Shchukin's first commis-
sion released a flood of images. Rapturous longing gave way to the kind of
headlong pursuit that can take account of nothing and no one else. His
letters to his wife remained affectionate and solicitous ("My poor sweet-
heart, I understand that the time seems long to you; there are days when
I'd like to take the first train back to Paris"), but there was no longer any
question of his returning home with his desires unsatisfied ("When I
come back, I'll be able to relax without a pang with you, with the whole
family, provided I've produced some work").[4]

He still wrote nearly every day, and urged Amélie to write back, how-
ever little she had to report ("I can tell you in advance your smallest details
are never tedious to me").[5] He bought her presents, and wished they could
afford the fare for her to join him, but from now on his tone grew brisker
and more cheerful. "Believe me, I'm right to stay on. We'll be much hap-
pier together when I've got some work done," he wrote on 14 December,
overriding her reproaches. "Don't talk to me like that again, it's the last

thing I need. I'm sticking it out here because I can sense work to be done.... You'll see, you'll tell me I did well to stay when you see what I bring back."

But his wife had already had as much as she could take. Stranded in the suburbs with her widowed mother-in-law and three children, facing a second bitterly cold winter (this time it brought an outbreak of diphtheria, instead of flooding) in a wilderness of half-built houses and frozen market gardens, with the studio closed down, few visitors and no distractions, Amélie relieved her feelings in a series of terse postcards. She complained of aimlessness and boredom, conjured up the cloud of gloom lying over the whole household, and accused her husband of having forgotten all about the distant outpost at Issy-les-Moulineaux, whose inmates counted the days till his return. Henri was stung by this last charge ("It cut me to the heart," he wrote; "it was devastating").[6] The family was his base of operations. His wife supplied essential life support. But he understood her discouragement, and perhaps already recognised warning signals of the depressive patterns that would increasingly shadow and distort their marriage. He sent her a daily checklist of simple practical tasks—to keep an eye on the boys' homework, to supervise their regular use of antiseptic mouthwash, to check that Marguerite had changed the tube inserted in her windpipe, and to make sure that the odd-job man had walked the dog—which suggest he was familiar with the inertia of full-scale depression.

This was the first time they had confronted their separate demons apart. Up till now Henri had depended on Amélie to counter the desperation that forced him in her absence to consult a doctor. But the doctor's diagnosis ("There's nothing clinically wrong with me, only an emotional imbalance—I pass too quickly from the wildest enthusiasm to the blackest despair")[7] failed to console Amélie. Her husband's self-reliance fed her despondency. She felt unwanted and excluded, perversely dismayed by his assurances that things were looking up. She retreated into the mute passivity of wounded pride, interpreting his attempts to manage without her as a rejection. Henri, who had met this response before ("You never think anyone else can feel as miserable as you do"),[8] redoubled his efforts to stop her worrying. But Amélie reacted badly to his accounts of sun-drenched palm trees, and even worse when Bréal arranged for him to attend a dance class so he could watch the local girls practising flamenco.

The final straw seems to have been his decision, after he had been away a month, to settle down on his own in Seville for a second month of solid work. Amélie, who had been expecting him home in mid-December,

left Issy at this point without telling her husband she was going, or where. Puzzled by her silence, anxious about money, worrying over how to pay the rent due on the last day of the year, he telegraphed home and got a cable in reply on 21 December from Marguerite, saying her mother was with the Parayres in Perpignan. Amélie's official explanation was that she had gone to help pack up the household for her sister Berthe (who had just been posted to a new job as principal of the Ecole Normale Supérieure at Cahors).[9] But in her last indignant letter to her husband, she seems to have accused him of being indifferent and unfaithful.

Amélie's father and sister knew her well enough for Henri to rely on them to take his part. "Dear Father-in-law, dear Sister-in-law, dear wife," he wrote on 22 December, setting out the situation and appealing to their judgement as calmly as he could. "I count on you to convince Amélie, who is absolutely furious with me, that I came here for the sole purpose of working, and that nothing in my past life could give reason to suppose I stayed on in Seville in order to spend my nights on the tiles." He explained that Seville out of season was far from the romantic and permissive pleasure ground of Italian opera. For him the city wore a frowning aspect, cold, harsh, and so repressive in its sexual mores that models were virtually unobtainable. The only equivalent of the routine nude drawing sessions available every afternoon at Colarossi's school in Paris was a private life class he attended in the evenings with Iturrino. "Contain yourself, Amélie, work has to be taken into account," he wrote wearily, pointing out that he could hardly abandon the first of Shchukin's well-paid still lifes now that it was going well at last. "I've been so messed about this year I've got very little done. . . . I'm counting on Berthe to persuade you that your resentment is somewhat excessive."

Berthe Parayre understood the gulf that lay behind Henri's protests and Amélie's bitterness. The sisters came of a line of tough, proud, independent women accustomed to operating on equal terms with men. Berthe had built a highly successful professional career on her reputation with the French educational authorities as a shrewd judge of character, a skilled mediator and an outstanding troubleshooter. Perhaps she also recognised that Amélie's suspicions, however groundless in literal reality, were only too well justified on another level. Henri's kind, fond, reassuring letters from Seville spelt out with painful clarity truths about their marriage his wife may have feared but had failed to face until now. He had meant exactly what he said when he warned her all those years ago that painting's claims were paramount. As far as work went, theirs was not, and never could be, an equal partnership. The sense of purpose and high

drama with which she had begun the marriage had dwindled, leaving her to face the fact that for the moment her husband needed little more from her than long-distance domestic back-up.

Things would be patched up again between them. Henri made efforts to modify his singleminded absorption in his work, or at any rate to include his wife on future painting trips, but after this unsettling episode, Amélie never fully regained her old self-confidence and certainty. In the short term her father and sister defused her anger sufficiently for her to accept Henri's invitation by telegram to join him for his second month in Seville. He sent money orders, a timetable and detailed instructions for the thirty-six-hour journey, trusting her fury had abated, and teasing her mildly in the words of an old Spanish jingle ("¡Cabezote, testarudo! ¡Cabezudo, obstinado! ¡Tener vena de loco, tener ramo de locura! [Pigheaded and stubborn! Pigheaded and obstinate! With a touch of madness, with a crazy streak!]").[10]

"Life on my own here isn't much fun, so my wife, who is in Perpignan at the moment, is coming to keep me company," he told Marquet on 27 December. Amélie changed her mind about joining him the same day. Money was still a worry, and Henri, who had now more or less finished the first of Shchukin's paintings, needed only another fortnight to complete the second. He stayed on alone at the Hotel Cecil in Seville, still hoping for letters that didn't come ("Amélie, you're wrong to go on sulking") and increasingly anxious to get home ("I'm beginning to be seriously bored here, whatever our dear Amélie may think," he wrote in another of his joint letters to the three Parayres, who had by this time reached Cahors).[11] His wife made her own way back to Paris, where people drew the obvious conclusion about Matisse's reasons for wanting to get away to a sunny Mediterranean country full of dancing girls.

His male friends were frankly envious ("What fun to have a studio in Seville," wrote Jean Puy, "and how enticing the nudes must be with nothing on").[12] The standard view was encapsulated in a comical vignette by Gertrude Stein, who had appointed herself Amélie's champion as part of an ongoing rivalry with her sister-in-law, Sarah, in whose eyes Henri could do no wrong. These were the years when Gertrude divided her acquaintances into Matissites and Picassoites, reporting with satisfaction that her French cook served M. Matisse fried eggs for dinner instead of an omelette because, as a Frenchman, he would understand that it showed less respect.[13] All their friends would have recognised a literary equivalent to this cryptic culinary slight in Gertrude's "Storyette HM," about a wife whose husband annoys her by "going off alone to have a good time."[14] The storyette ends pithily with a much-quoted spat between the couple:

He came in all glowing. The one he was leaving at home to take care of the family living was not glowing. The one that was going was saying, the one that was glowing, the one that was going was saying then, I am content, you are not content, I am content, you are not content, I am content, you are not content, I am content, you are content, I am content.

The only one of Matisse's friends to witness the full extent of his distress in Spain was Auguste Bréal, who had good reason to be sympathetic. Bréal had left his own wife behind in Paris and was living as a married man with a Spanish woman called Carmen Balbuena. Unlike the clever, cultivated and unconventional Mme Bréal, Carmen had no intellectual pretensions. She and her sister Consuelo posed for Bréal—who was known in Seville as Don Augusto—and ran his household, flitting gracefully about the pillared patio in long white dresses, and breaking into dance steps whenever they heard a street musician. Don Augusto struck Matisse as enviably carefree—"more of a Don Juan"—until his old friend explained the background to his broken marriage.[15]

Louisette Bréal had fallen in love with a widowed academic, who didn't return her passion but proved no match for her determination to bear his child. She paid no attention to the protests of her family or the

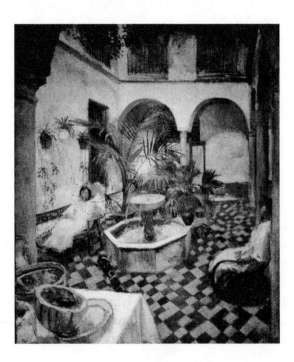

Auguste Bréal, *Courtyard of the Painter's House in Seville:* where Matisse was nursed back to health after his breakdown in 1910

pleas of her husband, who fell ill for months with grief and shock before reluctantly departing to make some sort of a new life, and a home where his two young children could visit him, in Spain. Bréal, who had aged considerably in the five years since he left Paris, seemed to Matisse to have taken his wife's defection far too passively. He remained in regular

contact, inviting her to stay in Seville, and even sending Carmen to the family home in Paris, where his fourteen-year-old daughter Hermine (an almost exact contemporary of Marguerite Matisse) kept house for her mother and her father's partner, both of whom were pregnant by their respective lovers (Carmen lost her baby, and Louisette officially registered hers as Bréal's son).

Matisse liked Carmen, and approved of the simplicity and directness with which she treated Bréal and responded to his paintings. He was amused by the contrast between her unassuming intuitive intelligence ("She's a bit like you in character," he wrote to Amélie) and her predecessor's more assertive style. But he was profoundly shocked by the way the broadminded Bréals had managed to dismantle their marriage and tear their family apart without apparently acknowledging, even to themselves, the destructive consequences of what they were doing. "I didn't hide my astonishment from Bréal, and I told him it was one of the most extraordinary examples of the kind of modern civilisation in which it isn't done to raise your voice. . . . They behaved, and still are behaving, like people so well-bred they have no instincts left," he wrote to Amélie on 1 December, adding that the outcome might have been different if Bréal could have brought himself to give his wife a good slap.

Bréal's revelation shook Matisse. It was still fresh in his mind when he found tensions erupting behind his own family façade a few weeks later, and perhaps it affected his response. It certainly made him realise, even before Amélie stopped writing, how much the family meant to him. "I think a great deal about you all, and about Maman . . . ," he wrote with uncharacteristic effusiveness on 8 December. "Let us love one another, let us give one another as much pleasure as possible while we're still together—that is where we will find our real happiness." Shchukin's suggestion that he paint his wife and children could not have been better timed, and Matisse posted off a rough sketch almost by return of post, telling Amélie he had been meaning to do something of the sort ever since they moved to Issy.[16]

He began his long, slow, frequently disrupted journey homewards in mid-January, stopping off on the way from Seville to Madrid to see the Grecos at Toledo, where he was held up for several days by snow lying four feet deep on the railway line. When he eventually left Spain, travelling via Barcelona along the Mediterranean coast, he broke the journey once again to spend a few days of unexpected sunshine with Etienne Terrus, talking and walking in the Pyrenees. Terrus, who was especially attached to Amélie and had seen her in Perpignan almost as soon as she arrived, must

have known or suspected something was up.[17] Even after he boarded the Paris train at Toulouse on 25 January, Matisse got off briefly again to consult the Parayres at Cahors.

What passed between him and his wife when he finally reached Issy is impossible to say. The trip that was to have taken a month at the outside had lasted more than twice as long, and produced nothing significant apart from two still lifes (which were immediately dispatched to Moscow). Otherwise, all he had to show was the little portrait of Joaquina, which was enough to confirm suspicions that he been captivated, like Bréal, by "the women of Seville in their patterned shawls with their flicking fans, their black eyes and tawny skins, mingling the Orient with the Occident in their dances."[18] Matisse called his picture *Gypsy,* and showed it at the Salon des Indépendants that spring with a bigger canvas called *The Spanish Woman (The Manila Shawl).* Amélie posed for this second painting, wearing a brilliant orange and green embroidered shawl, which her husband had brought back from Spain, pulled tight across her breast, not so much draped as flaunted like a flag, with her head held high,

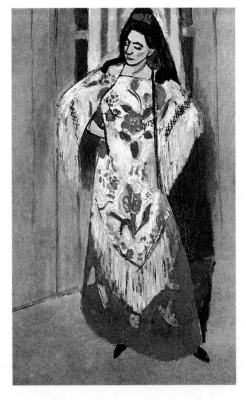

Matisse, *The Manila Shawl (The Spanish Woman),* 1911: the first painting Matisse made of his wife—"looking like a human ultimatum"—on his return from Spain

eyes averted and arms thrust out akimbo in a gesture of assertion or repudiation. The composition is, as Alfred Barr observed, a sumptuous decorative synthesis in which the painter has reduced his wife to little more than a sketchy, two-dimensional paper doll ("Though what a magnificent paper doll!").[19] On another level, the fierce, taut, emblazoned figure looks like a human ultimatum.

Amélie never again modelled for her husband in the studio at Issy. She had dressed up in Spanish costume for him once before, at another crisis nearly ten years earlier when the couple reached the lowest point of their fortunes with nothing

to live on, nowhere to go and no way out in sight. Amélie had tried to save the situation with characteristic dash by putting on toreador pants and strumming a guitar, urging Henri to turn out a slick product for quick sale. In a tense atmosphere with tempers running high on both sides, he averted a blazing row only by kicking the easel over, after which both of them burst out laughing. "If one day you manage to get out of this mess, all our troubles will be over," she said to him at the time. The clash between her stormy southern temperament and his infuriating northern phlegm emerges sharply from this incident as he described it long afterwards to his daughter. "I replied, 'Troubles are never over—if I ever do make a success of it one day, I shall have lost my father and my mother, your father and your mother, etc., etc.'—until your mother cried out in horror: 'Stop it, stop it!' "[20]

Public exposure of the *Spanish Woman* seems to have been more than Matisse could stand. The Indépendants opened on 21 April 1911, and within five days he had snatched back his wife's portrait, taking it away by cab and leaving in its place *The Artist's Studio* (later renamed *The Pink Studio*), a newly finished canvas still so wet that visitors to the Salon amused themselves by smearing their fingers in its sticky paint.[21] The kidnap caused hardly even a minor sensation in a year when people were more agitated about Picasso's Cubist followers than about Matisse, whose scandal quotient had fallen behind that of one of his own pupils. "They recoil in horror before the monstrous images of Olga Meerson," reported the *Journal*, citing her name at the head of a list of the Salon's worst outrages which included works by Picabia, Segonzac, Van Dongen and Vlaminck, "not to mention the frightful *Spanish Woman* of M. Henri Matisse."[22]

It was three years since Meerson had moved into the old convent on the boulevard des Invalides and put her career on hold to follow Matisse. She had learned fast, shedding her old armature of skills, retaining her sense of colour and design, enriching the gift for portraiture Matisse had urged her not to put at risk at their first meeting. After he gave up teaching, Meerson remained closer to him than any of his other pupils (apart from Sarah Stein and Hans Purrmann, who retained their respective roles as cheerleader and dogsbody). She had kept her room in an unsold part of the convent complex, where he dropped in on his days in Paris, and she became a regular visitor to Issy. Matisse modelled her in clay as a *Seated Nude*, and painted her portrait as well as his wife's in 1911.

Meerson also painted him at least twice that year. She sent one of these portraits to the Autumn Salon, where it presided over the Fauve section, giving the whole room, according to Guillaume Apollinaire, "the

character of an homage to the leading exponent of suave and powerful colour."[23] Meerson's new style was rougher, bolder, more expressive than before, making up in energy and attack what it had lost in subtlety and polish. Matisse relaxed for her as he rarely did for the camera, or for the various interviewers who tried over the next forty years to portray him in words. He was a wary and defensive sitter. Many years later, he explained to Louis Aragon that he couldn't function as an observer himself in the presence of someone who was simultaneously watching him. With Meerson, in the summer of 1911, he lowered his guard. He never did it again (indeed the next time he sat for a fellow artist was almost half a century later, for Alberto Giacometti). The striking likeness singled out by Apollinaire as a semiofficial portrait of the Fauve leader has disappeared, but something of its quality can be inferred from a small informal oil sketch that Meerson kept to the end of her life (colour fig. 7).

She painted Matisse lying on the studio couch, looking much younger and far more at ease than in any contemporary photograph. What provoked the *Journal*'s art critic was presumably the artist's confident, even humorous elimination of inessentials. Colour in her picture is restricted to the basic complementary red and green suggested by her subject's red-brown hair and work clothes of bottle-green corduroy. The canvas, adapting the standard format of a classical reclining nude, is diagonally bisected by Matisse's solid compact body, sprawled with a book on a red-check counterpane in the kind of unforced, casual, almost catlike pose he would encourage later in the girls who posed for him. Modelling is rudimentary. The brush picks out its subject's suntanned skin; warm, red-brown hair; slender, tapering fingers and unexpectedly long legs. The result is very different from Matisse's various versions of himself. It has none of the fierce brooding interrogation of his early self-portraits, nor the comic overtones he invariably took on in his own pencil sketches. Meerson's eye is gentle but not innocent. Her sunny observant little portrait demonstrates, with touching honesty and simplicity, the central precept Matisse taught his students, that truth of emotion matters more than anything else in a painting.

She was in love with him by this time and, although his response is not at all straightforward to assess, he seems to have been more involved with her than he cared to admit. She represented a restless cosmopolitan sophistication that did not normally interest him, a world of cultural and political dissidents where men and women worked together supposedly on equal terms, demanding new freedoms and dismantling old restrictive practices. In Munich, Olga had explored the novel approaches to percep-

tion opened up by the Theosophical Society (and subsequently developed, apparently at her suggestion, in Kandinsky's "The Spiritual in Art").[24] In Paris she experimented with drugs. She and her friends operated outside accepted social codes. Apart from Amélie and the occasional professional model, Olga was the only woman reckless enough to pose nude for Matisse in the years before the First World War. In terms of personal liberty and refusal to acknowledge conventional constraints, she had already shaken off the past more thoroughly than would ever be possible for Matisse, who remained enmeshed in bonds of family feeling, need and obligation to the day he died.

From the point of view of her respectable relatives in Moscow, Olga's precarious and unsettled way of life contrasted sharply with the marriages her sisters had made well before they reached her age. Matisse, whose experience with Marguerite's mother had made him pessimistic about the survival chances of a single woman without security or funds, shared their apprehension, and to some extent their disapproval. He and his wife made a favourable impression when Olga introduced them to one of her sisters, Sophia Adel, a fashionable lawyer's wife, well known in Muscovite society for good works, cultural contacts and lavish entertainment. Mme Adel, in Paris to keep an eye on her disreputable younger sister and check up on the company she kept, was surprised and relieved by the Matisses. Their evident normality was a comfort, but, like most people who met the artist in the early years of the century, she could make no sense of this polite, sedate, conspicuously reasonable man who turned into a savage beast on canvas. "It's a shame he ever took up painting, Matisse," was her verdict, reported back by Olga.[25]

Shocked by Matisse's work—and by the startling deterioration in Olga's under his influence—the Meersons were no longer prepared to subsidise a career that was clearly heading for professional disaster. As Matisse had predicted, Olga was finding it next to impossible to support herself by painting. She was thirty-three years old in 1911, living on the meagre income she could still earn from old master copies, and borrowing money from the Russian businessmen and dilettante aristocrats who had once been steady customers. "As she says, she can't do what she used to do any more, and she can't do what she would like to do either," wrote Matisse, confirming her own bleak diagnosis. "She despises what she could do naturally, but nonetheless she isn't able to do anything else."[26] He and his wife, desperately hard up for so long themselves, did what they could to make her situation easier. They invited her often to Issy to work in the studio and lunch at the house, included her in impromptu gather-

ings and generally treated her (like Sarah and Michael Stein, or Purrmann) almost as part of the family.

Matisse can have been in no doubt that the Meersons blamed him for Olga's problems. He was worried about her situation and nettled by her sister's patronising judgement of him, both as an artist and as a man. At some point during Mme Adel's visit, he burst unannounced one morning into Olga's room at the boulevard des Invalides, withdrawing at once (as he had done before, after surprising Marie Vassilieff in similar circumstances), and following his withdrawal with an almost incoherent note later the same day, begging her to forgive him and forget his intrusion: "I can only think of it as an impulse of madness. Nothing gave me the right to do it. My suspicions were imaginary."[27] This undated letter is baffling on several counts. Matisse, who had clearly lost control, pleaded with Olga to tell no one, explaining that he had said nothing at home, and adding that, even if she forgave him, he wasn't sure he could forgive himself ("Can things really become irreparable so quickly! Couldn't you allow for a moment of unreason, of irresponsibility. . . . I think I was mad").

Art historians have generally assumed that the letter dates from the beginning of their acquaintance, when Matisse was working on *Nymph and Satyr*. If so, Olga must have agreed to overlook the incident (like Vassilieff, who slept next door). But according to Matisse's daughter, the crisis between them came much later,[28] which would account for the casual friendly tone of the painter's other surviving notes to Olga, fixing meetings or sending holiday greetings (nearly half of them dated, or datable, to 1910). In any case, if Matisse was having an affair or hoping to start one, his suspicions are a puzzle. All accounts agree that Olga had eyes for no one else. She threw herself at him almost from the start, according to Alice B. Toklas.[29] Olga herself freely confided her feelings for him in letters to her Russian confidante, Lilia Efron. More than twenty years later, when news reached Matisse of Olga's death, he talked to Lydia Delectorskaya about his grief for "the beautiful Russian Jew" who had once been his pupil, and about the great love she bore him.[30]

The only plausible alternative is that Matisse's suspicions were not sexual at all. He certainly suspected Olga of ruining her life and jeopardising her work by taking drugs.[31] The possibility maddened him, and perhaps his instinct told him to confront her with the evidence, so as to shock her into giving up. This would explain the otherwise surprising testimony of Matisse's letters from Spain, which leave no doubt that he was still in love with his wife at this stage. They are punctuated on almost every page with his longing for her. He pleaded, urged, cajoled, even bribed her to

write back ("I send you and the children a thousand million kisses to get you to write as I ask") so that they could spend time each day in one another's company. Abstinence may have been his ideal in theory, but in practice he missed Amélie's physical presence, especially in the early mornings after yet another debilitating sleepless night. "Don't be too surprised at this endearment," he wrote fondly from his hotel bed on 6 December 1910. "It just slipped out naturally because I'm a bit drowsy in the mornings when I haven't slept properly for a couple of nights. You know how gentle I can be at these moments, and you too most especially."

But his letter came too late to appease the anger that dispersed only slowly after he got back. Amélie's black moods might envelop the whole house, but the one thing they could not withstand was Henri's need of her. Her old indomitable self took charge again when he accepted a pictorial challenge that spring almost as daunting as *Dance* and *Music*, and paid for it with the usual gruelling anxiety attacks. Amélie prescribed the remedies she had relied on in similar crises throughout their married life. She calmed her husband's nerves on long exhausting walks (family legend said that once they got as far as St-Germain-en-Laye, which is fifteen miles from Issy). When that failed to tire him out, she read aloud through the small hours night after night (the book was Chateaubriand's *Mémoires d'outre-tombe*, and every time she stopped because he seemed to have dropped off, she heard his implacable voice murmuring, "Continue").[32]

Matisse's marriage was grounded in longstanding intimacy and mutual dependence. It is easy to understand that he might have wanted to safeguard it by concealing a moment of madness from his wife, but difficult to see why he should have been suspicious of someone who made no secret of her feelings for him, and who came from an intellectual milieu where sexual liberation went hand in hand with artistic freedom. Olga told Lilia Efron that the physical side of lovemaking was not particularly important to her, but her letters make it clear that she had no moral inhibitions.[33] She had started out in Munich with Gabriele Münter and Marianne Werefkin, who shared their lives and studios respectively with Wassily Kandinsky and Alexei Jawlensky. Kandinsky had promised Münter that their bond would prove stronger than conventional marriage vows, and perhaps Olga dreamed of something of the sort with Matisse.

It would have been an uncomfortable dream, if so. Life with Matisse was never easy. Sometimes it came close to unendurable. When painting tormented him, he vented his frustration on anyone or anything that came or seemed to come between him and his work. It brought out a side of him that was jealous, exacting and possessive. To the end of his life, he

made impossible demands on those closest to him. Lydia Delectorskaya said she recognised only too well the kind of tyrannical scene he had once made in Olga's room on the boulevard des Invalides. All its elements—his "impulse of madness," his intemperate unreasoning fury, his groundless suspicions—would recur, throughout the years she knew him, in periodic tirades against the girls who posed for him at Nice. His complaints took no account of human frailty, his own or anyone else's. He felt his models should be prepared to submit to a higher cause, as he was. Whatever their needs or wants, by this time he would permit no exceptions to the rule that painting took precedence.

Even in his sixties and seventies, Matisse's singlemindedness could be terrifying, but it had acquired a kind of ritual absurdity by then. His young models learned to cope, patiently and humorously, with accusations of slackness and frivolity whenever they wanted to go swimming or dancing with their boyfriends, or to take time off to spend weekends with their families. Matisse, who had given up everything for his art, still found it hard to see why their devotion should be less absolute than his, but his indignation was better controlled than it had been in youth or middle age. In 1935, the year she began sitting for him, Delectorskaya posed for a painting of a nymph with a piping faun or satyr. This time the girl is being lulled to sleep instead of facing violation as in the first *Nymph and Satyr*, painted twenty-seven years earlier (colour fig. 1). "It was brutal for her," she said of Matisse and Meerson. "With me, he knew how to be gentle and soothing."[34] She meant that she, too, had found herself engulfed, enthralled, at times appalled by the passion that, for Matisse, overwhelmed everything else, including sexual desire. But even she could not be sure to what extent that desire had been sublimated, or superseded by the urge to paint, in 1910 or 1911. Delectorskaya thought it unlikely but possible that Matisse had been Meerson's lover. "He might not have been able to help himself," she said.

Whatever her relations with him as a woman, Meerson's progress as an artist was a source of constant friction. She had been barely into her teens when she began her academic training alongside male students much older and more experienced than herself. She had grown up in Moscow with the most radical generation of poets and theatrical iconoclasts Russia had ever known, taking her first steps in modern art in Munich under the personal guidance of Kandinsky. But she seems to have gone too far too fast. Matisse acknowledged her integrity—"She is purely an artist, and could never live at peace except through her art"—but he was increasingly dismayed by what looked to him like lack of stamina.[35] He complained that

she failed to concentrate, that she let herself be too easily distracted by financial anxiety or by other people's troubles, and that she refused to reconcile herself to the kind of goal she could reasonably hope to achieve. "If only she could learn to be less exacting with herself, she would occupy a highly honourable place in painting, and put herself beyond the money worries that are largely responsible for her mental torments."[36]

This kind of perfectionism, and the self-castigation that went with it, were problems Matisse struggled with himself. He had been responsible, at any rate involuntarily, for Meerson's change of course, and her sense of failure was his failure too. He contemplated her shortcomings with the asperity always uppermost in his dealings with pupils whose sacrifices in the name of art were less ruthless than his own. Her response to beauty was authentic but intermittent: "This response is unfortunately short-lived, and her total lack of confidence in herself doesn't help Mlle Meerson in seeking to express it. The need to share it with others is so imperative that her inability to do so with any clarity is ruining her life."[37]

Matisse's reproaches compounded Meerson's self-doubt. Although there is no way of dating his outburst in her room at the convent, it seems most likely to have been towards the end of 1910, or even the year after. If it happened just before Matisse left for Spain, it might explain both his wife's disquiet and the postcard he sent to Meerson from Madrid on 24 November 1910, hoping she was feeling better and had taken medical advice. By December, when Matisse himself consulted a doctor in Seville, Meerson had entered a Neuilly clinic for treatment. Matisse received news of her from his wife, and a reassuring postcard from Albert Marquet, who visited her in the clinic.[38] There can be no doubt that Matisse felt deeply uneasy about her at this point. His correspondence with his wife during his time in Spain (and more particularly when he was away from home again at the end of 1911) is full of concern for Olga, queries about her activities, suggestions for occupying her time, expressed in terms that make her sound more like a close friend of the family than a potential threat to its fabric. Both Matisse and his wife gave her support and encouragement that summer. Perhaps she even stirred a pang of sympathy in Amélie, who, whatever else she might have to put up with, never had to face the crushing weight of her husband's dissatisfaction with her as a painter.

The project that absorbed the combined energies of husband and wife in the first half of 1911 at Issy, and that continued to preoccupy Matisse throughout the year, marked the start of the most revolutionary phase of his career. It took the form of a dialogue with himself, appar-

ently sparked off by Shchukin's letter to him in Spain asking for three decorative panels on allegorical themes ("What do you think of youth, maturity and old age, or spring, summer and winter?"). By the time the Russian wrote again to enquire tentatively about his panels at the end of March, Matisse was already working on the first big canvas in a sequence that might initially have fitted the spring/summer/winter theme. *The Pink Studio* (colour fig. 8) is full of cool spring sunlight that washes evenly across the canvas, turning the studio's white walls and wooden floor pale pink, flattening them out and incorporating them in a decorative scheme of sharp greens, dark blues and ochres, which takes its keynote from the green-glazed pot and the cream-and-blue pomegranate quilt Matisse had started working with in Seville.

The impression of clear light and calm space contrasts strongly with the next painting in the series, *The Painter's Family* (another of Shchukin's commissions, colour fig. 9), a far more intricate, densely packed and interwoven overall design in hot summery reds, oranges and yellows. But if Matisse began with some idea of illustrating the kind of trite tripartite allegory Shchukin had proposed, he soon dropped it. *The Red Studio* (colour fig. 10) works at a deeper level of more ambivalent meanings. So does *Interior with Aubergines* (painted towards the end of the summer in a rented studio at Collioure, colour fig. 11), which is the fourth of what Alfred Barr called the symphonic interiors of 1911.

These paintings are among the most impersonal and at the same time the most insistently autobiographical pictures Matisse ever made. In the two *Studios*, he painted the tools of his trade (easel, frames, model stands, a box of sharpened crayons), his workplace and the works he produced in it. The models and studio managers on whom that work depended posed for *The Painter's Family*. Matisse, who had been alone in Seville when he first sketched this picture for Shchukin, must have set the scene when he got home—his wife sewing on a sofa, his two sons playing chess, his daughter holding a yellow paperback novel—like a director organising a theatrical production in the living room at Issy. Art historians agree that this strange, synthetic, four-part experiment is in some sense allegorical, but they differ as to whether to characterise the results as sacred or profane, modernist or primordial, essentially philosophical visions of utopia or, in the case of the family portrait, an artificial Oriental paradise superimposed on a standard suburban interior.

Matisse himself described his aim with characteristic plainness by invoking Cézanne. "Look at Cézanne: never an uneven or weak spot in his pictures. Everything has to be brought within the same picture plane in

the painter's mind."[39] No one has painted the view from his or her mind's eye more directly or with less fuss than Matisse. Colour, which for him meant feeling, showed the way. He found signposts in the Islamic tradition encountered in Spain, and at the Munich exhibition. "This art has devices to suggest a greater space, a really plastic space," he said, in a much-quoted discussion of Persian miniatures.[40] Chief among the devices he borrowed for *The Painter's Family* was the richly patterned surface decorated with stylised floral motifs and laid out in compartments, like a carpet, to represent a space where everything beyond the reach of the mind's eye is insubstantial, missing or impossible to apprehend.

All the elements in these pictures (including the four family members with faces reduced to masks) sink their individual identities in what became a prolonged meditation on art and life, space, time, perception and the nature of reality itself: a great central statement to which Matisse would return again and again from different directions all his life. These four works stand at a crossroads for Western painting, where the classic outward-looking, predominantly representational art of the past met the provisional, internalised and self-referential ethos of the future in what Dominique Fourcade called "a confrontation to which Matisse would never call a halt."[41]

Visitors to Issy in 1911 grasped immediately that no one had seen or imagined anything like this before. People were brought up short especially by the biggest and most baffling of the four, *The Red Studio*, which looked like a detached wall segment with rudimentary objects floating or suspended on it. "The colours of the things in one inexplicable way or other made the wall come alive," said a Danish painter, examining *The Red Studio* and trying to relate it to what he saw around him in the white space of the actual studio.[42] "You're looking for the red wall," Matisse said amiably, explaining as he regularly did to streams of puzzled colleagues, critics and collectors: "That wall simply doesn't exist." From now on, he painted realities that existed only in his mind. It would be nearly thirty years before *The Red Studio* crossed the Atlantic to America, where it would transform the vision of a whole generation of young New York artists who felt their way towards abstraction not through Picasso and the Cubists or their followers, but through Matisse.

Shchukin came to Paris for a few days in July to see *The Pink Studio* and *Painter's Family*.[43] He bought them both, but was beginning to feel understandably dubious about the small, dimly lit room he had set aside at home to house Matisse's decorative panels. At all events, he persuaded the painter to come to Moscow to inspect the space available after the open-

ing of the Autumn Salon in October.[44] Meanwhile, at the end of July, Matisse headed south again for the stint of uninterrupted work with his whole family at Collioure that he had promised himself the year before.[45] They moved into a house on the edge of town at the top of the avenue de la Gare, between the home of their old landlord Paul Soulier and Dame Rousette's inn, where Matisse had stayed with Derain at the beginning of the summer that made them both famous six years earlier. The house, rented from Marie Astié, had a studio made out of the storage space under the roof in which Matisse had stored his painting things ever since 1906. An iron staircase led up the outside of the house to the studio, which was roomy, quiet and filled with light from a big window looking out over the dry, rocky valley of the river Douy, with the main railway line to Spain running along the far side and the Pyrenees beyond.

The children loved Collioure, especially Pierre, who dreamed of becoming a cabin boy like the other eleven-year-olds of his generation (the local fishermen's sons with whom he had first started school all left this year or the next to go to sea).[46] The young Matisses had grown up on the harbour front beneath the windows of their father's former studio, where the life of the port was played out among the boats on the fore-shore. The boys rejoined their old companions. Marguerite, whose own contemporaries were mostly married or planning their weddings by now, divided her time between acting as her father's studio assistant and helping her mother keep open house for family and friends. Their grandfather came from Cahors to stay. Jean Puy arrived, and so did Hans Purrmann. Picasso, also spending the summer in the Pyrenees at Céret, stayed away, but Georges Braque (who shared his studio) came over on foot at the end of September to see what was going on.

All the artists of the Roussillon dropped in too, headed by Etienne Terrus. Foursquare and solid with a massive forehead and spade-shaped beard, looking like a peasant or a local country god from the stony slopes of his native Catalonia, Terrus was revered by Matisse and Derain. Both spoke of him in Paris as a great, undiscovered artist of the Midi. "The Mediterranean, the golden hills, the trees beneath the azure sky, the sun-warmed, red-tiled roofs, everything that shines or flowers or ripens, that flows or sleeps or sings under the sun of the Roussillon, the whole of our rich, broad, joyful land, lives beneath his brush," wrote a poet of the region.[47]

Terrus was ten years older than Matisse, and one of the most com-forting friends imaginable. His advice had been more constructive than anyone else's at the beginning of the year, when he posted long practical

bulletins to the younger painter in Seville telling him to keep his hands busy and his mind distracted, to avoid anything likely to stir him up, above all to accept periodic breakdown as the natural result of overwork and prolonged strain: "What has always worked for me when I've been in a state like yours is to go and bury myself somewhere surrounded by familiar things.... I know how one suffers in the condition you're in, and it took me a long time to understand why."[48] Terrus had made his own bargain, perhaps more successfully than any other of Matisse's friends, with debilitating depression. "He worked when he wanted to, and he also knew ... that smoking his pipe was not a waste of time."[49]

The northerner Jean Puy, another compulsive worrier tormented by self-doubt, said he would never forget the warm and simple hospitality he found that summer—"the daily contact, the exchange of ideas, the conversations, the things I learned about myself"—in the studio and round the Matisses' table at Collioure.[50] All their guests carried away a memory of long, sunny days and convivial evenings presided over by the majestic presence of the work that absorbed Matisse throughout August and the greater part of September. This was *Interior with Aubergines*, the last of the four great paintings of 1911 that realigned the chaotic, crude, disruptive elements of ordinary life according to another order of reality.

Matisse worked on it in a fluid, quick-drying medium of glue-and-distemper which he had learned from Terrus (who used it for scene-painting in the local theatre). The composition is based on three small, blue-black aubergines arranged on a fancy tablecloth before a florid screen between a heavy gilt-edged looking-glass and the studio window framing sky and hills beyond. The picture's patterned surfaces endlessly echo, reflect and open into or out of one another like a hall of mirrors. In its own strange terms, *Interior with Aubergines* is as much an apotheosis of the Midi as anything Terrus painted. Everything about Collioure—from its abundant light and colour to its landscape, its market produce, the purple-flowered bindweed growing up the wall outside Matisse's studio and the Paris–Barcelona express puffing past his window—falls into place within the kind of riotously decorated, miraculously ordered whole that was in large part what Matisse took from the marvel of the Alhambra.

It would be many decades before the painting was publicly acknowledged as one of the twentieth century's great leaps forward into modernism, but its importance was apparent to many who first encountered it that autumn in Collioure or Paris. Among them was Georges Braque, who walked twenty miles to see it, and explored its implications that summer in *La Fenêtre, Céret*.[51] Simon Bussy, who had for years found his old friend's

work incomprehensible, if not actively repulsive, capitulated almost against his will to the simplicity, sobriety and power of the new work.[52] Sarah and Michael Stein, who bought it, immediately rehung their entire apartment to give *Interior with Aubergines* pride of place.[53] Eleven years later, Matisse reacquired the painting and presented it to the museum at Grenoble, where it remained, the only one of the four symphonic interiors to find a permanent home in France, largely forgotten, increasingly dilapidated, eventually recognised long after the painter's death as a key work in his imaginative evolution. By this time the picture itself was in need of urgent restoration, which proved less successful ("This canvas has absolutely nothing in common with what my father painted," Marguerite Matisse said categorically when she saw the restored painting).[54]

The only snag that nearly spoilt this companionable summer at Collioure was that Olga Meerson came too, without Matisse having warned his wife beforehand.[55] Her arrival revived all of Amélie's old anger and suspicion. Olga, more dubious than ever about herself and her work, complained of the heat in a postscript to a letter from Matisse to Marquet on 30 July. The atmosphere of tension—at its height, by Marguerite's account, while her father was working on his *Aubergines*—is palpable in a group photograph, taken in front of the big canvas in the studio, in which everyone gazes at the camera except for the two women seated one on either side of the painter. Olga looks directly across at Amélie Matisse, who looks down at her lap.

But once again Amélie's sense of being slighted collapsed in the face of her husband's evident bewilderment. Furious outbursts were followed

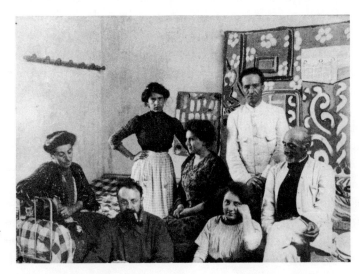

The studio at Collioure, summer 1911: Matisse flanked by his wife and Olga, with Marguerite and Armand Parayre in front, a visiting painter (Albert Huyot) and a serving girl behind, *Interior with Aubergines* against the wall

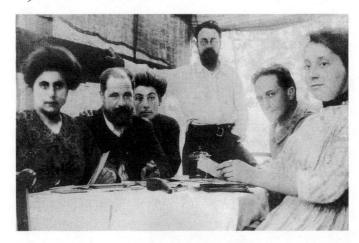

Lunch party on the terrace of Etienne Terrus's studio at Elne, 1911: from left, Olga, Terrus, Amélie, Matisse, Huyot and Marguerite

by reassurance and reconciliation. In another photo, taken over lunch on the shady terrace outside Terrus's studio at Elne (Terrus was a keen photographer, and so were Paul Soulier and Olga herself), Olga stares straight at the camera from a seat on the right hand of their host, while Amélie on his left hugs him affectionately, and Henri flings his arm out over her from the other side. However indignant she had been at the start of the summer, Amélie returned to Paris at the end of it in radiant health and spirits. "Your wife is looking superb with her skin all golden from the Mediterranean sun and sea," Georgette Sembat reported to Matisse.[56] "What's the latest news from your part of this exceedingly disturbed region—mistral, storms, explosions!" he wrote cheerfully on 6 October to Manguin at St-Tropez. "Here all is calm again after a torrid summer. . . . My wife and the children have gone back for the start of term at the lycée. I'm staying here with Margot and Mlle Meerson." When the three of them finally returned to Paris a week later, Olga would be reinstated on the old friendly terms at Issy as a kind of honorary daughter of the house. "The storm had passed," said Marguerite.

Meerson's public portrait of Matisse went on show alongside a sketch for his *Interior with Aubergines* and *View of Collioure* at the Autumn Salon on 1 October. The little picture she painted for a private keepsake shows him lying on the bed with the checked counterpane that can be seen in photographs of the Collioure studio, where she also posed for him. Olga was naturally statuesque, not tall but upright, like the plumb line, which remained the measure of order and balance in any composition for Matisse. She is always erect and often wary in photographs, in the clay *Seated Nude (Olga)* (which seems to grow upwards, like a plant, centred on the spine dividing the figure's elegant long straight back), and in the beautiful

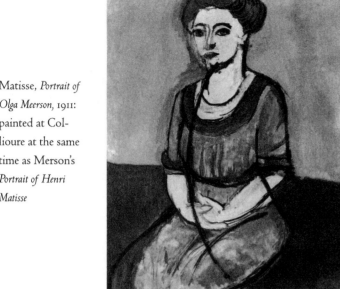

Matisse, *Portrait of Olga Meerson*, 1911: painted at Collioure at the same time as Merson's *Portrait of Henri Matisse*

Portrait of Olga Meerson.[57] For this last canvas—presumably the reason the two of them stayed on together in Collioure—Matisse chose a low-keyed palette of tender greens, soft blues, pink and russet brown. The sitter's unassertive poise, emphasised by her modest, round-necked dress, neatly rolled sleeves and meekly folded hands, gives her a self-contained stillness at odds with the way the face seems to shiver and dissolve beneath the painter's brush. But, for all her air of primness, her body curves in harmony with the two fierce black arcs—plunging respectively from neck to thigh, and armpit to buttock—that slash through it like scimitar strokes, as Alfred Barr observed, destroying its reality on one level, and heightening it on another.[58]

Matisse presented Meerson with his palette, which she kept ever afterwards, together with a drawing from the year before and a rapid sketch of herself wearing a bathing towel wrapped round her head like a turban.[59] She came as close as she ever would to happiness with him in this brief interlude of calm and contentment when they painted one another at Collioure. If they also became lovers, it can only have been, for him at any rate, a brief and casual connection compared to the intensity of their exchange on canvas. Meerson had come to him in 1908 at that terrifying moment of transition which felt, according to Gabriele Münter (who faced it with Kandinsky the same year), like leaping from safe familiar territory into an abyss.[60] Matisse said you had to jump the ditch.[61] Meerson jumped it while he stood by to show the way and catch her if she fell. But the effort strained her to the limit. In the years that followed, she needed his help more, not less, and her appeals grew more urgent as she was repeatedly dragged back by anxiety and fear. Her fellow artists urged her on. Marquet, Terrus and Puy all made a point of remembering Mlle

Meerson this year in letters to Matisse. "It is essential for her to put aside black thoughts and work with confidence," Puy wrote after the summer at Collioure, "because, though there are a great many painters around, there aren't all that many real artists, and you can always tell a note that rings true in the middle of so much falsity."[62]

Meerson's black thoughts threatened to overwhelm her again after her return to Paris. She said she dreaded the depression—"so many worries, turmoil and sleepless nights"[63]—she could do nothing to control. Now more than ever she needed the kind of mutually supportive working alliance she had seen in Munich between Münter and Kandinsky, or Werefkin and Jawlensky (both relationships were in fact heading for disaster: Kandinsky would leave Münter without warning to marry a girl almost half her age in 1916; Jawlensky established a ménage à trois with Werefkin and her teenage maid, who bore him a son, and married him twenty years later when the income of her now elderly employer finally dried up). But if Meerson ever allowed herself to hope for a similar liaison with Matisse, she mistook the essential nature of French marriage, which is a business contract with binding legal and financial obligations on both sides. She also seriously underestimated the strength of his feelings for his wife.

Matisse got back to Paris in time to lunch with the collector Ivan Morosov, and visit the Autumn Salon with him on 14 October. A fortnight later, he boarded the train for Russia with Shchukin. For Matisse this journey to the eastern fringes of the Byzantine Empire was a logical extension of the search begun in Spain for what he called revelation from the Orient. Rumours of cholera in Italy had forced him to abandon a preparatory detour, on the way home from Collioure, to revisit the Byzantine mosaics at Ravenna.[64] Both painter and patron envisaged his stay as a working trip: "Shchukin said to me: 'You'll see something completely new, because you know the Mediterranean, and a little of Africa, but you don't know Asia, and you'll get an idea of Asia in Moscow. Because Moscow is Asia.' "[65]

At noon on Saturday, 4 November (22 October by the Russian calendar), after three days on the train, Matisse and Shchukin reached St. Petersburg only to find the Hermitage Museum closed for refurbishment. The director had been alerted to their coming by Shchukin's cousin Ilya Ostroukhov, who put their failure to follow up his introduction down to shyness; but it sounds more like a mutual reluctance to waste time. Both had their attention fixed firmly on the future, which both agreed meant facing East precisely so as to escape from the classical Western past ("He

used to say modern art was hard to take at first," Edward Steichen said of Shchukin in Paris, "but then the old masters were so fatiguing. He used the word *fatiguant*").[66] Matisse was beginning to warm to this stern, stubborn, enigmatic Russian, whose hesitations over *Dance* and *Music* still cut like knives. "You won't believe this, but during the journey we talked the whole time with no problem," he reported to his wife, adding warily, "We get on very well—so far."[67]

On 6 November they reached Moscow, which looked to Matisse like a European capital grafted onto a huge, gaudy Asiatic village with gaily painted wooden houses, modern luxury shop fronts and filthy, unpaved streets. Shchukin had by now all but turned his home over to his collection, retaining only modest private quarters and his eldest son's apartment in the converted chapel where Matisse was to stay. The salons hung with choice works by French painters from Gauguin to Picasso were still used for concerts and parties, but essentially the old Trubetskoy Palace on Znamensky Lane was now the world's first permanent gallery of modern art, regularly open to the public, with its contents bequeathed to the city in Shchukin's will. It was a long, low, two-storeyed, eighteenth-century building, capacious but not especially imposing, with offices and service rooms on the ground floor and reception rooms above, reached by the notorious staircase for which Matisse had painted his two panels. Shchukin was nervously aware as they approached the stairs of the dab of red paint[68] with which he had covered up the flautist's genitals in *Music* but, to his acute relief, Matisse blandly announced that it made no difference (twenty-three years later he would try without success to persuade the Soviet authorities to clean it off).

He knew well enough that he was entering a field of battle, and he soon grasped, if he hadn't before, what a superlative strategist he had found in Shchukin. On the arrival of the two panels almost a year earlier, their new owner had been as appalled as Ostroukhov, who unpacked them with him.[69] Ostroukhov considered him half-cracked when, instead of acting on his first fierce impulse of repudiation, Shchukin shut himself up with them to undergo a long solitary reeducation. He said afterwards that he spent weeks cursing himself for buying them in the first place, sometimes almost weeping with misery and rage, knowing that he must subdue his own violent misgivings before he could begin to cope with other people's. But he can't have been in doubt about the outcome, because he almost immediately embarked on a two-pronged plan of action.

On the one hand, he fired off the series of further commissions to Matisse in Spain.[70] On the other, he started showing the panels privately

to some of the brightest columnists and critics, describing the patience needed to make a difficult painting open up—"You have to live with a picture in order to understand it. . . . You have to let it become part of you"—until what initially seemed arbitrary, exaggerated or grotesque revealed its own natural sense and rhythm.[71] He took particular pains to explain the process to more conservative friends like Ostroukhov and Alexander Benois, whose cautious advocacy went far to defuse the indignation of fashionable Moscow.

By the time Matisse arrived, people still habitually made fun of Shchukin, but his more sophisticated dinner-party guests were beginning to relish the piquancy of *Dance* and *Music* in this elegant palace with its pale silk furnishings, rococo plasterwork and liveried doorman ("Matisse is such a contrast he has the effect of strong pepper").[72] Valentin Serov, speaking for an older generation of Russian painters who were never fully reconciled to Matisse, admitted in private that he somehow made other artists look insipid.[73] On Matisse's first Sunday afternoon in Moscow, Shchukin took him to the Morosovs' house, where it was clear that even the owners now recognised Maurice Denis's *History of Psyche* as a mistake. "Denis' star is fading here, and will fade more and more," Matisse reported to his wife. "The music-room he decorated for Morosov is quite lifeless. I wouldn't be proud of having a dead weight like that on my hands."

It was the end of a contest in which Denis had been the winner up till now. He had for years discounted and patronised Matisse's experiments on the strength of his own international renown as a modern master, receiving star treatment from the Bernheim-Jeunes and regular large-scale public commissions (he had just completed a frieze on the theme of dance and music for the Théâtre des Champs-Elysées) of a kind his disreputable contemporary had no hope of getting from anyone but Shchukin. The two Russian collectors were close friends, but the contrast in their taste that afternoon was glaring. Of the seven Matisse paintings owned by Morosov and his wife, four were safe choices from the painter's student days (Shchukin owned nearly four times as many, including most of the most radically innovative works Matisse had yet produced). "The Morosovs seemed pretty embarrassed," Matisse wrote, describing his visit to their music room, "but there's nothing to be done—I didn't say anything."

Shchukin had arranged for a correspondent from the Moscow equivalent of the London *Times* to call on Tuesday morning, when Matisse set out his aims, explaining the background to his work and describing

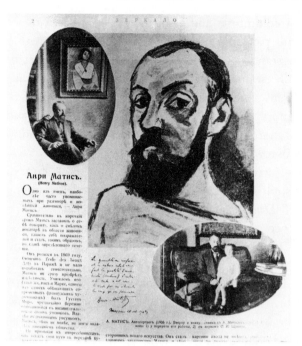

Matisse photographed with two of his own paintings and one of Shchukin's grandchildren, alongside an article in the Moscow *Mirror (Zerkalo)*, denouncing him as either degenerate or deluded

how he had fallen in love at first sight with Russian icons.[74] This article, translated for him by his host from the next day's morning paper, set the tone for the whole visit. Matisse became a celebrity overnight, fêted and followed everywhere by journalists who repeated his comments and reported his hectic schedule in the press. Conservative critics complained, but they failed to check the Matisse craze that swept Moscow. People could not get enough of him. The cast at a prestigious private performance of Tchaikovsky's *Queen of Spades* held a reception for him afterwards. Poets and philosophers clapped when he entered the hall at the Free Aesthetics Society. The art world assembled at the smartest of Moscow cabarets, Nikita Baliev's Bat, for an uproarious celebration that ended in the small hours with the presentation of a painting showing the guest of honour on a pedestal receiving homage from a ring of naked ladies with the caption: ADORATION DU GRAND HENRI.[75]

Matisse did his best to retain his northern cool ("I'm not going to get carried away," he wrote home on his third day. "You know me"). He was baffled, touched and well aware who was responsible for his reception: "Shchukin is more moved than me—for him it's a triumph." This Moscow visit turned the commercial transaction between painter and collector into something more like a collaboration, involving reorganising and redecorating whole areas of the palace. Shchukin's son Ivan remembered the painter sketching out ideas on huge sheets of paper pinned directly to the wall.[76] Almost before Matisse had time to settle in, Shchukin proposed a commission on an unprecedented scale for ten decorative paintings to go "above the still lifes" in his drawing room, each one

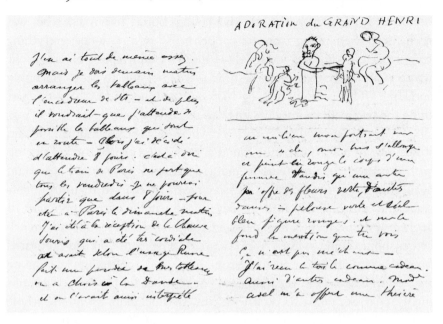

Matisse, Adoration du Grand Henri: homage from the art world at a Moscow cabaret, reported by the painter in a letter to his wife, 16 November 1911

to be larger than the largest canvas covered by Matisse's contract with Bernheim-Jeune.[77]

Within a week, they had finalised the details. Shchukin would pay 6,000 francs per canvas, stipulating the size (in the end they measured up the spaces and agreed on eleven paintings, eight of them outside the terms of the Bernheim contract), but leaving the choice of subject to Matisse. This was a princely way of doing business. "It frees me completely with regard to the Bs," wrote Matisse, whose attitude to his dealers had been permanently soured by their opportunism over the Puvis affair. "They disgust me deeply," he told his wife.[78] Shchukin by contrast stated his goal unequivocally—"I want the Russian people to understand that you are a great painter"—and planned to achieve it with the nerve and vision that had turned his father's trading company into Russia's leading textile enterprise.

Matisse had never met organising ability of this order before. Nor had he seen (even in the Steins or the Sembats) anything quite like the contagious excitement described by visitors to whom Shchukin personally showed his collection, stammering in his eagerness, running ahead through the rooms, flinging open doors, making them screw up their eyes on the threshold of a darkened antechamber and squint across the landing at *Dance*. "Just look! What colours! The staircase is lit up by this panel, isn't it?" he cried with sparkling eyes to the journalist I. Zhilkin. He rec-

ommended the same trick to the young Boris Ternovets, who was enchanted: "Something fantastic happens, like in a fairy-tale: everything comes to life, and moves and whirls about in a wild irrepressible surge," he wrote in a passage that comes as near as it is possible to get to Shchukin speaking. "This is the best thing Matisse has done, and perhaps the best thing the twentieth century has given us so far."[79]

The enthusiasm Matisse met everywhere he went was mutual. He said it was only in Moscow that he found connoisseurs capable of keeping up with the latest developments in modern art, and he repeated again and again that it was the riches of Russia's past that enabled them to understand the future. "Your students have incomparably better specimens of art here at home, namely icon painting, than they could see abroad. French artists should come to learn from Russia."[80] The icons that had captivated him at first sight belonged to Ostroukhov, whose collection was among the best in Russia (and the first to be put together for the sake of art, not piety). Matisse, taken to dine with him by Shchukin, spent the whole evening marvelling at it, declaring as he left that "for the icons alone it would have been worth coming from a city even further away than Paris."[81] Shchukin telephoned the next day to say that excitement had kept his guest awake all night. Ostroukhov proposed a tour of the Tretiakov Gallery, where he grasped at once that Matisse was no more interested in canvases by Europeanised Russian masters than he had been in the fabled paintings of the Prado or the Hermitage. They opened up glass cases (Ostroukhov was a gallery trustee) in the icon rooms instead. "I have spent ten years searching for something your artists discovered in the fourteenth century," Matisse said that day.[82]

Ostroukhov's reservations about Matisse's work could not withstand his visual finesse, and the way he trembled with delight in front of normally despised and neglected works from the Russian past. "I find Matisse extraordinarily likeable, he's such a subtle, cultivated and original man," he wrote, dropping everything to act as guide on a tour that enthralled them both: "I'm still spending all my time with Matisse, who absorbs me more and more."[83] They visited the cathedrals of the Kremlin, and the Novodevichi convent with its gold-topped palaces and bell towers set high above the Moskva River. They examined the rare icons of the Iverskaya chapel, and listened to old Russian plainsong at the Synodal College. Above all, they drove out through woods of birch and beech to the rarely visited treasure-houses of the Old Believer churches tucked away in ancient, mossy settlements of carved and coloured fretwork houses along the riverbank.

They visited the Nikolsky Edinoverchesky monastery, and spent a whole day at the Rogoshky cemetery.

Among a wealth of precious icons in the Cathedral of the Intercession at Rogoshky cemetery was a fifteenth-century painted panel showing the people of Byzantium sheltering from their enemies beneath the spread cloak of the Virgin, at whose intercession a great storm scattered the army about to sack the city. The scene was a favourite with the Old Believers, who had always been a persecuted sect existing on sufferance from the Tsar in a state of more or less permanent siege. Born of Old Believer stock himself, Shchukin's unbudgeable determination went back to an ancestral tradition of opposition and dissent in Russia, and Matisse prized it as highly as the icons themselves. "I think this journey is going to be enormously important for me," he wrote in one of his first letters to his wife.

Matisse's regular bulletins from Moscow were full of energy and vigour, with no trace of the chasms of loneliness and despair that had opened up in his letters from Spain. Amélie, left behind again at Issy, must have recognised the signs that, unlike the last two winters, the one ahead promised to be productive. This time there would be no question of separation. They had discussed the possibility of a working trip together to Collioure, and meanwhile she was to see to the heating in the greenhouse and buy pots of cyclamen for him to paint in case they decided to remain in Paris. The Moscow visit was planned to last no more than a fortnight (in the end Shchukin insisted on an extra week), during which Amélie had company in the form of Olga, who was constantly on tap to attend dress fittings or translate press cuttings from Moscow. The Matisses both now apparently agreed that, far from posing any kind of threat, Olga needed looking after.

Matisse had taken a trunk of her things to Moscow, and he sent back a rousing message inspired by his first glimpse of contemporary Russian art at a dismal exhibition in St. Petersburg: "Tell Olga I send her my compliments, and the assurance that, if she wanted to, she could be the best painter in Russia." He saw her sister, Mme Adel, on the day of his arrival, and dined two days later with her other sister, the pianist Raissa Sudaskaya. If Matisse was taken aback by the attention he attracted in Moscow, so was Olga's family ("Mme Adel, who can see all this enthusiasm, is somewhat stunned by it"). They took him to the Moscow Art Theatre, where Anton Chekhov's leading lady, Olga Knipper, greeted him at the door,[84] invited him with Shchukin to an opera at the Bolshoi, and

tried in vain to get into *Queen of Spades* ("Olga's sisters are devastated that they can't get tickets").

They crowned their hospitality by throwing a party for him on 11 November in the Adels' house, attended by everyone who was anyone on Moscow's cultural scene. Mme Sudaskaya entertained the guests at the piano. Radical young artists turned out in force, including Michel Larionov, Natalya Goncharova, David Burliuk and a friend of Olga's from Matisse's school, the sculptor Melitsa Curie. This was the crowd that congregated hungrily on Sunday mornings at Shchukin's house to catch up with the latest developments. Matisse talked to them at length about his work in Paris, the lessons he had learned in Spain, and the discoveries he was making now in Russia. Where other visiting Parisians (like Denis) made Muscovites feel backward and provincial, Matisse put them centre stage. "It's not you who should be coming to learn from us, we should be learning from you."[85] Next day the enthusiasts from Mme Adel's officially founded the avant-garde group called Jack of Diamonds, electing Shchukin its first honorary member, and choosing as president Pyotr Konchalovsky, whose studio Matisse had promised to visit the night before.[86]

These were Olga's peers—the generation galvanised by Shchukin's finds in Paris—among whom, in Matisse's view, she should now take her rightful place. When he finally got home, loaded down with gifts (including a gold-and-black porcelain tea set from Mme Adel, and Baliev's spoof portrait), he acknowledged his thanks by dispatching a painting for Ostroukhov, and a packet of three drawings. One was for Nikita Baliev at The Bat, the second for Olga's friend Mme Curie, and the third for her niece, Tamara Adel (all three went on show at the Jack of Diamonds' first exhibition in January).[87] Matisse discussed Olga's prospects with her family, and approved their scheme for her to divide her time between Russia and France, spending half the year in each, and earning enough from her Moscow patrons to subsidise six months a year at the cutting edge of developments in Paris. He outlined the proposal to his wife, asking her to tell Olga, and promising to write to her himself.

But the rescue plan came too late. Isolated, anxious and deeply depressed, Olga felt herself disintegrating. Perhaps the last straw was the news that Matisse had talked about her behind her back with her sisters, whose meddling she detested. At all events, she wrote to tell him she had found her own solution to her troubles. "Olga . . . says she's feeling better since she discovered something which stupefies her in the daytime, and that she lives as if in a dream," he wrote to his wife. "She tells me that you know nothing, and nor does anyone else, that she's doing her best to con-

ceal it—and that I should say nothing about it to her sisters. What can it be, morphine probably."

Matisse was appalled. He urged his wife to find out what was going on, and to warn Olga that he could do nothing more for her if she was taking drugs ("She's going to ruin her life completely"). He said he would feel it his duty to tell her sisters, and advise them to put her in a clinic. He begged his wife to help ("Look after Olga, if you can"), but by the time he got back from Moscow in late November Mme Adel or her sister had arranged, presumably at his suggestion, for Olga to enter a Swiss sanatorium run by Dr. Paul Dubois. Already in his sixties, professor of neuropathology at the University of Bern, Dubois was one of psychotherapy's brightest stars at the turn of the century, celebrated throughout Europe for his work with neurasthenic patients and subsequently eclipsed only by the rise of Sigmund Freud. At the end of November 1911, he received two long letters about his new patient from Matisse, making no mention of any emotional involvement but emphasising her outstanding quality as a painter, and setting out her professional history in the light of the forebodings he had felt at their first meeting three years earlier.[88]

Olga never forgave him. For her this was an unconditional betrayal by the man she had loved, looked up to and trusted to support her and her work against a hostile world in general, and the interference of her family in particular. She felt she could never have faith in anyone again. "Of course you understand what the real trouble is," she wrote six months later to Lilia Efron, describing a brief return to Paris where she discussed what had happened with Efron's own therapist, Dr. Majerzak. "The doctor explained a lot to me about Matisse: there is no end to his baseness and cowardice. I recall every detail with pain."[89]

Amélie also felt betrayed. In three weeks alone at Issy with Olga as her only adult companion, she had had enough of the Russian's problems and of her dark hints about a special relationship with Matisse. "Olga amused herself, while I was away in Moscow, by pestering my wife, who has been so good to her this summer, with insinuations as clear as they were malicious (perhaps unconsciously malicious)...," Matisse explained afterwards to Mme Adel. "Admittedly, I know that Olga is ill, irresponsible, but even so the harm she's doing won't heal her." Matisse's iron determination to subordinate life to work had foundered in conflicting currents of passionate emotion. Always a clumsy liar who could never hope to keep anything from his wife for long, he now made things worse by attempting concealment. Amélie intercepted a message from Efron telling him to col-

lect an envelope from the post office and, having insisted on accompany-
ing him herself, collapsed when she read the letter. "My wife found out
about the feelings Olga has for me from a letter addressed to me poste
restante by Dr Dubois. . . . My wife has been ill ever since, and I have to
leave my work and take her to the Midi," Matisse wrote to Olga's sister,
telling her to apply to a Paris-based Moscow collector, Dr. Kritchevsky,
for more details. "Kritchevsky can tell you what a state of nervous exacer-
bation my wife is in."[90]

Whatever the cause—actual or pictorial seduction or (which comes
to much the same thing in the circumstances) the concentrated passion for
his work that overrode ordinary human feeling—Matisse had now driven
not one, but two women to distraction. The household at Issy was in tur-
moil. "Madame Matisse slammed the door shut," said Marguerite.[91]
Amélie's instinct was for flight, as it had been twelve months earlier. This
time there would be no more concessions on her part, and no further hes-
itation on her husband's. He broke off relations with Olga and her family,
abandoned work in progress, and accompanied his wife south in an
attempt to repair the damage.

Olga remained in Dubois's clinic at Bern, undergoing a cure that con-
sisted chiefly of rest, massage and careful diet together with practical
tuition in self-knowledge and what the doctor called moral hygiene. In the
spring of 1912, she emerged to rebuild her life in Munich. The break with
Matisse, and with her own family, left her nowhere else to go. "I suffer a
great deal," she wrote to Efron. "I am truly in anguish."[92] She picked up
an old friendship with Thomas Mann's brother-in-law, the musician
Heinz Pringsheim, who had an engagement as leader of a provincial
orchestra at Bochum in the Ruhr, where she agreed to follow him. Prings-
heim would do much to restore her confidence over the next year, but it
was a long, slow, uncertain process. Olga told Lilia that she felt like a poi-
soned animal, contaminating everyone with whom she came in contact.

She started to work again, struggling to cope with Matisse's absence
("It is so hard for the sake of the paintings to have lost him as a friend"), a
northern climate ("There's practically no sun here, and I love brilliant
colours"), and crippling self-contempt ("There's no connection between
true art and the stuff I'm producing"). She went back to earning a living
by selling copies of Boucher and Fragonard. Eventually she would acquire
a reputation as a portrait painter, especially in musical circles in Munich
and Berlin in the 1920s, painting Otto Klemperer's brother and Wilhelm
Furtwängler's wife, exhibiting in a mixed show of women painters along-
side Marie Laurencin and another former pupil of Matisse, Greta Moll.[93]

She showed for the last time at the Paris Autumn Salon in 1913. She had married Heinz Pringsheim by then, and borne him a daughter. Matisse sent a wedding present (one of his impressionistic Corsican landscapes from more than a decade earlier, the kind of picture Olga's sisters and her new in-laws would have no trouble understanding).[94] He kept her portrait, and she kept his, to the end of their respective lives, but the two never met again.

The affair was decisive for Matisse, and perhaps also for his wife. As a rival for his attention, Olga had come uncomfortably close to embodying painting in person, but from now on no one would ever again stand between him and his work. On 27 January 1912, the Matisses caught the steamer from Marseilles, as they had done on their honeymoon fourteen years earlier almost to the day, heading this time for the coast of Morocco on the southern shore of the Mediterranean. They landed in torrential rain at Tangier, where, as one door slammed shut, another opened for Matisse that spring.

CHAPTER FOUR

~

1912–1913: Tangier and Paris

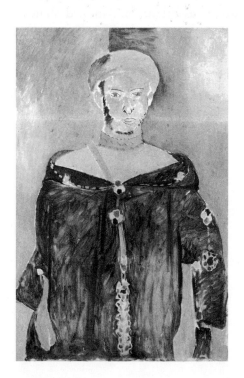

Matisse, *Standing
Riffian*, 1912

The last thing Matisse had done before leaving Russia was to stage a retrospective for himself in Shchukin's drawing room in the Trubetskoy Palace. Over the past six years the collector had bought twenty-seven paintings from him, all from periods of radical experiment, many of them commissions that stretched him to the limit, others

snatched from the studio before the painter himself had time to grasp what he had done, let alone absorb its implications. "He always picked the best," Matisse explained, adding that once Shchukin's unerring eye had settled on a canvas it was useless to protest that the work was not for sale or had turned out a failure ("I'll take the failure," said Shchukin).[1] This was Matisse's first chance to see where he had come from, and how far he had got, before starting the next leg of the journey into unknown territory for which he had been strenuously preparing ever since he finished *Dance* and *Music*.

His only serious criticism in Moscow was of Shchukin's installation of his paintings, which had been framed behind glass and hung at a steep angle to the wall, like the French and Italian old masters in other people's palaces. Matisse said he had to do battle with his host before he could unglaze and rehang the pictures.[2] Shchukin insisted in return that he stay on an extra week to wait for *Painter's Family* and *Pink Studio* to arrive from Paris.[3] Matisse took down the paintings by Cézanne and Degas in the drawing room on the first floor, collected his own works from all over the house and hung them two deep, directly beneath the richly moulded cornice and jutting out over the plaster medallions projecting from the walls. All accounts agree that the impact was unlike anything ever seen before. Reversing the principle of the two Studios, where he had sucked the life out of a room to recreate its essence on canvas, Matisse now drew a whole room after him as if by magic into the world of his imagination.

"I did not fully know Matisse until I saw Shchukin's house," wrote Jacob Tugendhold, returning home to Moscow after eight years in Paris to write the best of all descriptions of the transformation that overtook this eighteenth-century drawing room with its gilt-legged Louis XVI chairs, rose-patterned silk upholstery and gilded chandelier hanging from a vaulted ceiling painted with birds and garlands:

Matisse, *Portrait of Sergei Shchukin,* 1912

Here we have in Shchukin's home a hothouse, an apotheosis

99

of Matisse's paintings.... You appreciate them together with the environment that surrounds them—the pale green paper on the walls, the rose-pink ceiling, the cherry-coloured carpet on the floor—among all of which the blues and cherry-reds and emerald-greens of Matisse blaze out so brilliantly and joyfully. Indeed you cannot actually tell who is responsible for what: whether it is the room that does things for Matisse, or Matisse for the room. You have only the overall impression that the whole ensemble—the walls, the carpet, the ceiling and the pictures—is the work of Matisse's hands, his decorative mise-en-scène ... the true metaphysical life of his art is revealed only in this drawing room.[4]

It was Shchukin himself who first compared the room to a perfumed hothouse, "sometimes poisonous, but always filled with beautiful orchids."[5] Over the next two years—as the canvases Matisse painted in Morocco reached Moscow to take their places on the walls—the room's enchantment grew, and so did the underlying scent of risk and danger.

The Archangel Michael, c. 1457: an icon of the Novgorod school from the Tretiakov Gallery in Moscow

Fruit, flowers, fabrics, even people gave up their solid separate existence in these pictures, becoming dematerialised and abstracted. "Not things, but the essence of things," wrote Tugendhold.[6] Individually each work produced a powerful effect, but together their decorative impact based on linear form and colour—"pure colour divorced from subject"—was of another order: "This is not decoration in the European sense, but decoration as it is understood in the East." The gilt-framed canvases, hung side by side one above another from floor to ceiling, followed a pattern Matisse had seen in the churches of the Old Believers, who built their eighteenth-century Cathedral of the Intercession to hold ten thousand people and adorned it with crystal chandeliers, painted ceilings and elaborate plasterwork as the setting for a sumptuous iconostasis: patriarchs,

prophets and apostles four tiers deep, framed in gold or silver cases and accompanied by slender, stylised saints delicately painted in clear, flowerlike colours on the pillars round about.

"Here is the true source of all creative search," Matisse said of Moscow's icons. "Russians do not realise what treasures they possess . . . everywhere the same vividness and strength of feeling. . . . Such wealth and purity of colour, such spontaneity of expression I have never seen anywhere before."[7] Even Shchukin could not have foreseen the strength of the painter's response, although it confirmed the faith each now had in the other. Among the many artists Shchukin collected, Matisse was the only one with whom he formed a personal relationship, the only one whose work he bought directly from the studio, and the only one to whom he gave commissions: "For me Matisse is above all the rest, better than them all,

Matisse, *The Moroccan Amido*, 1912: the hotel boy who became Matisse's guide in Tangier

closest to my heart."[8] Shchukin never intervened or attempted to impose his will, but, of all the great Muscovite merchants who filled their houses with French artworks in these years before the First World War, he seems to have been alone in seeing that the traffic between Moscow and Paris need not necessarily be one way.

Matisse arrived in Tangier in January 1912, ready to start on the commission for an extra tier of paintings to add to the secular iconostasis in Shchukin's drawing room. Although the collector had given no specific instructions, he had a clear preference for figure paintings (and proved it by declining an offer of *Red Studio* that February).[9] Every letter Shchukin sent Matisse contained a gentle reminder, but there were no models to be had in the Muslim city of Tangier. Matisse despaired at first of finding anyone to pose for him. It would be many anxious weeks before he finally began recruiting the mixed bag of locals—a hotel boy, a teenage prostitute, a street pick-up and a mountain bandit—who agreed more or less reluctantly to let themselves be painted. On his canvases, each of them

turned into the kind of grave hieratic figure he had seen in Moscow icons: tall slender saints who fit their narrow space so neatly, prophets facing the spectator, apostles turning sideways, all with small heads, long sensitive fingers and bare or delicately shod feet emerging from their robes, each poised lightly like a flower on a flat ground of turquoise, gold or black.

But initially there was no question of painting figures, or landscape for that matter. The Matisses landed on 29 January and checked into room number 38 at the Hotel de France,[10] the best European hotel in town, with a spectacular view from their window looking down over the white roofs and terraces of the old town, and out across the bay to the far side of the Mediterranean, where on a clear day you could see the faint, scallop-shaped outline of the Spanish coast. But the hotel turned out to be cramped, dirty and expensive, on top of which for six weeks they could barely step outside. Rain had been falling since the beginning of the year, filling the unpaved streets with foul-smelling liquid mud. Swollen rivers made it impossible to visit the interior, and the whole country was cut off by storms at sea. Matisse posted off furious lamentations to all his friends, and a stream of reproachful postcards to Marquet, whose accounts of Tangier the year before—together with the beautiful, austere, sunlit paintings he brought back—had made the place out to be a painters' paradise. "Tempest, equatorial rains," Matisse wrote indignantly. "I can't think what it means, and nor can the people of Tangier, they've never seen anything like it. My God, what are we to do! To go back would be ridiculous, and yet it seems the obvious thing. There's as much light here as in a cellar. . . . Ah, Tangier, Tangier! I wish I had the courage to get the hell out of here."[11]

Unable to leave the hotel, let alone work out of doors, Matisse painted flowers in his small, bare room darkened by rain lashing at the windows. In clear intervals he painted the view from the window under lowering clouds with black boats tossing on the choppy waters of the bay. On 6 February, he started work on a bunch of lively, luminous purple irises tossing on long green stems against the black depths of his bedroom mirror (this was the first of many variations played on the same theme by Matisse, whose sole luxury when travelling was always fresh flowers jammed into landladies' jars or vases on the humble commodes, wash-stands and dressing tables of countless middling-priced hotels). Still wait-ing for the rain to stop, he painted a basket of oranges on a square of white silk brocade embroidered with big, floppy bouquets of peonies, orchestrating a palette of pink, orange, turquoise, purple, lemon yellow and plum red with voluptuous delight and consummate lucidity. More

Matisse, *The Bay
of Tangier,* 1912

than thirty years later Picasso bought *Basket of Oranges,* and his young lover,
Françoise Gilot, enchanted by its warmth and vigour, was astonished to
learn from Matisse himself that he had been penniless in Tangier and seri-
ously contemplating suicide at the time. "It was born of misery," he
said.[12]

This was the mood that had produced the Fauve explosion at Col-
lioure. People found it hard to credit when Matisse explained the depths
of frustration that lay behind the sunny, carefree radiance of paintings
like *The Open Window* (1905) or *The Gypsy* (1906). "It has to be said that the
latter shows the energy of a drowning man whose pathetic cries for help
are uttered in a fine voice," he wrote grimly in retrospect. "Painting which
looks as if it's made through gritted teeth isn't the only kind that's worth
attention."[13] Afterwards he was appalled when he looked back to those
weeks that seemed like months spent cooped up in the Hotel de France.
"The famous Room Number 38" would become Matisse family short-
hand for a pit of desperation.[14]

On 12 February the downpour dried up sufficiently for the hotel
guests to explore outside. Entranced by the sun, which shone with a mirac-
ulous soft sheen, and by the haze of spring green that instantly clothed the
earth beneath it, the Matisses rode out together along the beach, or up
beyond the town through fields of iris and asphodel. Amélie (who rode
a mule with her husband beside her on horseback) reported everywhere
blue morning glories, purple heliotrope and flame-coloured nasturtiums.

"Once the rain stopped, there sprang from the ground a marvel of flowering bulbs and greenery," said Matisse. "All the hills round Tangier, which had been the colour of a lion's skin, were covered with an extraordinary green under turbulent skies as in a painting by Delacroix."[15] This was the exuberant annual awakening recorded in paint and words by generations of Frenchmen led by Delacroix, and later Pierre Loti. "What melting light, quite different from the Côte d'Azur," Matisse wrote to Manguin. "The vegetation has all the blazing brilliance of Normandy, and such decorative force!!! How new everything seems, too, and how difficult to do with nothing but blue, red, yellow and green."[16]

His immediate need was a shady and secluded place to work. Matisse consulted Walter Harris, the Moroccan correspondent of the London *Times,* a colourful character who knew everyone and could fix anything in Tangier from a treaty with the Sultan to a man to tile the patio. Harris canvassed the European residents with villas on the western slopes above the bay, and duly forwarded the response of an Englishman, Jack Brooks, who put his grounds at the disposal of the French painter any time he cared to ring the bell for a servant to show him round. The gardens of the Villa Brooks were famous for their size and splendour.[17] "The property . . . was immense, with meadows stretching as far as the eye could see. I worked in a corner planted with very tall trees which spread their foliage high and wide," said Matisse, who was fascinated by the glossy green acanthus that carpeted the ground in counterpoint to the rich canopy of leaves above.[18] Acanthus could grow taller than a man in Tangier. For Matisse, who had started out as a student copying stone acanthus on fragments of Corinthian column at the Ecole des Beaux-Arts in Paris, their luxuriant life and energy pointed to an art of the future freed at last from classical gridlock.

He hired storage space for his painting things in one of Brooks' outhouses, and settled down to paint acanthus on a daily basis for the next month and a half with Amélie at his side. This was the first time they had been free to concentrate on his work alone together, without distraction or interference, for any stretch of time since their honeymoon, when Henri had painted olive trees and peach blossoms in the garden of the Old Mill at Ajaccio. Now, as then, he was breaking new ground. Amélie's confidence in him reinforced his absorption, which in turn confirmed her sense of purpose. Their partnership regained its old balance and resilience in Tangier. "Your mother is looking young again," Matisse had written to Marguerite from the boat even before they landed, and they were if anything drawn closer by his sleeplessness and sense of disorientation in the

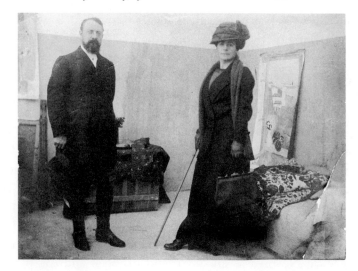

Henri and Amélie
Matisse in their
room at the Hotel
de France

first weeks, when all he had to hold on to was his wife.[19] Years later he compared it to finding himself alone in London in thick fog. "I've been in a blind panic ever since I got here, and yesterday I remembered when I'd been in a similar state before," he wrote to Amélie from the Savoy Hotel in 1919. "It was when we reached Morocco where it had already been raining for a month, and found ourselves stranded there like lost souls."[20]

Amélie made a special effort to please him by agreeing to go riding in breaks in the rain on their first two days ("She's not too sure about it, even though it's the second time," Henri reported to his daughter).[21] She told her elder son that she was determined to overcome her fear of horses so as to be able to accompany her husband on rides through the woods when they got back to France. After two years at Issy, they had finally decided to buy the property, completing the contract with their landlady on 3 January 1912.[22] The price agreed was 68,000 francs with a down payment of 25,000 francs already handed over and the balance due within five years. Whether or not Matisse already had some inkling of a major commission in the offing when he left for Moscow, Shchukin's request for eleven canvases at 6,000 francs each—almost exactly the sum needed to buy the house at Issy—came in the nick of time. But the first instalment on the purchase price seems to have taken everything the couple had, and the impossibility of finding models in Tangier made Shchukin's prospective payment look remote. For the moment Matisse could only hope to work on two landscapes he had promised to paint the year before for Morosov, together with a third canvas commissioned as a surprise by Morosov's wife in Moscow.

Financially as well as pictorially this winter in Morocco was a gamble. It had the backing of the couple's entire family, who banded together on both sides to prevent a repetition of the previous year's Spanish fiasco by ensuring that on this trip Amélie could go too. The problem then had been the house and the children. This time the youngest—ten-year-old Pierre—went to his aunt Berthe, who was switching jobs once again that January, moving for the sake of her father's health to Ajaccio to take charge of the only Ecole Normale Supérieure for girls in Corsica. Charming, bright and funny, always the closest to his aunt of her three little "Matissous," Pierre became the pet and plaything of the training college, entertaining his grandfather and testing out the students' teaching skills. Berthe also recommended a boarding school for Jean, whose education was making little or no progress at the Lycée Michelet. The headmaster of the Collège de Noyon was an old friend of hers, and the place itself within easy reach of Bohain, where Jean's paternal grandmother had always been a second mother to him (as Berthe was for Pierre). A private tutor was engaged to prepare him at home, and Jean promised his parents to do better. Henri's brother Auguste visited Issy with his wife Jane in February, and Maman Matisse herself promised to come up from Bohain the month after.

Marguerite was left in charge of the household. A city child, born and bred in the heart of Paris, she found the silence and isolation hard to bear at Issy, where the family still had few neighbours, and no real friends. Marguerite was seventeen, in all practical matters experienced far beyond her years, but very young to take sole responsibility for dealing with tradesmen, overseeing her brother, demanding reports from the tutor and giving instructions to the new gardener (a German called Gustav, whose manner she found bullying and oppressive). Her upbringing had cut her off from her own contemporaries, and she was reluctant to call for help on either of the two protectors nominated by her parents: her forceful and eccentric great-aunt Nine (still in her late seventies the proprietor of a run-down Paris hat-shop), and the kindly but even more formidable Sarah Stein. Visiting either of them meant taking the train, with a fifteen-minute walk alone to and from Clamart station along a road where even grown men went armed at night.

Marguerite worried about the inmates of the lunatic asylum lower down the hill, and lay awake listening to sudden noises in the bushes or branches tapping at the window after dark. "*Le jour l'ennui, la nuit la peur*" ["Boredom by day, terror at night"], she told her own son long afterwards. At the time she poured out her anxieties in letters to her parents, who were

sympathetic but bracing. Her father promised to write to the gardener, but otherwise could only advise her to get out more, draw up a regular timetable and practise the piano. Her mother sent hugs and kisses, and urged her to be brave. They had left at short notice without making any firm arrangement about money, or fixing a date for their return. Matisse sent cheques for her to cash at the end of February, and promised that her mother would return as soon as she had seen him settled to his work, which was likely to take another month or so. "I'm sure there's one person at Issy who'll be only too glad to see her dear maman again," Michael Stein wrote after a visit to check up, "and that's Marguerite Matisse."[23]

Tangier was a shock, at any rate to Amélie, who had hardly ever left France (except for ten days at the start of her honeymoon in London, and one brief trip to Italy), and had never glimpsed the Muslim world before. European-style shops, cafés and hotels made the foreign quarter on the summit of the hill look, as Matisse said himself, like seedy suburban Paris.[24] The Great Souk, or market, immediately below was as picturesque as any romantic painting, with its camel trains straight from the desert, its flute-players, sorcerers and snake charmers. But this was far from the fashionable Orient beloved by Parisian department stores. Beggars in the Souk displayed open wounds or bloody eye sockets, and the ground underfoot was a midden strewn with chicken feathers, bones, excrement and scraps of rotting flesh. Arab society remained closed to foreigners. Unveiled European women were treated as freaks or worse outside Tangier, an international city abandoned by its sultan as a den of infidels even in Pierre Loti's time, more than twenty years before.[25] Muslim women on the streets looked like surgeons masked and gowned for the operating theatre, according to the Irish painter John Lavery, a prominent winter resident whom the Matisses met through Walter Harris.[26]

Lavery was everything Matisse was not. He, too, had escaped in his twenties from a disapproving family to Paris, enrolling at the Académie Julian under Bouguereau, whose teaching he absorbed so smoothly that his paintings brought him fame and fortune from the start. By 1912, Lavery's self-portrait already hung in the Uffizi Gallery in Florence, and he was about to begin work on a state portrait of the British royal family (the picture pleased King George V so much that he himself painted in his Order of the Garter, reminding the artist that Philip of Spain had done the same for Velasquez). He would shortly receive a British knighthood on top of honorary membership of the Paris Salon and the Institut de France. One of the secrets of Lavery's success was his wife, a cosmopolitan beauty celebrated on both sides of the Atlantic in society fashion plates as well as on

Matisse, self-portrait on muleback

her husband's canvases. Her willowy elegance appealed strongly to the romantic side of Amélie Matisse, who held up the lovely Lady Lavery ever after to her sons as the model of what a painter's wife should be.[27]

The two couples were invited to lunch together by Harris to meet the British Ambassador, Sir Reginald Lister, just back from an excursion with his host through the mountains to Tetuan. Harris was among other things a British secret agent. He spoke several Arab dialects, and, where many Europeans (including Loti and Matisse himself) tried on Moroccan costume as a kind of fancy dress, Harris could pass among the local brigands for one of themselves in hooded burnous and yellow leather slippers.[28] He and Lavery were in their very different ways striking specimens of British imperial confidence and pluck. Both enjoyed the role of swashbuckling adventurer, unlike Matisse, whose preferred disguise was almost comically conventional and timid. He drew himself in Tangier as a portly, bespectacled painter on a flimsy folding stool with a collapsible easel balanced precariously on his knee, or wearing a straw sunbonnet and perched astride a disproportionately small mule. The last thing he wanted was to look like the kind of rakish daredevil whose painting had outraged Paris, Moscow and London, and whose first sculpture show was causing consternation ("Decadent, unhealthy, certainly unreal, like some dreadful nightmare") that spring at Alfred Stieglitz's gallery in New York.[29]

Tangier swarmed with painters, mostly Orientalists following Delacroix, as subsequent generations would follow Van Gogh (and Matisse himself) to the south of France. At one point half the modernists in Paris threatened to turn up, urging Matisse to find them rooms on a postcard signed by practically everyone he knew, from Marquet, Manguin

and Paul Signac to Guillaume Apollinaire (a portrait of a pipe-smoking baby on the front of the card was captioned in Marquet's handwriting: "Maurice Denis, 1912. The Childhood of Ingres").[30] Matisse avoided anyone conspicuously arty or bohemian in Tangier because, as he told his wife, people like that always took him for a madman when they saw his work.[31] Lavery himself became sufficiently worried a few years later to consult a trusty colleague, the Scots colourist James Guthrie, who assured him that Matisse's stuff need not be taken seriously ("It may command attention, but it won't wash in the long run").[32]

Matisse visited Lavery's studio to inspect his studies of Tangerine markets, mosques and moonlit alleys ("What lousy painting," he wrote home tersely)[33] with another former student from the Académie Julian, the Canadian James Wilson Morrice, who was also staying at the Hotel de France. These two got on well, no doubt because the fact that they spoke different visual languages did not stop them accepting and admiring each other's work. The Canadian advised young would-be modernists like the Englishman Clive Bell to pay attention to Matisse, while never deviating himself from the elegant, accomplished sub-Impressionism that made him, in Bell's phrase, "a typically good second-rate painter (first-rate almost)."[34] Morrice painted the view from the Hotel de France in Whistlerian shades of pearl and oyster: grey clouds glistening over grey sea and grey-white houses set off by sombre, dark green foliage. Matisse's *Open Window at Tangier* renders the same view beneath the same rain-laden sky with fierce, thin, energetic brushstrokes scrubbed across the canvas in jagged bands of yellow ochre, inky blue, veridian and burnt umber.

Tangier's weather had turned out chancy, and the town itself had little to show of the wonders of the Orient that had mesmerised Matisse in Munich and Granada. The mosques were closed to Christians, and there were no museums, galleries or great houses open for foreigners to inspect their gleaming mosaics, latticed marble screens and intricately patterned tiles. Apart from merchants selling silks and carpets in the bazaar, the nearest Matisse got to the artefacts that had inspired his visit was probably in Harris's house, which stood in its own park three miles outside the town, a magnificent Moorish villa constructed to its owner's specifications and embellished by Moroccan master craftsmen trained in the same elaborate skills as their ancestors who built the Alhambra.

Matisse faithfully reflected his own and his compatriots' situation when he faced the camera looking awkward in an Arab djellabah, or sketched himself as a tourist in a town whose people believed that contact with foreigners made them unclean. Even acting as a servant—valet, door-

man, hotel waiter—to a Christian was degrading for a Muslim. Posing was a form of self-destruction. Lavery said that the few Arab sitters whose reluctance he managed to overcome were all convinced that as a painter he possessed the Evil Eye, which meant that anyone modelling for him was damned for eternity.[35] He had been smuggled into position to paint his *Moorish Harem* by a daring friend of Harris', but, when it came to procuring female sitters, the best even Harris could manage was a couple of elderly candidates from the local brothel, who proved so unsuitable when unveiled that Lavery sent them back.

A girl willing to pose for Matisse was found with difficulty towards the end of March by the French management of his hotel.[36] Zorah was young enough to be still under her family's protection (ten or twelve was the normal age for girls to marry or, at worst, support themselves by prostitution). Matisse painted her quickly and lightly, seating her on the ground in a soft, billowing yellow robe against a pale turquoise wall, and emphasising the decorative quality of his picture by enclosing her body in a graceful curving line offset by the smaller oval of her face. The proceedings were risky and illicit. On the advice of the hotel proprietor, Mme Davin, he hired a studio to which Zorah could have access without being seen, but even so the sittings had to stop almost at once. "Her brother has been with her," Matisse reported on 6 April. "Apparently he would kill her if he knew that she was posing."[37]

Matisse, *Three Studies of Zorah*, 1912

Morocco was still the strict, fundamentalist, male-oriented society the French had found when they bombarded Casablanca five years earlier ("They entered a closed house," wrote Harris, "tenanted by suspicion, fanaticism and distrust").[38] "Feminists are unheard of in this country," Matisse wrote to Gertrude Stein on a postcard showing female coal-porters from the charcoal market near his hotel, "a pity, because the men abuse their privileges."[39] Euro-

pean residents in Tangier swapped grisly anecdotes about what happened to foreign men rash enough to overstep the bounds of Arab hospitality. Lavery told the story of a young subaltern invited to dinner by the Pasha of Tetuan, who sent him a parcel the next morning containing the head of a dancing girl he had admired the night before.[40]

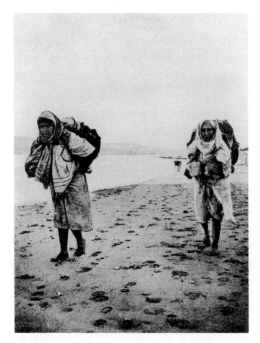

Women Coal-Porters, Tangier, postcard from Matisse to Gertrude Stein, deploring the lack of feminism in Morocco

The ferocious aspect of the civilisation Matisse had glimpsed in Spain lived on in a country that had remained in many ways unchanged since the Moors ruled Seville and Granada. Violence was in the air. Loti said that even the harsh, rasping intonations of ordinary conversation in the Arab quarter sounded as if people were slitting throats or eating one another beneath his window. Amélie Matisse later described to her grandson her terror when she found herself trapped in a narrow street between high white walls by a princely rider galloping towards her, preceded by armed bodyguards driving a panic-stricken crowd before them with cries of *"Balek!"*:

> Mme Matisse knew herself to be lost, and the scene imprinted itself forever on her memory like the last vision of a drowning person. The rider, whom she glimpsed only for a second, had great gleaming eyes in an oval face framed by a hooded cloak of some stuff brilliantly white and light as muslin. She even noted the whiteness of his hands on the reins. The guards rushed closer, shouting and flailing huge leather-tailed cudgels. A few paces short of the European woman, the rider made a curt sign and gave the order: "Madame is not balek!" The men lowered their whips, the crowd scraped past her . . . drawing level, the rider saluted her with his head and sketched with his hand a gesture of farewell![41]

Travellers like Harris reported severed heads still exhibited on palace walls, and atrocious mediaeval tortures inflicted on captives in public places. It was only just over twenty years since Loti had seen bullocks sacrificed to the French ambassador as he rode out from Tangier to present his credentials to the Sultan, who received him in Fez on a white mule caparisoned with gold, beneath a red fringed canopy borne aloft, like the Queen of Sheba's, by giant Negro slaves. That Sultan's successors had infuriated their people by the series of concessions they had been forced to make to France as Africa was split piece by piece among European colonial powers. Popular anger culminated in 1911 in a widespread revolt put down by a French expeditionary force ("Do you think we're going to go to war over Morocco?" Matisse asked Marquet, who was in Tangier that summer, when Germany sent a warship to anchor off the port of Agadir).[42] The provisional treaty in November, which made it safe for Matisse to revive his scheme of wintering in Tangier, looked to Moroccans more like a bill of sale. Resentment built up against the French. By the time the Matisses arrived at the end of January 1912, the Sultan was once again besieged in Fez by his own tribesmen. French troops were dispatched from Casablanca, and the Matisses prudently abandoned plans to visit Fez, which would have meant riding for ten days along unmarked tracks (there were no paved roads in the interior, and no wheeled vehicles) through country criss-crossed by streams in spate, at constant risk of ambush from vengeful Arabs.

Instead they settled for a day's ride to the Riffian village of Tetuan, just over forty miles away and warmly recommended by Harris for its rugged scenery and spectacular sea views. The Matisses made up a party with two or three other guests from the Hotel de France, accompanied by a couple of Arabs to show the way and do the catering, all mounted on mules with big, flat, wooden saddles ("The sort of saddle you feel you could sit on without discomfort for forty-eight hours at a stretch," Matisse said cheerfully).[43] They set out soon after dawn, riding first through a broad, sloping valley full of tall grasses mixed with buttercups and daisies that came up over their saddles. "We rode in among this sea of flowers as if no human being had ever set foot there before," said Matisse, for whom this paradisal meadow in the radiant light of early morning stood out among his two or three indelible memories of Morocco. Tetuan itself, set against a ring of mountains on a site nearly three hundred feet above the sea, pleased him so much that he wished they had decided to go there sooner.

This expedition up stony mountain trails through disturbed tribal territory in time of mounting tension impressed the two Matisses in very different ways. Amélie would entertain her grandson long afterwards with dramatic stories of being held up in Tetuan for three whole days by armed Riffians.[44] For Henri, all memory of physical danger was blotted out by the exaltation of the ride through the valley, which took him back to the day his life was changed forever by the gift of his first paint-box ("It was a tremendous attraction, a sort of paradise found in which I was completely free, alone, at peace").[45] As soon as he got back from Tetuan on 28 March, Matisse arranged sessions with the model Zorah. He also returned to the garden of the Villa Brooks, hoping to recreate his feelings in the flowery valley that he described in prelapsarian terms as exquisitely pure and free from people. He said he recognised the spot from a passage in Loti's *Au Maroc* or *Roman d'un Spahi*. Neither book contains anything that corresponds exactly to Matisse's account, but both amply justify his admiration for the painterly quality of Loti's prose in evocations of the devouring sun or the febrile, sensuous African spring:

> Everything turned green, as if an enchantment lay upon the earth; little patches of moist warm shade fell from the leafy trees to the humid ground; the mimosas, flowering in profusion, looked like huge bouquets or festoons of pink or orange . . . even the heavy baobabs had put on for a few days fresh foliage of a pale and tender green. . . . In the countryside the ground was covered with strange flowers, wild feathery grasses, daturas with their great scented cup-shaped petals; and drifting over everything waves of hot and scented air.[46]

In the three canvases produced in Brooks' garden—*Acanthus, Periwinkles (Moroccan Garden)* and *Palm Leaf, Tangier* (colour fig. 13)—Matisse painted the complex layers of greenery for which Loti said you would need colours unknown on any palette, colours that would incorporate the strange sounds, the rustlings and above all the silences of Africa, its thundery undertones, its darkness and its translucent delicacy. In these paintings Matisse came close to pure abstraction, "not things but the essence of things," in the phrase of Jacob Tugendhold. All three canvases are shaped or framed by the slanting shafts of tree boles rising through the dappled half-light beneath the leaf canopy. Within this scaffolding of uprights, the underwood becomes a patchwork of grey, turquoise or lime green and

orangey pink, ornamented sparsely here and there by stylised coils of ruf-
fled creeper, drooping swathes or fan-shaped spurts of foliage, serrated
acanthus leaves or tiny star-shaped periwinkles.

Amélie stayed just long enough to see her husband fixed up with a
model and launched at last in the new directions opening for him in
Brooks' garden. On 31 March she sailed for home on the weekly mailboat
to Marseilles. Already strained and sleepless, Henri let his nervous tension
show in a heated exchange as the two said good-bye on board the steamer
in Tangier harbour. Returning to shore on the launch of the French
Chargé d'Affaires, he managed to control himself thanks to the kindness
of the minister's wife, Mme de Beaumarchais, who covered his distress
with a stream of small talk. "That stopped me breaking down," he wrote
to his wife next day, explaining that the crisis had forced him to consult a
Russian doctor recommended by Mlle Davin at the hotel.[47] The doctor
blamed Matisse's collapse on exhaustion after the trip to Tetuan, and pre-
scribed much the same regime (rest, hot baths, daily exercise and early
nights) as his colleague in Seville just over a year earlier.

As Amélie slowly steamed away from him, Henri grew increasingly
agitated, picturing her alone with her dismal thoughts in stifling heat
("How bitterly I regret parting from you like that. I'm following your voy-
age, you've only another eighteen hours to go—but having to make such a
long journey upset as you were when you left me—truly I curse myself").
He worked himself into such a state over the next three days that when she
failed to announce her safe landing in Marseilles by telegram, he called at
the offices of the steamship company, pursuing the director to his home
to ask about storms at sea.

Amélie, whose boat had been slightly delayed by rough weather,
reached home in good spirits, and wrote two long letters to tell him so.
But Henri was haunted by their parting row on shipboard. He said he had
achieved nothing in Tangier, and only stayed on in hopes of finishing the
paintings for Morosov that would redeem an otherwise wasted trip. His
contrition took the practical form of daily telegrams to his wife keeping
her posted on his previous night's sleep (by 5 April he had managed an
unprecedented seven hours twice running) as a gauge or sleep-metre for
measuring his work rate the next day. He announced that his underlying
problem was pictorial, diagnosing the source of all his troubles as two
misplaced spots of sunlight on the trunk of the pine tree in *Acanthus* ("If
only I'd realised sooner, I wouldn't have been so desperate just before you
left").[48] He explained that he could not live with himself without self-
knowledge and that, although he produced results unconsciously, he

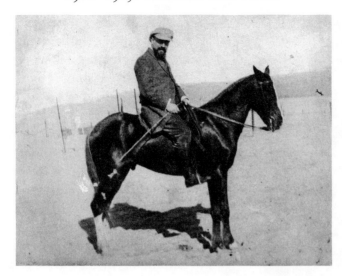

Matisse out riding
in Morocco

always needed to know and understand what he had done ("To give your-self completely to what you're doing while simultaneously watching your-self do it—that's the hardest of all for those who work by instinct"). Squeezed in apologetically, between the lines of this candid self-analysis, was a confession—"I get worked up too easily"—that ran through their marriage like a refrain.

Matisse spent his remaining time in Tangier working furiously, riding for two hours every morning and retiring early at night with a comedy-thriller by Charles Dickens that had been a popular hit on the Paris stage ("It's not terrifying at all, it's mild and charming," he reassured his wife).[49] He saw virtually no one apart from the hotel people and Morrice, with whom he planned to leave on the next boat or the one after. The two took tea with Lavery, and went back for lunch a couple of days later. The Irish-man was an expansive and entertaining host, but it was Harris, dropping in to say good-bye before they left, who got a preview of the prodigal inventiveness and luminous, unearthly beauty of Matisse's three garden canvases from the Villa Brooks.

In the first two weeks of April he finally burst through the barrier that had blocked his path for weeks, making him so desperate that he ruined his last hour with his wife. But it is clear from his letters to her afterwards that this crisis freed him, like a fever breaking. He said he was enchanted all over again each time he went back to the Villa Brooks, recalling long afterwards that *Palm Leaf, Tangier* came easily and sweetly "in a burst of spontaneous creation—like a flame." He made a little painting of a Mus-lim marabout, or shrine, and another of the model Zorah. When she had

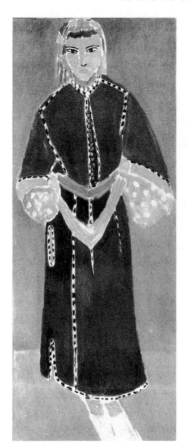

Matisse, *Zorah
Standing*, 1912

to give up posing, he replaced her at the last minute with a boy called Amido, an alert, French-speaking, thoroughly Westernised ex-groom from the Hotel Valentina. Amido posed so gracefully and well that Matisse completed in a few rapid sessions the figure painting he had despaired of producing for Shchukin, working with a freedom of touch that gives the picture the same captivating youth and freshness as its subject.

This last fortnight was darkened by catastrophe in Tangier. On 30 March the Sultan in Fez had finally signed the treaty that would turn his country into a French protectorate. In almost daily despatches printed in the *Times* that week, Harris reported unrest in Fez and sporadic fighting, culminating on 7 April in a pitched battle which lasted thirteen hours before the Moroccans were decisively defeated by the French general marching in with a relief column to mop up insurrection. Matisse (who showed his work to Harris a few days later)[50] was as well informed as anyone in town. But Tangier's attention had been distracted on 7 April by a tragic accident, when the launch ferrying people to and from the mailboat capsized in heavy seas with all its occupants, including the Chargé d'Affaires and his wife, M. and Mme de Beaumarchais, whose three young children were drowned with their English governess and seven others before the eyes of the horrified foreign community assembled on the harbour front.

Appalled and more than ever anxious to be gone, Matisse sailed for France on 14 April, travelling by the same boat as Beaumarchais, who signed to him to say nothing about what had happened. Matisse responded instinctively to what he saw as an almost frantic stoicism (he would remember Beaumarchais's signal twenty-eight years later when he, too, confronted catastrophe and loss on a previously unimaginable

scale).[51] On 17 April, the day he reached Paris, mayhem was finally unleashed in Fez. Moroccan soldiers mutinied, and murdered the seventeen military instructors who were the only French army personnel left within the city walls. "The Moorish women in the streets egged the rabble on," wrote Harris, "inciting them with piercing cries to massacre the Christians, and the place became a pandemonium ... native soldiery ran amok through the city.... The bank, the French hotel, the tobacco works and other establishments were sacked. The insurgents marched through the streets carrying the severed heads of Frenchmen on pikes."[52] The killing continued for two days until, at dawn on 19 April, three squadrons of French cavalry with infantry and artillery support stormed the gates at bayonet point to find the surviving Europeans barricaded inside their houses. Among the many bodies that had been decapitated and thrown into the river, or stripped, tarred and burned, were the French hotel proprietress, the correspondent of *Le Monde*, his wife, and the entire staff of the telegraph office.

One of the Fez instructors who survived (presumably because he was on leave or posted elsewhere at the time) was Matisse's old friend, the genial, art-loving Capitaine le Glay, who had been his host in Algiers on his first encounter with the Muslim world in 1906.[53] Matisse did not discuss these horrors when he reminisced afterwards about Morocco, but he could not rid his memory of them, or of the silent exchange with Beaumarchais that lodged forever at the back of his mind. Death and destruction were inextricably linked to the Islamic vision of paradise that he had first glimpsed at the Alhambra, and now they quickened his pursuit of the same purity and intensity in Tangier. A craving for peace was the driving force behind Matisse's Moroccan paintings, according to Marcel Sembat, who published an enthusiastic account based on their conversations in the spring and summer of 1912. Matisse told Sembat that he found himself instinctively simplifying or abstracting his work in order to come closer to capturing a sense of ecstasy, adding disarmingly that at any rate it calmed him down. "Calm!" wrote Sembat, developing his theme with the zest and brio of a crack parliamentary speechmaker:

> How many times, and for how many years, has he said that over and over again to me! Calm is what he longs for! Calm is what he needs! Calm is what he wants to convey! ... Matisse keeps his troubles to himself! He has no desire to share them round. He has no wish to offer other people anything but calm.[54]

Sembat and his wife bought a landscape, *View of the Bay of Tangier,* as soon as Matisse got back to Paris, and were so delighted by his painting of Zorah that Georgette asked hopefully if 1,000 francs would be enough for them to commission a small companion version of their own on his next visit to Morocco.[55] The Sembats were far from wealthy, living modestly on Marcel's salary as Socialist deputy for Montmartre together with his journalistic earnings, most of which were spent on the paintings, pottery and artworks crammed into his tiny working flat on the rue Cauchois and the country cottage where Georgette had her studio. They had neither means nor space to collect on a grand scale, but they had the nerve to back their judgement, and their two small Moroccan canvases would remain for nearly thirty years (until Picasso bought *Basket of Oranges* in 1940) the only ones in France.

Sembat was surprised to find that growing understanding of the work increased his liking for the complex character who made it. Behind the popular image of Matisse as frightening, pitiable, sick or downright mad, he found a thoughtful and slow-spoken man, unexpectedly open and only too anxious to demystify his public image by emphasising his ordinariness in private. This was what most impressed a second interviewer that summer, the American Clara MacChesney, who expected to meet a screwball when she got to Issy, and was taken aback to find that Matisse seemed neither unhealthy nor unhinged ("He bade me goodbye and invited me to come again like a perfectly normal gentleman").[56] She found his work incomprehensible—"abnormal to the last degree"—but she could not get over the simplicity and friendliness Sembat identified for French readers as the essence of "the real Matisse, the one who hurries to open the door in his gardening clothes when you ring the bell."

Issy was within easy reach of the Sembats' house on the river at Bonnières, and the couple often came for lunch, spending a whole day with the Matisses at the end of April, when the four of them walked along the Seine to Port-Villez and back on the far bank.[57] Georgette painted a portrait of Marguerite, and dropped in occasionally on her own to see the garden. She liked both Amélie and her daughter, admiring the unconditional support they gave Matisse, and understanding better than most people how much it sometimes cost them. For all their boredom in his absence, and the joy of family reunion that spring, they could never count for long on daily life at Issy remaining smooth. In his letters Matisse had asked anxiously about the garden ("Is it looking pretty? Will I be able to work there?"),[58] which struck him when he first got back as wretchedly small ("The opposite of how I had imagined it in Morocco, I thought I'd

never work up an interest again in those mean little Paris suburbs").[59] The instructions he sent his wife and daughter to keep fit, ready for his return, by cycling for two hours each day suggest that he anticipated disenchantment with the people as much as with the place.

At all events he planned a fresh start for the three of them that spring. His strenuous energy could be irresistible, bringing with it such a blast of sheer virility that even Gertrude Stein was transfixed by it every time she saw him.[60] But Matisse's sights as an artist were set so high ("He's rising up towards the eternal, the sublime," Sembat told his readers, "and he means you to go with him") that he had trouble adjusting them to an everyday human level. Failure to master a new technique—whether it was painting a pine tree or simpler skills like handwriting and horseback riding—infuriated him in himself or anybody else. Marguerite's despairing appeals from Issy earlier that year had touched his heart, but once he had commiserated with her and suggested how to solve her problems, he also sent four excoriating pages itemising the spelling mistakes, grammatical faults, poor calligraphy and weak composition in her letters, even enclosing one of them inked over with corrections ("Don't think I'm nagging you, my dear Marguerite, it's affection that forces me to make these little criticisms, which you'll soon see are justified").[61]

He demanded too much from himself, and could not see why he should expect less from other people. "I ask you simply—and it's no small thing—to work towards self-improvement," he told his daughter, adding that, if only she could grasp his meaning, she would have no reason to feel cross. His wife said that, for all his good intentions, her husband had no idea when to stop. His withering remarks about her own inexperience on muleback ("Your father's remonstrations are scarcely likely to encourage me," she wrote to Marguerite from Tangier)[62] put paid forever to her own daydream of riding with him in the woods at Issy.

One of the things Matisse did at Issy in the spring or summer of 1912 was to finish the painting of himself and his wife begun four years before. The seven-foot-long and nearly six-foot-high *Conversation* (colour fig. 12) took its format from a stone stele in the Louvre, showing an Assyrian king greeting a seated goddess.[63] Matisse borrowed this hieratic image for a double portrait, posing his wife in her black-and-green housecoat on a thronelike armchair at one side of the drawing-room window overlooking their back garden, with himself standing on the other side in the striped pyjama-suit he wore for work. The painting looks like a graphic version of the scenario outlined in his last apologetic letters to Amélie from Tangier ("How sorry I am to have tormented you like that"). It commemorates a

domestic spat or grievance in the sense that a pearl is the end product of a speck of grit. When Matisse came back from Tangier to complete his picture, he emphasised the gravity and stillness of the two figures, and the brilliance of the luxuriant green garden that separates them, by flooding the rest of the canvas with the rich expansive blue of a Moroccan sky. Discussing luminosity long afterwards with his son-in-law, he said that a picture should have the power to generate light. Shchukin (who had also graduated to modern art through looking at flat, stylised Egyptian statuary and frescoes) visited Issy in July, and wrote afterwards to say that the painting glowed in his memory like a Byzantine enamel.

Archaeological finds from Egypt, Russian icons and Islamic decorative art all suggested ways of revitalising the failing and restricted vision of tired Western eyes. In the summer of 1912, Matisse gave a new meaning to the concept of decoration, painting his studio (which now contained a bowl of goldfish as well as its usual paraphernalia) with tremendous gaiety and vigour in a series of related works that mix life and art in perpetually surprising permutations. Each canvas is powerfully absorbent, drawing the viewer into an enfolding element, like air or water, which seems to be the medium of Matisse's mind. Individual entities—fish, flowers, textiles, painted canvases and patterned screens—dissolve or take on one another's characteristics, pictorial realities melt and merge, inanimate objects seem to breathe and stir. In *Corner of the Studio*, a current of air lifts the deckchair canvas and whisks round the edge of a windswept blue curtain whose woven arabesques seem to grow like big pink blossoms from the foliage of a potted plant spurting up and cascading down the translucent, green-glazed pot from Seville. In *Goldfish* (colour fig. 14), the spade- and spear-shaped leaves of plants dancing in concentric rings across the canvas circle the fish, themselves circling in their cylindrical glass tank on the flat disc of a tabletop, the whole painted in exuberant hothouse colours— scarlet, emerald green, cyclamen pink and black—that give off an almost palpable powdery warmth and light.

In *Goldfish and Sculpture*, the most extreme of four variations on the same theme, a plaster *Reclining Nude* (for which Amélie had posed six years before) takes on the casual sensuality of a real woman stretching in a microcosm containing the fishbowl and the vase of flowers arranged beside her, an animated still life suspended against a film or blur of blue representing the studio beyond the focus of the artist's eye. Matisse made two successive paintings of a segment of *Dance (I)* propped up against the studio wall so close to his easel that, apart from a triangle of floor space, the canvas of one painting is entirely given up to the canvas of another. In

all these pictures the familiar studio props of life at Issy are woven into the fabric of the parallel painted world—a calm, stable, mysteriously potent alternative reality—where Matisse felt completely free, alone, at peace.

Shchukin, arriving in July to inspect the first results of his most ambitious commission to date, can hardly have anticipated the full extent of developments since the two last met in Russia. "It was in front of the icons of Moscow that this art touched me, and I understood Byzantine painting," Matisse said, analysing not only the plastic and spatial pointers but the moral courage he got from Oriental design. "You surrender yourself that much better when you see your effort confirmed by such an ancient tradition. It helps you jump the ditch."[64] He celebrated their partnership that summer with a drawing of Shchukin that was intended, according to Marguerite Matisse, as a preliminary sketch for a full-scale portrait.[65] Shchukin chose five canvases: The Conversation, Nasturtiums with "Dance," Corner of the Studio, Goldfish and Amido. Delivery was held up because the first had been earmarked for the second Post-Impressionist show in London in November, and the next two for the Paris Autumn Salon, but when all three eventually reached Moscow, Shchukin hung them on the end wall of his long, panelled dining room, which already contained sixteen paintings by Gauguin. The effect, by Tugendhold's account, was a modern equivalent of the sumptuous visionary ensembles—"stained glass, gleaming enamels and ceramic tiles"—created by medieval craftsmen in the polychrome nave of a cathedral, or the mosaic dome of a basilica:

> This becomes especially clear when you first glimpse, from the doorway of Shchukin's drawing room, Nasturtiums and the "Dance" and The Conversation. The orangey-pink bodies in the first picture flare out from their blue ground like arabesques of glass. Look at Gauguin's paintings, and then back at Matisse's Nasturtiums: the former will seem like a matt fresco, the latter more like a translucent stained-glass window. Matisse's palette is richer, more complex and grander than Gauguin's. Matisse is the greatest colourist of our time, and the most cultivated: he has absorbed into himself all the luxury of the East and of Byzantium.[66]

At the end of September, Matisse returned alone to Tangier, intending to stay just long enough to satisfy Shchukin (who wanted another figure painting to go with his Moroccan boy), and Morosov (whose two landscapes had been regularly postponed for more than a year now). Back

in room 38 at the Hotel de France, he picked up his old routine of work and riding, going steady with a horse called Allouf ("which means pig in Arabic: but he's a pig who goes well"),[67] spending the mornings sketching or exploring the old town, and painting in the afternoons. He reckoned to be home by November, when he and Amélie planned a second productive winter in somewhere less likely to be deluged than Tangier—Corsica, Collioure or Barcelona—now that the children were old enough to manage on their own.

Last year's experiment had worked so well that this year all three young Matisses left home. Their grandmother in Bohain (still stubbornly independent, in spite of a heart attack and her doctor's warning to take things easy) provided background support for Jean, who started his first term as a boarder at the Collège de Noyon in September. Pierre returned to his aunt Berthe in Ajaccio, accompanied by Marguerite, who hoped to salvage something from her disrupted education before it was too late. Their father spent his evenings writing to them all. He sent daily four-page bulletins to Amélie, and shorter letters every other day to Jean, who was facing the same ordeals at twelve as his father and grandfather before him. Matisse advised him gently not to give in to unhappiness, reliving his own schooldays as wintry rain, ice and freezing fog closed in on the North, asking his son if he had wet feet and whether he wore wooden sabots.

Jean received a stream of postcards urging him to concentrate on work, collect the foreign stamps and never let himself believe that he had been forgotten. One showed a Riff tribesman from the same village as the bandit king Raisouli, a local Robin Hood famous for charging exorbitant ransoms to release Westerners (including Walter Harris) whom he kidnapped on the outskirts of Tangier. "For the sake of peace and quiet the Sultan gave him a province to govern," Matisse wrote cheerfully on the back. "So then he became an official thief—oppressing the people under his administration."[68] Marguerite got letters from her father delighting in her rapturous response to the Corsican sun, encouraging her and Pierre to learn to dance and ride, asking for more details of the weather so he could picture them settling into their new life (for Matisse fair weather was a professional necessity, like sleep, that coloured everything he did). "You ask what I do all day here alone in Tangier that stops me writing to you for a week," he answered patiently when she complained of being neglected, "—but, my sweet, I'm working."[69]

With the weather on his side and sleep for once under control, Matisse was calm, confident and full of projects ("I'm nothing like I was this time last year," he told his wife, "—luckily, otherwise I wouldn't stay

a week").[70] Work went well from the start. The hills round Tangier were burnt dry and tawny by the sun, and the place itself seemed smaller than the space it had grown to fill in his imagination (dissatisfied with his painting of *Acanthus*, Matisse had brought the canvas back to check on what he had left out, only to find that, on the contrary, he had put into it things that were not present in reality at all).[71] But the extreme clarity and precision of the light gave great satisfaction, and this time he had Amido to act as companion, guide and middleman with potential models.[72]

Matisse came across one by chance almost immediately, lounging in a doorway, "stretched out like a panther, a mulatto in Moroccan costume that showed off the slender, supple elegance of her young body."[73] Fatma was more African than Arab, bold, forthright and unveiled. She had the youth and catlike panache of Loti's tough little heroine in *Roman d'un Spahi*, who was part virgin bride, part tiger and part monkey. Matisse painted Fatma out of doors in a stiff breeze on a roof terrace (the traditional province of women in Morocco), organising his long narrow canvas round the emphatic thrust of jawline, shoulder, elbow, wrist and the slim, straight legs outlined in green inside her purple-frogged, pink-flowered, turquoise caftan. In a second, much smaller canvas (destined for the Sembats), she sits cross-legged against a rich blue ground in plum-red blouse and pants with a sumptuously embroidered orange front and patterned sash. Fatma intrigued him and she knew it, complaining that their sessions tired her, upping her charges by the day, and threatening to stop posing altogether if he failed to pay up.[74]

Her behaviour exasperated him, and so did unresolved problems with the first canvas, which he abandoned at the end of October, turning it to face the wall ("I brought it home and haven't the courage to turn it round for fear of disappointment").[75] But in the end their bickering added its own tension, like the wind, to the electric brilliance of both pictures. Fatma's abrasive personality contrasted sharply with the softness and compliance of Matisse's other model, Zorah, who had disappeared when he first went looking for her on this second trip to Tangier. With Amido's help he tracked her down to a brothel whose inmates were forbidden by police regulations to work elsewhere, so he arranged for her to pose for him on the brothel's flat roof between jobs downstairs (after the few minutes she spent attending to each client, the painter got her back, looking flushed and munching petit beurre biscuits).[76]

Matisse had now liberated himself from standard visual preconceptions so thoroughly that, without being either provocative or absurd, he could paint a Tangerine prostitute kneeling between her sole possessions

(a pair of slippers and a bowl of goldfish) in a pose of iconic purity and simplicity used for centuries in Western art to convey the innocence of the Virgin Mary. He borrowed another sacred image for the Riff tribesman ("magnificent and savage as a jackal"),[77] who reminded him of Christ's head on a Byzantine coin.[78] Matisse placed his subject at the centre of a flat, geometrical composition of ochre, blue and emerald green, adding a broad expanse of deep cherry pink in a second version. The abstract simplicity of both paintings intensifies the natural majesty of the model. "Isn't he splendid, that great devil of a Riffian with his rugged face and fighter's build," wrote Sembat, for whom this contemporary Moroccan bandit belonged with the chivalric warrior Moors from the twelfth-century *Chanson de Roland*.[79]

The modernity of these images is still startling today. Matisse painted each of his three models twice in the winter of 1912–13, conjuring up their solid physical presence by magical techniques of suggestion and sleight of hand. Each retains a sharply individual identity within an overall pattern structured by his or her gaudy carapace or costume (Matisse was fascinated by Zorah's blue, gold-braided caftan, the only one she had, designed to be discarded when it wore out and replaced with a fresh one, like a snakeskin).[80] All these figures have rudimentary features in highly expressive faces, slippered feet represented by streaks of yellow paint, and hands even more cursorily indicated (in the grave and beautiful *On the Terrace*, Zorah's clasped hands are, in Rémi Labrusse's phrase, "a stupefying absence").[81]

Within a month it was clear that Matisse would not be beating a quick retreat to Paris. Ominous letters started arriving from his wife. On 25 October he begged her to resist sinking back into apathy and loneliness, to get dressed, go out, force herself to take the train to Paris, above all to be patient ("We'll be together again soon . . . you must accept this short separation without getting too fed up, otherwise I'll leave here right away").[82] He recommended things for her to do—call on the Steins, visit Jean at school, take her aunt Nine to a concert or a play—but her only response was to stop writing altogether, which alarmed him even more. It was Amélie who had insisted, in spite of protests from her husband, that she could manage perfectly well alone at Issy. "I won't listen to her another time," Matisse promised his daughter, "and I won't leave without her."[83] Albert Marquet and Charles Camoin both took the train to Issy to call on Matisse's wife at his request that autumn. Georgette Sembat, who invited her over to Bonnières, was shocked by her listlessness and depression. "I

told her that in her place I would long ago have left to join you, even without permission," Mme Sembat reported to Matisse on 12 November. "In short I preached *insubordination.* I would have suggested leaving for Ajaccio but that didn't appeal to her, it's *you* she's missing."[84]

Even before this letter reached him, Matisse himself had written and telegraphed his wife to take ship for Tangier. She left Paris on 20 November escorted by Camoin, who had enthusiastically accepted Matisse's offer to negotiate special terms for a winter's board and lodging at the Hotel de France. Camoin had split up the year before with his partner, the painter Emilie Charmy, whose departure precipitated a prolonged crisis of confidence in his own worth as a painter. Like virtually all Matisse's artist friends, he liked Amélie, and thoroughly approved the marriage: "Mme Matisse was exceptionally devoted, always working to make sure he had nothing to do but paint! Charming, courageous and full of faith in her husband's work."[85] Camoin's image of her as a model wife was stronger than ever after this Moroccan adventure. A woman who would drop everything, abandoning children, home and friends in order to follow her husband at a week's notice by sea and land to another continent ("100 hours by boat and 24 by train" was Matisse's estimate of their journey time) was the kind of steadfast and supportive companion he would have liked for himself.

Amélie now found herself back where she had always been happiest, in the company of painters and their work. Bold, self-confident women who admired her husband's art—and underestimated the key role she played in its most radical phase—tended to write her off as drab and unadventurous ("She's too timid, though very sweet, a good creature, absolutely devoted," wrote Mme Sembat. "You're very lucky to have such a charming companion").[86] But fellow artists, who knew more about the realities of this kind of working marriage, were perpetually amazed by Mme Matisse's unconventionality and lack of prejudice. They elevated her, only half ironically, to hero status, and she teased them gently in return. All of them recognised that beneath her gaiety and good humour she was at bottom as single-minded as her husband. In Tangier she fell in readily with the two painters' routine, exploring the old town with them in search of motifs, joining them after work for trips to the cinema or games of dominoes, drawing the line only when it came to galloping with them through the narrow alleys of the Arab quarter (Camoin, who learned to ride this winter under his friend's supervision, remembered Amélie as still "a bit refractory" in that department).[87] Family legend said that Matisse's

wife even accompanied her husband in search of Zorah, causing uproar in the bawdy house, whose inmates had no idea how to treat a Frenchman who brought his wife with him.[88]

Not that Matisse was an ordinary client. Brothels were a standard resource for painters, supplying models along with other services in every French seaport from St-Tropez to Marseilles. Camoin, who certainly checked out the local talent on arrival in Tangier, reported with amusement the tip Matisse gave him at the brothel door, advising him to remember that they were present in a strictly professional capacity, "like doctors."[89] Much has been made of this remark by art historians, who apparently assume that the only reason Mme Matisse could have wanted to see Zorah again was to check on what her husband was getting up to with a girl at least five years younger than his own daughter. But the comic point of Camoin's story was precisely that Matisse drew the line between work and leisure differently from other people.

His male friends knew well enough that his adherence to their bawdy subculture of racy jokes and saucy postcards was largely vicarious. He sympathised with Camoin's predicament after Charmy left him, packing him off for a working summer in Collioure, and posting after him a postcard of a medieval chastity belt endorsed on the back, "To exhort you to be patient" (Amélie added her own ribald postscript underneath: "And to preserve you from the assaults of Père Terrus").[90] He entered appreciatively into Marquet's rackety exploits, roaring with laughter over his account of a gang of small Arab boys who offered themselves as guides to a luxury brothel in Tangier only to sneak in behind the back of the madam, giggling and bouncing on the chairs while she greeted her new

Postcard of a medieval chastity belt, posted to Camoin after his girlfriend left him, with consoling messages on the back from the Matisses

French client at the door. "It's as real to me as if I'd been there," said Matisse, who kept up a running gag with Marquet about his own bashfulness and inadequacy in this sort of situation.[91] "In Tangier we don't wait for Christmas to make merry, we're out on the tiles the whole time," he wrote, urging Marquet to join them for the winter. "Camoin & I can hardly stand upright, you can easily picture the scene—in bed every night by ten."[92]

In fact Matisse's sobriety was legendary. In Marquet's worldly terms, he was an innocent. With Camoin, who was ten years younger, he had always played the part of dependable elder brother, seeing him through crises in his love life ("Getting me going again as you did last summer was like throwing me a life-belt," wrote Camoin),[93] picking him up and rushing him to hospital when he fell critically ill with diphtheria in Tangier.[94] Left to himself, Matisse led a life of monastic regularity, seeing virtually no one except the people from the hotel. "Don't imagine there's anything madly exciting going on here, apart from work," he told his wife soon after he arrived, writing the same week to his children, "Except on my canvases, it's always pretty much the same here, one meal follows another, and one night the next."[95] For Matisse none of the standard forms of addiction or debauch could hope to match the risk and lure of painting.

When Morrice returned in December, the three painters formed a companionable trio, painting the same motifs, comparing and contrasting canvases, discussing critical theory and the current thirst for innovation. From a practical point of view, they worked well together. The only snag was that Morrice was seldom sober, exasperating even Camoin when he started taking his first tot of rum after breakfast, lurching unsteadily round the hotel and ending up hopelessly fuddled by lunchtime. A string of street boys chanting "Whisky, whisky!" followed him through the narrow streets.[96] "Outside working hours, we were always together," said Matisse. "I used to go with him to the café, where I drank as many glasses of mineral water as he took of spirits."[97] Matisse's abstemiousness, and even more his capacity for work, inspired a kind of awe—part envious, part appalled—in the other two. Both were restless, rootless bachelors ("Always on the wing like a migrating bird with nowhere to touch down," Matisse said of Morrice), perpetually in search of external stimulus to invigorate their output, unlike Matisse, who travelled in order to see his inner landscape in a fresh light. Exotic settings meant nothing to him. When the rains started in the New Year, he hired a photographer's studio in the centre of the Arab town above the bay, full of light from huge glass

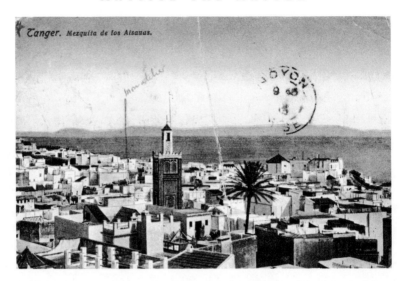

Tanger. *Mezquita de los Aïsauas.*

Matisse indicated
the location of his
studio on this
postcard view
of Tangier.

windows, so that the three of them could work indoors, whipping up a masterpiece "with an orange, three carrots and a rag," as he reported in a rare moment of complacency to Manguin.[98]

The company of other painters was crucial for Matisse in phases of reckless experiment, whenever he felt impelled to jump yet another ditch, to launch himself into nothingness as he had done with Derain in 1905, and as he did once again in 1912–13 in Tangier. This time neither of the other two could follow his relentless drive towards abstraction, although by Camoin's account they talked at length about the need to push beyond naturalistic conventions towards a simpler, sterner, more concentrated expression of reality. Camoin pondered ways of condensing his own work (over the next twelve months he would write to Matisse in rising panic, which culminated in a bout of frenzy when he burned or ripped up eighty canvases, after which he went back to less extreme procedures). At the time, he said that the best thing about the whole winter was that Matisse had given him back the will to paint, "something I couldn't help but find again in your company."[99] Even Morrice, never apparently tempted to abandon his own easier solutions, told Camoin how much he admired Matisse, who seems to have felt that his increasingly solitary struggles would have been almost unendurable without his friends' support.

But the painter most vividly present in his mind in Tangier was Delacroix, who had recharged his own vision eighty years before under the brilliant soft light of the Moroccan sun, drawing strength, like Matisse, from the power and harmony of Oriental design and colour. Matisse dismissed suggestions that he (like the Orientalists) had picked Morocco in

Matisse, sketch of a galloping horseman on the foreshore at Tangier in tribute to Delacroix, 1912

order to retrace the footsteps of Delacroix, but he saw his work reflected everywhere in the landscape, even recognising the background to *The Capture of Constantinople by the Crusaders* as the view from the terrace of the Casbah café.[100] When he sketched the same headland from the same spot, he added a galloping horseman in salute to his great predecessor. In Tangier under the sign of Delacroix, Matisse negotiated a wholly new balance between form and meaning, design and content, external appearance and inner reality. "Where does pattern end and subject-matter begin?" wrote Jacob Tugendhold, discussing the structural principle Matisse pushed to its furthest extreme in his Moroccan paintings, the principle of resonant or vibrating colour, "which is the basic law of oriental colouring as perceived by Delacroix in *Women of Algiers*."[101]

For Matisse, as for Delacroix, travel was a means of cleansing the eye. He needed an unfamiliar world and a new light, for the same reason that he needed the alien decorative discipline of Oriental art, so as to break through to a fresh way of seeing. Tugendhold, who left by far the fullest and most lucid contemporary assessment of the paintings Shchukin collected, analysed Matisse's work, in terms that made little sense in the West before the First World War, as construction by pure colour:

> From this further conclusions follow, the first being the high degree of abstraction in his work. Objects rendered by Matisse—whether it is a tablecloth, a vase or, in exactly the same way, a

129

Eugène Delacroix,
Women of Algiers, 1834

human face—are dematerialised, transformed into coloured silhouettes, distillations of colour that spill in ornamental streaks and splashes over the canvas. Not things but the essence of things. . . . In his canvases there is an ornamental harmony which is not so much contained as projected upwards and outwards. . . . It is this fluidity . . . that gives his paintings a kind of life that reaches out from the walls beyond the boundaries of their gilt frames. And here we come up against the essential nature of his decoration: Matisse's paintings seem not so much separate entities as parts of a non-existent frieze, in other words an oriental frieze.

Within a few weeks of his return to Morocco in the autumn of 1912, Matisse jotted down ideas for "two Tangier panels" clearly intended for Shchukin.[102] These two decorative compositions would prove on completion stranger and more ambitious even than the studies of trees and foliage he brought back from the first trip, or his beautiful iconic figure paintings. Both started out as café scenes. A quick sketch of a group of Arabs drinking on the flat roof of the Casbah café contained the germ of *The Moroccans,* one of the most uncompromising of the great, austere, semi-abstract canvases Matisse produced in isolation and turmoil in Paris during the First World War. In his last weeks in Tangier he was already working on the other panel, which he called *Moroccan Café.*

It grew from sketches made in a second café just below the first,

housed in the small, cube-shaped white building, covered with trellis and overhung by purple morning glories, which can be glimpsed through the archway in Matisse's painting of *The Casbah Gate*. The interior consisted of a single room with one small window overlooking the bay, a low white arcade running round blue-painted walls, and twelve cages of singing birds hanging from the ceiling. Matisse had discovered the place in his first weeks alone in Tangier, when he heard violin music one day as he was passing after work. He went inside, took the instrument from the Arab fiddler and began to play himself, pouring the feelings aroused by his painting into music that held the half-dozen customers spellbound. "I played well," he told his wife. "My sensibility had been stirred up by the work session I had just finished, and I gave them some nice sounds."[103] The people in the café responded by making him feel at home, and Matisse took to dropping in regularly in the early evenings.

The violin had provided imaginative relief—an escape from drab everyday routine—for Matisse ever since his schooldays, and now it catapulted him once again into another world. He and Camoin (who had taught themselves to draw at top speed as students twenty years before by following Delacroix's instructions) both produced paintings from sketches of the café with the violin and the caged canaries. "It's a quiet café full of serious people," said Matisse, who drew the customers talking, standing at the window, reclining dreamily full-length or squatting on the ground to play cards and smoke hashish. *Moroccan Café* (colour fig. 15) shows two of them bent meditatively over a bowl of goldfish and a single pink flower drawn up before them on the floor. Amélie reported that her husband had made a good start on this painting in his Tangier studio by early January 1913.[104] But, whereas both the café and the customers retain their picturesque appeal in Camoin's canvases, Matisse systematically suppressed everything that makes his sketchbooks so lively and engaging, stripping the features from the faces of his human figures, eliminating their long pipes and their slippers lined up at the door, reducing even their canaries to an invisible presence.

"Matisse took care not to paint the cages," wrote Marcel Sembat (who was one of the few to grasp the implications of Matisse's "instinctive transition from the concrete to the abstract" in 1913), "but a little of the sweetness of the birdsong passed into his picture."[105] The people in it are no more than flat grey, white and ochre shapes on a pale blue-green ground with two goldfish and a flower reduced respectively to a couple of ochre slashes and three vivid crimson blobs. Matisse told Sembat that

Matisse, sketches of the Arab café where he borrowed a violin to entertain the customers after work

what he was after was the quality of Oriental meditation: "That's what struck me: those great devils who remain for hours lost in contemplation of a flower and some goldfish."

The Matisses left Tangier in mid-February, travelling via Ajaccio for a brief family reunion and stopping off on the mainland to see Henri's widowed mother, who was wintering in Menton with a companion from Bohain. Photographs of Matisse buttoned into Edwardian travelling gear of frock coat and leather leggings, or muffled up on the rocks at Menton with his party in voluminous skirts and stately hats, seem to inhabit a different world from the revolutionary works he brought back from Morocco. They went on show for just six days, 14–19 April 1913, at the Bernheim-Jeune gallery in Paris. "No one who saw it will ever forget that

show," wrote Marcel Sembat.[106] Virtually all the paintings in it (except for the Sembats' two small canvases) already belonged either to Shchukin or Morosov. "Soon your pictures won't ever be seen again except in Moscow," Sembat's wife had written sadly to Matisse the year before. "How many of them are already there, alas, including some of the most beautiful, which no French artist has ever seen? It's a great shame for the development of taste in France."[107]

After one week's public display in Paris, the pick of Matisse's Moroccan canvases headed east. Shchukin subjected his collection in 1913 to a comprehensive overhaul, which included rehanging the drawing room to accommodate the new works from Tangier, documenting the hang in photographs and overseeing the compilation of a catalogue. Tugendhold was appointed the collection's first professional curator. Matisse now had a museum to house his paintings with an enthusiastic young keeper and a director passionately committed to a programme of expansion and public education. Shchukin had already taken delivery of three of the eleven canvases specifically commissioned for his drawing room, and was about to receive four more.[108] He had also bought three much larger, decorative panels: *Conversation, Corner of the Studio* and *Nasturtiums with "Dance (I)."*

Over the past twelve months he had more than established his creden-

Shchukin's drawing room rehung in 1913 to incorporate paintings from Morocco

tials as a working partner. The one thing that had threatened to disrupt Matisse's steady progress in Tangier was the news, which reached him in October 1912, of Shchukin's death. In fact it turned out to be Sergei Ivanovich's elder brother, Pyotr, who had killed himself (this was the fourth suicide in the collector's immediate family since he met Matisse), but for a few days, before he realised his mistake, the painter was deeply shaken. "Mme Matisse told me how you felt when you feared Shchukin had died," wrote Georgette Sembat. "Luckily he's in very good health, and you can carry on working hard for his museum."[109]

It wasn't simply Matisse's livelihood that was at stake. Shchukin offered a future for his work, and the hope of comprehension. In *Moroccan Café*, Matisse had reached a pitch of abstract purity and intensity unprecedented at that point in the West. One of only three paintings offered for sale in April at Bernheim-Jeune, it failed to find a buyer until Shchukin arrived from Russia in the summer and bought it on the spot. When it reached Moscow, he hung it in a small private dressing room where, he told Matisse, he spent at least an hour a day contemplating his latest acquisition, which he had come to like better than all his other paintings.[110]

"There are certain truths which transcend the power of the intellect to grasp, which can only be conveyed by evocation," wrote Matisse's friend Matthew Prichard, exploring the common ground between Matisse's work and Oriental art. "Reality is one of the truths which exceeds the power of the intellect to grasp, but appearance is a simple intellectual fact."[111] Painting solely by instinct and feeling, Matisse had broken through to a new visual level of reality where few of his contemporaries could follow him. It took faith as well as courage and imagination on the part of both painter and collector to make this leap into the future. "The essential thing about Matisse's painting is not to judge it except by eye," wrote the painter Jules Flandrin, reassuring a friend about one of the baffling, semi-abstract little landscapes Matisse produced at the turn of the century, when he abandoned himself for the first time to the light and colour of the south: "You have to look at it as you would look at the sunshine through the window. And then it works, I promise you."[112]

≈

1913–1915: Paris and Tangier

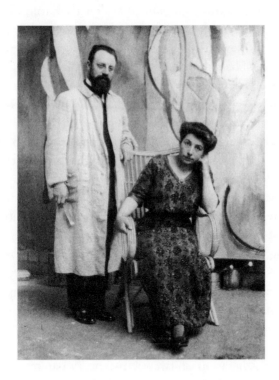

Alvin Langdon
Coburn, *Henri and
Amélie Matisse in the
Studio at Issy-les-
Moulineaux with the
Unfinished "Bathers by
a River,"* May 1913

*I*t was in 1913 that the first full-throated roar rose from America in
opposition to modern European art," wrote Janet Flanner, describing
the impact of the exhibition that introduced New York, Chicago and
Boston for the first time to current trends in painting and sculpture.[1] Traf-
fic jammed Lexington Avenue outside the disused armory in Manhattan

where the show opened in February, and queues formed inside the building. Henri Matisse was generally agreed to be the ringleader in this den of lewdness, profanity and pollution. The *New York Times* famously pronounced his works ugly, coarse, narrow and revolting in their inhumanity. Students from the Art Institute of Chicago planned to celebrate the day the exhibition left their city by hanging Matisse in effigy. When the authorities intervened, a huge crowd of students burned copies of his most offensive works, *Le Luxe* and *Blue Nude,* and went on to stage a public trial for treason of Henry Hairmattress ("Artist Hairmattress... was stabbed and otherwise thoroughly killed and dragged about," reported the *Chicago Examiner* on 17 April).[2] A representative of the Senate Vice Committee confirmed that the exhibition was immoral.

"The dry bones of a dead art are rattling as they never rattled before," Alfred Stieglitz wrote happily.[3] "We are going to put a mark on American thought that will be simply indelible," Walter Pach told Gertrude Stein.[4] By the time they had finished, a quarter of a million people had visited the Armory Show in New York alone, and the disruptive energy of modern art was firmly established in the public mind. This huge show of sixteen hundred works, ranging from Ingres (still barely known in the United States) to Matisse's work-in-progress (*Back I,* the first of a sculpture sequence that preoccupied him at intervals over the next two decades), was a rush job, hurriedly assembled in a few months by a group of artists with no official funding, no institutional backing and no professional experience in the field. Neither its president, Arthur B. Davies, nor Pach, who was his European talent scout, ever got anywhere near the top class themselves as painters, but between them they inaugurated a century of American modernist collecting in the grand style together with a tradition of swashbuckling, groundbreaking, no-holds-barred exhibitions. Like Roger Fry's two Post-Impressionist shows in London, the Armory Show opened doors for young artists who otherwise had no access to anything but academic art. "The impact of Cézanne, Gauguin, Matisse etc on my horizon was equivalent to the impact of the scientists of this age upon a simple student of Sir Isaac Newton," wrote the Londoner Mark Gertler, speaking for the first generation of twentieth-century painters to come of age before World War I.[5]

Matisse himself was well aware that any prospect of finding a public for his work depended on supporters like Pach, Fry and Shchukin. "I work entirely for America, England and Russia," he had told a Moscow reporter in 1911.[6] He might by now have added Germany as well. In May 1913, his Moroccan paintings touched down en route to Russia at Fritz

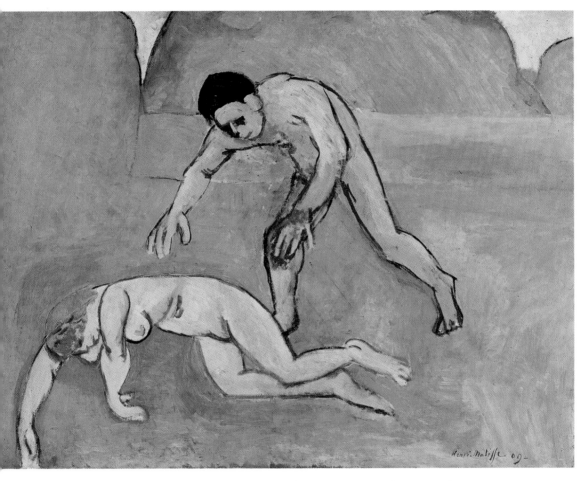

1. Matisse, *Nymph and Satyr*, 1908–9. Oil on canvas, 35 × 46″ (89 × 117 cm)

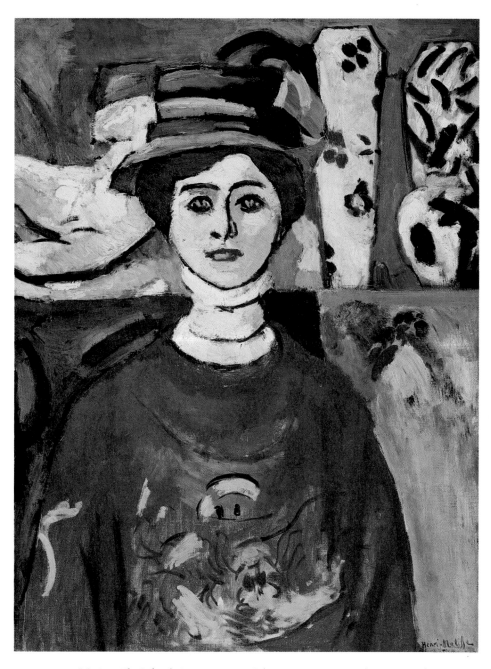

2. Matisse, *The Girl with Green Eyes,* 1908. Oil on canvas, 26 × 20″ (66 × 50.8 cm)

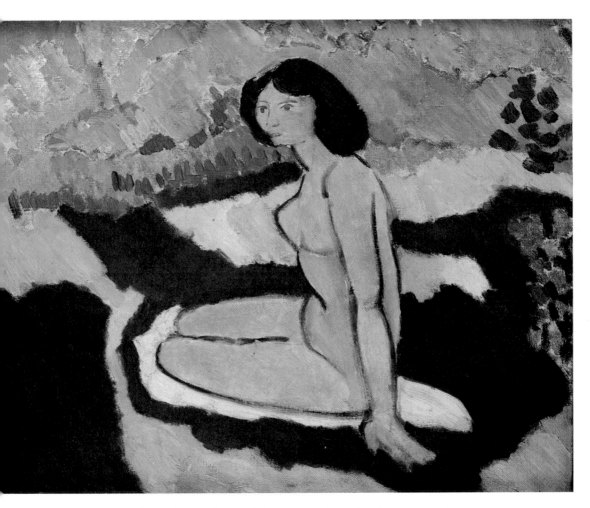

3. Matisse, *Seated Nude*, 1909. Oil on canvas, 13⅛ × 16⅛″ (33.4 × 40.9 cm)

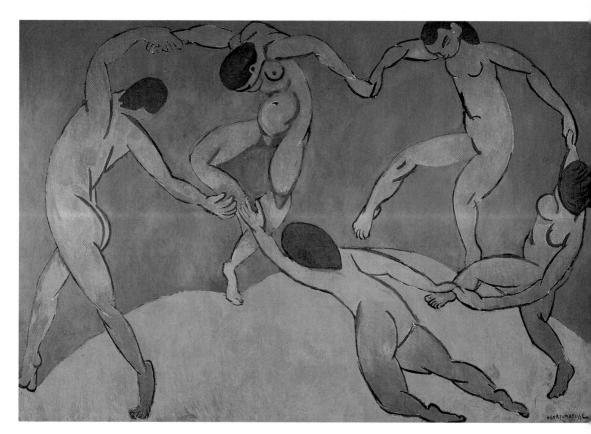

4. Matisse, *Dance (II)*, 1910. Oil on canvas, 111⅝ × 153½″ (260 × 391 cm)

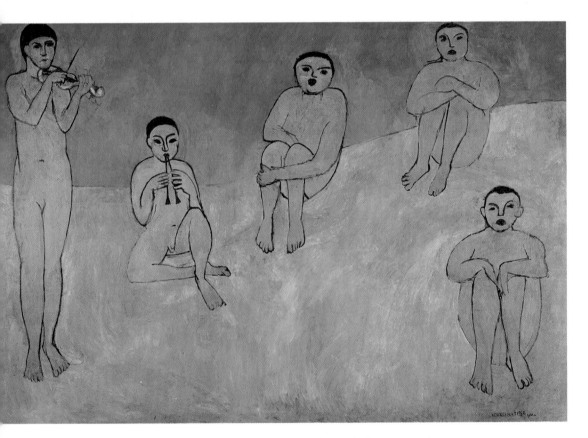

5. Matisse, *Music*, 1910. Oil on canvas, 111⅝ × 153¼″ (260 × 389 cm)

6. Matisse, *Seville Still Life*, 1910–11. Oil on canvas, 35 × 45⅝″ (89 × 116 cm)

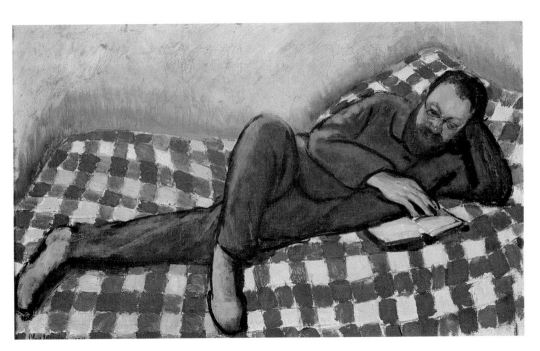

7. Olga Meerson, *Henri Matisse*, 1911. Oil on canvas, 14 × 22⅝″ (35.5 × 57.5 cm)

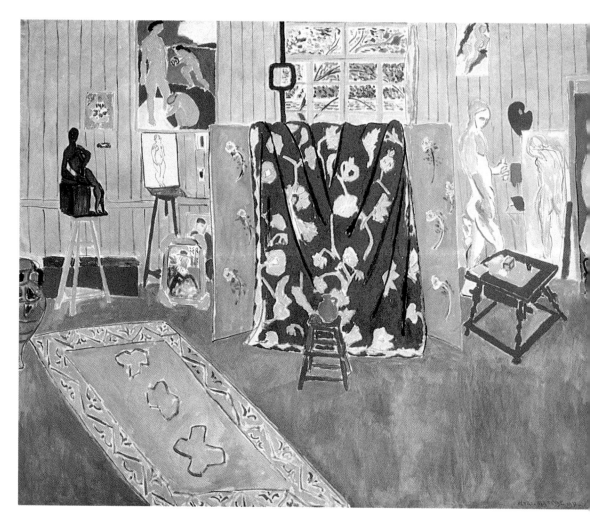

8. Matisse, *The Pink Studio*, 1911. Oil on canvas, 70⅝ × 87″ (179.5 × 221 cm)

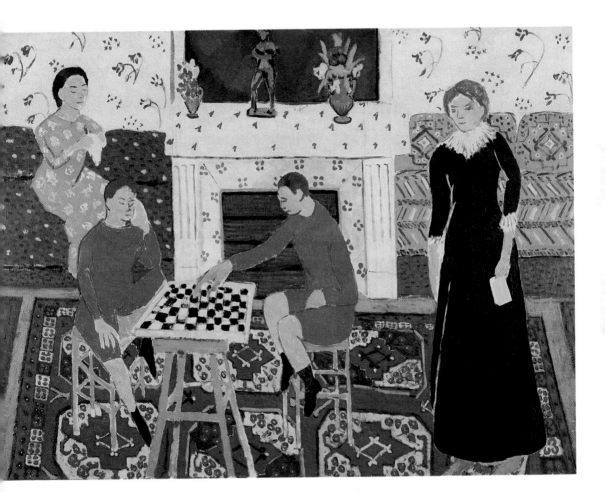

9. Matisse, *The Painter's Family*, 1911. Oil on canvas, 56¼ × 76⅜″ (143 × 194 cm)

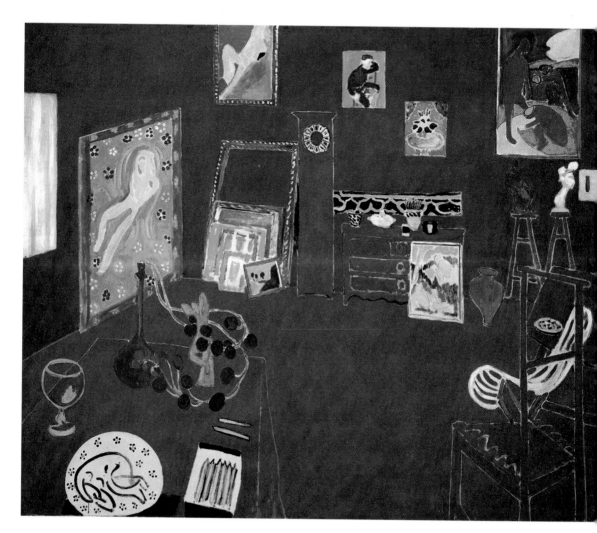

10. Matisse, *The Red Studio*, 1911. Oil on canvas, 71¼ × 86¼″ (181 × 219.1 cm)

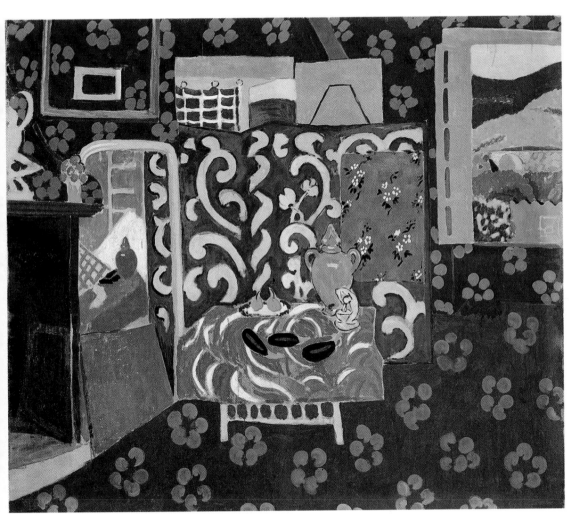

11. Matisse, *Interior with Aubergines*, 1911. Distemper on canvas, 82⅜ × 96⅞″ (212 × 246 cm)

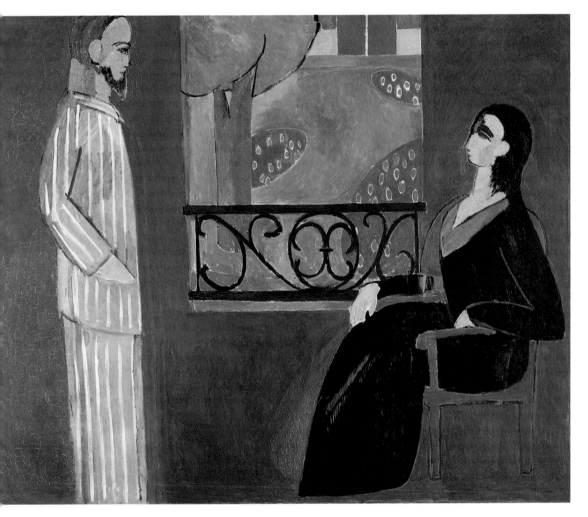

12. Matisse, *The Conversation*, 1908–12. Oil on canvas, 69⅝ × 85⅜″ (177 × 217 cm)

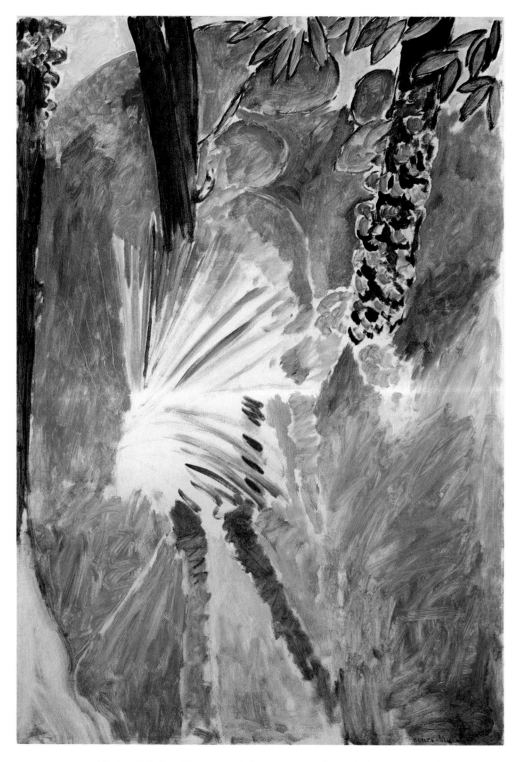

13. Matisse, *Palm Leaf, Tangier*, 1912. Oil on canvas, 46¼ × 32¼″ (117.5 × 81.9 cm)

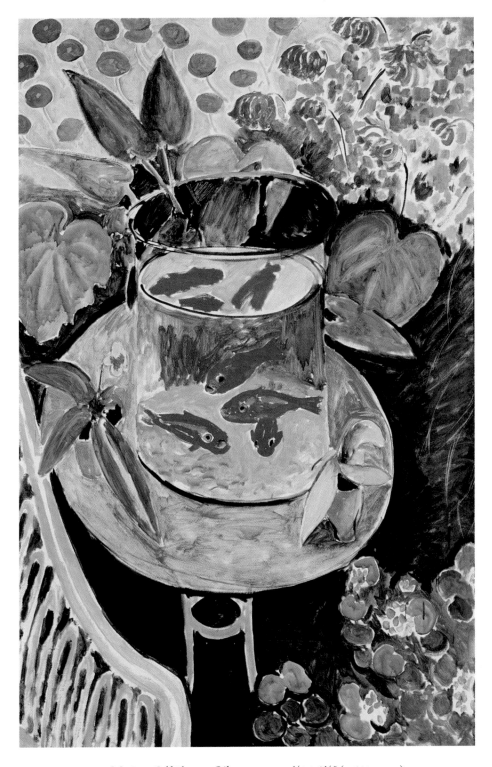

14. Matisse, *Goldfish*, 1912. Oil on canvas, 57½ × 38⅛″ (146 × 97 cm)

15. Matisse, *Moroccan Café*, 1912–13. Distemper on canvas, 69¼ × 82⅝″ (176 × 210 cm)

Gurlitt's gallery in Berlin, which gave him a second one-man show six months later. In October Shchukin received a delegation of eight German museum directors, all doctors of philosophy, all hailing Matisse as a modern master, and all asking where to buy his work.[7] Neue Kunst, Kandinsky's Munich dealers, planned to mount a Matisse show in the spring but were preempted by Gurlitt, already working on a major retrospective scheduled for Berlin in July 1914.[8]

Meanwhile, back in Paris, Matisse seemed to have been sidelined. His brief preview at Bernheim-Jeune of work verging on twentieth-century abstraction roused little or no interest in an art scene mesmerised by the Cubist take on nineteenth-century realism. Cubism was fast becoming mandatory. The Chamber of Deputies debated whether or not the new movement posed a national threat. Artists who couldn't get the hang of it often preferred not to show their work at all, "for fear," as Jules Flandrin said, "of looking slow and awkward beside sharper and more fluent colleagues."[9] Matisse had initially coined the term "Cubism" as a putdown, according to Apollinaire, who implied with relish that the joke had now seriously backfired. Matisse's own work still looked like a freak show to the public, the art establishment and disgruntled revolutionaries from a previous era ("I can just see Sembat putting Matisse on a golden pedestal," grumbled one of Signac's henchmen on hearing of the article that accompanied the show).[10] But more up-to-date observers tended either to write him off as a spent force or to lump him with the reactionaries on the grounds that anyone not lined up alongside the Cubists or the Futurists was against them.

One contemporary who never underestimated Matisse was Picasso, himself increasingly disconcerted by the mass of crude, trite or flashy imitations currently flooding the market under the Cubist label. In the summer of 1913 the two drew closer than they had ever been before. Each had reached the end of one experimental stage and was ready for the next. Picasso's analytical phase—so rigorous that Shchukin said just entering the room where he hung his Cubist canvases made him feel as if he had put his foot in a bucket of broken glass[11]—would be followed that summer by the invention of the Cubist collage. Each felt isolated by his achievements. Picasso was anxious to distance himself from his crowd of followers; Matisse had taken steps to ensure that he had none. No one was better placed to sympathise with Picasso's predicament, which mirrored Matisse's own revulsion a few years earlier at sub-Fauve excesses. Somewhat to their own surprise (as well as other people's), the two found themselves comparing notes, exchanging ideas and discussing techni-

cal problems. When Picasso went down with fever in July, Matisse came into Paris to sit with him, bringing fruit, flowers and funny stories. In August, Picasso took the train to Clamart to join Matisse on his daily rides through the woods. For Picasso, who was no horseman and detested appearing at a disadvantage, this was the equivalent of a public gesture of reconciliation between leaders of two warring countries. Each promptly wrote to inform Gertrude Stein, who had done more than anyone to foment and publicise the rivalry between them.[12]

Sembat said it was round about this time that he heard one or other of them—"Whether it was Picasso, or whether it was Matisse, I don't know or care"—make a much-quoted remark: "We are both searching for the same thing by opposite means."[13] In the summer of 1913 their ways and means briefly converged. Matisse had come to what was always a turning point in his internal battles, the climax when feeling seized control of his work. He had reached it in Toulouse in 1899, in Collioure in 1905, in Tangier in 1911–12. What both repelled and attracted him about Cubism was precisely its analytic content, the dry cerebral aspect that contrasted so sharply with the passionate impulses of his own divided character. "Of course Cubism interested me," he said long afterwards, "but it did not speak directly to my deeply sensuous nature, to such a great lover as I am of line and of the arabesque, those two life-givers."[14] In Morocco he had pushed that side of himself as far as it could go. Now it was time for a drastic change of course.

Matisse, *Back II*, 1913

The four major projects he worked on through the summer at Issy looked to other people like wilful exercises in human disfigurement and deformity. All but one were serial experiments started three or four years earlier, and each of these proved such tough going that it had to be set aside to be continued later. The earliest was *Bathers by a River*, which Matisse had initially sketched out as a companion for Shchukin's *Dance* and *Music*, and now pro-

posed recasting as a Moroccan beach scene.[15] He erected a gigantic canvas that filled a whole wall in his studio but got no further than repositioning his four larger-than-life-size bathers in a provisional layout finalised only three years later. Perhaps he was waylaid by a related work, the massive plaster *Back I*, which gave rise on its return from the Armory Show to a still more monolithic *Back II*.

Matisse, *Jeannette (V)*: the "bust with the tapir's nose" that defeated even the most sophisticated visitors to the studio at Issy

Matisse's third project was more worrying than either of the other two at this stage. He returned to a set of busts of Jeanne Vaderin, a model whose portrait he had also painted as the shy, charming *Girl with Tulips* of 1910. The first two busts were inoffensive, semi-impressionistic studies of a perfectly conventional young lady, but in two more, made a year later, he recklessly exaggerated the liberties he had taken in his painted portrait with her hair, nose and the tilt of her head. "The sculptor goes after the gargoyle in human nature," the *New York Evening Post* said reprovingly of *Jeannette III*, when it went on show at Stieglitz's gallery in 1912.[16] In 1913, Matisse began to pummel the clay for a *Jeannette V* of such extreme distortion that even the most sophisticated customers found it hard to stomach.

"I confess to you in a small voice, M. Matisse," wrote one of them, "that I could not follow you when you said: 'This profile, apparently so unformed, even horse-like—viewed from here, from this angle, doesn't it suggest to you the idea of freshness and youth?' I became evasive."[17] The diplomatic young visitor was Robert Rey (who went on to become successively curator at the Luxembourg Museum, professor at the Louvre and Inspector General for the Ministry of Beaux-Arts). He claimed to have come to his appointment at Issy as to an initiation, expecting to be given a magic key to the mystery of Matisse's deformed figures and hallucinogenic colours by the artist himself, whom he pictured as a noble savage, clothed in hair and animal skins. Pach said people often travelled all the way to Issy just to check out what Matisse looked like ("They were always reassured by his appearance").[18] Another young American, Henry

McBride, remembered a terrifying occasion that summer when he motored out with a party headed by Gertrude Stein and her fearlessly outspoken friend Mildred Aldrich, to find Matisse waiting for them with four pictures, which they looked at in mounting disbelief, relapsing finally into panic-stricken silence. "At last Miss Aldrich blurted out, 'I—I don't quite understand that,' said she; or rather, she said: '*Je—je ne comprends pas ça.*' '*Moi non plus*' ['Me neither'], replied Matisse coolly, lighting a cigarette as though nothing had happened."[19]

This was the provoking, punitive Henry Hairmattress hellbent on driving ordinary people wild. When bewildered onlookers protested that no human being resembled the creatures of his imagination, Matisse agreed, adding cheerfully that if he met one in the street, he would probably flee in terror. Meanwhile his house was booby-trapped with shocks for the unwary. First-time visitors, already rattled by the bulging foreheads and staring eyes of the African carvings in the drawing room ("Wooden fetishes surround you and seem to follow you"),[20] were nearly always floored, when they crossed the garden to his studio, by the *Bathers* or the *Backs* ("Vast neo-Assyrian bas reliefs which Matisse cuts out of enormous planks of plaster"), and what Rey called "the bust with the tapir's nose." Again and again people who reached Issy in the years immediately before 1914 made it sound as if they had stepped into the future: a strange, scary, savage world that filled them with foreboding and disquiet. "We see as 'frightful' what Matisse sees as suave," wrote Rey, too subtle and far too intelligent to misunderstand what he had seen, however much he might dislike it. "The contemplation of extreme novelty cannot please a man whose taste is already formed, because he sees in it signs of an evolution that no longer depends on him, something like an announcement of death."

Shchukin, who had long since got over his own qualms about the future, came in June or July to catch up with developments in the studio, and ask hopefully about the four canvases still needed to complete the top tier of paintings in his drawing room. Matisse set to work to fill the gap, starting with a canvas that gave more trouble than the rest of his programme put together. He worked on it for the rest of the summer without a break, except for the rides that had become a daily habit in Tangier. Matisse rode regularly with friends like Picasso, with Michael Stein and his son Allen, or with his own three children in the school holidays, on ponies from the riding stable known as Robinson at Clamart. Soon he switched to hiring horses by the month, stabling them in an outhouse next to the studio so they would be ready before or after painting sessions. Rid-

ing was his only respite from work on the subject commissioned—perhaps even suggested (like *Family Portrait*)—by Shchukin. "I've just finished a picture that has exhausted me," Matisse wrote at the end of October to his mother. "Luckily it's a good one—they say it's one of my best—but it didn't come easily; it's three months now that I've been working on it. It's for Shchukin; it's a portrait of Amélie."[21]

The new painting drove him frantic. By the time he finished it his nerves had been at snapping point for weeks. "Saturday with Matisse," Marcel Sembat wrote in his diary on 21 September. "Crazy! weeping! By night he recites the Lord's Prayer! By day he quarrels with his wife!"[22] All his life Matisse reverted to the paternosters of his childhood to calm himself when rage and frustration threatened to overwhelm him. His family learned to keep their distance at these times. The portrait of his wife brought on palpitations, high blood pressure and a constant drumming in his ears.[23] His mother also suffered another crisis that summer, presumably a stroke or minor heart attack brought on, in her son's view, by her own folly and imprudence. "If I were feeling stronger, and if I had a bit more authority over you, I'd come and sort out your house myself," Henri wrote in exasperation, "and barricade off the whole of the first floor—which is no use to you—so don't start that again—you *don't need to do this sort of thing* to live—you don't need to economise in ways that leave you laid up for a couple of months, and end by costing you a hundred times more in *doctors' bills* etc."[24]

Matisse understood well enough his mother's obstinacy, and her inability to stop work before she dropped. He thought gloomily of other low points in his own life. Bitter memories of Tangier flooded back with the autumn storms at Issy ("It rained so hard that my wife and I, lying in bed, each thought of the famous Room no. 38, from which we once watched it rain for a month and a half").[25] By this time Marguerite had returned to her aunt in Corsica. The boys had also gone back to boarding school (Pierre was despatched the term after his twelfth birthday to join Jean at the Collège de Noyon), leaving their parents face-to-face with each other in the studio.

Portrait sittings took place daily, and sometimes twice a day. Amélie posed for her husband seated in a rattan chair wearing a plain dark suit with a scarf or stole and a chic little ostrich-feather toque topped by a perky feather and a pink flower: a frivolous Parisian hat at the furthest extreme from the austere and sombre gravity of the painting. Matisse, who had seen Cézanne's *Woman in a Yellow Armchair* on show in Paris in May, gave Amélie the same touching composure as Cézanne found in his own

Matisse, *Portrait of Mme Matisse*, 1913: the valedictory painting that took over a hundred sittings, and made the sitter weep when she saw it

wife, a tenderness of feeling inherent in the shell-like oval of the face and the slight, graceful inclination of the head.[26] But Amélie Matisse, in her husband's portrait, has an elegance and an unyielding, stony stoicism all her own. She leans forward against sharp greens on a blue ground, her head and body painted ash grey, as if her masklike face were covered by a grey veil and her hands sheathed in grey suede gloves. The painting expresses perhaps more movingly than any other what Matisse meant when he located emotion at the core of his art. It is suffused with the feelings that had to be mastered, refined and transmitted to canvas where, as he so often said in letters to his family, everything of any real importance happened.

It was a harsh and inhuman process, even when the subject was an acquaintance or hired model. In *Portrait of Mme Matisse*, the airy poise and delicacy of the Moroccan figure paintings overlay, perhaps even intensify, a residue of suffering. It took over a hundred sittings to reach this clarity and purity of expression. The portrait was finished as the winter closed in at Issy, a time of year that felt like "the equivalent of a demi-suicide" to Matisse, who for three years running had fled the country at this point in pursuit of painting.[27] Each of his departures had precipitated a crisis in his marriage. This year the couple stayed at home together so that Matisse could subject his wife to the ruthless scrutiny he brought to bear on *Bathers by a River*, the *Backs* and the *Jeannette* busts.

The portrait became a mutual reckoning, demanding intense concentration from both painter and sitter. In fifteen years together, the dynamics of their marriage had shifted irretrievably. During that period, Matisse had changed from an unknown young art student into one of the two key innovators to whom the art world looked for leadership from New York to Moscow. He had built up a circle of energetic and responsive support-

ers, radiating out from the Sembats and Sarah Stein in Paris through Prichard to movers and shakers like Fry in London, Purrmann in Germany, Pach and his associates in the United States. He had a home of his own with ample working space, a viable income and, in Shchukin, a collector and curator unequivocally committed to his work. The couple had finally reached the goal that had seemed virtually unattainable when Amélie first gave him her backing: the point at which, in theory at any rate, Matisse's only problems were pictorial.

But Amélie had not foreseen the corollary, which was that her contribution to the partnership was no longer needed. The nerve, courage and energy that made her invaluable in any kind of crisis were largely surplus to requirements in a settled future centred on children, home and garden. She had been the rock on which Matisse's work depended, and pride now forbade her to settle for the lesser role of public consort or studio hostess. She chose instead to abdicate, delegating the running of the house and studio from now on more and more to Marguerite. Accounts by visitors to Issy in these years make virtually no mention of the painter's wife, who remained invisible, absent, often ill, obliterated by the renunciations he had warned her long ago that painting would exact.

Amélie wept when she saw her portrait. Perhaps she remembered sitting for her husband in a toreador outfit early in their marriage, and the tension that had ended then in tears of fury followed by laughter and reconciliation. *Portrait of Mme Matisse* commemorates a stillness and withdrawal at the opposite extreme from the bold, frank, challenging gaze of *Woman with a Hat* eight years before. These two portraits mark the beginning and the end of the heroic years of active collaboration between husband and wife. Over the next twelve months or so Matisse produced a fierce sketch of her confronting him in a helmetlike hat with a striped veil that looks like bars across her face, and a beautiful, spare etching showing her stooped and sad, clutching her Japanese kimono with her head bent in a gesture of resignation or defeat. The couple would remain together for another quarter of a century,

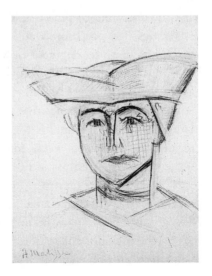

Matisse, *Portrait of Madame Matisse*, 1915: probably the last time the painter's wife posed for him

but he never painted her again. It was as if she had given him everything she could, and he had acknowledged the gift in his great elegiac portrait with all the skill and passion at his command. For him, in years to come, the memory of this painting had the valedictory sweetness of a pressed flower: "the one that made you cry," he said, reminding his wife a decade later, "but in which you look so pretty."[28]

The ordeal of the sittings in the summer and autumn of 1913 drained them both. Amélie left as soon as it was over to join her mother-in-law and the boys assembled in Bohain on 1 November, the Feast of All Saints, to lay flowers on their grandfather's grave. Henri stayed behind alone at Issy because, as he told his mother, "I can do without grief at this moment—especially since it cures nothing, and I don't need a cemetery to make me think of those I have lost."[29] *Portrait of Mme Matisse* was his only submission to the Autumn Salon, which opened on 15 November. "It didn't come easily," the painter wrote the same month to his daughter. "I could well say, in showing it, this is my flesh and my blood."[30]

Madame Matisse may have slipped away, but the impact of her portrait was immediate and lasting. It impressed both Prichard and Shchukin (who returned to Paris to see it finally completed). Apollinaire recognised it as a masterpiece.[31] Although it disappeared to Russia as soon as the Salon closed, it continued to exert a powerful influence in black-and-white reproduction on younger painters like Pach, who knew it only from photographs.[32] It represented a bright new world to the next generation in the shape of the precocious schoolboy Louis Aragon, who saw it in a magazine ("If that's the sort of thing that interests you, wretched boy," said his mother, "you're lost"), and his friend, the seventeen-year-old André Breton, who cut it out to pin up above his bed.[33]

Restlessness overtook Matisse that winter. By December, the temperature had fallen to six degrees below freezing, light was beginning to fade in his studio at Issy by three o'clock in the afternoon, and frost lay on the garden thick and white as snowfall. He was torn between the longing to get away and an inner voice that told him he needed to stay put to consolidate what he had begun. He toyed with the idea of renting a friend's studio in Montparnasse, while making simultaneous plans to escort his mother south to Menton and find a spot along the coast where he could settle down to paint. Destinations wavered between Collioure, Ajaccio and Barcelona. By Christmas, he and Amélie had packed their bags for Morocco, only to unpack them again when Matisse dropped in at his old digs on the fifth floor at 19 quai St-Michel, now occupied by Albert Marquet, who told him that the flat below was vacant. "I visited it. I liked it

immediately. The low ceilings gave a particular light, warmed by the sun reflected off the walls opposite (the Prefecture of Police). Instead of leaving for Tangier, the trunks came to Quai St-Michel."[34]

The new flat was modest in size but well suited to the relatively small pictures he had in mind to paint. He described it to his daughter on 26 December: "Main room with two windows opening on the quay, bedroom, dining room, kitchen, hall—well laid out—rent 1300 francs—so I took it, realising at last that this was what I wanted—your mother, who found the idea extraordinary to start with, is quite happy now." Considering how lonely and despondent his wife had been at Issy, Matisse was no doubt correct in saying she was glad to get away. But the fact that he made up his mind without apparently consulting her, or even showing her the flat, suggests how far she had already moved towards the periphery of his life. The desire and need to paint were the only things he consulted now. He set aside thirty-six hours to accompany his mother to Marseilles, seeing her onto the next train for Menton and pausing just long enough to dash off his surprising news in a letter to Marguerite, before rushing back to Paris to reorganise his life.

He and Amélie moved into the new flat on 1 January 1914, the day after his forty-fourth birthday, taking their big double bed, their most precious pictures, Henri's violin and the piano with them. The maid, Marie, had a cubbyhole in the attic, and there were two makeshift beds, one in the dining room and the other in the studio at the front, for the boys on their monthly weekends home from school. Jean and Pierre were growing fast ("They're as tall as men now," their father told Marguerite, "real men"), but they were well trained in studio routines and, by the time their sister got home at Easter, the family would have moved back to the country. Meanwhile the Issy property was left in charge of the washerwoman, who moved in as caretaker for 50 francs a week. Matisse was now back where he had started (except that, as a penniless art student, he had been able to afford no more than a half share in a sixth-floor maid's room like Marie's). Apart from seven years of family life, he had spent virtually his entire adult existence in the same building opposite Notre Dame on the left bank of the Seine in the shabby, noisy, crowded, lively heart of Paris.

Matisse felt more at home in this small rented studio flat than he ever had living in semibourgeois state at Issy. After a couple of months he told his mother he was working hard and sleeping better now that he had moved back to the quai. He also spelt out for her the triumphant vindication of modern art by André Level's Peau d'Ours syndicate, which had bought up works for practically nothing ten years earlier from poor

painters like himself, and now resold them at a handsome profit in a well-publicised sale on 2 March. Matisse's *Still Life with Eggs*, painted in his mother's kitchen and sold in 1904 for 400 francs in cash (which had seemed such untold wealth at the time that friends suspected him of having killed to get it), fetched 2,400. Buyers paid 5,000 francs for an early still life, and another 1,850 for *Studio Under the Eaves*, the small, dark, richly charged canvas painted in an attic at the height of the Humbert scandal, when Matisse's parents had had to endure ridicule and disgrace for harbouring their son in Bohain. "It's a great success, more significant than a gold medal at the Salon," he assured his mother, an allusion neither would have missed to his father's lifelong disappointment in him, and his own humiliating history in his home town.[35]

At the end of March he attended a fancy-dress ball with Marquet and Camoin, all three happily reliving the days when they draped themselves in bedsheets, with fake beards and burnt-cork moustaches, for artists' parties.[36] This time they set out dressed as white-robed Archimandrites (or possibly Renaissance popes), planning to astound the company

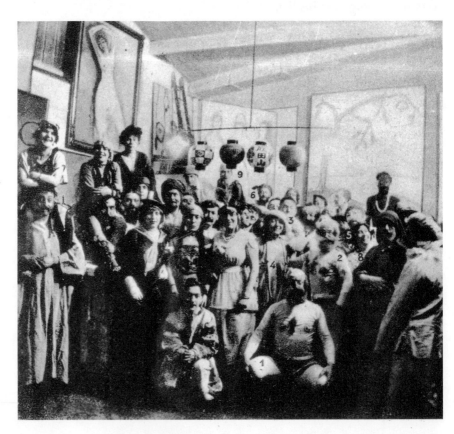

Van Dongen's fancy-dress ball, 1912: Matisse squatting right of centre with Camoin and Marquet behind him in suggestive homemade costumes

by revealing them-
selves kitted out
underneath as fair-
ground strongmen
in stripey trunks
with padded calves
and highly sugges-
tive, long, floppy
truncheons. Their
get-up was a back-
handed compliment
to their host, Kees
van Dongen, who
had just scandalised
the Autumn Salon
with a saucy, sexy
picture of a girl
throwing open her
cloak to show her-
self nude under-
neath. Matisse sent
Camoin a sketch of
the offending work,

Matisse, sketch of
Van Dongen's sexy
picture seized by
the police at the
1913 Autumn Salon

which had been removed from the show with maximum publicity for the
artist and embarrassment for the authorities. Van Dongen, who had
moved rapidly upmarket from his early days as a meat porter, now turned
out to possess a stylish studio at a smart address, with a well-heeled soci-
ety clientele who attended his party en masse, to the consternation of his
old friends in tacky homemade costumes. The three of them were hope-
lessly out of place, as Matisse explained with relish when he told this
story later, in a crowd of fashionable Pierrots and Pierrettes, soigné Arab
sheikhs and haute-couture Greek gods (Paul Poiret came as a gilded Bac-
chus).

The beginning of 1914 was one of the periodic points when Matisse
stripped his life back to essentials. He also pared his work down, starting
with three teenage girls and a stone subject. The familiar, looming mass of
Notre Dame outside his window became evanescent on his canvas, its
solidity transformed into a weightless, see-through, floating cube enclosed
in black shadows, lines or scratchings on a sky-blue ground. A patch of
pink paint in one corner conveys a sudden intense wintry blaze of sun-

shine on stone far more vividly than the naturalistic canvas, almost identical in size and structural format, which he painted at the same time. The more conventional view appealed to everyone except the Sembats, who preferred the bolder painting: "For us it is the finer of the two, the more appealing, the one in which Matisse is the more personal."[37] Prichard correctly predicted that the process of compression and elision in this hard-edged, proto-abstract canvas would make it a classic, "in the sense that it typifies a new formula."[38]

Prichard haunted the studio at quai St-Michel as he had at Issy, looking eagerly for a future that would obliterate the folly and blindness of the present. He was in no doubt about the momentous changes taking shape on Matisse's canvases: "What has happened is that we are being taught a new vision."[39] This was the radical innovation he had called for that would express unprecedented sensations and demand fresh responses. "We cannot react to Byzantine art as did the Byzantine...," he wrote. *"Art must always be modern."*[40] Prichard was a model witness, clear, observant and astute. The notes he and his young followers jotted down provide unique snapshots of Matisse in action as three successive models—an eighteen-year-old professional from Montmartre, the young wife of the art critic Maurice Raynal, and the sister of one of Prichard's disciples—were each in turn subjected to the same reductive formula as the cathedral of Notre Dame.

The nature of perception, which preoccupied Matisse, was one of the key questions currently being addressed by the philosopher Henri Bergson in a wildly popular series of public lectures at the Collège de France. Prichard and his band of followers, all passionate Bergsonians, shuttled between Matisse's studio and the Sorbonne, laying the philosopher's findings before the painter, who recognised a basic system that might take him further even than masters like Delacroix and Corot. Matisse conceded that Delacroix had been wrong about how useful the invention of photography would be to painters: "Its real service was in showing that the artist was concerned with something other than external appearance," he said, pinpointing what that something was in the two views from his window.[41] "He accepted Bergson's idea that the artist is concerned with the discovery and expression of reality...," Prichard noted. "He accepted also the position that a picture by Corot was meant to be looked at, while his own painting was meant to be felt and submitted to."

This was the nub. Matisse's determination to reach places where photography could not go meant digging down further than he ever had before towards the inner source of life and energy, to currents and stir-

rings deep within himself, what Bergson called "the vital spark" and Socrates had identified as the daimon. Matisse was irresistibly drawn, like his whole generation in these first years of a new century, to the unconscious. At the same time he was tugged back from it by the artist's need to control and order, "to give yourself completely to what you're doing while simultaneously watching yourself do it," the goal that had struck him in Tangier as almost impossible to achieve for a painter as instinctive as himself.[42] Matisse needed Prichard's clear, sharp, legal mind now more than ever if he was to negotiate a new deal between thought and feeling. In the winter of 1913–14, he set himself to unravel and, with Prichard's help, articulate the theory behind everything he had known and done by instinct in Morocco.

He could not have found a more indefatigable assistant. Prichard proved invaluable, scrutinising, probing, prodding, asking questions, drawing analogies, playing Socrates to Matisse's Plato in a series of studio dialogues conducted before an audience of attentive young philosophers. Prichard's little band, many of them recruited through Bergson's lectures, included several Sorbonne students headed by Camille Schuwer and Georges Duthuit, the Oxford aesthete William King, and various more or less free-floating offspring from cultivated, affluent, cosmopolitan families, like the Greek Paul Rodocanachi and the Brazilian Albert Landsberg. The first priority was to clear the ground. On 10 January 1914, King recorded a conversation in which Matisse described how he would train—or retrain—a student disabled by the corrupt practices of the Ecole des Beaux-Arts to trust his eyes by copying nature, starting with the studio goldfish:

MSP: The student would say you had to kill the fish first, because they're moving.
HM: I would stop him immediately because these fish are life itself.
MSP: Then you would admit that there are two modes of expression, one concerned with life and the other only with dead subjects.
HM: I admit it.[43]

Matisse's two gleaming orange fish, together with the plant arching towards the window on the stool beside them, animate a beautiful *Interior with a Goldfish Bowl* (colour fig. 16) painted in muted purples, greys, pinky brown and turquoise in the low light of the New Year. He said he wanted

a sense of movement within an overall design, and reckoned that this constantly shifting process involved everything from the fish to the furniture in his painting room. "Take this chair," said Prichard. "Yes," said Matisse, "but when I paint it, I see it in relationship to the wall, to the light in the room that encloses it and to the objects that surround it. It would be different if I wanted to buy it: I might perhaps have a first impression of its beauty, but then I'd check to see if it was solidly built, etc." Even the humble, wooden, upright studio chair—forerunner of more exotic protagonists in a whole series of love affairs Matisse would conduct over the years with chairs—had now become a vital element in the effort to resee and refeel reality. Matisse agreed when Prichard pointed out that his intuitive and reflective vision was the opposite of the shrewd, heartless, bargain-hunting appraisal of the Beaux-Arts student.

Matisse needed an external response more urgently than ever as his experiments grew steadily more extreme. Once Prichard counted eleven other people crammed into the big studio at Issy ("I said to Matisse it was like an afternoon at the Bon Marché").[44] This was 3 November 1913, the day on which the painter unveiled his wife's newly finished portrait and plunged immediately into a fresh engagement with a total stranger. Mabel Bayard Warren was a friend of Sarah Stein, daughter of an American ambassador to Britain, and widow of the president of the Boston Museum of Fine Arts, who had been Prichard's sponsor in the United States. Matisse claimed she was descended from the great French chivalric hero Bayard, too.[45] Unfazed by either the African tribal carvings or the

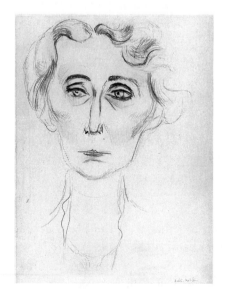

Matisse, *Portrait of Mrs. Samuel Dennis Warren*, 1913: a portrait that astonished the sitter, like a magic trick

equally unsettling effigies produced by Matisse himself, the intrepid Mrs. Warren accepted the painter's invitation to return on 6 November to sit for her portrait.

According to Prichard, Matisse spent the intervening three days purifying and preparing himself to draw her. Certainly he was in a highly receptive state throughout the session, which left him thrilled and shaken. "I couldn't do that every day," he said. "It was like travelling in an aeroplane. I passed two hours of

the intensest strain."[46] The resulting drawing was so life-like it resembled not only the sitter but several of her relatives as well. When Mrs. Warren told him he had somehow conjured up her daughter, her father and her aunt, Matisse said it only went to show the vitality of drawing by comparison with photography. To Prichard, who was beginning to speak of Matisse as a spiritualist or seer, it seemed as if he could tap into and transmit deep unconscious tides of feeling ("He was to take hold of the current of Life itself and hand it on to us").

This episode, which astonished the sitter and her friends like a magic trick, clearly demonstrated Matisse's ability to grasp and penetrate a subject by means not always easy to explain. "There was a constant movement of her will forwards and backwards, giving and withdrawing, opening and closing," he told Prichard afterwards, sounding like a fisherman tickling a trout, even waggling his fingers to emphasise the moment when his slippery subject all but got away: "There was no change in the features unless in the light of her eyes, but there was a constant vibration [Matisse moved his hand rapidly], it was like a rippling lake, like sunshine on water, there was nothing whatever to seize and there was no point where it seemed possible for me to begin."

This was the germ from which his paintings grew. All the most disturbing portraits of this period (including the *Portrait of Mme Matisse*) secrete within the final version a first, naturalistic image agreed by observers to be strikingly like the sitter. The process that led from one to the other remained mysterious, even to Matisse, who said it came from a level below conscious thought. Here Bergsonian reasoning could not help him. All Prichard's attempts to elucidate a set of rules met with dogged insistence from Matisse that, in his precarious position, there were none:

MSP: It follows then that a philosophy is necessary.
HM: Yes, certainly, it's easier to subscribe to a philosophy, a religion, a family; there's something comforting about finding yourself supported by an organisation.
MSP: Bergson said there was only one philosophy.
HM: Yes, I can conceive that as a possibility.[47]

Matisse's scepticism was partly constitutional, partly a reflection of his (and Prichard's) dismay over Bergson's admiration for the most conventional forms of academic art. Matisse felt that, if Bergson's taste in painting could not be taken seriously, the validity of his philosophical positions was also questionable (the nearest he got to reading him was in

Tangier, where he kept one of Bergson's books with a detective story beside the bed for light reading in the mornings after a sleepless night).[48] For all his need for support from other painters in Tangier, and from philosophers in Paris, when it came to firsthand exploration, Matisse was on his own.

His canvases grew darker and more austere as he pushed forward with the programme of progressive elimination begun in his painting of his wife and continued in his next portrait, *Grey Nude with Bracelet.* "My model is a young girl of eighteen from Montmartre but very simple and pure," he told Prichard, explaining that he had got rid of colour because it interfered with the tender plastic quality of his model. "There's a breath of innocence about her, and I found colour fought against that feeling."[49] He was more stringent still in his painting of the nineteen-year-old Germaine Raynal, perched on a studio stool and reduced to a series of flat rectangles—torso, thighs, long narrow skirt—laid out more or less at right angles to one another in straight lines and leaden greys. Splashes of peacock green and blue on her skirt, a tawny red licking along the stool-strut and filling the tabletop behind her, make little headway against a darkness which Matisse said closed in of its own accord without deliberate intervention on his part ("He would never have dared paint consciously a picture like that of the *Girl on the Stool,* for he never would have thought it possible to construct a picture based on a simple neutral grey").[50]

Matisse, Woman on a High Stool (Germaine Raynal), *1914*

Woman on a High Stool made a funereal impression on Prichard's friend Bertie Landsberg, who volunteered his nineteen-year-old sister Yvonne as Matisse's next subject in April.[51] The drawing was commissioned by their mother, whose first choice (the more modish William Orpen or Paul Hel-

leu) had been abandoned at her son's insistence in favour of Matisse, largely because of the girl's hopelessly unfashionable looks. Yvonne was tall, with quirky features and long limbs. As the younger sister of a beauty of classical regularity, she had had her own ugliness relentlessly dinned into her by her family. Shy, sensitive and desperately unhappy, she drew herself in the mirror as a big, plain, bug-eyed, rather chinless teenager. "It was felt that her defects would be absorbed by the deformations of a modern painter," Pierre Matisse recalled drily.[52]

At their first meeting, when her brother brought her to the studio, Matisse said Mlle Landsberg reminded him of a magnolia bud, and not surprisingly she flowered for him after that. His drawings suggest a natural poise, grace and frivolity as well as sharply pronounced individuality. He set her at ease as an experienced photographer might coax a tense subject today, sketching her smoking, lounging, pouting, and turning away from him with hands on hips. Her brother, who chaperoned the sittings, watched Matisse draw her from the waist down, kneeling with her back turned in a long frilly skirt that disclosed the turned-up soles of her elegant French shoes. "I remember at the time marvelling that these frills and soles should, somehow, have the power of evoking—at least, for me, subtly but distinctly, much of my sister's personality," he wrote.[53] The drawing that was formally submitted for approval in May split the family down the middle, one faction complaining that the nose was far too large, the other (which included the sitter and her two brothers) declaring the nose was not a problem. "Their friends range themselves under one banner or the other," reported Prichard, "and even the servants are recruited by one side and by the other."[54]

Mme Landsberg eventually agreed to let Matisse paint Yvonne's portrait on the same terms he had once proposed to Greta Moll: he would be free to paint what he pleased while the family's right to buy implied no obligation. Prichard and his band came to see the portrait launched on 8 June, and continued to attend sittings throughout the month.[55] Although nothing could reassure her about her looks, Yvonne clearly liked and trusted Matisse, and so did her brother. The painter himself was expansive and good-humoured in breaks between sessions. He had moved back with his family to Issy for the summer but kept the studio on the quay, which was ideal for this kind of small-scale work, handy for Prichard and the Landsbergs, and surrounded by other painters. Marquet upstairs was a convivial companion, and Matisse had been too long away from Paris. In May he attended the first night of Rimsky-Korsakov's *Golden Cockerel* (noting with interest the influence of his own *Harmony in Red* on the décor by

Natalya Goncharova, who knew the painting from Shchukin's house in Moscow).[56] He bought himself a beautiful and costly violin that month—a luxury that could have been justified only as necessary for work—and played it regularly to calm his nerves after painting sessions.[57]

He also acquired round about this time a small, second-hand printing press, which he installed in the flat at quai St-Michel, practising his skills in rapid etchings, drypoints and lithographs of friends and family that have the casual immediacy of snapshots. One day he sketched Bertie Landsberg's head ("He first drew a beautifully elongated oval, but—on looking at one more carefully—pulled it out cubistically, saying that its ... real structure ... was *squarish* and its whole character far more *vigoureux* than at first appeared").[58] He made serial etchings of Yvonne, framing her in a garland of magnolias. A couple of impromptu etchings of Prichard, looking critical and also surrounded by magnolias, did not please the sitter ("I doubt he can make a drawing of me in five minutes," Prichard grumbled to Georges Duthuit. "I am more complicated than he supposes").[59] Landsberg said that these images rose spontaneously from the depths of Matisse's imagination, brought to the surface "while playing, as it were, at the point of his pencil, or etcher's needle, on shield paper or copper plate."[60]

Matisse, *Yvonne Landsberg*, July 1914

Meanwhile the portrait of Yvonne contracted and expanded on canvas: "At the end of the *first* sitting the oil portrait too greatly resembled the sitter," Landsberg recalled long afterwards, "but it became more 'abstract' with each sitting, and more—I then thought—'like a Byzantine icon.' At each sitting it became *less* physically like, but—possibly—*more* 'spiritually' like my sister." The charming, lively, funny girl captured so effortlessly in Matisse's drawings disappeared behind masklike features with

black voids for eyes and hornlike protuberances arching from her brow-bone. Her neck became a fluted column, her body a lacy carapace or shell in soft, steely greys and black enlivened by flickers of pink and turquoise against a delicately painted ground of dark, feathery brushstrokes. Prichard left to spend the summer holidays in Germany on 27 June, having watched with approval as the painting grew, in his view, steadily better, more hieratic and inhuman.

After Prichard left, Matisse reversed his brush at the end of the final sitting and scratched

Matisse, *Portrait of Mlle Yvonne Landsberg*: a picture completed a month before the outbreak of the First World War in which the painter recognised a force greater than himself, "a Socratic demon, the enemy"

great white lines in the wet paint, circling the body and swirling out from it like a bud unfurling or wings clapping open. The slight, grave, pale figure within this vortex of whorls and claw marks conveys a poignant sense of human vulnerability and endurance. Marcel Duchamp, seeing the *Portrait of Mlle Yvonne Landsberg* for the first time two years later, preferred it to the *Portrait of Mme Matisse*.[61] But Yvonne's mother recoiled from the finished painting, and so initially did the artist. "Matisse says himself it's a bit of an enormity," Prichard wrote from Germany on 7 July. "His picture shocks even him a little, he feels uneasy and slightly surprised. He seems to me like a sparrow hawk that has hatched an eagle. He feels in himself something greater than himself, a Socratic demon, the enemy."[62] The demon that looked out of Yvonne Landsberg's blank black eyes on canvas in the summer of 1914 was the same disturbing intuition recognised long afterwards by the American collector Albert Barnes, who said it would be hard to overestimate the significance of the Armory Show: "The war came from the social malaise expressed in the paintings."[63]

In Paris in the summer of 1914 an envoy from Gurlitt's gallery in Berlin

called on Matisse, who, with help from Hans Purrmann, persuaded a reluctant Sarah and Michael Stein to lend nineteen paintings—the pick of their Matisse collection—to the German retrospective scheduled for July. The Sembats prudently declined to send anything at that juncture to Berlin. Shchukin, returning home after a holiday on the Italian Riviera, stopped off in Paris that month to finalise arrangements for the last three canvases still missing from the top tier of paintings in his drawing room. He chose *Woman on a High Stool,* and agreed on subjects for two new works: a picture of boats to be painted in Collioure (where the Matisses planned to spend the rest of the summer), and a self-portrait to go with Matisse's painting of his wife.[64] But none of the three missing works ever reached Moscow. The *Portrait of Mme Matisse,* which had arrived in the spring, was the last of Matisse's paintings to enter Shchukin's collection.

Paris, like the rest of France, had no premonition of disaster up until Austria's declaration of war on Serbia on 28 July. The Russians began to mobilise two days later, the French followed suit, and on 3 August Germany declared war on France. Trains had already been commandeered to transport nearly two million soldiers south and east towards Alsace and the Swiss border, where a short, sharp war was expected to be over well before the winter. Buses stopped running in the capital overnight, and taxis disappeared from streets suddenly full of men heading for the stations. Gun batteries assembled in the Tuileries Gardens, and soldiers with fixed bayonets guarded bridges across the Seine. Theatres closed, food prices rose and huge queues formed outside the banks. "The weirdest thing in Paris, now that all else has been sacrificed," Jules Flandrin wrote home in the first week of the war, "is the sudden obliteration of anything to do with work, values, any kind of comfort or settled future."[65]

The precise sequence of events may have been unexpected, but few seriously questioned that the time had finally come to avenge France's defeat by Germany in 1871. The mood was calm, resigned, even relieved. Matisse, Marquet and Camoin had themselves photographed on horseback beside an airship tethered on Issy airfield, and posted the picture off to Manguin with a cheerful message on the back: "As you can see, we have just formed a squadron for the defence of France. I imagine you won't hesitate to join us, and we shall be the first to enter Berlin. We impatiently await you—see you soon—Marquet."[66] All four were waiting, like every other Frenchman between the ages of eighteen and forty-eight, to be called up officially by the army. Matisse, finding it for once impossible to work, relieved his feelings through the violin, driving the rest of the family distracted with his playing for up to four or five hours a day. "That was a

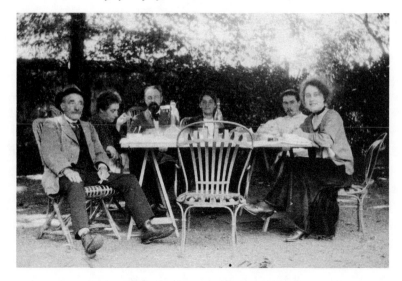

The Matisse family
at Issy in the sum-
mer of 1914 with
Berthe and Armand
Parayre

time of gloom and confusion," said his son Pierre, who was also obliged
to practice daily. "The whole household was in a state of jangled
nerves."[67] Berthe Parayre, staying at Issy that summer, found herself
stranded, unable to get back to her college in Ajaccio now that travel had
become almost impossible for civilians. Even coming in and out of Issy
required a special pass.

After a fortnight or so the family moved back to Paris, where three
adults cannot have fitted easily with three adolescents—two of them as
tall as men—into a three-room flat. These first weeks of suspense and dis-
location were so hard to bear that Amélie appealed to the town hall to find
her husband some sort of temporary occupation ("My own work is going
nowhere, inspiration being obviously lacking," he explained to his mother,
"and I've other things on my mind").[68] Foreigners disappeared almost
overnight from Paris. Berthe eventually managed to squeeze into a third-
class carriage crammed with homing Italians on a train that inched its way
south at the rate of thirty miles in four hours. Newspapers were so heavily
censored that it was impossible to be sure what was happening. There were
wild rumours of German armies speeding through Belgium, but no real
doubt at this stage about France's ability to send them packing in a month
or two at most.

Britain had entered the war the day after France, and the towns and
villages of Matisse's native North turned out to welcome British troops
marching through Flanders from the Channel ports. Their headquarters
in Le Cateau was a stone's throw from Henri's birthplace, and popular

confidence was so widespread that on 20 August his mother telegraphed him to send Pierre to her in Bohain. Matisse tactfully replied that both boys were quite happy working at their holiday tasks in the mornings, and fishing in the long hot afternoons from the quay above the Seine. British troops had been streaming though Bohain for a week on their way to Mons in Belgium, but neither Matisse nor his mother was particularly alarmed when word came that the Germans had reached Brussels. "I think that, if they've been allowed to get away with it so far for whatever flimsy reasons," he wrote the day he got her telegram, "they'll be given a good pasting as soon as things look serious."

Brussels fell that day to the Germans. Belgium was overrun. The French were decisively defeated in the Battle of Charleroi, which lasted three days, 21–23 August, and left forty thousand Frenchmen dead. The Allied armies fell back on 24 August, retreating rapidly in forced marches through Picardy and Flanders before the unstoppable German advance. Matisse and Guillaume Apollinaire lunched the day after the defeat at Charleroi with André Level, who recalled the occasion nearly half a century later in his memoirs:

> What we talked about at that time, and in the days that followed when our whole future as a people lay in the balance, one can well imagine, and one can still remember. A communiqué located our front on the River Oise. What haste in our precipitate withdrawal! The government fled the endangered capital. It seemed for a while as if she would have no defence, planned or otherwise, and wretched were those who believed in despair that she would be taken. I was one of them.[69]

The Oise flows close by Bohain. The first bewildered English stragglers reached the town on 24 August, followed by a mass of beaten and exhausted soldiers who passed through, leaving the inhabitants to the mercy of their pursuers. The Belgian refugees who had trudged ahead of them, telling tall stories of an invading army on their heels, turned out to be right after all. Madame Matisse, like all those old enough to remember the last German occupation, buried her valuables in the back garden. Le Cateau fell after fierce fighting two days later, and the wounded were treated in an improvised hospital set up in Matisse's old school, the Lycée Henri Martin at St-Quentin. On 27 August, the people of Bohain prepared to receive the German army in silence, with closed shutters and empty streets, as they had done on 1 January 1871, the day after Matisse's

Louis Joseph Guillaume, photo of occupying German troops marching past the Matisse seed-store in Bohain

first birthday. He had nothing to go on at this point but rumours, and the stories of terror and humiliation he had heard endlessly as a child growing up in the aftermath of the Prussian war.

A squadron of British lancers on horseback charged a detachment of Prussian dragoons a few miles outside St-Quentin on 28 August 1914, but by nightfall the Germans had taken the town by force. This second battle of St-Quentin was a more savage replay of the first, four decades earlier. Once again the invaders paused just long enough to pillage the area, raiding cellars, slaughtering poultry, pigs and cattle, loading stolen carts and wagons with loot ("It's an army delirious and drunk with victory and wine," wrote one of Matisse's compatriots),[70] before pushing on deeper into France. Communication with the population in occupied territory abruptly ceased. The first definite confirmation Matisse had of his family's situation was a curt communiqué informing the stunned and incredulous French nation on 29 August that from the river Somme to the Vosges mountains their country was now in German hands.

Distant cannon fire could already be heard in Paris. No one had envisaged a need to defend the capital, but makeshift barricades of earth, railway sleepers and barbed wire were now flung up to block the gates. On 1 September, the army officially requisitioned the Matisses' property as a military headquarters, strategically placed on the bluff above Issy, near the fort and the airfield (where Matisse's distant cousin, Raymond Saulnier, would shortly design and build the first French fighter planes in the

Morane-Saulnier workshops).[71] By 2 September the Germans were in Senlis, less than thirty miles from Notre Dame. Half a million Parisians followed the government when it fled south that night to Bordeaux. There was pandemonium on the roads and at the railway stations. Jean Puy said that if he hadn't had his wife with him, he would have fled by bicycle or on foot.[72] The Matisses had already sent the children to their grandfather and great-aunt in Toulouse, and done what they could—rolling and stowing canvases, burying sculpture in the garden—to clear the house, but, with no transport and almost no notice, serious preparation was impossible. Anything might happen now that there was a wholly unexpected enemy at the gates. "I remember our state of turmoil as the Germans advanced on Paris...," Matisse wrote to his wife four years later, when the capital faced invasion for the second time; "that was no joke, do you remember?"[73]

In the first frantic week of September 1914, Parisians scrambled onto any train they could, no matter what its destination. The Matisses and Marquet managed to get to Nantes in Brittany, making their way south via Bordeaux to Toulouse. They finally reached Collioure on 10 September, the day after the Germans received their first defeat, just short of Paris, in the Battle of the Marne. The capital had been saved by what many thought of as a miracle. The invaders fled with the Allies in pursuit, but French hopes of beating them back behind their own frontier faltered after a few days when the Germans halted and refused to budge beyond the Aisne River. The two armies now turned northwards to the sea, fighting their way across the devastated plains of Picardy and Flanders all through the autumn, digging themselves in along the Somme, facing one another on either side of a line enclosing the regions where Matisse had grown up and gone to school. Having crossed France to fetch up in its furthest southwest corner, he could hardly have been worse placed to hear anything of his mother or his brother, who was stranded with a wife and two small daughters behind German lines in the northeast.

Anxiety would soon drive him back to Paris, but for the moment the family settled back into their old rented house at the top of the avenue de la Gare, and found a tutor to give lessons to the boys (whose school at Noyon, now on the front line, was one of the first casualties of the war). The tutor had a couple of Parisian lodgers who turned out to be Picasso's young friends, Juan and Josette Gris, overtaken in Collioure by the war with nothing to live on and no prospect of money coming in. Their income had dried up with the departure from France of the Cubists' dealer, the German Daniel Kahnweiler, who had supported Gris with

small but regular monthly payments. Matisse and his wife remembered well enough how it had felt to face destitution without warning at almost exactly the same age. He and Marquet went with Gris to Céret to consult another of Picasso's friends, the sculptor Manuel Manolo, who offered to find the couple a place to live while Matisse contacted alternative sponsors in Paris. By far the most impressive of the Cubists following Braque and Picasso, Gris was more rigorously analytical than either of the others. His ability to transmit feeling through the strict logic of his grid systems suited Matisse, who took up again with him the technical discussions he had begun the year before with Picasso. A solid friendship sprang from this month at Collioure, when the two talked painting so relentlessly that Gris said the unspeculative Marquet could hardly bear to listen to them.[74]

The only work Matisse produced that month was a strange, stripped-down painting that he never exhibited in his lifetime, and which would have been almost impossible to decipher if he had. Its subject was an open window, a motif he had first sketched as a boy bored out of his mind in his first job, copying documents as a provincial lawyer's clerk. Life opened up for him as soon as he became a painter, but he returned to the same theme at intervals whenever he felt blocked or threatened, most notably in *Studio under the Eaves,* painted in 1903 at the height of the Humbert scandal, a canvas almost entirely given over to deep shadow except for a small central window opening onto brilliant sunlight beyond. Now he reversed the formula. He painted a pair of faded, sun-bleached, wooden shutters at each side of an open French window, reducing them to vertical bands of soft blue, grey and turquoise framing a black void. The effect is majestic, bleak and sombre, but at the same time suffused with

Matisse, *French Window at Collioure,* 1914: a window opening onto war in what Louis Aragon called the most mysterious picture Matisse ever painted

light. The poet Louis Aragon said in retrospect that *French Window at Collioure* was the most mysterious picture Matisse ever painted:

> When we note its date, 1914, and it must have been in summer, this mystery makes me shiver. Whether or not the painter intended it, and whatever that French window once opened onto, it remains open. It was onto the war then, and it's still onto events to come that will plunge the lives of unknown men and women into darkness, the black future, the inhabited silence of the future.[75]

When this canvas was finally shown in 1966, more than fifty years after it was painted, it made perfect sense to eyes trained on American abstraction.

Matisse left Collioure reluctantly to travel back alone to Paris on 22 October, breaking his journey in Bordeaux to talk to Marcel Sembat, who had been roped in as Minister of Public Works to represent the Left in a hastily reconstituted cabinet in the first month of the war. Sembat confirmed Matisse's suspicions about the optimism reflected in the government-censored press. They discussed German brutality towards civilians in the occupied zone, and the fact that the government had no plans as yet for returning to the capital. "There have been things we don't read about in the newspapers," Matisse reported ominously to his wife. "They reckon here that the war will last a long time."[76] Business required his return to Paris, but his letters were largely given over to such meagre news as could be guessed or gleaned about the fate of friends. On 25 October, Gertrude Stein filled him in on a batch of artists ("Basler and Nadelman have left for America—there is no news of La Fresnaye—Segonzac is wounded . . . Derain has left for the front"). The next day there was more gossip from Jean Puy ("They say Picasso came back to Paris before the war and drew 100,000 francs in silver out of the bank . . . that Vlaminck is a Belgian military painter—that Uhde and Lévy were spies and have been shot in a concentration camp"). Shells had fallen on the Left Bank all around the quai St-Michel. When Matisse went to inspect the house at Issy (still intact, although somewhat dilapidated after occupation by French staff officers, who were on the point of moving out), the neighbours told him of sons wounded, killed or taken prisoner.

Unable to get word of his mother, tormented by nightmares and crushed by the atmosphere of foreboding in Paris, Matisse longed to be back in Collioure, where it was still possible to attend to matters other

than the daily news bulletin. "I saw the prospect of enough work there to last me the whole winter. I'd already begun the open balcony, and I wanted to go on with it, and I had other things in mind, for I was beginning to get into my stride at last," he wrote, adding wistfully, "and it's so far from the war."[77] But his hopes of making a quick getaway were dashed by his failure to drum up funds, either on his own account or for Juan Gris. He persuaded Gertrude Stein to make Gris a modest monthly allowance, topped up by further contributions from the sculptor and art dealer Joseph Brummer, one of Matisse's former pupils, now serving as a Red Cross stretcher bearer. Gris was to repay them with canvases, but, at some point after he and Josette joined Matisse in Paris at the end of October, Gertrude apparently went back on the agreement. "To my stupefaction, I learned later from Gris that she had done nothing about it," said Matisse, who never spoke to her again.[78] Relations between the two had cooled as it became increasingly clear that Gertrude no longer understood Matisse's painting, and tended to write him off in consequence. Her inability to influence him, and his dislike of her mischief-making, made him seem to her stuffy and censorious. Keeping on equally good terms with Gertrude and her sister-in-law was in any case notoriously tricky, and Matisse made no secret of how much more highly he rated Sarah.

His attempts to consolidate his own financial position were even more unsuccessful. Plans to extract a substantial sum by putting pressure on Félix Fénéon at Bernheim-Jeune came to nothing.[79] On 27 October, Fénéon courteously explained that there was absolutely no prospect of advancing anything whatsoever, given the rocky state of the market, and the uncertain outcome of the German thrust northwards to the coast. Matisse was paying for the mutual distrust between himself and his dealers that went back to their attempted double cross over *Dance* and *Music.* The scheme he had cooked up with Shchukin—to bypass Bernheim-Jeune by producing canvases too big to fall within the terms of their contract— meant that the bulk of his work over the past two years had gone direct to Moscow with no question of the dealers taking a percentage. Matisse immediately telegraphed Shchukin, who replied on 2 November that the Moscow stock exchange had closed and money could no longer be transferred to France.[80] "This could go on for a long time," Matisse wrote grimly. His twin sources of income had dried up simultaneously, leaving him with a family to support, little in the way of savings and no apparent buyers for his pictures, even supposing he could bring himself to paint again.

One of the reasons for Matisse's return from Collioure was an urgent

appeal from Walter Pach, who turned up from New York on 16 October to find soldiers occupying the house at Issy and no one in the Steins' studio on the rue Madame. Pach had come to organise a Matisse exhibition for the Montross Gallery in Manhattan as part of a personal campaign to consolidate and extend the ground gained for modern art by the Armory Show. His French friends were astounded and impressed by his refusal to let his plans be deflected by world war. He told Matisse that this was the only stand he could make, as an American, against German barbarity: "I consider the fact that these brutes have set the physical world on fire doesn't mean that all reasonable activity must cease."[81] Pach's stubborn insistence on business as usual was a comfort in the circumstances. The American ambassador lent support. So, after an initial flurry of bewilderment, did Sarah and Michael Stein, responding warmly from the Mediterranean holiday villa where they had settled down to see out the war ("Don't fail to impress on him that he must now look to America for a market for his art for some time to come," wrote Michael, urging Pach to contact the painter directly. "Now is the time to have the Americans begin to own Matisse").[82]

The show was to be a retrospective, offering work for sale from the *Studio Under the Eaves* of 1903 to the latest *Portrait of Mlle Yvonne Landsberg*, with a catalogue more comprehensive than anything that had yet appeared, except in Russia. Matisse chose and supplied the pictures, co-opting Fénéon at Bernheim-Jeune to organise shipping and insurance. Pach's plan to consult Fry in London had to be dropped at the last minute because the Channel ferry had been requisitioned for a British military convoy. But the American's doggedness and his touching faith in a transatlantic future were heartening at a time when the rest of the world seemed on the point of disintegration. Pach, who spent much time in the studio on the quai St-Michel, was perplexed by Matisse's inability to paint: the most he seemed able to concentrate on was his series of casual, snapshot-style portraits of friends and acquaintances, drawn at top speed directly onto the lithography stone. One day, just as Pach was leaving for his next pressing appointment, Matisse put him in a fever of impatience by making him wait five minutes to have his picture taken ("It's the soul of Walter Pach as seen by angels," said the museum director Bryson Burroughs, when this etching reached New York).[83]

He made seven etchings of Josette Gris, who with Juan was the only other person Matisse saw regularly in these uneasy weeks when the promised liberation of France seemed against all expectation to be receding. He ate with the couple most nights, on condition they let him con-

tribute towards costs and pay model fees for the portrait sittings. "After all, it's wartime," he told his wife (Gris would find an alternative means of support a few months later from the dealer Léonce Rosenberg, who took on many of Kahnweiler's clients at this point). Like Pach, they provided company and some semblance of normal life. He could still discuss Cubist practice with Gris, and with Marcel Duchamp's brother, the sculptor Raymond Duchamp-Villon, whom Pach took him to meet towards the end of October. "It's a projectile," Matisse said, admiring the streamlined elegance and massive compact force of Duchamp-Villon's *Large Horse* in his studio at Puteaux.[84] But talking and thinking about art gave only limited respite from more urgent anxieties. The eldest of the three Duchamp brothers was already at the front, and Raymond himself had been drafted into the medical corps to tend military casualties at the local hospital of St-Germain. "He said we weren't in the firing line at Issy," wrote Matisse, whose letters to his wife reflect the almost universal sense of numbness and shock. "Paris is dismal when you're away . . . give my best to Marquet, who's in luck if he can go on working in the midst of so much suffering."[85]

This was written on 11 November, the day the last convulsive struggle of the year in Flanders reached its height at Ypres, which was savagely attacked and ferociously defended, before the two opposing sides settled down to shell one another for the next four years across ramparts and trenches running for 350 miles from the Swiss border to the North Sea. Official sources still insisted that the war would soon be won, but, in the absence of hard news, premonitions of carnage on an unimaginable scale were beginning to filter through to ordinary people. Numbers could be guessed at from the trainloads of wounded soldiers filling civilian hospitals. Georgette Sembat, who had visited the front, brought dreadful stories from the shattered towns behind the lines. Sembat himself told Matisse that the combined losses, in soldiers killed, maimed or captured on both sides, came to well over three million in the first three months of war.[86] Twenty-five thousand Frenchmen killed in the Battle of the Marne would escalate to twelve times as many by the end of 1914.

Charles Camoin, posted that autumn to the southern tip of the western front, sent word of crops destroyed, abandoned villages looted and fired, barbed-wire fortifications protected by fields sown with mines. Civilians who had failed to flee in time survived as best they could under German martial law. In Bohain, as elsewhere, anyone infringing regulations could be shot on sight. Any house suspected of harbouring resistance was burned down. The invaders confiscated everything from firearms, axes,

saws and spades to livestock, fuel and means of transport. Banks closed, shops emptied and supplies dried up. As winter set in, the inhabitants of occupied towns and villages had nothing but their dwindling stores and the produce of their gardens. Matisse's brother had been rounded up at the end of September with almost four hundred other able-bodied men from Bohain, and deported to a prison camp at Havelberg in east Germany. Their seventy-year-old mother remained in her house alone in failing health with one elderly female servant and a daughter-in-law across the street. "I have no news of my relations, or my brother," Matisse reported in December to Camoin.[87]

All their friends (except for Marquet, who was too frail, and the Spaniards, like Gris and Picasso, who were exempt) were either at the front or waiting to be posted. By the time Matisse finally received call-up papers summoning him to a medical examination, he was running a raging temperature with flu and so obviously unfit for active service that the board rejected him, relegating his name to the auxiliary reserve. He made a good story afterwards out of the doctor, who let him off because he felt bad about having passed the man ahead of Matisse in the queue, in spite of protests that he had throat cancer ("You'll do to make a corpse," the doctor said prosaically).[88] But at the time the rejection provoked mixed feelings. Matisse had made his dispositions, prepared himself to leave his family, even bought his army boots. He tried twice to get the verdict reversed, and was turned down both times on grounds of age (at forty-four he was four years short of the conscripts' upper age limit) and a weak heart. All he could do was send regular letters to friends at the front, run errands for them and keep an eye on their affairs at home. Quantities of postal packets went out that winter from the Matisses in Collioure and Paris. Matthew Prichard, interned from the first week of August 1914 in a camp for English nationals at Spandau, near Berlin, received food parcels, warm clothes and (which mattered more to him than either) prints and picture postcards. Camoin got chocolate, sweets, shoes, gloves, powdered milk, a bicycle and the first volume of *Les Liaisons dangereuses.*

Paris, with half its population gone, felt like a ghost town. Matisse said only two things could make him want to stay. One was the need to remain as near as possible to his mother, "for when Bohain is liberated, so as to be able to get there."[89] The other was the prospect of trying to earn a living outside the capital: "The terror of working as a copying clerk in an office in Perpignan," he said, picturing himself starting out again on the alternative career he had narrowly escaped by running away from home to be a painter. But Amélie and the children, already bored and restive in

Collioure, rebelled at the possibility of having to move to Perpignan. Henri was clearly relieved when his wife preempted his return south by deciding to pack her bags, close up the Collioure house and bring the family back to Paris in November. "I'm longing to see you all," he wrote, arranging reduced fares through one of Sembat's ministerial colleagues, and reminding her to economise: "Things will be better for me when you're here—though I guess I'll still be sorry to give up my winter."[90]

He bought wood for the stove at Issy, and replaced items missing from the house with hired furniture, beds and blankets. He planned to feed the boys (who were to come on ahead) by taking them to a restaurant at mid-day, and improvising an evening meal himself. Parisian friends thought the family mad to leave Collioure, but none of them could bear to be away at this stage. The boys resumed their education at the Lycée Montaigne (where Pierre shared a bench with a boy he would hear more of later, Yves Tanguy). Marguerite laid tentative plans to be a painter. Their father went back to the relentless practising that drove him to the brink of exhaustion. "Where did you put the violins?" he asked anxiously when one of the Collioure trunks went missing.

He arranged lessons for himself and Pierre from the Belgian violinist Armand Parent, in exchange for drawings. Music provided the outlet Matisse could no longer find in painting, as the weeks that were to have decided the fate of France stretched out into months with no end in sight. "I'd rather be doing something useful for the defence of the country," wrote Jean Puy, also trying unsuccessfully to work and longing to be mobilised, "but I don't even know how to knit socks."[91] Matisse dashed off a whole series of portrait etchings of young string players, including the Argentinian cellist Olivares, the Spanish violinist Massia, and Eva Mudocci, whose passionate violin playing spoke directly to Parisians in this first winter of the war. He made a last attempt to join the army, appealing for help with Marquet to Marcel Sembat, who wrote back that the best either of them could do for France was to stay at home and paint. "So Marquet and I have ended up going back to work ...," he wrote to Camoin at the end of 1914. "What else can we do, we can't sit all day just waiting for communiqués."[92]

The last thing Matisse had worked on in July was a sequence of small head-and-shoulders portraits of Marguerite, who looked debonair and summery in a striped jacket, a straw boater trimmed with roses, a chic little saucer-shaped leather hat. Now the two resumed sittings with a fresh canvas that quickly abandoned all pretence of naturalism ("This picture wants to take me somewhere else," Matisse told his daughter. "Do you

feel up to it?").[93] The sitter's touching human presence was barred out or blocked off behind a striped grid, spreading out from her own jacket to invade a canvas that, alone among Matisse's work, looks as if it had been constructed as Gris plotted his paintings, with set-square and ruler. Harsh, impersonal and heavily overpainted, *Head, White and Rose* is testimony to everything that simultaneously attracted and repelled Matisse in the work of Picasso, Gris and Duchamp-Villon: "What he feared in the new group," Pach reported, "was the submerging of every sensuous quality in the rising tide of intellectualism."[94]

He solved the problem in his next painting, intended as one of the two canvases he had promised Shchukin at their last meeting six months earlier. "It's my picture of goldfish which I'm re-doing with a figure in it, holding a palette in his hand and observing," he explained to Camoin, sketching himself seated beside the still-life table with goldfish bowl and potted plant at his window high above the quai St-Michel.[95] This time he transposed the domestic scale of his earlier goldfish paintings into a register altogether deeper, darker and more powerful. He reconstituted the studio on canvas in flat black, blue and whitish strips, folding into and out of one another like stage flats, as Alfred Barr observed, and aerated by lively shreds and patches of soft grassy green, violet and apricot pink, yellow and warm orange. In the end the human figure vanished altogether, abstracting itself, leaving nothing but a thumbprint on the vestigial blank palette at the right. *Goldfish and Palette* (colour fig. 17) is a Cubist work impregnated with a mysterious, unmistakably Matissean intensity of feeling. "I've examined this picture twenty times," André Breton wrote, hailing it almost a decade later as one of the three or four most important works produced by the modern movement. "In truth it possesses at once unheard-of freedom, intelligence, discrimination and audacity. Formal innovation, profound penetration of every object by the artist's own life, magical colours, it has everything. . . . I'm convinced Matisse has never put so much of himself into any other painting."[96]

Matisse's chosen role—the observer with a palette in his hand—had been forced on him against his will, at a moment when for the first time he had no heart to play it. In January 1915, he obtained an official permit as a war artist to visit the ruined quarter of Senlis, which had been shelled, sacked and burned by the retreating Germans. But excursions like this seemed futile, if not frivolous, when set beside Camoin's accounts of journeys to another world—"The country of the trenches, a nameless land, filled with mud and snow"[97]—where other painters crouched in excrement and foul water, cold, hungry, thirsty, plagued by lice and rats, dodg-

ing shellfire and bullets. A steady stream of them passed through Issy on their way to and from the front. The house became a haven for soldiers on leave, from Prichard's philosophical young friend Georges Duthuit to old comrades like André Derain, who came in the spring to confide his work, and his wife, to the Matisses' care. Vlaminck, Braque, Flandrin and the only other artists on the route de Clamart—one of Moreau's former pupils, Jean Chaurand-Nairac, and the local house agent, a Sunday painter named Georges Burgun—had all left to join their regiments by this time. Even Puy passed his medical board, departing at short notice in January with joyful whoops ("When I come back from the war, I'll bring you a necklace of Boches' heads to decorate your studio").[98]

"Can this last much longer?" Camoin wrote wearily in April. When a letter arrived via the Red Cross that spring from Auguste Matisse, describing the Germans' treatment of their half-starved French prisoners, Henri went into action. He set aside eleven etchings, pulling fifteen plates from each, to raise funds for a relief scheme organised through the Société des Prisonniers de Guerre. By early May he was posting a weekly parcel of eight kilos of bread or biscuit to his contemporaries from Bohain. He organised publicity, contacted critics, drew up lists and canvassed potential subscribers in Paris and the United States with an energy he could never muster on his own behalf. Mabel Warren offered to sell drawings for the scheme in Boston.[99] The great French couturier Jacques Doucet (who had caused a sensation shortly before the war by switching his holdings as a collector from old to modern masters) acquired his first Matisses under it. "I thank you," wrote the painter, formally acknowledging a promise of 1,500 francs from Doucet, "in the name of my unhappy compatriots, who are deprived of everything, dying of hunger, regularly beaten (as my brother, who is one of them, writes to me), and without news of their loved ones left behind in occupied territory."[100]

Like everyone else, Matisse scoured the official bulletins and begged friends at the front for information ("Père Matisse," Puy wrote unhappily, when he found himself posted away from the Flanders front, "forgive me for not being able to give you the news you want of your relations").[101] Matisse feared especially for Puy, whose health and strength were wretchedly unequal to the forced marches, alternating with "violent drenchings from machine guns, shells, torpedoes and other dirty tricks," described in his resolutely cheerful letters.[102] "Are we really going to have a winter campaign?" Matisse asked in disbelief as the stalemate in Flanders dragged on towards a second year, adding in a fierce, uncharacteristic outburst to Camoin, "What has happened to my mother, to whom the doc-

tors gave one or two years to live three years ago, when she had a heart attack? You can see, *mon vieux*, that this war is terrible for everyone."[103]

As the war shifted eastwards to Russia and the Turkish campaign in 1915, people slowly began to realise that the generals' unbudgeable determination to rid France of invaders could only bring disaster (attempts to breach the German trenches at Arras, thirty miles from Bohain, ended in failure, with French losses of 134,000 in May, 96,000 in September, and another 143,000 that autumn in Champagne, where Puy was in the front line). The western front had become a human abattoir. Matisse told Camoin, on leave that summer, that the war made a mockery of civilisation, but his own enforced exclusion from it left him with a heavy sense of impotence and unreality.[104] Reports of his New York show at the beginning of the year might as well have been news from another planet. Matisse sent an engraving with friendly messages to Pach (who had persuaded John Quinn—about to become one of America's prime modernist collectors—to buy two canvases, and sold the *Portrait of Mlle Yvonne Landsberg* to a close friend, the writer Walter Arensberg). Work continued intermittently, in the studio and on a brief escape from Paris to Arcachon in the southwest, but Matisse felt himself out of place, in the wrong job, in some ways as frustrated as his friends at the front ("That bitch Painting has given me so much trouble over the past ten years," Puy wrote philosophically, "that I can easily divorce her for the next few months").[105] Puy fell silent for three weeks in the autumn after the release of poison gas over his section of the trenches. Camoin, who was transferred to a camouflage unit at the end of the year, described narrow shaves of his own, working at night to erect huge painted screens in the killing fields lit by flares before the German guns.

Matisse sent sympathy, news and urgent instructions to take care. Enforced inactivity made him look back to his past, contemplating the life he might have led as a lawyer's clerk if he had followed his father's wishes (or as a violinist if he had chosen music instead of painting). In the summer of 1915 he came across the small canvas on which he had painted his student copy of Davidsz de Heem's *Desserte* in 1891. Now he copied his original copy on a second canvas twice as big as the first. "I'm adding to this copy everything I've seen since," he wrote to the critic René Jean, and described his difficulties with the new *Desserte* to Camoin (who had seen the canvas roughed out on his leave in August): "Still it's making a little progress. I know better what I know."[106] He told Jean that he had set himself to counter his sense of helplessness, the horror and revulsion that was

beginning to modify civilian approval of the war, by turning once again to Heem's majestic affirmation of peace and plenty.

This minor Flemish masterpiece had served Matisse as a turning point or testing ground twice before. His first, faithful and highly accomplished copy had dispelled his fears of being unable to paint like other students. A few years later he had returned to the same subject for a full-scale attempt to come to terms with Impressionism in his own *Desserte*. Now he dissected and reorganised the sensuous richness of Heem's canvas—the great fruit platter spilling cherries and grape clusters, the elaborate glass goblet, the embossed bronze chalice with its bird-lid, the crenellated pie, the napery and glassware—in a composition that combines brilliant clear colour with Cubist structural severity. Based on a simple geometrical black grid, and anchored at the centre by a pair of small, round, red-skinned onions, this second *Still Life after de Heem's "La Desserte"* exudes vigour and a sharp, springlike radiance emanating from the central patch of pale, yellowy greens and the harsher turquoise greens in the jagged folds and falls of the white cloth. The canvas confronted a crisis in the perennial clash between passion and discipline from which Matisse told Camoin he rarely emerged victorious: "You have to cross that barrier to reach the light, coloured, soft and pure, the noblest of pleasures."[107]

Camoin replied at once to say that this long letter had distanced him as nothing else could from the demoralising misery of trench life, and to

Matisse, *Still Life after Jan Davidsz de Heem's "La Desserte,"* 1915: a painting into which Matisse said he put everything he had seen since he first copied this still life as a student nearly a quarter of a century before

reassure Matisse ("In the end it's your instinct that gets the upper hand").[108] The picture certainly seems to have dislodged the blockage that had obstructed its creator since August 1914. It took him two or three months to complete, and left him exhausted. He fell ill for two weeks with bronchitis, writing to Pach as soon as he was well enough on 20 November to repeat in more general terms the position he had outlined to Camoin, that the secret of painting was to reconcile theory and practice, thought and instinct, to appease the exacting, analytical side of oneself in order to gain free access to the depths and power of feeling. "At least, that is how it works for me," he assured Pach, who had asked for criticism of two of his own recent works, "—and we are not after all so different from one another that the same discipline . . . can't achieve results."[109] Matisse was full of unreserved encouragement for his former pupil and cautious confidence on his own behalf. "I'm leaving tomorrow for Marseilles, where I'm going to spend a fortnight so as to recover completely from my bronchitis. I am taking only my violin. I shall resume painting on my return."

CHAPTER SIX

❧

1916–1918: *Paris and Nice*

Matisse, *Study for "The Studio, Quai Saint-Michel,"* c. 1915–16

Souvenirs of Tangier invaded Matisse's canvases when he took up painting again at Issy in December 1915, after his fortnight in the south. He set about two inordinately ambitious works, both based on ideas he had mentioned to his wife in letters from Morocco. One was a café scene based on a group of Arabs lounging beneath a striped umbrella

Matisse, initial sketch for *The Moroccans* in a letter to his wife from Tangier, 25 October 1912

on the terrace of the coffeehouse inside the Casbah gate, and the other was a group of women bathing. "The problem is to dominate reality," he said to the Italian Futurist Gino Severini, who watched him working on these new Moroccan canvases, "and, by extracting its substance, to reveal it to itself."[1]

For the greater part of 1915, reality had dominated him. Now he reversed the position, slashing and wrenching at shape and meaning on his canvases with a controlled ferocity more relentless than even he had shown before. No theory had yet been formulated for this sort of practice, and Matisse had to improvise terms as he went along to explain to Severini what he was doing. "He said with reason that everything that did not contribute to the balance and rhythm of the work, being of no use and therefore harmful, had to be eliminated. That was his way of working: constantly stripping the work down, as you would prune a tree." In *The Moroccans* and *Bathers by a River*, reality has been so thoroughly mastered that parts of it, especially in the first painting, remain almost indecipherable. The watermelons in the bottom left-hand corner of *Moroccans* (colour fig. 18) look to most observers more like robed Arab figures than the geometric vestiges standing in for café customers at top right. The human beings have dematerialised, the umbrella's stripes have been transferred to a bunch of stylised flowers, and the medina's turreted ramparts have been rearranged in a design of flat blocks and discs. The effect of light itself has gone into reverse, the clear Tangerine sunshine being replaced by the uniform black ground with which Matisse warms and intensifies his colours. "He compelled the picture to take on a new form, a structure of analogy and interplay for which there was essentially

no precedent," wrote Lawrence Gowing, analysing the reckless, ruthless process that reached its height in Matisse's work in 1916–17.[2]

Severini, one of a group of Cubist-oriented young painters who congregated often in the studio at Issy in 1916, left a record (unlike his friend Gris) of what Matisse did and said. The older artist brought out his original Moroccan canvases from two years before, explaining his intentions—"You rarely hear a painter's reasons and reactions so clearly put"[3]—and consulting his visitors about the work in progress. He said he reckoned that his years of experiment had clarified his thinking, and taught him "to manipulate without danger the *explosives* that are colours" (it was Derain who said the paintbrushes in their hands in the Fauve summer of 1905 felt like sticks of dynamite). What currently preoccupied Matisse was construction. For Severini, these strange, synthetic versions of a North African setting at the furthest possible remove from wartime France constituted "an architecture of the will": an art that would be stable, inscrutable, set apart from and uncontaminated by the squalor and mortality of everyday reality. The Frenchman seemed to have found a way to defy the limitations of the human senses. "Utilising sensations in this way as constituent parts of the work, rather than its sole purpose or point of departure, Matisse rediscovered by means of Cubist theory the liberated architectural approach of the Byzantines. . . . And his colour became ever more spiritual and abstract, almost independent of the real objects on which it lay."

There was a heavy price to pay for so extreme an act of will. Matisse had begun *Moroccans* in November with bronchitis, struggling on with it all through January, when the entire family except Marguerite came down with flu. He was already beginning to despair of his picture by the middle of the month ("I'm not in the trenches," he wrote ruefully to Camoin, "but I'm in a bad way all the same").[4] A continual monotonous music plagued him from an abscess in his ear.[5] The canvas on which he had laid out his design turned out to need widening by two feet.[6] Grumbling that the good side of painting only ever materialised in dreams, he itemised for Derain the professional vexations that overlay worse torments in February 1916: "The lack of news from my family, and the anguish that comes from the continual suspense we live in—the little we know, everything they hide from us—all this will give you an idea of how it feels to be a civilian in wartime."[7]

Long afterwards Matisse recalled a memory from these years at Issy of lying in bed beside his wife in the early mornings, dreamily tracing the great airy patterns made by the interlocking branches of two tall lime trees

planted at either side of the back garden gate.[8] He marvelled at the rhythmic balance of form and line that filled his window, and never forgave the gardener who insisted on pollarding the lime trees, chopping off both their heads and leaving them so brutally mutilated that even after they grew back with renewed grace and vigour, Matisse could no longer bear to look at them. But when it came to painting and its needs, he had no such compunction. He chopped and lopped with implacable energy at his own life, and at the lives of those closest to him.

Every place the family ever lived in—cramped Paris flats, disused convents, borrowed houses in Bohain and Lesquielles, seaside lodgings in St-Tropez, Collioure and Cavalière—became primarily a studio. At Issy Matisse regularly produced major works in the garden, the living room and upstairs in his bedroom (his wife's dressing table with its hatpin stand and ring saucer was the subject of a majestic dual response to Cézanne and Cubism, *The Blue Window*). The family fitted their activities round his breaks and work sessions. Silence was essential. Rules were enforced. Life at Issy became a variation, transposed into a different key, on the strict, work-centred, patriarchal household in which Matisse had himself grown up. "Above all, discipline your children—don't just be a comrade to them—you must remain their father," he would advise his younger son years later, passing on precepts inherited from his own father. "It's hard, but it's your duty."[9]

Matisse's canvases represented stability, continuity and cohesion for the whole family. Through all the shocks and upheavals, the assaults of scandal and public hostility that reverberated in the background of his children's early years, the work remained a bulwark. For the painter himself, the family was always his first, crucial audience. In the war years, his wife and children provided the main, sometimes the only, response he got to each fresh breakthrough in his work. He set immense store by their opinions, and all of them took their critical role with corresponding seriousness. "I know the place your paintings occupy in our family," Pierre wrote in 1927, describing his first major success as a young picture dealer in New York in an impassioned letter to his father (who had just confided the first public showing of *Moroccans* to him). "Each one represents a period, a new enrichment of our common world, each has taken a place in our daily lives whose importance you only realise when it goes."[10] Pierre was fifteen years old at the beginning of 1916. The works his father was producing in these years would shape and drive his life. He said he had his first conscious inkling of the power a painting could exert from the

family's reaction to a proposal to raise money by selling off their prize possession:

> I shall always remember the lunch at Clamart, during the war, when for the first time I realised the importance Cézanne's *Bathers* had taken on in what was then the small circle of my life—the unanimous and spontaneous opposition to the idea of packing it off to Bernheim-Jeune! Do you remember? Of course that attachment was partly habit, but it was also the loss of something that belonged to the fabric of the family, as well as the separate inner life that picture led for each of us, to speak only of us children who knew nothing of the sacrifices it represented for the two of you, and what an act of faith it embodied on the part of Maman, for whom it remained silent for so long.

This was the small canvas for which Amélie had pawned the emerald ring given her as a dowry by Madame Humbert. The painting meant nothing to her in those days, but she believed absolutely in her husband—as he believed in Cézanne—at a time when most people wrote both painters off as mad. The couple had hung on to their *Bathers* through all the hardships that followed, and now it was their children who insisted on finding some other method of retrenchment. In the first winter of the war the Matisses sold their Gauguin (bought from Vollard at the same time as the Cézanne) for 3,000 francs through Walter Pach in New York.[11] A year or so later the rented house in Collioure was given up for good and the boys left school. Marguerite's constant health problems meant that she had had virtually no education until the age of seventeen, except for what she could pick up at home and intermittent lessons at Issy from a governess she disliked. She had pinned high hopes on her aunt Berthe and the training college in Ajaccio, planning to make up for lost time, pass her Baccalauréat and fulfill a childhood ambition to be a doctor. At her aunt's suggestion, and in spite of her father's misgivings, she found a place to study for her examinations at a local convent sixth form, but her first experience of normal schooling in the company of her contemporaries came as a shock.

She had little in common with the other girls, the nuns seemed bossy and unsympathetic, and even with Berthe's steady encouragement, mastering maths, physics, chemistry and Latin all at once from scratch threatened to defeat her ("Take it slowly," Matisse advised gently. "Calm and

confidence. Don't wear yourself out").[12] Her letters home reported constant fatigue, migraine, lack of appetite and loss of concentration. Her father, recognising many of the problems he had faced himself at her age, sent consolation and reassurance. "Your character, like mine, tends to despair when things go badly, but forgets to take the credit for what goes well," he wrote, congratulating her on a French essay that had been enthusiastically passed round the Steins. Looking back to the black pit of his own adolescence, he urged her not to panic ("But I'm not afraid of that for you—you are courageous"). Marguerite battled on, eventually collapsing with a bad back before she could sit her second-year exams (as her father had done himself at intervals throughout his years at school). Both parents understood her bitter sense of failure and humiliation. There was no more talk of academic qualifications after her return to Issy for her twentieth birthday in the summer of 1914.

It was Juan Gris, going through a sticky patch himself in Collioure that August, who restored Marguerite's confidence by advising her to paint.[13] The solution was warmly seconded by Matisse, who could never see much point in any other calling. Amélie, unreservedly in favour of opportunities for girls, said that for a woman to cultivate her gifts was a sacred duty.[14] Marguerite combined an innate flair for design with a highly refined and cultivated visual intelligence. Her intrepidity and ardour, the combination of worldly innocence and pictorial sophistication conferred on her by her unique relationship with Matisse, enchanted his young admirers. Gris and Severini were both nearer to Marguerite in age than to her father, and she was three years older than Severini's sixteen-year-old wife, Jeanne (precocious daughter of another famous father, the literary modernist Paul Fort), who posed for her with her new baby.

Marguerite had lived her entire life at the sharp end of the artistic avant-garde. By now she was her father's ablest and most fearless critic, trained by him to be as hard to please as he was himself. As a small girl, she had spent hours with Amélie scrubbing the surface of any canvas suspected of betraying traces of the kind of charm likely to appeal to customers. As a young woman and fellow painter, she had no qualms about letting Matisse know if she considered a new work unworthy of him. "I am, alas, one of those who cannot see a house on fire without giving the alarm," she told him sternly.[15] She was inexorable, and if he sometimes quailed before his daughter's judgement, it was for the same reasons that he had once dreaded submitting work in progress to Shchukin's scrutiny: "Only decadence can come of a lukewarm attitude on the part of those

who paint, or those who look," warned Marguerite. "You have to have the energy and courage to throw yourself wholly into whatever you're doing, that's half the battle."

The pent-up fury of years of setback and frustration poured into Marguerite's debut as a painter. A big glassed-in bay, built onto the main bedroom over the garden porch at the back of the house, became her studio. But her new career was checked almost at the outset by an ominous interruption. "I'm utterly crushed at the moment," Matisse wrote in February 1916 to Derain, "because they have just carried out an in-depth examination . . . of Marguerite's larynx, and for that they had to anaesthetise her with cocaine as for a major operation. After the examination, she had a three-hour nervous crisis which terrified me."[16] Matisse was filled with foreboding. The effects of cocaine on the central nervous system were difficult to control, always unpredictable and sometimes fatal. Any attempt to rebuild the damaged trachea would almost certainly fail, given the limited surgical techniques available at the time, but the only alternative was continued use of the cannula combined with repeated attempts to stretch the windpipe by inserting wads of cotton, and regular cauterisation to keep the passage open. Marguerite, who had borne these excruciating procedures for years with stoical endurance, now faced the terrifying prospect of experimental surgery. All her father's old fears sprang back into action. "I'm crushed by this affair of Marguerite's," he wrote at the end of his long letter to Derain.

Jean also posed urgent problems in 1916. Long-term prospects were not good for a seventeen-year-old male approaching the third year of a

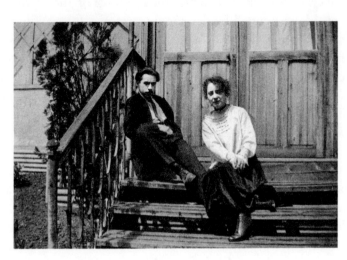

Jean and Marguerite Matisse on the steps of the studio at Issy

war that consumed men and looked set to last forever. But the chance to fight for his country seemed almost miraculous to a boy who was bright, sensitive and deeply unsure of himself in a family where artistic talent far outranked practical ability. Skilful, fastidious and good with his hands, Jean took after his paternal grandfather in style and outlook rather than his father. He had always loved the powerful, sleek dray horses that drew the delivery carts for the seed-store at Bohain. Even before war broke out, he had been torn between wanting to work with aeroplanes and going for a soldier.[17] Now it looked as if a sardonic fate was about to grant both wishes. Modern invention, engineering and design had transformed Issy, creating the successful industrial settlement along the riverbanks and putting the Morane-Saulnier workshop at the cutting edge of French aeronautical technology. The town's factories worked overtime to manufacture warplanes, and the military parade ground had been redesignated as an annexe to the airfield. Matisse could no more grasp his son's fascination with machines than he had understood his father's head for business, and the atmosphere at home grew thick with the kind of suppressed resentments that had poisoned his own adolescence. The painter, whose father had once agreed in bitterness and rancour to let him have twelve months to try to become an artist, now capitulated himself, reluctantly allowing his own son to fill the interval before conscription at eighteen by taking a job as a trainee mechanic in the town.

Jean was always the odd one out of the three children, and the one who suffered most from loss of contact with their northern origins. Matisse dreamed of artistic success for both his sons, and Jean (who played the cello) was the first to face the full force of their father's disappointment. He responded by developing strategies for avoiding head-on collision, cultivating the role of daredevil or outlaw with a saturnine streak that made him moody, aloof, impervious to correction and dangerous if crossed. His status in the family was summed up by a favourite story about the day the home quartet—Jean on cello, his father and Pierre on violins, Marguerite at the piano—was sabotaged by the cellist apparently playing from a different score to any of the others. Asked to explain himself, Jean said coolly that he had lost his place and decided to cut his losses, turn the page and carry on regardless.

When it became clear that the elder son would never make a professional cellist, their father switched his attention to the younger. Matisse persuaded himself in these years that Pierre would become a virtuoso violinist, fulfilling the musical destiny he always faintly regretted having turned down himself. A chance remark (which Pierre bitterly repented

later) about a boy at school learning the violin had taken Matisse back to his own misspent youth, when he and Léon Vassaux next door regularly dodged their hated violin master by hopping over the back garden wall whenever he rang at the front door. Pierre was fourteen when his father bought him a Prescendra violin from Armand Parent, and arranged tuition for them both. Highly musical like all the Matisses, Pierre was serious, willing, anxious to give satisfaction but quite unprepared for what happened when his father—always acutely mindful of being handicapped as a painter by his own late start—took him out of school so that he could give himself to music. "He thought that by working very hard he could catch up with the others," Pierre said gloomily, "and so I could do the same."[18]

Being accepted as a pupil by Parent was no joke. The master had started out as a prodigy himself, making an impressive debut in 1883 at the age of twenty as leader of the orchestra at the Concerts Colonne (where Matisse and Vassaux began their musical education as students ten years later). It was Parent who first introduced Parisians to Beethoven, Schumann and Brahms, going on to popularise French contemporary composers (Ravel's string quartet was given its premiere in Paris by the Parent Quartet), and train a whole generation of young string players. Now he reintroduced Matisse to the repertoire of his youth. Father and son worked their way through Mozart, Corelli and Vivaldi, finally graduating together to Bach's Double Concerto in D. "Father took up the violin as a discipline," said Pierre. "That was not a pleasant way to play."

In spite of his illustrious past, Parent proved a dry and uninspiring teacher who pounced mercilessly on Matisse's false notes, and made Pierre's life a torment.[19] "Each time I went to him, it was like a purge that had to be swallowed."

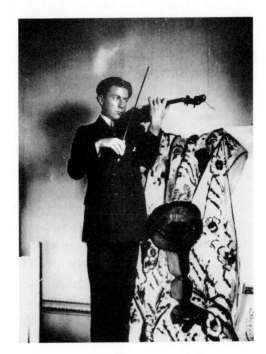

Pierre Matisse
playing the violin

At home things were not much better. Matisse, trained under martinets himself, instituted a routine that began with his son rising daily at six to practice scales for two hours alone in the salon. Whenever the piano fell silent as the child dozed off, he would be woken by thunderous knocking on the ceiling from his father upstairs in bed. Marguerite, painting all day in the studio, seemed to have got off lightly by comparison ("Lucky you," said Pierre, "at least Papa can't tell when you stop").[20] Pierre wore his brother's cast-off suits, a size too big, with the sleeves left long to protect his hands. He was forbidden to play rough games for fear of cuts or bruises. Piano practice in the mornings was followed by violin all afternoon.

"These exercises are a kind of gymnastics which you have to do in order to master construction," Matisse had written when his daughter protested in Ajaccio against the dull repetitive grind of a standard liberal education.[21] His letters to her had been patient, wise and comforting ("We are truly touched by your efforts—don't wear yourself out by too much eagerness . . . try to be a bit content with yourself, and have confidence in the future"). But from his son, setting out to master the altogether more demanding disciplines of art, he required an adult commitment beyond the powers of a bewildered and increasingly unconfident fifteen-year-old. Worse even than the punishing schedule was Pierre's sense of his failure to please his father. He possessed innate musicality, and a natural touch that made the fingering come easily, but his belief in himself was systematically squeezed out of him ("It was crazy, because I just couldn't do it"), leaving an abiding sense of inadequacy. It was only long afterwards that he could make sense of the disaster of his adolescence. "Obviously, if I hadn't mastered these disciplines by sixteen, it was hopeless," he said, looking back. "Besides, I had no talent."[22]

Matisse depicted this deadlock between father and son in the painting of a child practising at the Pleyel miniature grand piano in the salon at Issy, which he called *The Piano Lesson* ("Yes, it was me," Pierre would tell respectful young art historians in front of this canvas half a century later, "and you have no idea how much I detested those piano lessons").[23] On one level this is an almost wholly abstract work, constructed from vertical bands and horizontal bars, mostly black or pale blue grey, which define and articulate the flat, dark grey spaces filling three-quarters of the canvas. The human presence has been reduced to three rudimentary icons strung around the edges of the picture: a diminutive but particularly assertive version of the little plaster *Decorative Figure*, sketched or rather scribbled in the

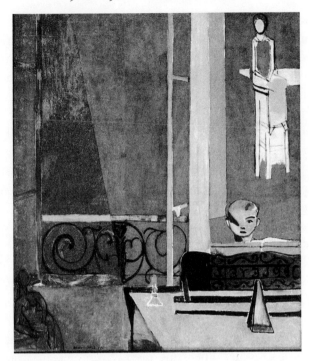

Matisse,
The Piano Lesson,
1916

lower left-hand corner, and an almost graffiti-style rendering of the *Woman on a High Stool* at top right, both sternly focussed on the small, docile captive behind his keyboard at the bottom. Pierre's face, skewered by a wedge-shaped grey missile and hemmed in by two of his father's works, is surrounded, as John Elderfield and others have pointed out, by the trappings of coercion (the metronome, the hourglass and the iron grille at the window shutting off a tantalising green slice of the garden in which he was not allowed to play). The boy looks much younger than Pierre's actual age, more like six or eight years old, Matisse's own age when he, too, first encountered and rebelled against the drudgery of daily music practice.

The picture cannot be confined to any single source or meaning. It reflects duress: the authoritarian controls inflicted on father or son when young; the ruthless demands of art closing in on Matisse in his middle years, dehumanising him and all who shared his life; the crushing forces bearing down on France in 1916. What is incontrovertible is that in *The Piano Lesson*, where his domination of the real world is virtually complete, Matisse distills a sense of human pathos sharper than ever before or after. The pruning process that strips the central figure of individuality, flattening and stylising the soft, unmoulded, childish features, intensifies the

impression of human fragility and helplessness at the core of this lucid, limpid painting which, like a Bach concerto, is at once measured, harmonious and steeped in feeling. "There are some Cubist vestiges in *The Piano Lesson*," wrote Alfred Barr, "but no Cubist ever surpassed the beautiful divisions, the grave and tranquil elegance of this big picture. Nor did Matisse himself."[24]

The Piano Lesson, *The Moroccans* and *Bathers by a River* were all painted at the time of the Battle of Verdun, which began on 21 February 1916 and reached its climactic height in July when the British offensive on the Somme began to relieve pressure on the shattered French army, enabling it to regroup and retake disputed ground before the fighting was finally called off on 18 December with no gains on either side. Verdun was emblematic. Once the gateway for Germanic hordes massed against the ancient Gauls, it was now a citadel more symbolic than actual, commanding the country's eastern border and confronting the lost lands of Lorraine and Alsace. Nothing could have been better calculated to outrage the French, drain their reserves and break their nerve than the Verdun offensive, which turned into a dreadful replay of the war's opening campaign eighteen months before. The same massive, unforeseen attack was followed by sickening capitulation to overwhelming force. For five months the entire nation was gripped by a frenzy of horror and denial ("The French were to be fastened to fixed positions by sentiment," Winston Churchill wrote grimly, reviewing German strategy in retrospect, "and battered to pieces there by artillery").[25] Queues formed at dawn before Parisian newsagents, as civilians followed each lurch and twist in the struggle to hold on ditch by ditch. Hundreds of thousands of Frenchmen disappeared in the shell-storms of Verdun, or died in atrocious holes and dugouts behind the lines. Matisse, whose impulse was to join them, felt that their loss coloured and tainted his survival. "I shall always regret that I could not be part of these upheavals," he wrote, deeply shaken by a frank account from Derain (in Paris on leave in May) of this slaughterous mayhem. "How irrelevant the mentality of the rear must appear to those who return from the front."[26]

This letter was written to the dealer Léonce Rosenberg on 1 June, at the height of the fighting, when it cannot have been easy for a Frenchman to contemplate the future, let alone to think calmly and without rancour about the long-term effects on combatants and noncombatants, whatever the outcome of the battle. Verdun made everything else seem trivial by comparison. "These are the important things of my life," Matisse wrote, listing the paintings recently completed or still in hand in the studio:

Matisse, *Composition No. 2*, 1909: initial sketch for the painting that eventually became *Bathers by a River* seven years later

I can't say that it is not a struggle—but it is not the real one, I know very well, and it is with special respect that I think of the *poilus* who say deprecatingly: "We are forced to do it." This war will have its rewards—what gravity it will lend to the lives even of those who did not participate in it, if they can share the feelings of the simple soldier who gives his life without knowing too well why, but who has an inkling that the gift is necessary. Waste no sympathy on the idle conversation of a man who is not at the front. Painters, and me especially, are not clever at translating their feelings into words—and besides a man not at the front feels good for nothing.

The feelings that could not be translated into words found expression on canvas, above all in *Bathers by a River* (colour fig. 19), which Matisse took up again at this point. Initially conceived in 1909 as a scene of Arcadian leisure to go with Shchukin's *Dance* and *Music,* and tentatively re-sited four years later in Morocco, this gigantic canvas measured well over twelve feet wide and eight feet high. Matisse now divided it vertically into roughly equal, hard-edged bands of green, black, white and pale dove grey, suppressed the waterfall, condensed the foliage and transformed his four columnar bathers—cutting off the head of one, severing another's legs at the ankles—into massive, mutilated, stone-grey caryatids.

This canvas marked the reconciliation between form and feeling, rea-

son and intuition that Matisse had been working on ever since he got back from Tangier. At least once a week he exchanged views in his studio with the young modernists who now took the place of Prichard's philosophers (the rich Americans had gone home, and the Sorbonne students were at the front). Most of them were foreigners or army rejects, hard up and disorientated, only too glad to wrestle with pictorial rather than material problems. They included, besides the three main theorists of Cubism—Gris, Severini and their friend Pierre Reverdy—more intermittent visitors like the Mexican Diego Rivera, André Lhote and Le Corbusier's future business partner, Amédée Ozenfant, who remembered their host expostulating so vehemently that his spectacles bounced on his nose.[27] Lhote maintained afterwards that Matisse made up his theories only when he saw what he had done, unlike a true Cubist, who worked the other way round. Severini insisted that, on the contrary, Matisse knew precisely where he was going from the start:

> I myself, having often seen his pictures in course of execution, can testify how much there is to learn from having watched, say, the lengthening of an arm revolutionise the whole or, next day, the changed position of a leg call everything in question once again until the work binds itself together with an invisible thread that will only ever be perceptible to those who respond to the poetry of painting.[28]

Matisse's dialogue with Cubism was at its richest and most complicated in these months when Severini came regularly to watch him paint. Gris made a drawing in Matisse's studio in 1916, analysing the little Cézanne that had almost been sold the year before, another powerful picture of bathers by a river that now added its own contribution to the energetic debates going on in front of it. "There was perhaps a concordance between my work and theirs," Matisse said cautiously when asked later how much he owed the Cubists: "But perhaps they were trying to find me."[29] Picasso had certainly found him the year before, when he responded to *Goldfish and Palette* with a masterly, metaphorical self-portrait in his *Harlequin*. Matisse rated it Picasso's greatest success to date (so did its creator), and openly claimed credit for having given him a launchpad.[30] Picasso did much the same for him when he exhibited *Demoiselles d'Avignon* for the first time at the end of July 1916, in a new gallery installed by Paul Poiret alongside his couture showrooms on the rue du Faubourg St-Honoré.

Matisse (who had two pictures in the same show) had seen *Demoiselles* before, probably soon after the canvas was painted in 1908, when it baffled and repelled him. Eight years later there were clear parallels between *Bathers by a River* and Picasso's leering life-size nudes, also strung out across the canvas, also confronting the viewer head-on, this time in a paroxysm of rage and derision (which would come to seem to many an eminently sane response to the carnage of 1914–18). Although one is roughly twice the size of the other, both pictures operate on the same grand public scale. Picasso had turned a sailor's visit to a provincial brothel into a manifesto for the modern movement. Now Matisse transposed his Arcadian or Moroccan bathing beach into a monumental image of grief and stoicism. The mood is lightened only by the sensuous beauty of the paint itself, the fine, feathery brushstrokes and glints of colour—exuberant greens, patches of sky blue, gleaming pinks on belly and breast veiled by translucent grey—which give human delicacy and warmth to the gravity of the figures and their semiabstract setting.

Matisse worked as always on a slower fuse than Picasso. When his painting was first exhibited in Paris in 1926, the public laughed and even the more respectful critics were loftily dismissive. Unsaleable virtually throughout Matisse's lifetime, *Bathers by a River* was finally acquired the year before he died by the Art Institute of Chicago. Matisse told the institute's director at the time that he ranked it among the five pivotal paintings of his life. It was not until 1990 that one of the work's custodians in Chicago, Catherine Bock, first recognised the poetic, elegiac, perhaps unconscious metaphor underlying *Bathers by a River,* with its stately movement from left to right regulated by bands of colour—"as percussive and insistent as a drum beat"—its four grey witnesses or mourners, its lively greens on one side of the canvas separated from the funereal shades on the other by "an impassable trench or black maw, dividing past from present."[31] What Matisse called "the modern method of construction" enabled him to draw on ancient myths of the passage from light to dark, earth to underworld, in a canvas impregnated (like Cézanne's *Bathers*) with nobility and passion. There is something heroic about his sombre, solitary effort to confront a reality that remained unfaceable for most of his contemporaries. "This work could only have been painted in 1916," wrote Bock, "at the moment when the enormity of World War I was finally realised, but before the disillusionment and cynicism of 1917 had set in."

At the time, those who took the train to Issy to see Matisse's latest work, and tell him what they thought of it, fell mostly silent before *Bathers.* Roger Fry, enormously impressed by the contents of the studio on 3 July,

must have seen it but said nothing.[32] The equally enthusiastic Danish painter Axel Salto reported both *Bathers* and *Moroccans* being painted that summer, but was far more dazzled by Madame Matisse's herbaceous borders and her husband's African carvings in the salon.

> ...the small red-bearded man with the Chinese spectacles stood in a halo of sunshine and flowers as brilliant as the rainbow. As we came into the house from the garden, the light still sat full in our eyes, so that we had to wait momentarily for our sight to adjust to the half-dark room. In the room we noticed a table with a sculpture of a black man, and an army of house gods. The young daughter of the house, herself a painter, showed them to us in a subdued voice full of excitement. On the wall hung bunches of South Sea fruits. Their dark colours, hard gloss and spicy aromas suggested an indefinable feeling of the Orient.[33]

In wartime the Matisses turned their house into a meeting point and shelter for friends, neighbours, refugees, taking in stray foreigners and homeless artists, even putting up a couple of sub-Cubists—Albert Gleizes and Jean Metzinger—at one point.[34] There was a steady flow of conscripts on leave. Prichard's young friend Georges Duthuit spoke for many when he wrote to thank Madame Matisse for everything at Issy— "Your kind welcome, the pictures that always give confidence, the table

Matisse family on the studio steps at Issy with Walter Halvorsen and Greta Prozor

surrounded by friends, the whole room brimming with happiness and sympathy"[35]—which made a return to army life easier to endure. But when Matisse sketched the visitors pouring through his house and studio, it was nearly always women who materialised at the tip of his etching nib or pencil. Besides Josette Gris, he made crisp little engravings of Alice Derain and Fanny Galanis, the wife of Gris's friend the engraver Demetrius Galanis (who also had his picture taken). He sketched two small girls, Jeanine Chaurand-Nairac, who came to stay when her mother fell ill in her father's absence, and Irène Vignier, granddaughter of the great Oriental dealer Charles Vignier, whose collections Matisse knew well. He etched his own daughter, looking purposeful and workmanlike in a dragon kimono, and a lively girl brought home by Jean, who had lost his heart in his first job to the boss's daughter.[36] "In the '14–18 war it was the women who emerged with new assurance," Matisse said in retrospect (and his portfolio recorded the process at the time), "because they had to take on responsibility, and they didn't forget it."[37]

Amélie, always more than equal to an emergency, presided over this busy and hospitable household, organising support systems, dispensing comforts, clocking up record totals on the home production line of knitted socks ("She's worked her fingers to the bone for the troops, Madame Matisse," Camoin wrote appreciatively after finding a pair of woollen gloves wrapped in a letter from her husband).[38] Issy became a centre for relief distribution. "A prisoner is always hungry," wrote Prichard, who received fortnightly hampers throughout the war. "The food you sent to me was princely."[39] Pictures were dispatched to fundraising tombolas. Matisse's wife and daughter became pin-ups for people who had never even met them. Duthuit's contemporaries Aragon and Breton, in training together as medical orderlies, hung reproductions above their bunks of the two great portraits of Amélie, *Woman with a Hat* and *Mme Matisse*.[40] Prichard, who spent the war initiating his fellow prisoners into the byzantine mysteries of Matisse's painting, constructed a kind of shrine in their freezing unheated barracks around a painting of Marguerite. "I know that we threw our burden on to you and Madame Matisse, and you succoured us as only great-hearted persons can," he wrote after the war. "But more than that, you gave us your moral support too. It is easy to forget a prisoner. He knows that."[41]

All through the summer and autumn, the distant thumping of guns on the Somme could be heard on still nights in and around Paris, as Flanders became a graveyard for the British army. There was no word from Matisse's mother, or his brother, who had been sent home soon after the

start of the Verdun offensive along with all the other deportees from Bohain to a routine of forced labour on starvation rations. Bohain was twenty miles inside enemy lines ("We knew there had been a great battle," wrote an inhabitant, "but we didn't know exactly in what part of France. Some said on the Somme. Others said the Marne").[42] Attempts to smash through German entrenchments at nearby Bapaume and Cambrai came to nothing. As the campaign dragged on, Matisse's native region was squeezed dry to feed and fuel German fighting divisions. Bread rations for the French in Bohain had been reduced the year before to just over four ounces a day, homegrown vegetables and fruit were requisitioned, and there was no meat. Elderly or disabled civilians who could not work in the fields were forced to take to the roads (Matisse's mother was sentenced to four days in gaol for refusing to leave her house). The coming winter promised to be exceptionally severe.

Matisse's own anxiety made him particularly sensitive to other painters' troubles. He went out of his way to visit younger colleagues, and buy their work. Severini, turned down by the Italian army on health grounds and struggling to support a wife and two babies (one died in 1916), would always remember Matisse suddenly arriving in his studio to buy a picture on the day the rent was due ("And God knows, the sale came in the nick of time for handing over that damned rent").[43] Matisse helped out again when Severini was hired to advise a Swiss collector hoping to make a killing from a capital investment in modern masters. Matisse introduced the Italian to all the Paris dealers, dropping everything to put together a collection that followed his own trajectory from van Gogh and Cézanne to Rouault, Derain and one of his own paintings (the collection would have shown handsome postwar dividends, if the French government had not refused to grant an export licence). He organised a second show that autumn to raise money in Oslo for French artists and their families, working with a former pupil, the Norwegian Walter Halvorsen, who was astonished by the time and trouble Matisse was prepared to give to each of the studios on their rounds.[44]

By 1916, people in Paris had learned to live for the short term. Rationing and shortages had given rise to a prosperous black market, theatres and restaurants were crowded, and the art world had recovered from its brief shutdown in August 1914. Dealers now did a brisk trade with foreign collectors from neutral countries ("The Swiss and the Norwegians buy a lot," Matisse told Pach, "but the war has gone on a very long time").[45] It became smart to attend showings of the weird new Cubist paintings in offbeat locations, like the exhibition in Poiret's showrooms

selected by André Salmon in response to a programme picked for Poiret's sister, the couturière Germaine Bongard, by her lover, Amédée Ozenfant. Matisse, who liked her style, attended Mme Bongard's elegant concert parties and had two pictures in her first show.[46] He was an enthusiastic supporter of contemporary concerts given by young musicians like the pianist Alfred Cortot and the rapidly rising Erik Satie ("Very chic, Matisse," noted Satie after one of Bongard's soireés, "he admires me, and he told me so. How polite he is!").[47] All three figured in a series of manifestations held at the back of a shabby Montparnasse courtyard at 5 rue Huyghens, a studio converted from a wooden hangar "more like a broomstore," according to a Parisian journalist unused to patronising events in a semi-slum.[48]

This outfit grew from concert sessions put on by the studio's tenant, an enterprising but penniless Swiss painter named Emile Lejeune, and his partner, "a Russian artist, no taller than a man's boot," who turned out to be another of Matisse's old pupils, Marie Vassilieff. Hyperactive and unstoppable as ever, Vassilieff was now running her own studio round the corner on the avenue du Maine as a soldiers' canteen. Matisse became a regular at rue Huyghens, decorating one of the concert programmes with a portrait of the Swedish composer H. M. Melchers, and contributing a still life when Lejeune started showing pictures. On 19 November the first private view in Lejeune's studio, renamed for the occasion "Lyre and Palette," proved a huge success, with fashionable limousines lined up along the pavement, Satie strumming at the piano and poems specially written for the catalogue by Blaise Cendrars and Jean Cocteau (proceeds

Arvid Fougstedt, *The Opening of the Lyre and Palette,* 1916, with Picasso in flat cap and Erik Satie at the piano

Marie Vassilieff, *The Braque Banquet*, 1916: from left to right, Vassilieff with carving knife, Matisse with turkey, Blaise Cendrars, Picasso, Marcelle Braque, Walter Halvorsen, Fernand Leger, Max Jacob, Beatrice Hastings and her lover aiming a gun at Modigliani in doorway, Braque in laurel wreath, Juan Gris

went to the most prolific and penurious of the exhibitors, Amedeo Modigliani).

It was years since Matisse had been part of this kind of rackety student life. He spent the night of his forty-seventh birthday, 31 December 1916, at a party given to celebrate Guillaume Apollinaire's return from the trenches and the publication of his new book, *Le Poète assassiné*. Moving among his eighty guests with bandages wound round his head and a Croix de Guerre pinned to his uniform, Apollinaire managed to irritate so many people that his admirers' speeches were shouted down in a hail of insults and bread pellets.[49] There was an even rowdier banquet two weeks later for another revenant from the front, Georges Braque. This one ended in uproar when Modigliani gate-crashed the party and narrowly escaped being killed by an armed rival, after which some unknown joker locked the door. According to Vassilieff (who recorded the scene in a drawing), the situation was saved by Matisse's quick thinking and Socratic calm.[50] Matisse's own recollection long afterwards was that he turned the key himself from the outside and pocketed it by mistake when he left early so as to catch his train home to Issy.

True or not, the story reflects genuine isolation and detachment. Matisse was more acutely aware than ever in these years of the age gap imposed by his late start as a painter, which meant that he had always been older than his closest friends. Paris was full of smooth operators who had managed to exploit or evade conscription, but in the circles in which Matisse moved he was one of the few—perhaps the only person at Braque's party—to have been discarded as too old by the army. He reacted

to what was happening at the front with none of the scabrous defiance and black humour of a younger generation. Matisse's response was sadder and more sombre. He expressed it for the last time that winter in a portrait of the great Impressionist collector Auguste Pellerin, who owned some eighty canvases by Cézanne, many of them bought directly from the artist.

Matisse had been visiting Pellerin's collection at Neuilly for at least ten years, and he returned there three or four times in 1916, taking Halvorsen with him. It took a bold man to commission a portrait from Matisse at this point, but Pellerin's courage was not in question, and he had considerable respect for his visitor ("Old Pellerin was always there," Halvorsen said of their trips to Neuilly).[51] The two had another link besides Cézanne. Pellerin had made his fortune out of margarine, like Emile Gérard, Matisse's uncle and godfather, who had been the first person ever to buy his pictures. Gérard had died ruined and disgraced a few years later, but the painter must have mentioned his family connection with the margarine trade because Pellerin promised him a job for

his brother as soon as the war was over (Auguste Matisse became a salesman in 1919 for Tip, the brand that had enabled the Margarine King to become Cézanne's greatest collector).[52] Memories of Matisse's early years certainly fed into the extraordinary, virtually abstract variation on a Renaissance model he produced for Pellerin: a full-frontal, formal portrait of male pride and power, reinforced by the red ribbon of the Légion d'Honneur, the heavy gold-framed Renoir on the wall, and the modern magnate's desktop trappings of hooded typewriter and blotter.

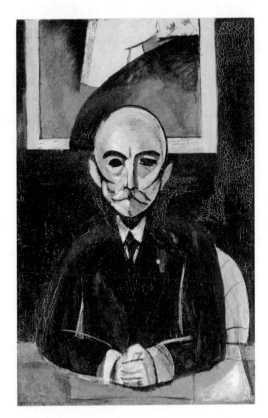

Matisse, *Auguste Pellerin (II)*, 1917

This is the most impersonal and strictly geometric portrait Matisse ever painted. He might have used a compass to plot the circular dome of the sitter's bald head bisected by symmetrical arcs of eyebrow, cheekbone and curled moustache, with the black shadow of his chin precisely centred over the black rhomboid of his tie and the clasped hands below. But the rigid plumb line of Pellerin's body and the black pools of his eyes could hardly be more expressive. This relentless, bleak, black figure invokes shades of all the bearded patriarchs who from his youth had reined the painter in and spurred him on, starting with the two hard-headed northern businessmen, Henri Matisse Senior and his brother-in-law, Gérard. The portrait invokes forces that shaped the painter's life in a format that echoes a celebrated photograph of Cézanne in front of his *Grandes Baigneuses,* and Ingres's even more famous *Portrait of Monsieur Bertin.* It also recalls Manet's portrait of Georges Clemenceau, the old tiger who was about to become his country's most impressive wartime prime minister. For many people Clemenceau came to embody what he himself called "France bleeding in all her glory";[53] and it is this savage, tenacious and heroic, even tragic aspect of his countrymen that Matisse painted.

Pellerin's was the last of a series of dark wintry portraits, as constricted as they are compelling, painted in the wake of *Bathers by a River.* This was the first time in six years that Matisse had not gone south when the days darkened and the cold closed down in Paris. On 12 January 1917, in a letter thanking Paul Rosenberg for a New Year box of mandarins

Matisse, *Study for the Portrait of Greta Prozor,* 1916

("It's the only sun we've seen"),[54] the painter reported rainstorms, floodwaters rising and coal so scarce it was impossible to heat the studio. Jean's eighteenth birthday, on 10 January, put the whole family in a state of suspense, which dragged on into the spring and early summer as his call-up papers were repeatedly delayed. France seemed to be disintegrating into anarchy, with civilian strikes, political turmoil, and mutiny at the front after a last desperate assault on the virtually impregnable Hindenberg Line in Flanders cost the country another hundred thousand men in April. All through the time Jean

waited at home to join the army, Matisse worked on the Pellerin commission, pushing steadily further and deeper into his own feelings as a son and as a father. He had initially produced a more naturalistic and far less imposing portrait that was rejected by the sitter (who bought both in the end, paying up in full when the painter refused him a reduction for bulk purchase). The second version, completed in May 1917, finally solved the problem Matisse identified for Severini: how to dominate and reveal reality through a process of abstraction.

Matisse, *Portrait of Greta Prozor*, 1916

He had reached the limits of the kind of formal and human interrogation begun in his Tangier portraits, and for months his work had been showing signs of transition. To celebrate the Steins' return to Paris in the autumn, he had painted Michael in the relatively straightforward mode of the first Pellerin canvas, and Sarah with something closer to the boldness of the second. Neither painting is wholly satisfactory, partly perhaps because the Steins' interest in Matisse had slackened now that they had lost the bulk of their collection (still held hostage in Berlin). He also invited Halvorsen's future wife, the young actress Greta Prozor, to sit for him.[55] Slight, angular, intense, half Lithuanian and half Swedish, Mlle Prozor was exotic and arresting in a strictly Nordic style. She specialised in Ibsen and the modernists, reciting poems by Pierre Reverdy at the Lyre and Palette in a programme introduced by Max Jacob (who said she was incomparable).[56] She emerges from Matisse's preliminary sketches as a relaxed and jokey individual, but in the oil painting she moves to another level of reality, becoming insubstantial, even ghostly, with black lips and a flower like a dead beetle in her hat, her head just clearing the top of the canvas and the tips of her elegant, slender shoes skimming the bottom like a creature poised for flight.

The Parisian model pool had all but dried up in wartime, but Georgette Sembat recommended an Italian that winter.[57] Her name was

Matisse, *The Italian Woman*, 1916

Lorette, and she posed in November 1916 for the first of a series of canvases that would increasingly absorb Matisse over the next twelve months. Not that there was anything particularly seductive to start with about this *Italian Woman* with her tight lips and reticent gaze. The model's hollow cheeks, sticklike bare arms and cheap, flimsy blouse suggest an almost nunlike austerity reinforced by the black cowl of her hair and her drab, sack-coloured skirt. Soft, feathery brushstrokes lick at the edges of the figure as they do in the portrait of Prozor, whose body seems about to dissolve into the tide of brown-orange colour flowing across the right side of the canvas, invading her blue dress in shadowy strips and triangles, spurting up beneath her armpits and occupying both her shoes.

The painting shows precisely what Matisse meant when he said he needed the friendly human presence of a model to help him break through to a wholly detached, impersonal level of picture-making.[58] The pathos that evidently touched him in this sad and wary Italian girl dressed in an outfit hopelessly unsuited to the freezing temperatures of a Parisian winter still lingers faintly in the severe black lines and angular folds of the geometrical composition enclosed by the ovoid of her head and hands. But *Italian Woman* goes further than any other in a long line of portraits, from Landsberg to Prozor and Pellerin, in which the fabric of the paint itself has all but absorbed its human subject, blurring outlines, merging forms, deconstructing the arms and hands, and here eliminating the right shoulder altogether beneath a swathe of encroaching, lively, grey-brown brushstrokes.

Pictures like this looked as uningratiating to contemporaries as any Cubist canvas. "Frankly, I can't see anything in Picasso," Puy wrote to Matisse that Christmas from the trenches, in a tiny, cramped scrawl on three minute pieces of card. "It's not like that with you, for running

Matisse, *The Studio,*
Quai Saint-Michel,
1916–17

through all your experiments I have always recognised in your painting a
call to my painter's heart that touches me directly, and I shall always
defend you against those who say you're trying to pull off some kind of
bluff. I've seen you made to suffer by and for your work too often to find
those accusations funny—you are one
of those always in search of sweeter
perfumes, larger flowers, pleasures as
yet untasted (those were the tempta-
tions of St Anthony)."[59] Like a hermit
in the desert, Matisse had now stripped
away everything that was of no use,
and therefore harmful, to him in the
pursuit of modernism's strange new
inner realities. At the height of his
powers in the darkest period of the
war, he reached the end of a process
begun twenty years earlier (when he

Gustave Courbet,
The Sleeping Blonde,
1849: one of four
Courbets acquired
by Matisse in 1917

first encountered the work of the Impressionists, especially Claude Monet) by bringing painting to the verge of pure abstraction.

Matisse had emerged triumphantly from one of the most gruelling phases of his career with a batch of works so far ahead of public taste and critical comprehension that some of them would not be fully understood, even by other artists, for decades to come. But he had simultaneously painted himself into a corner from which there was no obvious way out. Early paintings of the Italian model suggest how hard he found it to move forward. *The Painter in His Studio* of 1916 shows her bundled in a corner in a shapeless green robe while the artist in the centre of the canvas, seen from the back and painted in a kind of shorthand, is barely more than a tense, naked, brooding presence with a palette at the easel. A companion painting, *The Studio, Quai Saint-Michel*, looks back directly to the *Studio Under the Eaves* of 1902–3, painted at a time of desperation in a Bohain attic with the same drab walls, dark ceiling and bare wooden floor, also empty except for the work in progress tilted on its easel to catch the sunlight streaming through the window. Each canvas powerfully evokes the absent artist. The general sense of being imprisoned conveyed by the earlier painting has been transferred in the second to the nude model, Lorette, lying trussed up on the narrow studio bed in what looks like a net of thick black strokes or bindings.

It was Lorette who liberated (or was liberated by) Matisse. Together they embarked on a series of experiments that would open up new directions in his work for another decade and more. She first arrived in his studio at a moment when he was already beginning to turn to other painters

Jean-Baptiste-Camille Corot, *Forest of Fontainebleau* (detail), 1834: the figure of a young girl lying in a flowery meadow who captivated Matisse for the second time in 1917

Matisse, *Lorette Reclining (Sleeping Nude)*, 1917

(as he always did when his own work was in transition), this time to his immediate predecessors rather than the classical masters in the Louvre. He went through the Cézannes in Pellerin's collection three or four times in the winter of 1916–17. He included a section of Renoir's *Portrait of Rapha Maître* in the top half of his own portrait of Pellerin, and wrote wistfully to Paul Rosenberg to say how much he would have liked to meet Renoir himself.[60] Instead he arranged for the Bernheims to introduce him to Monet, visiting the older painter several times among his water lilies at Giverny.[61] Matisse bought his first painting by Gustave Courbet in November, going on to acquire four more in 1917, including a sketch for the richly sensual *Demoiselle Beside the Seine* and the lovely *Sleeping Blonde*.[62] At the same time he looked again at J. B. Corot's *View of Fontainebleau Forest*, with the girl lying in a patch of daisies in the foreground who had captivated him as a student twenty years before. "The picture makes a strong decorative effect," Matisse wrote to Walter Pach three months after his first session with Lorette. "The figure of the young girl lying reading beside the water on the flowery grass is delightful."[63]

The model lying ready to be painted in *The Studio, Quai Saint-Michel* is depicted in short slashing brushstrokes as a baleful human challenge. But the canvas-within-a-canvas barely sketched out in that painting turned into a pastoral idyll—*Lorette Reclining*—with the red daisy-patterned studio bedspread transformed into a floral meadow, and the clenched black figure on it reconstituted as a relaxed and graceful sleeping nude, more Courbet than Corot. For once the finished painting retains the fluidity and humour of the thick black line that leaps and glides across the paper in Matisse's preliminary pencil sketches, greasy, sensuous and caressing, emphasising the supple curves of breast, belly, hip and haunch, catching two comically alert black eyes peering out from under the plump, rounded pillow of an

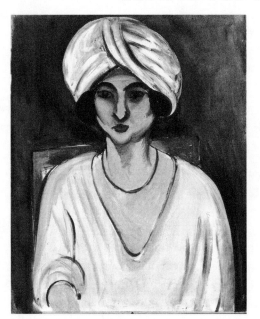

Matisse, *Woman in a Turban (Lorette)*, early 1917

arm, blocking in the vivid, swirling tress of hair that pins down the whole decorative composition.

From now on Lorette unfolded, becoming confident, expressive and adaptable. She had a theatrical gift for transformation, switching from ethereal purity to luxuriant abandon, seeming to change mood, age, even size as readily as she tried on costumes. She could sleep at will like a cat, retaining a regal dignity even when slumped, dozing, in her green robe and Moroccan leather slippers against a purple shape that might as easily be a throne as the bulging, comfortable studio armchair. Whatever her previous professional experience, she was perfectly at home with the Salon painter's standard repertoire of teasing and provocative sexual disguises. She dressed up for Matisse as a flirtatious Spanish señorita in a black lace mantilla, put on a white turban and a Turkish robe to become the distinctly European inmate of an Oriental harem, and impersonated a Parisian cocotte, sprawling on her back at the painter's feet in a peignoir and matching shift hitched up to show the frilly garters clasping her white cotton stocking-tops.

Nothing like this had ever happened in Matisse's studio before. The nearest he had come to this sort of frivolity was when he tried to relieve the family's abject poverty in 1902 by kitting out his faithful model Bevilacqua in toreador pants for the tourist market, and painting the actor Lucien Guitry dressed as Cyrano de Bergerac, with melancholy results.[64] Now he responded to Lorette's expert lead as spontaneously as a dancer taking to the floor. She released in him an observant gaiety and speedy, casual attack suppressed in years of strenuous sacrificial effort. He painted her energetically from odd angles and in exotic outfits, but mostly he returned to her simplest pose, seating her facing him in a plain, long-sleeved top and improvising endlessly inventive rhythmic variations on the central theme of her strong features, heart-shaped face and the black ropes

of her hair. Sometimes he multiplied his range of decorative possibilities by importing a second figure, Lorette's younger sister Annette, or an incisive and arresting North African model called Aicha Goblot. He even teamed the Italian sisters with a much blander hired model to pose for what eventually became the majestic *Three Sisters Triptych.*

Matisse painted Lorette almost fifty times, or roughly once a week, over twelve months. Recent commentators have taken it for granted that theirs was a sexual as well as professional partnership, but if so, there were no apparent repercussions at the time within the painter's family, and no gossip outside it among his highly observant contemporaries. His absorption in Lorette had none of the emotional overtones associated with his wife and daughter (or even Olga Meerson), who had been his principal models up till now. She set a pattern for successive relationships with hired models in the future, each of which took on the obsessive, exhaustive intimacy of a love affair played out (whatever may have happened in work breaks) with maximum intensity on canvas. Matisse himself said long afterwards that it was his son Jean who fell madly in love with Lorette, and had to be firmly disabused of his dream of marrying her.[65]

Jean's mobilisation orders finally arrived in early summer, drafting him by his own choice as an aeroplane mechanic and giving him forty-eight hours to join his regiment at Dijon. Matisse seized his last chance to dash off a second family portrait, borrowing the format of *The Piano Lesson* ("The one in my salon with Pierre at the piano," he told Camoin, "which I've taken up again on a fresh canvas adding in his brother, his sister and his mother"),[66] and dramatically reversing its mood in two days flat. *The Music Lesson* recreates the living room at Issy as a lacy linear pattern, lightheartedly embracing the radiator and the music stand alongside the human occupants: Marguerite supervising Pierre at the keyboard, Amélie hunched over her sewing outside the open window, and Jean himself, viewed with a sardonic paternal eye as a truculent adolescent already turning into a jaunty adult male, signalling his independence with his generation's key accessories of cigarette, paperback and stylish moustache. The picture does not attempt to explore the underlying strains in a family facing break-up and potential loss. Rather it suggests an exuberant fresh start, embodied by the jungly garden growth that seems about to burst in through the window and engulf the household, especially Amélie, dwarfed on the back porch by a wild, pneumatic, blown-up version of the clay *Reclining Nude* she herself had posed for ten years earlier.

Jean Matisse was drafted into an army more demoralised in the summer of 1917 than at any point in the war. Over twenty thousand men

deserted after a wave of revolt swept the ranks in May, when whole regiments had to be secretly pacified, ringleaders shot and public access temporarily barred to Parisian stations receiving soldiers from the front. Jean, who had longed to go to war, found his jauntiness knocked out of him almost at once. His father told Camoin that the boy's first letters home showed him already disillusioned with his metier as a mechanic. Matisse himself was badly shocked, on a visit to Jean's training camp a few months later, to find the young conscripts hungry, cold and dirty, living ankle-deep in mud without latrines or anywhere to wash except, once a week, in an icy stream. "They live like pigs," he told his wife, giving his son his own shirt, buying him an army greatcoat, and posting after it a tin washbasin and a woollen jumper.[67]

By 1917, civilian responses had been numbed and coarsened by the impossibility of relating official communiqués to the reality they suppressed. Relentlessly upbeat reporting of guns captured and troops advancing on the western front had to be reckoned against the pitifully small parcels of ground gained, and the illimitable casualty lists. There was devastation in Matisse's own home region of the Aisne, where the Germans had withdrawn to newly fortified positions, systematically blowing up bridges as they went, destroying crops, burning houses and reducing whole villages to rubble. St-Quentin (where the painter went to school) became a ghost town that spring, its population forcibly evacuated, its factories and public buildings smashed and pillaged. There was no means of knowing what was happening in Bohain, now only ten miles behind the enemy line. Measured by the general scale of destruction, the fate of Matisse's paintings seemed, as he said, relatively insignificant. But the survival of either Shchukin or his collection looked uncertain in the light of reports of revolution and civil war engulfing Russia. Nothing had been heard of Matisse's pictures in Berlin (they were apparently sequestered by the German government after America entered the war in April, an event greeted in France with wild enthusiasm).[68]

Parisians had long since learned to carry on living with guns booming on the Somme as routine background noise. Matisse bought his first motorcar in the summer of 1917 (a second-hand Renault, chauffeured in Jean's absence by the seventeen-year-old Pierre), and tried it out on painting expeditions along the banks of the Seine, or through the woodlands linking Clamart, Meudon and Versailles.[69] He still sometimes applied a terse structural geometry to corners of the garden at Issy—a flower-bed, a small pink marble table—or to the play of sunlight and shade in a series

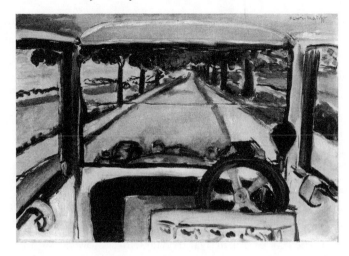

Matisse, *The Wind-shield, on the Road to Villacoublay,* 1917

of beautiful, semiabstract paintings based on the nearest woods at Trivaux ("Corot reinterpreted by Gris," wrote Pierre Schneider of *Tree near Trivaux Pond,* now in the Tate Gallery).[70] But more often he stopped the car apparently at random, propped his canvas against the steering wheel, and painted whatever he could see through the windscreen with something of Courbet's vigour and directness. Half a dozen or more of these small, unassertive pictures show a road or river stretching ahead into the distance. Matisse said landscape allowed his hand and eye free play—"These little things are relaxations, diversions"[71]—at a time when the future held only uncertainty and confusion.

He made two impromptu oil sketches of the chateau at Chenonceaux near Tours, newly sold by the father of a friend of Bertie Landsberg and young Duthuit to the Menier family.[72] The chocolate-making, art-loving Meniers invited Matisse to stay twice that summer, the first time with his neighbours from the quai St-Michel, Marquet and Jacqueline Marval (who had moved in next door to Matisse while her partner, Jules Flandrin, was at the front). These three always worked well together, the two men cheerfully paying the forceful and flamboyant Mme Marval the tribute rightly due, in Marquet's words, from mere talent to sheer genius. They planned to meet up again later for another working session in Marseilles, where Marquet rented a room each winter, regularly urging Matisse to join him in the sun. The sexual side of these proposals was not lost on Marval, who responded to male painters' routine bawdy talk by stationing a wicker laundry-basket inside her front door to be filled up with sexy pictures by

visiting colleagues, starting with Matisse and Marquet.[73] The pair put on their usual comic double act for her, with Marquet's pressing invitations to brothel-crawling expeditions on the old port countered by Matisse's perennial excuses that he was too old, too feeble, too afraid of upsetting his wife. When he finally decided to take his usual winter break in the south, Matisse signalled his intentions to Marquet with another flurry of bawdy jokes.

Why he went is another matter. His departure put a stop to his sessions with Lorette, who, after twelve months of intensive, even obsessive collaboration, stopped posing for him that winter and never sat for him again. It has been widely assumed up till now that he left home after some sort of showdown with his wife, but the regular journal-letters he sent Amélie from the day of his arrival in Marseilles show no sign of conflict or tension between them. In fact both were chiefly worried at this point about their eldest son. Jean's posting to the airfield at Istres on salt marshes thirty miles west of Marseilles seems to have been the deciding factor for his father, who left Paris in mid-December without even waiting to hear the outcome of the latest of Marguerite's periodic throat operations.[74] Matisse had managed to get hold of an introduction to Jean's camp commandant through an army contact supplied by his old friend André Rouveyre. He caught the overnight train to Marseilles on Thursday, 13 December, booked in at the Hotel Beauvau ("I've completely seized up in the knee and kidneys," he told his wife),[75] and spent Friday night recovering at the local music hall with Marquet. The port was full of troops en route for Italy, and Matisse, who had to wait four days for permission to see Jean, calmed his impatience by experimenting with a brand-new, lightweight, portable paint-box. On his first day, he made two paintings in the harbour, followed, when it poured with rain on Monday, by a tiny portrait of the critic George Besson, who was staying in a neighbouring hotel.

The state of the young soldiers at Istres confirmed Matisse's worst fears ("All of them long to get to the front," he reported to Rouveyre. "It's a prison camp").[76] He took Jean back with him to Marseilles on a twenty-four-hour pass ("The men never get passes," said the camp commandant. "They wouldn't know where to go"), treated him to the civilian delights of shops, cafés and a night at the Variétés, and sent him back to camp by the dawn train next day, full of good food and wearing clean, warm clothes. "His heart was heavy when he left me," Matisse wrote to his wife.[77] He himself had caught a chill on the windswept flatlands round Istres, and proposed to cure it by retreating along the coast to the sheltered bay of Nice as soon as he had done all he could for Jean by firing off

letters, organising food parcels and enlisting Rouveyre's help to arrange an urgent transfer.[78]

Matisse reached Nice on Christmas Day, 1917, meaning to stay for a few days at most and taking a room on the sea front in the modest Hotel du Beau Rivage.[79] The town was bleak, windy and deserted ("It's freezing in this pig of a place," he told his wife). His hands would scarcely hold a brush, and he had to wear sheepskin foot-warmers to paint views of the castle above the old town. When it snowed on his birthday, 31 December, he bought himself a new canvas and stayed indoors, painting his room at the Beau Rivage in sunshine reflected off snow and sea: "From my open window you can see the top of a palm tree—white lace curtains—coat-rack on the left—armchair with white lace cover on the back—on the right a red table with my suitcase on it—sky and sea blue—blue—blue."[80] He had used identical words to his wife on their honeymoon twenty years before to describe a blue in a butterfly's wing that pierced his heart (the butterfly, bought from a souvenir shop in Paris, came to symbolise for both of them the common goal of their marriage). Matisse said he had seen the same blue for the first time as a boy burning sulphur in his toy theatre in Bohain at the climax of his famous staging of the Neapolitan volcano erupting in 1885. This was the blue he would succeed in recreating only at the end of his life in the stained-glass windows of the chapel at Vence. "Me, I'm from the North," he said long afterwards, looking back to that first week in Nice when the weather almost sent him packing. "What made me stay was the great coloured reflections of January, the luminosity of the days."[81]

His thoughts turned to his mother in the North on New Year's Eve: "I'm sure that in a moment at eight o'clock Maman will be thinking of me," he wrote in the hour of his birth to Amélie. On 1 January 1918, rain poured down all day. Matisse took a wet walk to the post office to send his wife a telegram, and sat down again to work on a second canvas with rain lashing at the window and surf crashing on the beach below. "I painted myself in the wardrobe mirror," he wrote home next day. This was the last self-portrait he ever painted (frontispiece). It shows him at work, gripping his palette with a paint-smudged thumb, sitting on a hard chair in glasses and a shabby suit at the far end of his dark, narrow hotel room with an umbrella dripping into a bucket beside the washstand. The painter fills the canvas, his head pushing at its top edge, one leg cut off by the bottom, his back against the left-hand side, his hands and eyes busy with that other canvas holding the work-in-progress just visible on the right. The painting monopolised him for the next fortnight. It is a powerful, anti-heroic,

oddly provisional image for a man approaching fifty with an international reputation and a key show coming up that would consolidate his position as one of the two leaders of the Western world in painting.

This was the first two-man exhibition to set Matisse alongside Picasso. It was brilliantly orchestrated by Apollinaire in collaboration with an ambitious young Parisian dealer, Paul Guillaume, who announced his intentions in a letter on 16 January, a week before the show was due to open, by which time it was too late for Matisse to do more than protest angrily that it was against his principles to make any kind of major showing in wartime. He suspected Guillaume of setting him up in a contest loaded in Picasso's favour ("I see it as the boxing match between Carpentier and Joe Janette," he grumbled to his wife, comparing himself to the Frenchman defeated by an American light heavyweight in 1914: "It's the height of manipulation to get hold of someone's works while he's not there in an attempt to demolish him").[82] The affair confirmed his view of Apollinaire as an unscrupulous hustler, and reinforced his mistrust of dealers in general, especially his own (several pictures had been supplied by the Bernheim-Jeunes, with whom Matisse had agreed to renew his contract on highly favourable terms the previous October). He felt that he had somehow been wrongfooted, taking particular exception to the "ultra-modern publicity campaign" launched by an unprecedented nineteen-second film clip shown by Gaumont News in cinemas all over Paris.

But the sensational repercussions of Guillaume's show in Paris seemed like echoes of another world to Matisse, whose life had already taken on the same simple repetitive pattern in Nice as in Tangier. He rose early and worked all morning with a second work session after lunch, followed by violin practice, a simple supper (vegetable soup, two hard-boiled eggs, salad and a glass of wine) and an early bedtime. He paid a formal call in his first week on Renoir, dropping in regularly afterwards at the older painter's house a few miles along the coast at Cagnes, but otherwise seeing virtually no one. Even Matisse was taken aback to find himself safely tucked up in bed by half past eight most nights ("In Nice of all places, it's shameful"). Besson, who had turned up again to sit for a second portrait at the Beau Rivage, was astounded to see the painter settling into a frugal and monastic routine inconceivable to connoisseurs of seaside brothels, like himself and Marquet. "Forgive me, I've been completely ensnared by a woman," Matisse wrote to Marquet, explaining his failure to return as planned to Marseilles. "I'm spending all my time with her, and I think I'll definitely be staying here for the rest of the winter."[83]

The temptress who engrossed Matisse turned out to be a plaster cast

in the local art school of the greatest of all Renaissance nudes, Michelangelo's *Night*. By mid-January, she was already beginning to absorb him as exclusively as Lorette had done the year before. Looking back thirty years later, he remembered a month's solid rain before a sudden sunburst changed his life ("I decided not to leave Nice, and I've been there practically ever since").[84] In fact, the sun came out much sooner. He told his wife on 13 January that he was strolling out without a coat, and that work was going so well it would be a mistake to budge. Jean was on leave with the family at Issy, Pierre was toiling at his violin, and Marguerite was resting after one of the surgical cauterisations she now needed once a month. Matisse reckoned she could count on three clear weeks between treatments, and telegraphed his wife and daughter to join him in Nice. "Hurry up," he begged Amélie. Envy of Besson (who had brought his own wife with him) and the activities of an energetic young couple in the room next door made him long more than ever for Amélie's arrival, which he told her would make every day a feast day.[85]

He spent afternoons drawing at the art school ("I'm trying to absorb into myself the clear and complex concept of Michelangelo's construction," he wrote to Camoin).[86] In the mornings he painted his room with light streaming through the window and no sign of human habitation except for the few possessions he had brought with him: a battered suitcase, a canvas propped against the wall, the violin or its empty case lying on a chair. "Remember the *Interior with Violin*," Marguerite wrote later, recalling the work awaiting inspection when she and Amélie came south in February. "Remember the state it was in when we reached Nice, and the discussion we all three had together. . . . You set out once more from a canvas already marvellously balanced by your natural gifts . . . to attack the hard place, the high rock from which you either discover a new horizon, or destroy the canvas."[87]

All her life Marguerite had heard her father insisting that it was better to risk ruining a painting than to be satisfied with quick results, however harmonious and easy on the eye ("It's always necessary to force your whole being beyond this level because it's only then that you start to make discoveries, and tear yourself apart in the process"). *Interior with Violin* in its first stage showed a vase of flowers in a room with wooden shutters barred against the sun, except for a small flap opening onto a strip of beach, blue sea and palm fronds.[88] The standoff between father and daughter at this point passed into family legend ("It was enough for Marguerite to say . . . it was pretty, for Matisse to take up the canvas again and bring it to the tense, violent state we know today").[89] He cut out the flowers, sup-

pressed his soft pinks and ochres, and intensified the light licking through the shutter like a flame by repainting the interior black. This work was pivotal: "In it I have combined all that I've gained recently with what I knew and could do before."[90]

Matisse's wife and daughter were in no doubt about the significance of this turning point, or the inner perturbation it exacted. The painter was practising the violin obsessively again (and so loudly that the management banished him to a distant bathroom to forestall complaints from other guests). When Amélie asked what had put him in this musical frenzy, he said it was terror of going blind, which made him determined to perfect his playing so that, if he lost the power to paint, he could always provide a living for herself and Margot by fiddling on the street.[91] The chances of Matisse ever having to earn his keep as a street musician were remote. But his fearful fantasy suggests he already recognised the move to Nice as a gamble that meant staking everything—his settled life, his family's income, his achievement so far as a painter—against an unknown future.

In fact it was Matisse's elder son whose sight was threatened at the beginning of 1918. Jean had gone into hospital in February with an abscess on his leg, and been discharged after three weeks with the wound still open.[92] Now he wrote from Istres to say he had developed abscesses on his arm and eye as well. His mother and sister left Nice on 6 March to visit him before catching the train back from Marseilles to Paris, where Marguerite's doctors refused to answer for the consequences if she missed her treatment for longer than a month. Soon after their arrival the bombing changed pace. "There's a wave of panic in Nice just now," Matisse wrote on 23 March, the day the Germans began shelling Paris with new artillery of such unimaginable power and range that incredulous citizens all over France assumed there had been some mistake in the radio transmission.

"So it wasn't a false rumour," Matisse wrote grimly after reading the communiqué next day, which also brought news of fresh assaults on the front near Bohain between St-Quentin and Cambrai. The Allied armies fell back, unprepared for the ferocity, speed and scale of an onslaught intended by the Germans to bring final victory in Picardy and Flanders. Matisse rose before dawn each day to scour the papers ("The Germans have captured Montdidier, they've got it in for Amiens," he wrote on 28 March. "The atmosphere isn't at all reassuring here—and as I haven't worked today, I've lost my usual ballast"). Communications were disrupted or agonisingly slow. Telegrams took days to get through, and telephone calls meant waiting for hours, often with no connection at the end. Matisse, who had had no word from his wife except a telegram requesting

money, appealed to his bank manager and begged the editor of the local paper for information. Bitter cold gripped Nice. "If I could see the Germans being stopped, it wouldn't be so bad," Matisse wrote home as the battle raged. "We'll have to trust in Joan of Arc! I can only embrace you all from the bottom of my heart—Henri."

Marquet (who had returned to Paris, taking several of Matisse's pictures with him) wrote from the quai St-Michel in an air raid to say that his neighbours had all descended to the cellar with Madame Marval at their head.[93] "By now spring has come to Clamart...," wrote the Danish painter who had been entranced by the Matisse house the year before. "Perhaps artillery fire has shattered the house and made great holes in the garden's pathways. It will take a merciful God to protect this place in the day of reckoning, which now seems so near."[94] The bombardment reached its height on Good Friday, 29 March, when a direct hit on a Paris church killed or wounded 165 people attending Mass. Once again the inhabitants fled the city. Cars were banned on the exit roads on orders from Clemenceau himself. Amélie dismantled the house and studio, methodically sorting and packing in a hail of postal advice from Nice, where her husband was driven nearly frantic by his inability to reach or help her. "I've been within a hair's-breadth of leaving," he told Marquet. "My wife tells me to stay. While waiting, I work."[95] He spent Easter Sunday alone in the art school, modelling a little clay *Crouching Venus* based on Michelangelo, while his wife dispatched all but his biggest canvases by train, in the care of Marguerite and Pierre, to her aunt Louise in the Parayre family home in Toulouse.

By the following week the Allied retreat had halted, and panic died down in Paris. Brother and sister took the train along the coast to Nice, arriving on 7 April to help their father move into a rented apartment at 105 quai du Midi, next door to his hotel. He described the three of them to his wife, settling down companionably together in the comfort of their own fireside while fierce winds lashed the sea. Both children thoroughly approved of his newly completed *Interior with Violin*. Marguerite posed for him each day, well wrapped against the cold, on the balcony of the new studio above the bay. Matisse also made a drawing of Pierre playing the violin, and used it as the basis for a strange, stripped-down painting of a standing figure outlined against the light, which he called *The Violinist at the Window*.

After Marguerite's return to Paris on 18 April, Pierre surprised his father by adapting cheerfully and competently to a routine of domestic chores, hard work and early nights. Landscape was beginning to preoccupy

Matisse, sketch of himself taking a siesta under an olive tree on Mont Boron, in a letter to Camoin, 23 May 1918

Matisse again, and when the hotel and the block next door were requisitioned by the army, he found lodgings for the two of them on Mont Boron, the stony escarpment above Nice, where he could paint wild roses, pines and olive trees. They took the second floor of the Villa des Alliés ("For once I'm going to have to do a move without you," Matisse wrote forlornly to his wife),[96] a small, plain, suburban house standing among building plots in spiny scrub, a twenty-minute walk up a steep hill from the tram terminus, surrounded in wartime by trenches and temporary shelters for an encampment of Moroccan troops.[97] Their rooms faced west, with panoramic views along the coast to Cagnes and across the old town to the mountains beyond. Matisse rose at dawn each day to watch the sun come up. "I feel like a human being again," he wrote on their first day in the new quarters, 16 May, swearing never again to let himself be stuck for months on end in a hotel. Father and son lived simply, like students, fiddling, painting (Pierre was beginning to think he too might like to be an artist), and taking it in turns to do the housework ("Everyone's astonished, especially that we do our own cooking"). Jean came over from Istres on a forty-eight-hour leave, and, after a delicious lunch cooked by the boys, they walked at Jean's request high in the hills above the town.

Matisse made the most of this brief peaceful interlude of family reunion and contentment. He sent Amélie a drawing of canna lilies that spring with white petals pearled like a grain of rice ("Since I've never seen them in flower before, I thought you wouldn't have either, so I drew them

Matisse, sketch
in the margin of a
letter to his wife,
8 May 1918

for you"). He decorated another letter with a little sketch in the margin
showing himself, all bristly beard and thrusting lips, planting a kiss on his
wife's cheek while she presents her profile, looking young and firm with
her hair pinned up on the nape of her neck in a style he found particularly
charming. It was a graphic image of a partnership that always functioned
best at times when the absorption and isolation required by Henri's work
imposed the greatest demands on Amélie. The practical difficulties and
dangers that reduced him to dithering indecision only made her more
unflappable. "My dear Amélie, you in Paris are astonishing...," Henri
wrote in an ecstasy of admiration on 21 May, after two shells exploded on
the roof of his studio at Issy. "We're more frightened here than you are.
Just as I'm about to depart from one moment to the next, you write:
'Carry on painting quietly, everything's under control.'" This was the
tough, cool Amélie, as dauntless as she was resourceful, whom he had
loved from the day they met.

On 27 May the Germans launched a further massive offensive in the
north, sweeping forward in three days to the Marne. By 3 June they were
within thirty miles of Paris. "It's dreadful to be here when I know you're at
your wits' end," Henri wrote, "the only way I could ever be as brave as you

is in my work." But even painting could not distract him now. He caught the tram into Nice to wait for the communiqué posted every afternoon in the avenue de la Gare. Once he was obliged to swallow a beer to calm his nerves. Often he sat staring in disbelief at the passers-by going calmly up and down the street ("But then the people who see me don't know what's going on inside. I look calm enough myself, sitting over my coffee"). Marguerite left for Toulouse again with a second batch of canvases, while Amélie prepared the house for final evacuation. Henri packed his bag to join her, sending instructions as to what to save: his big Courbet was to be rolled ("better with cracks in the surface than left behind"), his antique sculpture buried in the garden, and his *Moroccans* chopped in half and posted (he enclosed a diagram with a dotted line showing where to cut the canvas with a razor).[98] A telegram from Amélie telling him to stay put was followed by another announcing her own departure on the advice of Marcel Sembat. Henri wrote daily, distracted by anxiety for his wife, for France, and for the artworks that would have to be abandoned to the enemy. "But I think of my big paintings, which surely can't be left behind at Issy, especially the *Bathers* on which I spent so long," he wrote sadly. "Courage, my brave Amélie, and be prudent."[99]

At the height of the crisis, when the German advance was already faltering but had not yet been decisively stalled, Pierre had his eighteenth birthday, on 13 June. His father added a fond postscript in a letter to his wife, remembering the birth and the heroic early days of their marriage. For their son, the day meant liberation. "I was saved by the war," Pierre said long afterwards.[100] For three years he had endured the drudgery of daily music practice with a sense of futility if anything, heightened in Nice by contrast with his father's passionate commitment to his work ("I paint to forget everything else," said Matisse).[101] With no company of his own age, no distractions apart from visits to the cinema, and nothing to look forward to but a promised outing to Monte Carlo that was perpetually postponed, Pierre had counted the days all summer until he would be old enough to enlist. Without waiting to be called up, he left alone for Paris to join an army desperately mustering reserves for a second Battle of the Marne that summer.

The Matisses' fears for their sons were compounded by worry about lack of medical backup for Marguerite now that the family was scattered and Paris hospitals had been evacuated. Treatment facilities in Toulouse or Nice were hopelessly inadequate. Surgeons had been drafted from all over France to operating theatres near the front, and Matisse's plan was to follow them. He proposed to rejoin his wife in the north, look for a tem-

porary base where the family could sit out the fighting if Paris fell, and establish Marguerite meanwhile in a rented room behind the lines, probably in Le Mans, within reach of one or other of her two Parisian surgeons so that her treatment could continue. "You must surely know we haven't come this far only to give up now," he wrote to his daughter on 14 June, backing up his letter with a telegram "to tell her we would do *the impossible* for her throat."[102]

A card had reached Issy at the beginning of the year from Henri's brother, Auguste, to say that the Germans were beginning to allow useless sick or elderly civilians to leave Bohain.[103] Now word came that their mother had at last consented to join the refugees straggling across Flanders on foot with bundles and handcarts, but Matisse knew his parent too well to hurry back to receive her. "I'm glad maman is getting ready but counting on her to be late," he wrote to Amélie on 23 June. "She'll never be finished. She's going to want to clean her house before she leaves." In the end it was his daughter who fetched him back from Nice, where painting made him forget everything else. Marguerite had been undergoing a new course of treatment since May ("The idea of seeing her again in this state makes me almost sick with fright," Matisse wrote to his wife).[104] Alarmed by the news that she had been too weak for cauterisation when she got back from Toulouse, Matisse booked the first available seat on a train, arriving in Paris on 30 June to confront her doctors. The shelling of the capital resumed next day. Matisse spent several nights with his family in the cellar at Issy, and swept up the glass in his and Marquet's studios when bombs shattered the windows at 19 quai St-Michel. Amélie had planned to retreat to Maintenon, just north of Chartres, and after nine days of bombardment Henri himself moved there to reconnoitre the

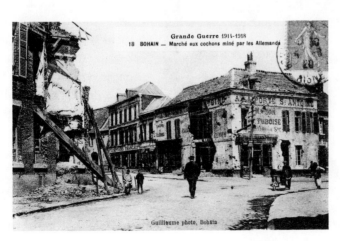

Louis Joseph Guillaume, Bohain after the occupation in 1918

hotel as a possible family refuge, painting the viaduct to the sound of cannon fire, and narrowly escaping death when the train just before his own was wrecked at St-Cyr.[105]

In August, an initial counterattack on the western front was launched by the French from Amiens. Jean was serving behind the lines as a ground mechanic. Pierre, training at Cherbourg as a driver in an artillery regiment, was about to be posted to the front. When his younger son fell ill in a cholera outbreak on the northwest seaboard, Matisse left immediately for Cherbourg, reporting that seven of Pierre's contemporaries had died on 12 September, and another ten the day before.[106] Pierre himself turned out to have flu, but Matisse, advised by another grieving father to run no risks, managed to get leave to take him home. At the end of the month successive waves of Allied forces swept eastwards, pushing the Germans back across Flanders. British troops retook St-Quentin on 29 September, and entered Bohain on 8 October. Matisse was one of the first civilians to reach the town in their wake. "I feared to see my native land again," wrote his compatriot, the historian Gabriel Hanotaux, describing his own return in October through an unrecognisable country of mud, craters, blasted trees, dead animals and twisted metal, blocked rivers, skeletal towns and gutted villages: "But I didn't imagine anything like what I saw! In truth it was the death of the earth itself, a landscape of the Last Judgment."[107]

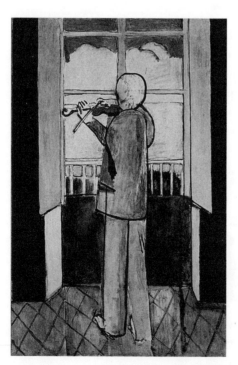

Matisse, Violinist at the Window, *1918*

Roads had been mined in Bohain, buildings sacked and the town hall set on fire. People had been living under shellfire in their cellars for two months, surviving on turnips, black bread and dried beans. Auguste Matisse was packed and ready to flee with his wife, his two small daughters and his seventy-four-year-old mother, taking only as much as they could carry. Forced to work twelve hours a day unloading German shells and shifting crates, Auguste had collapsed with tuberculo-

sis, but his mother remained doughty, unbiddable and unbowed. The only things that had apparently frightened Maman Matisse were the Germans' endless requisitions ("She trembled like a leaf," Auguste reported) and the Teutonic thoroughness of their even more rapacious looting.[108] Her home was the inheritance she and her husband had built from scratch to hand on intact to their descendants. "It was absolutely impossible to make her leave for France, in spite of all our pleading...," Auguste told his brother. "We hurled ourselves against her obstinacy. She would not abandon her house to be pillaged." She had sold her piano for food, and used the sheet music to wrap provisions. Henri found her, as he had known he would, preparing to bring out the treasures buried for four years in her cellar, and embark on a stiff programme of washing, rubbing, scrubbing and mending what was left. "I'd rather have them spoilt than know the Germans had got their hands on them," she said, protesting vigorously that the first English soldiers to liberate Bohain had made off with both her clothes brushes.[109] She had sworn to live long enough to see her eldest son again but, though she thanked him kindly for the gifts he brought, nothing he could say would make her return with him to Issy until her house had been comprehensively scoured out.

Matisse's mother was indomitable, like his wife and daughter. The three of them framed and shaped his life, pointing him towards the stern and sacrificial path he followed to the day he died. Picasso's lover Françoise Gilot described Madame Matisse and Marguerite long afterwards as two caryatids or columns supporting the entrance to Matisse's temple.[110] The painter himself always insisted that he was by nature feckless, disorganised and chaotically undisciplined. On 11 November, the night the armistice was signed to bacchanalian rejoicing all over Europe, he brought out his violin and played a wild fandango on a café table. "Phew," said Marquet, "well, *mon vieux*, if Amélie could see you now..."[111] Just over a month later Matisse headed south again to Nice in pursuit of painting. At the very end of Matisse's life, Picasso would evoke his presence in a ghostly painting called *The Shadow*, which echoes his old rival's *Violinist at the Window* of 1918, showing the artist as a spare, taut, concentrated figure at an open window. It perfectly expresses the provisional quality of Matisse's life at this point: the sense of stepping out, travelling light, starting a journey in which reality would find new forms and meanings in the world of his imagination.

CHAPTER SEVEN

~

1919–1922: *Nice, Paris, London and Etretat*

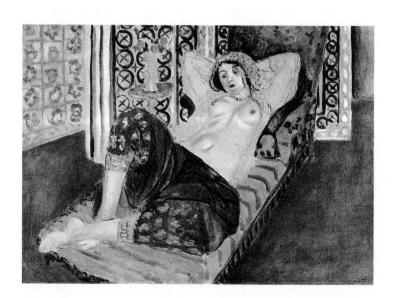

Matisse, *Odalisque in Red Culottes*, 1921

All through the spring of 1919 in Nice, Matisse visited Auguste Renoir, who was dying in his house, Les Collettes, at Cagnes. Renoir was in his late seventies, widowed during the war and so pitifully wasted he had to be shifted from his bed to the studio in a carrying chair. "He slumped in it like a corpse," said Matisse, who had formed the habit the year before of calling in at Les Collettes after a day's work on the surrounding landscape.[1] Frail, gaunt, swathed in bandages and too crippled by arthritis to hold a brush, Renoir lived only to paint, which he

still did every day with his brush-handle padded and wedged between his right thumb and forefinger. "You could pick him up in one hand quite easily," said Matisse. "His eyes held all the life of his body, his eyes and his tongue and his poor, twisted, deformed, bleeding paw."[2] The visitor said that talking to the old man, or seeing him wince and grimace as he forced himself into action at the start of each painting session, was like watching the dead come back to life. "The pain passes, Matisse, but the beauty remains," Renoir said with a radiant smile, explaining that he meant to live until he had finished his latest love song to health, strength and physical well-being, *The Bathers*.

The canvas had to be wound on a roller so that the painter could work on it bit by bit in his garden studio, a wooden hut standing beneath olive trees on a hillside above the sea with big windows to let in the light on all sides. The English writer Frank Harris said Matisse had tears in his voice when he described Renoir at Cagnes: a tiny mummified figure stripped of everything but intelligence, memory and the passionate will to transfer what he saw in front of him—two girls lolling on a grassy bank—to a deeper and more stable level of reality in paint. Renoir's example marked Matisse indelibly. He looked back to it long afterwards when age and ill health capsized him in turn. In his first years in Nice, he drew courage and consolation from a visit to Cagnes whenever his own problems threatened to get out of hand.

Renoir for his part was well aware that he owed his unexpected late flowering in part at least to Matisse, who had transformed his last years by finding him a new model in the winter of 1917–18. She was Andrée Heuschling, a seventeen-year-old refugee from Alsace looking for work at the Nice art school, where Matisse recognised her plump graceful figure, red hair, pearly skin and wide catlike smile. "You're a Renoir," he said, packing her off on the train to Cagnes.[3] Dédée's gaiety revived Renoir, and she glowed in turn in the warmth of his inner vitality. Her lively, generous, affectionate presence animated the whole household. It also eased relations with Matisse, whose first visit, on 31 December 1917—his forty-eighth birthday—had been a sticky affair, according to his companion George Besson, who remembered the older painter's amazement at the younger's extreme formality ("It was rather like Rubens in the role of ambassador presenting his credentials to some aged Pope," Besson wrote cattily).[4]

In fact, this semi–state visit brought back memories that still rankled with Renoir of the days when the wild young King of the Fauves had deliberately set out to overturn everything the Impressionists held dear.

Matisse told his wife that the great man apologised indirectly later for his prickliness during that first encounter with Besson. At the time, Matisse had been paralysed by nerves. He went back again with his newly finished self-portrait to show Renoir how far he had changed since the Fauve years, but it was months before he plucked up courage to bring more work for inspection, and even then he almost gave up the idea, tossing a coin in the street to decide whether or not to leave for Cagnes with his roll of canvases. Matisse's lack of confidence, inconceivable to people like Besson, was only too obvious to Renoir. "You're talking to someone who hasn't perhaps achieved anything much," he said reassuringly after looking at Matisse's work, "but who has managed to produce something that's absolutely his own. I worked with Monet, and with Cézanne for years, and I've always remained myself."[5] Matisse confessed in return that however great his self-doubt, he always knew he hadn't a hope of painting any other way. "Well," said Renoir, "that's exactly what I like about you."

At the end of the 1918 season, when Matisse stood packed and ready to leave for Paris, he brought over a batch of his most precious possessions, feeling, as he said himself, like a Nawab spreading out his treasures before his host. They included Cézanne's little *Bathers,* a couple of Renoir's own canvases ("He said he was truly moved—people generally bring out horrors painted by me, but I'm happy with these"), and Courbet's *Sleeping Blonde* ("He was astonished, and said he wouldn't have believed Courbet could paint a masterpiece").[6] Renoir responded to one painterly gesture with another, proposing an exchange of canvases when the younger artist tentatively asked if he might buy one. Matisse, who had learned much as a student from Pissarro and Monet, and who revered Cézanne all his life as a god of painting, still thought of the Impressionists as belonging to another world. Even in his prime he could not quite put himself on an equal footing with Renoir—"I'm truly touched but I can't accept," he said, "I'm not worth it"—although Les Collettes was the nearest he got to a second home in his first unsettled years in Nice.

He came regularly in the early evenings to sit with the old man, who was gripped as the light faded by dread of the night's suffering ahead. They swapped gossip, told frisky stories, compared notes about their beginnings (Renoir said he had spent the proceeds from his first picture sales on a sack of haricot beans to feed his children). Sometimes Matisse came for lunch bringing friends like Marquet and the young Halvorsens, who were often in Nice staying with Greta's father, a retired Swedish ambassador. Walter had relaunched himself as a dealer in wartime ("You remind me of a lion tamer in the middle of the cage," Matisse told his ex-

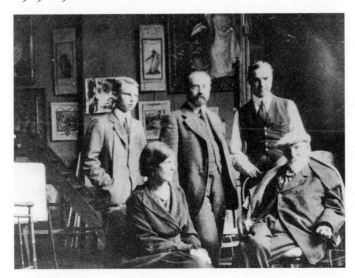

In the studio at Cagnes-sur-Mer, 1917: Greta Prozor and Auguste Renoir seated, with Matisse standing between Claude and Jean Renoir, photographed by Walter Halvorsen

pupil, warning him to watch his back).[7] Renoir rashly agreed to part with a couple of works over lunch, complaining to Matisse afterwards that he had palpitations three nights running for fear of what Ambroise Vollard might say. The two painters had developed a comfortable system of mutual sniping and support by this time. Matisse brought his wife to Les Collettes together with Marguerite, who was the same age as the middle one of Renoir's three sons, Jean. Invalided out of the army like his elder brother Pierre in the first twelve months of the war, Jean had come home to look after his father and recover from a near-fatal leg wound. The youngest boy, Claude, a year younger than Pierre Matisse, was still a schoolboy. Matisse, who had one son waiting to be posted to the front and another about to be mobilised when he first came to Cagnes, understood the helpless fury behind his friend's sardonic solution: "Renoir said it should be the old and infirm sent to die in holes, not the young with their lives before them."[8] Painting was all they could do. They discussed technique, reputation, posterity, the whole question of shifting focus and vision that had been the main battlefield for their two generations. Matisse explored Renoir's work and produced his own latest canvases, describing his misgivings and the panic attacks which his host assured him never let up. Renoir objected to Matisse's pure, strong colours, which contradicted Impressionism's fundamental beliefs about nature so flatly as to be, in Alfred Barr's words, "almost sinful."[9] He was especially indignant about a preposterous slash of black paint, representing a curtain rod in a painting of Matisse's hotel bedroom, which stayed in place when it ought by Impressionist rules to have disrupted the whole composition. Matisse

explained long afterwards how he did it, in a famous passage outlining the work agenda of his first decade in Nice:

> It's through a combination of forces brought together on canvas, which is the particular contribution of my generation. And it's also, I think, the feeling of space that I always get from observing the models, and that even makes me put myself into the space. This space is constructed from a convergence of forces that has nothing to do with the direct copying of nature. It's difficult to explain more fully because, with this sort of construction, a large part is down to the mysterious workings of instinct.[10]

As always when instinct showed signs of getting out of control, Matisse needed someone to help him stand back and assess his work critically. Renoir, taking over from Prichard and the young Cubists a few years earlier, forced him to articulate what he was doing as he tried once again to tear himself free of the immediate past. Arriving in Nice a month after the end of the war, Matisse had taken a room overlooking the sea in the little old Hotel de la Méditerranée, sandwiched between two more grandiose giants, the Hotels Royal and Westminster, on the promenade des Anglais. After four years of chaos and disruption, he had no time to waste. The exuberant New Year greetings he sent his wife at the start of 1919 already included a sketch of the basic elements—the dressing table, the balustrade and the swagged muslin curtains framing the bedroom window—with which he would construct and reconstruct painted spaces that broke all known rules of pictorial correctness.

On 2 January a freak storm broke over Nice. Seas pounded up onto the front, pouring across the promenade and turning the street into a rushing grey river. Winds tore off the hotel shutters, smashed the windows and shattered a big mirror in the entrance hall. "It's so extraordinary that I haven't enough eyes to take it all in," Matisse wrote to his wife next day, painting the scene from his window with hands that still shook from elation and shock. The luminous, rain-washed atmosphere after a storm always exhilarated him. The main reason he gave afterwards for coming to Nice was the Mediterranean sunlight: clear, silvery and soft in spite of its phenomenal brilliance. He said he couldn't believe his luck when he first realised he would open his eyes every morning on the same light. Now it seemed not only beautiful but cleansing and liberating. With its steady, unchanging light and its sense of being somehow insulated from the rest

of Europe, Nice provided the pictorial equivalent of laboratory conditions in which to reshape the future.

To a Parisian, the town was an outpost at the back of beyond. Even the port of Marseilles at the height of its wartime activity had seemed like a different country at first to Matisse's northern eye and ear. "It's theatre wherever you look," he said, describing the dramatic gestures and emphatic speech of the street-sellers, "or rather a circus."[11] Nice—culturally isolated, physically intact, geographically cut off from both France and Italy by mountains and sea—seemed to have slept through the war. "Nice is utterly *Niçois*," Matisse told his son Jean. "I feel myself a complete foreigner here."[12] His sense of unreality was heightened by the old-fashioned décor of his hotel room: pink-tiled floor, rococo plasterwork and an Italianate painted ceiling lit from below by sun reflected off water, intensified and directed through shutters like stage lighting. Its artificiality ("Everything was fake, absurd, amazing, delicious")[13] served his purpose as much as its anonymity. "Matisse is always the great devil who jumps up out of the box again as good as new," wrote Besson, who watched him start the process of reinventing himself as an artist in Nice.[14]

Impressionism, which had effectively blocked off the future in the

Matisse, *Interior with a Violin Case*, 1918–19

Fauve years, now suggested a way out of Matisse's current impasse. "Renoir's work saves us from the drying-up effect of pure abstraction," he said, explaining to an interviewer in 1919 that once you have explored as far as you can go in a particular direction, you must change course, if only as a matter of hygiene.[15] Consultations with Renoir were always about work in hand (except that once Matisse sent home for a key transitional painting to take to Cagnes, *Lorette in a Green Robe on a Black Background*). From now on the problems resolved with such labour in the great radical canvases of 1916–17 ceased to interest him. One of the things that struck Halvorsen most about Matisse in his first two seasons at Nice was how calmly he accepted the prospect of seeing almost his entire life's achievement to date engulfed by the general tide of destruction. "He watched everything collapsing around him. . . . The great collection of Matisses on show at the Steins had been sold. Of all the work he had produced in the ten years before the Great War, nothing remained. But no sign of all this showed in Matisse's face."[16]

By 1919 external events had drastically extended Matisse's own instinctive stripping back. Of his key pre-war supporters who survived the war in Europe, Prichard had been broken by his years as a prisoner in Germany, Sembat was ill, with only a few more years to live, and the faithful Purrmann found himself stranded on the far side of a gulf almost impossible for Germans to cross in the rancorous first years of a precarious peace. Purrmann's last great service was to retrieve the Berlin canvases at the end of the war and return them to Sarah and Michael Stein in Paris, but his efforts came too late. By the end of 1918 the Steins had secretly sold the paintings, apparently in a fit of financial panic, for a knockdown price to an elderly Dane whose persistence matched his shrewd eye for a bargain.[17] Scandinavian neutrality, coupled with the unusually sophisticated visual understanding promoted by Matisse's Scandinavian students, had produced a booming modern-art market for local speculators prepared to back their own nerve and judgement, like Christian Tetzen-Lund, who snapped up the Steins' collection. But the transaction meant that at the start of the 1920s the only place in Europe to see a representative collection of Matisse's work in the run-up to modernism was a private apartment belonging to a retired feed-and-grain merchant in Copenhagen.

Matisse himself had accompanied Halvorsen on one of several unsuccessful attempts to intercede with the Steins, whose evident embarrassment and strenuous denials were as dismal as the spaces on their half-empty walls. But there was nothing Matisse could do about even more worrying developments in Russia. Rumour in Paris said that his

Dance and *Music* had been burnt or otherwise disposed of after the Revolution of 1917. In fact, Shchukin's house and its contents had been confiscated by Lenin himself, to be reopened as a Soviet museum with the former owner installed in a servant's bedroom and employed as guide to his own collections. Matisse, who had refused all offers for the *Interior with Goldfish Bowl* he had painted for Shchukin in 1914 ("It's part of the decoration of his drawing room"), now reluctantly sold it to Halvorsen.[18]

Shchukin left Russia a year after the Revolution, slipping out of Moscow unnoticed to rejoin his family in aimless, if relatively affluent, exile in France. He set up winter quarters in Nice, where Matisse welcomed him warmly, taking him to see Renoir at Cagnes, calling on him at his hotel and hoping for a return visit. But a chance encounter on the street, when the collector turned his head away to avoid meeting the painter's eye, made it painfully clear that this new, one-sided relationship could never replace their old, active, working collaboration.[19] In fact the two men were at loggerheads. Shchukin, believing like most Russian emigrés that the Soviet regime could only be temporary, was dismayed to find Matisse too absorbed in his present work to pay much attention to the fate of a collection from which he had no more to learn. Matisse for his part felt hurt by Shchukin's failure to respond to the struggle that consumed him in Nice.

Work monopolised him from the start. Throughout the first months of 1919, he complained that the road lay uphill, that he was toiling like a carthorse, that his labours exhausted him and made him despair. But he had no doubt that he was on to something. "As for telling you what it will be like," he wrote to his wife on 9 January, "that I couldn't say since it hasn't happened yet, but my idea is to push further and deeper into true painting." Four days later he acquired a new model. Young women prepared to pose were in such short supply that Paul Audra, the head of the art school, infuriated Matisse by sending her simultaneously to all the leading painters in the area, including Renoir.[20] Perhaps Renoir recognised a prospective partner for Matisse in this new girl at the furthest possible remove from the ample, apple-cheeked models he liked himself. At all events she was soon posing regularly at the Hotel de la Méditerranée. Antoinette Arnoud was nineteen years old, pale, slender and supple with a quintessentially urban, indoor chic and the kind of responsive intelligence Matisse required at this point from a model. Over the next two years, the two would collaborate on a steady stream of paintings and an even more remarkable series of drawings.

Matisse drew Arnoud dressed and undressed, reading or lounging

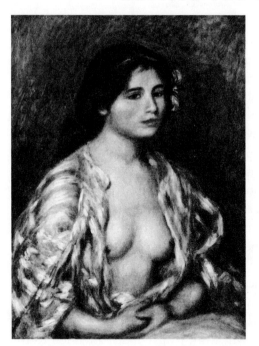

Pierre Auguste Renoir, *Gabrielle in an Open Blouse*, 1907

through their work sessions but mostly gazing gravely straight at him. In his paintings he added local accessories—a vase of anemones or carnations, a couple of lemons, a loaded paintbrush—laid out on the frilled muslin dressing-table top, with its oval mirror sometimes blank and black-faced, sometimes projecting reflections from odd angles in close-up, at others opening onto sky and sea beyond the windows of the narrow hotel room. He started a series of canvases on the theme of his model and himself at the easel ("A pale grey day, very tender pinks—," he reported excitedly to Amélie on 25 January, "and a pink rug on the floor—everything else is pearl grey, you can even see me in pearl-grey with my palette in the mirror"). In another series, he posed Arnoud on an upright chair in the open door of the balcony wearing a fashionably short, loose tunic, with a green umbrella, mauve stockings and big dark bows on her chunky high heels. In the most extreme of this sequence, *Woman with a Green Parasol on a Balcony*, light spills and splashes in streaks of muted grey, blue and black paint, enveloping an almost geometric composition—the highly stylised woman, the doorway, the balustrade, vertical strips of the beach and the sea beyond—in an austere, self-sufficient space of its own.

This was one of those major transitional phases when Matisse needed a model to humanise the ordeal of painting. He took on Arnoud initially as a stand-in for his daughter, whose health prevented her from joining him at the beginning of 1919 to continue in Nice a series of paintings started at Issy before she went into hospital. Marguerite had dressed up for him in outfits designed by Germaine Bongard, with hats—a fur-trimmed cap, a smart little toque of blue feathers, an absurd velvet bonnet shaped like a giant puffball—from a favourite milliner on the rue Royale. Now he himself produced a sumptuous confection made from a cheap

Italian straw hat with a single white ostrich plume curling and frothing over the brim and yards of blue-black ribbon looped underneath.[21] Matisse, who had married into a family of Parisian *modistes*, grasped instantly the style best suited to this latest model (who would go on when she left him to work for the smartest dress store in town). Arnoud wore the new hat with a flair and panache that made a simple white peignoir seem like a ball gown. By turns stylish, seductive and demure as a schoolgirl, she could look stately wearing nothing but her hat. As summer drew on, Matisse trimmed a second hat with flowers and took her round the headland to the bay of Villefranche, where she posed beneath a pink parasol in an old-fashioned, high-necked, long-sleeved white frock on a hotel terrace with turquoise-blue flowerpots and a blue balustrade.

Daily painting sessions alternated with hours on end devoted to drawing, a corrective Matisse would use from now on whenever he felt his work was in danger of losing its balance between colour and feeling on the one hand, and line and form on the other. At the end of this first postwar season in Nice, he told the Scandinavian critic Ragnar Hoppe that he was trying to reconquer ground he had been forced to give up for the sake of simplicity and concentration. Now he hoped to find a way of retaining clarity, concision and force without sacrificing volume, spatial depth, the individual character and texture of fur, feathers, fluff, fabric or flowers. He returned over and over again to a lace collar, drawing it first in minute detail ("each mesh, yes, almost each thread") until he had got it by heart and could translate it at will with two swift lines "into an ornament, an arabesque, without losing the character of lace, and of that particular lace."[22] The same procedure was repeated with Arnoud's embroidered tunic, her hat, hair, hands and face. Matisse was evolving methods he would use for the rest of his life. He published fifty of these drawings in a portfolio called *Cinquante Dessins* to coincide with his exhi-

Matisse, *Antoinette with Long Hair*, 1919

Matisse, *The Plumed Hat*, 1919

bition at Bernheim-Jeune in 1920. A surge of renewed energy pulses between the lines of the letters he wrote home as he drew them.

Living, sleeping and working in one small room, he had finally succeeded in narrowing his existence down to painting alone. "I'm the hermit of the promenade des Anglais," he wrote to his wife, well aware how penitential his routine looked to outsiders, "that would make a good title for Max Jacob."[23] He broke off work to select pictures and supervise their hanging by post for his first one-man show in six years at Bernheim-Jeune, returning so eagerly to his easel that he forgot all about the opening on 2 May.[24] The blatantly unnaturalistic *Woman with a Green Parasol on a Balcony* caused a minor flurry in Paris (this canvas, nicknamed "Woman with No Eyes," struck André Breton as the most significant thing Matisse had done since his masterly *Goldfish with Palette*).[25] But for the most part the new work was cheekily dismissed as old hat by up-to-date youth in the person of Jean Cocteau, who (like Renoir) had stereotyped Matisse as a Fauve painter, and knew next to nothing about what he had done since.

Apart from Arnoud, Renoir and the staff at the art school, Matisse knew virtually no one save a few fellow Parisian exiles like the Bessons, who followed him to Nice for six weeks, Count Prozor and the Halvorsens, and an old Montparnasse neighbour, the novelist Jules Romains, with whom he often took coffee after lunch. The Sembats arrived to inspect the latest canvases in May, and Marquet came over from Marseilles to keep Matisse company and do his best to subvert him with a tour of local brothels. As usual Matisse missed his family and followed their doings by post, encouraging his mother to move with her maid to Issy, fixing up his brother with an agency for Pellerin's margarine, urging Pierre to restart violin lessons and Jean to cut down on smoking.

But bleaker anxieties underlay the optimism in Matisse's letters that

spring. Decisions about Marguerite's future could not be postponed. She herself was tormented by fears that even her habitual stoicism could no longer conceal. Her father sent encouragement, advice, instructions to read less and paint more, and reminders to submit to the periodic ordeal of having her tube changed. Her doctors' definitive report in March diagnosed ongoing constriction of the windpipe exacerbated by years of wearing a metal canula, and caused by defective development that went back to the first tracheotomy.[26] The proposed alternatives were either to do nothing or to perform a final laryngo-tracheotomy in an attempt to rebuild the damaged airway. The first meant more or less slow deterioration almost certainly ending in suffocation. The second relied on pioneering techniques made possible only because of unprecedented surgical advances in wartime, but still problematic, with a record of repeated failure. This operation was eventually scheduled for late May.

The surgical procedures were risky, and the subsequent healing process even more so in an age without antibiotics. It was agreed that Matisse, always apt to make himself sick with fright where Marguerite was concerned, should stay well away, returning only after the initial intervention, when she would need all the support she could get to see her through convalescence. "Until very soon, dear Marguerite," he wrote in May. "I dearly hope this will be the last station of your Calvary—say that to yourself over and over." Amélie, as devastated as her husband by Marguerite's predicament, was her old calm, confident self in a crisis. Pierre stood in for his father, taking three weeks' leave from a new regimental posting in Paris so as to be able to drive his mother and sister to and from hospital. The Matisses' regular doctor and his wife, both family friends, offered private and professional backup.

Amélie kept the exact timing of the operation from Henri, contacting him the same day to let him know things had gone well so far. "Be patient," he wrote immediately to Marguerite, whose tendency to despair he understood only too well. "You've already come through so much, almost by accident, that you can't give up now you've embarked on a meticulously planned procedure that has already been tried out, and succeeded several times. I don't think your surgeon would risk having a failure on his hands."[27] Apprehension was swamped by tidal waves of relief. Matisse told his daughter it took real courage to finish his painting season in Nice, when he longed to be with her in Paris. She still had to breathe through a temporary tube that was due for removal, if all went according to plan, once her throat had healed sufficiently for a further graft of cartilage to close the hole in the windpipe. "Remember the anxiety we went

Matisse, *Tea in the Garden*, 1919

through this time last year over the tube in my larynx," Marguerite wrote in retrospect, describing the submerged nervous tensions that had built up at Issy through the summer and autumn, when no one dared mention how much might yet go wrong.[28]

But relief was still uppermost when Matisse returned home at last, having paid what he must have suspected was his final visit to Renoir, who told him he meant to finish his *Bathers* before he died ("And, in fact, that's what happened," Matisse said with approval long afterwards).[29] He reached Paris in the week of the official victory celebrations that engulfed the city on 28 June. "I'm the happiest man in the world," he told the Swedish interviewer who caught him at his sunniest and most expansive that month.[30] He gloried in the flowers in his garden, painting poppies going off like fireworks and a brilliant bouquet for Bastille Day on 14 July. The whole family regrouped, including the dog and the accommodating young model Matisse had brought back from Nice. He captured their mood of serenity in the last great work he ever made at Issy, a painting of his daughter, gentle and relaxed in a summery frock, cradling the cat and drinking lemonade with Antoinette Arnoud at a pink marble table under the nut trees in the back garden.

Tea in the Garden is a pastoral idyll full of rustling movement and dappled light. Matisse picked a canvas roughly similar in size and shape to the other great decorative compositions set at Issy over the past decade, from *Harmony in Red* to *The Painter's Family* and *The Music Lesson*. The grouping is jokey and informal, the palette soft and low-keyed, the treatment straight-

forward except that, when the painter came to his daughter's face, his brush jerked back to the old, fierce, expressive habit of abstraction. Like practically everything he did, Matisse's *Tea* was at once too literal-minded and too sophisticated to please its public. Bernheim-Jeune claimed they could have sold the picture forty times over if it weren't for the dog looking up from scratching her fleas, and the unsightly blur distorting Marguerite's features.[31] Perhaps potential customers sensed the elegiac undertones in a picture that marked multiple farewells: to a style of painting that had served its purpose (the tea table—up-ended, flattened and severely dysfunctional in the *Pink Marble Table* of 1917—now resumed its familiar three-dimensional format); to the house and garden that had generated so many masterpieces; and to the life the family had led there together.

Serge Diaghilev and Igor Stravinsky turned up one day in early summer to commission sets for the Ballets Russes. Matisse, who had already turned down their proposal and had no intention whatever of changing his mind, was seduced in his own living room at Issy partly by Diaghilev—a man whose charm could revive a corpse, according to the London impresario Charles B. Cochran[32]—but partly also by the images projected on his internal screen as he listened to Stravinsky strumming out themes at the piano from *Le Chant du rossignol*. The Russians envisaged something richly Oriental, preferably barbaric, probably in black and gold, but Matisse saw Hans Christian Andersen's Chinese fairy tale as a myth about resuscitation and renewal, "spring-like, very fresh and youthful, and I couldn't see what on earth that had to do with black-and-gold sumptuosity."[33] He imagined the central confrontation between Death and the Nightingale in terms of simple shapes, clear light and pure colour. "Well, that's it!" cried Diaghilev, when the painter outlined his idea. "There's your décor all settled.... It's absolutely essential you do it...there's no one but you who could do it." Diaghilev swept out in triumph, ignoring his host's feeble protests. But Matisse by his own account was haunted over the next few weeks by his vision of the life-giving Nightingale, and grew increasingly impatient to hear again from Diaghilev.

The upshot was that Matisse agreed to design the *Rossignol* ballet for an opening at the Paris Opéra in the New Year alongside Picasso's *Tricorne* and André Derain's *Boutique fantasque*, a spectacular triple coup to mark the Ballets Russes' peacetime comeback. Diaghilev returned to the company's current headquarters in London to prepare for the start of their autumn season at the Empire Theatre, Leicester Square, on 29 September. Matisse apparently heard nothing more from him until he was summoned by

telegram for an urgent consultation that autumn. He crossed the Channel reluctantly, on 12 October, only to be confronted with an ultimatum: Either he stayed put in London long enough to design and deliver the *Rossignol* sets, or the company would manage without him.[34] He and Diaghilev went through the same routine as before, a pattern of outrageous demands, determined resistance and rapid capitulation that set the tone for a collaboration rooted, on Matisse's side, in resentment rising to crescendos of rage and loathing. "Diaghilev is Louis XIV" was his final verdict, delivered with hindsight in the relative calm of old age.[35]

Overruled, unprepared and disorientated, Matisse seemed to himself at the time to be lost in a thick London fog that was both actual and metaphysical. Speaking virtually no English ("Tell Pierre I daren't even say *yes*"), unable to buy a stamp or find his way back from the theatre to his room at the Savoy Hotel, fuming at his own folly, cursing the Ballets Russes, he was consumed by the sense that each day given to *Rossignol* was stolen from his real work, a sacrifice no man on earth could have forced him to make but Diaghilev. "You've no idea what he's like, that man," he complained to Amélie. "He's charming and maddening at the same time—he's a real snake—he slips through your fingers—at bottom the only thing that counts is himself and his affairs."[36]

Matisse had met his match in point of obstinacy, but he also recognised a creative will that, like his own, acknowledged no limits to the power of imagination. It was his own vision that Matisse could not resist, and Diaghilev knew it. The painter had come with no set designs, no precise idea where to start, nothing but an unformed concept at the back of his mind. He told his wife he felt the same blind panic as had paralysed him initially on his first trip to Morocco. He called on Prichard and William King, who recommended the Victoria and Albert Museum ("Marvels such as rugs of all kinds, costumes, carpets, faience," said Matisse, who allowed himself a whole day there),[37] and a quick tour of the Chinese department at the British Museum (the painter said it was a revelation and that his guide was a poet, presumably King's close friend Arthur Waley).[38]

But when Matisse finally got to grips with practicalities, he reverted to his own earliest intuitive beginnings, building himself a toy theatre out of a wooden crate as he had done more than thirty years before as a schoolboy in Bohain. This time the packing case was a scale model of the Empire Theatre, with state-of-the-art electric lighting specially fitted in the lid by the stage carpenter.[39] Matisse chose sky blue as before for his décor, essentially a brightly lit space with props and costumes once again

cut out of coloured paper. Diaghilev's Russian set painter was amazed by the Frenchman's unorthodox methods ("He set to work in the studio, scissors in hand, cutting out and piecing together a model"),[40] and by his ignorance of conventional stage technique.

Matisse said he conceived his décor "like a painting, only with colours that move."[41] The moving colours were the costumes, embroidered with strips of silver or dotted with yellow flowers to act as what he called light splashes. His lighting effects were painterly rather than mechanical, relying relatively little on the still crude and primitive resources of electricity. He devised what the only surviving detailed, firsthand account of this ballet described as "a hundred ingenious, elegant and logical ways" of using colour to make light. The curtain rose on sixteen dancers with painted lanterns, vermilion outside and lemon yellow inside to render them luminous ("more so than an electric light-bulb") against the turquoise backdrop. The warriors' armour was black ("the blue-black of a crow's wing, since a pure black would look reddish"). The mourners in the final scene on a darkened stage wore light-absorbent white felt robes decorated by midnight-blue velvet triangles, "which spread gloom over the whole décor." The final coup de théâtre was a more sophisticated modern equivalent of the burning sulphur of Matisse's boyhood. Andersen's story ends with the song of the nightingale breathing life back into the dying Chinese Emperor. Matisse proposed that the Emperor should rise from his dimly lit deathbed and reverse his black cloak to unroll a gold-embroidered crimson lining twelve feet long on a stage inundated by a blaze of electricity under a billowing white skycloth cut in great black-edged festoons to give, in the painter's own words, "the impression of a crystal ceiling lit by the full white light of day."

By the end of his first week, Matisse was working from nine in the morning until late at night, too busy to write home or walk round the back of his hotel to look at the Thames. He worked in the company's scene-shop at the top of the basket store belonging to the Covent Garden fruit-and-vegetable market. The only way to reach it was by climbing a long, narrow ladder in the dark, clutching a rope rail in one hand and a lighted taper in the other. One night flames from a building on fire in the market lit up the whole loft. "Look," said Matisse, "the pink reflections turn orange against my blue. What if I made my costumes pink . . ."[42] Diaghilev and his choreographer, Léonide Massine, called daily to inspect the work, take Matisse out to lunch, calm his fears and test out his ideas in the theatre itself. When his colours didn't work on stage ("What looks good in the daytime looks wrong after dark, and vice versa"), they spent

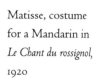

Matisse, costume
for a Mandarin in
Le Chant du rossignol,
1920

the rest of the night discussing the problem with him. Matisse had got on well with Massine from the start, and now his distrust of Diaghilev was overlaid by unwilling admiration. "You can't imagine what it's like, the Ballets Russes—there's absolutely no fooling about here—It's an organisation where no one thinks of anything but his or her work—I'd never have guessed this is how it would be."[43] His ordeal ended with a six-hour session in the scene-shop (Diaghilev, who was out to lunch, sent over a slice of smoked salmon to keep Matisse going), by the end of which the décor was done. "They're enchanted," Matisse wrote to his wife on 24 October. "Now all that remains is to paint it to scale, and do the costumes."

He returned to Paris with Diaghilev and Massine at the beginning of November to discuss costumes with one of France's top theatrical costumiers, Marie Muelle, who announced that the Emperor's cloak alone would take her team of embroiderers three months to complete. Matisse replied he could do it himself in three days by laying the red stuff on the floor, cutting an imperial dragon out of the kind of ready-made cloth-of-gold sold in department stores, assembling the different sections and tacking them down. The only designer in Paris prepared to connive at this monstrous violation of the laws of haute couture was Paul Poiret, roped in by Diaghilev, who found himself worsted for the first and only time by Matisse on their first day in Poiret's workshop. The painter spotted a fabulous, and fabulously expensive, roll of red velvet, ruthlessly overriding the impresario's pleas that he had already bought the fabric ("You showed me a sample of cotton velvet in a fake red, a dark velvet, a dead velvet that didn't sing at all").[44] Matisse took his shoes off and mounted a vast cutting table "like a trampoline," with the velvet spread out beneath his bare feet, shaping and placing his scraps of gold stuff, attended by four or five of Poiret's assistants to pin and stitch at his direction. The great cloak was finished in two days. Matisse looked back with pride afterwards on this heroic feat, adapting the method for the huge wall decorations commis-

sioned twelve years later by the Barnes Foundation in America, and revert-
ing to it again at the end of his life for the stained-glass windows at Vence
and the majestic cut-paper works that followed.

Matisse returned to London for an opening of his own on 15 Novem-
ber at the Leicester Galleries, opposite the theatre: a modest show of
recent small paintings which sold out almost immediately, to his own and
the owners' surprise. "These English are mad," said Matisse, as he
watched one of them buy seven of his works in a single swoop.[45] All Lon-
don came, from Vanessa and Clive Bell, Duncan Grant, Maynard Keynes
and the rest of what was about to become the Bloomsbury set to Arnold
Bennett, pillar of the opposing faction (who bought a drawing), and the
future head of the National Gallery, Kenneth Clark (then a seventeen-
year-old schoolboy unable to sleep for excitement). Over the next few
days the gallery and its quiet, friendly, unassuming proprietor, Oliver
Brown, provided a haven of refuge from Diaghilev, who now precipitated
a final explosive showdown that began with Matisse threatening to walk
out, and ended with him meekly agreeing to paint a drop-curtain nine-
teen metres wide. "I daresay he'll change his mind when he sees the cur-
tain," Matisse wrote grimly, planning to curb the Russian's taste for
eye-catching excess once and for all by cutting back on his reds and blues,
and eliminating yellow altogether from what was essentially a minimalist
design in black and white.[46] He sketched it out in five days flat before
catching the boat-train for Paris, and left the scene painter to finish the
job.

Matisse could not get over the waste of two months' good working
time given up to London's impenetrable mists instead of the Mediter-
ranean sun. He got back to Nice at last on 12 December, just too late to
see Renoir, who had died the previous week. The Hotel de la Méditer-
ranée had let his old room, so he had to move into another, with no bal-
cony. At the end of the month, Arnoud found a better job and gave up
posing, leaving him to make do with her larger, plainer, round-faced sister,
who turned up irregularly and had none of her sibling's finesse. Matisse's
mother was ill in Bohain, and his daughter's condition increasingly precar-
ious in Paris. The ballet continued to give trouble, forcing him back to the
capital to supervise costumes for a week before the première, which was
postponed at the last minute by an orchestra strike. When it finally
opened on 2 February 1920, *Rossignol* fell flat. The fashionable Parisian
public, enchanted by the gaiety and throwaway wit of Derain's *Boutique fan-
tasque*, beginning to get the hang of Picasso's crazy Cubistic visual wise-

cracking in *Parade*, could make nothing of dancers treated as moving colours in Matisse's bare, light-filled, sky-coloured space.

In the aftermath of 1918 people wanted to be charmed, cheered and distracted, not confronted with a fable about life and death operating, as Marguerite said in an attempt to console her father, "on a level altogether more serious, with more depth and nobility."[47] Looking back later, Matisse identified the *Rossignol* première as the first time the Cubists ganged up on him ("All the people who usually said hello to me turned their backs").[48] Diaghilev, furiously indignant on his designer's behalf, blamed the ballet's failure on its choreography. Although Matisse made sure the two never worked together again (the impresario died before he could finish testing his theory that, even if the painter refused to collaborate forty-nine times, he would agree on the fiftieth), he would do justice later to Diaghilev's courage, and his horror of taking the easy way out. Each of them understood only too well the fate of the Chinese Emperor, who loved the true song of the nightingale so much that he pined to death when his courtiers insisted on substituting a more impressive, jewelled and gilded mechanical bird whose song was reliably bland and always the same.

At the time, the *Rossignol* fiasco was overshadowed by worse catastrophes. On 25 January, a week before the opening, Matisse's mother died in Bohain. It was exactly fifty years since she and her husband had first opened the seed-store with a section selling paints, where the young Henri had watched his mother weighing out coloured pigment for her customers before mixing it with turpentine and linseed oil. Her love of colour had launched him as a painter, and her support had been unconditional ever afterwards. Matisse was preoccupied with mourning and a sense of mortality intensified that winter by an approaching crisis in his daughter's struggle for survival. Marguerite endured constant pain, dizziness, and swellings that blocked the airway and prevented her from speaking as her body successively rejected the rubber or metal contraptions intended to keep her breathing hole open long enough for the reconstructed larynx to stabilise. By the beginning of 1920, she had been waiting under severe and increasing strain since the previous summer for the decision to close the aperture. When her father went back to work in Nice at the end of February, Marguerite hoped against hope that the whole affair might be over before his return. Mother and daughter retreated into themselves, huddled together in the apartment on the quai St-Michel, concealing their worst fears from each other, glossing over their desperation to the outside world, pursued by tart comments about the interminable fuss and the spiralling cost from beady-eyed relations, especially Amélie's aunt Nine ("I think

she sees the figure 6,000 written in the air over my head," wrote Marguerite who, like her father, could crack jokes even in the jaws of death).[49] After endless cat-and-mouse postponements, her surgeon finally performed the operation in late spring, monitoring her even more closely afterwards for fear the larynx might contract yet again.

The year 1920 saw the end of an era for the whole family. Maman Matisse's house was to be sold, her possessions cleared out and the seed-store given up so that Auguste, always a lacklustre businessman, could retire on the proceeds. Henri Matisse never went back to Bohain, nor to his birthplace of Le Cateau. It was his wife who stayed on to wind up her mother-in-law's affairs after the funeral, and his daughter who from now on would pay regular visits to oversee the family's remaining property, deal with lawyers and sign the deed of sale on the house four years later. Matisse would build a new life in the south.

Not that his plans were clearcut at this stage. When he returned alone to the Hotel de la Méditerranée in February, he meant to stay no longer than was necessary to finish off his disrupted season, having already discussed with his wife the possibility of the family moving south at a pinch, if work forced him to come back next year. "Nice gets more and more boring, and I'm alone here when I ought to be with you all—I hope this will be the last time," he wrote plaintively in March. "I have to remind myself how little I should get done in Paris, so as to get up the patience to stay here."[50] He had persuaded Arnoud to pose for him again, but, although he drove himself to the brink of exhaustion, he was restless, dissatisfied and still unsure what sort of turning point he had reached in his work.[51] He said that before he could come home, he needed to make sufficient progress to be clear about the route he was taking.

At the end of April, he posted off seven canvases, all but one so out of character that the family had no idea how to respond ("On arrival, we preferred the figure with a bunch of anemones but then little by little the others, which seemed more lightweight, took on their own existence, and grew stronger," Marguerite reported cautiously).[52] These pretty girls in brightly coloured interiors with frilly curtains and sun pouring through the window mystified even Matisse himself at first. But by the time he left Nice in May, he had recognised an underlying consistency that would continue to elude the rest of the world for decades to come. Among the objects that resurfaced at Issy from his mother's house in Bohain were the first two pictures he had ever painted, homely little still lifes of books and candles in the earthen colours of the traditional Flemish palette. Far from feeling that his switch to the south marked a total break with the past,

Matisse said it gave him the shock of his life when he saw them to realise that after twenty years of unremitting exertion, his essential identity as a painter had not changed in the slightest.[53]

Marguerite's recovery was the family priority that summer. As soon as her doctors let her leave Paris, Matisse took his wife and daughter to recuperate in sea air at Etretat in Normandy on the Channel coast. They booked into a beach hotel for a month. Matisse produced rapid oil sketches of exultant vitality, painting the boats, the sea front and the bay with its curious cliff formation that had appealed to so many of his predecessors. "I've been at Etretat for two weeks now amid green-topped white cliffs beside a tender blue and turquoise green sea," he wrote on 20 July to his Nice companion, Jules Romains, "from which I can see emerging superb creamy-white turbots, iron-grey dogfish, lesser spotted dogfish and skate, skate all over the harbour."[54] He bought the pick of the daily catch, paying a boy to water the fish from a bucket as they posed for him, and tipping them back into the sea afterwards.[55] The sleek, lithe, powerful creatures in his canvases, thrashing their gleaming tails on beds of seaweed, are as energetic and alert as the painter himself. "They are amazing," wrote Roger Fry, who saw a batch of these fish pictures on show in October at Bernheim-Jeune. "His certainty and invention are almost uncanny. They're almost intoxicating to look at."[56]

But the canvas that reveals most about Matisse's feelings at Etretat is a little painting of Marguerite, whose exhaustion was frightening. After living under threat for so long, she allowed herself to collapse at last and be put to bed, where her father painted her for the first time without the black band she had worn since childhood to conceal the opening in her throat. She lies asleep, looking like an illustration from a child's fairy tale—rounded swan-like neck, long lashes outlined on a pale cheek, dark hair spread on the pillow—in a canvas whose surface sweetness is undercut by the troubling mauve pallor and the dark patches circling the eyes of this real-life sleeping beauty. The artless innocence of

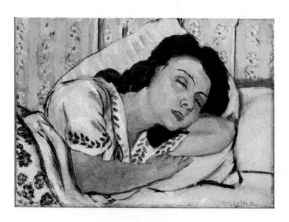

Matisse, *Marguerite Asleep*, 1920

Portrait of Marguerite Asleep contains the same fierce emotion as the first picture Matisse ever made of his daughter, the 1901 *Portrait* showing her as a vulnerable six-year-old with staring black eyes in a white face. When they got back to Paris in August, Henri and Amélie hung the new painting over their bed.[57]

Pierre Matisse, *Portrait of Amélie Matisse*, 1921

The three of them now set out by car, with Matisse at the wheel, for the ancient spa town of Aix-les-Bains in the Savoy, where the two women were to take the cure while Henri turned back again to complete unfinished business in Normandy. Amélie received a rapturous list of fresh fish—"one lobster, one bass, one codfish, one conger eel, one long blue fish like a mackerel, two oysters and two little skates the size of this sheet of paper"—emerging from the waves to be painted.[58] Matisse would visit Etretat once more, alone, out of season the following summer. It was a last return to his roots in northern realism, a confrontation with Courbet in a setting which both had painted, before he committed himself wholly to an unknown future in Nice.

At the end of September 1920, he headed south again, picking up Amélie from Aix and moving with her into roomier quarters on the first floor of the Hotel de la Méditerranée with French windows and a terrace above the bay. She was near collapse herself by this time. "I felt wretched to see her in such a state of misery and fatigue," Marguerite wrote to her father, "for at bottom I know I'm the cause, involuntary it's true, but all the same it's me that got her into this state of fatigue."[59] Mother and daughter were paying the price for two years of mutual strain, fear and deception ("for we couldn't admit what we were going through, even to each other").[60] Worn out by successive upheavals—coping with the effort and danger of war, dismantling a whole way of life in Bohain, providing Marguerite with intensive care—Amélie sank back into depression.

Marguerite meanwhile was moving slowly and shakily towards full recovery. She was right when she told her son long afterwards that the

1914–18 war had saved her life. Patients who survived serious damage to the breathing mechanism, let alone resumed anything approaching a normal existence, were virtually unheard of in medical history. For her surgeon, Dr. Hautant, this case was a triumph: he called her *l'enfant chéri,* the precious child, and treated her like a flower in his buttonhole.[61] The three young Matisses now took over the apartment on the quai St-Michel. Jean, newly discharged from the army and looking for work, enrolled for a part-time course at the Ecole des Arts et Métiers. Pierre already had his first job (technically still a soldier, having enlisted for a four-year stint rather than wait for conscription, he had been seconded at the end of 1919 to Clemenceau's private secretariat in Paris). Marguerite took charge of the household, running her brothers as she always had done and beginning at last to catch up with the pleasures of being young in peacetime, dancing, dressing up, going out with the boys and their friends. Fragility made her flame burn more fiercely ("She's truly the life and soul of the house," said Jean in an uncharacteristic burst of emotion).[62] Over the next few years all three set about painting in earnest, starting out in the same place at the same age to follow in their father's footsteps.

Family life fell into a regular pattern based on Matisse's season in Nice, which lasted from early autumn to late spring or early summer interspersed with visits from his children working in Paris, while Amélie shuttled between the two households, and everyone migrated each summer to Issy. Henri was disconsolate each time Amélie left him ("Everyone else is going out to celebrate, and I'm writing to you all before getting off to bed," was the first line of his letter home on Christmas Eve, 1920). In these first years he signed himself "Henri no news" or "Henri Matisse— *le vieux solitaire,*" which, as he pointed out to his wife, could mean not only a recluse or hermit but also a lone wild boar.[63] Bitterly as he complained about his solitude in Nice, he never seriously reckoned it too high a price to pay for the richness and intensity of the life he was leading on canvas.

Other people, at the time and since, detected frivolity, weakness and backsliding where Matisse saw only a steady push forward, with periods of exploration and experiment followed by consolidation. "As for my work, there's only one thing I can say," he told Amélie on New Year's Day, 1921, "I'm searching for the density of things—instead of reducing what I see to a silhouette, I'm trying to convey volume and modelling." He discussed each stage with his wife and children, especially his daughter, whose sharp eye could be counted on to miss nothing. It was Marguerite who pointed out that each phase of strenuous, studious observation paid off in a burst of almost inconceivably audacious colour, which in turn enhanced the

luminous subtlety of Matisse's alternative low-key, brown-and-grey, northern palette; and Marguerite who first grasped that *French Window at Nice* (one of the batch of paintings that had baffled the family in the spring of 1920) had to do with the power and softness of the light investing the hotel room and everything in it with what J. D. Flam called, more than seventy years later, "an almost gothic splendour."[64] This majestic canvas (colour fig. 20), which shows Arnoud flanked by tied-back grey curtains like pillars at the foot of a tall, blue-shuttered window towering above her like a vault, was known in the Matisse family as "the Cathedral."

This is perhaps the grandest of the Nice hotel paintings. Where once the windows in Matisse's pictures opened onto an unattainable world of light and colour, here the sea front glimpsed through the wooden shutters is undeniably real with its palm trees and passers-by. Now it is the interior that has taken on magical qualities. "First, this room was smaller than I had supposed," wrote Jules Romains' friend, the poet Charles Vildrac, describing his surprise on meeting Matisse in his makeshift studio at the Méditerranée. "From certain of his pictures, I had formed the impression that you could walk freely in it, with long strides, or dance with ease." Vildrac felt as if the room, with its tall, round-headed window, its drapes and its clutter of furniture, had not only contracted but dulled over and lost some indefinable grace. "The painter . . . had lent it a soul that in reality it did not have. Certainly it was a pleasant hotel room, but with the soul of a hotel room."[65]

With Arnoud—sometimes solemn, sometimes coquettish, but often bored, listless, even mutinous in these canvases—there was clearly a limit to how far the transformation process could go. For the public, the abstract compositional quality of Matisse's paintings at this stage was more or less completely obscured by the lifestyle they depict. *French Window at Nice* shows a young girl with bare legs and long loose hair, wearing a transparent top and scarlet harem pants, seated beside the bed in the painter's hotel room. People drew the obvious conclusion from the fact that Matisse posed Arnoud and her two or three substitutes amid all the trappings of an affair, endlessly painting one or other of them wearing a slip at the dressing table, seated in a wrapper over a breakfast tray, or newly emerged from the bath clutching a towel with her hair in a turban. From *Conversation* onwards, Matisse had painted himself wearing the striped pyjamas that were his normal working gear at home in Issy and in the various hotel rooms that became his studios in Nice. Posterity has confidently discounted the painter's own statement that these Nice interiors are suffused with sublimated sexual pleasure, and that his intense state of

arousal discharged itself not so much through the model's body as through the lines and forms orchestrated on canvas around that body.[66]

In Arnoud's case, the evidence suggests that Matisse's explanation was true. In all the weekly, sometimes daily, letters he exchanged throughout their collaboration with his wife and children, there is nothing to suggest more than the usual professional tensions on his part, and no hint of friction, resentment or jealousy on theirs. Matisse and his family referred to Arnoud by her surname, and treated her as a work colleague. He painted her for the last time in *The Painter and His Model*, posting off a sketch to his wife and daughter in triumph the day after the picture was finished, 24 April 1921. In it he shows himself from the back, seated bolt upright at the easel, pyjamaed and bespectacled, in the act of sizing up his composition: an image of concentration, severe and straight as a plumb line, which Matisse had painted before in *The Violinist at the Window*. The model sprawling naked at his side contributes a note of indifference and anomie to this unsentimental valediction. Arnoud not only had a boyfriend of her own but had been visibly pregnant since the beginning of March, when Marguerite reported her condition to Amélie.[67] Later that spring she gave birth to a stillborn baby daughter ("Perhaps just as well," said Matisse, who knew all about the penalties inflicted on an unmarried mother attempting to keep her child).[68] When the two next met two years later, she was working as a fashion *vendeuse* for the Galeries Lafayette on Nice's

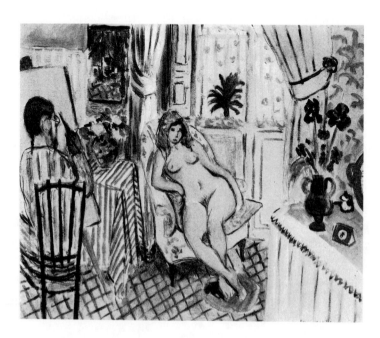

Matisse, *The Painter and His Model*, 1921

grand central boulevard, elegant as ever but "still with the same sulky look," he told Amélie.[69]

No one who knew him well at the time ever doubted that, for Matisse, models were working partners, not sexual captives. Sex was one of the things he grumbled about having to do without in Nice, quoting his doctor friend Elie Faure, who warned him that excess of chastity could be as much of an abuse as its opposite.[70] But Matisse maintained that, so far as modelling went, the same rules applied to human beings as to a plate of pastries or a fish dinner. Pressing your nose up against the cake-shop window makes your saliva run far more than slaking your appetite, he said, remembering his hungry youth. That was why he threw the turbot back into the sea at Etretat, and left his plate of shrimps untouched on the lunch table in *Pink Shrimp.* "I've never sampled anything edible that had served me as a model, even when posing didn't affect its freshness," he said, explaining that the oysters he painted at intervals throughout his life were brought round each morning by a café waiter, who returned to fetch them to serve to his customers at mid-day ("Although I savour their smell, it never occurred to me to have them for lunch—it was others who ate them. Posing had made them different for me from their equivalents on a restaurant table").[71]

Arnoud's place was filled in the spring of 1921 by Henriette Darricarrère, who had been posing intermittently for Matisse for the past six months. He had first noticed her working as a film extra at the newly opened Studios de la Victorine on the western outskirts of Nice, where Charles Pathé and the Gaumont brothers built lots on a site intended at the start of the 1920s to become the European Hollywood. He picked her out initially for her innate dignity, her athlete's carriage, the graceful way her head sat on her neck.[72] Henriette was younger but steadier and less worldly than her predecessor, which meant she fitted in far more easily with the Matisses' highly unconventional existence. She was a dancer and violinist, a trained musician with natural gifts as a painter, talents Matisse encouraged in her as in his own children.

Amélie got on well with Henriette that autumn, and so did Marguerite when she moved down to Nice at the end of January 1922 for another dose of sea air. The two girls posed together, playing chess, making music, wrapped warmly in Spanish shawls to watch the processions of the *Fête des fleurs* from the balcony. On sunny days they stood or sat on the grass to be painted under the cherry blossoms in a private park called Liserb, where Matisse had permission to work for a month.[73] Henriette's poise and fluidity, her regular features and oval face, her air of being at

ease in her body, added up to a kind of physical perfection that delighted Marguerite, and made her even more determined to get rid of her own invalid status. Henriette for her part looked up to Marguerite, who was six years older and incomparably more sophisticated, but so run-down after a winter in Paris that at first she could only pose lying on a chaise longue, or sitting on the ground out of doors ("I'm incapable of staying upright, it makes me feel I'm being cut into little pieces").[74] Matisse worked them hard, six days a week, two sessions a day with an afternoon nap in between, rewarding them every so often with a drive up into the hills to the viewpoint called La Lanterne, or to the top of Mont Boron to see the sunset gild the sea and bathe the mountains in violet vapour. Once they all three lunched at the Casino and watched a horse race along the beach.

Both parents were still exceedingly anxious about Marguerite, whose physical torpor too often looked like despair. Her father planned a carefully monitored programme of distraction and stimulation. He filled her room with red roses the day she arrived, and hung eleven new paintings on her wall to keep her company when she went to bed straight after dinner. He planned to teach her to drive, and to take her on a round of visits to friends like the Signacs, the young Renoirs at Les Collettes (where Jean had married his father's model Dédée, who would star in his first films as Catherine Hessling), and the Bussys at Roquebrune, whose house guests that spring included André Gide ("conversation particularly brilliant," wrote Marguerite, noting that Gide was one of the few French purchasers of *Cinquante Dessins*).[75] Matisse had even taken dancing lessons so that he and his daughter could try out the band at the Casino ("Papa does the foxtrot like his sons," Marguerite told Amélie, "not quite so light on his feet, but not bad. You can see he's doing everything to stop me getting bored").[76]

Within a few weeks she was eating better, losing the dark smudges under her eyes, looking, to her father's critical eye, plump, pretty and rested. Marguerite said he was as proud of her regained health and spirits as of any of his own canvases. He took her to a concert in a new dress from Mme Bongard that drew all eyes ("You can't be alone with that frock," Matisse reported with satisfaction).[77] Soon she was strong enough to attend a carnival fancy-dress party at Cagnes hosted by Jean Renoir, who cast himself as an extravagantly decadent Roman to the local police chief's severe Roman judge. There was a toreador, a Charlie Chaplin, a Japanese in a kimono but, of all the couples who danced till three in the morning, perhaps the most significant, from posterity's point of view, were the two Matisses, who went as an Arab potentate and a young beauty

from the harem. "Papa wore the green-and-gold robe with a turban on his head of gold silk striped in red and green . . . ," Marguerite wrote home. "As for me, I had loose trousers made from a length of folded stuff, an Algerian muslin top from Ibrahim, the jacket in turquoise blue silk I brought with me, and the white turban."[78]

She posed, still drooping with tiredness in her improvised costume, with Henriette bare-breasted in loose red trousers beside her, for a painting called *The Arabs*, later retitled *The Terrace* or *Odalisque on a Terrace*. Matisse had been collecting Oriental bits and pieces—waistcoats, jackets, silk robes, rugs, lamps, trays, a little inlaid table—for years from a Lebanese couple called Ibrahim, who kept a boutique on the rue Royale in Paris. He used them to improvise the kind of settings women endlessly made for themselves in Tangier from rugs, cushions, pieces of stuff and small portable tables or stools. Both Lorette and Antoinette Arnoud had been painted in the white turban before Marguerite. Matisse had sent home for it, along with an Oriental chaise longue and a Persian robe, on his return to Nice after his session in the Ballets Russes' scene-shop, which seems to have opened his eyes to the potential of costume.[79] From then on he experimented enthusiastically with Middle Eastern trousers and tops, Spanish shawls, combs and mantillas, a Venetian robe from the costumier Mme Muelle, and the Bongard outfits designed for his wife and daughter. But none of his earlier models ever made an Oriental costume look like anything but fancy dress. It was Henriette, so neat, even prim, in her street clothes, who wore the filmy open blouses and billowing low-slung pants without inhibition, becoming at once luxuriant, sensual and calmly authoritative.

The Arabs released something in Henriette that opened up new pictorial possibilities for Matisse. Marguerite twice postponed her departure so that he could finish the picture.[80] On 7 April, a week before she finally left for Paris, he drove both girls along the coast to try out their costumes in the open air beside the mosque at Antibes. They took the precaution of hiding their exotic outfits under coats, but they needn't have bothered, since the first thing they saw on entering the simple little fishing village of Cagnes was an Arab caravan with three camels and a film crew.[81] *La Sultane de l'amour (Love's Sultaness)*, shot at Liserb the previous spring, proved to be one of France's first postwar screen hits, and film-makers rushed to follow it up, erecting Moorish palaces with pools and harems at the Studios de la Victorine for more and more extravagant blockbusters like Rex Ingram's *Garden of Allah* and Alexander Wollkoff's *Shéhérezade*. Throughout the 1920s, while the silent cinema invented its own powerful daydreams at one end of

Matisse sending his car to Paris by rail, from a letter to his wife, 9 May 1921

the bay of Nice, Matisse was working with similar ingredients, taken from the same sources, on quite different pictorial illusions at the other.

Diaghilev turned up again in mid-April, coming over from the Ballets Russes' headquarters at Monte Carlo to persuade Matisse to draw Serge Prokofiev for the programme of *The Love for Three Oranges*. By this time Marguerite had returned to Paris, and Matisse's plans had been clarified. He accepted Diaghilev's proposal, driving back specially to Monte Carlo at the end of the month to borrow one of Léon Bakst's odalisque costumes from the *Shéhérezade* that had electrified pre-war Paris. It was too tight for Henriette, but the painter had got what he needed ("I saw how it was made, and I could make one like it myself").[82] The season was over and the hotels shutting down, but from now on there was no more talk of Matisse resuming the old routines at Issy. His base had shifted. He said he hoped his wife would stay with him next year, instead of leaving him to fight his battles alone. He found a two-room flat to rent beginning that autumn, sent his car home by rail (sketching himself on his knees with hands raised in prayer as the doughty little Renault was sheeted and roped to its slow goods truck), and followed it himself by fast train on 15 May.

The new flat, on the third floor of 1 Place Charles Félix, was strategically placed at the head of the flower market, below the castle and near the cathedral, in the heart of the old town within a stone's throw of the sea.

For the better part of the next two decades Matisse's existence outside the studio would be largely confined to an area roughly a mile square, bounded to the east by the rocky outcrop of the castle hill, to the south by the beach with fishing boats drawn up on the stones, and to the north by the art school on the far side of the river Paillon, where washerwomen still worked along the banks. He walked a daily beat between his lodgings in what had once been the senate house, a shabby but imposing eighteenth-century building with plaster mouldings lime-washed in soft ochre, through the market on the Cours Saleya to the Café Pomel under the pink arcades of the Place Masséna.

It was like another country after the late-nineteenth-century new town he had left behind on the promenade des Anglais. As the postwar tide of fashion receded from Nice, its imperial winter pleasure grounds stood empty, its sumptuous palaces, like the Villa Liserb at Cimiez, went on sale, and its seafront hotels began shutting off wings or closing down altogether. "It feels to them as if the end of the world has come," Matisse said of the staff at the Hotel Méditerranée.[83] He encountered the new breed of gamblers, profiteers and speculators only on rare forays to the Casino, where he went to write letters after dinner within earshot of croupiers calling 10,000 francs a throw ("It's shameful considering the way things are going this year," wrote Matisse, revolted by the ostentation of the women's jewels in the harsh climate after the war).[84] He felt far more at home, as he always had done, among people whose idea of riches was 100 sous a day (five francs, or roughly twenty cents in American money). The melancholy stagnation of the visitors' quarter contrasted sharply with the noise and activity on the steep twisting lanes behind his new flat, where the native *Niçois* lived jammed together in tall old houses with no piped water, sanitation, gas lighting or heating. There were cages of canaries and bedding hung out to air at the windows. Shopkeepers sold chickens, wine, olives and groceries in dark, narrow, windowless hutches opening off the sunlit street like an Arab soukh. Painting was a job like any other to the flower-sellers, fishmongers and café waiters who were Matisse's neighbours on the market place.

He marked the start of his new life by taking an unprecedented summer break, a leisurely drive south with his wife and daughter. They stopped off at the museum in Grenoble and at Aix, where he sampled the waters before leaving the other two to complete the cure while he drove on to Nice to take possession of the new flat at the end of August 1921. Henriette helped him unpack, and her father took charge of overhauling the car. "I've gone back to work after three weeks of laziness," Matisse

announced to Walter Pach. "It's the first time in thirty years as a painter that such a thing has happened to me.... It's as if I had never painted before, as if I had to start all over again from the beginning."[85]

He had worked for four seasons running in hotels, painting interiors whose decoration he could not alter except by shifting the furniture, introducing jars of flowers and draping lengths of stuff over the tables and chairs. Now he needed an interior he could control and manipulate. The studio Matisse set up at 1 Place Charles Félix, in two rented rooms opening into one another, was organised, quite unlike any previous work space, to enable him to change the scenery as quickly and easily as in a theatre.[86] Trunks of props, costumes and backcloths travelled down from Issy by rail. He bought nine yards of cotton material, dyed it himself and lined it with hessian to make a border for a decorative window-grille supplied by Ibrahim.[87] One of the first things he did in the new studio was to pose Henriette against it, wearing a turban and harem pants, the long, graceful, curving line of her body accentuated by the window's rectangular grid.

He found a local carpenter to make him a folding screen from an Arab portière or door curtain, a length of fabric printed with round-headed, lattice-filled archways that would feature in countless paintings over the next few years.[88] Henriette posed again and again in front of it, sometimes nude, more often wearing the exotic outfits that suited her so well, standing, sitting or sprawled at full length, alone or with a second model. *The Moorish Screen* of 1921 (colour fig. 21) combines the stylised patterns of the screen itself, the rug, the carpet and at least two wallpapers with the flowers, the two girls in pale summer frocks and the violin case on the brass bedstead behind them, interweaving colours and shapes in a single flat, patterned surface contiguous with the canvas itself. This was the fusion between realism and abstraction Matisse had proposed two years earlier to Ragnar Hoppe, a fusion that retained its subjects' identity while at the same time absorbing them within an essentially abstract and wholly imaginary alternative reality.[89]

Matisse's apartment opened out on canvas, expanding or contracting as if by magic, like theatrical or cinematic space. In it he could adjust his gaze like a tracking camera, switching filters, plunging from long to close focus, creating colour and light effects that correspond less to anything in front of him than to an invisible synthesis in his mind's eye. These unreal interiors matched the essential theatricality of Nice, a city where décor had been more important than architecture from the eighteenth century onwards, and where the 1920s saw the invention of an entirely new medium based on unreality. Matisse, along with the rest of the inhabi-

Matisse, sketch of a film sequence being shot outside the Nice Casino

tants, got used to coming across a caravanserai of sheikhs on location, or a freak rainstorm laid on by local firemen with hoses. Once he stayed out until one in the morning watching a film crew at work outside the floodlit casino, sketching the scene for his wife afterwards as a graphic linear ballet of arches, pillars and firemen's ladders criss-crossed by shafts of rain, with scurrying stick figures below, the entire maneouvre controlled through a megaphone by the director. "This interested me greatly," wrote Matisse.[90]

He recruited models at the film studios, or the café on Place Masséna where extras collected each morning in search of work. Like the silent cinema, he borrowed the make-believe settings of French painterly orientalising for ends of his own. Contemporaries who accused Matisse of slipping back into reactionary mode missed the point. So do posthumous, art-historical charges of colonial exploitation, since Matisse, like the popular cinema, positively emphasised the fact that his odalisques, with their up-to-date hair-dos and frank body language, come neither from North Africa nor the Middle East but from contemporary France. Their blatant modernity intensifies the erotic charge that distracts attention, as Matisse said himself, from other, less obvious explorations going on in the same canvas.

Chief of these was his attempt to make colour create light by exploiting what he called a thirst for rhythmic abstraction.[91] To do this he consulted predominantly two disparate sources. For at least six years after

Renoir's death, Matisse continued to visit Les Collettes to paint in the garden and go through the canvases in the studio ("I examined Renoir's paintings at leisure, and it helped me a lot").[92] Perhaps he took specific tips from the Impressionist's firm, rounded models in filmy blouses, or the Parisian women who dressed up for him as Algerian odalisques round about 1870, but what seems to have interested Matisse more than either was the way Renoir abolished the distinction between figures and background, merging the two in great surging waves of colour on canvases that hum and glow with sensuality. Matisse accompanied this chromatic crash course with structural tuition from Michelangelo, visiting the plaster casts from the Medici Chapel at the art school, and getting Pierre to order him a cast of *Dying Slave* from the Louvre.[93] In the late spring of 1922, Matisse spent mornings painting Henriette and afternoons drawing Michelangelo's *Night* ("This drawing marks real progress in my study of form, and I hope that tomorrow my painting will feel the benefit").[94]

Matisse said that what mattered with each new model was finding the pose that made her most comfortable ("and then I become the slave of that pose").[95] Henriette, who had trained as a ballet dancer, had an athletic body quite unlike Antoinette's. Marguerite maintained that the main reason her father switched models was the contrast between Antoinette's soft curves ("Antoinette was flabby, and her body did not catch the light") and Henriette's lithe, well-developed figure, which took and gave back light like a sculpture.[96] Henriette fell easily into Michelangelo's poses, relaxing quite naturally on a couch or armchair with one leg drawn up and one or both arms raised over her head. In the seven years they worked together, Matisse multiplied variations on the same theme with ferocious audacity in paintings, drawings and prints which use straight lines (as Michelangelo used architectural detail) to offset the roundness of belly and breast against window frames, screen edges, hanging panels, the angle between wall and floor.

The model stares back in moods which range from quizzical or sombre composure to almost feral abandon or the tough, masklike impassivity of the astonishing *Moorish Woman* or *Seated Odalisque with a Raised Knee*. Few would identify Michelangelo's muscular nudes as an obvious source for this big-breasted, soft-bellied houri in a transparent skirt, with rouged nipples and a fake tattoo on her forehead. Now as then, many may well feel too bemused to look closely at the exquisitely observed and miraculously painted texture of her body and legs, set against pink striped upholstery, seen through embroidered silk gauze, and outlined with flicks

of turquoise green which stabilize the composition, establishing what Matisse called its architectural underpinning, interacting with the turquoise turban and the purples and pinky mauves of the floral back-cloth in a pulsing, shimmering framework of colour.

The process drove him to black gulfs of despair, when his work revolted him and he longed to destroy it. "You know the state," Amélie wrote to Marguerite after putting up with one of these moods for three days on end.[97] Matisse, never easy to live with, could be almost unbearable at close quarters in two cramped rooms, when his wife could do nothing but tidy the studio with him buzzing round her like an angry fly, or sawing away as loud as he could on his violin. Amélie's visits in these years were constantly promised, and constantly postponed or cut short on account of Marguerite's health or her own. She would arrive from Paris, often preoc-cupied with troubles she had left behind, to find him obsessed by whichever big nude was currently demanding all he had to give ("The big nude, after surviving various tragic periods, has regained its serenity, and I tremble to see it change," Amélie reported tartly. "If ever I had any say, I'd make sure it stays as is, for I like it a lot").[98] Work now claimed him so insistently that the life his wife represented outside it came to seem less and less real. He had left her to cope with his family's affairs in Bohain after his mother's death, and when her father died suddenly in Ajaccio in November 1922, Matisse could not tear himself away from the studio even for a few days to attend the funeral. He longed for news, begged for visits, missed his wife desperately. But his schemes for returning to Paris in mid-season to see the family and catch up with one or other of his annual one-man shows at Bernheim-Jeune invariably fell through.

In the end he missed five of these shows in a row. The paintings he sent back to Paris—mostly fruit, flowers and nudes in cushioned and car-peted interiors—gave an impression of ease and comfort that conditioned the way people looked at Matisse's work ever afterwards (cf. *Nude with Goldfish*, colour fig. 22). But, to the painter himself, this fresh start in Nice felt like a more inhuman version of his harsh beginnings as a student thirty years earlier. The more generous painting's rewards, the bleaker his existence became out of working hours. He bought himself a pair of goldfish for company and painted all day, with reluctant stops for a frugal lunch of cold ham or hard-boiled eggs and a solitary dinner at a teashop or café followed by a nightly session of letter-writing. Cold weather set in hard in his first winter in the Place Charles Félix, with two feet of snow on the ground by early December. Matisse bought wooden sabots, wrote

Matisse wearing the winter night-cap in which even his goldfish didn't recognise him

home for blankets and an overcoat, and froze at night when he had to let his stove go out for fear of poisoning the model next morning with a build-up of noxious fumes.

If his paintings occupied a space and time of their own, so did he. When the nation's clocks were put back an hour to save winter daylight, Matisse confessed that he found out only twenty-four hours after everyone else. Most years he barely noticed Christmas ("For me it was a day like any other"),[99] and paid scant attention to his own birthday a week later ("In twenty-four hours I'm going to be fifty-two," he wrote in an agitated postscript to Marguerite on 30 December 1921, "*fifty-two* already!!!!"). Occasionally he took time off for one of the Renoirs' New Year's Eve parties, but mostly he wrote letters after supper as usual before going early to bed. One cold winter's night he sketched himself looking like an off-duty magician in a striped, woolly dressing gown and checked carpet slippers, with a pot of tea on the table, spectacles propped on his nose and an absurd, sausage-shaped, rabbit-skin nightcap on his head in which, as he said, even his goldfish didn't recognise him.[100]

The few friends Matisse saw intermittently were all in one way or another fugitives like himself: Romains, who had been a dashing young professor of philosophy at the boys' lycée in wartime, and returned regularly afterwards as an increasingly successful writer; various other Parisians for whom Nice provided a refuge or hideout, like Félix Roux and Gaston Modot; painters including Bussy, Bonnard, the young André Marchand and Charles Thorndike, a hospitable American who built a villa for himself, his Breton wife and his sea-captain stepson on the far side of the old port. Occasional dinner invitations from friends' wives provided Matisse's only female company outside the studio. Living alone for long stretches for the first time in his life, he put himself on a strict regime. A late riser who loved food and seldom took exercise outside the studio, Matisse in

his early fifties reversed the habits of a lifetime by forcing himself to rise at six, swim before breakfast and cut back on his lunches. In the same precautionary mode, he even accompanied Thorndike to the brothels he had so stubbornly resisted with Marquet ("They're not much fun, to be frank, and always the same").[101] He told Lydia Delectorskaya long afterwards that he patronised them throughout the years Henriette modelled for him, fitting them in dutifully and without enthusiasm ("*Tiens*, I forgot to go to the brothel again"),[102] in the pragmatic French spirit that treats sex without the rituals of courtship or chase as a bodily function no more romantic than any other. It was at this point that Matisse recommended abstinence to Romains (himself about to split up with one wife and take another), who responded with baffled respect.[103]

For Henriette, too, Matisse's schedule was gruelling. She worked with him all day every day except Sunday, shut up in the studio apart from a two-hour lunch break when the whole town closed down at mid-day ("She can't even go shopping," Matisse said ruefully).[104] Studio chores like running errands, washing brushes and making the tea were part of her routine. It was a kind of bondage, but it was also an apprenticeship. Matisse opened doors that would otherwise have remained firmly closed to an aspiring young female artist denied access to books or painting by a limited education ("She's afraid to send you a letter, not knowing how to write properly," he told Marguerite)[105] that had been broken off early in the interests of earning a living. Henriette's parents were working people from the north, and proud of it. Like Arnoud, she had a lover, an educated, middle-class boy with whom she had already been walking out for twelve months before coming to work for Matisse. She successfully concealed the affair from her parents, who were outraged when they found out after three years, not so much by her having a lover as by his bourgeois origins ("They had hoped to marry her off to a good working boy," Matisse reported to his wife, who, like himself, was touched by both Henriette and her family).[106]

The Matisses regularly took her with them for drives, or to see the opera at Monte Carlo. Henriette accompanied Amélie on shopping trips, and outings to the mountain resort of Peira-Calva. Marguerite sent her parcels of clothes, the boys asked after her in their letters, and Matisse practised duets with her when the day's work had gone well. On his return to the Hotel de la Méditerranée to paint the carnival procession each spring, he invited Henriette with her mother and her two little brothers to watch the fireworks from his window. When she fell ill, he took her to consult a doctor for the first time in her life. Born in 1901, a year younger

than Pierre Matisse, Henriette became in some ways a substitute daughter for the Matisses as their own children prepared to leave home. She responded to their warmth as eagerly as to the opportunities they offered. "Oh! It's so nice to see a happy family like yours," she told Marguerite in 1923.[107] By this time the flat that was to have provided the Matisses with a home of their own in Nice had been entirely taken over by the studio, and the painter and his wife were living out of suitcases again in a modest hotel round the corner.

Painting as always remained the pivot on which the family turned. Matisse's canvases consoled his daughter in sickness, and roused his wife from depression when nothing else could. Once he posted her a picture at

Marguerite Matisse, sketch of Matisse's latest work hung alongside Cézannes and Renoirs in the family salon at Issy with a snapshot of her father tucked into the mirror at Easter, 1923

Jean's suggestion, and Pierre, who had gone off to work in the morning leaving his mother ill in bed, came home to find her singing to herself ("I've been sent something!!! I've been sent something!!!"), dancing round the room to the gramophone. "The little picture, which is a real gem and Maman's delight, has cured her completely," Pierre reported to his father. "She's getting more and more impatient every day for your return."[108] The arrival of a crate of new canvases, sent up from Nice each spring in time for Matisse's show at Bernheim-Jeune, caused wild excitement at Issy. "We often picture the scene...," Amélie wrote to Marguerite from Nice in 1921, "with that little devil Pierre capering about in the middle, and you and Jean trying to quiet him down." The year after, the tension was even greater, only this time it was Amélie who jumped every time the bell rang and had to be calmed by her children.[109]

The annual ritual of unpacking, stretching, framing and hanging ended with the whole family settling down to respond to the paintings. "I feel this evening as if I'd had three solid hours of music," Marguerite wrote after one of these sessions. "I'm drunk with it, and can't either look or judge any more."[110] The family's private picture shows, lasting at most a few days before the dealers arrived to take their pick, became the high point of the year. If Matisse was increasingly absent in person, a sense of his presence now filled the whole house. In 1923 Marguerite made a diagram of the spring hang for her father, showing his latest painting of Henriette flanked on one side by Cézanne's portrait of his wife and on the other by Renoir's *Alphonsine*, with more Renoirs, Cézannes and Matisses alternating two deep on the long wall of the salon, and a snapshot of Papa tucked into the frame of the mirror over the fireplace.[111] This was the cause and purpose of his sequestration in Nice. "There's nothing to be done but to live in and for yourself—to work towards becoming a real force that can't be dismissed," he wrote, when his wife and daughter complained about the slights of the art world, and the strain his absence imposed, "—today you're a great genius—tomorrow they'll despise you—It's only natural.... We have a genuine collection of pictures—I'm working with the courage of independence, my pictures have a market value etc, I've quite a reputation even with those who know nothing of painting.... We are one of those rare large families whose members live in unity—don't you think that's enough to make people envious and jealous?"[112]

CHAPTER EIGHT

~

1923–1928: Nice and Paris

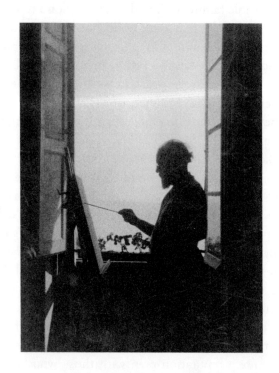

Matisse painting
at his third-floor
studio window,
Place Charles Félix,
Nice

*M*atisse's reputation split in two at the beginning of the 1920s (and
has continued ever since to produce powerful and opposite reac-
tions). On the one hand, the art establishment and the public of
two continents recoiled in shock from the work of his pre-war period.
"It . . . provoked a strange, unknown horror, something akin to an image

of the cadaver of reason, the decomposing corpse of Intelligence," wrote a Spanish critic.[1] Three Matisse canvases in a mixed show at the Metropolitan Museum of New York in 1921 were denounced as pathological, and when the Detroit Institute of Arts bought a semiabstract painting the year after, the museum's journal was obliged to defend its purchase on the grounds that the artist had a nice, clean house and a thoroughly respectable lifestyle.[2]

Matisse's latest work, on the other hand, was selling as never before, which did him no good at all with informed opinion in Paris. Pictures that people had no problem in liking looked tame and unimportant to admirers of heroic insurrection, like Marcel Sembat, whose *Henri Matisse* launched a popular series backed by the highly influential *Nouvelle Revue française* in 1920. Sembat's fiery and incisive defence stopped short in 1913 with *Moroccan Café,* which (along with all the other key paintings in Russia) would not be seen again in the West until nearly forty years after the painter's death. For Matisse, who read an advance copy alone on his fiftieth birthday in Nice, the book came as a shock. "First of all, he denies me any future—by claiming I've already won," he wrote home bitterly, "then he makes all sorts of blunders—is this the moment to say I look like a German professor? And to drag in Nietzsche?"[3]

Matisse correctly foresaw that Sembat's approach, with its damaging gaps and its emphasis on a largely inaccessible past, would set the tone of response to his work for decades to come. The text passed over the great sombre wartime paintings in silence, apparently because Sembat (like most other people) had never seen them. Journalists interviewing the painter throughout the 1920s would inevitably insist on refighting the Fauve campaign and its immediate aftermath. "These people are honest, I grant you," Matisse wrote home wearily when asked to justify yet again the battles of twenty years earlier, "but if one isn't hurt by their malice, one is by their stupidity."[4]

In his own view, he had already moved on to a new phase of the struggle that would end only with the cut-paper compositions constructed directly from colour in the last decade of his life. But the sexy subjects and harem connotations of his chromatic experiments in Nice made them seem more like capitulation in the 1920s. "He's given in, he's calmed down, the public is on his side," Sembat wrote in disgust to Signac in March 1922, when the French state bought its first Matisse canvas, *Odalisque in Red Culottes.*[5] Matisse found no new advocate to compare with the pre-war collectors who had campaigned so effectively on his behalf. Sembat himself died of a heart attack in September 1922, closely followed by his wife, who

shot herself twelve hours later. She left instructions for their collection to go to the nearest museum to Paris that had the courage to take it (this proved to be Grenoble, under an enterprising new curator, Andry Farcy, who had already been given *Interior with Aubergines* by the painter himself, and now acquired the only serious collection of Matisse's work in France).[6]

Sarah Stein sold a Renoir in 1924 to buy *Tea in the Garden*, for which Bernheim-Jeune had failed to find any wealthier purchaser.[7] But Matisse, who still eagerly awaited Stein's comments each year, was repeatedly disappointed by her blank response to his more recent work. Most of the major paintings she and her husband had assembled were sold off piecemeal in the 1920s by Tetzen-Lund in Copenhagen (many would end up in Denmark's national museum, which owns to this day Europe's finest collection from Matisse's first revolutionary period).[8] In 1923, Jacques Doucet bought *Goldfish and Palette*, pairing it with Picasso's *Demoiselles d'Avignon* in what might have become a unique French modernist collection if Doucet's adviser, André Breton, had not almost immediately parted company with the collector, who died shortly afterwards.[9] Another formidable collector, the American John Quinn, whose sights had been trained on Matisse since 1915, wrote to propose a more formal version of the ad hoc pre-war arrangement with Shchukin, but Quinn, too, died suddenly in 1925.[10] Félix Fénéon, the only person whose eye inspired confidence at Bernheim-Jeune, retired in 1924, leaving Matisse for the first time with no external backup except for commercial dealers, whose judgement he did not trust, whose maneouvres he aimed to outwit, and whose sole long-term goal appeared to be to maximise profit.

Matisse's isolation was more nearly complete than it had ever been before in these years when for long periods he cut himself off from even the support of his family. "You say I'm leading a nice peaceful existence down here," he wrote when his wife reproached him in the autumn of 1923 for leaving her to cope alone with the turmoil of family life, "—don't forget that my storms take place in my work, which is the rudder that steers our whole house."[11] Dissatisfaction at home was the only thing that seriously threatened to knock him off course. Complaints that he rated human concerns second to painting fed his perennial sense of being excluded, misunderstood and unjustly blamed for sacrifices that were greater for him than for anyone else. "I don't want to be always held responsible," he protested from Nice. "Work is going well, and I'm doing good things—which are developing all the time—and I trust that, when you see them, you'll judge me less severely."[12]

The event causing commotion at Issy in 1923 was Marguerite's marriage. She had dismayed her father and delighted the rest of the family by accepting one of her brothers' companions, the most brilliant of Prichard's pre-war disciples, Georges Duthuit, who had formed the habit of dropping in at Issy as a conscript on wartime leaves. Amélie liked him from the start. The two boys were fascinated by his knowledge of the world, especially the army (born in 1891, eight years older than Jean Matisse, Duthuit had completed three years' military service before being sent to the front in 1914). Clever, disrespectful and exceedingly funny, he con-

Matisse, *Georges Duthuit*, 1924

tributed a note of irreverent gaiety that lightened the atmosphere. He could sing all the popular songs and perform the cabaret routines of legendary, turn-of-the century clowns like Chocolat and Footit. He combined impeccable, old-fashioned, French upper-class manners with casual English chic (his elegantly modified version of soldierly turnout was said to have got him arrested at one point by the military police). Orphaned early and handed over to the harsh charge of a rapacious uncle who was also his guardian, Duthuit had learned young to live by his wits. He knew everyone who counted for anything, intellectually speaking, in anarchic young postwar Paris, and his background was sufficiently mysterious to give rise to endless stories. Rumour said he had inherited a fortune in *louis d'ors* on his twenty-first birthday and confided it to a friend, who lost the lot in rash investments in Nicaragua. Men were intrigued and impressed by him, women commonly found him irresistible.

This kind of urbanity, so remote from anything Marguerite knew or cared about, left her indifferent. She had no intention of becoming anybody's conquest ("I don't want him thinking he can add me to the ranks of women *at his feet*, whom he maltreats perhaps so as to keep them in love with him!" she wrote scornfully to Amélie).[13] But for all his glamour and robust good looks, Duthuit had darker attractions. He could be as mercilessly self-critical as she could, and as capable of driving himself to extremes. It was his abstemious, solitary side that appealed to Prichard, who had first encountered him as a nineteen-year-old reading Plato in a Left Bank vegetarian café ("An ascetic regime which, under his influence,

reduced itself to the point where I was living on a lettuce a day," Duthuit wrote in retrospect, "tricked out, in fine weather, by a handful of cherries").[14]

Duthuit courted Marguerite with a nervous and imaginative intensity that matched her own. She said he did it by telling her the story of his life. The child of an unhappy marriage between a successful Parisian architect and the daughter of landowners in the Auvergne, young Georges had grown up in the capital acting as his father's alibi on nightly excursions backstage at the theatre, and watching his mother succumb to corrosive loneliness and depression. After the premature deaths from tuberculosis of both parents, his only ally, a much-loved elder brother, also died as a teenager in a drowning accident at school, leaving Georges to be brought up by his guardian with such brutal indifference that eight years in the army seemed to him like salvation. He belonged to the same subversive, transitional generation as Aragon and Breton, and, like them, he had discovered Matisse for himself as a schoolboy, responding unconditionally to the explosive power of the *Blue Nude* at the Salon des Indépendants in 1907. Prichard had supplied him with a solid Bergsonian base for his generation's faith that art and artists could find ways to redeem the worn-out moral and spiritual heritage of a corrupt and cynical world.

Marguerite lived by this faith, and was touched by the unshakeable, at times almost desperate conviction with which Duthuit clung to it. He had idolised Prichard, and he approached her father with awe. He said that he and his contemporaries found themselves confronted by a fractured civilisation in which traditional rules and concepts no longer made sense, "a situation with no precedent since the sack of Constantinople by the Franks."[15] Matisse's paintings had shaped him at a formative stage. With Marguerite's help, he hoped to pass on the new ways of thinking and feeling absorbed in front of canvases that now formed part of what he called his spiritual baggage.[16] It was the kind of destiny for which each felt he or she had been born.

Duthuit was the only one of Marguerite's suitors who talked in the same uncompromising terms as she did herself. He was also probably the one who in human terms needed her most. The winning grace and sweetness of her childhood returned, together with an inner radiance that shone from her dark eyes and lit up her pale, almost transparent skin. Even Prichard found Marguerite adorable at this stage.[17] To Duthuit she was irresistible. The social inexperience that could make her seem awkward, even gauche, to more worldly contemporaries was for him a purity untouched by gross material reality. He relied on her underlying toughness

but he was enchanted by her delicacy, and by the fastidious discernment she brought to everything from her moral code to her style in frocks and hats ("She is lovely as the day," he wrote to her brother Jean).[18] For Duthuit, Marguerite would always remain on some level one of those magical beings who had dazzled and transformed his vision in paintings like *Family Portrait* and *Piano Lesson*, inhabitants of another world so heady with possibilities that it brought him, in his own words, "to the brink of overthrow, total upset, conversion, vertigo."[19]

Matisse himself remained dubious about the programme Duthuit envisaged as a practical basis for marriage. Many fathers might have hesitated to entrust an only daughter to a perpetual student in his early thirties who had abandoned plans to follow an architectural career, like his father and grandfather, in favour of switching to aesthetic theory, with nothing to live on, no outlet in view except little magazines, and no immediate plans for working on anything but a putative thesis on the lost art of the Byzantine Copts. There were sticky interviews that summer with this prospective son-in-law whose reverence for the artist as seer stopped well short of filial deference. Even Matisse was daunted by Duthuit's flamboyant assurance ("I should have liked him, when I told him what provision I was making for Marguerite, to have talked to me about what he had," he admitted to Amélie, "—he told me nothing, and I didn't dare ask").[20]

He took refuge as usual in painting, interrupting his summer vacation at Issy to escape back to Nice for three weeks in July, accompanied by Jean, who was beginning to make progress on canvas ("I've hung Jean's studies in my room and I look at them often with pleasure," Matisse told his wife).[21] Both boys conscientiously followed a training schedule designed to give them a smoother ride than their father's by eliminating all taint of Beaux-Arts contamination. Pierre spent his office lunch hours copying in the Louvre, with encouragement and occasional advice from André Derain. Jean, still happiest stripping down motors on temporary assignments in the local garage, painted still life and landscape under the friendly eye of his father's old school friend, once the pride of the St-Quentin art academy, Emile Jean. All three young Matisses had pictures accepted from time to time by the Indépendants, and the two boys regularly posted off batches of work for long-distance monitoring in Nice.

But at the end of this troubled summer Pierre returned from a last holiday in Ajaccio with his aunt Berthe (whose next posting was on the mainland) to announce that he, too, had found the love of his life and meant to marry her. She was one of his aunt's students, Clorinde Peretti, the daughter of a Corsican engineer and a Spanish mother, who kept her

in seclusion at home according to the custom of the country, allowing her out unchaperoned only to cross the road to the training college opposite the Perettis' house. Pierre had secretly wooed and won her over the garden wall. Matisse did not oppose the match, but made its consequences relentlessly plain. Mlle Peretti could have no inkling of what life with a penniless artist entailed, and, since she had clearly aroused in Pierre the consuming passion that painting had failed to ignite, his father told him flatly to pick another profession.[22] He suggested dealing instead, and found an opening for his son with a smaller rival of the fashionable Bernheims—Barbazanges, Hodebert et Cie—alongside Poiret on the rue du Faubourg St-Honoré. It turned out to be shrewd and affectionate advice, but, given Matisse's ineradicable contempt for the dealer's trade, it planted a knife between father and son that retained a cutting edge for the rest of their lives.

Preparations for Marguerite's wedding at the end of the year were fraught with still sharper misgiving. Matisse retired thankfully again to start his work season in Nice in September. Marguerite grew steadily paler, slighter and more fine-drawn from nerves (by November she was on a milk diet, and so fragile that her father hoped for a postponement). Duthuit was pursued by recriminations from women who felt he had jilted them. Amélie directed operations with military precision, organising civil and religious ceremonies, drawing up guest-lists for a family lunch-party and a reception afterwards, planning a hand-stitched trousseau. The whole affair struck her husband as over-elaborate ("It's useless to wear yourself out in order that she should have everything just so . . . that seems to me decidedly bourgeois"),[23] but his wife and daughter ignored his protests. This was, after all, precisely how Amélie had been married herself: for love in great haste at short notice, with a splendid send-off and nothing in prospect but romantic poverty and years of struggle stretching ahead.

The couple were married from the flat on the quai St-Michel on 10 December in a civil ceremony at the *mairie* followed by a service in Notre Dame with musicians, flowers and six carloads of guests, ranging from the Marquets and the Camoins (both Matisse's old comrades had finally married that year) to the bride's godfather, Dr. Vassaux, Sarah and Michael Stein, assorted friends, neighbours, critics and numerous Bernheims.[24] Matisse chose the music, and the bride looked so lovely that the great Orientalist Charles Vignier insisted her father must have designed the wedding dress himself. Next day, while the new M. and Mme Duthuit began their honeymoon in Vienna, the guests reassembled full of compliments

for another party at Issy. Matisse bought presents for the family, and dined with the Steins that night ("Your father was very happy and showed it, which enchanted everyone," Amélie reported to Marguerite).[25] On 12 December, he returned to Nice with a framed photograph of his daughter, specially commissioned from the young American Man Ray, to hang in his studio.[26]

Marguerite's marriage had looked at one point as if it might split the family apart. Battle lines were drawn up over Duthuit, with Matisse on one side confronting solid opposition from his wife and daughter on the other ("Don't thank me, dear Margot, for all I've done for you," Amélie wrote to her adoptive daughter after the wedding, "you have given me nothing but joy and tenderness ever since I've served as your mother—I'm the one who should be grateful to you").[27] But when Marguerite wrote tentatively to ask her father if she and her husband might stop off to see him on their way home from Vienna, Matisse welcomed them warmly. He even laid on a concert, consisting of a string duet performed in their honour by Henriette and himself. His fury and foreboding had evaporated, clearing the air like thunder, and leaving the promise of new beginnings all round. The upheaval that had driven them apart now drew the painter and his wife together, turning their thoughts back to their own honeymoon, and eliciting a rare declaration of love and faith from Amélie, reviewing the past in her long confessional letter to Marguerite. "I had the best, it's true there aren't many men like your father, and my dearest wish is that you, too, may know the best," she wrote, describing the mutual trust that had rooted itself quite naturally in her own marriage from its first days: "I can say that, if I had to start all over again, I wouldn't change my life for anything in the world."[28]

When Amélie joined Henri in Nice, arriving at the end of March to avoid the noise and crowds of the carnival, she found him run-down and fretful, pining for company, weakened by winter flu and complaining of stomach-ache. In previous years, it was Amélie who had found it hard to get through the days with no one to talk to and nothing to do in Nice. Her head ached and her feet swelled in the heat, but she recovered miraculously each time she got back to Paris to find she could fit into her shoes again. Matisse had sent her a sketch the year before showing a sturdy, bare foot planted on the ground beside a tiny, buckled and pointed Cinderella slipper half its size.[29] Now it was as if the shoe fitted. In the spring of 1924, there was no more talk of health problems, as the couple returned to the simple routines laid down at the start of their life together. Amélie presided over the studio again and accompanied Henri on painting expe-

ditions, sitting beside the easel beneath shady trees on the crest of Mont Boron, with a writing pad on her knees and the bay of Villefranche spread out at her feet. Sometimes she pottered round the antique shops, picking up patterned plates and a painted screen for her husband. Each morning she shopped in the market beneath the studio windows, and had to prevent herself forcibly from posting off daily parcels to Paris full of strawberries, cherries, asparagus, artichokes, tender young peas and beans. Young Mme Duthuit, settling down to married life at 19 quai St-Michel, received enough flowers—arum lilies, bloodred tulips, irises, roses and a whole box of carnations—to fill every vase in the place.

Matisse made his wife laugh by mimicking his latest sitter, the American wife of the collector Baron Napoléon Gourgaud (who owned several choice Matisses, including the *Interior with Goldfish* of 1914). The painter had accepted the commission on condition he could put Henriette in the picture, driving her over to the Hotel Crillon at Cannes for the sittings, and inserting her by his own account as a kind of accessory in the foreground, where he often placed a favourite mascot or plaster-cast. He imitated the Baroness with her bright eyes and big smile urging Henriette to marry for money, proposing to frame the finished portrait in gilded crocodile skin, and complaining that it was a poor likeness ("She wants a mouth that reaches right round to her ears").[30] He filled Amélie in on local gossip and took her out in the evenings with friends, but more often they dined alone at home ("We went to the cinema," she reported happily to Marguerite, "and then, like two good little children, we came back to bed at ten o'clock").[31]

They discussed plans for the family and the future. Matisse, who still thought of himself as a temporary resident in Nice, proposed retaining his flat for another year and possibly renting or even buying a second to live in instead of putting up at hotels. His wife liked the idea of two flats in the same building with enough room for family visits. "Your father and I are very keen on this scheme," she told Marguerite, ". . . now that you're married with Pierre about to follow and Jean in line to do the same—it seems to me that we'll settle for the greater part of the year in the apartment in Nice, and any or all of you can come when you please."[32] Matisse signed a lease that summer for the flat immediately above his own, when it fell vacant in the autumn. By this time, he had amazed Amélie by agreeing without protest to take an Italian holiday with the Duthuits, so that he and his new son-in-law could iron out any initial misconceptions.[33] "To visit Italy with Matisse—it's my dream," Georges said when he heard. His parents-in-law celebrated by buying three basket chairs in a junk shop.

Amélie left for Aix in June to take her usual cure with Marguerite, who was called away at the last minute by a summons from the Auvergne, where Duthuit's maternal grandmother lay dying at the family estate of Champeix with her descendants gathered around her. Frozen with misery at losing the only surviving relative who had ever cared for him, Georges retreated into himself, brooding alone in morose silence over his books, as he must have done as a boy. Marguerite nursed the old lady with the intuitive skill that would have made her a first-rate doctor. Her husband, captivated all over again by her sensitivity to peo-

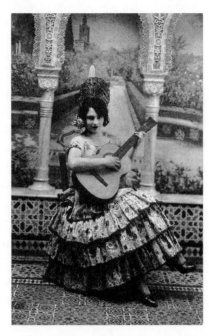

Clorinde Peretti before her marriage to Pierre Matisse

ple in trouble, said no one else could have eased his grandmother's passing so gently ("All of us feel that here, even the roughest of the country cousins").[34]

Matisse spent the month trying to do the same for his old friend Francisco Iturrino.[35] Serial disasters had overtaken the Spaniard since they shared a studio in Seville: encroaching age, ill health, a failed marriage, the amputation of one leg and poverty so extreme that his fellow artists organised an appeal on his behalf in Paris. Iturrino survived, thanks to generous contributions from Matisse and Picasso, to make a fresh start in Cagnes after the war with a new partner and baby daughter. Now he, too, lay dying at sixty in atrocious pain, made worse by violent altercations between his French girlfriend and his two grown-up daughters from Spain, who thought she was stealing their birthright. Matisse visited every day, torn between pity and horror. He postponed his departure and put his own work on hold, staying on even after the funeral to try to make peace and secure justice for the Frenchwoman who had transformed Iturrino's last years.

He eventually returned to Paris on 6 July, three weeks before Pierre was due to marry Clorinde Peretti. She was unlike anyone the high-minded, hard-working Matisses had ever harboured at Issy before. Born in 1901 in Bolivia (where her father had gone to build bridges), she had spent

the first half of her life running wild in the backwoods of South America, and the second half secluded in her father's house in Ajaccio, watched over and cultivated like a prize orchid. She looked like a luxuriant hothouse flower, and moved with a Spanish dancer's contained energy and suppleness. Pierre called her his Inca princess. He had played tennis, climbed trees and gone swimming with Clorinde's brothers on visits to his aunt from childhood, and, in a male-centred society where a girl was never left alone with a man until she had married him, he remained the only boy she had ever met outside her immediate family. Any slur on female honour was still commonly settled in Corsica by the knife or the gun. Matisse, always a prudent parent ("It's the stories of betrothals and reprisals that impressed me in Corsica all those years ago"),[36] had made Pierre return to Ajaccio to submit a formal request for Clorinde's hand in marriage. But her father, who had already arranged a more suitable match with a middle-aged doctor, rejected this twenty-two-year-old trainee art dealer from Paris on the perfectly reasonable grounds that he had no qualifications of any sort, and no means of supporting a wife. "My father was terrible," said Clorinde, "so I abandoned my studies to marry Pierre Matisse."

She came to the wedding in Paris alone, with no dowry, bringing nothing but her clothes. "I don't know why my family let me do it," Pierre said long afterwards. "If they had been more strict, they could have stopped it."[37] But Amélie was in favour of runaway elopements in principle, and her husband, looking back perhaps to his own first love for Marguerite's mother, had no wish to impose a parental veto.[38] Both were encouraged by Berthe Parayre, who understood the determination and courage that lay behind her pupil's flight. The Matisses organised religious and civil formalities, supplied a lawyer to draw up a marriage contract and provided a home at Issy for the young couple with a monthly allowance of five hundred francs. Clorinde approached them warily, deferring to Pierre's mother with elaborate formality and treating his father as an ogre. "My brother-in-law may seem terrifying in manner," Berthe wrote reassuringly. "He's a nervous artist, I know he can be a bit authoritarian, but behind his outward appearance he's a man of thought and feeling—serious, affectionate—and you will be his daughter as Pierre is his son."[39] The couple were married quietly on 31 July in a side chapel of Notre Dame, with none of the fanfare of the year before. Mlle Parayre came from the Pyrenees (where she was running the training college at Pau) to support the bride, and the rest of the groom's family acted as witnesses. Matisse lent his car and his flat in Nice for the honeymoon.

He and Amélie travelled further south with the Duthuits to the bay of

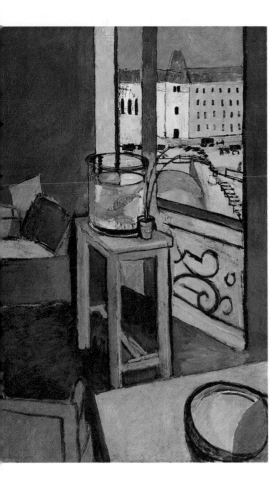

LEFT: 16. Matisse, *Interior with a Goldfish Bowl*, 1914.
Oil on canvas, 57⅞ × 38⅛″ (147 × 97 cm)

BELOW: 17. Matisse, *Goldfish and Palette*, 1914.
Oil on canvas, 57¾ × 44¼″ (146.5 × 112.4 cm)

18. Matisse, *The Moroccans*, 1915–16. Oil on canvas, 71⅜ × 110″ (181.3 × 279.4 cm)

19. Matisse, *Bathers by a River,* 1909, 1913 and 1916. Oil on canvas, 113 × 154″ (261.8 × 391.4 cm)

20. Matisse, *French Window at Nice*, 1919. Oil on canvas, 51⅛ × 35″ (130 × 89 cm)

21. Matisse, *The Moorish Screen*, 1921. Oil on canvas, 36¼ × 29¼″ (90.8 × 74.3 cm)

22. Matisse, *Nude with Goldfish*, 1922. Oil on canvas, 8¾ × 10½″ (22 × 27 cm)

23. Matisse, *Decorative Figure on an Ornamental Ground*, 1925–26. Oil on canvas, 51⅛ × 38⅝″ (130 × 98 cm)

LEFT: 24. Matisse, *The Fall of Icarus*, 1945.
Cut-paper collage, 14⅛ × 10¼″ (36 × 26 cm)

BELOW: 25. Matisse, *Tristesse du roi*, 1952.
Cut-paper collage, 115 × 152″ (292 × 386 cm)

Naples, visiting Capri, Salerno and Positano, and crossing by ferry to Palermo in Sicily.[40] But the trip did not revolve around the archaeological sites or the gallery-going Duthuit had dreamed of, nor did it cement the alliance Marguerite longed for between her father and her husband. Matisse left the other three to explore the Blue Grotto while he returned to Nice on his own to start work. Things had not gone well in the apartment on the Place Charles Félix, either: a series of sobering shocks had shaken confidence on both sides. Pierre was enthralled by his wife's grace and daring, which she displayed to stunning effect at a time when sea- and sunbathing were still practically unheard of in Nice. Clorinde could arch her body over in reverse like an acrobat, walk on her hands and launch herself backwards off the Casino pier, describing an effortless curve and somersaulting twice in the air before entering the sea like an arrow. She never forgot her father-in-law's incredulous delight in her diving ("He could not get over it"),[41] and perhaps he remembered it too, when he invented dives and backflips for his blue acrobats a quarter of a century later.

But on all other levels it was as if the new husband and wife came from different centuries. Brought up with a house full of staff, a carriage, and a lady's-maid to dress her and do her hair in the mornings, Clorinde had never in her life shopped for food or set foot in the kitchen at home. In her world, a lady wore net gloves to protect her hands and waited for the maid to answer the bell. She had defied her father and abandoned her family to marry Pierre, but his way of life was as inconceivable to her as being stranded among ape-men or aliens. "*It's not possible,*" she said on her first day in Nice, when he explained that there were no servants. Born into a family that saw painting as an integral part of a honeymoon, Pierre had packed his paint-box, and he was as bewildered as his wife when he emerged from the studio at mid-day to find there were no plans for lunch. Everyone in Pierre's family, including his father, could fetch coal, lay and light a fire, buy provisions and prepare a meal, sweep floors and make beds at a pinch. His mother and sister not only did their own hair and designed their own clothes but ran the business side of the studio, dealing with galleries and framers, briefing collectors, arranging sales and filling in tax returns.

In their company Clorinde was hopelessly out of her depth. She seemed cold, unfeeling, complacent, hellbent on making her husband conform to conventions rejected by his family as intrinsically futile. She was pictorially illiterate, and her key values, based on status and material possessions, struck them as flimsy and insipid. Everything the Matisses did or

said repudiated her and the bourgeois background she came from. Both Clorinde and Pierre had mistaken her fierce desire to escape from a tyrannical father and an arranged marriage for a more fundamental revolt. To Matisse her attitudes embodied a smug, repressive, philistine narrowness that had revolted him all his life. Pierre was intoxicated by Clorinde, but there were times on his honeymoon when he wanted to flee from her.[42]

Once the couple moved in with the household at Issy, the situation got worse. The family closed ranks to save Pierre ("When he reasoned like a sensible man he saw the differences opening up between the two of them, and that one or other would have to change," Marguerite reported to her father in Nice, "and he feared he might be forced from weariness to give up his ideas, his tastes, and everything that distinguishes him from her").[43] Clorinde felt herself under hostile surveillance, criticised and corrected at every turn. Nothing had prepared her for the upside-down world she now inhabited, where everyone painted and no one thought seriously of earning a living or felt in the least ashamed of flagrant violations of social decency, from the absence of staff to Marguerite's illegitimacy. "I was dazed and disoriented," Clorinde said in retrospect.[44] She dreaded her new sister-in-law's raised eyebrows and sarcastic comments, and she still could not bring herself after two months to address her mother-in-law as anything but "Madame." Pierre was torn between the two factions, and immobilised by pressure from both sides. Neither of her new brothers-in-law intervened to protect Clorinde. Knowing no one else in Paris, she finally appealed for help to the wife of Pierre's employer, Mme Hodebert, who said that even when she took her in her arms to comfort her, Clorinde was too frozen to weep.[45] She was a casualty in a much larger battle between two ways of thinking and feeling, a conflict that threatened to engulf Pierre too, if the marriage lasted much longer. "The more I think about it, the more sure I am that, whatever the cost, he must break it off," wrote Matisse, whose relationship with Marguerite's mother, Camille Joblaud, had foundered on the same clash between artistic freedom and bourgeois conformity.[46]

The couple split up in October after only two months of marriage. Clorinde left Issy, returning her ring and confiding only in Berthe, who loved Pierre as if he had been her own son, but understood and sympathised with his wife as well (a disloyalty for which Amélie never forgave her). Pierre also moved out, to live in a rented room on his own. He saw himself from now on in his father's eyes and his own as a failure who, having already come to grief as a violinist and a painter, had now managed to turn even his marriage into a fiasco. But Matisse had not forgotten a simi-

lar confrontation between his parents and himself at the same age, involv-
ing shame and disappointment on one side, and smashed pride on the
other. The painter who had been known by neighbours in Bohain as the
triple raté (or three-times failure) now focussed his formidable will on extri-
cating his son, and mounting a strategy of damage limitation. Matisse
arranged an allowance for Clorinde to live on and proposed a getaway for
Pierre, envisaging a trip to the United States, perhaps with a stopover in
London, and reluctantly ruling out the Midi as a bolthole for fear of retri-
bution from the Perettis ("Nice is too close to Ajaccio"). Meanwhile he
engaged a divorce lawyer, and sent his son back to Corsica to explain what
had gone wrong to Clorinde's father, who had turned him down in the
first place, and whose daughter's future he had now effectively ruined.

Divorce was not an option in Corsica. Revenge was a way of life. But
Pierre's abject despair touched even Père Peretti, who put away his revolver
and grudgingly conceded that at least his son-in-law had courage. Over-
whelmed once again by his feelings for Clorinde, Pierre caught the ferry
back to Nice, and broke down, with tears pouring down his face, in the
middle of a string duet with his father. "He's going through a harsh test in
which he needs support in his moments of weakness . . . ," Matisse wrote
to his wife on 16 November, urging her to make sure that the entire family,
including Duthuit, combined to prevent Pierre's nerve giving way again.
"He's reached the end of his strength, and he's close to falling. . . . *I'm
counting on you. . . .* Pierre is a sick man in need of a cure—*a sick man who
dreads the operation*—it's natural enough."[47] Father and son talked at length.
Matisse described the wretched compromises and the self-contempt that
could only be avoided by a clean break at this stage, and Pierre agreed to
leave France at once. The unprecedented intimacy and openness of this
exchange radically affected their relationship, establishing a mutual confi-
dence and a sensitivity to one another's suffering that would survive even
the worst upsets that lay ahead. Matisse took his son to the theatre, never
leaving his side and giving up work next day: "I found a more cheerful
Pierre, as if relieved of a burden—interested in everything and talking of
leaving for New York to look for a job—you can imagine how glad I felt."

The next three weeks passed in a blur. Fear of intervention from Cor-
sica added urgency to the family's haste and confusion. Matisse joined the
others in Paris at the end of November to help with preparations for
Pierre's journey, supplying him with fifty engravings and 10,000 francs,
pressing the Bernheims to back his son's scheme for mounting some sort
of exhibition in America, applying to the Steins for advice and to Pach for
support in New York.[48] Pierre sailed on 9 December, leaving his family in

a state of collective shock. "So now our Pierrot's gone," Matisse wrote sadly when he got back to Nice. "I didn't give him all the advice I should have liked because things don't come to mind all at once, and he left in such a rush."[49] "Now that I've left, I hope calm will return to you all," Pierre wrote no less forlornly from shipboard.[50] He landed in New York, like thousands before him, speaking rudimentary English, with no fixed plan and only the vaguest idea of what to do next. He told his own son long afterwards that throughout a career that spanned the central decades of the century in America he felt like a man forced to go out on a broad raging river, jumping from one ice floe to the next, never knowing where he might land, unable to tell how far he would get or even to control which way he was heading.[51]

This was the third major upheaval in twelve months in a family that was, as Marguerite said, as close in foul moods or fair as the five fingers of one hand.[52] Matisse spent Christmas Day, 1924, in bed with flu. His work had been disrupted all season, and his new apartment upstairs was still in the hands of plumbers and decorators. Amélie, too, was close to collapse. "I'm afraid the last thread holding her back from depression may snap before we leave," wrote Marguerite, preparing to escort her south with Duthuit, accompanied by trunkloads of household linen and furnishings. "Once in Nice, I'm hoping that Papa—and the whole business of making the place habitable—will distract her."[53] The three of them reached Nice on 5 January, the same day as Pierre's first letter to his parents, and Marguerite wrote back at once to report them snatching it from one another in their haste to read what was in it. Matisse could not talk of his son's departure without tears in his eyes. "These things wouldn't make such a mark except on a nature as complicated as it is generous," Marguerite wrote to Pierre, describing their father's state and putting it down to nervous exhaustion. "From that comes an uneasiness that spreads over everything. It latches onto the uneasiness caused by his work—an uneasiness that seems to be growing—and so everything that comes up fills him with dread."[54]

After a brief intense scrutiny of the studio contents, and a quick tour of the living quarters above, the Duthuits returned to Paris, leaving the new occupants to unpack and settle into their fourth-floor apartment. It was bigger than the work space below, with a newly installed bathroom and superb views over the bay, but this was not an auspicious start. Amélie suffered severely from rheumatism, followed by a bad back, kidney trouble, general lassitude and recurrent depression. Henri's chronic fatigue slowed and hampered his work. Their doctor diagnosed their troubles as

nervous in origin ("In a word," Marguerite reported briskly, "he told me you were both going through a period of inner turmoil").[55]

Private stress was exacerbated by unrest in the country at large. France had now waited six years to reconstruct her devastated northern heartlands and rebuild her shattered industrial infrastructure with the compensation Germany had promised but failed to pay. The whole nation seemed to be lurching unsteadily towards bankruptcy, breakdown or war. Matisse had worried about the possibility of Pierre having to fight against Soviet forces in Poland in 1920, and Jean being remobilised as France prepared to invade Germany the year after. "Better not to think about it too much," said Marguerite, when French troops occupied the Ruhr in 1923, "for the future looks like the abyss."[56] By 1925 the country and everyone in it was struggling to cope with political and financial chaos while ministers and prime ministers tumbled, taxes rose and the value of the franc spiralled downwards. "As for politics, things have gone very badly in France for a hundred years, as fathers have always said to their sons, having heard it from their fathers before them," Duthuit wrote in response to horrified enquiries from Pierre in New York. "It may look bad, seen from America, but let them come to Clamart and they'd be agreeably surprised by the calm that reigns here in the cells."[57]

The inmates at Clamart (or Issy) looked long and hard at the new paintings Matisse posted home in the spring of 1925. Their subjects—nudes, fruit, flowers, ornaments posed against various striped or floral stuffs—could hardly have been simpler, or the overall impression more richly sensual. They gave no overt sign of disquiet. On the contrary, they set out to elaborate what Dominique Fourcade called an architectonics of light. "We've just received the canvases, which as always have lit up the big room," Marguerite wrote to her father on 7 April; "the subtlety in tone of the new canvases in harmonies of

Matisse, *Odalisque with a Bowl of Fruit*, 1925

269

mauve and pink is extraordinary, it's the light sliding over and caressing the objects—and, in spite of their insubstantiality, setting up a solid equilibrium on the wall—that constantly astonishes you."[58] Six out of eleven works were still lifes or flowers, including the resplendent mauve and pink, scarlet, purple and gold *Anemones in a Terracotta Pot.* "Matisse advances an amazing stridency in this still life," Fourcade wrote of a canvas that operates on an altogether exorbitant chromatic risk level. "The bouquet is a kind of delirium withheld and released by the light in which the elements of this painting float."[59]

The pot of anemones was one of the flower arrangements Matisse said he kept ready for emergencies, meaning the days when Henriette asked for an afternoon off.[60] Henriette was a living sculpture. The finely modelled planes of her torso and limbs caught the light (like the little clay figures which Matisse no longer felt any need to include in his canvases).[61] Her body articulated itself like a cat's into compact rounded volumes—breast, belly, haunch, hip, calf, knee—flowing smoothly into and out of one another from the calm regular oval of her face to the balls and heels of her bare feet. But Henriette was also more subtly alert than any previous professional model to the growing uneasiness behind Matisse's gaze. In the early stages of their partnership, he had bought a second-hand piano and painted her playing it, with her two younger brothers crouched over a chess-board, recreating the group portraits for which he had once posed

Matisse, *Pianist and Checker Players*, 1924

his own children. Now that, as Matisse complained only half jokingly, Pierre seldom wrote, Jean was too lazy to write at all, Amélie was otherwise occupied and Marguerite was busier still, the young Darricarrères were only too glad to make themselves available. But there is nothing restful or reassuring about the predominant heavy reds in these canvases, and the harsh emphatic patterns of the fabrics flattening walls, floor, table, even the boys themselves in their black-and-white-striped tunics poring over a board whose invasive checks reappear on the pedestal of Michelangelo's *Slave*. It is as if the realities behind the seductive artifice and fakery of Nice were becoming increasingly insistent.

Henriette watched Matisse intently, following his brush with her eyes and grasping more fully than anyone outside his family the consequences of total commitment to what he was doing. She had the hunger to use her own gifts which he found missing in his sons. Work swallowed up her waking hours as it did his. The two shared a violin master, François Eréna, a leading figure in Nice's highly active musical life. Eréna was a disciplinarian, and, when he chose Henriette at twenty-one as the soloist in a violin concerto at one of his public Sunday concerts, she needed the combined support of Matisse and his wife to see her through the months of rehearsal. Once she fainted during a posing session, worrying them so much that both of them accompanied her home and made her promise to rest. Even a private performance for Madame Matisse in the studio made Henriette sick with nerves for three days ("Emotion chokes and paralyses me when I play"). On the day of the concert, she very nearly cancelled her appearance, having lain awake all night with agonising pain in her ears. In the event, Henriette played brilliantly: "Even though she suffered wretchedly from stage-fright, she showed her fine qualities," reported Matisse, who gave himself the day off work and sat next to the violin-maker Blanchi, from whom he had once commissioned an instrument for Pierre.[62] Both agreed that, in point of colouring and power, Henriette's playing outstripped the professional musicians from the Opéra and Casino orchestras, who crowded round to congratulate her and urge her not to give up.

But the whole experience had shaken her deeply. Henriette left Eréna after the concert, replacing him as her teacher with a Madame Spinelli.[63] In 1924, she became Matisse's pupil instead, at the instigation of the Baronne Gourgaud, who had been so exasperated by Henriette's artistic aspirations and her lofty indifference to money that she advised her tartly to take up painting herself.[64] Matisse made up a palette for her, and began giving her regular lessons. He painted her at the easel, looking earnest and

effortful, stripped of the poise and detachment she took on in her role as odalisque. In 1925, she showed four paintings in Nice, going on to exhibit the year after at the Indépendants in Paris, where she sold a painting to the Society of Friends of the Beaux-Arts at her first attempt. Matisse predicted a brighter future for her than for any of the other young painters at work on the Mediterranean.

Henriette was a perfectionist who set herself almost unattainable goals and paid for driving herself towards them with periodic anaemia, exhaustion and crippling discouragement. She had no more idea of relaxation than Matisse. At home, she and her mother supported one another through a series of infections and ailments ("Whenever I get better, maman gets sick, and when it's not maman it's me, and it's been like that all winter, either one or the other of us," Henriette confided to Marguerite).[65] Henriette's father had a history of alcoholism, for which Matisse blamed many of the daughter's troubles. Different members of the family were regularly in and out of hospital with pneumonia, typhoid, appendicitis ("it's desperately sad, a ward full of suffering children," Matisse wrote of a visit to Henriette's brother Paul that brought back memories of having had to leave his own small daughter in a public hospital ward).[66] Paul Darricarrère found a job as a hotel lift-boy, and Jean, who trained as a pastry cook, won a place at the local conservatoire to study the violin like his sister. Their lives were more stable and less precarious than many in the 1920s, when Nice slowly lost confidence in its belle epoque splendour as its luxury hotels continued to shut down, and visitors moved further along the coast to sample the emerging international beach culture of Cannes and Antibes.

The young Darricarrères, even more than the young Matisses, belonged to the rootless and disintegrating postwar world reflected in Matisse's painting. Even the wealthy in Nice were elderly, convalescent, tubercular, dispossessed in one way or another, marking time in retirement or exile. The town's film industry mirrored their sense of dislocation. One of Matisse's regular diversions was to take in a film after supper in these years, when many of the titles turned out by the Studios de la Victorine— *Fête espagnole, Fleurs sur la mer, L'Île sans amour*—might have applied just as well to his own pictures. "Obsessions filter through and anguish emanates from the succession of images these fifteen years of painting offer us," wrote Dominique Fourcade in the catalogue of a groundbreaking exhibition, "Matisse, the Early Years in Nice," put on at the National Gallery of Art in Washington three decades after the painter's death. This was the

first time that these works were looked at without prejudice or preconception, presented in context, and allowed to speak on their own terms:

> The depicted world is one of waiting and sadness; a world of heavy eroticism, almost a world of the voyeur. A distant world in which communication seems impossible, or futile; besides, human beings have become painted things in this world, colour events in view of obtaining light on the painting's surface—they are dispossessed of all but their chromatic lives. The world of these first years in Nice is a world behind glass—the world in a fishbowl, the world infinitely repeated in a kind of insistent, existential loss. As if the light one had to obtain resulted in nothing but solitude, and demanded a fatal renunciation.[67]

It would take sixty years or more for this hidden emotional residue—the disturbed and disturbing feelings described in Matisse's correspondence at the time—to become palpable in paintings that portray on the surface a carefree existence of ease and leisure. The Matisse of the 1920s and '30s, for so long dismissed as facile and complacent, looks very different today. "Canvas after canvas is filled with images of boredom, claustrophobia, alienation and sexual yearning," wrote J. D. Flam in 2003.[68] The models lounging in make-believe harem costumes on improvised divans in the studio were drawn from the tide of human flotsam washed up in Nice between the wars, transients or immigrants often struggling to earn enough to pay for rented rooms or keep families afloat with short-term jobs as film extras, dancers or musicians. Many of them were harassed, distracted, unreliable. One fell sick and spat blood. Another was unable to raise her train fare back to Paris. All were in some sense seeking asylum, like the painter himself. "In these Nice portraits of a handful of models, he recorded the restless anxiety of women gazing at the sea, pining at open windows, neither dressed nor nude, going nowhere, twisting in their chairs, inert on their couches with unread books and unplayed instruments in their hands, never facing themselves in the omnipresent mirrored vanity table, indifferent to bouquets, absorbed in their own mute presence," wrote Catherine Bock in 1986. "These are the women one finds in postwar novels, the women described by Jean Rhys or Paul Morand, available, bored in their self-absorption, and adrift."[69]

But the underlying ambivalence of these canvases remained invisible to Matisse's contemporaries, who saw only a return to comfortable, familiar

methods of ordering reality. By progressive Parisian standards, the wrong people now increasingly admired Matisse. He was made a chevalier of the Légion d'Honneur in the summer of 1925, going on to be voted one of France's most popular artists by *L'Art Vivant*, and included in English *Vogue's* hall of fame the same year. This kind of success sharpened the responses of those who detected the taint of moral cowardice and culpable self-indulgence in Matisse's paintings of women and flowers. Former admirers responded with more or less embarrassed disclaimers. Picasso's dealer Daniel Kahnweiler elaborated a philosophical programme for Cubism that made "decoration" and "ornament" dirty words, writing off Matisse's work by implication as not proper painting at all. Breton issued a public recantation in *La Révolution surréaliste*, denouncing all painters who had strayed from the true path to succumb to the snares of bourgeois reaction, and famously singling out Matisse and Derain for the full force of his anathema ("They are lost for all eternity to others as to themselves.... I should bear a grudge against myself if I paid any further attention to such a dead loss").[70]

Georges Braque, brought by Halvorsen to the apartment on the Place Charles Félix in April 1925, made no attempt to conceal his discomfort. "Braque didn't condescend to look at what I've done," Matisse wrote home, reporting that Braque's only comment on the sculpture in progress was to say that the clay was a pretty colour. "As for the paintings he avoided looking at them ... and on the fourth floor he turned his head away whenever his eyes would have fallen on them.... All he wanted to see was Renoir and Courbet."[71] Episodes like this dismayed Matisse, and emphasised the gulf that was opening once again between himself and his most able contemporaries. The two sculptures Braque thought it best to ignore were a massive bust of *Henriette*, the first of a sequence of three as startlingly innovative as the five heads of Jeannette, and the *Large Seated Nude*, which Matisse reckoned the most important and demanding piece he had ever made (he had already been struggling with it for three years, and it would take him another four to complete).[72] By this time he had so little expectation of being understood by critics or public that he called off his annual exhibitions with Bernheim-Jeune, having already told them he would not be renewing his contract when it ran out in 1926.

This was the moment when an enthusiast of acute and refined visual perception like Georges Duthuit might have volunteered his services to mediate between Matisse and an uncomprehending world. Duthuit said he asked nothing better than to follow in the footsteps of his chosen elders, the most precious of whom was Matisse. The younger man still

dreamed that together they might tap into a deeper reality that would go beyond painting to renew the threadbare fabric of society itself ("How to attain that reality?" he asked his father-in-law. "That is one of the things I should have liked to discuss with men like you, who would point me towards the beginnings of a response").[73] But Matisse, unwilling to take on the role of Socratic mentor, especially with a disciple whose fervour was by his own account almost delirious at this stage, advised him instead, in the spring of 1925, to accept an offer to take over Charles Vignier's firm on Vignier's retirement.[74] Matisse and Vignier agreed that Duthuit possessed the three key gifts for a dealer—intelligence, intuition and charisma—but the scheme foundered on vehement opposition from Marguerite, who felt that the purity of her husband's objectives would be fatally compromised by contact with commerce. It was Pierre, back in France for the summer after mounting a small but successful mixed show in Manhattan, who confounded his family's misgivings by revealing an unsuspected talent for business ("He had arrived in New York as almost nobody," wrote John Russell, "and when he sailed for France in May, 1925, left as almost somebody").[75]

The whole family regrouped at Issy except for Matisse, who was detained in Nice by his sculpture until mid-July. In August the Duthuits moved out, taking over the empty flat in Nice so that Georges could spend the rest of the holidays working in peace (he had obtained a temporary educational post at the Louvre that autumn on his father-in-law's recommendation).[76] Matisse, who had sold a batch of drawings to buy another second-hand car, left too, setting out with Jean for Holland in an open-topped Buick. Their route lay through Soissons, which Matisse had seen reduced to rubble in 1915, and on via Mauberge and Laon, skirting Bohain and Le Cateau, across the familiar landscape of Flanders and Belgium with blasted trees and fields of newly dug soldiers' graves stretching to the horizon on all sides.[77] The trip was planned to please Jean, who drove the Buick ("You've touched the heart of the mechanic he still has inside him, and made it beat faster," said Marguerite).[78] Jean's ambition was "to become a Dutch Chardin"[79]—a master of the arts of grey like his father before him at his age—and Matisse gave him the kind of intensive Dutch painting course he would have liked for himself thirty years earlier. He drew up a list of museums in his notebook, methodically ticking them off one by one as they passed through Anvers, Rotterdam, The Hague, Haarlem and Amsterdam. But the mutual enthusiasm of father and son was damped by Matisse's crushing disappointment when Jean's own work showed no immediate profit from all they had seen.

"Thunder was in the air," Amélie wrote to Marguerite on their return, describing the kind of electric atmosphere that frayed everyone's nerves, generally ending in an explosion on her husband's part and obstinate silence or tearful threats to walk out on her own. "Today he's on form, but I'm completely done up," Amélie reported. "Don't worry ... lightning won't strike again."[80] The summer was not proving the tranquil interval of rest and relaxation Matisse had anticipated. Jean was on the defensive, Duthuit resentful and brooding in Nice, Marguerite dejected, and Pierre, for all his newfound confidence, still in danger from Corsican plots. The Matisses' lawyer had hired a detective in the spring to tail Clorinde (who was teaching in a French school), and warned at the end of the year that any overt move towards divorce was liable to provoke death threats.[81] The rift deepened between Amélie and Berthe, whose support for Clorinde made her a monster in her sister's eyes. The two had not spoken since Pierre's marriage broke down, and, although Amélie made a special trip to confront Berthe at Pau, the sisters parted without either ever mentioning the subject they had met to discuss ("I could see she wouldn't understand me," Amélie told Pierre, "and I kept my mouth shut").[82]

Pierre ran a genuine risk on his return to France each summer until 1927, when M. Peretti died ("My father died of grief," said Clorinde. "He came to Paris with a revolver to kill Pierre Matisse").[83] Enforced separation on the far side of the Atlantic turned Pierre increasingly into a family counsellor, a part he played with a gentleness and tact beyond his years, keeping in touch with his aunt, urging his mother to be more conciliatory, cheering Jean up, cracking jokes with Duthuit and explaining Marguerite's divided loyalties to their father ("If no one is prepared to disarm, the house will become a living hell, and we'll reach the point at which we can't see one another any more," he wrote with a frankness he could never have used to Matisse's face, "and what good will that do?").[84] His letters show him growing rapidly from a strained, apprehensive twenty-three-year-old trying hard to put on a good front into his father's confidant. Pierre was so shocked by the impression of unrelieved loneliness he got from Matisse in Nice in these years that he begged his mother to take pity and move down from Paris.

In the autumn of 1925, Matisse consoled himself by acquiring a dog, a lively, affectionate young bitch called Ghika who could be even more sensitive than he was himself. She trembled for a whole hour when Matisse complained about her wetting the carpet, and she could not bring herself to touch food at all after he rebuked her for being late for dinner. He had been so tired when he left for Paris in July that he said he would have liked

to sleep for a month, but back in Nice he felt wearier still.[85] The most he could manage was a single work session a day, and soon even that was beyond him. He prescribed himself a fortnight's rest in October, retreating to a hotel in the mountains at St-Martin de Vésubie, where he spent his days dozing or walking the dog ("It's a bit like a prisoner's exercise round," he told his wife).[86] In November he suffered from high tension, cold sweats, nosebleeds and lassitude ("an empty head with no desire to do anything whatsoever") coupled with such anxiety that he had to take another whole week off work.[87]

Amélie, whose own health was so shaky she hesitated to risk a train journey, finally arrived on 5 December 1925, after which both of them felt better. They treated one another's infirmities with attentive concern, and for the first time engaged a couple to come in to look after them. Amélie began to feel at home in the upstairs flat—"Little by little my household is sorting itself out"—and less of an outsider in Nice itself.[88] She not only brought her own sewing, but also sent for her dressmaker from Issy to work on her spring outfits, an annual ritual that normally retained her in Paris until Easter. Matisse, who said inactivity was making him flabby and fat, stopped smoking and took up exercise in the new year, working out twice a week with a gym instructor, and sticking to a strict schedule of swimming or foxtrotting alone to the gramophone, followed by sunbathing and a stroll along the front.[89]

The year 1926, which would bring convulsive upheaval for the whole family, started quietly enough. In the first week of January, Matisse's *Still Life after de Heem* went on show at a Quinn memorial exhibition in New York. "Your still life lights up the whole room. . . . It's splendid, the colours have remained as fresh as when you first painted the canvas. It gave me quite a jolt to see it again," wrote Pierre, who had been fifteen when this picture was painted, and who found himself swept away on a tide of family patriotism: "The Seurat looks pale beside it . . . and the Gauguin flat, while the Picasso and the Derain look like gouaches that have been squared up and enlarged."[90] The Duthuits left the Matisse apartment in Paris in January to move into a cheap pension in Toulon. Jean stayed behind alone to run the family business at Issy, sending aggrieved and incredulous reports to his sister listing people to be seen, bills settled, proofs checked, photographs taken, pictures framed and sculpture supervised at the foundry. After three months he said he was so worn out he could barely stand upright. When Marguerite eventually returned to take charge again at the end of April, Jean had to retreat to Duthuit's empty family house at Champeix to recover.

Jean's predicament was made worse by the nerve-racking pressure exerted, without conscious effort, by the absent Matisse. When it came to minding the office, all three of his children lived in fear of offending their implacable, inaccessible, inscrutable Papa, who issued instructions by letter or telegram, sometimes remaining ominously silent for weeks, at others erupting volcanically to dispense favours or, more often, hurl thunderbolts from Nice. All three seemed to themselves to expend endless time and effort on attempts to placate a capricious and irascible deity who sent them scurrying this way and that in New York and Paris, simultaneously patronised and fawned on, and painfully conscious of their own equivocal footing in the art world. The name of Matisse was a burden as much as a benefit. It made the painter's children perpetually vulnerable to exploitation by people currying favour, critics expecting preferential treatment, dealers demanding appointments for their clients. Museum officials, gallery owners, exhibition organisers and art editors required Matisse to donate work, lend pictures, contribute catalogue texts or supply illustrations. Marguerite and her brothers, fielding this stream of demands that seldom gave satisfaction in Nice, dreaded overstepping their authority, giving wrong decisions, making rash promises or disclosing sensitive information. The best they could do was shore one another up (and sometimes their father as well).

Matisse, for his part, learned slowly in these years to adjust to what felt on bad days like solitary confinement. Shut up in his studio, sucked dry by his work and missing his family's support, he was often exasperated by their incompetence, and wounded by their callous indifference to sufferings that could only be exacerbated by endless petty queries, disputes and complaints from Paris. At times, he wished he had never bought Issy or had any truck with dealers who made outrageous profits on his work while blaming him for driving up prices. But, in a generation for whom postwar disruption had more or less wiped out the job market, none of his dependents (apart from Pierre, whose foothold in New York still looked desperately precarious) had any actual or prospective source of income beyond the allowances he made them. By 1926, the struggle for survival had scattered the Matisses in all directions. At times, they seemed to be pursued by furies, breaking out in blisters and boils, collapsing with kidney trouble, dogged by exhaustion, depression, headaches, nervous tremors, swollen feet, stomach problems, spinal torsions. It felt to the painter as if the further he got from his family's problems, the greater their need for attention and guidance. As the years passed, the plaintive cries in his early letters from Nice—"I'm alone . . . my life doesn't change,"

"Have pity on the old solitaire," "Write to me, Amélie"—changed tone, becoming sterner and more peremptory.

Of all the observers who tried to unravel the mystery of Matisse and his work in these years, the one who came closest to its core was Georges Duthuit. He was an outsider himself, on intimate terms from earliest years with self-doubt and trepidation. He understood what he was seeing when he watched his father-in-law undergo the torments of the damned, preparing himself with suffering and fasting, each time he started a new work. "The resistance he encountered was so great—I've witnessed it myself—that Matisse put himself into a veritable state of trance with tears, groans and shuddering. It was a matter for him as a man of immersing himself, each time, in the darkness of his most disturbed and confused perceptions and feelings . . . and galvanising every particle of his being to go through with it."[91] No one knew more than Duthuit about the inner impediments and vacillations that could paralyse a nervous sensibility. He and Marguerite had been deeply demoralised in the winter of 1925–26 by Matisse's lack of response to Duthuit's manifesto, *Byzance et l'art du XIIe siècle*, a book that would establish his credentials that spring, both as a Byzantinist and as a commentator on contemporary aesthetics.

Matisse, having long since absorbed all he needed in this line from Prichard, had found the book tiresome and overblown. But he set himself to repair relations with the Duthuits, coming alone in March to Toulon, where Georges was working on his thesis and Marguerite had sent for her sewing machine, determined at last to develop her considerable gifts (never fully approved by her father) as a dress designer. Both felt hurt and rebuffed. Duthuit said it was as if a nightmare had lifted when Matisse arrived—relaxed and expansive, full of interest in their projects—to invite them to visit him in Nice. His son-in-law responded with an extraordinary ten-page typed letter that reads more like a peace treaty, setting out the causes of his discontent, acknowledging the mistrust and irritation he knew his effusions provoked in Matisse—"But what is to be done, and how can I conceal something so dear to my heart now that the best and happiest of events has tied me so closely into your life?"—and modestly proposing himself as the advocate the painter needed to interpret his work to the public.[92]

Duthuit warned that any further repulse would provoke a definitive rupture, and that pride prevented him from accepting a sham reconciliation ("A polite compromise, made up on my part of dissimulation and submission, an equivocation of which I know myself to be absolutely incapable"). The offer was part apology, part ultimatum, and Matisse

Matisse and
Georges Duthuit

accepted both. When the Duthuits reached Nice on 14 April, Georges found himself for the first time included in the casual studio intimacy Matisse had only ever shared up till now with his family, his models and his fellow painters. The next few days were instructive all round. Marguerite contributed a practical expertise very different from her husband's speculative and theoretical approach. Duthuit learned fast, asking questions, making conjectures and drawing Matisse into areas he had rarely, if ever, tried to put into words before. The visit proved a success. Matisse encouraged his son-in-law to take photographs and write about his latest work. He even arranged through a friend of the Thorndikes for Marguerite to present her collection to a head of department at one of the grandest of Parisian couture houses, Maison Worth.[93]

One of the works Matisse had hoped to complete in time for the Duthuits' arrival was the *Large Seated Nude*, the sculpture he said he worked on for hours at a time in a kind of trance, without making a single false move and without conscious control over what he was doing. "It goes like a game of chess, and I'm so sunk in my work that I shrink back in shock if I catch sight of myself in the mirror, and I don't even notice until the end of a three-hour séance that my feet are bleeding."[94] These strenuous sessions, for which Matisse had been limbering up with an exercise programme ever since January, were the direct outcome of the affair with Michelangelo's *Night* that had started in 1918. The *Large Seated Nude* leans back with hands clasped behind her head in Henriette's pose, sleek, taut and unmistakably modern, but the muscular balance and thrust of her body recall, more openly than any of the odalisque paintings, the figures on the Medici tomb which presided over the whole of Matisse's first decade in Nice. Henriette herself photographed the *Large Nude*, seated

Michelangelo, *Tomb of Giuliano, Duke of Nemours*, detail (*Night*)

(like the models) on a raised platform against a background of flowery fabrics in a studio setting that recreates the looped-back curtains, fancy Algerian mirror and Oriental carpets of the harem in Delacroix's *Femmes d'Algier.* There is nothing camp or self-conscious about this juxtaposition. The statue looks both incongruous and thoroughly at home in the Nice studio where Matisse held his two great predecessors steady in his sights by the austerity and intensity of his concentration.

The *Large Seated Nude* grew and changed from one day to the next. After the Duthuits left, it acquired a severity that it lost again in the summer ("It had a hierarchic Egyptian quality," Matisse told his daughter in June, "today it's more elegant and more tender in feeling.").[95] Matisse pictured himself as a kind of Pygmalion in reverse, enslaved by a statue whose living will dominated its creator. Every year he fetched a skilled workman from Marseilles to mould his statue in plaster at the end of the season, every year he postponed his departure hoping to finish it before he left for Paris, and every year it defeated him. The amount of time and effort expended already struck him as ridiculous in July 1925. Two years later, he swore to either finish

Matisse, *Large Seated Nude*, 1922–29

his statue or ditch it for good. In March 1929, he fell on it again in a frenzy, working six or seven hours a day with the trance-like assurance which he recognised as the culmination of everything he had ever done as a sculptor.

From his earliest days as a student, Matisse needed sculpture—the physical release of pummelling clay—at intervals as a counterpoint to painting. In Nice, drawings and clay figures based on Michelangelo enriched and invigorated his work on canvas for more than a decade. "I shall go back to painting transformed, I'm sure of that," he wrote during his last combat with the statue. "I'm beginning little by little to get rid of the feeling that, if what I'm doing is only sculpture, it isn't really serious."[96] *Large Seated Nude* would finally be cast in bronze from a plaster mould made in July 1929, at the end of its seventh season in Nice.

In the spring of 1926 Matisse completed *Henriette II*, a second radically simplified bust with something of the primal power that he said distinguished Michelangelo from sculptors like Donatello, who relied on surface modelling ("the Michelangelo could be rolled down a hill until most of the surface elements were knocked off, and the form would still remain").[97] *Henriette III* closed the sequence three years later. The model's innate steadiness and gravity—her clearcut features, straight nose, chiselled brows, firm chin and columnar neck—are accentuated in these massively compacted bronze heads, which are as much icons of female strength and authority as Matisse's early Fauve portraits of his wife. He rose to a climactic peak at the beginning of 1926 with a painting of Henriette (colour fig. 23) that combined riotous colour and pattern with the sobriety of the *Large Nude*. "Relying on this sculpture, the *Decorative Figure on an Ornamental Background* is the brutal reinsertion of volume into space, and moreover the most *niçois* space Matisse ever dared paint," wrote Dominique Fourcade.[98]

The statuesque nude in this painting is hard and unyielding—more like a woodcarving than a clay model—vertical, impassive, totemic. It is the textiles that surge and swell round her: the soft white wrap billowing between her thighs, the tipsy patterning and blowsy curves of the wallpaper with its floppy red blobs signifying flower petals. This is a last spurt of diffused sensuality, a world away from the flirty, curvaceous odalisques once impersonated by the same model in see-through boleros and embroidered satin pants. The contrast was underlined by Matisse's old friend, always one of his most astute observers, Jules Flandrin. When the *Decorative Figure* went on show at the Tuileries Salon in May 1926, Flandrin cut

Matisse at work in
his Nice studio

out a pair of articles from *L'Art Vivant,* the first devoted to another stylish
painter of odalisques, Flandrin's own partner, Jacqueline Marval, the sec-
ond reinforcing the worldly and essentially frivolous image of Matisse
that would imprint itself ever after on popular imagination. Flandrin
enclosed both in a letter to a friend that vividly conveys the impact on a

sensitive and sophisticated contemporary of *Decorative Figure on an Ornamental Background:*

> Flowered wallpaper leaping off the wall . . . in the middle a vague shapeless form, vaguely feminine, deliberately mishandled, in opposition to the trompe-l'oeil wallpaper flowers; on the carpet a plate of lemons. All this in order to look strong, ugliness being a sign of strength. But I can't begin to convey the brilliantly successful contrast between the wallpaper flowers and the woman so skilfully mishandled. Above all she has one side of her body running straight from her upper arm to her thigh like a side of meat on a butcher's hook (packaged meat, I mean). This isn't to be taken as a harsh criticism, coming from me who have always been charmed by Matisse's art! No, it's just that it's like an insect that puts yellow stripes on its back: it's the why and the how that's curious.[99]

The long, laborious effort that led to this climax left both Matisse and his model worn out. "Can Papa really have aged so much?" Jean asked in alarm when he saw Duthuit's photos of his father in April.[100] Henriette was pale, drawn and so debilitated she had to leave Nice for a rest cure that summer.[101] At the end of May, Matisse escorted his wife on the first stage of her own annual cure (this year it was a course of twenty-one mud baths at Dax, on the northern tip of the Pyrenees), seeing her onto the train at Marseilles and returning to Nice alone to take stock. He was fifty-six years old, and felt himself as much out of step with his contemporaries as he had been in the years of scandal and vilification before the war. He set out his position in a long letter to his daughter, comparing the hardships facing her generation with his own past ("You force me to look back at my beginnings, which were as terrible as yours in a period that was far more indifferent"), and describing his current life with a statue that kept him on his feet until seven or eight every night, often sending him to bed without dinner because he was too tired to eat. "It's not the good life with no cares, believe me. . . . It's still a harsh life, Marguerite, at nearly sixty years old—surrounded by almost total incomprehension—I would rate the chances of success for even my best exhibition in the future no higher than the toss of a coin—that shows how little confidence I have in public reaction at all levels—they'll come round in the end, I daresay, but only when I'm far away and can't hear them any more—my life is as hard, believe me, as it's always been."[102]

Circumstances might change ("Putting food on the table is no longer

a problem, it's true") but not the underlying situation, said Matisse, handing down with relish the motto of his stoical northern parents: "Suffering is with you for life." Now that pictures were selling well at last, money had gone mad. The franc, which had more than halved in value in the last three years, lost almost as much again in the first three weeks of July 1926 (ending up at 240 francs to the pound sterling compared with 26 in 1918). The nation was virtually bankrupt, with cabinets resigning every few days and panic-stricken crowds besieging the banks, hoping to withdraw savings in time to switch to gold bars or property. The Matisses had already decided to buy themselves a second apartment in central Paris, so as to free quai St-Michel for the Duthuits, and to sell or let Issy. Matisse plunged into the task of clearance, marshalling house agents, lawyers, builders and decorators all summer at Issy with a renewed surge of the joyful energy always released in him when it was time to move on. His wife reacted as if it were her life as well as her home that was being dismantled, starting each day with storms of weeping before sinking into a torpor neither she nor anyone else could do anything to lift. Matisse was bewildered, and perplexity made him peremptory. In September, Amélie left to recover at a rest home in the mountains at Bourbonnes, where her husband joined her briefly before taking the train on to Nice to find his landlady had put up the rent, and builders' scaffolding was blocking his studio window on the Place Charles Félix.

Matisse financed the repairs and repainting at Issy, and the purchase of a new apartment on the boulevard Montparnasse, through the sale of four paintings to Paul Guillaume in September 1926, when his last contract with Bernheim-Jeune expired.[103] Guillaume's purchases included *The Piano Lesson* and *Bathers by a River*, which he talked of presenting to the Louvre (something he was quite safe in doing, as Marguerite told him tartly, since there was no way the Louvre would accept).[104] He planned to maximise impact by devoting a whole show to these two monumental precursors of the modernist movement that had never been seen in public before (in the end he also borrowed from Pierre the smaller and slighter *Branch of Lilac* of 1914). They were to be introduced at the opening on 8 October by a talk from Duthuit in a gallery emptied of everything except the three paintings and a piano, on which the pianist Marcelle Meyer played pieces by Stravinsky, Satie and Georges Auric ("Music as clear-cut and brilliant as silver and crystal," said Duthuit).[105]

This was Duthuit's first public appearance in the role of Matisse's official champion. Speaking on behalf of disillusioned modern youth—"the men of my generation"—he began by analysing the incoherence and

lack of commitment endemic in the contemporary art world, and ended with a ringing affirmation of faith in a future that would one day open its house and its heart to paintings like these.[106] The text of his lecture is remarkable as much for its clarity, grasp and perceptiveness as for the insights contributed at firsthand by the painter himself. A listener to Beethoven responds not so much to the sounds themselves as to the force of emotion they convey, Duthuit once said to Matisse, playing him one of the late string quartets.[107] His account of *Bathers by a River* is a sustained and intensely musical evocation, starting from the painting's distant origins in Matisse's memory of a mountain glade on a country walk in the Roussillon, exploring the ways in which the original concept grew and adapted in response to the constraints of time and space, transforming itself, taking on new levels and layers, proceeding by apparently haphazard suppressions and accretions to the majestic generosity and inclusiveness characteristic of all Matisse's greatest and most nearly abstract works.

Using Beethoven's *Pastoral Symphony* as an analogy, Duthuit described the process that enables the artist to dredge his own consciousness and transpose the contents—"emotion, sensation, image, that is to say instinct, everything that shapes and limits him as an individual"—in a form that is at once unrecognisable, impersonal and deeply moving.

Pablo Picasso, *Large Nude in Red Armchair*, 1929

Guillaume had invited him to defend Matisse's paintings against charges of being too abstract (a word used by contemporaries to mean dry, cerebral and unfeeling), but Duthuit ended up delivering a defence of abstraction itself at a time when the concept in painterly terms had barely yet been invented. No previous commentator had analysed Matisse's work with anything like this degree of sophistication, which invokes a scale of values wholly alien to the polemics and factions of 1920s avant-garde Paris.

It was an impressive performance ("His text was brilliant,

young, lucid, new," said Guillaume),[108] and drew unexpected congratulations even from Picasso's chief spokesman, André Salmon. Few in an invited audience that included Marc Chagall, Jacques Lipschitz, Francis Picabia and Marie Laurencin in the front row can have been unaware that Matisse counted for less and less as a painter in the key debates of the day. Guillaume had a loaded revolver ready in his desk drawer and four policemen posted at the door, in case the Surrealists decided to attack. In the event their only overt response came from Picasso, who (like Matisse) had stayed away from the opening, but shortly afterwards started painting savage Surrealist nudes leering and writhing in striped or flower-patterned armchairs ("Matisse's odalisques were in Picasso's sights," wrote Elizabeth Cowling, pinpointing relations between the two at this point).[109]

But the Guillaume show was overshadowed by another crisis for the Matisses, who were already beginning in the first week of October to pack up at Issy for a move that would absorb their energies over the next three months. Marguerite and Jean took charge of operations. Amélie retired to bed, obliterated by what Pierre called a veil of heaviness, a protective veil covering depths of anger and loss that spurted out at intervals in tirades of criticism and complaint.[110] The Matisses' doctor, François Audistère, attributed her sudden violent spasms as well as her underlying depression to nervous aggravation, advising the whole family, and especially her husband, to avoid topics that might upset his patient. Audistère, who came to understand probably more than any other outsider about the workings of the painter's family, blamed this latest collapse in large part on Matisse, whose passion for painting now raged virtually unchecked. The diagnosis

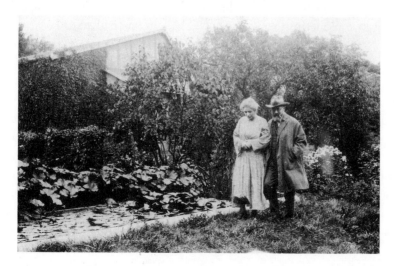

Henri and Amélie Matisse photographed together for the last time in their garden at Issy

disturbed Matisse far more than armed Surrealists ("If it's really me who's responsible," he wrote sadly to Amélie the day before his show opened, "I ask you to forgive me, and promise you it won't happen again").[111]

Pierre left for Nice at the end of the month, bringing his father news from Paris before catching the boat back to New York on 3 November. "It seems such a long time since I left you," he wrote as soon as he landed, "and the situation I left you in together with Maman and Marguerite never ceases to trouble me . . . it's a poison you're all allowing to infiltrate when you ought to defend yourselves against it."[112] Pierre's solution was for his parents to take off with a paint-box for a couple of months to Algeria or Marrakesh, a scheme that instantly revitalised Amélie but had to be vetoed in the end by Henri because every painter who heard about it, from Marquet to Marchand and Thorndike, wanted to tag along too. Amélie, installed at 132 boulevard Montparnasse in December, stayed in bed, plaintive and apathetic, visited daily by Marguerite and tended by the faithful Marie, who had moved with her after nearly twenty years of looking after the household at Issy. Everyone caught colds. "We've scarcely yet completed this terrible uprooting," Marguerite wrote to Pierre on 26 December. "Luckily the blood of Maman Matisse runs in my veins."[113]

Matisse marked the new year of 1927 by laying out his hopes and fears in a painfully frank appeal to his wife, begging her to believe he did not want to distress her or make her do anything against her will: "We're too old for that—but I can't resign myself to believing that we are to live separately—and that you will no longer be with me here where my work calls me. Dear Amélie, I'm not reproaching you, just telling you of my very great distress . . . it's the only thing I want—that we should put our lives back together again . . . we lived as one before, why couldn't we again, if I haven't lost all merit in your eyes?"[114] The letter articulated a habitual pattern of retreat and advance, flight or rejection on her part, protestations and pleading on his, and it provided Amélie with the reassurance she needed. By late January, when Henri came up from Nice to view the new flat and plead his cause in person, the crisis had passed.

They spent the week amicably interviewing prospective brides for Jean, who had tired of temporary alliances with girls more interested in art than domesticity, and had asked his parents to pick out a proper wife for him in the traditional French way. Nothing came of their efforts, perhaps because respectable families were put off by the Matisses' hopelessly unbusinesslike, strictly painterly approach ("Tall, well made, limbs a bit long—sprawling movements like a young dog—intelligent, very gifted

and very reserved," wrote Matisse, assessing a Mlle Agelasto who had sat for one of his portrait drawings as a child, and who was the candidate Jean liked best).[115]

In January, Pierre, who had acquired a business partner with a gallery of his own in New York, mounted a Matisse retrospective presided over by *The Moroccans,* making its first public appearance since it was painted in 1916. It was a major success, and Pierre celebrated by buying a Bugatti in the spring.[116] Even the problem of his divorce no longer looked insoluble after the death of his father-in-law in February. But the idea of exchanging paintings for money still cost him un-American pangs of shame and remorse. "This horror of dismembering the family, of dispersing, bit by bit, everything that bound our family together," he wrote to his father in a passionate reiteration of the faith in painting that ruled both their lives, "it's the same feeling that makes you recoil, in spite of the material advantages, from finally giving up Issy."[117]

In the end his parents decided to let Issy, and rent the flat next door to theirs on the fourth floor of 1 Place Charles Félix. Amélie finally moved south in the first week of February ("She's held up by the dressmaker, who is making dresses for her that she'll never wear," Matisse reported gloomily to Pierre).[118] By this time, her husband was contemplating a painting that would mark the end of his collaboration with Henriette. Both had been forced to accept that she might have to give up modelling altogether after her collapse in the summer. Matisse investigated the possibility of her making a career in films, like Renoir's model Dédée (who had just completed her third starring role, appearing under the name of Catherine Hessling in *Nana,* directed by her husband, Jean Renoir). The Hollywood director who had taken over the Studios de la Victorine, Rex Ingram, sent his cameraman to photograph Henriette in Matisse's studio in the summer of 1926.[119] She hoped to be strong again by September, but in the series of paintings for which she posed that winter, the reclining odalisque is scarcely more than a compact rectangular shape placed vertically to balance the horizontals in complex constructions of red, white and yellow or sharp greens and purply plum pinks. Henriette, in filmy grey culottes, lies prone, almost inert, in these canvases. It is as if both painter and model mourned her infirmity, the ruthless erosion of health and energy softening and slackening her body so that its volumes and surfaces no longer responded to light like a sculpture.[120]

Matisse painted a last small, powerful, valedictory portrait in which Henriette gazes gravely back at him, dressed formally in a loose, flowing

two-piece outfit and a close-fitting hat with a veil. The sittings left the painter distraught. Amélie described waiting for her husband to join her after his morning work session at their usual lunchplace: "I watched him arrive at Camus, red in the face, looking as if he was about to put his head down and charge at the customers."[121] Too strung up to eat, Matisse only slowly relaxed enough to discuss the problem with his wife: "Tea-time found us both together in front of his paintings exchanging ideas, and putting off the moment when he would have to turn his canvas round, the one he thought he had ruined." His wife's positive verdict, confirmed by Marchand, who joined them in the studio, restored Matisse's confidence sufficiently for him to complete the painting.

Woman with a Veil is the saddest and perhaps the most deeply felt painting Matisse ever made of Henriette. She sits huddled up, her chin propped on one hand, her face darkened and distorted by the veil itself, which seems to refract one side of her head as if it loomed through thick glass or water. Behind her is the length of toile de Jouy that had seen service in so many key paintings of twenty years before. Henriette's veiled eyes, her head-on pose, the uncompromising mass of her body muffled rather than revealed by the bright, heavy folds of her dress, all recall the 1913 *Portrait of Madame Matisse*, but where that was a tragic confrontation, this rich and sombre canvas—impersonal, austere, charged with the taint of grief and loss—marks a last mutual salute between two former partners, each with nothing left to give.

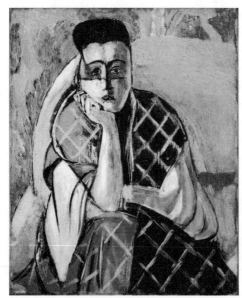

Matisse, *Woman with a Veil,* 1927: valedictory portrait of Henriette, posed ceremonially against the toile de Jouy

At their final sitting, Matisse reversed his paintbrush as he had done once before in the *Portrait of Yvonne Landsberg,* lightly scratching fine white lines in the paint to outline Henriette's eyes, lips and bare arm, emphasise the fall of her scarf and create a flurry of agitation round her fingers.

Any potential opening in films vanished with the invention of talking pictures in 1928, which put a stop to Ingram's cinematic career. The Matisses remained on

friendly terms with the Darricarrères in Nice, maintaining contact long after Henriette married a schoolteacher and bore a daughter, who would grow up to pose in her turn for Matisse. He found other models ("Odds and ends, all rather ordinary," he complained at the end of the year),[122] notably a vivid, dark-haired Italian girl with a long plait, called Zita, and various ballet dancers. "The foam of this tutu, and the way the legs spurt out of it, the purity, the delicacy, the...strawberries and cream would be...," Matisse told Duthuit,

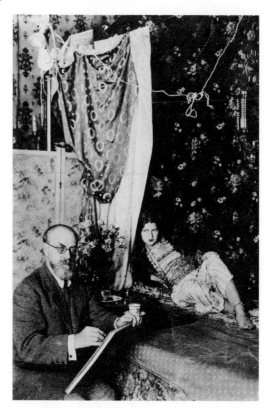

Matisse and the model Zita, 1928

finding words hopelessly flat and clumsy. "Really at moments like these, I feel all the adoration I am capable of before nature. Emotion takes over so absolutely that I reach blindly for pen and paper, and I truly don't know what I'm doing. My line is unbroken and, as it travels from the tranquil to the piquant, it recreates along the way how I feel."[123]

One outcome of the Guillaume show was a proposal for Duthuit to write the text for a lavishly illustrated book about his father-in-law commissioned by the Bernheims ("because they felt me slipping through their fingers," Matisse said sourly).[124] Initial resistance on the painter's part was swiftly defeated by a family line-up headed by Amélie, indomitable as always as soon as she scented a cause worth fighting for. "There's no reason to attempt the sort of thing that could be done by any passing hack," Duthuit explained grandly to his prospective subject. "On the other hand, the sole book readers will look for on your work is the one we are planning at this moment.... The Bernheims greet me like a king received by kings."[125] But Matisse's misgivings about the Bernheims' intentions were

well founded. When their notion of funding turned out to be wholly inadequate, the project was transferred first to Guillaume (whose initial enthusiasm also evaporated), and next to the founder of the new and ambitious *Cahiers d'Art*, Christian Zervos, who broadened the brief to take in all the other Fauve painters as well.

It would be another ten or twenty years before paintings from the Fauve period could be taken seriously ("The pictures that interested me in those days enjoyed no prestige whatsoever," wrote Duthuit),[126] and, from the point of view of critical or public awareness, much of Matisse's subsequent work might as well never have existed. His *Blue Nude* of 1908 created a sensation when it resurfaced briefly in Paris at the Quinn sale in 1926. The *Red Studio* of 1911 was finally bought the same year to decorate a nightclub in London, but the groundbreaking wartime canvases—above all *The Moroccans* and *Bathers by a River*—dropped out of sight again after waiting a decade for their respective first public showings.[127] Meanwhile even Matisse's supporters disapproved of his latest pictures. Duthuit, who told his father-in-law to his face that much of what he was doing was pointless, published a survey of Matisse's recent work in *Cahiers d'Art* without mentioning a single one of the paintings in question, except for a passing reference to *Odalisque with Tambourine* ("I've re-read your prose poem with pleasure," Matisse wrote politely when the article reached Nice, "and accept it without demur as one would a ceremonial costume intended to show off one's few discernible good points").[128]

In the summer of 1927, the last of the annual family gatherings at Issy, Matisse said he learned to keep his mouth shut when his son-in-law insisted on thrashing out their differences. "He's thirty, I'm nearly sixty," the painter grumbled, comparing the younger man to a runner toeing the starting line, and himself to an athlete resting before his next race. "At his age perhaps I might not have been able to put up with a more open approach, and probably I would sometimes have been just as irritating."[129] Matisse refused to take on Duthuit or Breton or any of the other excitable young spin doctors spoiling for a fight in Paris. "I don't want any more struggles in my life," he told his daughter, "I've got quite enough in my work." He made some of his most serenely beautiful paintings in the winter of 1927–28, but he was already nerving himself for a fresh start. "I don't feel up to work . . . ," he admitted to his wife. "It seems so difficult and complicated that afterwards I'm a wreck. . . . Probably I'll need a complete physical overhaul before I can stand the major effort of setting off in a new direction all over again."[130]

The turmoil of the year before slowly subsided as the family

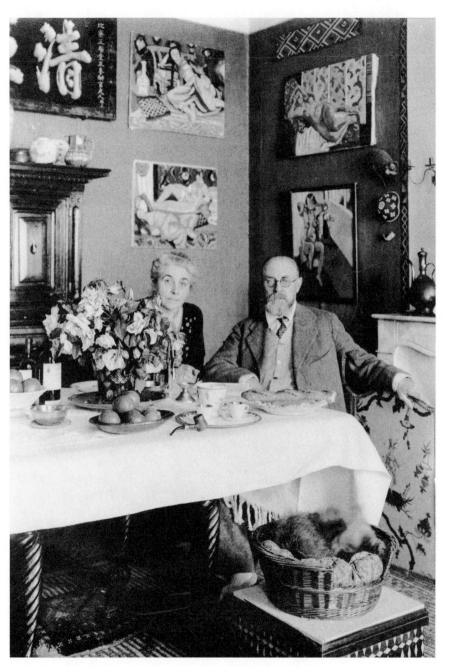

Henri and Amélie
Matisse with their
dog in their Nice
apartment

regrouped. The new apartment meant that the Matisses now possessed the entire top floor of 1 Place Charles Félix, with superb views commanding the bay, the town, the mountains and the coastline as far as Antibes and beyond. Workmen moved in that autumn. When Amélie reached Nice at the end of December, after a cure at Aix and a course of injections in Paris, Matisse was still painting in the studio on the third floor and living in the small corner flat above. The couple settled down cheerfully to await completion of their new home ("I get out a bit, I sew, the time passes peacefully," Amélie reported to Marguerite, ". . . your father adores my toque with the grey feathers . . . my new dresses please your father").[131] In February 1928, Matisse accompanied his wife by train across France to settle her into the sanatorium for another cure at Dax, following her progress and ticking off her mud baths day by day in letters from cold, wet, wintry Nice ("All quiet here except that I miss you").[132] Pierre, newly arrived from the United States, escorted her back again in March. "The new apartment's making progress, it's superb, you'll all be bowled over when you see it," Amélie wrote to Marguerite in May.[133] There was ample living space, storage, spare bedrooms, a big kitchen and room for a new live-in couple to run the place. Amélie had a large room looking out to sea

Matisse, self-portrait in his working pyjamas from a letter to his wife, 15 July 1928

next to the dining room, Henri's smaller bedroom, and the double studio with a huge glass window giving onto a balcony running right round two sides of the building. "Shan't we go back to being the two inseparables of the good old days?" Henri wrote hopefully of their new life together.[134]

He was experimenting with compositions constructed round two or three figures, posing Zita with Lili and Hélène, ballet dancers from the Compagnie de Paris who were constantly being called away for extra rehearsals (once the company director came himself to intercede with Matisse), or performances at Perpignan and Marseilles. There was still no sign of anything to match the sustained concentration of Matisse's seven-year partnership with Henriette when Amélie returned to Paris at the end of June, leaving him to finish a refractory still life. He worked on it through the sweltering heat of midsummer, sleeping under a mosquito net at the shady north-facing end of his third-floor work space while work-men erected an awning on the sea side of the new studio upstairs.[135] Matisse painted in loose, light pyjamas, with windows open to catch the slightest draft of cool air coming in off the sea, and sketched himself din-ing alone on his balcony, looking like a keen young student again in striped top, spectacles and a wispy beard.

He was beginning to sense a future opening out of his still life, an unpretentious arrangement of a jug, a plate of peaches and a checked tea towel on top of a simple wooden cupboard. "You'll see, there's something new here . . . ," he announced to his wife on 7 July. "This will extricate me from the odalisques—I can feel it inside myself, like a release. I had pretty well come to the end of what I could do with construction based exclu-sively on the balancing of coloured masses."[136] He worked on, scrubbing out and repainting, stupefied by the heat and by the possibilities of his new canvas. "At the moment I'm completely gripped by fruit," he wrote on 14 July, "—and I couldn't go back to figures, this is a hand-to-hand encounter with painting—I'm really pleased with the effort I'm making in this still life, it's going to renew me." By the seventeenth it was so hot he stayed indoors all day, drawing fruit, reading or dozing on the studio couch, feeling his feet swell and thinking about his *Still Life on a Green Side-board*. It was the one painting he took with him when he left by train for Paris five days later. He had reached the moment captured by Duthuit in a beautiful passage about the emergence of the Fauve palette, which describes what happened each time Matisse discarded an old way of painting or seeing: "A secret fire devours it from within, then bites its way to the surface in incandescent trails, and finally bursts out freely."[137]

〜

1929–1933: *Nice, Paris, America and Tahiti*

Matisse, *Brise marine*
from *Poésies de
Stéphane Mallarmé,*
1932

W̲hen Charlie Chaplin released *The Circus* in 1928, Matisse saw it twice with his friend Thorndike in Nice, and was struck by its extreme simplicity: "Nothing picturesque about it, no flourishes ... it's like someone who talks as simply as possible using only very few words to express himself."[1] Chaplin himself seemed to have aged, and

his playing of the tramp had moved on from captivating charm to something sterner and more touching: "From start to finish you're glued to what he's doing, you can't miss anything because nothing is unnecessary."

This was the kind of streamlined fluidity Matisse wanted in his own work. He responded both as a painter and as a man to the extraordinary gravity he found in Chaplin's film, which ends with the tramp turning down a fairy tale ending—the girl of his dreams, top billing as a circus star—in favour of a solitary and uncertain freedom. Matisse would be sixty in 1929. A painting of his was on course to enter the Louvre that year. He had already won first prize at the 1927 Carnegie International Exhibition in Pittsburgh. Success, public honour and a comfortable old age lay within his grasp. Rumours circulated in Paris that he intended to retire and take up religion. A New York journalist turned up in Nice to ask if it was true that Matisse had summoned his disciples to announce he was reverting to safer, more traditional methods and abandoning modern art.[2]

He declined to comment on the contemporary art world to a sympathetic young interviewer, Efstratios Tériade, who arrived in January 1929 to question him about the past. Matisse, briefly in Paris to fetch his wife home after a course of injections, said he could no longer stand the frenetic atmosphere of the capital, "the noise, the movement, the latest news and trends you're supposed to follow."[3] He insisted that the only show that interested him was the Boat Show. Rowing had become a passion in the last two years. He rowed across the bay in his own skiff most days ("It's a sport that suits me," he told his wife, ". . . it's a question of suppleness, rather than brute force"),[4] winning a medal for taking his boat out more often than any other member of the Sailing Club in Nice. He grew tanned and fit, showing Tériade his calloused palms as if he were in training for some unspecified event. They discussed what lay behind his spectacular breakout as a Fauve in 1905, and Matisse explained that he couldn't live in an excessively tidy, over-regulated house: "You have to head for the jungle to find simpler ways of doing things that don't stifle the spirit."[5]

Back in Nice, he couldn't settle. When Amélie returned to Paris to complete her treatment, Henri was disconsolate ("My dear Amélie Noélie, Come back as soon as you've finished your injections for I'm miserably bored all on my own . . . there's no reason to go out and nothing interests me").[6] The dog did her best to fill the blank—"Ghika treats me with a touching tenderness"—but the highlight of his day outside working hours remained his nightly walk to the station to post a letter to his wife before going home to bed.[7] When the sculptor Aristide Maillol turned up with his son in Nice, Matisse took a whole week off work in

March to show them round the town and tour the scenery in his Buick ("an open torpedo," said Jules Romains, recalling hair-raising excursions with the painter at the wheel).[8] They visited the heights of Mont Boron and sped round the coast to Monte Carlo, taking in Matisse's favourite restaurants and lunching on their last day with Bonnard and the collector Arthur Hahnloser. Maillol reminisced about the old days in Collioure, and scrutinised his host's latest work intently. *"He looked at everything, the old fox,* but anyway I was glad to see him," wrote Matisse. "Our understanding is totally different—next to him, I'm a Cubist, a Surrealist even."[9]

Maillol was enthusiastic about Matisse's new studio, impressed by the apartment with its spacious rooms opening into and out of one another ("He found the way we've done it up superb"), and deeply envious of his old friend's domestic set-up. He told Pierre later how much he wished his own wife could be more like Mme Matisse, who embodied his ideal of calm and gracious living.[10] Amélie was at her best that summer, scouring the junkshops for rugs and wall-hangings, stitching curtains with embroidered borders for the Duthuits' new flat in Paris, coordinating a last tremendous onslaught on the Nice apartment by builders, plumbers, carpenters and tiling specialists ("Your father and I have sworn we'll never build ourselves a house: we'd go mad").[11] She suffered recurrent bouts of the back trouble that always incapacitated her in a crisis, complicated by a kidney attack earlier in the year in Paris, and she still spent up to three days out of six in bed, but the depression itself had evaporated. Marguerite said she watched her mother click out of it one day as if a switch had flipped.[12]

Matisse had finally found another dancer to replace Henriette. He had spotted Lisette Löwengard in an antique shop, where she and her widowed mother were trying to sell a few pieces to the owner.[13] An alert, independent seventeen-year-old, Lisette was the daughter of a leading Parisian antiquarian, Charles Löwengard (who died when she was twelve), and the niece of another, Ernest d'Albret, both well known to the Matisses, a link that immediately reassured both families. When Lisette's mother went back to Paris, she left her daughter in the care of the painter and his wife, who engaged her to come in daily and found her a room in a nearby hostel run by nuns. She started out as Matisse's model but quickly became a companion for his wife. Lively and capable, Lisette knew how to tend an invalid, and soon she was massaging Matisse's painful arms as well, and tucking him up in a rug for his siesta on the balcony after lunch.

Full of plans for the future, Amélie talked of putting the Montparnasse apartment up for sale and finding another studio flat as a pied à terre

in Paris to replace the one on the quai St-Michel (finally given up that year when the Duthuits moved out).[14] "She's never been so happy here before," wrote Matisse, who had finally achieved the balance between life and work in Nice that he had longed for ever since he first arrived.[15] For a few months in 1929 the couple showed every sign of settling down into a contented old age. Amélie decided to learn to type ("Your father's going to buy me a machine"),[16] and Henri entertained her as he used to do in his student days, with energetic antics to the latest pop tunes. "He's playing jazz and all the most suggestive tangos on the gramophone," she reported cheerfully at the end of May; "at the moment he's dancing the tango 'Poule de luxe' in his dressing-gown and his black silk night-cap."[17] Three weeks later the painter booked a double cabin to the South Seas aboard a steamship called *Tahiti*, leaving the following spring from San Francisco.[18]

When people asked him at the time and afterwards why he suddenly set off for Tahiti at the start of 1930, Matisse gave one of two reasons. The first was that his doctor had ordered a complete rest, and forbidden him to use a brush because he suffered acute neuritis in both arms, especially his painting arm.[19] The second was that he was looking for a new light—the tropical light of the Pacific Islands, where he would find dawn and darkness unlike anything he had seen before.[20] The two reasons were intimately connected. Matisse habitually linked his periodic flights southwards towards the sun with the need to simplify his work and make it more expressive. Physical and moral compulsion came to much the same thing in these upheavals. His body had always reacted violently to anything that came between him and painting, starting with the mysterious back pains that had crippled him as a teenager whenever his father mentioned alternative careers. "Nervous people produce external symptoms out of proportion to whatever is wrong with the organ in question," Marguerite explained, reminding her father in retrospect of the complaints that plagued him as he approached the age of sixty and found himself disabled by knifelike cramps and nosebleeds so copious he hardly dared move, let alone paint.[21] "God knows how often you told me at the time that you were an old man, that everything was over," she wrote, pointing out that his aches and pains invariably disappeared as soon as he began to paint.

That prospect receded as the birthday celebrations advanced. Duthuit's ambitious dream of a book that would do justice to Matisse's entire career had shrunk in practice to six more or less journalistic publications due in 1929 ("I hope they don't come to blows in your hall," Marguerite wrote tartly, when two rival authors proposed to descend simultaneously

on Nice with questionnaires).[22] There was to be a small Parisian sculpture show and a big Berlin retrospective in 1930, followed the year after by three more retrospectives in Paris, Basel and New York. Matisse dreaded the public tributes, which he correctly predicted would deplore his latest work, consign his achievements firmly to the past and write him off as a spent force in the present. Worse still was his own growing suspicion that painting had indeed abandoned him. For twelve months, he tried to call it back. *Still Life on a Green Sideboard*, the wonderfully serene and confident homage to Cézanne that had released Matisse from his odalisques, failed to lead as he had hoped to a new way of working, something more solid and less showy. He gave the canvas to the Friends of New Painting, a pressure group of collectors and curators who proposed to infiltrate the French state collection by presenting modern paintings to the Luxembourg in the hope that some at least would end up in the Louvre. The Director of National Museums, Henri Verne, had assured Matisse that his picture would make the transit, but even Verne could not prevent *Sideboard* from being hung—where Matisse feared his contemporaries meant to situate his entire output—so high up and far away as to be practically invisible.[23]

Throughout 1929, painting eluded him. Neither his new model nor the great glass-walled, white-tiled studio filled with gleaming reflected light from sky and sea could ignite a spark in his imagination. He had begun the year by setting up a composition for which he had high hopes—"It's a large-scale thing in colour to be done very quickly along the lines of the big *Riffian*"[24]—but an unexpected snowfall blotted out the colours in his studio, and Lisette caught flu. "She's gone from round and fresh to listless and wax-pale," he told his wife, abandoning his *Woman in a Madras Hat*, the first and for a long time the only major canvas he attempted with Lisette.[25] He said he got so sick of invoking colour that refused to come that he switched to print-making instead. "Painting is going nowhere," he wrote. "I force myself for nothing—but lithos flow of their own accord."[26] He was half delighted, half appalled by the ease and spontaneity with which he drew straight onto copper plate or stone, working six hours a day and producing three hundred works in five months ("They're astonishing, incredibly full of life—it's as if you used the etching point and copper like pencil and paper," Marguerite wrote from Paris. "They're a joy to see").[27]

He divided his days between print-making and sculpture, completing two projects generated by the absent Henriette, the *Large Seated Nude* and the last of three small, harshly distorted and exquisitely sensuous *Reclining*

Nudes. In the summer, the Matisses retreated from the heat and glare of the Mediterranean to the cool, dim, quiet Hotel Lutétia in Paris (the Montparnasse flat had proved too much for Marie, and Amélie could no longer manage it without help). Issy was let to tenants, all except the outbuilding where Jean had set up his studio and living quarters, and where his father now returned to another piece of unfinished sculptural business. This was his final variation on a theme taken initially from the *Bathers* by Cézanne that exerted peculiar moral and pictorial power over the entire Matisse family. Cézanne's small, sturdy bathers, each with a long straight

Matisse, *Back IV,* 1929–30: "You will find there the whole life of Henri Matisse: an extraordinary equilibrium, returning always to the plumb line."

tress of hair hanging down her spine, were transposed over twenty years into the four massive, elemental, sculpted *Backs*, which Matisse produced at intervals like a repeated affirmation of steadiness and purpose. They remained virtually unknown in his lifetime, but their plain rough surfaces and simple geometric volumes embody a private obduracy.[28] "If you let yourself respond fully to them," said the sculptor's eldest grandson, "you will find in them the whole life of Henri Matisse: an extraordinary equilibrium, returning always to the plumb line."[29]

It was as if he needed to touch base before veering blindly in a fresh direction with no clear idea what he was looking for, or whether he would find it. Doubts and nightmares assailed Matisse now that, no matter what he tried, painting had come to a full stop ("I've set myself up at the easel to do some work several times," he told Marguerite at the end of 1929, "but, in front of the canvas, I have no ideas whatever").[30] Flight seemed the only option, as it had done the first time he headed south at the start of his career. "I've got Polynesia waiting for me," he wrote, "though at times I say to myself: why?"[31] He told the other oarsmen at the Sailing Club in Nice that he wished he were back home again before he even started, but at bottom he sensed with an unreasoning, almost visceral certainty that he had no choice. "The retina tires of the same old methods,"

he had told Tériade in January. "It demands surprises."[32] Maillol's visit had confirmed what Matisse already knew, that he could not endure to live like his cautious old friend without ever looking over his own garden fence (Maillol had spent his life in the garden of the Greeks, Matisse told Duthuit).[33] "What harmed Maillol a good deal as a sculptor is that he so often called a halt as soon as his work reached a *satisfactory stage*," Matisse wrote long afterwards to his daughter. "And what has helped me a lot is pushing on beyond that point, in spite of the high risk."[34]

Matisse, who had for years found it almost impossible to take a few days off work, even for his father-in-law's funeral or his own shows in Paris, now planned a journey that would last five months without so much as a portable easel in his baggage. His original idea of a visit to Tahiti (by Matisse's own account, his destination mattered so little that he picked Tahiti, rather than the Galapagos Islands, because it was a regular port of call for Pacific steamers)[35] expanded into a world tour, crossing America on the way out and returning by sea through the Panama Canal. He assembled a travel library, studied Lucien Gauthier's luscious photos of Tahitian jungles and lagoons, read Robert Louis Stevenson's *In the South Seas*, Marc Chadourne's best-selling novel *Vasco*, and a popular account by the sailor Alain Gerbault of a recent voyage from Panama to Tahiti.[36] Pierre sent his father a Maori grammar.[37] Chadourne, a former administrator of the Leeward Islands, offered an introduction to his Tahitian ex-girlfriend, the heroine of *Vasco*, who would book a hotel for Matisse in Papeete.

Amélie spent a wretched summer punctuated by kidney trouble and spinal problems so severe that, in spite of her annual mountain cure, she had to stay behind in Paris for further treatment, installed alone at the hotel, instead of joining her husband in Nice. He had booked a cabin for two on the *Tahiti*, but the chances of her being fit to travel looked slim. When she more or less stopped writing to him, he composed a batch of sample letters for her to sign, describing her calm, orderly progress towards recovery, and declaring her willingness to accompany him round the world: strange documents in which the painter enthusiastically impersonates the fond, supportive, miraculously reinvigorated wife he hoped to take with him to Tahiti.[38] The gap between daydream and reality was wide, and growing wider. Henri's desperation, now that he could no longer paint, had done nothing to draw the two together. Where once Amélie would have taken charge, treating his setbacks as a joint defeat, recklessly expending her own resources to dislodge obstacles and shore up defences, now she no longer had the energy or will.

Their brief domestic interlude in early summer had been for her a

form of make-believe at a point when the dispersal of the family left her own aimlessness and lack of purpose painfully exposed. Marguerite was due to leave for Egypt with her husband, who was awaiting confirmation from the Ministry of Arts of his posting as a lecturer to Cairo. Jean had finally found the companion he had been looking for, a fellow painter in process of divorce whom he planned to marry as soon as she was free. Pierre, himself divorced at last and moving steadily towards opening a New York gallery of his own, was about to make a second marriage to Alexina Satler, an American his parents had never met. Amélie's own heroic dreams had petered out. Her husband's latest project contrasted sadly with the first time the couple had set off together in pursuit of painting, on their Mediterranean honeymoon. It had been Amélie who initiated and organised that legendary "Revelation of the South." This time, even if she went with him, she would be at best a passive companion, at worst an encumbrance.

Marguerite, reviewing her parents' marriage with characteristic trenchancy a few years later, recognised that Amélie had always acted as its safety valve. Her explosions of anger, and even the querulous lamentations issuing from her sickbed as her health deteriorated, were a way of relieving pressures that threatened to become intolerable. Still her father's severest critic, Marguerite warned him that he was in danger of forgetting the essential generosity and breadth of his wife's vision:

> It comes from the ability to see things in a large context, a quality that was necessary, indeed indispensable to you for twenty years of your life together—her capacity for optimism was for you the happy counterweight to your fundamentally pessimistic nature. When you felt crushed, your spirit was lightened by her moral sanity and balance, and by the inner force she possessed at thirty. Have you never thought what those days might have been like with a woman who was always whining—or feeble or easily daunted—who found it difficult to uproot herself, or who belonged to the type traditionally defined as normal, the type that creates a perfect interior where everything is rigorously clean, neat, organised, but where the air is stifling, poisonous—sterile— where you feel an itch to destroy everything by kicking the place down?[39]

Amélie's vision launched and shaped her husband's career, but the constant tension under which he operated bore down on everyone who

worked with him, especially on her. At the beginning of October 1929, she collapsed so completely that Dr. Audistère had to be called to the hotel to administer morphine. Over the next few weeks, he was in constant attendance. Both her sons came every day. Pierre hired day and night nurses. Matisse sent telegrams, telephoned each night for news and offered to come up himself from Nice. Marguerite, in Barcelona with her husband, returned after a fortnight to find her mother pitifully wan and shaky. This was the kind of crisis the family tried at all costs to avoid. Amélie had been a girl of sixteen when she suffered a first frightening attack that gripped her whole body in convulsive writhing and vomiting. For the better part of her marriage she had been free from these excruciating spasms, which began to recur with the onset of depression, causing cumulative damage to her spine, placing grave strain on her kidneys, leaving her physically battered and emotionally drained.[40]

She dreaded them, and so did everybody else. Amélie's breakdowns were liable to precipitate a collective release of feelings that had built up for months or years in brooding silence, and could no longer be contained. At times like this, engulfed by ancient rancour, the whole family briskly traded insults with marksmanship and verve. Far away in Nice in the grip of a different panic, too engrossed by his own anxieties to attend adequately to other people's, Matisse felt his lifelong sense of being excluded and misunderstood rising up in him again, this time with his own children ranged accusingly against him. "My dear Papa, you can believe in my devotion, and don't let yourself think you're all alone, as you say you are," wrote Pierre, assuring his father that all of them, including Duthuit, remained deeply attached to him. "As for the rest of us, if we tear ourselves to pieces, it's because our love for one another is too strong. Do you really think that, if we were so unfeeling, we would manage to inflict such wounds?"[41]

The commotion subsided as quickly as it had arisen. Amélie revived as always under her husband's genuine affection and concern ("Your phone calls are the sweeteners in Maman's days," Marguerite told her father).[42] But by the time she was well enough to make the journey down to Nice in December, there was no longer any question of further travel. She could not even leave her bed. Her doctors ordered her to spend the next few months flat on her back, warning that she must not think of trying to get up until Easter at the earliest.[43] Her best hope of returning to anything like normal activity was to remain immobile in the sickroom prepared for her in Nice. Lisette moved in, bringing her cat and two parakeets, which

became part of the household along with Ghika, Marie the cook, and her husband Michel. Lisette would sleep in Amélie's room.[44]

Pierre and his new wife, spending their honeymoon in France, were due to visit, and the Duthuits would follow for a week at Easter. Berthe was on full alert in Aix. Local friends like Bussy and Bonnard were standing by in case of need. Henri promised to keep a journal in the form of letters, posting off instalments so that Amélie could feel he was talking to her every day. She had agreed to do the same, dictating her bulletins to Lisette if she felt too weak to write herself, and assuring her husband she would wait patiently for his return. Henri's last letter before he embarked included a sketch of his wife in a frilly jacket, reclining on her pillows with raised knees and arms crossed behind her head, looking more like a lithe, frivolous young model than an elderly invalid requiring attendance from a stern-faced Lisette. Matisse had done everything he could think of to make her incarceration bearable when he finally sailed for New York on 25 February 1930, aboard the *Ile de France.*

Gloomy and apprehensive on the crossing, unable to tear his thoughts away from Nice, half tempted to turn round and take the same boat back, he remained full of misgiving until, sailing slowly up the Hudson River on the evening of 4 March, he saw Manhattan—"this block of black and gold mirrored by night on the water"—and was bewitched.[45] He wrote to his wife next day to say his impulse was to cancel all other plans and go no further than New York.[46] The city electrified him. He had told virtually no one he was coming, but he made friends on the ship with Henry Farré (a former pupil of Moreau), who blew his cover. New Yorkers did their best at short notice to lay on parties, press coverage, sightseeing, private views. In seventy-two hours in town, Matisse rose at dawn to watch the sun rise over the sleeping city, went up the Woolworth Building, saw a powerful play at a black theatre in Harlem, and toured the Metropolitan Museum (noting with approval a procedure the opposite of the Louvre's: "All the old pictures are dubious or mediocre—the modern ones are extremely good").[47] He was interviewed by Henry McBride for the *Sun* and photographed by Edward Steichen for *Vogue.* Pierre's partner, Valentine Dudensing, showed him round their gallery, and took him to a show on Broadway.[48]

Apart from Broadway ("Absolutely infernal, hideous, the only thing I've seen that I can't stand"),[49] Matisse loved everything, from his first ice cream soda to the traffic system on Park Avenue (his letter home included a helpful diagram). Prodigious energy flowed into him. He was enchanted

by the light ("so dry, so crystalline, like no other"),[50] by the combination of order, clarity and proportion he found everywhere, and by a quintessentially modern, wholly un-European sense of space and freedom which struck him the moment he looked out of his window on the thirty-ninth floor of the Ritz Tower Hotel ("It's a new world, grand and majestic as the sea—and at the same time you sense human effort").[51] He said that if he were young again he would relocate to the United States.[52] "Why did everyone say I wouldn't like it?" he asked Charles Thorndike on 7 March. "Since I've been here I've lost at least twenty years."[53]

He left that night for Chicago, then on again to California by the Santa Fe Railroad, two nights and three days in transit with stopovers en route. He told Amélie it was impossible to form an inkling of America from photographs or films. The architecture impressed him as much as the architects' readiness to tear things down and start again ("The perpetual demolition and rebuilding of the houses makes the whole place look like something under construction").[54] He said it was easier to think and breathe on New York streets than in Europe's cramped, ancient city centres or amid the clutter and confusion of the Paris boulevards. Wherever he went, he marvelled at the infinite variety of skyscrapers, filling the distance, modelling the sky, tapering upwards until they assumed the quality of light itself. "There is nothing ridiculous about these skyscrapers as we Europeans suppose," he wrote from Chicago, trying to articulate for his wife the combination of grandeur with a modest human sense of scale that made him feel immediately at home.[55] He visited museums with Farré (who was married to a top Chicago dress designer) and inspected Farré's paintings, which were sensitive but sleepy, as if the modern world had passed him by ("Although he's a few years younger than I am, he could be my grandfather—in everything but his appetite at table").[56] America made Matisse feel like Rip van Winkle in reverse: as if he had just woken, after sixty years on a continent littered and encumbered by the past, to find himself in a purpose-built, twentieth-century environment where for the first time he felt that he belonged.

Light changed from Chicago's velvet softness to an atmosphere more like the Côte d'Azur as Matisse passed from cowboy country, dotted with grim reminders of resistance and assault ("The poor Indians have paid heavily for it since"),[57] to the endless, pale, bright California desert full of colours and a light he had never seen before ("Is it already the light of the Pacific?"). He allowed himself two days in Los Angeles, amazed by the Pasadena landscape, and bemused by the studios of Metro-Goldwyn-Mayer. For almost a week he prided himself on travelling incognito, but

when his train pulled into San Francisco, the first city in the United States ever to see a Matisse painting, there was a reception party waiting on the platform, including a delegation from the Art Institute with a list of official functions that made their visitor's heart sink. "You must see that with a worldwide reputation like yours there is a price to pay," his hosts told him sternly, brushing aside his protests until eventually the French professor of fine arts relented and let him off the worst.[58] Matisse took tea with two old pioneering friends from the trail blazed by Sarah Stein: the formidable Harriet Levy (whose *Girl with Green Eyes* he had just seen hanging in a loan show at the Fine Art Museum), and his former pupil Annette Rosenshine, whose delicacy touched him, and whose work he found full of life and spirit. He enjoyed himself at a dinner given in his honour by fifty local artists, and spent hours with the art school's staff and students, posing for photos with them, admiring their spacious studios and indulging in a secret rapture in their storeroom. "He fondled the tubes of fresh colour, unscrewing the caps and sampling each," wrote a local journalist, who watched Matisse's hands go from one tube to the next, fingering, caressing, sniffing up the contents like a relapsing addict. "At that moment he was a painter among paints."[59]

A crowd came to see him off on 20 March, packing his cabin with fruit and flower baskets and waving from the quayside as buglers played a farewell lament. RMS *Tahiti* turned out to be a battered old English mailboat with a surly captain, dismal food, and dull company consisting almost entirely of Australian businessmen and sheep traders. The best part of the ten-day passage came as they approached the equator, when the colour of the sea lightened from blue black to the richer, rarer blue— "a blue like the blue of the morpho butterfly"—that had possessed talismanic properties for Matisse all his life.[60] The voyage went badly because there was no refuge from the stifling heat reflected off the water, and it ended worse when the captain did his passengers a last nasty turn by docking an hour early in pitch dark so that Matisse was cheated of the sunrise over Papeete, which he had crossed the world to see. Chadourne's friend was not expecting him, because the letter alerting her to his arrival was still locked in the *Tahiti*'s mailbags. But the whole town had turned out to meet the boat, and the first resident Matisse asked readily identified the beautiful Pauline Chadourne, whose looks and personality would have singled her out in any company. She promptly took charge of the painter and his baggage, settling him into the newest of Papeete's three hotels, the Stuart, a stark concrete block at the far end of the quai du Commerce on the sandy, tree-lined sea front.[61] Within a few hours of coming ashore on

Tahiti, Matisse had acquired the basics he needed for survival: a room, a view, a shady verandah and a guide prepared to place herself at his disposal for the duration of his stay.

"What haven't I seen since yesterday," he wrote on Sunday, 30 March, the day after he landed. "Everything is so new to me—in spite of all I've read and seen in photographs, and Gauguin—I find everything marvellous—landscape, trees, flowers, people—and I've seen nothing yet." He had risen at five so as not to miss the cool of the morning when the traders in the covered market at the centre of the town set out an unimaginable profusion of fresh fruit, flowers and fish ("lumpfish, huge seabream, orangey red mullets, purply crimson mullets, Prussian blue and emerald green fish streaked with white . . . extraordinary tones virtually impossible to describe").[62] Soon his pen abandoned the effort to translate sensation into words, swooping and looping round the burgeoning top of a banana palm before the whole page burst into a riotous dance of fruit and foliage. "It all makes an earthly paradise you can't imagine," he added up the margin of the next page of his letter, which was entirely filled with an exuberant breadfruit tree.

Matisse's first move in a strange place, as soon as he had arranged somewhere to stay, was always to look out for a shady, secluded garden within easy walking distance of his lodgings. Pauline found him what he wanted on his first day in Papeete: the gardens of the Bishop's palace in the compound of the Catholic mission at the back of the little town, past leafy streets and palm-thatched houses, along an approach shaded by

Matisse, *Trees in Tahiti:* first impressions of Tahiti

tamarind trees, through an imposing gateway and across an old stone bridge over the river Papeava. Here he would come early every morning, alone with his drawing pad ("If I go on like this I shall run out of paper," he wrote after a fortnight),[63] to wander among groves of elegant coconut palms, mango, papaya, avocado and the great, spreading breadfruit trees with pale, glimmering, yellowy-green fruit, each cupped by a rich, dark ruff of serrated foliage whose decorative perfection almost overpowered him ("It's lovely, lovely, lovely . . . each part is lovely and the whole is extraordinary").[64] He drew continually, as much to relieve as to formulate his feelings. His sketchbooks filled up with tumultuous foliage, feathery palm fronds, silky banana leaves, tall, tufted coconuts, the tentacles of pandanus and blunt, stumpy limbs of banyan.

The shapes and rhythms of trees preoccupied Matisse on Tahiti more even than the flowers—fragile, short-lived, fantastically shaped—growing wild, or gathered and plaited into garlands by Tahitian women, who dressed themselves and their houses every morning with fresh blossoms as a European woman might apply make-up to her face. Flowers were every-where, festooning town gardens, spilling across front porches and tum-bling down the mountainside, many of them familiar from the relatively spindly versions sold as potted plants by French florists: hibiscus, bougainvillea, bird-of-paradise, croton and philodendron, the Tahitian gardenia called *tiare*. "Giant caladiums grow here like couchgrass at home," Matisse reported on his first day: "Curly ferns . . . poinsettias, pink, white and yellow jasmine, and an undergrowth of pelargoniums white instead of pink."[65] The whole island sometimes seemed to him a luxuriant outdoor conservatory or winter garden, extravagantly planted and imaginatively designed. He had arrived in time to catch the end of the rainy season, but as soon as the ground dried out he set out by car with Pauline to drive right round the island, a circuit of roughly forty-five miles on a narrow coastal road of white coral sand with wooded ravines, waterfalls, pinnacles and crags rising to Tahiti's volcanic mountain core on one side, reefs and ocean on the other. They completed the circuit in a day, fording rivers, crossing rickety plank bridges, swerving to avoid stray pigs and hens, stop-ping every few minutes for Matisse to sketch or take photographs with a camera specially acquired for his Polynesian trip. The day reinforced his sense of the immensity of the Pacific, and the multiplicity of plant life crammed into the island's tiny compass. "Everything's close-packed," he said, "as it would be in a bouquet."[66]

Matisse's morning walk to the Bishop's Garden became a familiar beat, so regular that local people looked out for him passing and returning in

time to catch the market, which packed up at nine. Before the sun rose too high for comfort, he was back in his hotel room: the kind of bare provisional space in which he had lived and worked at the four main pivotal points of his career in Ajaccio, Collioure, Tangier and Nice. The Hotel Stuart was far from luxurious. Matisse's room on the second floor had neither bell nor door (Tahitian buildings traditionally left free passage for any breath of air blowing from sea or mountain), but M. and Mme Stuart were efficient and their site well chosen, with coconut palms on the slopes behind and the lagoon in front, bounded by a line of white surf where the reef met the open sea. Matisse drew the room itself, the boats tied up outside his window, and once or twice his own reflection peering from the dressing-table mirror, ready for action with sketchpad and pith helmet, or resting in a Tahitian *pareu* (a length of flowered cotton worn wrapped round the hips).

These fleeting likenesses of the artist look tentative and uncertain compared to the careless, confident vitality he imparted in his sketches to the Bishop's breadfruit trees, or even to the curvaceous wooden rocking chair provided by his hotel management. At the start of his voyage, he had told his wife that he watched images unroll in front of him with as little involvement as if he were at the cinema.[67] For much of the next three months he felt he had been relegated to a limbo of enforced idleness and apathy, although he also recognised at some level that his drawing was a form of registration, stocking up on sensations and impressions for attention later. He photographed the trees, the sea, the waterfront and the route around the island, but his densely detailed snapshots dissatisfied him. What he looked for and found in his rapid linear sketches was spontaneous underlying patterns of growth and movement.

Matisse on Tahiti was fascinated by the sensitive plants—*les sensitives*—that shrank from the slightest contact, folding their leaves defensively when the painter stooped down to tickle them with his hat or Pauline's fan. At times he, too, felt a reluctance that made him want to duck and flinch. "On first contact that landscape was dead for me," he said, remembering Tahiti more than a decade later. "At first it was a disillusionment I didn't want to admit even to myself."[68] In this mood the vegetation seemed overwhelming, the heat intolerable, the light implacable and without gradation. "You don't react immediately," he explained, "which means you have to relax through working."[69] Eventually he learned to accept and revel in the light of the South Seas, characterising it as pulpy, pithy and caressing, telling different people on several occasions that it felt like plunging your eye into a golden goblet.[70] But in the first few weeks he

fought off fears that his journey had been pointless by throwing himself into a programme of relentless, almost feverish activity.

Every morning Pauline reported to discuss plans for the day: a round of local visits in Papeete followed by lunch and a drawing session from three to five, until the searing mid-day heat had passed, when they set out to see the island. "I took him everywhere," she said. "He wanted to see *everything.*"[71] Pauline had considerable experience of initiating Frenchmen on Tahiti, many of them recommended by two former lovers (Chadourne, who had been the first, sent her personalities from Parisian society and the literary world; his successor was an officer in the French navy through whom over the next half century she met increasingly high-ranking naval personnel). But Matisse was unlike any other visitor she had ever known. In the first place, he had been appalled on the night of his arrival by the party held at the restaurant Tiaré to welcome passengers from the mail-boat, mostly middle-aged white males who paired off with local girls in an erotic free-for-all that seemed to him to exploit traditional Tahitian gen-erosity and lack of inhibition with European avidity and lewdness. Matisse, who drank only water and declined to dance or flirt, found the spectacle crude, rowdy and depressing, and made a point of dining early so as to avoid feast nights in future. It left him with a dismal view of European colonial life ("In order to stick it out here, you have to stupefy yourself with an addictive vice—opium, alcohol or women"), which he never essentially revised.[72]

Pauline was impressed, even overawed to start with by this portly, bearded old gentleman who treated her with old-fashioned politeness, and demanded services no one had ever asked of her before. Occasional eccentrics might want to know about ethnic artefacts and folklore, but she had never met anyone as inquisitive as Matisse about the current life of the island and its people. "He was endlessly curious at the market, *oh là là*," said Pauline, "he missed *nothing.*" The official government campaign to bring tourists to Tahiti had hardly started in 1930. Access to what eventu-ally became its legendary beauty spots was still difficult or impossible, and Papeete had neither comfortable hotels nor curio boutiques.[73] Matisse at sixty walked Pauline (who was twenty-six) all over town, talking to the shopkeepers and market traders, examining their wares, visiting work-shops and design studios to see traditional skills in practice from the mak-ing of the bark-cloth, *tapa,* to the weaving of pandanus leaf hats (so striking and effective that the painter abandoned his pith helmet and wore Tahitian sunhats for the rest of his life, with fresh supplies forwarded to Nice at intervals by Pauline). He sampled the local cuisine with a

gourmet's relish, describing a Polynesian feast or *ma'a tahiti* (shrimp in coconut milk, raw fish marinated in lemon juice, suckling pig wrapped in palm leaves and cooked on hot stones in a pit) in appreciative detail for his wife.[74] His questions were shrewd and practical. Pauline was captivated by his jokes and stories ("He could be *so* funny"), puzzled by his curiosity, and taken aback by his disapproval of the young women of her generation who enthusiastically rejected their parents' and grandparents' social and cultural norms ("They behave like tourists," Matisse reported in disgust. "They hang out in bars, drinking cocktails, and their sole reading is the seasonal catalogues of Parisian department stores").[75]

Once she got over her perplexity, Pauline proved a highly intelligent and resourceful guide. Child of a Tahitian mother and a French father, brought up initially as a European and educated at a French school, she was living when she met Matisse with a new partner, Etienne Schyle, handsome, energetic, a year older than herself and owner of the Union Garage in Papeete. It was Etienne who took the wheel on expeditions, negotiating the tour of the island in his big blue Buick, and sending the

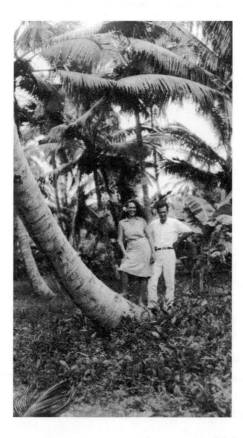

Matisse, photograph of Pauline and Etienne Schyle

car with another driver when he couldn't come himself. The young couple were intrigued by Matisse's aloofness from a colonial world where hardly anyone yet questioned the supremacy of white power and values ("In short, in Papeete the Maori is despised—even by the Maori," Matisse wrote home, explaining that the social standing of a mixed-race child was assessed exclusively by skin colour).[76] Pauline herself had grown up with a dual allegiance and many names. Matisse knew her as Pauline Chadourne. As a small child, reared by an adoptive European father (arrangements of this sort were not unusual in a society that traditionally saw nothing

Matisse, *Pauline Chadourne (Schyle)*

odd in non-nuclear families or communal parentage), she had grown up as Pauline Adams, and she would become Pauline Schyle when she eventually married Etienne. But she was born Pauline Oturau Aitamai. She had lived as a teenager on her mother's vanilla plantation on the island of Moorea, listening to the songs and legends Matisse made her recount for him, and learning to weave the flower garlands she brought him every morning. Pauline wore skirts as short as any Parisienne but, unlike most of her contemporaries, she had not cropped her hair.

She had been eighteen when she first met Chadourne, who called her his lioness on account of the thick springy mane of blue-black hair falling to her hips that contrasted dramatically with the almost conventual pallor of her skin. Chadourne saw glints of pearl and undertones of amber in her colouring, and waxen frangipani petals in the modelling of her nostrils flaring beneath fine black eyebrows. Before he left France, Matisse had promised the novelist to supply drawings for an illustrated edition of *Vasco.* At some point he made a set of pen-and-ink sketches of Pauline, reclining on a daybed and looking every inch the sultry heroine of Chadourne's novel, "with her shining eyes and gleaming teeth, her fiery glance, the tossing motion of her head that sent waves rippling through her hair."[77]

But Matisse soon abandoned the illustrations, unable to reconcile romantic fiction with the reality he saw around him.[78] "I've never seen men or women better built or more vigorous," he wrote home, comparing a group of visitors from the Paumotu, or Tuamotu, Islands to sea-gods, mythic beings out of paintings by Leonardo or Raphael, the sort of models who would undoubtedly inspire Maillol.[79] The Paumotans responded

to Papeete's strict dress code by wearing their unaccustomed European outfits with indescribable panache, topping off the effect with spectacles, often several pairs at once. Matisse, who loved their sense of style, said it would be hard to convey without parody to Western eyes the authentic alien splendour of Tahitians, with their red-gold skins, their solid bodies and high foreheads surmounted by crownlike hairdos buttressed with braided flowers. "You have to come here to understand," he explained to Amélie. "Their reality would seem like clumsiness on the part of the artist."

Apart from Pauline, there was in any case no question of any Tahitian woman posing for him, clothed or unclothed. Matisse was baffled by the combination of sexual freedom and a prudishness implanted by Catholic missionaries that seemed in some ways to reverse European concepts of modesty and shame. By ancient Polynesian rules of hospitality, making love to a stranger and bearing his child, especially a white man's, was an honourable practice conferring status on the child, the mother and her husband. Pauline had two sons, one by each of her French lovers, and introduced them to Matisse with pride the night he landed.[80] He admired the handsome little boys but found it hard to grasp that, in a town where no one minded who you slept with, people would be outraged if you walked down the street in shirtsleeves: "They bathe more chastely than at Cannes—and when I tell them about sunbathing and swimsuits, they won't believe me."[81] In the end, he managed to persuade a waitress from the Tiaré to sit for him, producing a series of strong and stylish heads, which was as much as she would let him draw.

Matisse, *Tahitiennes*

Matisse's perennial, barely contained anxiety was eased by the warmth and gaiety of Pauline and her friends, especially Lucie Drollet, a massive motherly masseuse who came to the hotel each morning to attend to his rheumatic arm ("They roared with laughter," said Pauline. "She told him endless stories, the two of them egged each other on, each as full of humour as the other").[82] Pauline organised his shopping, saw to his laundry and generally looked after him. He advised her to marry Etienne, and offered to help educate her son by Chadourne in France. Alone in the evenings, he dropped in at the Cinéma Bambou two or three nights a week to watch old American films and even older newsreels, entertained not so much by the screen as by the running commentary of the man hired to translate the subtitles, and the audience's keen participation in every gunfight, clinch and car chase. After a day's strenuous confrontation with the island, Matisse said he needed somewhere to relax, take his shoes off and scratch his insect bites. "It beats even Tangier," he wrote, describing the Bambou to Amélie.[83]

A Frenchman who wore pandanus hats, spent his evenings at the local fleapit and put in only token appearances at the Governor's residence inevitably invited comment from the European colony. Papeete's function from a government point of view was to make France's presence in the Pacific as conspicuous as possible, but the social protocol separating white from black and mixed-race communities grated on Matisse, who said the colonial administrators in their white tropical kit and round-topped head-gear reminded him of painted skittles ("You instinctively look for a ball to knock them down").[84] A month later, he was even less forgiving ("It has to be said that the politics . . . are ferocious here and, between one lot and the other, liars and crackpots, it's impossible to make head or tail of what's going on"). His temper was not improved by an unfortunate incident at an official dinner party, when he overheard the Governor's wife gossiping with her friends about him and Pauline. Matisse unleashed his formidable powers of righteous indignation in a tirade that would have gone down well in his hometown, rebuking their foul tongues, ordering them to cease their slander, and announcing that Pauline's relationship to him was that of a devoted daughter. "That shut their traps," he told her emphatically next morning.[85] Pauline was touched and bewildered by the vehemence of his denial. Flattered by the allegation that she was his mistress—a position that would have raised rather than lowered her status in Tahitian terms—she could not comprehend the rancour it stirred up in Matisse, who had spent his life escaping from the scandalmongering and petty snobberies of narrow, inturned communities like Papeete.

The colonists had not yet got over the mistake they made with Gauguin, and often complained about the staggering prices currently being paid in Paris for canvases they or their predecessors could have picked up for nothing. "The bureaucrats speak of him with respect," Matisse wrote home, after ascertaining that none of them had ever actually seen a canvas painted by Gauguin on Tahiti. "It's just the money they respect, as usual."[86] No one in Papeete had so much as heard of Matisse himself, except possibly the Governor, but that did not stop fellow Westerners demanding his professional opinion of local artists, and bombarding him with prize specimens by the island's favourite contender to replace Gauguin, Octave Morillot, a hugely popular specialist in Tahitian womanhood whose idyllic, rubbery fantasies were the pictorial equivalent of Chadourne's *Vasco*. "A very sexy subject," Matisse grumbled to his wife, describing a particularly poor Morillot presented for inspection by an optimistic American: "That's how the Americans see Tahiti—it's absolutely all they see here—animal sexuality. I already suspected they despised the indigenous population, in spite of helping themselves to their women."[87]

In later years, Matisse was as irritated by the assumption that he trailed after Gauguin to Tahiti as he had been by people taking it for granted that he had followed Delacroix to Tangier. His own sights were trained on the future, not on debts he had once owed in the past, but he took some trouble to track down Gauguin's son, who turned out to be living a few miles outside Papeete as a Tahitian fisherman ("That should please his father, if he knows," said Matisse).[88] Gentle, powerful and illiterate, easily recognisable on account of his heavy eyelids and hawk-beak nose, Emile Gauguin explained to Etienne Schyle, who translated for Matisse, that he had no memories of his father, and no desire to change the life he led ("watching coconuts ripen and fishing at night," Matisse remembered nearly two decades later, still impressed by the son's un-Gauguin-like contentment).[89] He visited Mataiea, where Gauguin painted, and Atuona, where he lay buried, sending photographs of the unmarked grave back home to the Duthuits in hopes that publicity might prod the authorities in France to take action.[90] Neglect and ignorance of his great predecessor compounded the faults Matisse found with the French colony, in spite or perhaps because of marked attention from its individual members, especially Governor Bouge (who arranged for him to sail to the Marquesas Islands—which Matisse knew from Stevenson as well as Gauguin—and, when that fell through, offered a passage to the Tuamotus instead).

Impatient with his compatriots, enervated by the steamy heat, exhausted and dissatisfied after three weeks on the island, Matisse opened his travelling paint-box for the first time on Easter Sunday, completing a single tiny tree study before putting his paints away again for good. "I've been here almost a month now...," he wrote on 28 April, posting a mammoth bulletin home by the monthly mailboat. "This country means

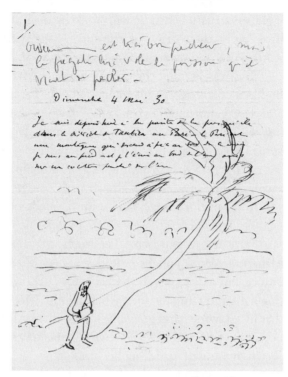

Matisse living rough on the edge of the lagoon at Taiarapu, from a letter to his wife

nothing to me, pictorially speaking. So I give up." A week later, he started a fresh letter with a sketch of himself as a bearded castaway, seated on the trunk of a coconut palm on a deserted beach beside an empty ocean with

a notepad on his knee. He was photographed writing home on this tree trunk by F. W. Murnau, the great German film director, in a break from filming the final sequences of his Tahitian masterpiece, *Taboo*.[91] Murnau's co-director, Robert Flaherty, had invited Matisse to watch the shoot on the peninsula of Taiarapu, the wildest part of the island, primal, uninhabited and accessible only by canoe. The painter spent a week there, 3–9 May, living in a grass hut at the edge of the lagoon, lying awake at

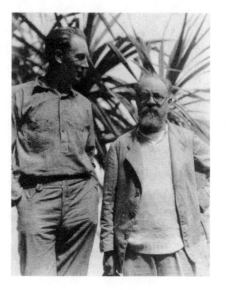

Matisse and the filmmaker Friedrich Wilhelm Murnau, during the shooting of *Taboo*

night on a rusty bedstead with rock-hard pillows and a mouldy mattress, listening to the roaring of the surf as the wind rattled the hut's loosely woven walls and drummed on its low tin roof like rain.

This was literally the untamed jungle Matisse had insisted he had to find as a corrective, in his interview with Tériade at the beginning of the year. Every morning he rose before dawn to wash in the stream and breakfast with the film crew before crossing the lagoon to a tiny island, Tapu *motu* in Bora-Bora, where Murnau filmed and Matisse drew among tangled layers of trees "that grow, die and grow again without anybody touching them."[92] The ground was strewn with rotten wood that crumbled when you trod on it, releasing warm, sweet smells of mildew and tiare flowers. Matisse and Murnau were both too intent on the exigencies of their respective arts to pay each other much attention. The painter had admired Flaherty's *Moana*, and he would see *Taboo* three times after its release in France, but at the time, he had eyes for nothing but the new world of pristine light and rampant energy before him. Mosquitoes swarmed so thickly that his drawing hand grew black with them. "Little by little the country is beginning to reveal itself," he wrote, finishing off his letter with a second sketch of himself paddling his canoe home at nightfall beneath a spectacular sunset gilding the clouds beyond the blue-black reef.

Back in Papeete, Matisse felt so sure he had got what he came for that he longed to leave for France at once instead of waiting another month for the ship on which he had booked his passage home. Within the week he set out again aboard the government schooner carrying supplies to the Tuamotus, an alarming voyage of one day and two nights on rough seas in a small, leaky, heavily laden boat ("It rolls, it tangos," wrote Matisse, who was seasick the whole way)[93] manned by Tahitian convicts. His landing on 17 May on the coral island of Apataki was a magical reprieve. The administrator of the Tuamotus, François Hervé, a close friend of Pauline and Marc Chadourne, proved only too glad to welcome a painter from Paris into the comfortable, cultured French household he had established with his wife at the end of an irregular supply chain on a tiny, windswept, largely uninhabited coral atoll (the occupants had left to fish for pearls), barren except for tufts of coconut, with nothing to drink but rainwater and no fresh food but fish.

An ex–sea captain and pioneer pearl farmer, Hervé was entertaining and well read, with an intimate knowledge of his archipelago and a daughter who was herself an artist (the twenty-four-year-old Anne Hervé turned out to feel such blazing scorn for modern art and all who made it that, as their guest reported happily, conversations about painting quickly

ceased).[94] Every evening the Hervés and their guest walked right round their island, a leisurely stroll of just under a mile. Matisse drew the four of them seated on a bench to watch the sun go down at six, subsiding in shimmering silver over the desert islet of Pakaka and casting towards the watchers on the shore a scarf of lilac blue, shading from pale to dark with a rippled silver edging of waves along the water. Matisse described sunsets for Amélie like a collector bringing out his choicest treasures: "I've also seen here at night an ash-blue sky alive with stars, brilliant and very close, on the side of the sunset—while the side of the rising sun was crimson purple. It was at midnight, this lingering pale crimson reflection of the sun—which had in fact set at six o'clock on the opposite side from the crimson sky (is that clear?)."[95]

After a few days Hervé left for a tour of the atolls, depositing his guest on Fakarava, not so much an island as a circular rim of land, eighty miles round and two or three hundred yards wide—"a coral towpath," in Stevenson's expressive phrase[96]—enclosing an inland sea so big its far side remained invisible. Matisse stayed with two hospitable young Polynesians, Gustave Terorotua and his wife Madeleine (a school contemporary of Pauline's), whose simple, frugal, hardworking way of life made him feel at home. The painter had been deeply impressed, before he left France, by Stevenson's account of something that seemed to him more curious than any curiosity he had ever paid to see: the fish— "stained and striped, and even beaked like parrots"—cruising among coral thickets in the phenomenally deep, still, clear lagoon of Fakarava. Stevenson had watched them from the deck of his yacht, but Matisse dived in

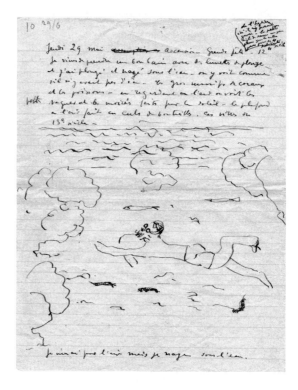

Matisse in the lagoon at Fakarava

after them, gliding with Gustave Terorotua down through transparent water the colour of grey-green jade shading to absinthe, peppermint green and blue, among fish glinting like enamel or Chinese porcelain, minute, jewelled specks and streaks of colour swarming round his legs, outsize sea-trout drifting by like huge dark airships, the whole shifting, swirling composition punctuated and pinned down by the inert black accents of sea cucumbers.[97]

Matisse gazed into the lagoon all day every day, alone or with Gustave. Once they watched a pearl fisher diving far below them with a three-metre-long harpoon ("He's so supple and slow he's like a fish—he swims alongside the fish, who have no fear of him—he moves like a slow motion film—he makes you think of a vast seaweed floating gently in the water").[98] Matisse drew himself swimming underwater in locally made wooden goggles, or perched precariously on spiky clumps of coral to peer through a cumbersome glass-bottomed viewing box.[99] As usual, he saw himself as comically clumsy and absurd, but his concentration had never been more ferocious than in this brief interlude when he strained to grasp and penetrate the duality of Fakarava, the fresh, shining, unpolluted air filling the hemisphere that stretched to the horizon, and the strange, muted brilliance of another world beneath it, "that undersea light which is like a second sky."[100] He experimented with focus, depth and angles, staring down from above into the green floor of the lagoon, looking up from below at a watery ceiling opaque and wavery as medieval glass, plunging repeatedly between the two, schooling the retina to compare the different luminosities of sky and sea.

Matisse spent four days on Fakarava, but he would draw in retrospect on what he saw in those four days to the end of his life. "Pure light, pure air, pure colour: diamond, sapphire, emerald, turquoise," he wrote laconically to Bonnard, "stupendous fish."[101] On 26 May, he returned reluctantly with Hervé to spend a final fortnight on Apataki, where he said he slept like an angel and soaked up impressions like a sponge. His chief memories, when he summed up the atoll later, were the quivering of its waters, the continuous susurration of the trade winds rustling its coco palms like silk, and "the overall impression it gave of power, youth, fullness and completion."[102] Matisse insisted afterwards that it had taken him three months to acclimatise in the Pacific, and that it was not the fleshpots of Papeete, nor the hothouse luxuriance of the jungle, but the austere simplicity of this bleak, bleached outpost that tuned his responses to their highest pitch. He said no visitor to the South Seas should miss it: "He will see sky and sea, coconut palms and fish—that's all there is to see—with a

pure radiance that makes them incomparably precious."[103] Matisse's voyage to Tahiti, and its culmination on the Tuamotus, marked the last of the dramatic shifts or leaps of vision that liberated him at intervals all his life. It was on the shore at Apataki that his whole being was repossessed "by the profound emotion born of solitude" that had shaken him as a boy in the high, Gothic nave of the cathedral at Amiens, "where the rumbling of the surf is replaced by the music of the organ."[104]

Readjusting to Papeete was a dismal business ("I might as well have been in Paris," he said flatly; "cars, dust, cinema").[105] Matisse spent his last week at the Hotel Stuart in a fever to be gone, packing, paying farewell calls and devouring mail from home, decorating his own last letter from dry land with a sketch of himself in his Tahitian sunhat running to the post. He sailed aboard the *Ville de Verdun* on 15 June, loaded down after another splendid send-off with leaf hats, *tapa* cloths, dried bananas and vanilla pods. Pauline wept to see him go. Governor Bouge, who had been summarily recalled to France with half his staff, left by the same boat. "I call it a shipload of the blackballed—nothing but more or less disgraced civil servants," Matisse said gloomily, anticipating six weeks of bickering, which he planned to avoid by reading, sipping rum and sunbathing in a deckchair on the poop.[106] The fearsome monotony of the voyage was enlivened on the painter's part by a supremely graceful fall, when he managed to plunge headlong to the deck without breaking his glasses or dislodging the cigarette between his lips, and a final fierce spat with his old enemy, Mme Bouge ("Her eyes were like pistols," wrote Matisse, "and I don't suppose mine were tender either").[107]

Steaming homewards through the Panama Canal ("glaucous green like the rivers of France") and on under shadowy grey skies towards Atlantic waters ("the texture of black grape-skins"), Matisse pondered the purpose of his journey. The problems he had left behind in France were still with him, a basic fact from which he logically concluded that he could not live without them. "That is the great lesson I brought back from the South Seas," he wrote long afterwards, at a moment of terror and desolation in the Second World War.[108] Looking back, it seemed to him that a life of idleness and torpor in the tropics insulated Europeans, and brought them face-to-face with their own inadequacies ("In Tahiti there's nothing, no troubles of any sort, except the inner trouble that makes the European long for five o'clock, when he can get drunk or inject a dose of morphine").[109] The island that had entranced him on his first day—an earthly paradise of unremitting sunshine and unrestricted sexual availability—led back ultimately to the same code of practice as his northern

roots: toil, abstinence and the discipline of the plumb line. "I got fed up there in the end," he said, "but I had learned the meaning of the horizontal and the vertical from the shoreline and the coco palms."[110]

Pictorially speaking, he said he returned empty-handed ("Strange, isn't it, that all those enchantments of sky and sea elicited no response at all from me at the time").[111] He landed at Marseilles on 31 July, and went back to work the day after he reached home on *The Yellow Dress,* a painting he had started before leaving Nice.[112] Matisse posed Lisette bolt upright at the dead centre of his canvas, stiff as a poker, with five symmetrical bows down the front of her dress, against a background frieze of slatted shutters, corrugated curtain folds, window frames and verandah bars which is practically a hymn to the horizontal and the vertical. The whole elaborate construction becomes an instrument for catching the play of light and colour, grey bars of sunlight sifting through the shutters, refracted in the pane of glass, picked up in the pale turquoise window frame and the soft blue strips of curtain, expanding across the red-tiled floor and dissolving in the watery greens, dappled greys and ochres of the dress itself. Matisse said the painting accompanied him at the back of his mind throughout his travels. Sometimes it seemed more vivid than the reality before his eyes, as if it opened a window for him in the tropics on the subtle, nuanced, constantly shifting luminosity of the northern hemisphere.

Matisse wrote longingly of his *Yellow Dress* to Amélie, who had also crossed America and circled the islands with him in his imagination. He treated his letters home as an extended conversation with her, dashing down everything that caught his eye and posting off his jottings by the monthly mailboat in batches of up to seventy-four pages at a time. To his wife he remained resolutely cheerful, but it was clear to Pauline and others that he was haunted by her absence. "Shadows are rare here," said Murnau, photographing Matisse writing home on Taiarapu. "There's sunshine everywhere except on you." "That's just what I'm saying to my wife," replied the painter.[113] A telegram announcing that Amélie had got out of bed for the first time came as a relief in May, but he wrote anxiously for further news to Marguerite. In the last instalment of his journal-letter, posted the day before he sailed in June, he begged his wife to wait for his arrival so they could retrace his circuit of the Tuamotus together as he read his daily entries aloud to her at home in August.

At a low point on Tahiti he had sworn never again to leave her side, but he was caught up in preparations for departure almost as soon as he reached Nice. As a former Carnegie Prize winner, he had accepted an invi-

tation from Pittsburgh to sit on the prize jury himself in 1930, which meant he had just time to reestablish contact with his wife and work before leaving to catch a boat back to New York on 12 September. All his old troubles closed once more around him. By 1930 the brief bonanza when buyers on both sides of the Atlantic competed for his canvases was over. Prices tumbled as his stock of pictures dwindled. Matisse now had an invalid wife to support as well as allowances to find for three anything but prosperous children and their partners (Duthuit's Cairo posting had come to nothing, Jean had just married a woman who like him was struggling for survival as an artist, Pierre's future as a dealer looked more precarious than it had ever been). When Matisse set out again for the United States, he had painted virtually nothing for two years. The two major works he had attempted with Lisette—*The Yellow Dress* and the *Madras Hat* of 1929—were still unfinished. The solution to the structural riddle of his *Yellow Dress* came to him on the voyage, but there was as yet no sign of any long-term lifting of his blockage. He had nothing in prospect except a potentially disastrous collaboration with the brilliant but perennially underfunded Swiss dreamer Albert Skira, who chose the start of a global slump to launch his first two luxury art books, editions of Ovid's *Metamorphoses* and the poems of Stéphane Mallarmé, illustrated respectively by Picasso and Matisse.

Pierre, who had inherited his mother's steely optimism, intended to dig in for the duration in New York, and treat financial viability as a minor issue. "Whenever you get too worried by it, just do a little sum in your head," he had advised his father on 25 October 1929, the day after the Wall Street Crash, "and count up all the canvases . . . you could part from without distress. You'll see that you haven't really anything to worry about." A year later, the United States art market had reached a virtual standstill. Matisse's steadiest and most serious collectors in the past decade had been Americans, chief among them the infamous Dr. Albert C. Barnes, whose aggressive tactics, propensity for bulk buying and apparently inexhaustible resources had secured him a collection of modern French painting unequalled anywhere in the world, except in Moscow by the holdings of Shchukin and Morosov (which had recently been combined to form the Soviet Museum of Modern Western Art). On 20 September, his first day in New York, Matisse telegraphed Dr. Barnes to ask if he might visit his Foundation at Merion in suburban Philadelphia.[114]

The Carnegie International Prize was awarded by an essentially academic institution gingerly feeling its way towards the contemporary world. Matisse had been the first modernist winner, in 1927, elected unanimously

save for a single dissenting vote from his old rival Maurice Denis (whose *Cupid and Psyche* frescoes were currently relegated to the cellar of the new museum in Moscow).[115] This year the prize went to Picasso (Matisse tried but failed to persuade his fellow jurors to nominate Bonnard as runner-up).[116] The jury's deliberations, satisfactorily dispatched in a single day in Pittsburgh, were followed by a strenuous week of pleasure, including pit stops at some of America's richest art collections on the way back to New York ("Cocktail parties and banquets all the time—Americans are all alcoholics," Matisse told his wife ungratefully, declaring he would never have come if he had realised the overwhelming scale of his hosts' generosity).[117] In Washington the Pittsburgh party visited the collection of Duncan Phillips, and lunched at the White House in torrid heat ("like out-of-control central heating") that made even the South Seas seem cool. As soon as they moved on to Philadelphia, Matisse skipped his morning schedule to keep his appointment with Barnes, a man who had made himself feared and loathed throughout the art world, but especially by his closest neighbours ("There is no use entering into a pissing contest with a skunk," wrote the director of the Philadelphia Museum of Art, goaded beyond bearing by some fresh piece of skulduggery on Barnes' part).[118]

Barnes habitually used his massive chequebook and unerring visual judgement to outwit and taunt his rivals. On buying trips to Paris, he liked to start the day with a mob of hungry artists lined up on the pavement outside his hotel, each proffering a rolled-up canvas.[119] A chemist by training, self-taught in the art field and inordinately sensitive to slights, he had made a fortune by manufacturing and marketing an antiseptic called Argyrol, selling his company with characteristic timing three months before Wall Street's collapse, so as to be free to concentrate on collecting. Bullying, spiteful and vindictive, he imported the strategies that had made him a first-class businessman into a world that crumpled in the face of his innovative brashness and bulldozer drive. People told innumerable stories of the humiliations he routinely inflicted on curators, dealers, painters and fellow art lovers, above all on anyone rash enough to ask to visit his collection.

But Barnes had another side. He watched out for pictures like a hawk, swooping to snatch his prey before more hesitant and less clear-sighted operators got off the ground. He had built up singlehanded at great speed a collection so far ahead of its time and place that Philadelphia had confidently dismissed him with mockery and rebuff. Barnes' arrogance was a function of his intelligence and originality. He loved painting more than he loved people, explaining that the pursuit of the best in art had infected

him like rabies. He said he talked to his pictures and they talked back to
him, with none of the turmoil and fury that characterised his human con-
versations.[120] By the time of Matisse's visit he owned nearly two hundred
Renoirs and eighty Cézannes, and had been accumulating canvases by his
visitor for almost a decade, including *Bonheur de vivre* and the *Three Sisters*
snapped up with much else from Tetzen-Lund. Alone with his pictures he
was judicious, unassuming and receptive ("I can criticise them, and take
without offence the refutation that comes silently but powerfully when I
learn months later what they mean, and not what I thought they meant").
Matisse, who had only met this combination of humility with passion
once before in Shchukin, could have found no one more apt than Barnes
in this mood to release the creative energy dormant in him since his voyage
to Tahiti. At the first encounter between the two men on Saturday, 27 Sep-
tember 1930, Barnes asked Matisse to decorate the central hall of his newly
built museum at Merion.

Painter and collector were so absorbed by the possibilities of this
proposition that they forgot about Matisse's interpreter (a professor of
French from the University of Pittsburgh, brusquely dismissed on the
doorstep by Barnes with instructions to come back in two hours), who
had to force an entry down a coal chute in order to collect his charge.
Matisse felt dubious but sorely tempted as he resumed his official sight-
seeing that afternoon ("the
tomb of masterpieces," he
wrote grimly in his diary, com-
paring the reverential gloom of
Philadelphia's Widener collec-
tion with the open and infor-
mal installation designed by
Barnes for what he called his
"old masters of the future").[121]
He described America as an
ideal home for artists in an
interview with *Time* maga-
zine, which marked Picasso's
Carnegie triumph by put-
ting "grizzle-chinned, wrinkle-
browed Henri Matisse" on the
cover.[122] By this time, the
painter was back in Paris. He
had stayed an extra day to fit in

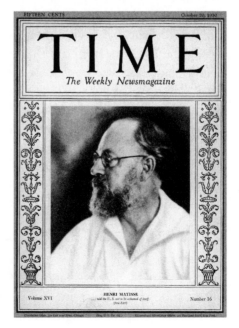

"Grizzle-chinned,
wrinkle-browed
Henri Matisse" on
the cover of *Time*,
20 October 1930

a second visit to Merion, sailing for home on 3 October hotly pursued by Barnes, who arrived in Paris at the end of the month to finalise the contract. Both men had set their hearts on this commission, both were notoriously tough bargainers, and both emerged well satisfied from the deal. Barnes was to get a wall painting three times the size of Shchukin's *Dance* and *Music* put together, involving at least twelve months' work, for $30,000 in three instalments (just twice the price he had paid earlier the same year for a single moderately sized canvas). Pierre's amazement outstripped even indignation when he heard these terms, but his father rated loss of earnings well below the chance to raise his profile and reach out to a new public in America ("Although there'll be no profit in it for me," he wrote confidently to his wife, "this work will have important consequences").[123]

He returned for a site conference at Merion in December, making his fifth Atlantic crossing in twelve months. This time the trip included a visit to the only other collector whose Matisse acquisitions in the 1920s came anywhere near matching Barnes' in either quantity or quality, Miss Etta Cone of Baltimore. Etta had bought a first small Matisse canvas through her friend Sarah Stein before the 1914–18 war, going on after it to acquire two dozen more in tandem with her older, bolder and far more brilliant sister, the majestic Dr. Claribel Cone. Affluent, independent, extravagant in every sense, the two bought lavishly and well without premeditation or advice on colossal annual shopping sprees in Paris, operating on the Barnesian principle spelt out by Claribel for Etta: "If it is pretty ... and pleases you—why care a darn what anybody else says of it ... if it gives you a thrill, why I guess the thing is to take it."[124] It was Claribel who bought the *Blue Nude* from the Quinn sale, an astonishing purchase for an elderly maiden lady from the solid conservative upper crust of the American South.

In 1929 Claribel Cone died suddenly, leaving her collection to her sister. Shy, retiring, to Matisse always the more touching of the two, Etta was crushed by grief and shock. At the time of Matisse's visit in December 1930, she was sixty years old, tentatively beginning for the first time in her life to emerge from the ample shadow of her sibling and take control in her own right of a collection as individual, and in its own way as imposing, as the contents of Shchukin's palace or Barnes' purpose-built museum. The sisters had occupied next-door apartments so crammed with statues, ornaments, tapestry and lace, heavy old Italian furniture and contemporary French art that, when Claribel's rooms filled up, she simply bought a second apartment upstairs to accommodate the overflow. As soon as he stepped through the door into Etta's narrow hall, Matisse

was surrounded by
his pictures, hanging
everywhere including
the bathroom and the
bedroom, their power
and sensuality inten-
sified at close quarters
in these small, dark,
cluttered spaces. To
the steady stream of
visitors who knocked
on Miss Cone's door
over the next twenty
years and more, this
eighth-floor apart-
ment seemed like a
time capsule ("One
looked at the walls
and saw the future,"
said a young friend)
suspended above the
roofs and towers of

Matisse in Etta
Cone's apartment,
Baltimore: "One
looked at the walls
and saw the future."

sleepy, unsuspecting, still largely nineteenth-century Baltimore.[125] For the
painter, the collection was a private ark. "In our home he was like a mem-
ber of my family," said Etta, commissioning him to make a posthumous
portrait drawing of her sister.[126] Out of this encounter grew a collabora-
tion that would outlast them both, and prove in that respect more valuable
to Matisse than any other relationship he ever had with a collector.

His weekend in Baltimore was squeezed between four successive visits
to Merion, where he engaged for the first and last time in a calm, rational
and constructive dialogue with Barnes. Both were still exalted at this stage
by mutual anticipation ("We have many points in common," the painter
told his wife, "but I'm not so brutal").[127] They spent Christmas week tak-
ing measurements and working on a template for Matisse to use in Nice.
The space Barnes wanted him to fill was not promising: a surface roughly
forty-five feet long by seventeen feet high, divided by projecting shafts of
masonry into three round-headed arches, obscured from above by the
shadow of the ceiling vaults, and from below by sunlight pouring in
through three tall glass doors opening onto the garden. It was too high,
too awkward, abominably lit and impossible to see fully from ground

level. None of this deterred Matisse. "I'm full of hope and eager to get going...," he wrote to his wife on 26 December, announcing that he had already picked his colour scheme and sketched out a format. "I don't think it's going to be so very difficult for me because I sense that my year of rest has brought great progress in clarity of mind."

Before he left Nice, Matisse had hired a large garage that would fall vacant in the spring, and laid down a strict exercise regime for Lisette, who was to model the nude figures that would be needed both for Barnes' decoration and for the Mallarmé illustrations due to be produced over the same period. Lisette was slender but not supple or fit enough for Matisse, who had tyrannised over her by post for much of the past twelve months, sending regular instructions to his wife to oversee her diet and gym schedule. Now he became dictatorial in the extreme. He made her pluck her thick black eyebrows and dye her fashionable white fox fur black.[128] In an attempt to calm his nerves before he got to grips in earnest with his decoration, he even tried painting Lisette in harem pants, with a long silk Persian coat, or revamped as a vaguely Hindu beauty in nothing but a transparent bolero and a string of beads with decorative blue dots and crosses which he drew himself on her cheeks and forehead. His impositions were exorbitant, but she remained unruffled. However hard he tried nothing could make Lisette, clothed or unclothed, look other than what she was: a stylish young Parisienne with the bobbed hair, neat features, small high breasts, flat belly and narrow hips essential for the boyish figure currently in vogue.

By the spring of 1931, Matisse could think of little but his new commission. From now on, all other wants or needs were secondary. The whole household was under starter's orders. Lisette had to be in early every evening in order to be fresh for the next day's session. She was forbidden to swim except briefly, first thing in the morning, for fear of sunburn. Once she was battered by a freak wave and came home badly bruised, only to be severely reprimanded for spoiling the immaculate purity Matisse needed for his work. It required long hours, short breaks and exclusive concentration from both painter and model. They left after breakfast every day for the garage in a back street near the art school, no. 8 rue Désiré Niel, big enough to hold the three huge canvases destined to fill the hall at Merion. Matisse's punitive programme was hard on his model, harder on himself, hardest of all perhaps on his wife, whose hopes of recovery seemed to be receding. Her only regular visitor was Berthe, who had stayed with her over Christmas, and would come to spend most holidays in Nice at a flat bought by Matisse for her retirement in two years'

time. Otherwise Amélie's world had drastically contracted. Her doctors still prescribed bed rest. Marooned with a bad back at the top of five flights of stairs, effectively a prisoner for the past twelve months, she now lost both her young companion and her husband to the ineluctable demands of painting.

The choice of form and content for the new work had been left entirely to Matisse, who apparently never considered painting anything but a *Dance*. At Merion he rediscovered *Bonheur de vivre*, the painting (then owned by the Steins) that had inspired Shchukin to commission the first *Dance* in 1909. Back in Nice, Matisse pinned a reproduction of Shchukin's panel to his garage wall, roughed out a set of small variations on an overall design, and drew his new *Dance* freehand ("It was in me like a rhythm that carried me along") directly onto three adjacent canvases more than twice his height, using a stick of charcoal tied to a bamboo pole.[129] Matisse had written to Pauline Schyle when he got back from Tahiti to say space had expanded for him on his return to Nice.[130] In this first sketch he peopled it with immense leaping figures, plunging and thrusting in a dance that extended far beyond the three great arches containing his decoration. Heads, arms, legs, hands disappear off the edges of the canvas to link up with other unseen bodies, half glimpsed flickering in the curves of the arcade. The dancers' energy flows from one extremity to another, surging

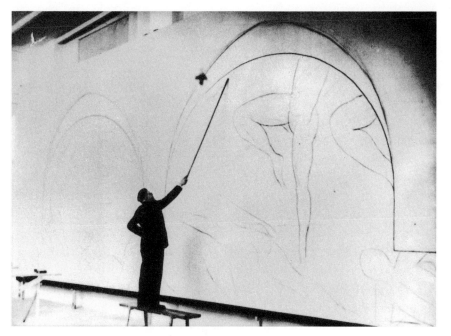

Matisse at work on *The Dance* with the bamboo stick compared by André Masson to a magician's wand

across the projecting blocks of masonry and out into an imagined space beyond. Matisse said this was one of those periodic points of departure, like Fauvism, when it was necessary to turn back from complexity and refinement to the beginnings of human perception in pure colour, shape and movement—"materials that stir the senses"—elementary principles that give life by coming alive themselves.[131]

At the end of April, he posted photographs to Barnes showing two successive stages of the initial layout. By June he was beginning to add colour, and so confident of having reached a halfway mark that Barnes paid over the second of three cheques for $10,000. The two met at the opening of Matisse's exhibition at the Georges Petit galleries, his first Parisian retrospective in twenty years, mounted by the Bernheims (who left the organisation to one of Barnes' Paris agents, Etienne Bignou). This was a dealers' show, prestigious and celebratory, concentrating (like the batch of picture books published to mark Matisse's birthday the previous year) on paintings from the last decade in Nice, with little attempt to present a coherent survey of what had gone before. By the time it opened, Matisse had already moved on into unknown territory. It was three years since he had abandoned the series of Nice odalisques whose dazzling pyrotechnics marked him down, for a public currently mesmerised by Surrealism and its offshoots, as essentially superficial, a kind of twentieth-century Fragonard producing suavely titillating confections for rich men's Manhattan apartments and villas in the south of France. Pierre, who had come from New York to hang the Petit show at his father's request, acknowledged afterwards that its limitations played into the hands of those who saw Matisse as at best a minor decorative master with little relevance to the modern world. "All this so as to end up identifying Picasso as the great renovator etc.," wrote Pierre, confirming his father's view that the patronising and largely dismissive homage he had received over the past two years was a way of burying him alive.[132]

The mistake would be triumphantly rectified that autumn in a smaller but more rigorous transatlantic retrospective put together by Alfred Barr, the young director of the newly founded Museum of Modern Art in New York. "Barr has done his best, and succeeded beyond my hopes," Pierre reported to his father. American critics, headed by Henry McBride, rose to the occasion ("They are delighted to find the artist better understood and appreciated in New York than in Paris with a show that serves rather than crushes him—and it's true! When you see this show, you get a far greater shock than you did in Paris"). Pierre sent home a detailed assessment of the exhibition, describing its hang and the perspective it

imposed on the long march from Matisse's first copy of Chardin in the Louvre through the Fauve years to the *Aubergines* from Grenoble and the austere wartime abstractions. Groups of relatively small-scale canvases— early works, paintings of Lorette, a handful of more recent odalisques— fell into place as punctuation, pauses to rest and reward the eye in breaks from the effort required by the demanding and disturbing works at the centre of the show. This was MoMA's first full-scale appraisal of a European artist, and it covered every phase of Matisse's career (except the works in Moscow, which the Soviet authorities had refused to lend) with a pellucid sense of structure, pace and growth.

But by this time the damage to Matisse's reputation had been done. The attention focussed on him by the Paris show, magnified by national and international coverage before and afterwards, stamped him as facile, self-indulgent and inevitably, in relation to Picasso, the lightweight of the two. From now on Matisse would be dogged by a public image based largely on a misconception of his activity in the 1920s, a view that distorted his overall achievement and made it difficult to look clearly at the work he subsequently produced ("People know nothing of your previous output," wrote Duthuit in his role of spokesman for the post–First World War generation. "If your decoration were to be exhibited here, it would come as a revelation").[133] By 1931, the moment when his image as a reactionary crystallised in the popular imagination, Matisse was already struggling with a mural intended by himself and Barnes to bridge the gap between public and private art, a goal that would become a major preoccupation over the next decade in revolutionary Russia, Mexico and France. His isolation at this point came, as Pierre Schneider pointed out, "not from his conservatism but from the fact that he had made the transition to the characteristic work of the 1930s before any of his contemporaries."[134]

As the decoration took shape, Barnes himself—"part bulwark, part ball and chain," in John Russell's graphic image[135]—became ominously proprietorial, harassing the painter with demands to see the work in progress, threatening to descend on Nice, boasting about his own rapid progress with a book that in his view would be the greatest ever written on Matisse's work. After six months, *The Dance* was no longer flowing as smoothly as its creator had anticipated. At the beginning of September, Matisse took a break from his partly painted mural at the Italian resort of Abano Bagno, where he treated his bad arm with a water cure each morning, and refreshed his eye each afternoon with a drive to Padua, to see the frescoes by Giotto that had renewed his power of attack in the Fauve years a quarter of a century before.[136] On his return to Nice, he adopted a new

method. Setting aside his brushes, he hired a professional housepainter to cover sheets of paper in the four colours finally selected, producing a stack of painted paper in flat, uninflected black, grey, pink and blue that could be pinned onto the canvas. Matisse now drew and redrew his entire design, outlining shapes on coloured paper for an assistant to cut out with scissors.[137] After posing all morning, Lisette would put her clothes back on and spend the rest of the day pinning, shifting and repinning a composition that was perpetually on the move. "Nothing comparable was ever invented, before or afterwards, to resolve the problem of form and colour," said the Surrealist painter André Masson, who watched Matisse using his bamboo pointer—"truly a magician's wand"—to direct an extraordinary performance of shapes and figures emerging from his imagination only to dissolve and reform in endless fluid, filmic permutations.[138]

The workshop on the rue Désiré Niel was overlooked by the boys' lycée. Matisse's working day was accompanied by shouts and catcalls from the pupils, racketing round their playground or peering from their windows hoping to catch a glimpse of the old wizard manoeuvring his weird, headless bodies and truncated limbs in a mural utterly unlike anything they had ever seen in the municipal galleries and town halls of France. The boys' former teacher, Jules Romains, dropped in expecting to find the kind of decorous public nudes appropriate to the artist's age and eminence, and was shocked to see Matisse standing on a bench in an abandoned garage fooling about with a stick and scraps of coloured paper.[139] Another old friend, the painter Georges Desvallières, was frankly appalled. "He is working himself to death on imperceptible changes that bring others in their wake, any of which he may well think better of next day," wrote Desvallières, who reckoned that Matisse had surrendered all power of reason, feeling and imagination in a ruthless drive to mechanise production ("If the Cubists and Futurists were as logical as he is, they would go mad").[140]

Desperate for some kind of informed response, Matisse drove over to Grasse to look for Masson (who was a friend of the Duthuits), surprising the younger man by paying close attention to his work and inviting him back to inspect progress in the garage.[141] Whenever panic loomed in Nice, Bussy received a telegram in Roquebrune (DECORATION IN TERRIBLE STATE COMPOSITION COMPLETELY OUT OF HAND AM IN DESPAIR LIGHT SUITABLE THIS AFTERNOON FOR GODS SAKE COME AT ONCE MATISSE).[142] Throughout the long, slow evolution of *The Dance*, Bussy regularly arrived to find his old comrade fraught and frantic ("struggling

with his vast composition like a kitten with an outsize ball of wool," wrote Bussy's daughter, Janie, never particularly sympathetic to her father's friend and notably unimpressed by his latest crackbrained scheme. "The great dim monstrous de-individualised figures he had conceived began to wind themselves into impossible knots"). Matisse's problems were compounded by the Mallarmé etchings, which paralleled on a small scale the complexity of his decoration. Both projects demanded surgical precision and the calculation of a chess player. Matisse divided his time between book and mural in a state of continuous high alert, attempting entirely by instinct to conjure unity out of almost infinite combinations of variable elements—page margins, borders, typographical texture, scale and spacing on the one hand, and the twenty-four limbs of his six gigantic dancers on the other.[143] "I could proceed only by groping my way forward," he said of *The Dance.* He compared the organisation of each set of two facing pages, with Mallarmé's text on one side and his own spare, linear image on the other, to juggling two balls, one black, one white.[144]

The coordination of mind, hand and eye required by this double balancing act was intimately connected for Matisse with the disruptions of the year before. He said that travel rests parts of the brain that have been overused, and releases others previously repressed by the will, acknowledging even his intervals of boredom and discontent in Tahiti or Tangier as essential to this process, a sign of something stirring at levels far below the conscious mind.[145] "I sometimes think that my stay in Tahiti and the Paumotus has enriched my imagination," he wrote to Pauline, sending her a photograph of himself at work with his bamboo pole, "as if all that sumptuously lovely light I couldn't get enough of . . . is coming out now in my work."[146] By the winter of 1931–32, he had externalised the sensation of expanding space released by his visit to Tahiti, and transferred it to his decoration. "Papa says every so often that he's very happy with it, when he's not in complete torment," Marguerite wrote to Pierre from Paris. "Tante Berthe talks of lightness and grandeur—Skira says it is magnificent—Masson is astonished each time by the latest developments."[147]

Masson stood godfather to Marguerite's son, Claude, whose birth in Paris in November 1931, a few months after Pierre's daughter, Jacqueline, and Jean's son, Gérard, completed a trio of grandchildren born that year to the Matisses. The financial havoc threatening to engulf both America and Europe was offset for the whole family that winter by a mood of private and professional optimism. Pierre had made a considerable impact with the opening of his gallery in Manhattan in spite of the calamitous state of the stock market, which made it impossible to sell anything, even

at famine prices ("Lean cows have replaced fat cows...," he reported philosophically to his father on 2 January 1932. "At all events there's nothing to be done but wait quietly for the storm to pass while trying to avoid false moves"). Barnes' decoration was nearing completion more or less on time. The popular success of the MoMA show in New York was to be followed in Paris in the spring by a first public showing of *The Dance* at the Petit galleries, with specially installed lighting and opening hours extended until midnight so that it could be seen by ordinary working people before it was shipped to the United States.[148] The American press was already preparing a noisy reception for it, when Matisse made the horrible discovery that he had been working for twelve months from measurements miscalculated by almost a metre. An exchange of telegrams confirmed his fears. Barnes responded angrily (YOU HAVE MADE AN ENORMOUS MISTAKE), and sailed at once for France.[149] At their meeting in Paris on 4 March, Barnes was sufficiently mollified to agree that, instead of attempting a salvage operation, Matisse should start all over again on a second *Dance*.

Habits of drudgery and persistence drummed into him from childhood ("Where willpower isn't enough, I'll tell you the trick, you have to fall back on stubbornness instead") carried the painter through the next twelve months.[150] He completed his first abortive decoration, whose six tumbling figures became increasingly agitated and aggressive, before turning to a second set of three freshly stretched canvases on which, at the beginning of July, he sketched out a new, looser and more lyrical *Dance* with impressive speed and confidence. By the end of the summer, he was ready to start the laborious and exacting job of marrying form to colour, using scissors and a stack of painted paper in place of brush and palette. Lisette remained at the Place Charles Félix as Amélie's sickroom attendant, leaving Matisse to manage as best he could with casual hired help or students from the nearby art school. In late September he found an unexpectedly reliable assistant, a young Russian film extra called Mme Omeltchenko, who took over cutting, trimming and pinning his shapes in place.[151] Matisse was simultaneously correcting the proofs of his *Poésies de Stéphane Mallarmé*, incorporating innumerable, infinitesimal, last-minute adjustments that drove his printer to distraction. Images of *The Dance* tormented his waking hours and invaded his sleep at night. In the intervals of drawing and redrawing, while he waited to see his latest changes implemented, Matisse left the studio with his dog to walk the short distance to a shooting booth beside the Paillon River. He told his studio assistant that

his only relief from tension came in the moment when he raised and levelled his rifle at the target.

In January 1933, Matisse travelled to Mallorca for what proved a nightmarish confrontation with Barnes, who followed him back to Nice at the end of the month to inspect *The Dance* for the first time. Barnes approved of what he saw, but could not prevent himself from capitalising on the fact that in a collapsing art market ruled by panic and stagnation (both artist and patron were well aware of rumours circulating in Paris that Bernheim-Jeune faced bankruptcy, and the Petit galleries were about to be turned into a garage), he was now Matisse's only potential source of income.[152] Being treated like a junior employee at a time when he was already exhausted and discouraged did nothing to restore the painter's confidence. After Barnes left, Matisse worked with feverish concentration in a state of heightened awareness that blocked out everything except his decoration. "The end is near," he wrote to Bussy on 7 March, "—win or lose." Bussy's disapproving daughter watched her father repeatedly respond to Matisse's summons that spring only to return exhausted and groaning, "having . . . saved the decoration from annihilation, if not its creator from suicide."[153] By 20 March, the design emerged complete at last, the studio assistant left, and the housepainter returned to spend the next month painting in the outlines of *The Dance* on canvas.

André Masson was in Monte Carlo that spring, working with Massine on the ballet *Les Présages,* which he redesigned four times in a state of such violent frustration that Matisse invited him to stay in Nice (" 'It'll calm you down,' he said, 'and it will be good for me to take time off' ").[154] The two spent mornings in the Nice workshop or drove over to Monte Carlo together to watch the corps de ballet rehearse, distancing one another from their respective frenzies in long walks and talks each afternoon. Masson never forgot Matisse's bleak confession as they walked back one day from the garage to the Place Charles Félix: "He suddenly stopped, after a long silence that I didn't like to break, to say to me: 'I've lost my touch, everything I do has gone cold.' " Nothing would reassure him. Matisse insisted that his powers had left him ("Remember the canvases I used to paint"), and flatly rejected Masson's protests ("He seemed to have no inkling that he was entering into a new manner, full of sap and vigour . . . a new phase marked by the miraculous alliance of grace with maturity").

At this point Marguerite arrived with Claude from Paris to find her father in despair ("His philosophy is very close to that which advises tak-

ing to your bed and awaiting death," she wrote to Pierre).[155] Matisse attended the dress rehearsal of Masson's ballet on 12 April, and finished his own *Dance* just over a week later.[156] For the next ten days the painter and his dog held an informal preview at 8 rue Désiré Niel. Massine was one of the first arrivals, declaring that Matisse had embodied his dream of what the dance should be.[157] Duthuit arrived, and Gide came over with the Bussys. Matisse sent his car to fetch young Mme Omeltchenko, and invited Dorothy Dudley, an American journalist who had asked him for an interview.[158] Plans to exhibit *The Dance* in Paris had to be dropped ("I'm so tired and desperate that I don't care what happens, and I haven't the energy to see to it . . . ," Matisse told his daughter. "Forgive me, Marguerite, but I'm completely drained").[159] Duthuit warned his father-in-law to think again, correctly predicting that he risked losing all credibility with a younger generation for whom he was nothing more than a painter of sexy girls in harem outfits: "We would lose an essential force with the departure of your decoration. . . . People realise this in Paris, I can assure you. Your abstention will seem to many an act of deliberate hostility or contempt."[160]

But by this stage it was almost more than Matisse could do to organise packing and shipment. He sailed for New York on 4 May with his crated decoration in the ship's hold. On Friday, 12 May, the day after he landed, he was driven down to Merion by Pierre (who was received with Barnes' usual brutal dismissal on the doorstep). On Saturday the first of the three canvases was fixed in place in an atmosphere so tense that Matisse suffered a minor heart attack, turning blue and having to be revived by Barnes with whisky. A heart specialist called in that night, and three doctors who sub-

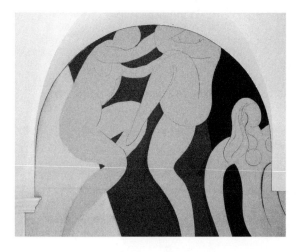

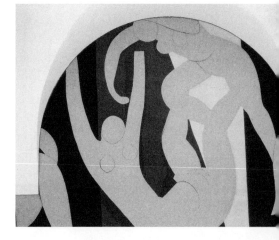

sequently examined him in Philadelphia prescribed total rest for the next few months.[161] Matisse told his daughter that overwork had probably placed irreparable strain on his heart, and warned her to say nothing to her mother, but his own anxiety was swallowed up in the overwhelming relief of seeing his decoration installed at last. "It has a splendour you can't imagine without seeing it," he wrote immediately to Bussy, reporting that Barnes had compared the radiant light and colour streaming through his hall to the effect of the rose window in a cathedral.[162]

But their mutual jubilation was shortlived. Barnes, whose newly published book on Matisse had been comprehensively mauled by the critics, announced that he had no intention of letting anyone see his decoration.[163] To Matisse, his behaviour seemed almost unhinged. Pierre, who drove down again early on Tuesday morning to fetch his father, was allowed into the hall just long enough to take two photographs of *The Dance* before being hustled out.[164] When Matisse telegraphed to arrange a second viewing on Friday, Barnes had already locked up his museum and left to spend the summer in Europe. "He's *ill*," Matisse reported to his daughter. "He's a monster of egotism—no one but *him* exists . . . nothing can be allowed to interfere with him! Above all not now, when he's bruised black and blue by the failure of his book. . . . All this between ourselves, because what counts is that he gave me the chance to express myself on a grand scale, and that he recognises as best he can the excellence of the result."[165]

Matisse never saw his *Dance* again. Its ten days on display to close friends in a Nice garage turned out to be the nearest it ever got to a public showing. Having left home expecting a rowdy reception in America,

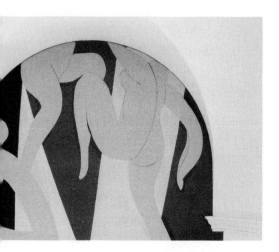

Matisse,
The Dance, 1933

LE PITRE CHÂTIÉ

Yeux, lacs avec ma simple ivresse de renaître
Autre que l'histrion qui du geste évoquais
Comme plume la suie ignoble des quinquets,
J'ai troué dans le mur de toile une fenêtre.

De ma jambe & des bras limpide nageur traître,
A bonds multipliés, reniant le mauvais
Hamlet! c'est comme si dans l'onde j'innovais
Mille sépulcres pour y vierge disparaître.

Hilare or de cymbale à des poings irrité,
Tout à coup le soleil frappe la nudité
Qui pure s'exhala de ma fraîcheur de nacre,

Rance nuit de la peau quand sur moi vous passiez,
Ne sachant pas, ingrat! que c'était tout mon sacre,
Ce fard noyé dans l'eau perfide des glaciers.

Matisse, *Le Pitre chatié (The Clown Punished)* from the *Poésies* of Stéphane Mallarmé

Matisse returned to Nice still barely able to take in what had actually happened. As soon as he got back, he went round to call unannounced on Dorothy Dudley, who asked about the critical reception in America ("He said there was none"), and in particular what their mutual friend McBride thought of the decoration. "But," he said, "he never saw it. As I told you, nobody has seen it. You're the only one!"[166] Nothing was said explicitly about the purpose of this visit, but Dudley got the strong impression that Matisse wanted an article from her because he could not bear to see the work that had drained him physically and mentally over two years sink altogether without trace (in the event her article, which she had hoped to place with *Vanity Fair* or *The Studio*, appeared in Lincoln Kirstein's *Hound and Horn*, the only publication in America or Europe to carry an eyewitness account of Matisse's *Dance*).[167] For the rest of his life, and Matisse's, Barnes ensured that his decoration remained for all practical purposes unknown. No one was ever admitted to the Foundation without his personal permission, which he refused on principle not only to the press but to collectors, curators, art lovers, anyone suspected of the faintest previous connection with the art world (the list of people turned away eventually extended from T. S. Eliot and Le Corbusier to visitors arriving with Matisse's personal request that they might be allowed to see his decoration).[168] Colour reproduction of *The Dance* (or anything else in Barnes' collection) was forbidden.

Matisse was never again commissioned to make a mural, although he told Gide he would happily live on bread and water if he had another wall

to decorate.[169] The blow Barnes dealt him left him impotent and helpless, sprawling upended on his back like the figure in his illustration to Mallarmé's poem *Le Pitre chatié (The Clown Punished)*. This was not the comical clownish self-projection of his letters to his wife, more like the private nightmare of a boy who dreamed of becoming a circus clown and grew up to be treated by the neighbours as a village idiot, *le sot Matisse*, the fool whose paintings made no sense to anyone. Matisse rarely talked about his private bitterness and humiliation, except to his son Pierre, but he did insist that no artist could exist without a public ("Painting is a way of communicating, like language").[170] One of the things he liked about Chaplin's film *The Circus* was that it embodied his own image of the artist as the little man trying to entertain a fairground crowd, who would slink away with his hands in his pockets if you took away his audience.

~

1933–1939: Nice and Paris

Lydia
Delectorskaya,
Henri Matisse, 1935

At the beginning of 1934, Matisse agreed to illustrate James Joyce's *Ulysses* on the advice of his son Pierre, who predicted an enthusiastic welcome in America for this rare conjunction of two prime modernists.[1] Having discovered from the Bussys that the novel's structure was based loosely on the *Odyssey,* Matisse proposed to bypass the intrica-

cies of Joyce's text (which he had not read), and supply an accompaniment or continuo by illustrating familiar scenes from Homer instead. This solution would cause trouble later, but at the time, its beauty was precisely that it gave him a free hand. He closed with the American publisher George Macy in February, and by mid-March had already picked out six Homeric episodes to work on (Calypso, the Sirens, the Cyclops, Nausicaa, Circe and Penelope).[2] All but one involved women, starting with the various nymphs and seductresses Odysseus encountered on his travels and ending with

Matisse, *Lydia Delectorskaya*, 1935

the patient wife he left behind him. The first sample illustration submitted to Macy in New York showed "two women quarrelling, to represent the disorder in Odysseus' household," an image that had more to do with the artist's own home life that summer than with either Joyce or Homer.[3]

Matisse's marriage had been under pressure ever since he started work on Barnes' decoration, and the situation was not improved after he got back from America by his decision to continue with the original, abandoned version of *The Dance*. The twelve months initially envisaged for this project stretched out in the end to three times as long. Amélie responded by putting her life on hold. She spent the entire period immobilised in her room high above the sea, busy with her embroidery, going nowhere and receiving no one except her doctor and Berthe. When Henri finally accepted the need to rest, renting a seaside villa for two months on the leafy green peninsula of St-Jean-Cap-Ferrat, he said that it was the first time in four years his wife had left her room.[4] He reflected ruefully on the contrast between what looked like wilful lethargy on her part and the relentless over-exertion that had weakened his own heart, lowered his resistance and now tortured him with kidney pain. On doctors' orders, he retreated at the end of August to take the waters at the spa town of Vittel,

where his daughter posted him her own prescription for a moral as well as physical cleansing of the system.

Pierre had complained for years of his family's tendency to hold their tongues for fear of saying too much whenever they came face-to-face, but on paper all of them could speak their minds with devastating accuracy and frankness. Marguerite's long letter to her father in the autumn of 1933 radically transposed the dialogue at the centre of her life and his, "a dialogue sustained from the beginning in long hours of posing when his daughter was at once his subject, his observer, his pupil and his critic."[5] Trained under Matisse's tutelage, she turned her scrutiny back on her father, itemising his failings, urging him to put more effort into repairing the foundations of his life at home, warning that his exclusive absorption in himself and in his work threatened the fabric of his marriage. Marguerite was well aware that her father felt he had been abandoned in his time of greatest need by a wife so sunk in her own troubles that she could no longer even oversee the smooth running of his household. Far from relying on Amélie to calm his inner torment, he found himself advised by the family doctors in Nice and Paris to conceal all problems from her. His perennial anxiety consumed him, fuelling a sense of injury that made him exacting, overbearing and intolerant.

In an impassioned defence which became a statement of her own core beliefs, Marguerite reminded her father that his existence as a painter was inextricably bound up with Amélie's ability to look beyond the child-rearing and housekeeping traditionally allotted to her sex, that her courage and elasticity had been worn out in pursuit of a larger goal, and that their loss now condemned her to the lonely inferiority of an invalid routine. "How do you imagine that someone suffering in the depths of her being for so many years can possess the resources of a strong and healthy nature that continues to flourish and expand?" she wrote bluntly.[6] "Men of iron have been known to break under the slow insidious action of a hidden malfunction. Do you never think of that? Napoleon is a celebrated example." The letter ended with a stinging rebuke to Matisse for attempting to insulate himself with his wife and work in Nice from the internal and external conflicts already threatening to tear France apart ("This . . . is not a healthy way to live—above all not at a time when the entire world is in convulsion").

Matisse remained defensive but immovable. It would be almost a decade before he encountered something very like Marguerite's diagnosis in the writings of her contemporary, the Nobel laureate Pearl Buck, another intrepid and observant daughter whose whole life was in some

sense a response to her father's iron will. Matisse recognised his own compulsions in Buck's novel *The Patriot* ("Read this book, and you will understand by analogy the family disaster that has overtaken me," he told Pierre in 1941).[7] He went on to read *The Fighting Angel*, Buck's biography of her missionary father, whose wife and children paid a heavy price for subjection to a lofty but inhuman cause. The book is a tragicomic study of a man set apart by an unalterable purpose ("He was a rock in the midst of all the frothing—unmoved, unresentful, serene, but so determined, so stubborn in his way, that I know there have been those who, seeing that high, obstinate, angelic tranquillity, have felt like going out and beating their heads against a wall in sheer excess of helpless rage").[8] It is also a memorable portrait of a marriage between two powerful personalities with a slow fuse of anger and resentment smouldering beneath the surface. Matisse saw the purity of his motives and the nobility of his sacrifice reflected in the book's distorting mirror, and was sufficiently disturbed to urge both Marguerite and Pierre to read it ("Yet surely I'm not like the character of the fighting angel in Pearl Buck").[9] No member of Matisse's family ever seriously questioned the overriding imperatives of art, but all of them suffered from the selfless dedication that could make him as impervious as Buck's angel to other people's desires and plans.

Like Odysseus' Penelope, or the mute, stormy, stone-faced missionary wives struggling to discharge an innate sense of grievance through their knitting needles in *The Fighting Angel*, Amélie had for years stitched feelings that could find no other outlet into tapestries, embroidered cushions, soldiers' socks in wartime, fine silk lingerie and baby clothes in the interlude that followed. At Issy she knew how to hold the whole family to ransom with her brooding silence. But in Nice the balance of her marriage shifted. Painting had always been Matisse's first love, and his involvement in his early sixties was as intense as it had ever been. "Dr Barnes, it's no good violating a young girl," Matisse said sternly at Merion, when the collector tried to force his attentions on *The Dance* in too much of a hurry: "You have to wait until she gives herself."[10] Even after his return to Nice, Matisse could think of little but his decoration. In spite of heart trouble and a kidney crisis, he sneaked back for another look at the original design still waiting to be transferred to canvas in his garage workshop ("It's like an old stallion sniffing the mare," he wrote to Bussy, explaining what he meant to do to his *Dance* as soon as he was well again).[11] Involuntary separation only increased his longing to shut himself up once more with the second set of three huge canvases stretched and hung ready for him by mid-September.

Isolated and excluded from the life of the studio that monopolised her husband, Amélie's exasperation erupted in dramatic scenes whose vehemence frightened both of them that autumn. At the beginning of October, she moved out, decamping without warning to her sister's flat on the western outskirts of town. Her old energising dreams of a brave new world revived briefly with a scheme for taking an apartment of her own around the corner. "If only I could win the lottery," she cried, raising clenched fists above her head in a characteristic gesture of defiance. "But, Amélie, you already won it," Berthe said calmly. "It's Henri."[12] Berthe, who had just retired at the summit of a remarkable career, was renowned as a peacemaker able to restore order, quell mutiny and reverse decline in failing or demoralised institutions by sheer power of personality. She had passed up a final prestigious posting to Bordeaux or Toulouse in order to respond to an emergency call from a smaller college on the verge of cracking up at Aix.[13] Berthe was her family's lifeline. She had looked after both parents, making a home for her father until the day he died, and shortly afterwards taking in her mother's sister, the ageing but still fearsome Aunt Nine. Berthe's own reserves of energy and stamina were running low, but when her own sister required support, she had postponed plans for retirement to the Roussillon, exchanging a roomy house and garden in her native village of Beauzelle for a small apartment on the avenue Emilia, in suburban Nice. Now she put her skills as a mediator at the disposal of her brother-in-law, who arrived on her doorstep every afternoon, baffled and contrite, bearing gifts for his wife of pastries, chocolates or books.

In mid-November, when Henri finally completed the second *Dance*, proposing to bring it back and unroll it ("like a theatre curtain")[14] on the wall of his big studio at Place Charles Félix, Amélie came home too. Her husband made strenuous efforts to give satisfaction, offering every concession short of modifying his work habits. The whole apartment had been fitted up to suit an invalid, with the gramophone and radio moved from the studio to her room, which was bigger and more comfortable than any other. The day revolved around her morning outing, when she would be carried downstairs to the car in a thronelike armchair by the driver and the cook's husband (Marie and Michel had been replaced by a Czech couple, Marie and Emil Kas) with the whole household in attendance, carrying rugs and cushions. Matisse had acquired a big American car with impeccable suspension largely because the Renault was too bumpy for his wife, and now he hired a professional chauffeur until Emil could learn to drive slowly and smoothly enough to prevent the slightest upset to her back. Doctors warned that she must not be confronted with anything that

might provoke strong feeling.[15] Since she could no longer visit the down-stairs painting studio, Matisse came up regularly instead to report on progress at her bedside. She had tired after twelve months of being looked after by Lisette, who was dismissed by Matisse on his wife's insistence at the end of August 1933. When the next two attendants left in swift succession, it was Amélie who suggested replacing them with the Russian who had proved the most dependable of all her husband's studio assistants, Lydia Omeltchenko.

Lydia was young and beautiful but also, unlike many of the temporary helpers employed by the Matisses, amenable, available and unobtrusively efficient. She possessed a natural gift for solving problems, like Berthe, who had got to know and trust her in the month when she came every day to the avenue Emilia to attend to Amélie's needs. Lydia's health and strength made it possible to plan a longer break on doctor's orders in the spring, when Amélie proposed returning to the Roussillon with Berthe to take possession of the former rectory at Beauzelle where they had both grown up. Matisse saw his wife off from the station at Marseilles in May 1934, with Lydia to look after her on the journey. The young woman would remain on hand all summer, to fetch and carry for a household that included the two sisters, their elderly aunt, and the Matisses' two-year-old grandson, Claude Duthuit, who came from Paris while his mother visited her brother in America.

Amélie approved of the tenacity and resilience that made Lydia a battler like herself. Born in Siberia in 1910, the only child of a leading pediatrician in the city of Tomsk, Lydia had been orphaned by the age of twelve, when both her parents died in successive epidemics of typhus and cholera that swept the country after the Revolution. She was brought up by an aunt who fled with her to Harbin in Manchuria, and eventually to Paris, where their arrival coincided with the slump that swallowed the family's remaining capital and left them facing ruin. Lydia, who planned to become a doctor like her father, had already been accepted by the medical faculty at the Sorbonne, but the prohibitive fees charged to foreign students were now hopelessly beyond her reach. At nineteen, she accepted a proposal from the much older Boris Omeltchenko, making a disastrous marriage in 1929 that lasted less than a year (a divorce eventually came through seven years later, by which time Lydia had resumed her maiden name of Delectorskaya).[16]

She next fell in love with a handsome, dashing, irresistibly confident young compatriot, whose imagination conjured up a dazzling future for the pair of them. The couple set out to seek their fortune among the large

community of Russian exiles surviving precariously in Nice at a time when a tide of right-wing xenophobia was rising all over Europe, backed in France by stringent regulations that made it illegal to employ foreign immigrants for anything but casual unskilled labour. Lydia, who had earned her living in a furrier's showroom during the few months of her marriage in Paris, joined the pool of looks and talent on hire in Nice as film extras, artists' models and casino dancers. She was twenty-two years old when she first knocked on the door of no. 1 Place Charles Félix in the autumn of 1932, after a chance encounter at a bus stop with another Russian, who had just abandoned her part-time job pinning up sheets of paper for an elderly painter whose name Lydia had never heard before. Penniless, half starved, beginning to suspect that her lover's ambitious schemes might never find a footing in reality, Lydia saved them both from destitution by finding six months' work that autumn as Matisse's studio assistant.

The painter and his wife had always made sure his models got enough to eat by including them in family meals, or laying on a substantial spread at break time in the studio. Matisse regularly kept Lydia back for half an hour at the end of the morning session, paying her overtime so that she could buy a steak for lunch at the café opposite his workshop. When her six months was up, he dismissed her with a modest loan as starter capital for a scheme to take over a small Russian tearoom with her partner. "If we give her the 500 francs, we'll never see them back again," Matisse warned his wife, "but we can't very well do anything else." His prediction was correct insofar as Lydia's lover staked and lost the entire sum the same night at the Casino. But Matisse had misjudged Lydia, who immediately took a two-month engagement as an extra in a foot-of-the-bill nightclub act at Cannes for three hundred francs a month (the monthly salary of Mme Matisse's attendant at this point was just under a thousand francs, with free board and lodging). After four weeks, she handed over a first repayment of two hundred francs to Matisse, who invited her to view his completed *Dance*, currently awaiting shipment to the United States in the garage on the rue Désiré Niel.

Here she met Georges Duthuit, who was intrigued to discover that this striking stranger had signed on for a four-day dance marathon at the Casino (an endurance stunt for which the management paid twenty-five francs per twenty-four hours with a bonus for anyone managing to last the full course, as Lydia meant to do in order to pay back what she owed). Matisse was appalled by his son-in-law's disclosure. A veteran insomniac himself, he had seen dazed and stupefied young women, sleepless, grey-

faced, blank-eyed, propped up by the sailors who volunteered as their partners, stumbling round the ballroom floor in a parody of the dance, a gruesome freak show with undertones of sexual subjugation laid on for the benefit of the Casino's patrons. He sent his driver to fetch Lydia, who found herself hauled up before him the same afternoon, hatless and dishevelled, too startled to deny her intentions, and too intimidated by his anger to refuse the cancellation of her debt. The episode revolted Matisse, but the stony pride behind it impressed his wife. Amélie understood this way of thinking and warmed to Lydia, whose resourcefulness would become steadily more useful to her in the next few years.

In March 1934, when Matisse's household seemed to be disintegrating round him, he told Pierre that his life was drawing to a close amid troubles worse than any he had ever known before. He said he stood at his window, staring out to sea like someone on an interminable ocean crossing.[17] Painting offered no way out. The first picture he produced after Barnes' decoration, *Interior with Dog*, dissatisfied him ("I need something richer"),[18] and brought him up against the barrier that had for so long blocked his way forward as a painter. Sometimes Matisse feared his critics were right in assuming that, at his age, he had no future. He said mortal dread pursued him night and day. Worry about his work underlay other worries about his wife and provision for his family. He had already made plans for retrenchment, cutting back on expenses, selling one or both cars, and reducing the substantial allowances he paid his children.[19] Apart from Pierre, whose business was at a standstill, none of the young Matisses or their spouses had yet found any regular outside employment. Their father in Nice prophesied ruin as their grandfather in Bohain had done half a century before. "Unfortunately these days we're not just living in a house that's cracking up...," Marguerite wrote tartly, pointing out that the problems of Matisse's youth had little bearing on current developments in Hitler's Germany, or the political explosions detonated by economic calamity in France: "we're living through an earthquake on an altogether different scale, and it has to be said that energy, hard work, courage aren't going to produce the results one could have counted on before—now it's a raging storm and all we can do is try to keep our heads above water."[20]

The predicament of Matisse's children was in a sense a mirror image of his own. Art was for all of them the only calling worth considering. Exposed from birth to its boldest and most exhilarating forms of risk-taking, his children rejected all substitute thrills, and shared their father's horror of anything facile or second-hand that might dilute its power. Their problem was internal, not external, prohibition. Jean, who persisted

as an artist longer than either of his siblings, summed it up with poignant clarity during a painting summer at Collioure. "I have to force myself not to fall back on turning out 'Matisses,' " he wrote, recognising (as generations of young painters would do after him) that his father had literally sucked the life out of the church tower and the port:

> It's as if Papa has seized the essence of any impressions you could experience in front of this landscape, and there's nothing left to do . . . it's been done so often and so thoroughly you end up stupid and discouraged. . . . I think that Papa's had the best of it, and that since we've already responded strongly with more or less discernment and power of analysis to this and other periods of Papa's painting, there's nothing there, you no longer have any desire to capture on canvas impressions you can only feel through other impressions you've felt before. . . . Of course I know you can go on working, that is to say you can set yourself up in front of a canvas and paint what you see, but without gaining anything, I think, except a more or less sensitive copy of nature which adds nothing to the general sum of work for work's sake.[21]

This was the uncompromising instinct of a true Matisse. Where art was concerned, the whole family was implacable. The asperity with which their father judged other painters' work had disconcerted the young André Masson, and would have shocked others if Matisse hadn't remained politely noncommittal when asked in public what he thought of young contemporaries like the Bloomsbury painters in London, or the Soviet Realists in Moscow. But with his children he exercised no such restraint. His duty as an artist and a father required him to be mercilessly honest. For well over a decade Jean remained his pupil, submitting work for a weekly appraisal by post to Nice, and waiting with sickening apprehension for a response ("the kind of correction only Papa knows how to give," Marguerite said grimly)[22] that too often justified his worst expectations when it came. He eventually switched from painting to sculpture ("I'll never forget the sight of Jean, chisel in hand, cutting into the wood of his statue," Pierre reported loyally. "It seems as if he was born for it"),[23] becoming an assistant to Maillol at Banyuls, and producing on his own account a small quantity of work whose quality intermittently impressed even Matisse. But contact between the two remained for the most part a replay of Matisse's relationship with his own father, who had gone to the grave believing his eldest son a failure.

Pierre grumbled in later life that parental intervention had cut short his own career as a painter, but he must have known at some level that flight had saved him from the corrosive self-contempt inevitable for anyone who, as his father put it, was not strong enough or sufficiently convinced of his own purpose to withstand demolition on a weekly basis.[24] The correspondence they kept up from either side of the Atlantic expressed profound mutual affection and concern, taking on a deeper tone in the early 1930s, when outbursts of grief on Matisse's part were answered by almost fatherly reassurance from his son ("Are you sure you're not exaggerating, even rather wildly!" Pierre wrote in response to his father's despairing letter in March 1934).[25] But in person their exchanges were often harsh and grating. They clashed painfully on almost everything, from the annual quota of pictures Pierre could have to sell in the United States to the unfortunate affair of his wife's dog, Rowdy. A cheerful, friendly, entertaining schnauzer, left behind in Nice in the care of the senior Matisses while Pierre and Alexina (always known as Teeny) went on their honeymoon, the dog had changed his name to Raudi by the time they returned to fetch him, and established himself as a companion from whom Teeny's father-in-law could not be parted.[26] Matisse, who got on well with his sons' wives, and especially with Teeny, explained to her long afterwards that he had expected his son to put down his head and charge, concluding, when he didn't, that Pierre was tacitly conceding his own need to be less urgent than his father's. Inability to get his wife's dog back for her rankled with Pierre as yet another routine humiliation that could not be effaced by even the most phenomenal success.

Marguerite, who had stopped posing once she was married, gave up painting shortly afterwards for much the same reasons as her brothers. But she remained her father's personal assistant, running his Paris office and regularly representing him abroad. She was also in a sense his conscience, maintaining a strict grip on quality control, a gruelling, time-consuming and often thankless task, whether it involved alerting Matisse to substandard work, rehanging his pictures at exhibitions in Berlin and London,[27] or seeing his etchings through the press. From the *Poésies de Stéphane Mallarmé* onwards, printers trembled at her coming ("There's only one person who gives printers a harder time than I do," said Georges Rouault, "and that's Matisse's daughter").[28] Still the closest to him of his children, Marguerite was always the one most intimately involved in the workings of the studio. "Immersed from infancy in an aesthetic turbulence ruled only by truth and rigour, Marguerite felt its jolts and setbacks," wrote her only son, to whom she bequeathed a family tradition of scrupulous and unsleeping

vigilance. "She became to some extent his privileged companion on this hard road without knowing either its triumphs, or its moments of completion. Her path lay in her father's wake."

The constraint and conflict of a permanent supporting role became harder to accept after her marriage. Older, more outgoing and unhampered by the close bonds of her upbringing, Georges Duthuit brought with him a witty, worldly gaiety that subverted the arduous virtues—sacrifice, dedication, exaltation—of Matisse's studio. At times, his breezy disrespect seemed like sedition, and his casual, offhand manner like outright revolt. It was Duthuit who told Matisse to his face in the late 1920s that his work was going nowhere, and perhaps her husband's scepticism sharpened Marguerite's severity towards her father. She stood up to him more directly than her brothers ("You're the only one who'll never give in to me," he said appreciatively).[29] In these years, she grew sterner than ever over any sign of laxity in his work, or in his handling of it. She countermanded his rash decisions ("Couldn't I give them the *Dancer with Tambourine?*" Matisse pleaded, when Marguerite insisted he had too few paintings available to waste on provincial showings), and deplored his openhandedness ("You have to throw a bone even to a bad dog," Matisse said, overruling her reluctance to donate a canvas to Christian Zervos's fundraising appeal in aid of *Cahiers d'Art*).[30]

In the early years of their marriage, Duthuit pursued his studies on frequent trips abroad, visiting sites or museums in Egypt, Spain, Germany and England, becoming almost as much at home in London as he was in Paris: "a large handsome man with the chest of a Percheron horse," wrote a fellow journalist and critic, Peter Quennell; "one of those Frenchmen who especially charm the English because they so closely resemble the Anglo-Saxon idea of what a Frenchman ought to be—tempestuous, high-spirited, eloquent, irascible, demonstrative."[31] Duthuit was a key member of the Gargoyle Club in Soho and a close friend of its founder, the Hon. David Tennant, one of the last disciples of Matisse's pre-war champion Matthew Prichard (who had returned to England after his release from a German prison camp in 1918). Tennant ran his nightclub as an enclave for the more raffish reaches of the British upper class to fraternise with the ritzier end of the literary and artistic avant-garde. The whole place was an eccentric English dream of bohemian Montparnasse, translated with lavish generosity and imaginative flair into a hard-drinking Soho dive where Society could meet the Arts ("The hope was that the gilded pollen of the latter would rub off against the bare pistils of the former," wrote a member. "This ideal was seldom fulfilled").[32]

Duthuit contributed Gallic gallantry and chic, Prichard was the club's spiritual guru, and its presiding genius was Matisse. His *Harmony in Red* hung in the dining room, and his semiabstract *Studio, Quai Saint-Michel* of 1914 at the foot of the stairs leading to the Club's third glory, its glass ballroom, designed by Tennant in consultation with Matisse as a homage to the Alhambra, with a gilded ceiling and walls lined with tiles cut from eighteenth-century mirror glass.[33] It was in the bar of the Gargoyle, among broken glasses left over from the night before, that Prichard educated the young John Pope-Hennessy and other future magnates of the Anglo-Saxon art world by continuing in the 1930s the seminars on aesthetics he had once held in Matisse's Paris studio.[34]

The loose-living, high-thinking Gargoyle was Duthuit's natural habitat in London, where he gave two successive lecture courses at the brand-new Courtauld Institute of Art in the winters of 1933 and 1934. For ten years he and Marguerite had struggled to follow her parents' austere example ("Give yourself entirely to your husband, work and health, and let everything else go," Amélie advised Marguerite, passing on the formula that had produced outstanding results in the first decade of her own marriage).[35] But Duthuit had neither the stamina nor the training for the stony path laid down from birth for his wife, who embodied an ideal of purity—"so lofty that nothing can really sully her and all other creatures seem, beside her, poor and soiled"[36]—which became for him increasingly unattainable. Faced with the gap between aspiration and performance that had defeated Jean and forced Pierre to build a career on the far side of the Atlantic, Duthuit consoled himself with less exacting conquests in London. When Marguerite discovered in the winter of 1933 that her husband had been having an affair with the wife of the youngest of the celebrated Sitwell siblings, she reacted with excoriating heat and vigour. Theirs was a pact based on mutual allegiance to the highest cause—defined in Matissean terms as work, or the ferment of creation—and this defection struck at its foundations. It was the kind of crisis that stirred the blood of Maman Matisse in her descendants' veins, and Marguerite's scorn was unequivocal. Later she would come to feel that the attempt to live on her father's all-or-nothing terms had corroded and undermined her marriage. At the time, its break-up was a shattering blow. She said it felt as if her whole house had gone up in flames.[37]

Her parents watched the conflagration in helpless consternation, united in their efforts to avert disaster. They provided shelter, sympathy and support for Marguerite in Nice that winter and the next. Amélie mourned to see another ideal partnership cracking apart in the gulf

between reality and dream. Matisse attempted a salvage operation by finding Duthuit a job, mounting a final energetic effort in the spring to secure the Cairo posting for which his son-in-law had been in line for years, interceding himself with the authorities at the Louvre, and activating the Bussys' powerful contacts in Paris and London.[38] But Simon, for so long a tower of sanity and strength in Matisse's troubles, was struck down himself in the spring of 1934 after a minor operation that went badly wrong in London. In the first week of May, when Bussy lay close to death in hospital, his wife and daughter posted daily bulletins to Matisse, who responded, as his old friend slowly rallied, with a steady stream of letters full of affection, encouragement, jokes and plans to visit him in London. Amélie had by this time left Nice, to move into her sister's house at Beauzelle. The Duthuits were in process of separating their lives and dismantling their apartment in Paris. A will of steel had enabled Marguerite to survive the physical ordeals of her youth, but even she could not live on nervous energy forever. When her husband finally left Paris, she collapsed in a high fever, unable to eat or sleep, alone in her parents' apartment on the boulevard du Montparnasse. A new and agonising health crisis overtook Amélie at this point in Beauzelle. Matisse went from his wife's sickbed to his daughter's, finding a competent doctor for Amélie in Toulouse and moving on in mid-June to organise home nursing for Marguerite in Paris.[39] At the end of the month he sent Bussy a prayer—"Give me strength to resist, patience to endure, and constancy to persevere"—which, as he said, could come in useful at times like these even to hardened unbelievers such as themselves.[40] As soon as she was well enough, Marguerite sailed back with Pierre to the United States to recuperate with his American in-laws on the coast of Maine. When she left in early August, Matisse was still making daily telephone calls to check on his wife's precarious condition in Beauzelle.

In these turbulent months, Matisse turned to his illustrations for Joyce's *Ulysses.* All through the six weeks he spent in Paris with his daughter, he was experimenting at the printers with different methods of engraving his study for *Calypso,* "a scene of chaotic disorder" embodied by two struggling women.[41] His second illustration showed Odysseus confronting the nymph Nausicaa and her two companions, a trio not unlike three nubile young models auditioning for Barnes' *Dance.* There was trouble as soon as proofs of these engravings reached New York. George Macy at the Limited Editions Club responded by demanding the relevant page numbers in Joyce's text. Matisse posted off references to the *Odyssey,* and refused to continue without a down payment.[42] He had already tele-

phoned Joyce from Paris and claimed to have secured his backing, although there must have been some misunderstanding, since the author himself got the impression from their phone call that his illustrator was working closely from the French translation of *Ulysses*.[43] Worried about the Dublin setting of his novel, Joyce even proposed a meeting in the autumn to sort out any problems arising from the fact that Matisse had never set foot in Ireland. Meanwhile a young friend of Joyce's inspected the illustrations instead, and succeeded in reassuring both parties ("We've agreed that I'm doing something that runs parallel to the course of his book, which I don't touch at any point, and that he'll write to the publisher to confirm his agreement," Matisse explained with relief to Marguerite).[44] But Macy remained doubtful, plaintively demanding page numbers, and withholding payment until well into the new year.

Matisse told Joyce in August that he was working on Aeolus, the wind-god whose tempests battered Odysseus' boat, knocking him off course and driving him back the way he came.[45] The episode occupied him on his return to Nice until he left to fetch his wife home from Beauzelle at the end of the month. By the beginning of September, he had moved on to the blinding of the Cyclops. He based his composition on a small, vivid picture painted five hundred years before by Antonio Pollaiuolo, showing Hercules crushing the life out of an opponent in a ferocious deathlock, a scene Matisse drew and re-drew as if to restore his confidence over the next few years, when he felt himself under attack from all directions.[46] The thrust of his *Blinding of Polyphemus* lies not with the puny, almost insignificant assailant plunging his long stake into the Cyclops' eye, but with the body of the giant himself, prone and powerless, arching to receive the impact, back taut and limbs braced against all four edges of the paper. Matisse's final engraving is an image of contained shock, violence, male strength and impotence: "the only true image of pain in all his work," said Louis Aragon.[47]

He extracted, or abstracted, it from a raw agony of clawing hands and contorted legs in the preliminary sketches (eventually published by Macy, at Matisse's suggestion, alongside the finished plate), which he jabbed down in a flurry of stabbing movement, scarifying lines and spurts of ink like black blood. "I do not reason when I draw," Matisse explained, when asked afterwards about his method. "I don't know where I'm going. I rely on my unconscious self."[48] Terror of blindness, or inability to paint, returned to haunt him at moments of great danger or disruption. Matisse habitually compared the images dredged up from his subconscious by his pencil or engraver's pen to bubbles rising from a pond, or ripples fanning

Antonio Pollaiuolo,
Hercules and Antaeus:
Hercules crushing
the life out of an
opponent

out from a stone dropped into deep water. When he drew flowers for his illustrated Mallarmé, he said he was surprised to recognise a clematis that had grown in his Issy garden twenty years before. For the remaining pair of his Joyce illustrations, he used more easily accessible memories. To illustrate the temptations of Circe, he constructed an elegant brothel scene around an acrobat he had watched descending a ladder on her hands at the Concert Mayol, and he based the landscape of Odysseus' homecoming on sketches of rocks and aromatic scrub on Mont Boron.[49] But *Ithaca*—the last of the set of engravings, completed on a return visit to Paris in October 1934—looks less like a classical Mediterranean palace than the long straight path between waist-high bushes leading to the door of the studio at Issy, where Matisse had broken through so many barriers as a painter in the past.

By the beginning of 1935, he had done virtually no easel painting for six years. He had been trying for many months to regain what he called his "coloured vision," but the few canvases he had produced seemed to him to be marking time or going backwards.[50] His home life had at last resumed something like its normal pattern, although his wife remained frail and still too weak to walk. Marguerite had just left to rebuild her life in Paris, leaving her small son in Nice with his grandparents. In January, the whole household contracted a particularly virulent strain of flu. Lydia Delectorskaya, who had been coming in daily for the past year as Mme Matisse's companion and her grandson's nanny, moved into the apartment to nurse the invalids, and promptly caught flu herself.[51] Many people died of it in Nice in a new year marked by tempests, cyclones and snowfall. Matisse, who remained more or less bedridden for six weeks, was kept indoors by

his doctor until halfway through March. "I've aged a great deal," he told Pierre.[52] But in late February he sat up and started painting again with a pretty Sicilian model, who turned out to be too absorbed in her own affairs to suit Matisse's schedule.

One day he opened his sketchbook and drew the nanny ("Don't move!"), who sat half listening, half day-dreaming, with her head leaning on her arms while her employers chatted in a break between work sessions.[53] After this first sketch, Matisse asked Lydia to sit for him in the studio. He had admitted to Pierre at the end of Janu-

Matisse, *Hercules and Antaeus*, 15 March 1935: a scene Matisse drew and re-drew in these years when he felt himself under attack from all directions

ary that he still had no clear idea where he was heading, but a few weeks later, he invited Bussy with evident excitement to come and inspect a canvas that would surprise him.[54] This first painting of Lydia in her favourite pose, *The Blue Eyes*, was the signal he had been waiting for. Matisse looked back on it later as the first shot in an experimental campaign that could not be judged except in the context of his entire work.[55] Marguerite saw its simplicity as deceptive, concealing a density that took time to decipher, "charged with everything that went before like a distant fire."[56] It initiated a period of intense and sustained activity that gathered momentum over the next few months, accelerated by a single brief trip to Paris to see a Cubist retrospective containing a couple of Picassos that reverberated "like two cannon bursts."[57]

Throughout the first year Lydia spent working under his roof, Matisse had paid her scant attention. She remained a dim figure in the background, "the Russian who looks after my wife,"[58] remarkable only for punctually discharging duties that enabled him to retreat thankfully to the studio. He had already drawn her twice, once soon after she arrived and again six months later, when he asked her to let her hair down ("It was my long hair he needed," she said)[59] for a study that produced an elaborate

Matisse,
The Blue Eyes,
1935

engraving. Then he lost interest: "When after several months or perhaps a year, Matisse's grim and penetrating stare began focussing on me, I did not attribute anything particular to it . . . ," Lydia wrote in retrospect. "I was not 'his type.' With the exception of his daughter, most of the models who had inspired him were southern types. But I was a blonde, very blonde. It was probably for this reason that, after something about me caught his eye, he had been studying me with a meditative, dour look."

Lydia was twenty-four years old in February 1935. She had long golden hair, blue eyes, white skin and clear-cut, classically regular features set in a heart-shaped face. Hers were the looks of an ice princess, as Matisse said himself, but her beauty had been overlaid when they first met by a protective mask assumed during years of exposure to the kind of treatment commonly encountered by refugees from eastern Europe in the increasingly xenophobic and nationalistic climate that followed the 1914–18 war in France. Lydia was used to being lumped in a general category of Russian exile—*l'âme Slav*—supposed by Frenchmen to be primitive, uncouth and absurdly temperamental ("As for me, I was an immigrant who didn't know a thing, who understood nothing," she said dryly afterwards).[60] She spoke very little French at that stage. It would be some time before Matisse discovered that, unlike himself or any of his children, Lydia possessed sufficient grades to qualify her for a university place. But her fluent English, and the solid all-round education she had acquired at high school in Harbin after leaving Siberia, were no help in earning the only kind of living now open to her on the margins of survival as film extra or nightclub performer, marathon dancer, au pair or artist's model. The last was the occupation she disliked more than any of the others: "From the time that I had work as a companion on a steady basis, I wanted to think I was

forever through with modelling, which I had found detestable."[61] Working for Matisse was a relief because, unlike the first three artists who employed her, he did not paw at her or assume an automatic right to take off her clothes. In the first drawing he ever made of her, at the end of 1933, she might be any wary, watchful hired help, dressed in a drab work shirt, with unsmiling face and scraped-back hair.

Matisse, *Lydia*, 1933: first drawing of the wary hired help who gradually gained confidence in the painter's studio

It was so long since she had encountered routine politeness or consideration that for many months she was chiefly thankful to have landed in a family whose own early experience made them automatically aware of hardship in others. Amélie, always on excellent terms with her husband's models, picked out clothes for Lydia and enjoyed watching her relax and acquire confidence as she wore them. Matisse made it easy for her to accept money for food or a new jacket ("After all, it's for when you go out with Mme Matisse"), and to charge professional posing fees ("I'm not going to exploit an employee while saving money on a model!").[62] She thought of him as *un vieux monsieur,* a kindly and correct old gentleman with the formal manners of her father's generation. "Gradually I began to adapt and feel less 'shackled'; in the end, I even began to take an interest in his work." In 1935, she agreed to move in with the Matisses, who provided room and board as well as a regular annual salary (a common but strictly illegal arrangement under French immigration rules).[63] She had had enough of make-believe after five years of living with a gambler whose moneymaking schemes grew wilder and more fraudulent as the couple's prospects dwindled downwards into penury and squalor. Lydia's lover left to seek his elusive fortune in Bordeaux, and she settled down to work for an employer whose honesty she could respect, and who needed basic domestic services she could supply. Matisse's innate fairness and delicacy appealed to her ("He would find a way so that the money offered would be neither lavish nor degrading charity").[64] Lydia may have entered his studio knowing nothing about either the painter or his work, but on a human level they understood each other perfectly. He was a man of the

North, but she came from Siberia, and there was nothing he could teach her about stubbornness, pride or reticence.

She recognised the desperation behind his methodical, matter-of-fact, foot-on-the-ground approach. On 15 March 1935, Matisse told her the story of Hercules and Antaeus, showing her the reproduction of Pollaiuolo's painting which he kept pinned up in his studio, and explaining that the mythical victim being choked to death in his killer's arms would regain strength and power only if he managed to make contact with the earth.[65] *Corsage bleu*, the pastel Matisse produced the same day, was the last time he ever portrayed Lydia looking sad, preoccupied or bored.[66] Next day she posed for a painting called *Nu rose crevette (Shrimp-pink Nude)*, whose progress Matisse recorded in photographs that show her serene and radiantly assured, wearing nothing but a necklace, seated knee to knee with the painter in shirtsleeves and spectacles, both of them reflected in the studio mirror that so often stands in, with Matisse, for the world of the imagination entered through his painting.

Bonnard, who particularly liked this picture, was shocked to find it partially scrubbed out a month later. A brief attempt to repaint it ended in total destruction of the canvas.[67] By this time, Matisse was working on *The Dream*, another deceptively simple, almost geometrical study of Lydia with her head pillowed on her arms, which brought him to a frightening pitch of anger and frustration. The only way she could think of to relieve pressure in the studio was by telling him stories in her turn about the frozen wastes of her Siberian childhood. All through April and May, as Matisse worked on a succession of nudes in Mediterranean heat and light, Lydia described the great stove that warmed the carved wooden house where she grew up in Tomsk, the high, hard-packed walls of snow between which she walked to school, and the larder outside the kitchen window filled with deep-frozen bricks of milk, bags of homemade Russian ravioli, and dead rabbits stacked stiff and straight like rifles in a gun-case.

Through Matisse's eyes, she looked back for the first time to the life that lay behind her. She said her earliest memories were of lying awake as a small child waiting for her father to return late at night from his hospital laboratory with bedtime stories that enthralled her, about the strange properties of microbes and the magical new bacillus that would eliminate tuberculosis. The security of her childhood had ended when Tomsk was overrun, after the Revolution, by Bolsheviks and anti-Bolsheviks in running battles finally resolved by the hastily formed Red Army, which had seized power in Siberia by the end of 1918. Lydia could remember walking across the town's main boulevard in the month of her eighth birthday,

holding her father's hand in a ceasefire agreed to by both sides so that Dr. Delectorski (who had been put in charge of the region's military hospitals) could cross from one front line to the other.[68] He died a few years later, weakened by overwork and finished off by typhus. Cholera killed his widow shortly afterwards. By the time Lydia reached Nice, she had given up her plan to study medicine, but in Matisse's studio she rediscovered the sense of purpose and passionate absorption that had marked her indelibly as a child. "He was like a doctor," she said of the painter, "completely bound up in himself and his concerns." Over the next twenty years, Lydia would find a cause worth serving and an outlet for her own considerable administrative skills in a role recorded by one of the few outside observers ever admitted to Matisse's studio during working hours:

Matisse (*a drawing session*). His incredible stress in the moment before starting his little pen sketches. Lydia told him: "Come on now, don't let yourself get so upset." His violent response: "I'm not upset. It's nerves." The atmosphere of an operating theatre. Lydia holding up one instrument after another— the bottle of India ink, the sheets of paper—and arranging the adjustable table. And Matisse drawing without a word, without the slightest sign of agitation but, within this immobility, an extreme tension.[69]

Matisse, three stages of *The Pink Nude*, 4, 14 and 17 September 1935

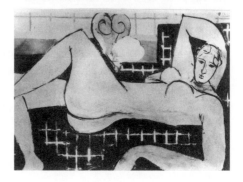

His first period of concentrated work with Lydia culmi-

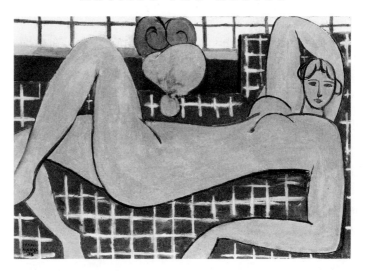

Matisse, *The Pink Nude*, 1935

nated in the *Large Reclining Nude (The Pink Nude)*, begun in early May 1935 and completed six months later, on 31 October. Matisse said he was trying to integrate the linear clarity and boldness acquired in six years' steady drawing with his old instinctive ability to compose spontaneously in colour ("Knowing myself a colourist, I picked my colours as I needed them").[70] He used the technique of pins and paper that he had invented to give cinematic fluidity to *The Dance*, photographing successive stages of his *Nude* in images that unfold like a film sequence. Day by day the nude seized possession of the picture surface, twisting and sprawling, extending and retracting rubbery, elongated limbs, establishing a constantly changing rhythm between the body's restless curves and the straight lines of checked fabric, tiled walls and the edges of the canvas. The model remained absolutely still throughout. It was Matisse who manipulated arms and legs, pushing the elements of his relatively simple composition to the furthest limits of distortion, but never losing contact with the reality represented by Lydia posing for him on a blue-and-white-checked coverlet with legs bent and one arm folded behind her head ("My pose didn't change," she said; "it was comfortable and always the same").[71] When Pierre arrived from the United States in June for his annual inspection of his father's work, he focussed immediately on *The Pink Nude*, still a bare canvas with its design worked out in outline and its paper colours pinned on ready to be painted. "It's the one in which you've renewed yourself," he told Matisse; "it's a sequel to the great decorations."[72]

The sequel had taken shape in a surge of energy released by superhuman effort after what seemed to Matisse the blackest torment of his life,

Matisse with
Claude Duthuit
in his arms

and he marked it with a break for resting and regrouping.[73] Pierre had brought his wife, his daughter and his infant son to France that summer, landing in the south in order to introduce the two-year-old Paul to his grandparents and his cousin Claude. Grandchildren were a joy to both Henri and Amélie. All the children learned very young to practise their best behaviour in Nice, drilled by their parents to be seen and not heard according to the code of an earlier generation. But for all his belief in discipline, even Matisse could seldom bring himself to be strict with Claude, who was a comical child, witty, astute and tender-hearted like his uncle Pierre as a small boy. Matisse taught him his colours, and took him on sketching expeditions with Raudi and Lydia to the slopes of Mont Boron behind the town. Like generations of his Matisse ancestors, Claude was born and bred to the rhythm of a life shaped by its work patterns. He spent much time in a swimsuit playing on the beach, but indoors he had to observe the adults' rule of silence in and around the studio, broken by occasional bouts of mayhem when Matisse produced a drum for him to beat as the pair marched around the table in the dining room.[74] At bedtime, Matisse dealt with signs of the family restlessness at night by playing low music on the radio until the child fell asleep holding his grandfather's finger.

"The two of them get along very happily," Amélie wrote reassuringly to Marguerite, who was in process of designing a couture collection in Paris.[75] Astonished and impressed on her trip to the United States the year before by the independence of American women, she planned to move on

from running her father's affairs to setting up a business of her own. Finance came initially from the sale of a suite of lithographs (one of three presented to each of his children by Matisse) on a highly successful trip to London, where the advance guard of the British art establishment— Samuel Courtauld, Lord Berners and the young director of the National Gallery, Kenneth Clark—energetically mobilised forces on her behalf. The prints ended up in the Victoria and Albert Museum, and Marguerite returned to Paris to work on a collection of evening dresses to be shown in England in the autumn. Claude remained with his grandparents, who moved in July to the resort of Beauvezer, which offered sunny days, cool nights and spectacular scenery in the foothills of the Alps. Amélie recovered something of her old vitality in the fresh mountain air, sewing or reading in the hotel garden with Claude playing nearby supervised by Lydia, while Matisse prowled about the grounds, taking photographs with a new camera.

He used the month's rest (which lengthened out to six weeks) at Beauvezer for stock-taking, both professional and personal. Pierre sent his father a severe and detailed analysis of the paintings he had seen in Nice, singling out *The Pink Nude* but dismissing the rest as ineffectual or backward-looking. His letter was followed by a mordant assessment from Marguerite, explaining that she, too, felt it her duty to point out that her father was fundamentally mistaken if he thought his recent work anything more than a recapitulation of his usual themes with no discernible forward movement. Pierre talked of facility, Marguerite of repetition and exhaustion.[76] Both reflected widespread assumptions about Matisse's work in Paris and elsewhere. He wrote back philosophically from Beauvezer, describing *The Pink Nude* as "a many-layered work following on a whole season's effort," and explaining that he found himself at the start of a journey whose destination even he could not foresee at this point.[77] "I know *The Dream* contains much but it's part of a route—like, alas, many of my paintings," he wrote to Marguerite.[78] "Things must always be judged by the goal they aim at, and by their future," he told Pierre, who had particularly objected to a series of small, bright, gleaming canvases in which, Matisse said, he was trying to compose in colour as fast and fluently as he could with line in drawing.[79]

Matisse was badly shaken by his children's findings. He said they made him realise that, like all artists who offer their contemporaries a new way of seeing, he could expect no mercy at this stage. He remembered his own contempt as a young painter for Impressionists like Renoir, with whom he felt increasing sympathy now that he, too, had been discarded by succeed-

ing generations who saw no use in anything he might still try to do. He even offered to submit his latest experiments to the judgement of a younger colourist, asking Pierre to appeal to Joan Miró (who had just joined the Pierre Matisse Gallery in New York) to act as a kind of umpire: "I'm not ashamed of my work ... I put myself into everything I do ... I'm not trying to protect myself." Matisse's divergence from his peers seemed more conspicuous than ever in the 1930s. As other artists were drawn increasingly to politics, meeting social disintegration with a disintegrating art, evolving a whole new pictorial vocabulary to parallel surreal developments in Nazi Germany and Fascist Spain, Matisse—still doggedly painting nudes in Nice—appeared even to his supporters to be cut off from reality.

To Matisse himself it seemed the other way about. He donated canvases and signed occasional petitions, protesting about the rise of fascism or the plight of refugees, but he had little faith in political solutions. His deepest instinct in the face of erupting violence and destruction was to respond with an affirmation of everything that made life worth living. He said he could not consciously control the force that drove him forward, but he made no effort to resist whatever propulsion had him in its grip.[80] Intimations of the Soviet reign of terror had reached him early through an indiscreet emissary from the Museum of Modern Western Art in Moscow.[81] A few years later, the predicament of Jews in Germany hit him hard with the news that Olga Meerson—"the beautiful Russian Jew who was once so much in love with me"—had killed herself in Berlin.[82] By the late 1930s, in a world uneasily aware that it was heading for disaster, Matisse was once again approaching in his work a concentrated purity of expression comparable to the intensity he had achieved at the height of the 1914–18 war.

Throughout this period, he worked against a background of family upheaval, estrangement and distress. Like all the Matisses, he was appalled by the extent of his daughter's continued suffering ("how to help her when her spirit is so tormented," wrote Pierre, "... her constitution must be made of iron, morally and physically, to stand so many blows").[83] When all hope of an official Beaux-Arts posting finally fell through, Duthuit left France, spending the greater part of the next decade abroad with various companions, returning for brief, painful encounters with his wife which punctuated a separation neither could in the end bear to make permanent. Marguerite blamed her parents, and especially her father, for undermining her marriage by taking up too much of her attention. When she threatened to give up managing her father's affairs in Paris, Amélie

decided to resume control herself. Her intervention was dramatic and unequivocal as always. She revoked her backing for Duthuit as vehemently as she had scorned her husband's doubts about him in the first place, denouncing both the marriage and Marguerite's reluctance to dismantle it ("I've tried to make excuses for her, but you know how absolute your mother is," Matisse wrote unhappily to Pierre).[84]

In the autumn of 1935, the painter exacerbated a tense and complicated situation by formally requesting his son-in-law to stop writing articles about his work.[85] The ban would be relaxed with time, but the two never spoke to one another again. Marguerite, still struggling to make a late start in a new career with insufficient funds or backing, regarded this or any other attempt to intervene on her behalf as gross interference. For nearly twenty years, she had been her father's eyes and ears in Paris, keeping him posted about prices, sales, collectors and the activity of other painters. When she picked out a Parisian show that he could not afford to miss, Matisse obeyed her summons, and he relied heavily on her to oversee his own exhibitions. But from now on contact between them slackened, becoming intermittent and eventually drying up almost completely after Claude returned in the spring of 1936 to live with his mother in Paris. Matisse, who missed them dreadfully, kept up a semi-clandestine correspondence, but his wife was inexorable. The handling of his affairs meanwhile shifted definitively to Nice.

Amélie's insistence on taking charge meant, in practice, that routine work devolved on Lydia, who added secretarial help to her duties as companion, nanny and model. She typed her employer's letters, translated articles on his work, and taught him enough English to find his way round London when he finally paid his long-postponed visit to Bussy. Matisse's prime appeal for Lydia, at any rate to start with, was the urgency and directness of his need. She said her father had implanted in her as a small girl an instinct for emergency relief ("I'm basically a stretcher-bearer: first-aid is written on my heart").[86] The Dance had reduced Matisse to desperation by the time of their first meeting in 1932, and he was very nearly frantic with frustration when she began posing for him nearly two and a half years later. The way he cursed and swore in the studio that spring surprised her.[87] On their return from Beauvezer in mid-August, he said the break had only intensified his apprehension, and by the end of the year he was once again a martyr to insomnia and night sweats, "panics that seize me when I'm assailed by worries that I can only envisage getting worse. . . . I'm wearing myself out floundering like a drowning man, and I don't see how I can work in this state," he complained to Pierre, mixing self-pity

with a shrewd pinch of self-knowledge, "unless it's work that's going to save me, and I can begin and continue it without being interrupted."[88]

The atmosphere Lydia established in the studio was impersonal, calm and orderly. She adapted the techniques of her scientific training, taking methodical notes on Matisse's work in progress, keeping track of his experiments, dating and preserving a photographic record. When he realised what she was doing, he was sceptical at first ("YOU HAVEN'T UNDERSTOOD A THING. Just like the art critics"), but almost immediately switched to dictating notes himself at the end of every work session, a practice abandoned only because both parties found it altogether too exhausting.[89] "He knew how to take possession of people, and make them feel they were indispensable," she said. "That was how it was for me, and that was how it had been for Mme Matisse."[90]

Matisse recorded this act of possession by returning to the theme of nymph and satyr that he had first broached more than a quarter of a century before. Preliminary sketches in the spring of 1935 led that autumn to *Faun Charming a Sleeping Nymph*, a five-foot-high charcoal drawing of a hairy faun crouching over a smooth young nymph and blowing purposefully down his panpipes. In September, Matisse transferred the couple to a woodland glade (based on one of his Mallarmé engravings) at the foot of a canvas eight feet high by six feet wide, to make a tapestry design called *Nymph in the Forest*, or *La Verdure*. He told Marguerite a year after he started it that the composition had particular significance for him, although he could not tell if he was in charge of it or it was in charge of him.[91] He

Matisse, *Faun Charming a Sleeping Nymph*, 1935: "With me, he knew how to be gentle and seductive."

reworked the same theme at intervals over eight years, ending with another enormous charcoal drawing, *Nymph and Faun*, which was finally completed in 1943. These works mark an active collaboration very different from the rape depicted in the *Nymph and Satyr* of 1908. There is nothing passive or inert about any of the nymphs modelled by Lydia, least of all this last one, sprawling on her back with one knee cocked, one arm flung wide and the other cradling firm, round breasts. The faun leans over her, wiry and taut, bringing his full force to bear—through music, in a flurry of blurred fingers and powerful forearms—on a partner who conveys an energetic response in every strong, supple curve of breast, hip, haunch and belly.

Lydia said that the first time Matisse played this theme for Olga Meerson, it was crude and brutal, unlike the tune he played in the studio for her. "With me, he knew how to be gentle and seductive. He was charming, and so touching. He knew how to tame me."[92] Lydia felt her pride and power revive in daily contact with a man who did not require from her the sort of sexual transaction that had been until very recently her only realistic prospect of survival. Over the next two decades, Matisse said, he came to know her face and body by heart, like the alphabet. He drew her in order to slow down his racing brain, and he drew her again to restart his imagination. But in his late sixties and seventies he needed more than ever to expend every last reserve of energy on his work. He told her a cautionary tale about a friend in Nice who wrecked his chances of becoming a serious painter by ending every session in bed with his model. If Matisse made love to Lydia, it was on canvas. For her, *Nymph and Faun*, and the variations that preceded it, represented a deep and durable exchange of confidence and commitment. For him, it was a final resolution of the theme through which he expressed the mystery of his relationship with painting: a rape in which, as Pierre Schneider pointed out, "there is no way of telling who is the rapist and who the victim."[93]

Studies for *Nymph in the Forest* in the autumn of 1935 led directly to a beautiful, free and boldly patterned series of pen-and-ink drawings of Lydia lying naked among cushions on a striped floral bedspread, contemplating herself in the mirror or more often gazing coolly back at the painter. The drawings were exhibited in February 1936 at the Leicester Galleries, in spite of the advice of Mme Bussy, who warned Matisse not to try putting them on public show in London: "She said there could be absolutely no question of it," he reported in perplexity to Marguerite. "People might read erotic intentions into them, which were not there in my case."[94] Dorothy Bussy turned out to be quite right. When Marguerite reached London with Matisse's sexy pictures (whose contents had been

concealed from HM Customs by paper stuck over the glass), the gallery directors became extremely nervous. They eventually agreed to hang the show ("No other gallery would have done it"), but Marguerite had to force them to put a large nude in the window.[95] The problem was her father's usual combination of absolute literalness with extreme aesthetic rigour. There was no mistaking the sensuality of his crisp humorous dancing line, swooping round the body's mounds and hollows, pausing appreciatively to outline suggestive fingers, florid nipples, lively swirls of pubic hair. But there could be no doubt either of Matisse's genuine indignation when his wife and daughter tackled him about the possibility of toning down details that made it difficult to show, let alone sell, these drawings.[96] He made a token promise of concessions, but any actual suppression of his explicitly sexual imagery meant radically compromising his freedom of expression. In the week of the show's opening, he dictated a defensive note to Lydia, explaining the technique he used "to relieve me of my passionate emotion," and pointing out with some complacency that he had achieved in the process "a very rare voluptuousness and elegance of line."[97]

The show made a satisfactory stir in London. No passer-by complained of indecency to the police, and many of the pictures sold, even though, as Matisse freely admitted, none of them could properly be hung in a respectable family home.[98] Keepers came from the British Museum and the Victoria and Albert Museum (which put on a special showing of its own newly acquired prints). Clark of the National Gallery bought a drawing, and Clive Bell published an enthusiastic review. Both had been introduced to Matisse by the Bussys, who played a key role in these years in shaping Matisse's reputation. Their support was generous and practical. They put their unique range of contacts on both sides of the Channel at Matisse's disposal, steering not only Gide but also Paul Valéry and the young André Malraux as well as English critics, painters and collectors towards his work in Nice.[99] They organised the offer of a studio from Gide when Matisse needed one in Paris, and described the fiasco of his Barnes commission to their influential neighbour at Roquebrune, the academician and former Cabinet Minister Gabriel Hanotaux, who arranged an official placing in the summer of 1936 for the second, homeless version of *The Dance*.[100]

There was, however, a price to pay for attracting patronage from the Bussys. They lived on next to nothing (by the time Matisse became their neighbour in Nice, Bussy's initial triumphs as a painter had been so totally forgotten by the art world that hardly anyone knew his work in France). But their villa of La Souco at Roquebrune was the main French outpost of

the highly efficient intellectual pressure group named for its headquarters in London's university district of Bloomsbury. Dorothy and Simon Bussy habitually spent summers in Bloomsbury's Gordon Square alongside Virginia and Leonard Woolf, Vanessa and Clive Bell, assorted Stephenses and Stracheys. Roquebrune became in turn a favourite autumn and winter watering hole for visitors from London who revered Matisse as an artist, and returned home bearing endless funny stories about his bottomless pomposity and dullness as a man.

The stories came from Bussy's wife and daughter, who were increasingly exasperated by the amount of time Simon spent apparently dancing attendance on his prosperous old friend. Janie especially resented the contrast between Matisse's international standing and her father's poverty and obscurity ("She was jealous on her father's behalf," Lydia said in retrospect: "Matisse was perfectly aware of the hostility felt for him by Bussy's daughter, but he discounted it because he felt it came from wounded pride at her father's lack of success").[101] Acutely intelligent and exceedingly well read, the two formidable Bussy ladies were chronically under-occupied (the housekeeping at Roquebrune was largely done by Simon).[102] Dorothy remained for thirty years hopelessly in love with Gide, whose works she translated into English, and who by her own account inspired *Olivia*, her own only book, a small jewel of a novel about unrequited passion.[103] Janie, whose wit, intellect and erudition could have made her an outstanding scholar, produced instead mild, unassertive paintings of landscape and flowers. Both amused themselves

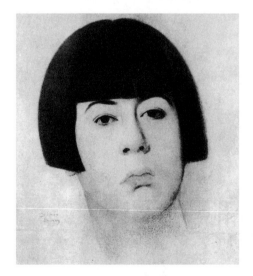

Simon Bussy, *Portrait of Jane Bussy at 20*: a comic satirist in her own right, like her uncle, Lytton Strachey

by including an ironic, mocking, mercilessly entertaining commentary on Matisse's latest doings in their voluminous correspondence with some of the finest minds and best gossips in London and Paris.

Painting, which consumed Bussy as it did Matisse, meant little to his wife ("Simon, to be sure, is, I think more or less happy," she wrote to Gide, "painting away as ardently as ever, with

no one to look at his work or take the smallest interest in it—nor any hope that anyone ever will").[104] The two painters prided themselves on refusing to make artistic compromises for the sake of wealth or fame but, where Matisse reached out hopefully to his public, exposing himself to constant rebuff, Bussy withdrew into the fastness of Roquebrune. "The work of Simon Bussy talks only to those who take the trouble to interrogate it," wrote Gide, "but then . . . it never ceases to answer back."[105] At home at La Souco, in the company of his wife's predominantly literary, English-speaking friends, Bussy himself seldom spoke. In London he retired to the zoo to paint small, subtle, marvellously composed and coloured portraits of birds, fish, butterflies and chameleons, whose combative character appealed to him ("Solitude is the only state they can endure," he said, "because the sight of their fellows drives them to inconceivable fury").[106]

Matisse sympathised strongly with his old friend, sidelined in his own house by relays of eminent, forceful and opinionated writers (the Bussys' visitors at Roquebrune included four Nobel literary laureates—Kipling, Gide, Romain Rolland and Roger Martin du Gard—besides the cream of Bloomsbury headed by Dorothy's younger brother, Lytton Strachey). Bussy remained for most of them an enigmatic, brooding presence shut up in his studio except at mealtimes. Matisse came over regularly from Nice to show solidarity as a fellow Frenchman and a painter ("His visits were made out of friendship for Bussy," said Lydia, "to give him some moral backing, now that he was no longer 'Bussy the painter' but 'Dorothy Bussy's husband' ").[107] The two retreated to the studio at the back of the house to talk painting and crack jokes. Over the years they supported one another through successive crises, from Matisse's long struggle with *The Dance* and Bussy's near-fatal operation to the annual crop of liver complaints, bronchial upsets and winter fevers, when each urged the other to wrap up warm and keep his windows sealed.

When either felt neglected or misunderstood, he looked for reassurance to the other. Matisse said a note from Bussy was like a ray of sunshine in his prison.[108] Bussy described himself waiting and watching at his window for a sign from Matisse.[109] There was no one else for whom Bussy's opinions still carried the weight and authority he had possessed in their youth, before he ever met his wife. Bussy in those days had been a legendary figure: the only art student in Paris who wore a fur coat, owned more than a single pair of shoes and exhibited his pictures at the most fashionable gallery in town, crowning a brilliant career by leaving for

England to marry a cousin of the Viceroy of India. Matisse repeated this fairy tale to Lydia with a relish undimmed by the fact that Bussy's wife (who was no relation of the Viceroy) actually belonged to a large family of hard-up, leftward-leaning, more or less subversive intellectuals.

Matisse respected Mme Bussy's cultivated mind and critical acumen, but he never felt comfortable in her company or her daughter's. He showed up at her tea table for Simon's sake, making solemn small talk and wearing the reddish-brown tweed suit he kept for polite occasions of this sort. But his attempts at conformity backfired. Like Gide and almost all their French friends, Dorothy and Janie were keen Communists by the early 1930s, reading the *Daily Worker*, revering Leon Trotsky and locating all hope of future human progress in Soviet Russia. One of their favourite private games was to make fun of Matisse behind his back by casting him as the epitome of the bourgeois complacency they despised. They enjoyed inviting him to tea and watching the effect on unsuspecting young visitors from England, like Clive Bell's son Quentin, who approached Matisse with awe, expecting a sublime genius as close as it was possible to get to divinity in human form:

> When I opened the drawing-room door I concluded that there had been a silly mistake. The guest who was discussing the weather with the Bussys was ... comfortably plump, fairly tall, his person assisted by an excellent tailor, and altogether very carefully trimmed. But of greatness I could see no trace. The chance visitor I had so absurdly supposed to be Matisse might well be eminent in the world of insurance or real estate, but he could not, surely, be the creator of *La Dance*.[110]

Bell based his published recollections closely on a memoir by Janie Bussy, whose uncle Lytton Strachey had scandalised the British reading public with his brief, humorous, scathingly irreverent portraits of imperial icons in *Eminent Victorians*.[111] Her own portrait-sketch of Matisse, "A Great Man," written to be read aloud at a meeting of Bloomsbury's Memoir Club, is a small masterpiece of deflationary wit and absurdist comic vision.[112] Matisse emerges as a fictive monster of insufferable vanity, banality and pretension. This was a wilder and more extravagant version of the portrait in the *Autobiography of Alice B. Toklas*, Gertrude Stein's brilliant, gossipy, self-serving reminiscences that caused a sensation in the United States in 1934, and shaped romantic Anglo-Saxon attitudes to bohemian Paris for the next half century and more. The book was seri-

alised in the *Nouvelle Revue française* before publication in France, when its findings were disputed in the transatlantic literary review *transition*, by a group of Frenchmen headed by Matisse and Braque, who pointed out factual errors and distortions caused by Stein's inadequate grasp of French and her basic incomprehension of modern painting.[113] Matisse was especially distressed by her patronising picture of his wife as a horse-faced housewife, which drew from him an impassioned defence of Mme Matisse's beauty, gentleness and unassuming dignity when he first knew her.

But public protest only fed and watered seeds sewn by the Bussys, who "took the view that Matisse was the greatest living painter, the greatest living egotist and the greatest living bore."[114] Their cartoon version of the painter fuelled jealousy and resentment even among those who didn't know him, like Virginia Woolf, who refused to attend a party given in Matisse's honour by the Bussys, out of a kind of vicarious pique: "He's the great god of the young; only so vain, so respectable, so slow I'm told, in his wits, that the entertainment is a horrid burden."[115] Lurid stories flew round London. What had begun as a harmless tease insidiously coloured attitudes to Matisse's painting. Part of the trouble was that, from Bloomsbury's point of view, the wrong people liked him. His pictures increasingly hung on the walls of the rich, smart and sophisticated, from David Tennant to the Clarks, the young Rothschilds and cultivated hostesses like Mrs. St. John Hutchinson and Mrs. Gilbert Russell (who sat for portrait drawings by him in 1936 and 1937 respectively). "In spite of all people say, I think he's delightful," said Mary Hutchinson, whose husband had persuaded the Contemporary Arts Society to buy its first Matisse in 1926 (it took another twelve years to overcome the Tate Gallery's reluctance to accept the painting as a gift),[116] and whose long-term lover was Clive Bell.

Matisse entertained Mrs. Hutchinson with his famous imitations of Ambroise Vollard, followed by a lively take-off of Helena Rubinstein, the cosmetics queen. Mrs. Russell found it harder to get on with him at first (he had put on his impenetrably formal manner along with his chestnut-coloured tweeds to draw her in stifling summer heat in his studio at the boulevard Montparnasse), but changed her mind when he came to England later the same year and made her laugh so much at lunch that the party lasted until teatime.[117] This was the private face Matisse showed to other painters, with whom he was friendly, funny and straightforward: "the antithesis of all the nonsense that both his friends and his enemies have written about him," wrote Christopher Nevinson, who was shocked

by the gap between reality and received opinion, and still more taken aback by Matisse's stoical acceptance of it.[118] The popular image of a smug, bland, self-satisfied Matisse reinforced assumptions about the superficiality and irrelevance of his work. In 1936, he signed a three-year contract with the dealer Paul Rosenberg, who showed, for the first time for a decade in Paris, a selection of Matisse's recent canvases, including *Nymph in the Forest* and several of the experimental colour compositions that had baffled Pierre the year before: "little tiny brilliant pictures like jewels," said Mary Hutchinson, who saw them at the Rosenberg gallery in May 1936, "...just larger than the side of a book—a woman's head—a figure—with stripes and flowers—but unbelievably brilliant and fitted into the space."[119]

The formation of a Communist-oriented, Popular Front government that May released a tidal wave of strikes and demonstrations in the ominous interlude between Hitler's invasion of the Rhineland in March and the outbreak of the Spanish civil war in July. A feverish conviction of the need to respond or intervene gripped the intellectual community. Matisse signed a telegram with Picasso sending support to the Republican government in Catalonia.[120] But widespread anger and frustration over the situation in Spain, coupled with growing anxiety about German aggression and European rearmament over the next few years, produced a steadily more politicised climate in which the long-term agenda of Matisse's latest work—so apparently simplistic, so patently apolitical, so transparently clear in form and colour—became almost literally invisible to his contemporaries. Roger Fry and Alfred Barr had both predicted as early as 1931 that Matisse was once again about to call his whole art in question.[121] But Barr had other claims on his attention and, when Fry died in 1936, he was succeeded as Bloomsbury's unofficial spokesman on contemporary French art by the relatively conventional Clive Bell, who did as much as anyone in these years to reinforce the prevailing view of Matisse as a lightweight by comparison with Picasso. "The painting of Matisse is a pure and simple delight," Bell wrote. "To get anything out of the pictures of Picasso ... requires an intellectual effort."[122]

A dismissive caricature of the Frenchman as a hedonist incurably preoccupied by blue skies and odalisques took root so deeply in the 1930s that it would be another half century and more before it could even begin to be dislodged. "Matisse ... is painting rapturously as a bird sings," wrote Bell, using the mindless frivolity of birdsong to encapsulate the reasons why what had once looked like becoming an Age of Matisse had turned out in the end to be the Age of Picasso. "I work *without a theory*," Matisse himself

explained defensively in 1939, insisting at the end of an ideological decade that his art was primarily organic and instinctive rather than conceptual: "I am conscious only of the forces I use, and I am driven by an idea that I really only grasp as it grows with the picture."[123] Ever since *The Dance*, he had been groping towards a simpler and more streamlined way of working, using traditional components—models in striped robes or embroidered blouses posing in the studio against bold, synthetic backgrounds of patterned fabrics, checkered tiling, the serrated leaves of philodendron—to invent a new dynamic of flat shapes and strong colour. He experimented with tapestry design as part of a scheme to rehabilitate the weavers' workshops at Beauvais by bringing in front-ranking modern artists.[124] Matisse's initial design, *Window at Tahiti*, opened up so many possibilities that he designed *Nymph in the Forest* as a companion piece, reporting hopefully to Pierre that Dr. Barnes was prepared to take both (Barnes changed his mind, and bought Picasso's tapestry instead). He longed for larger spaces to decorate in a style accessible to a wider public. "Don't assume all painters are against working collectively...," Matisse said angrily when Gide described the marvels commissioned from Soviet artists by the authorities in Moscow. "I'm ready to paint as many frescoes as you like, only remember, it's no good asking me to paint hammers and sickles all day long."[125]

In the summer of 1936, Matisse discovered with considerable bitterness that he was the only major French artist not offered a commission by the state in preparation for the international exhibition to be held the following year in Paris. He had to be content with an offer from the city of Paris, currently constructing a new museum on the site of the old Palais de Trocadéro to open at the same time as the exhibition.[126] Prompted by the Bussys' friend Hanotaux, the museum's director, Raymond Escholier, bought the alternative version of the Merion *Dance*, proposing to show it for the first time in Paris as a spectacular finale to his summer show at the Petit Palais, "Masters of Independent Art 1895–1937," which culminated in a room apiece for Picasso and Matisse.[127] In the late spring and early summer of 1937, Matisse visited Picasso several times to inspect progress on *Guernica*, which was to hang in the exhibition's Spanish pavilion. Escholier and his young architect planned to respond by installing *The Dance* against the curved back wall of their new museum's palatial entrance hall. But in the end the fair's visitors had no chance to set *Guernica*'s ferocious vision of destruction against the expansive leaping energy of *The Dance*. In the complex, longstanding rivalry between state and city, Escholier found himself overruled, outflanked and obliged to replace

Matisse's *Dance* at the last minute with *Electricity* by Raoul Dufy (an artist Matisse had long suspected of misappropriating and debasing his own ideas).[128]

The Dance was relegated to the museum's cellar, and Matisse remained for the rest of his life one of the few French artists never invited to embellish any public building. "I would have done many other decorations if anyone had asked me," he said resignedly in retrospect.[129] At the time, he expressed his anger and contempt for the whole elaborate system of state patronage with a characteristically munificent gesture suggested by his wife. At the end of 1936, the couple presented their most precious possession to Escholier's museum as a gift for the city of Paris. "What better way to teach the State a lesson?" asked Amélie.[130] It would be hard to overestimate the public or private significance for herself and her husband of the donation of Cézanne's *Bathers,* which for nearly forty years had symbolised the deepest meaning of their marriage, constantly replenishing Matisse's moral and pictorial courage, and binding the whole family together as the pledge of a common purpose.

Matisse seldom looked backwards, but when he did at this point, there was not a lot to show for four decades of struggle. "The worry that haunts me," he told Marguerite, "is that I'll end up being forgotten."[131] Sales had been more or less at a standstill for years in France, where, apart from three paintings owned by the state and the Sembats' collection in the Grenoble museum, his work had become difficult, if not impossible, to see. In America, Dr. Barnes had virtually stopped buying Matisses, and the fifty or sixty prime canvases at Merion remained largely inaccessible, with a long-term future that was at best problematic. The same was true, for different reasons, of the works in Russia. The Soviet state had abandoned tentative moves to sell off its incomparable modern collection in the early 1930s, but all attempts to borrow Matisse's canvases for exhibition in the West had been blocked.[132] Plans laid by Pierre to revisit them in Moscow with a view to producing some sort of descriptive catalogue had come to nothing, and when the painter himself tried to draw up a list from memory, even he could not be sure what exactly he had painted before 1914.[133]

Sergei Shchukin died in exile in 1936 with no regrets for the loss of a collection that he had always intended to present to his country ("It is a Tzar's gift," said Alexander Benois).[134] By this time the museum containing his and Morosov's combined collections had been designated a teaching aid to demonstrate the decadence and corruption of the West (the museum would be closed to the public in 1939, and abolished altogether in 1948). Meanwhile Matisse's work had been purged on almost identical

grounds from all museums in Germany. Several canvases (including *Bathers with a Turtle* of 1908 and the *Blue Window* of 1909) would be "virtually boot-legged," in Barr's words, by Pierre Matisse and others at public sales or in private negotiations with the Nazis on the eve of war.[135] Sarah Stein had left France the year before Shchukin's death, moving back to the United States to settle in California and taking the remains of her collection with her. "I feel as if the best of my audience left with you,"[136] wrote Matisse, who would hear little more from her beyond intermittent acknowledgement of his greetings for the next few years, followed by bewildering rumours that her paintings were being dispersed and sold off piecemeal. Of all the great collectors he had known and trusted, the only one still active was Etta Cone of Baltimore.

Since her sister's death, Etta had directed her collection with unexpected confidence, authority and determination. It gave meaning and purpose to her life, and she in turn treated it, and above all the Matisses in it, with professional seriousness. Her first independent initiative was to oversee production of a sumptuously illustrated catalogue, which was privately published with Matisse's posthumous portrait of Claribel as a frontispiece. It was Matisse who suggested drawing Etta too (she had been so unused to any kind of personal attention in her sister's lifetime that at first she was uncertain if she could even supply him with a photograph).[137] Etta confided in Marguerite Matisse that it had been her idea to collect paintings in the first place, and that this was the first time she had been given credit for it. "She's very happy to have her own position recognised," Marguerite told her father, "and not to have everything always attributed to her sister."[138] Drawings had been Etta's province from the first, and in 1932 she acquired a Mallarmé portfolio which Matisse prepared especially for her, a kind of working library including all his preparatory sketches, proofs and copper plates, used and unused, many of them preserving images that never reached the published *Poésies*. It was a unique collector's item, whose evident importance transformed its owner's standing in Baltimore. "She told me she was giving talks on modern painting . . . she's never been so happy," reported Marguerite, who became Etta's trusted confidante in these years, filling the role of favourite French niece to the American's fond adoptive aunt.[139] In Etta's company Matisse himself was gallant and avuncular, laying on entertainment for her, accompanying her on outings, and doing tricks with his ashtray at dinner to amuse one or other of her nephews ("This was behaviour expected from Picasso, not Matisse," wrote a Cone great-niece).[140]

The Cones' purchases had been abundant, careless and largely random

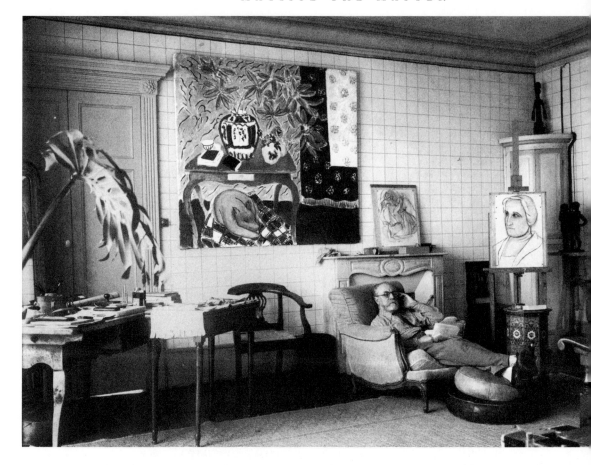

Matisse in the
studio with his
portrait of Etta
Cone on the easel
and *Interior with Dog*
on the wall

in Claribel's day (she said she didn't even realise she had a collection until the time came to make provision for it in her will), but Etta developed an orderly acquisitions policy based on consolidating existing holdings, filling gaps and keeping pace year by year with work in progress. "Since hers is essentially a Matisse collection, she would like people to be able to follow developments right up to the latest possible moment," Marguerite told her father. "On top of which, it makes her a personality in her own right, and her house has become a goal for visits, she told me, and a reason for stopping off in Baltimore."[141] Etta began the grand final phase of her collecting in the early 1930s by acquiring Matisse's two major transitional works almost as soon as each was painted: *Yellow Dress* (he left her in no doubt as to how much this purchase meant to him, surprising her on her next visit to Nice by having Lisette waiting in the studio, wearing the dress in the pose of Etta's painting), and *Interior with Dog*. From then on, he

greeted each of her annual visits to Paris by preparing a spectacular display of work for Marguerite or Lydia to bring out and lay before her. Etta took precedence over any other collector, picking a major painting almost every year from the two or three Matisse set aside for her to choose from. In 1935, it was *The Blue Eyes*, followed the year after by *The Pink Nude*, a purchase that became, with Claribel's *Blue Nude*, one of the two cornerstones of the Cone collection. Matisse had made clear its importance in advance by posting her his extraordinary photographic sequence of the canvas' successive stages.

It was agreed between them early on that the collection's final destination was the Baltimore Museum of Art, where Etta in her turn took considerable trouble to prepare the ground for its reception.[142] If summers were for buying trips to France, winters were for showing Baltimore her acquisitions, receiving collectors and curators, writing articles and giving lectures. "After all, M. Matisse, I helped to make you," she said complacently. "Oh no, Mlle Cone, I made you," replied the painter. Both of them were right. "I consider her one of my principal clients," Matisse wrote to his son in 1946, explaining why he still insisted on reserving each year's finest pickings for Etta long after she had, in Pierre's view, outlived any possible usefulness she might once have possessed. "Besides, Mlle Cone has a special interest for me in that she's forming a museum collection in which I shall be represented on as large a scale as possible."[143] Each perfectly understood the value of their collaboration for the other. Etta Cone may not have been the boldest, the most forceful or even the most discerning of Matisse's great collectors, but she offered him something nobody else could: stability, security and the certainty of a future for his work at a time when this was a rare and precious gift.

By the late 1930s, Matisse's existence had reverted to its oldest and most basic pattern. He worked and slept in the studio, where he felt himself both captive and set free, as if art had at last consumed his life. Anything that might divert or distract his concentration had been so far as humanly possible eliminated by Lydia, who knew nothing of his past or the work that had grown from it, and who had only the haziest notion of his international reputation in the present. Lydia waited on his wife, handled his routine correspondence and modelled for him in the studio. It was Lydia who oversaw the housekeeping, and made it possible to resume annual summer migrations to Paris, which by this time required the forward planning of a royal progress, with stretcher bearers laid on to transport Mme Matisse to and from her sleeping compartment on the train,

and a separate carriage reserved for Matisse with the two dogs and the growing collection of caged birds that now accompanied him on his travels.

He had begun bringing home fancy birds, five or six at a time, from the merchants along the quays of the Seine in the summer of 1936, when he found himself held up in Paris awaiting the late arrival of an American client, Mrs. Donald Paley, for portrait sittings arranged by Pierre. The oil portrait was eventually abandoned (Mrs. Paley found she could make do with the preliminary drawing, which she said looked just like her mother), but the birds invaded Matisse's life in increasing numbers. He delighted in their shapes and colours, their plumage and their singing. They reminded him of the musical thrush that sang for him in the tops of the palm trees outside the Hotel Stuart in Papeete, and the caged songbirds in the weavers' cottage windows of his northern boyhood.[144] He said that the songs of his captives both echoed and distanced him from his own predicament.

They filled the same place in his life as the inmates of the aviary or the aquarium at the London Zoo did in Bussy's. In the summer of 1937, when Matisse finally crossed the Channel to inspect his latest show at Rosenberg's London branch, he was dropped off one afternoon at the zoo by Mary Hutchinson with a piece of paper written out by her in capital letters—BUTTERFLIES—so that he could find his way to a rendezvous in the butterfly house with Bussy.[145] Both now in their late sixties, both single-minded as ever in pursuit of painting, both utterly impervious to styles or trends imposed by the outside world, the two old friends renewed the pact of mutual commitment and support, formed in Moreau's studio in Paris nearly half a century before, in front of a living, moving, coloured frieze of butterflies.

Back in Nice that winter, Matisse rashly stepped outside with a head cold and contracted flu, which turned to bronchial pneumonia. This was the worst of all the bouts of winter sickness that gripped him year by year. For nine days he lay barely conscious, wracked by burning fever, visited night and morning by his doctor and nursed by Lydia, who broke down and wept on the tenth day when his temperature finally began to fall. "I passed within a hair's breadth of the grave," Matisse wrote immediately to Pierre, who had packed his bags, confided the gallery to Teeny and was about to leave for France when a telegram from his father announced that the crisis had passed.[146] Matisse said his life had been saved by a massive injection of disinfectant, which drove the poison infecting his system into a huge swollen abscess that had to be lanced daily. The operation excited

the birds, especially an exotic yellow-and-black thrush called a troupiale, whose fluty whistle rose high and clear above the patient's cries. The songthrush that drowned his screams became of all Matisse's birds his favourite ever afterwards. The purity of its song spoke directly to his own will to survive the winter ordeals that came to seem to him a kind of ritual cleansing, from which he emerged deathly weak but purged and purified each spring.

"He came so close to death!" Berthe wrote to Teeny Matisse in December 1937. "My sister is very well; she is always courageous in a crisis. We all are in our family. *We are plucky people.*"[147] The Matisses had already decided to stay on in Nice when their lease at the Place Charles Félix ran out in the summer of 1938, rather than join the flow of people who had been leaving town ever since Mussolini allied himself with Hitler. Pierre had advised his parents to move westwards away from the threat of Italian invasion as early as 1936.[148] The holiday population dropped, and properties in the visitors' quarter were up for sale. In January 1938, Matisse bought two adjacent apartments in the old Excelsior-Regina Palace, the last and grandest of Nice's imperial hotels, perched on the rocks of Cimiez high above the seaside settlement: a fantastic pile occupied by Queen Victoria in the 1890s, already obsolete by 1914, boarded up for years after the First World War, and finally converted into private apartments at a moment when another impending war made them virtually unsaleable even at steeply reduced prices. Matisse was the first and for a long time the only purchaser. "Your mother is enchanted," Berthe told Pierre. "It's like a renewal of her wretched life! Your father is not so keen."[149]

By February, Matisse was once again in pain from an abscess in his mouth. Still shaky, frail and limping, he left to consult his dentist in Paris, taking Lydia, at his wife's insistence, to look after him. The treatment lasted for two weeks in early March. "Everyone is appalled by Hitler's latest encroachments...," Matisse told Pierre when the German army annexed Austria that month and stood poised to invade Czechoslovakia. "On the whole, people don't say much, because they don't know what the future holds, although they fear it."[150] All over France, civilians were digging in or preparing to flee. Matisse returned to sit out developments in Nice, having replenished his studio wardrobe with half a dozen evening dresses, picked up on a visit to the spring sales with Lydia in the couture district around the rue de Boétie.[151] Over the next decade these six dresses, worn by a succession of different models, would become a staple element—adaptable, easily portable and surprisingly durable—of his basic working kit.

Matisse used them in much the same way as he used sheets of coloured paper pinned to his canvases. Both supplied him with building blocks capable of being combined and recombined in the designs constructed from patches of flat colour that still preoccupied him, even though he had finally given up hope of ever being invited to decorate a public space. In the spring of 1938, knowing that he would never see his *Dance* fulfil its intended function as a wall painting, Matisse agreed to recreate it for the Ballet Russe de Monte Carlo in response to an urgent plea from Léonide Massine. Together they chose Shostakovitch's first symphony, and worked out a scenario that would dramatise the perennial human conflict symbolised for Matisse by the song of the troupiale, "the struggle between white and black, between man's spiritual side and his fleshly side."[152] Matisse started visiting rehearsals again at Monte Carlo, and watching the dancers intently. He made small, chunky, compact dancing figures with limbs like rods or pistons, patched and stuck together from rough-cut, odd-shaped scraps of coloured paper. The effect was forceful and expressive, but clumsy, as if something incoherent were taking shape and thrusting upwards in the depths of his imagination. He built another of his toy theatres, and used it to experiment with a décor based on the three white arches of Barnes' *Dance* against flat geometric expanses of red, black, blue and yellow. Massine's dancers were to move beneath the arches, wearing plain red, black, blue or yellow costumes like bodystockings, in a choreography of coloured bands and splashes ("I have complete confidence in him," said Matisse, when asked how he planned to coordinate Massine's input with his design).[153] Everything not essential to the dynamics or plasticity of the dance itself was eliminated from what became, in all but name, an abstract ballet. *Le Rouge et le noir*, like the *Chant du rossignol* of twenty years before, launched a whole new forward movement in Matisse's work.

Development of the ballet continued through months of upheaval as the Matisses prepared to move out of Place Charles Félix in June, packing household goods and canvases for storage, and retreating to Paris until their new apartment at Cimiez could be made ready for them. Pierre and Teeny arrived from New York with their children (the third and last, Peter Noel, was eighteen months old). All five grandchildren gathered with their parents at the apartment on the boulevard du Montparnasse that summer in a world on the brink of public and private disintegration. The family must have been aware that this might be their last reunion, given Hitler's threat to march into Czechoslovakia in the autumn. A general external sense of dread reinforced personal and internal barricades of silence and

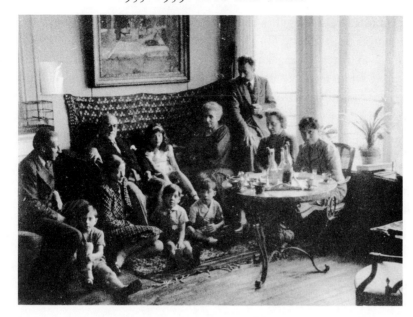

Henri and Amélie
Matisse with their
children and grand-
children in the
apartment on
the boulevard
Montparnasse

misunderstanding. Matisse felt his family no longer had faith in him, or in his latest painting, which came to the same thing. He missed the old solidarity cemented by unconditional commitment to his work, and the emotional intimacy that grew from it. Hurt pride fed a sense of mutual rejection that made him seem harsh and unapproachable. He felt cruelly cut off, especially from Marguerite and her son. The possibility that Pierre might have to apply for American citizenship precipitated painful confrontations, still unresolved when he and Teeny returned earlier than usual to the United States. Back in Nice, Amélie expressed her feelings in a letter so violent that her husband persuaded her not to send it, posting reproaches of his own instead that turned Pierre's heart to ice.[154]

All through September, people poured out of Paris anticipating an imminent German strike, and out of Nice, which came close to being officially evacuated for fear of an Italian attempt to seize it back (Nice had been in French hands for less than a century). Amélie fled in the middle of the month with a nurse and a stash of paintings to the safety of Berthe's house in Beauzelle. Marguerite and Jean followed with their families from Paris. Matisse remained in Nice with Lydia to salvage the contents of the house and studio, still in transit between the dismantled apartment on the Place Charles Félix and the new one at the Regina, only half decorated and now abandoned by the builders in the general panic. Lydia packed baskets of linen and china, crated furniture and rolled canvases, somehow

managing to cram herself with half a wagonload of trunks and packing cases onto a train leaving for Montauban, where Jean had arranged to store them in an empty garage. She spent a single night at Beauzelle before rejoining Matisse, who had stayed behind alone in Nice, dazed and exhausted, taking chloroform and belladonna to settle his nerves and stomach. At the end of September, the French Prime Minister, Edouard Daladier, flew to Munich with Neville Chamberlain of Great Britain to negotiate a last-minute reprieve from Hitler. Jubilant crowds greeted his return at Le Bourget. Matisse and Lydia listened on the radio to Daladier's announcement—"If one has to believe in a miracle to save France, then I believe in miracles"—that war had been averted.[155]

The country rapidly returned to normal. Builders drifted back to work at the Regina to find Matisse waiting at the gates, lodged in the small British Hotel and longing to start work himself on a decorative panel called *Le Chant (The Song)*, commissioned earlier in the year for Nelson Rockefeller's apartment in New York. Lydia cleared a space among the furniture crammed into Matisse's new studio, and cleaned it for him, before setting out again in mid-October to escort his wife back from Beauzelle. Amélie arrived to find the Regina still a building site, her own room uninhabitable and her belongings stacked up in a poky hotel bedroom where she was expected to camp out indefinitely. Matisse spent his days in the studio, regretting only that he couldn't spend nights there as well ("I can't sleep with my work as I usually do," he told George Besson, "which is hampering me a good deal").[156] He blamed Hitler's game of bluff, and his own folly in taking it so seriously, for the catastrophe that followed.[157]

Nothing could have demonstrated more clearly than Lydia's behaviour during the Munich conference that the support Matisse needed as a painter no longer came from his family. Her arrival at Beauzelle precipitated the kind of crisis that always rejuvenated Amélie, who responded energetically by demanding Lydia's immediate dismissal. Matisse insisted that he could not work without her.[158] She was essential to the smooth operation of the cut-paper system invented for Barnes' *Dance* and now in use again for Rockefeller's decoration. Lydia pinned and repinned the tracing papers, cleaning and recleaning the surface of the canvas as Matisse's colours changed day by day or hour by hour. She also modelled with her friend Hélène Galitzine for the various poses of the four women who sing or listen in *Le Chant*, forming a sombre frieze of black, pink and dark green interlocking bodies. Matisse in his seventieth year pleaded mortality, urging his wife to bear in mind the fragility of his inspiration and the dwin-

dling time at his disposal. But the more vehemently he spoke, the less effect he produced. Every argument he advanced to clinch his overwhelming need of Lydia confirmed his wife's determination that she must go.

The deadlock between them lasted all through the autumn, overshadowing their move to the Regina, which finally took place in mid-November. Matisse's heart trouble returned, and he suffered violent nosebleeds. He started seeing cloudy patches before his eyes, and reinforced his terror of blindness by reading *The Light That Failed*, Kipling's novel about a painter whose loss of sight plunges him into a downward spiral of destruction, despair and death.[159] Lydia was sent away as soon as *Le Chant* was finished, on 3 December. But Matisse's plan for her to return in early January, taking lodgings elsewhere and coming in daily to work as his secretary, produced an ultimatum from his wife ("It's me or her").[160] The choice seemed meaningless to Matisse. Like the hero of Kipling's novel, he no longer made a sharp distinction between art and life. Anything that blocked the one, in his view, destroyed the other. After an explosive interview with Amélie, during which his pulse rate rose from 69 to 100, Bussy removed him bodily from the apartment and walked him round the hillside until his heartbeat returned to normal.[161] Matisse's condition this winter alarmed the small circle of his intimates in Nice. Berthe, who understood the tangled roots of conflict on both sides, tried to reason with her sister. So did Charles Thorndike's wife. The family doctor warned Amélie that severe and prolonged strain was putting her husband at risk of a second and more serious stroke. Marguerite arrived at the end of the month, and Jean came twice from Paris, retreating baffled as much by his mother's intransigence as by his father's obstinacy. Even Bussy, who rarely intervened in other people's affairs, took Marguerite aside to deliver "a severe sermon . . . on the wickedness of driving eminent artists to death in their old age."[162]

Matisse and his wife seemed to have swapped roles. It was the painter, sleepless, feverish and unable to work, who needed a night nurse, while the helpless invalid was galvanised by revenge and fury. "Mme Matisse, after remaining bedridden for the last twenty years, suddenly rose up five months ago," Dorothy Bussy wrote to Gide in March 1939, "and has shown ever since the most terrifying energy, physical and mental, in a perpetual pitiless struggle with Matisse."[163] Bussy's old friend got no sympathy from his wife and daughter, who listened with incredulity and stifled giggles to Matisse's despairing account of the emotional tornado currently unleashed in the Cimiez apartment. "Mme Matisse . . . made a terrific scene every day for four months," Janie reported cheeerfully to

Vanessa Bell, who spread wild stories round London as others were busy doing in Paris and New York.[164] Matisse dreamed he was accused of murder and could find no way to refute the charge.[165]

But the ribald gossip of the art world was the least of his problems that winter. "I was sacked," said Lydia. "Madame wanted me to leave, not from female jealousy—there was no question of adultery—but because I was running the whole house."[166] She moved to a boarding house in Nice to consider what to do. Stateless foreigners in France faced a bleak future in the event of war. Having already lost everything that had mattered to her as a girl—her home and family, her native language, her country and her hope of qualifying as a doctor—Lydia felt it was sheer chance that had brought her against all the odds a job worth doing which she knew she could do well. Now her life was purposeless again. After ten days, she posted a farewell note to Berthe Parayre, explaining that she preferred suicide to an existence that caused misery to herself and others. Lydia shot herself, but the bullet lodged against her breastbone. After checking the gun by firing it out of the window, she found she did not have the courage to turn it on herself a second time. She wrote another note to Mlle Parayre, and left Nice the same day.

Berthe, who had seen her brother-in-law through forty years of family upheavals beginning with the Humbert scandal, accepted Lydia's view of the relationship without question. So did everyone in a position to judge the situation in Nice. Even Bussy's wife and daughter conceded that Matisse's dealings with his model were strictly professional.[167] That was the core of the problem. For Amélie Matisse, there could be no deeper betrayal. She had given up everything to build her life on the effort and endurance required by her husband's work, and now found herself excluded from the only world to which she attached significance. In February 1939, her lawyer drew up a deed of separation. One of its key provisions was that everything—paintings, drawings, etchings, sculpture and all other possessions—should be divided equally between the couple. The family met in conclave to preside over its own dissolution. Pierre came from New York to see everything that had held his universe together from childhood torn up at the roots.

Amélie left for an unknown destination in Paris in early March. Matisse felt as if he had been hit by a cyclone. His children had gone, Berthe was preparing to retreat to Beauzelle, the Bussys were leaving for London, even the cook departed with her husband. The painter remained alone in his double apartment on the seventh floor of the Regina, the only occupant of the whole vast, empty, echoing building looking out on sky

and sea high above the town. In one part of his mind, he brooded in a state of profound and poisonous disillusionment on the fifty years of painting that had devoured his life. In another, he revelled in this sudden lull of liberty, calm and solitude. War had become inevitable that month when Hitler finally engulfed Czechoslovakia and turned his sights on Poland. Matisse knew well enough that his respite was temporary. "The twittering of my birds, which had begun to leave me indifferent, even hostile, takes possession of me again in this great stranded ship at Cimiez, with thunder storms brewing all around to which I pay no attention whatsoever."[168]

He used the interlude to paint *Music,* or *The Guitarist,* completing it in three weeks as a companion for Rockefeller's *Song.*[169] "The canvas has the amplitude, richness and sustained power of an organ peal," Pierre wrote to his father as soon as he unpacked it in New York, recognising a solidity and strength that grew from the Barnes *Dance* and looked back to the great works of 1914.[170] Both agreed it was the best thing Matisse had done for years. "It sustained me in the cruellest and most painful moment of my life," the painter wrote, admitting with a brief glint of satisfaction that, if it had not been for the coming war, he would have shown it in Paris to silence all those who (like Marguerite) believed his powers were failing.

In May 1939, the Museum of Modern Art in New York opened its doors with Matisse's *Dance (I)*—the original version of the Moscow mural painted for Shchukin in 1909—in pride of place in the marble entrance hall of its new building.[171] Matisse attended the premiere of *Le Rouge et le noir* at Monte Carlo on 11 May, and then returned to Paris, where the ballet opened at the Théâtre du Châtelet on 5 June. His drawing for the programme was a last variation on Pollaiuolo's image of Hercules wrestling with Antaeus, depicting the captive this time not as a blinded giant but as a dancer surging upwards in a massive spurt of energy and release.[172] "In all my disarray, I've been sustained by the entire success of the ballet—and by the conception of another they've asked me to do," he told Bussy, outlining plans for a classical ballet that would end with the myth of Atalanta snatching triumph from defeat at a wedding attended by the gods of Olympus ("I've finished with one marriage, and I'm planning another," he wrote hopefully of a scheme that would evaporate when the Ballet Russe disbanded on the outbreak of war).[173]

Lawyers and their agents invaded Matisse's studio at the boulevard du Montparnasse. He counted eight at one point, emptying drawers, searching cupboards, counting drawings and compiling inventories.[174] He had appointed his dealer, Paul Rosenberg, to stand in for him at the division of

the spoils with Marguerite as his wife's representative (this was when he told his daughter she was the only person he could rely on to stand up to him, adding later that he hadn't realised quite how sternly she would interpret his commission).[175] Shocked by the human rancour and ruthless commercialism of the proceedings, Rosenberg suggested a meeting between the Matisses, each accompanied by an impartial witness, in some neutral public place. They met in the first week of July at a café on the forecourt of the Gare St-Lazare. "My wife never looked at me, but I didn't take my eyes off her—and I couldn't get a word out . . . ," wrote Matisse, describing how she and Rosenberg made small talk for thirty minutes while he stared numbly at her, unable to move or speak. "I remained as if carved out of wood, swearing never to be caught that way again."[176] It was the frozen pose in which he had painted himself, stiff as a board, confronting his wife twenty years before in *The Conversation*. He told Bussy he dreamed that night that he had been condemned to death and was waiting to be led out to execution. For once, perhaps the only time in Matisse's life, reality had outstripped his imagination, which was powerless to control or contain the chaos and destruction he felt always lapping at the dark edges of his brain.

CHAPTER ELEVEN

~

1939–1945: Paris, Nice, Ciboure, St-Gaudens and Vence

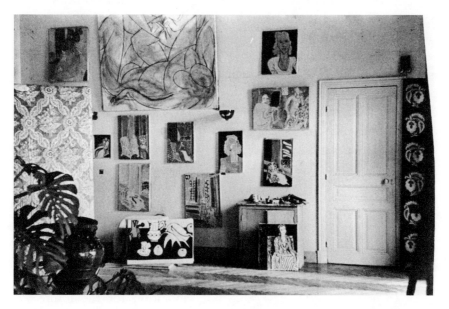

The studio wall at the Regina, Cimiez, showing a set of variations on the theme of girls in chairs on tiled floors, painted in 1942

*B*y the middle of August 1939, Matisse's entire output had been counted, classified and stored at the Banque de France in Paris, ready to be split down the middle after the summer holidays. He told Paul Rosenberg he felt demolished, and left for Geneva to visit an exhibition of masterpieces from the Prado, which he had last seen before the 1914–18 war.[1] The day after he got there, 23 August, Germany's sudden alliance with Soviet Russia put a stop to the uneasy peace established by

the Munich crisis. Matisse returned immediately to Paris. This would be the third war with Germany in his lifetime, and he told Bussy that his elaborate precautions twelve months earlier had exhausted his capacity for flight ("Maybe . . . I'll just stay here like a demoralised dog, waiting for the blow to fall without budging").[2] On 1 September Hitler's armies invaded Poland. Two days later France followed Britain in declaring war. Matisse joined the river of people heading west next morning with household goods strapped to the roofs of their cars, but after about thirty miles he stopped at Rochefort-les-Yvelines, halfway along the road to Chartres.

He spent almost a month in the village inn at Rochefort, watching refugees stream past, reading Gide's collected *Journals* and drawing trees in the forest.[3] He also drew Lydia Delectorskaya, who had fled with him. He had written to ask her to come back as his assistant in Paris once his wife made it clear she had no intention of returning. He told Lydia he already had a model (Wilma Javor, a young Hungarian who had worked for him before), but needed someone to handle the day-to-day distractions that ate up his working time. Lydia, who had taken refuge with her aunt on the outskirts of Paris, brought Matisse a bunch of garden flowers for his nameday on 15 July. He painted them at the centre of a semiabstract composition, reducing everything on his canvas—Lydia's bouquet of white daisies and blue cornflowers, the drawing on the wall, the still-life stand, even the model herself—to flat geometric planes of colour balancing one another on a black ground. *Fleurs pour la St. Henri (Flowers for St. Henry's Day)* is a sharp, bright, decisive painting, full of light and what Bussy called depersonalised emotion.[4] It commemorates a symbolic gift that became a conscious pact at Rochefort.

"It was there that our collaboration for the future was agreed," Lydia said in retrospect. "A decision had to be made there—whether or not he was to take me with him. I barely hesitated. I was alone, I had no ties, there were no strings attaching me to life. I realised what people would say about a young beauty and a rich

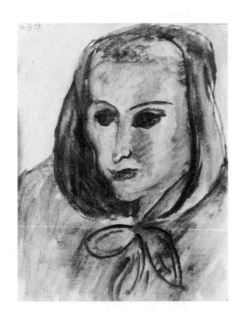

Matisse, *Lydia Delectorskaya in a Hooded Cape*, Rochefort-en-Yvelines, September 1939: the painting that sealed a pact between artist and model

old man, but I wasn't interested in protecting my reputation."[5] Both knew that, whatever happened, this was a turning point from which there would be no going back. Matisse, who drew himself looking perplexed and quizzical, was characteristically the more cautious of the two. "He said: 'You are young. You have your entire life ahead, a whole road stretches before you.' I said: 'A road leading where? To what?' 'Poor child,' he said. And at that moment he knew I was a blank sheet, which he could take over." Matisse's drawings of Lydia at Rochefort show her dressed in her travelling hood and cape at the outset of the long, difficult, sometimes dangerous journey they were about to take together. Long afterwards she came to see herself as the life-giving raven in the Russian folk tales of her childhood, the bird who flies to the rescue when the hero lies wounded or left for dead. She said that, at the time, Matisse made her feel that her life could still be useful.

The rain of blood and fire anticipated that September by Matisse and most of his countrymen failed to materialise. After the seizure of Poland, there was no further move either from Hitler or from Mussolini, who was still widely expected to retake Nice. France mobilised its civilian population. Paris remained empty ("Those who are left rush about like black rats with their gas-masks," wrote Matisse. "One shop in twenty or more is still open").[6] Vast numbers of foreigners were rounded up and interned in camps where many of them died of dysentery, cold and malnutrition. Emergency restrictions meant that Lydia could no longer move without a travel permit, which Matisse eventually obtained with help from one of his earliest collectors, the Socialist minister Albert Sarraut. Nice was bristling with troops when the painter arrived back with Lydia at the end of October. A company of Moroccans was quartered in the Regina, sleeping in the colonnaded hall, washing clothes in the gutters and hanging them out to dry on the wrought-iron balustrades.[7]

Upstairs Matisse resumed possession of his huge, high-ceilinged studio, thirty feet square, made by knocking two reception rooms together, and filled with rampant philodrendrons that had grown in his absence into a tangled indoor jungle. In preparation for the final division of property with his wife, the whole place had been stripped of everything except work in progress, a set of bronze casts, a plaster cast of a Greek kouros and a headless, limbless stone figure of a girl, an exquisite and much-prized Roman copy of a classical Greek original.[8] Matisse took comfort in his birds, nearly three hundred of them, installed in a room tiled specially for them and tended by a birdman who came in daily. The aviary divided the studio from the living quarters: a handsome dining room with

a patterned marble floor which the painter had chosen and designed him-
self, and his wife's cool, airy room looking out northwards to the moun-
tains. Both would become studios in time, but for the moment they stood
vacant, eerie reminders of a life that had gone for good. Like virtually
everyone all over Europe in these first uneventful months of war, Matisse
listened anxiously to news bulletins on the radio, trying to decide what to
do, finally resolving to stay put and wait for events to drive him out of
Nice.[9]

He settled into a provisional existence of extreme isolation and
anonymity, going nowhere, seeing virtually no one except his models,
poised for flight at any moment. He drew the Roumanian painter
Théodore Pallady, an old friend from student days who came to say good-
bye in the spring before being forced back to an uncertain future in his
native country.[10] Rosenberg also came, to take his pick of the painting
crop under the terms of a new contract.[11] But, outside working hours,
Matisse had only the birds for company. Lydia refused to move into the
apartment, preferring to sleep in a maid's room in the attic four floors
above and report for duty each morning when the models arrived. Her sta-
tus might look equivocal to other people, but she herself drew a sharp line
between what she was and wasn't prepared to do for her employer. "I
always wore an apron," she said, "to make it perfectly clear that I was
doing a job."[12] To the end of his life she addressed Matisse formally as
"*Vous*," defined herself as his secretary, and never called him anything but
"*Patron.*"

Both their families assumed that Lydia was living with Matisse as his
mistress. Her aunt, already scandalised by a niece who sued for divorce and
allowed nude pictures of herself to be exhibited in public, wanted no
more to do with her. His wife and children accused him, just as his father
had done half a century before, of dragging the family name through the
mud ("I'll end up snapping my fingers at this public opinion they wave in
front of my eyes like a fan," the painter complained to his dealer).[13]
Lydia's return, presented by Matisse as a simple question of improved
working practice, looked like provocation to his family, who felt he had
put himself on the far side of an impassable barrier. They thought of her
as a grasping, manipulative schemer, and dealt with her presence by acting
as if she did not exist. The legal separation process generated accusation
and counter-accusation in an atmosphere of extreme tension and pain.
Amélie's sense of loss was by now unappeasable, and she wore herself out
in relentless pursuit of the settlement that seemed to her husband to be
tearing him apart. Marguerite, whose role as go-between placed her

squarely in her parents' crossfire, was morally and physically exhausted, fainting several times when she came with a lawyer in the new year to check the contents of the Nice apartment. Matisse's eyes grew so dim he could not see his canvas properly by the end of a work session.[14] He insisted that spiralling lawyers' costs and a collapsing art market would bring destitution and doom on them all.

Berthe and Pierre, reluctant to take sides and helpless to intervene, both advised Matisse there was nothing to be done except wait for his wife's murderous rage to subside.[15] Berthe was recovering from a major cancer operation with steady support from Matisse (who had flown to Toulouse to be at her hospital bedside the day after his last encounter with his wife in Paris). He had made her an allowance and played the part of an affectionate elder brother for forty years, but now she told him that, although she exonerated Lydia of blame for the separation, loyalty to her sister meant she would not set foot under his roof again so long as the Russian remained part of his household.[16] Amélie, more than ever exasperated by Berthe's evenhandedness, never forgave her for refusing to condemn Lydia altogether. From now on the sisters lived side by side in Beauzelle, Berthe struggling to make ends meet, alone with her sick and dying aunt Nine in the presbytery that was impossible to heat in wartime, while Amélie, who had rented a grander and more capacious house in the village, refused to speak to her or return her overtures.

Matisse caught bleak glimpses of himself and his relations reflected in Pearl Buck's books and in François Mauriac's excoriating novel of family life, *Noeud de vipères (Knot of Vipers)*, but even in the bitter spring of 1940 he had no wish to cut the ties that had bound him more deeply than any other all his life: "You always come back to the family as you do to the land," he wrote to Marquet.[17] He said the same to Rosenberg, the only outsider fully aware of what exclusion from his family meant for Matisse ("In spite of my belief that I've been very badly treated, I love them still, as is only natural").[18] Pierre, stranded in France and temporarily conscripted into the army on the outbreak of war, declined to discuss anything to do with his mother, but on all other matters remained his father's closest confidant. Although Matisse did all he could to help his son get back to the United States, he dreaded the prospect of further misunderstanding between them. "That would be something terrible because, what then?" he wrote the month before Pierre finally secured his military exemption and flew home. "What would be left to me in life—my work. But all the same that is not enough for me—for in that case you become a prisoner, shut in by invisible walls which don't prevent you from working,

since you can still work in prison (look at Courbet). But at times it's unendurable."[19]

This was a grim admission of the ransom Matisse had paid, and still continued to pay, for his work. As the war dragged on with no sign of a military offensive, he planned to distance himself from his troubles by travelling south towards the sun, abandoning his long-term dream of a return to Algeria (where Lydia would not have been permitted to land), and settling instead for a voyage to Brazil, a month-long round trip with a fortnight in Rio.[20] The prospect of escape in the summer made it easier to face the property settlement that loomed over him in the spring. Matisse returned to Paris at the end of April, and spent the first week of May working several hours a day with Marguerite, exhuming trunks and crates of his work in a cold, damp cellar at the Banque de France.[21] He dreaded bronchitis, and suffered attacks of such acute stomach pain at night that the hotel porter had to call a doctor (who could find nothing wrong).[22] Hitler's armies were finally on the move, invading Norway and Denmark in April, pushing westwards on 10 May and racing through Belgium, Luxembourg and Holland. They crossed the river Meuse into France two days later. Bombs began falling on the capital (Matisse ignored the air-raid sirens on the grounds that he preferred the chance of being hit to the certainty of catching a chill if he spent any more of his time underground).[23]

Parisians took to the roads yet again, swelling the unprecedented, almost inconceivable exodus of millions of people from Flanders and Belgium. Auguste Matisse arrived by car with his wife from Bohain (overrun as always by the first wave of invaders), and headed south to find shelter with Amélie in Beauzelle. Marguerite sent her son Claude to safety in central France with the head of his school, and Jean's wife Louise left for the west with her son, Gérard (Jean himself had left months before to rejoin the army). As the Germans drove through the valley of the Somme to the sea, Matisse caught a train to Bordeaux with Lydia, planning to accept an invitation to stay with Rosenberg at his chateau outside the city. But, after a single night in Bordeaux with one of Rosenberg's relatives (who made it clear that Lydia's presence was unacceptable in a respectable family), and another at a hotel that turned out on closer inspection to be an upmarket brothel, they moved on to St-Jean-de-Luz, not yet swamped by refugees, on the coast near the border with Spain.[24] They found lodgings in a house on the harbour front in St-Jean's port of Ciboure, a few doors away from the birthplace of Maurice Ravel. Matisse sat at the window watching blue-and-scarlet fishing boats bobbing about in the harbour, and trying to

stop himself from thinking about events in the north by imagining Ravel listening to the local church bells as a boy.[25]

On 1 June, when the Dutch and Belgian armies had been smashed and the British expeditionary force was preparing to escape back across the Channel from Dunkirk, Tériade, in Paris, completed printing of what Matisse called "the war number" of the magazine *Verve*, dedicated to France and wrapped in a sumptuous black jacket designed by Matisse himself.[26] He had spent the final days of suspense before the declaration of war in the magazine's office, cutting letters and shapes out of coloured paper and pasting them onto the cover, watched impassively by Tériade, who put his own and his printers' finest skills into bringing out this first-ever-published of all Matisse's cut-paper compositions. In June 1940, it symbolised the only possible defiance in the face of unmitigated, igno-minious defeat. German troops entered Paris on 14 June, the government resigned, and the eighty-four-year-old Marshal Pétain, installed as Prime Minister next day, immediately sued for peace. "No one could have fore-seen what has happened . . . ," Matisse wrote to his daughter. "Since we can do nothing, let's say no more about it! That will help us to think of it as little as possible, which is essential, so as not to be annihilated." His mind went back to the Chargé d'Affaires who had watched his children drown in Tangier harbour in 1912, and remained ever after for Matisse a model of endurance in the face of devastating loss. "Each one of us must find his own way to limit the moral shock of this catastrophe. For myself . . . in order to prevent an avalanche overwhelming me, I'm trying to distract myself from it as far as possible by clinging to the idea of the future work I could still do, if I don't let myself be destroyed."[27]

He was appalled by his country's capitulation, sickened by the contin-uing slaughter, and consumed by fear for his family scattered over the face of France, especially for Marguerite, when word reached him that she had set out alone just before the fall of Paris towards the thick of the onslaught in search of her son. Letters and telegrams over the next two weeks brought news of the fugitives' safe arrival two by two at Beauzelle: Auguste and his wife, Louise with Gérard, and finally Marguerite with Claude after a hair-raising car journey, fleeing immediately ahead of the advancing Germans along the byroads and dirt tracks of the Auvergne. In every village they passed through, the inhabitants waited for the invading enemy in stupefaction and shock. "Never!" cried Marguerite, when told that France had officially surrendered. "I'd rather die with a gun in my hand."[28] It took her two weeks to reach shelter in the southwest, where she

was eventually joined by Jean, demobilised after the armistice which divided the country into a northern occupied zone and a nominally free zone in the south under Pétain's government at Vichy. "So now that's everyone safe," Matisse reported thankfully to Pierre on 4 July.

By this time he was on the run again himself, fleeing eastwards as German troops moved down to occupy the coastal zone. Mussolini had declared war on France in June, but life under a probable Italian occupation in Nice seemed a better bet than waiting for the establishment of Nazi rule in St-Jean. The town was packed with desperate refugees, pinned between advancing Germans and Spanish border guards, but Matisse (who had a valid passport and Brazilian visas in his pocket) said afterwards that it never occurred to him to try to flee France.[29] He found one of the few taxis in town with a full petrol tank, and left with Lydia by one gate as the Germans entered through another from the north.[30] The taxi ride ended after a hundred miles at the first inn with vacant rooms, the Hotel Ferrière at St-Gaudens. With no trains running, Matisse found himself stranded there for the whole of July, afraid to listen to the radio or open a newspaper in the mornings, and assailed once more by knifelike pains in the gut which mystified the village doctor ("I could have died like a rat in a trap at St-Gaudens," he said afterwards, when specialists finally diagnosed what was wrong with him).[31] He sent for the suitcases they had left behind in their hurry, along with his headless Greek statue, forwarded from Nice for fear of marauding Italians, and now liable to be looted by Germans.[32]

Matisse's marble torso finally caught up with him, strapped to the back of a second taxi from Ciboure. He packed it up and put it in the post (it was delivered safely to Raymond Escholier, director of the Musée de la Ville de Paris, who looked after it for the rest of the war) before accepting a lift on 3 August from St-Gaudens to Carcasonne ("Very imposing," he wrote to Bussy of that medieval stronghold, "and makes one realise that things weren't too good in those days either").[33] Railways had started running again, and a fortnight later Matisse and Lydia squeezed onto a train leaving for Marseilles at two in the morning.[34] In that blockaded port crowded with fleeing French citizens and hunted foreigners, Matisse was recognised on his first morning by Marguerite's friend Maria Jolas. Mme Jolas, who ran the school Claude attended, had escaped with him and his mother in the path of the German army, and was now about to cross the Atlantic, taking Marguerite's son with her own daughters to safety in the United States.

Matisse was cut to the heart by her news. Georges Duthuit was already in New York (where he would remain for the rest of the war), but Claude had been brought up by his mother and his grandparents. Matisse said he felt like a limp rag after the three days he spent in Marseilles, putting on a calm, cheerful front with Marguerite and drawing his grandson, whom he knew he might never see again.[35] "I love all my grandchildren without any particular preference, but all the same perhaps this one needs me more than the others," he wrote, begging Pierre to keep an eye on Claude and comparing him to Dickens' David Copperfield, facing adult ordeals alone, far too young, without warning or preparation.[36] Over the next five years, Matisse missed the child badly, asking after him often and anxiously, marvelling at the courage and endurance this parting cost Marguerite, who fell ill from grief in the autumn of 1940.

By the end of August Matisse was back in Nice, where people gloomily expected Italian Fascist forces to occupy the town at any moment. His first move was to put his own private economy on a wartime footing. All his pictures had already gone, and in September he arranged to send his record collection and his last remaining bronzes, with most of his furniture and hangings, to Beauzelle for storage. Matisse had furnished homes and studios all his life with odds and ends that caught his eye in junk shops: battered sideboards, worn, cobwebby tapestries and carpets—"noble rags," he called them—so threadbare anyone but an artist would have thrown them out.[37] Now there was little left beyond bare necessities: a bed, some basketwork garden chairs, a trestle table made from a single marble slab. In an autumn of punitive public cutbacks on food, fuel, and transport, Matisse added a further privation by starting to sell off his birds. "It's not the necessity of doing it that concerns me but the uncertainty we live in, and the shame—the shame of a catastrophe one had no part in," he explained to Pierre, quoting Picasso's derisive comment at their last meeting in Paris in May: "It's the Ecole des Beaux-Arts all over again," said Picasso, when the supposedly impregnable defences erected by France's elderly generals turned out to have been an illusion all along.[38]

The closing of the frontier dividing France in two meant a sudden total shutdown of contact with Paris. Rumours that Picasso was in Mexico proved as inaccurate as stories that Matisse had left for Brazil ("When they told me Pablo had gone to Mexico, it broke me up inside—although we have no communication, it's good to know one's not alone," wrote Matisse, who felt that to leave France at this point would be a form of

desertion).[39] News of old friends came from the American Varian Fry, founder of the Emergency Rescue Committee, who had arrived in France with a list compiled by Alfred Barr in New York of distinguished artists at risk from Nazi persecution. Matisse politely refused both Fry's offer of refuge, and an invitation to become a visiting professor at Mills College in California that autumn.[40] He said he was too old and frail at seventy to take root elsewhere.

The German authorities, who had persecuted his followers and got rid of his work in their own country, now had access to the strongrooms of the Banque de France, which were designed to be proof against theft, fire, or bombardment, but not official confiscation of the contents ("All my work, all my drawings and paintings, Cézannes, Renoirs, Courbets," Matisse wrote stoically, suspecting he might have lost everything, "—for I know what refined and robust removal men the Germans can be").[41] All he could do was wait to hear from Picasso, who had offered to stand in as his authorised key-holder at the bank, and who eventually sent word that his pictures were safe. In September, two German officers called to inspect the apartment on the boulevard du Montparnasse.[42] A letter arrived from Paul Rosenberg to say he had managed to escape to New York, but there was no news of the collection he had been forced to leave behind in Bordeaux ("I wonder what happened to my latest pictures, which he was going to roll up and take with him," said Matisse, who had already done his best to persuade officials from the Beaux-Arts to intervene on Rosenberg's behalf).[43]

In October Matisse was disturbed to find Georges Bernheim roaming the streets of Nice in a state of shock after his wife's death and the loss of his only surviving son (who was in a German prison camp), declaring that he got no comfort at all from his paintings, which he did not expect to see again in any case because he was Jewish.[44] Pierre had already warned his father that the government in Vichy planned to follow the Nazis in purging the art world of Jews, while vigorously promoting the aesthetic values embodied by the Beaux-Arts administration.[45] There was little Matisse or any of his friends could do, beyond supplying official testimonials in favour of Georges and his cousin Josse, and reiterating in private their abhorrence of Beaux-Arts methods.[46] But in the autumn of 1941, when the Ecole des Beaux-Arts moved its Prix de Rome headquarters to Nice, Matisse publicly expressed his distaste in an interview on Radio Nice, agreeing, after his aspersions were cut from an article in *Paris Soir*, to repeat them more explicitly and at greater length in a second broadcast, on the understanding that this time there would be no censorship of his remarks

about the Rome prize. The result was a withering denunciation of a system based on self-aggrandisement, coercion and prejudice, which came as near as was possible in Vichy France to expressing open contempt for the regime itself.[47]

Matisse felt he had aged drastically ("I watch myself changing rapidly, hair and beard growing whiter, features more gaunt, neck scrawnier") in the first year of the war.[48] A permanent haze of collective foreboding polluted the air in Nice. He had reduced his life to eating, sleeping and working, completing that autumn a beautiful, spare, meditative painting in a stripped-down style that he described severely to his friend Pallady as "the expressive marriage of differently coloured and proportioned surfaces."[49] The effort it required was so intense that he placed a regular order with a local agency to send along three or four of its prettiest film extras as models each week, explaining to Pierre that their human presence softened the inhuman austerity of what he was trying to do.[50]

The Dream is built round a sleeping girl, whose image had accompanied Matisse in his mind's eye throughout his travels, on a canvas he eventually finished after twelve months and forty sessions, moving smoothly, with a change of model at the last minute, from a relatively realistic start to an airy, translucent lyricism, like a motorist shifting into a higher gear.[51] He followed it with a stern and no less reductive *Still Life with Shells.* "I think I've gone as far as I can in this abstract vein," Matisse told Pallady on 7 December; "for the moment I can go no further."[52] He said he needed to wind down by letting his hand and eye run free on something more sensual, so he painted three plates of oysters in quick succession ("And for that, my friend, you need sensations of appetite, a painted oyster must remain to some extent what it is, a spot of the Dutch treatment"). *Still Life with Oysters* is a simple lunch for one—plate, knife, napkin, lemons and

Matisse,
The Dream,
1940

water-jug served up on a tray—painted with straightforward gusto, setting out by Matisse's own account from a point somewhere between Manet and Renoir, and performing a remarkable art-historical leapfrog from Impressionism straight into hard-edged abstraction.[53]

Matisse wrote about his work in great detail in an attempt to distract Pallady, who was holed up in a hotel room in Bucharest in December 1941, painting still lifes himself to combat despair in his newly defeated country. The letter said nothing about the sender's own problems. The abdominal pains that had attacked Matisse in Paris in May, and again in July at St-Gaudens, had returned as soon as he got back to Nice, where his doctor wrongly diagnosed heart trouble. A recurrence at the end of November nearly killed the patient, who was transferred in December to a clinic for further tests. On Christmas Day Lydia wrote secretly to Marguerite in Beauzelle to warn her that her father's life was in danger, that he was determined to resist an immediate operation, and that only his daughter could save him from the local doctors.[54]

Marguerite left for Nice the day the letter arrived. The trouble was agreed to be some sort of blockage, but Matisse lacked confidence in the facilities and the level of competence available in Nice, which had always been treated as a backwater by the medical profession. Marguerite organised a rescue operation, contacting a surgeon recommended by a friend in Lyon and removing her father bodily from his hospital bed on 7 January 1941, in spite of angry protests from the consultants that he could not survive a twelve-hour train journey through occupied territory in winter. "Marguerite went into action with all the energy of which she is capable," Matisse wrote with satisfaction a week later from the Clinique du Parc in Lyon, "and I ended up here."[55] He was examined by Marguerite's contact, Professor Wertheimer, and two distinguished colleagues, the venerable Louis Santy and René Leriche of the Collège de France, who decided on an emergency operation as soon as the patient was strong enough to undergo colonic surgery. The basic cause of the problem was the hernia that had saved Matisse as a boy from becoming a seed-merchant like his father. Half a century later it gave trouble again, causing minor inconvenience in 1937 (when Matisse entered a clinic for treatment), and erupting fiercely in May 1940, as the Germans advanced on Paris. Matisse's condition, undiagnosed and potentially lethal after seven months of neglect, was further complicated by a possible tumour that might or might not be malignant and severely compromised by risk of heart failure.[56] An exploratory operation was scheduled for 16 January.

Matisse spent the interval sorting out his affairs, making up a sealed box of documents to be given to his wife in the event of his death, writing to his family and sending tacit farewells to his friends. Picasso, Bonnard, Bussy, Camoin, Rosenberg, even Escholier, all received cheerful notes mentioning incidentally a small routine operation that was nothing to worry about. Matisse broke a lifetime's habit of reserve by telling Duthuit exactly what he thought of him, and posted two remarkable letters to Pierre.[57] The first enclosed a copy of his will and instructions that his estate was to be divided equally between his three children. In the second, written in the small hours the day before his operation, he reviewed the results of the bargain he had made between life and art. It was a dispassionate, honest and accurate reckoning, deploring the suppression and secrecy that had turned his family relationships into a minefield, attributing many of his children's subsequent difficulties to pressures imposed by his work when they were young, and holding the emotional turmoil of the past two years largely responsible for his own physical collapse. He warned Pierre affectionately to avoid his father's mistakes in bringing up his own children, insisted that he felt no fear on his own account ("Don't worry— I'm not planning to die, but it is in my character to take precautions"), and ended by reiterating his deep and abiding love for his family, including his wife. He added a postscript leaving his two latest paintings—*Dream* and *Oysters*—to the city of Paris and the French state respectively. A second postscript asked the military censor not to tamper with this last letter to his son from a father about to face major surgery.

Professor Santy, assisted by his two colleagues, performed a successful colostomy in two stages, following the first intervention with a second on 20 January. Two days later, Matisse suffered a pulmonary embolism, which he only narrowly survived. Marguerite and Lydia took it in turns to watch by his bedside. All through January and most of February, Pierre received two or three telegrams a week in New York from his sister, who finally left Lyon on 1 March, only to be recalled two days later by a telegram from Lydia with news of a second, near-fatal blood clot on the lung. Matisse lay for eight days in delirium and fever. His wound was infected, and his doctors despaired of his life. Some nights he, too, sensed himself slipping away, wondering in lucid intervals if he wouldn't rather be dead (he said afterwards the answer was definitely no).[58] The energy and determination of the two women never failed him, although in the three months they spent together in Lyon his daughter could barely bring herself to acknowledge his secretary's presence. By the time the patient was

out of danger, they were both almost as exhausted as he was. Matisse confessed later to Pierre that he regularly reduced each of the women to tears, bullying Lydia at one point so badly that even Marguerite hissed in his ear: "Stop that—what if she left you?"[59] He said he had asked his doctors to give him a respite of three years, and that his only way of stifling violent eruptions of fear and anger was to remind himself that from now on he was living in extra time.[60]

By the end of March he was well enough for Marguerite to leave again for Beauzelle, and to be moved himself, on 1 April, to a hotel near the clinic with Lydia. "Good-bye, I'm leaving," he said pleasantly to Professor Santy, "and I'm not going feet first."[61] He was still so weak that he couldn't even draw his own coffin, and had to ask Lydia to sketch it in for him after several bosh shots in the margin of a letter to Bussy, explaining that the nuns who staffed the clinic had nicknamed him *le réssuscité*, the man who rose from the dead.[62] Much of the time he lay watching the angry grey floodwaters of the Rhône through the branches of willow trees in bud outside his hotel window.[63] He said he had not known a moment, day or night, since his operation without being intimately aware of his wound. Gradually, as if from a great distance, he rejoined the rest of the world, catching up with the deaths of friends, the fighting in Libya and Greece, and the German invasion of Yugoslavia. "Napoleon is Hitler's god," Matisse said on 10 April, the day the German army entered Belgrade; "the only difference is, Napoleon didn't succeed."[64] He listened to reports on the radio of troopships torpedoed at sea, and the Luftwaffe reducing British cities to rubble.[65] He wondered if anything would survive the madness in Europe that looked set to destroy what was left of the ancient civilisations of the East as well.[66] On 2 May he sat up in bed and made his first drawing on a sheet of flimsy airmail paper, part of a letter to Pierre, who had heard nothing from his father for nearly four months, and now received a sketch of him reflected in his wardrobe mirror, wearing a nightcap and glasses, looking wry and battered but unmistakably alive and in his right senses.

Matisse was seventy-one years old when he returned from the grave in the spring of 1941. Inability to work made him look back for the first time in fifty years over the road he had travelled, trying to piece together a rough map of where he had come from and how far he had got. He relived student days with Jean Puy (who turned up in Lyon that April to work on a decorative mural), and he entertained Albert Skira (who stopped off in the middle of moving his publishing outfit from Paris to Switzerland) with anecdotes from the past. Skira instantly recognised the makings of a

book in the fact that, once started, Matisse couldn't stop talking. "I was overtaken by a sort of crisis of words," the painter said afterwards, "like someone who has lived a long time shut away from the world, and needs to get out."[67] He agreed to exploit his sudden access of memory in a volume of reminiscences for Skira, who sent along an enthusiastic interviewer from Geneva to ask questions, and a stenographer to take down the answers. The first session took place on 5 April and was followed in the next three weeks by seven more, ranging over Matisse's background, upbringing, training and early career.[68]

The account he gave Skira's envoy, Pierre Courthion, is occasionally unreliable on dates and factual details but brilliantly acute and accurate about people and feelings. It revolves round a series of key stories—in particular the successive revelations of the painter's vocation—that give a mythical dimension to his life (many of them would end up being passed round by subsequent commentators as substitutes for historical fact, losing colour and substance with repetition, acquiring a blandness wholly alien to the original telling, like folk tales or Bible stories). Although Matisse had sketched out some of this material before in interviews with journalists or critics, in a brief introductory book he worked on with Escholier in 1937, and in a series of substantial dialogues with Tériade, this collaboration with Courthion is the nearest he ever came to an auto-biography. The completed typescript—provisionally entitled *Bavardages*, or *Chats with Henri Matisse*—was a more elaborate equivalent in book form of the vivid, uningratiating, private glimpse of himself he drew from the hotel mirror for Pierre. Matisse said again and again that he needed above all to confront himself.[69]

Courthion went back to Geneva at the end of the month to work on the corrected and expanded typed transcripts posted after him by Matisse, who finally returned to Nice with Lydia in late May. His aviary was half empty and his birds were dwindling fast for want of the special ants' eggs impossible to obtain in wartime. The pair of songthrushes he prized more than all the rest died soon after he got home.[70] So did his dog Raudi, a touching and faithful companion, always consoling in trouble until he descended into blindness, deafness and death ("He was petted and stroked all his life, and never maltreated. . . . I don't know anyone who's had a life like his," Matisse wrote sadly to Pierre. "I guess it's only for dogs").[71] Matisse feared that each letter to Pierre might be the last, as America moved closer to entering the war and Hitler's invading armies swept eastwards, deep into Russia, all through the summer and autumn. The painter's own predicament seemed almost frivolous by comparison.

He adjusted to it with patience and ingenuity, putting up with its limitations, making fun of his own helplessness and humiliation, learning to tolerate the metal-and-rubber contraption he had to wear as a protective girdle whenever he got out of bed. "This regime of severe, sometimes excessive pain doesn't suit me too badly," he told Pierre. "It acts like a scourge."[72]

He engaged day and night nurses, and devised routines to restore something like normal functioning as fast as possible. When he found he could no longer manage even his usual five hours' sleep a night, he started getting up before dawn and either dozing in an upright chair or working from three to six in the morning, then taking a stroll and going back to bed until it was time to rise at mid-day for a second work session. He took immense pleasure in the activities left to him: eating, walking, drawing, seeing friends. Rouault, stranded further along the coast at Golfe-Juan after the Occupation, came over to Nice and insisted on climbing all the way up, on foot and in great heat, to the studio at Cimiez. Bussy resumed regular visits, and when Bonnard couldn't face the interminable journey from Le Cannet by bus and train in wartime conditions, Matisse travelled out to see him instead.[73] He organised supplies of scarce canvas and paints for Bonnard, provided Rouault with oil, and posted a magnificent parcel of goodies to Marquet (who was sitting out the war in Algeria).[74]

Matisse told Marquet and others that the operation had cleared his mind, sharpened his sense of priorities and made him feel young again ("It's like being given a second life, which unfortunately can't be a long one," he wrote to Pierre).[75] He compared himself to a traveller who had packed his bags for the last time. Painting made life worth living even on sharply reduced terms, and he had no intention of wasting the three or four years he had told his doctors he needed to conclude his life's work. He took on new models, and embarked on a series of still lifes culminating that autumn in the majestic *Still Life with Magnolia:* a humdrum collection of ornaments and a kitchen jam-pan, set out symmetrically like ceremonial insignia, reduced to flat shapes and rendered in a palette of acid mauvy pinks and blue greens on a rich, saturated red ground. "Matisse is a magician," Picasso said crossly when he saw this unprincipled canvas, which conjures extreme sumptuosity out of frugality and rigour in defiance of all Cubist logic: "his colours are uncanny."[76]

Matisse urged Rouault to write his memoirs and finalised plans for publication of his own in July, when Courthion arrived at the Regina with the revised typescript, a page layout, and a proof of the jacket design, which featured a specially drawn self-portrait.[77] "I can see him still, in his

tea-planter's pyjamas," Courthion wrote later, "just as I saw him then in the dark, cool hall with bookshelves lit by a small lamp. He pushed a door open, and cutting through the blinding daylight came a strident chirping from the huge aviary hopping with birds, whose glinting plumage looked as if it had escaped from his brush.... Spread out on the tables of the great studio...like a gathering of co-conspirators, lay the objects in which the artist exults, and which I recognised from having seen them magnified in his paintings: lemons lying about on the chair-seats, oranges drying on the tables, bouquets of lilies, shells, vases with necks of all different shapes, and at the back, above the cactus, a forest of lianas."[78] Courthion was dazzled by the light and heat, by the scent of flowers, by the view of sky and sea and the shimmering red roofs of Nice blocked off beyond the big bay window by a huge plaster cast, a larger-than-life-size, archaic Greek figure with a broken nose and an air of indomitable calm, clarity and power. For a visitor from neutral Switzerland entering a defeated, half-starved and demoralised France as the war approached a grim climax in the summer of 1941, Matisse's studio and everything in it radiated serenity like the paintings themselves.

But Courthion soon sensed turbulent undercurrents. A shrill outcry from the aviary prompted Matisse to explain tersely that one of his birds had lost its breast feathers in a fight the night before. The visitor was uneasily aware of unspoken constraints and invisible barriers that had not been present in Lyon. The luminous space took on a prisonlike aspect ("I'm a slave to this table...I'm chained to my canvas," said Matisse, describing a round of hard labour he dared not interrupt, even to visit Bonnard or Rouault, for fear of being ravaged by remorse). Like most people, Courthion dismissed the latest paintings of women and still life as irrelevant and narcissistic ("In the middle of the most terrible of catastrophes...they offer no echo...of the torment that gnaws at us all"), reading into them the chill egotism of a remote and uncaring voyeur. He was troubled by an aura of distress, even perversion, emanating from a series of paintings of two women in long, slippery, satin dresses, and by a monstrous vision of the painter as a spider trapped in the treacherous confines of his own silken web. The collaboration between artist and interviewer was beginning to take on a nightmare aspect for both of them.

"What you're making me do, or what I am doing here, is idiotic...," said Matisse, only half joking, in the course of his ninth and last conversation with Courthion at the Regina. "I relive my life, and I can't sleep.... You're putting me through a fearful debauch."[79] He was overcome by revulsion for the torrent of words that had poured out of him at Lyon.

He told Courthion that he had consulted psychiatrists three times in his life:[80] the first had listened without comment for sixty minutes, timing the two or three sessions they had together with an alarm clock; the second had told his patient there was nothing wrong with him; and the third had explained that his nervous disorders were not a sickness but an essential part of his make-up. Now that he was starting to paint again, Matisse looked back on the episode at Lyon as weakness or self-betrayal. After ten days spent slogging through Courthion's typescript, removing what he described as the interviewer's facile insertions and his own equally banal replies, Matisse gave the final draft to his jealous and somewhat resentful friend, André Rouveyre, a graphic artist with aspirations as a writer himself.[81] When Rouveyre turned thumbs down, the project was terminated with ruthless speed and finality. Matisse consulted a lawyer in September, Skira's publishing house in Geneva received a telegram cancelling the contract, Courthion wrote in shocked and horrified appeal, and Skira himself arrived, distraught, from Switzerland to be consoled with a proposition he could not resist: a luxury limited edition of the love poems of Pierre Ronsard which Matisse intended to illustrate.

Matisse dismissed Courthion as clumsy and intrusive, but the real trouble seems to have been not so much that he probed too deeply as that he stuck strictly to the terms of their agreement, making little attempt to look beyond the surface of the work or its creator. Courthion had glimpsed the underlying mechanism that drove Matisse's life—"He lives only in function of the next picture to be done"[82]—without grasping what for, or why. The instructive, entertaining and gossipy text of *Bavardages* leaves out a whole level of meaning that made sense of everything else for Matisse. He was as reluctant as most painters to try to express what any given work signified in words; but he made an exception that autumn when Rouault, who had finally obtained a permit to return to Paris, sent his daughter over to Cimiez with the only picture he had managed to produce in the Midi, a tragic canvas painted with infinite delicacy in a gamut of bruised blues. "The subject is *The Circus Girl and the Manager*, seated opposite one another like a lamb confronting a tiger. . . . It is powerfully and poignantly expressive, it is—the entire picture is—a portrait of Rouault," Matisse wrote to Pierre (he added that the painting disturbed him so much he had to keep it shut up in a cupboard).[83] Rouault's daughter spent two hours at Cimiez pouring out her family's complaints and grievances to Matisse, who recognised the situation only too well, and tried to get her to see that inner fires consumed her father, whose glaring

faults were inseparable from his great strengths. Afterwards he told Pierre there was no real difference between his case and Rouault's:

> A man who makes pictures like the one we were looking at is an unhappy creature, tormented day and night. He relieves himself of his passion in his pictures, but also in spite of himself on the people round him. That is what normal people never understand. They want to enjoy the artists' products—as one might enjoy cows' milk—but they can't put up with the inconvenience, the mud and the flies.

Courthion was replaced almost at once by an altogether tougher and more perceptive observer. Louis Aragon wrote to Matisse in September 1941, to beg a contribution for a little independent magazine started up by a friend, and was surprised to receive not only the pictures he wanted but a pressing invitation to visit as well. He arrived with his longtime companion, Elsa Triolet, to call on Matisse at the end of December ("You can't imagine how eagerly he expected you," Lydia said later, "and how long he had been wondering, why doesn't Aragon come to see me").[84] On Christmas Day Aragon submitted for Matisse's approval a brief text designed to accompany the reproductions, and on New Year's Eve he and Elsa drove round the town in brilliant sunshine in a horse-drawn trap with the painter, who took them out to dinner that night to celebrate his seventy-second birthday.[85] Matisse's welcome at Cimiez was so friendly that Aragon suspected some sort of trap. "Every time I came there were fresh drawings. Fresh temptations. He saw me coming, and he was ready for me."[86] Matisse had papered the walls of his studio from floor to ceiling with drawings, a hundred or so lined up side by side in five rows, one on top of another. At a time when Paris galleries were suspect (since any dealer still operating could do so only on sufferance from the enemy regime), Matisse had mounted his own exhibition, and was proposing to appeal directly to the public by publishing it in book form under the title *Thèmes et Variations*.[87] This was a harvest gathered over the past two years. Matisse said it was one of the great flowerings of his life ("If I manage to do in painting what I've done in drawing, I can die happy").[88] What he wanted from Aragon was a preface.

Seduced by the concerted force of Matisse's attention, mesmerised by his "blue hunter's gaze," Aragon said he could no more refuse than a mouse can resist a snake.[89] He had placed Matisse above all other painters

as a schoolboy, and now he found himself singled out in his turn: "The painter invited me to write what he had not found in previous writings about him, what he evidently seemed to believe me capable of, and me alone." A leading member of the French Communist Party (which had been dissolved on the outbreak of war), a veteran of Dunkirk and the Flanders campaign, demobilised at the armistice with the Croix de Guerre, Aragon was on the run that autumn, harassed and tailed by the police in Nice, expecting arrest any day for connections with the evolving underground resistance. He saw Matisse as one of the few ramparts still standing among the ruins of civilisation in their "mute, humiliated country," a guarantee of endurance and intellectual continuity badly needed at that stage of the war: "It simply seemed to me that the time had come to be aware of the national reality of Matisse . . . because he was of France, because he was France."[90]

Aragon set to work at once on an essay which he secretly hoped would grow into a book, delivering his text as he wrote it a few pages at a time and discussing each fresh batch with Matisse, who returned his visitor's scrutiny with interest ("He, whose portrait I thought I was drawing, had started to draw mine").[91] Matisse made nearly three dozen portrait sketches of Aragon: "The pencil flies over the great sheet of paper fast, as fast as possible, as if it were trying to beat a record. . . . Matisse does not for one moment glance down at his hand."[92] The sitter did not care for the results at first, claiming they looked nothing like him. Matisse had drawn an invincibly confident interrogator—debonair, fresh-faced, unmistakably boyish—when his subject was in fact forty-five years old, thin to the point

Matisse, *Louis Aragon*, 1942

of malnutrition like practically everyone in wartime France, permanently anxious about friends missing or murdered by the Gestapo, and harrowed by thoughts of his mother, who lay dying far away in the Lot. It took time for Aragon to recognise anything of himself in these drawings, longer still to realise that they captured not one "but thirty of my different selves," and longest of all to acknowledge that Matisse's humorous, glancing, gliding, inimitably casual line had penetrated him to the core.[93]

Painter and poet were haunted that spring by phantoms neither mentioned and both pretended not to see. Aragon, whose mother died on 2 March, returned to Nice after the funeral to find her ghostly presence looking back at him from Matisse's latest drawing, wearing precisely the expression she had worn on her deathbed ("I have exactly my mother's mouth, not my own, the mouth of my mother Matisse had never seen").[94] His own heightened sensitivity made him aware of another spectral companion, unseen but palpable, a sinister "character called Pain" who lurked in the painter's shadow, goading and jabbing, sometimes retreating to the doorway with a sardonic yawn but always ready to pounce and reclaim his victim. Matisse was often white and drawn, wincing from something worse than routine discomfort (which he complained about only occasionally in letters to his daughter). A crisis at the end of March—fever, dizziness, palpitations—left him too weak to hold a pencil.[95] He caught pleurisy, and had trouble with his ears. Aragon said he never looked well again. The preface was completed in late April, a month before Aragon was finally forced to flee Nice with Elsa, taking a portrait drawing as a parting present ("I made off with it like a thief," he wrote, "I had the feeling I was dismantling the Louvre").[96] Matisse, who had almost completed the thirty lithographs he planned to accompany Ronsard's poems, was looking forward to two months in Geneva in the summer, overseeing the printing with Skira. "But I felt uneasy," wrote Aragon. "The stranger was sneering in the shadows."[97]

Matisse had been more or less bedridden since March, prevented from painting by recurrent, excruciating spasms of pain in his liver and stomach. His doctors ordered X-rays. "This year is a write-off," the patient wrote in disgust to Marguerite on 12 May, reporting ominously at the end of the month: "I've missed out on the spring just as I did last year at Lyon."[98] A quarter of a century later Aragon wrote about the time they spent together in Nice in an essay, "A Character Called Pain," part prose poem, part memoir, evoking Matisse's invisible companion, who came to embody not only the painter's immediate danger but a brooding sense of their mutual grief and shame for things that could not be articulated at a time when the entire population of France was intimately acquainted with betrayal, deceit and concealment. The campaign of persecution instituted by the Vichy government against Jews and foreigners was accelerating. There were Fascist rallies in Nice, and checkpoints set up in the streets. Matisse knew or guessed something of the growing climate of fear and violence ("He was sickened by it," said Lydia) from Aragon, and his second broadcast attacking the Beaux-Arts system went out at the end of

April on a programme directed by Aragon's friend Claude Roy.[99] Officers called several times at the Regina to raise the matter of Matisse's Russian secretary, agreeing provisionally not to molest her provided she kept her head down.[100]

Aragon and Elsa (who was also Russian) found shelter with a friend in Villeneuve-les-Avignon. When the publisher of Matisse's *Thèmes et variations* objected to the inclusion of a preface signed by a Communist on the run, Aragon refused to adopt a pseudonym—"because I consider it an honour for me that this text should appear alongside your drawings," he wrote to Matisse on 11 July, "and particularly these drawings which have been this year a large part of my life and thoughts, and practically the only human consolation for the life of horror that now surrounds us."[101] The publisher was the dealer Martin Fabiani, who had arrived in Nice along with a good many others hoping to sign up Matisse after Rosenberg's flight, and had been taken on, initially for a trial period of a year, because he was a Corsican from Ajaccio, had a shrewd eye for pictures, and came with recommendations from Vollard's lawyer.[102] But, in the dispute over Aragon, Matisse overruled Fabiani—who had by this time developed advantageous contacts with the Nazi regime in Paris—and the preface appeared in due course under its author's name.

Aragon meanwhile spent the summer in Villeneuve, and was still there when police rounded up the town's Jews on the night of 31 August for deportation to concentration camps. "There must be a harsh wind blowing through the streets of Villeneuve in a temperature that often drops to freezing," Matisse wrote next day, improvising the kind of code which was the only way of evading the official censorship that muffled both private and public communication in Vichy France: "Nice is beguiling on the surface—although it's not like that for everyone these days. What horrors."[103] One of the things that impressed Aragon most about Matisse was the turmoil that could be sensed behind his immense power of surface dissimulation. The painter's nights at this point were more tormented than ever. He startled his night nurses with involuntary cries when he slept, and outbursts of rage and despair when he woke.[104] He said that all his life he had dreaded falling asleep for fear of lowering his defences against nameless demons: "I am inhabited by things that wake me, and don't show themselves."[105]

He fought by all the means at his disposal to reimpose reason and meaning in a daylight environment of brilliant sunlight where the exotic birds, the palm trees outside the window and the tropical vegetation indoors put him at the furthest possible remove from the shadowy night

terrors which, as Aragon points out, he confronted directly only once in his work, through the bellowing, blinded giant in *Ulysses*. "The magic of the world, the happiness of man, everything from which Matisse would create his universe of splendour, none of this implied ignorance of that cry, of darkness and of horror," wrote Aragon, who saw the studio at Cimiez as a bastion of defiance.[106] "Do you think it's easy to pass from those terrible years to the sounds of peace? . . . Henri Matisse in 1941, and afterwards, collects his thoughts, not following the scheduled dates in the newspapers, but returning to a moment that was his alone, to Tahiti, his Tahiti of 1930, restoring for himself in France under the Occupation an inner order through this return to Tahiti."[107]

Aragon was already dreaming of the book he would eventually write about Matisse, "that other Matisse, the one I have in my head," a Matisse more complex and far more disturbing than the placid escapist pictured by more conventional contemporaries.[108] His premonitions in the summer of 1942 proved correct on all levels. Matisse's spasmodic abdominal crises grew fiercer and more frequent. Abnormally pale, unable to paint, incapable of digesting anything but pap and vegetable broth, he sat up in bed and worked on his drawings for Ronsard. The prospective Swiss trip was postponed from June to August, then to the autumn, and finally until the following year. The situation grew so alarming that Marguerite arrived to take charge in July, galvanising doctors and keeping watch over her father from a hotel in Cannes. Consultants gathered in emergency session in Nice in the first week of August. Wertheimer interrupted his holidays, and a Dr. Guttman from Paris replaced Leriche. Both agreed that the patient was unlikely to survive a second operation, and were flatly opposed by Matisse's two local doctors in Nice, who insisted that he faced certain death by starvation if his surgeons refused to intervene. Matisse told Pierre he lay and listened to the two factions snapping and growling over him in the next room.[109] The surgeons eventually won, arguing that this was a liver problem caused by gallstones, nothing to do with hernia (and certainly not cancerous), best treated by diet, bed rest and medication.[110] "So no operation," Matisse reported to Pierre.[111] All he could do was struggle on from day to day, praying to be rid of his gallstone, and quoting Ronsard's sexy little sonnet about a mosquito biting his mistress: "*Qu'un rien qu'on ne voit pas, fait souvent un grand mal* (It's nothing you can see, though it can do great harm)."

By the middle of August Matisse had spent nearly six months in bed. Lydia caught an outsize mosquito with a proboscis like an elephant's trunk, just as in Ronsard's poem, and imprisoned it under an inverted glass

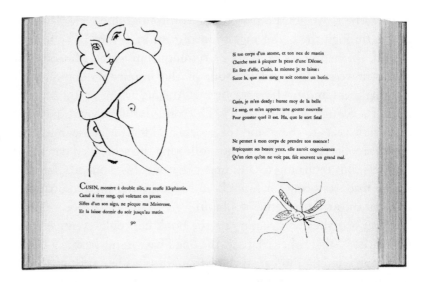

Matisse, Mosquito sonnet from *Florilège des amours de Ronsard*

by the painter's bed for him to draw.[112] Soon he had other distractions. The mosquito drawing became a tailpiece for the sonnet in its honour, balanced on the far side of a double-page spread by a sketch of Nézy-Hamidé Chawkat, a Turkish princess who had become one of Matisse's favourite models over the past two years. He had spotted her in the street and asked if he might paint her, requesting formal permission from her grandmother like a suitor applying for her hand. But Princess Nézy (who was a great-granddaughter of the last Sultan of Turkey) turned twenty and left to get married in the summer of 1942.[113] Her place was taken by volunteers from her band of friends: bright, bored, cosmopolitan young women, stranded in Nice by the war with little or nothing to do, amused and intrigued by her account of this singular elderly gentleman with old-fashioned manners who urgently needed their services in the afternoons. Lydia made sure that the whole strange set-up at Cimiez was impeccably correct. Nézy herself had brought a chaperone with her, and her replacements always wore swimsuits when asked to pose in the nude (to impersonate the mistress who reminded Ronsard of a slender young tree, for instance, or, later, the queen seduced by a bull in an illustration for Henri de Montherlant's play *Pasiphaë*).[114] On 14 August Matisse got out of bed to spend an hour at his easel for the first time, painting tentatively to start with, then with a steady renewal of energy.[115]

He began with Nézy's friend Carla Avogadro, a young Italian countess who posed in an abbreviated dancer's tutu, with her long legs coiled up in a padded armchair on a checked marble floor. *Dancer with Arms Raised in a*

Yellow Armchair launched an extraordinary set of variations which Matisse painted that autumn on the theme of girls in chairs on tiled floors, playing with light, multiplying and dividing it, making it glimmer and glow in compositions that reduced the minimal ingredients available—a door, a window, striped fabric, slatted blinds, sometimes a couture dress from his cupboard—to strips, swathes and swatches, broad bands and tilted planes of pure colour. These canvases have something of the speed and spontaneity of drawings. Matisse produced roughly one a week, working one or two hours a day for five months. He told Aragon it was the start of a fresh campaign, one that would strip away all unnecessary external refinements to leave an irreducible core or pictorial essence, which he called "the colour of ideas."[116]

The increasingly abstract paintings produced in the course of this campaign eliminated practically everything that made Nézy and her friends so charming. The princess herself (who reminded Matisse of the attendant on the right in Ingres' *Turkish Bath*) emerges from his drawings as a natural flirt, languorous, pert and seductive, with delicate Oriental features and a cloud of wavy dark hair, wearing a rose or a twisted rope of silk scarves or a smart spotted veil. There was something subtle, indefinable, even ethereal about Nézy, and Matisse captured it in *The Dream* (when she replaced an earlier, earthier model), but now he needed a harsher and more exacting spirit. He found it in the student nurse who was supplied by an agency in September as a temporary stand-in for his regular night nurse. Monique Bourgeois was twenty-one years old, a soldier's child, drilled from infancy in military discipline, whose family had been homeless ever since they were evacuated from Metz in cattle trucks, leaving everything behind, at the start of the war. Her father died soon afterwards, her mother fell ill, and she herself developed tuberculosis, which was still only partially cured when Matisse gave her the work she urgently needed to support herself and her family. "I was comfortable with him. I could breathe, I could relax, it was a haven of peace," she wrote, describing how he and Lydia helped her slowly escape from a prison of timidity, unhappiness and self-mistrust: "Life had maltreated me so badly in the last few years."[117]

Matisse gave her food coupons and grandfatherly advice about life and work. As a painter he loved the splendid mass of her dark hair and the way her neck rose from her shoulders like a white tower. Monique was a Girl Guide captain who had never worn make-up in her life, nor ever read a book without first asking her mother's permission. Matisse dressed her in a sleeveless chiffon evening frock with a plunging neckline, emphasised

her stately columnar neck with a string of heavy amber beads, and posed her in a straight-backed wooden chair like a throne to bring out her natural authority. Lydia said it was Monique, more than any other model, who renewed his determination to push forward once again as a painter into unknown territory. Monique, who had hoped to become an artist herself, was deeply shocked by the first portrait he made of her, *Monique in a Grey Robe*, a roughly painted composition of earthy yellows, pale grey and dark umber, anchored by the model's black hair and two black shoulder clasps, with her face and figure thickly outlined in yellow ochre brushstrokes that radiate out like fansticks between the flat planes of her dress.

To most people who saw it, this kind of thing looked like a senseless jumble ("It was just lines and blobs of colour," said the sitter).[118] Even the painter needed time to absorb the implications of what he was doing. In the most radical canvas of the whole sequence, *Interior with Bars of Sunlight*, he expunged his model almost completely, leaving her as a young-woman-shaped space of bare canvas in an otherwise geometrical arrangement of coloured bars and rectangles. He kept this apparently unfinished *Interior* by him, contemplating it from time to time "as if pondering a problem," finally signing it off as complete in 1945.[119] The painting is a time capsule whose contents would make sense only long afterwards in the light of optical experiments conducted by a generation of abstract artists as yet unknown. Matisse wrote a note to any future owners of his picture, urging them not to try colouring in the unpainted figure in the armchair at the bottom right of the canvas: "The figure, just as it is, has its own colour, the colour I wanted, projected by the optical effect caused by the combination of all the other colours in the picture."

It was as if Matisse had gathered all his forces for a last supreme outburst of energy in the autumn and winter of 1942, which his two local doctors predicted would be his last. Marguerite had been warned that without surgical intervention her father would reach the terminal phase of malnutrition by the following April or May.[120] Having successfully rescued him once, determined not to abandon him a second time to the mercy of doctors who had no confidence in his survival, she remained within call at Cannes, supporting his will with hers, suspending her own life so long as his was in danger, and renewing an uneasy alliance with Lydia for the sake of their common cause. Her efforts were seconded by Jean, who had set up a studio with his wife and son at Antibes and joined the local Resistance, organising sabotage, liaising with British Intelligence, and travelling around the region with a suitcase of dynamite for blowing up bridges. Matisse told Aragon (who came back to Nice in October) that

he trembled for his son, knowing he kept explosives concealed in his stat-
ues.[121] Aragon had the distinct impression that Matisse, who never openly
mentioned his visitor's underground connections, was warning him not to
risk his own neck for the Resistance. The German tide of conquest
reached its peak that winter when Hitler very nearly defeated Russia, while
his Japanese allies swept triumphantly through the Pacific. The United
States had made no move in the West since declaring war (Matisse's flow
of correspondence across the blockaded Atlantic with Pierre slowed to a
trickle, and finally stopped in October). On 8 November American and
British troops landed on the far side of the Mediterranean, in French
North Africa. Three days later the Germans responded by occupying the
whole of France, and the Italians finally invaded Nice.

Aragon escaped on the last train with another brown-paper parcel
delivered at the last moment by Lydia (this one contained proofs of *Thèmes
et variations* with his name intact on the title page).[122] Matisse and his little
group of elderly friends on the coast—André Rouveyre in lodgings in
Cannes, Bussy at Roquebrune, and Bonnard, whose wife had died earlier
that year at Le Cannet—were now potentially on a front line. Civilians
were required to observe a curfew and forbidden to move without a per-
mit. There was constant troop movement along the Mediterranean as fish-
ing ports and seaside resorts filled up with enemy soldiers. Charles
Camoin, who narrowly escaped arrest by an Italian patrol while painting
spring blossoms at St-Tropez, cheered himself up with the memory of a
visit to the invalid at Cimiez the day after the Allied landings. Camoin
said he felt as if he had stepped into the world of Greek myth, with
Matisse lying back lazily, like the nymph Danaë, ready to receive the atten-
tions of Jove descending out of the blue in a shower of gold—"Only, in
your case, it's the beautiful, ripe fruits of your palette that surround you.
What's astonishing is being able to play both roles at once."[123]

By the end of the year Matisse was beginning to justify his surgeons'
belief in him, eating more, suffering less, and ticking off the days one by
one since his last liver attack. He celebrated New Year, 1943, by ringing Dr.
Wertheimer in Lyon to say he had been free from pain and fever for fifty-
six days. He remained pitifully frail that spring, more prone than ever to
chill, bronchitis and pleurisy, and still not strong enough to get up for
more than a couple of hours a day. His eyes, always troublesome in time
of stress or over-exertion, began to cloud over again, although his doctor
assured him he was at greater risk of a stroke than of losing his sight.[124]
He maintained a precarious equilibrium, thanks to meticulous nursing
and constant vigilance from Lydia, but he found himself forced to paint

less and eventually to give up altogether. "He would have painted all day if he could," Lydia said, "but it was too demanding." For most of the central years of the war, in the starvation economy imposed throughout France by German depredations, Matisse said that he hungered above all to paint.

He made do with drawing instead, falling back on Ronsard, whose music entranced and sustained him ("He helps me keep my moral balance," Matisse told Pierre in the dreadful summer of 1942).[125] He filled the wall where he lay with constantly changing illustrations, merging and dissolving into one another like a film sequence (Matisse called it his private cinema) which he could direct from his bed, cutting, adjusting and redesigning images in his head when he was too weak to work.[126] The twenty or thirty illustrations he had initially proposed grew in the end to the 126 lithographs of the *Florilège des amours de Ronsard,* which took eight years to complete. When he felt he had gone far enough for the moment with Ronsard, Matisse moved on to the medieval court poet Charles d'Orléans ("What limpidity"), finding new delights in his work each day, "as you find violets under the greenery."[127] He said he gulped down the poems like the great gulps of fresh air that used to fill his lungs when he could still jump out of bed in the mornings. His drawings took on even greater freedom and fluency now that he could no longer sustain the physical and mental labour of painting. "It's like a juggler," he told Marguerite: "He works more smoothly, his spirit is less intensely involved, when he juggles with three balls rather than with a ball, a plate and a chair."[128]

Fantasy, gaiety and good humour pervade Matisse's voluminous correspondence with Rouveyre, who served him all through the years he devoted primarily to illustration as an unofficial editor-cum-literary-consultant. Sensitive, meticulous and tirelessly attentive, inexhaustibly knowledgeable on everything from prosody to layout and typeface, Rouveyre advised on the selection of authors to illustrate, which edition to work from, what title to choose, and whether or not Matisse's drawings of sprawled, entwined and eagerly interlocking bodies were too overtly erotic ("I never know how to do things by halves").[129] The painter himself was well aware of the element of compensation and consolation in these supple and elastic young lovers, who make an unmistakably Matissean music of their own, as direct, sensuous and passionate as Ronsard's. "Why, if my sensation of freshness, of beauty, of youth remains the same as it was thirty years ago in front of flowers, a fine sky or an elegant tree—why should it be different with a young girl? Even if I can't lay my hands on

her . . . ," he asked Rouveyre. "It's probably what made Delacroix say, 'I've reached the happy age of impotence.' "[130]

A famous lecher himself in his day, scabrous and lewd, reputed to have slept with his niece (among countless others), Rouveyre claimed in his sixties to have turned into a hermit ("He hasn't changed much," Matisse wrote shrewdly to Marquet, recalling the time when all three were students together at Moreau's studio in Paris. "He dresses like a monk; I can see him still forty years back . . . got up in black velvet like a court prelate").[131] Rouveyre, who had laboured for years on a trilogy of autobiographical novels which he freely admitted to be almost unreadably arid, liked to picture himself as a solitary recluse brooding at the back of dark caverns lit only by the brilliance and warmth of Matisse's enthusiasm. He had once compared his friend to an electric light bulb, and Matisse now responded as if he had been switched on.[132] He copied out whole poems in his own handwriting, or got Lydia to type them out for him, posting them off to Rouveyre decorated, looped and tied with coloured crayon ribbons and bows, like parcels done up in gift-wrap. These letters led directly to the lightness and throwaway elegance of Matisse's *Poèmes de Charles d'Orléans,* a homage from one master to another, both specialists in anxiety, care and melancholy—*"Soussy, soing et mérencolie"*—and the art of keeping all three at bay. Rouveyre said he loved to watch Matisse's sap rising in response to Orléans.[133] The two old friends readily reverted to younger, simpler student selves in a correspondence that is cajoling and flattering on one side, flirtatious, even coquettish on the other. It papers over the cracks of old age—infirmities, ailments, setbacks, loneliness, despondency, fear—with boisterous jokes, gossip and ragging. Letters were exchanged daily, sometimes two or three times in one day. Matisse turned his envelopes into baroque extravaganzas of coloured stars, stripes and flowers, addressed in wild scrollwork lettering that won him unexpected admirers in the local post office.[134]

The exuberant vitality of these letters, written when Matisse was in his seventies—physically disabled, often gravely ill, hampered by chronic weakness, eye strain and the distressing side effects of his bowel reconstruction—gives some indication of the terrifying pressure his energy must have exerted on his immediate entourage in his prime, and the inordinate amount of backup and servicing required from his family to cope with it. Now they monitored his progress from a distance with gloom and misgiving. Marguerite, who spent nine months in all camping out in a hotel in Cannes, found it increasingly hard to maintain even a token

alliance with Lydia, whose name she refused to use and whose existence she would have preferred not to recognise. An awkward situation was complicated for both sides by the presence of Amélie in Cannes, miraculously recovered from her own disability, still unreconciled to her husband but reluctant in her turn to desert Marguerite, at whose side she had fought long and hard in the past. Relations with Cimiez were strained. "They think they've got so many rights over me that they can be irritating . . . ," Matisse grumbled about his family to Rouveyre. "My life doesn't seem normal to them, especially the fact that I've adapted to it so well."[135]

One of his surgeons had compared Matisse to a crystal vase holding a sharp, heavy stone that was liable to shatter its container if shaken.[136] Lydia took this image literally, turning the entire household into a protective shell designed to conserve the painter's resources and shield him from the slightest annoyance. Marguerite was dismayed by what struck her as the climate of indulgence and unhealthy adulation at Cimiez. Her father seemed cocooned and cut off from anyone brave enough to speak out and tell him the truth. At the end of May 1943, a month after she returned to Paris, she sent Matisse a stern call to order, warning against laxity, complacency and the onset of failing powers. She reminded him that the path of duty was arduous, and that she had his best interests at heart. Above all she deplored the influence of his secretary, who had inadequate experience of managing his affairs, and whose untrained eye could not hope to provide the rigorous critical appraisal that alone could stave off decline.[137]

Matisse put off replying to her letter for almost two months. Nice was expecting bombardment and possible invasion by the Allies in the wake of German capitulation in North Africa at the beginning of May. There was talk of evacuating children and anyone over the age of seventy. Matisse decided to retreat inland, following Rouveyre, who had moved a few miles away to a small hotel in Vence and now found him a place to rent for a year on the rocky, terraced hillside just above the old town. The Villa le Rêve was a plain, modest house with an overhanging red-tiled roof and yellow ochre walls, standing alone below crags on a south-facing stone platform cut out of the hill. Lydia inspected the premises, interviewed the owner and organised the move, going ahead with the cook, Josette (promoted from cleaning woman at Cimiez), to prepare for the arrival of Matisse and his night nurse on 30 June. This was the first time he had left home in two and a half years, and he could still walk no further than a few hundred yards, wearing dark glasses to protect his eyes. He intended to follow his doctor's prescription of two months' complete rest, planning to use the time to reflect and compose in his head now that he could no

longer paint, nor be sure that he ever would again. His room on the ground floor of the villa opened onto a terrace with steps leading down to a garden full of palm, olive and orange trees. Lydia bought a wheelchair, and arranged with the local butcher to supply vegetables from his own garden for the simple, largely meatless diet that suited Matisse. There was no telephone at the villa, no car, and a silence so deep he said he felt as if he had moved to another country.[138]

Here he finally composed a reply to Marguerite's letter, reviewing his position as much for himself as for her in a mood of exhaustion and deep discouragement. He said that, even though he had no illusions about ever regaining the vigour he had possessed at the height of his powers, he felt he had completed a lifetime's experimentation, and meant to make use of his discoveries no matter how unsatisfactory they seemed to others ("Ever since Lyon I feel myself no longer affected by the critics...and who knows how what I am doing at the moment will be judged in twenty-five years?").[139] As he considered the future, a familiar sense of injustice took over ("I've had enough of being hunted all my life, finding refuge in working like a galley slave"), and he cited the great predecessors—Rembrandt, Beethoven, Monet, Cézanne, Renoir—whose contemporaries had abandoned them in old age as he felt himself discarded now. "Must I stop work even if the quality deteriorates? Each age has its own beauty—in any case I still work with interest and pleasure. It is the only thing I have left." Matisse's long letter, which had taken so many weeks to formulate, was part self-defence, part passionate, painful appeal to the past, to posterity, and to his daughter, of all people the one he most wished to reach: "Understand me—you know how."

One of the common complaints that Marguerite felt it imperative to lay before her father was that his work remained in these years hopelessly out of touch with reality. In Paris, rumour said he was dying, that his efforts had sunk into childishness, and that his recent canvases were worth buying only for the sake of the signature. *Thèmes et variations,* through which he had hoped to appeal to a student market, had sold virtually nothing (five hundred copies—half the entire edition—remained stored in boxes for years in a mice-ridden cupboard at Vence).[140] Wartime conditions had forced Skira to postpone his edition of Ronsard indefinitely, and there was as yet no prospect of a publisher for *Charles d'Orléans.* Matisse had been approached in February by Henri de Montherlant, who, after trying for years, had finally found someone prepared to publish an illustrated edition of *Pasiphaë,* which was the only one of his works that appealed to the painter.[141] Matisse had used ordinary children's crayons to

Matisse, *Pasiphaë*

illustrate Orleans' poems, and for Montherlant he experimented with another despised, childish medium, using the linocut to reverse standard assumptions by drawing in dazzling white lines on a ground as black as the night sky. "This is the book of a man who can't sleep," said Aragon, when he saw Matisse's *Pasiphaë*. Matisse himself said it was the play's mythological reverberations that interested him, demonstrating what he meant in a linocut that shows the heroine transfixed, with her head flung back in a silent shriek: "a single white stroke against the black background, like a jagged flash of lightning," wrote Aragon, singling out an image that seemed to him to carry a resonance beyond anything in Montherlant's text.[142] "Perhaps in reality it was other *sufferings*, taking place beyond the walls of his house, that turned this ancient story, at any rate in our eyes, into a cry, like an echo of things that no one talked about in Matisse's presence."

Drawing, on paper, copper plate or linoleum, was a way of dredging up images from below the surface of the conscious mind, whose significance was not always obvious even to Matisse himself. He worked more and more by night, or indoors with the shutters closed, in these months when he found it hard to see properly by daylight (the eye specialist he eventually consulted diagnosed tension, prescribed rest, and advised him to stop listening to radio bulletins and to avoid talking about the war).[143] Linocuts gave him the spontaneity and directness he wanted, and so did the scissors-and-paper technique he had used for the "war number" of *Verve*. Just before Matisse left Cimiez in June, as Lydia dismantled his home and Allied warships patrolled the Mediterranean preparing to invade Europe, he picked up his scissors and started cutting out shapes as he had done four years earlier while waiting in Tériade's office for the war to begin.

"It was in the summer of 1943, the darkest point of that whole period, that he made an Icarus ...," wrote Aragon. "The *Fall of Icarus* ... between

two bands of deepest blue, consists of a central shaft of black light with Icarus laid out against it in white like a corpse, and, from what Matisse said himself, it seems that the splashes of yellow—suns or stars if you want to be mythological—were exploding shells in 1943" (colour fig. 24).[144] Tériade, who had been pressing Matisse for years to embark on a second collaboration even more ambitious than the first, was deeply impressed when the painter showed him this cut-paper collage together with another design of white dancers and bursting shells or stars on a green ground. The two would become respectively the frontispiece and the cover of a special Matisse number published as part of *Verve*'s celebrations the year the war ended. This *Fall of Icarus* also led directly to one of the twentieth century's most extraordinary printed books, the triumphant cut-paper inventions of *Jazz*, which Matisse worked on all through his first winter at Vence.

Allied armies landed in Sicily in early July, began bombing Rome and Naples, and finally invaded Italy after six weeks of ferocious fighting. On 9 September, the day after the Italians surrendered, the Germans entered Nice. Matisse's basement at the Villa le Rêve was commandeered as a canteen for German soldiers heading down to the Italian front.[145] Vence became part of a military support zone on pre-alert, expecting orders at any moment for civilians to leave. Flight seemed almost impossible, given Matisse's colostomy, which was still so capricious and difficult to manage that he told Marguerite he would not wish his worst enemy to go through the miseries it imposed on him daily. He said he was not sick, but wounded, "like someone hit by a shell blast, for instance, with the wall of his stomach blown away."[146] Air-raid sirens broke the silence in Vence as Allied bombers strafed the Côte d'Azur. Posts were disrupted, roads blocked, and trains derailed by the local maquis trained by Jean to use firearms and dynamite bridges.

"Courage, my dear Marguerite," Matisse wrote in October. "I often take courage myself from remembering how you have suffered all your life."[147] He worried about Marguerite's health, her journeys and her long silences now that she had gone back to Paris. Perhaps he already suspected that she had joined the Resistance, like Jean (also back in Paris that autumn, having got out just before his network was rounded up by the police in Antibes). Matisse had substantially increased the family's allowances twice since the start of the war, and he now provided large sums in case of emergency for his daughter and for his wife, who had stoutly refused Marguerite's suggestion that they should separate at this point. "It's only when the house burns down that I'm at my best," said

Amélie, snapping back into her old heroic form. "We've gone through so many campaigns together that I'm not giving up on you now. So what is there for me to do?"[148]

In the months leading up to the Allies' long-planned assault on the French Channel coast, Marguerite acted as a courier for the *Francs-Tireurs et Partisans,* the military section of the underground Communist Party, carrying messages hidden in her glove to and from Paris, Bordeaux and Rennes in Brittany. Amélie spent much of her seventy-second year typing out reports with two fingers on a battered typewriter for the FTP to pass on to British Intelligence in London. "As for me, I am made of the stuff of warriors, fanatics and all those consumed by ardour," Marguerite wrote to her father, declaring she could no longer stand back as he did from the spectacle of destruction and death, "even if I get my wings clipped for it—and even if I can no longer write calmly, now that most things seem to me so utterly without importance."[149] Matisse watched RAF bombers pass over Vence, heading east towards Nice and returning by Cannes, where the sky was lit up when a bomb fell on the gasworks in November. Snow fell that month. An explosion outside the Villa le Rêve battered the front door and injured two passers-by. The painter arranged to escape if necessary with Lydia by ambulance to a hotel in Annecy, leaving everything behind but his work.[150]

Matisse celebrated his seventy-fourth birthday with Rouveyre, and marked the new year of 1944 by posting a box of mandarins to Camoin (who had returned to Paris). He sent more oranges and lemons with a warm shawl, mattresses and a silk coupon—rarer than rubies in wartime—to Marguerite (whose elegant outfits provided useful cover for an underground agent).[151] As the bombardment intensified, the Germans planned to evacuate the sea front at Nice eastwards from Matisse's old apartment on the flower market all the way round to the port on the far side of the headland. "Death weighs heavy!" he wrote to the widow of his old friend Charles Thorndike, pointing out philosophically that neither of them had much time left anyway ("We'll be leaving the theatre before the end, but one can always guess what's going to happen in Act 3").[152] Lydia spent three days with a removal crew transferring the contents of the Thorndikes' villa near the port into storage at Cimiez. Snow lay thick on the hillside at Vence. Word came from Bussy, hanging on at Roquebrune, and Bonnard, holed up with a broken leg and a sack of beans at Le Cannet. Matisse himself spent much of the winter in bed, working on his *Jazz* illustrations, and reminding Bonnard's nephew of Winston Churchill,

who was said to be conducting the war from his bed in London with writing materials, a radio and telephones within reach of his hand.[153]

Keeping Matisse and his studio going on a bare mountainside so close to the firing line required phenomenal perseverance and ingenuity. Lydia had no help at home except for the cook, Josette, no outside support apart from the local doctor, and no recourse to the illicit supplies peddled by a thriving black market, which Matisse refused to patronise. For two years the whole country had been bled dry to supply the German army ("There's nothing left in France, no thread, no nails, no materials, not to mention anything to eat," Berthe wrote in January 1942, sending a precious cauliflower and a rabbit as a New Year gift to her brother-in-law).[154] By the beginning of 1944, basic necessities—food, heating, transport, communication—were virtually unobtainable. "But Matisse's survival depended on it, and Lydia set herself to solve the problems," wrote Annelies Nelck, a young Dutch painter who tapped on the door of the Villa le Rêve in February to ask for help with her work.[155] Nelck was astonished by Matisse's studio—"a strange space, luminous, full of flowers and greenery, furniture, undulating objects and moving colours, exotic creations"—and even more by the majestic apparition seated in the centre of a big wrought-iron bed, propped up against a mass of white pillows "like God-the-Father emerging from whipped-cream stucco clouds above the altar in one of the little baroque churches in the country round about."[156] Nelck posed for Matisse that spring, slowly coming to realise, as she became almost part of his household, how much effort went into keeping his health and safety intact.

Cold was a greater enemy than bombs or shells, now that fuel for the fire was even harder to come by than food for the table. Lydia, mindful of her Siberian childhood, heated the studio with a wood-burning stove and hung thick, heavy rugs at doors and windows to block the icy wind from the mountains. She scoured the countryside on her bike for provisions, negotiating with the tradespeople of Vence, and took boxing lessons to give her confidence in dealing with marauding soldiers. She became adept at moral as well as physical studio management, countering the painter's spleen and despair as patiently as his practical difficulties. She had a knack of defusing outbursts so skilfully that Matisse became literally speechless, "like a pot of boiling water removed from the fire," in Nelck's expressive phrase.[157] As a last resort Lydia threatened to go back to her homeland to serve as cannon fodder on the Russian front ("And, you know, she'd be quite capable of it," Matisse observed to his night nurse).[158] The serenity

that struck Nelck and others in Matisse's studio, the impression of Jove-like calm and Churchillian control, was bought by a daily, unremitting, mutual campaign to subdue and control the inner turbulence that broke out at intervals in cries, palpitations and crises when his heart raced and he struggled for breath. "His feelings were very strong," said Lydia.

Bombs were still rattling the doors and windows of the Villa le Rêve in April, when Matisse received what turned out to be a last letter from his daughter, a hurried, anxious note written on Easter Monday, 10 April. Three days later she was arrested by the Gestapo as she stepped off the Paris train onto the station at Rennes. Amélie was taken to Gestapo head-quarters in Paris for interrogation the same day. "I've just had the worst shock of my life," Matisse wrote to Camoin, describing what had happened, explaining that he had been warned to tell no one, and urging his friend to destroy the letter as soon as he had read it.[159] Attempts to discover more than the bare facts were blocked on all sides in the climate of terror that had intensified throughout France in the last few months, as denunciations and police round-ups became part of normal routine. People constantly disappeared without explanation, imprisoned, deported or shot. Questions were met with closed doors and shut mouths. Matisse appealed to anyone he could think of who might provide information, sending copious funds for Jean to disburse in the search.[160] A promise of help came from the etcher Demetris Galanis, a family friend whose son had been torpedoed in the Atlantic, and whose daughter-in-law had put Marguerite in touch with the FTP in the first place. Vague offers to inter-vene came from Fabiani and from the playwright Sacha Guitry (who also had extensive Nazi contacts), but most Parisians were too nervous to be of much use. "Besides, it has to be admitted that all those who said they would do something had soiled hands—they were compromised," Matisse wrote afterwards. Any possible leads at the time were muffled in suspicion and secrecy. "Even the high-up Germans were afraid," Matisse reported, "because over them was the Gestapo."[161]

Apart from Lydia, almost the only person Matisse talked to about his family was Nelck, who had escaped from Holland when she discovered she was pregnant, leaving the child's father behind to work for the Dutch Resistance. "Things are difficult for everyone at the moment," Matisse said gently, telling Nelck of his own trouble, when news came at the end of May that her lover had been arrested and was being held in a prison hospital, awaiting deportation to Belsen.[162] In the first week of June the Allies landed in Normandy to begin advancing south and east, driving the Germans before them through France. Matisse had plunged back into

work, attempting to blot out his feelings by illustrating Baudelaire's *Fleurs du mal*. "I know he scarcely sleeps any more," Nelck wrote in her diary in June. "Anguish for his wife and his daughter gnaws at him ceaselessly, but he allows nothing to show." After three months without news Matisse finally learned from Galanis that Amélie was serving a sentence of six months in the prison at Fresnes. "I daren't think of Marguerite, about whom we know nothing. Nobody even knows where she is."[163]

Matisse collapsed in a fever with symptoms that made his doctor fear a recurrence of the liver problems of two years before. It was the middle of August before he could set foot out of bed. By this time Allied forces were landing along the coast between Marseilles and Nice, and beginning to sweep up through the Rhône valley to meet the armies marching down from the north. Paris was liberated on 24 August. Nelck, posing three days later for a drawing for the *Fleurs du mal*, cried out when she saw a troop of enemy occupants march past the window, but Matisse did not even turn his head. "Never let it be said that I stopped work to watch the Germans depart," he said grimly.[164] Vence was liberated without incident, except for three stray shells falling round the Villa le Rêve (Matisse descended with Lydia and the terrified cook to a shelter in the garden, where he spent thirty-six hours reading Bergson with concentrated attention for the first time in his life). The Red Cross headquarters in Switzerland, to whom Matisse had appealed for news of his daughter, sent word too late through their French representative in Rennes that she had been imprisoned there all along.[165] Matisse's money order arrived only after the Germans had deported their political prisoners the day before Allied troops entered Rennes, loading Marguerite along with the rest onto railway cattle trucks destined for the Ravensbruck concentration camp in Germany.[166] Nothing could be done or found out.

The country erupted in delirious rejoicing, with dancing in the streets and flags everywhere. A fever of vengeance swept France, producing girls with shaven heads even in Vence, and heaping public disgrace on the notorious band of artists headed by Derain and Vlaminck, who had rashly accepted official invitations to tour Germany two years before. Derain's reputation was ruined forever, and Vlaminck was arrested for publishing a series of venomous attacks during the Occupation on fellow artists (including Picasso, who now chaired the national committee busy purging the art world of suspected collaborators). "At bottom I don't believe it's up to any of us to torment people with ideas different from our own," Matisse wrote, as the hysteria of liberation turned sour.[167] By this time Picasso had joined the Communist Party, announcing his decision with

fanfares on 3 October in the same week as the opening of the first post-liberation Autumn Salon largely dedicated to himself and his work.

Amélie was released at the beginning of October. A few days later a postcard from Camoin reached Vence, announcing that Marguerite was free. This was followed by a card from Marguerite herself, posted from the Dole on her way home to Paris.[168] "In spite of everything, I always knew you would survive," wrote Matisse in a letter full of love, incredulous relief and passionate longing to be with her again. "Oh why can I not get to Paris?"[169] Over the next few weeks Marguerite wrote several times to her father, calmly and clearly describing her experiences in the five months of her disappearance. She had been tortured to the brink of death at Rennes in April. German Intelligence, suspecting that the Allies planned to land their invading armies in Brittany, urgently needed names and information. Marguerite was interrogated by Gestapo agents who beat her with their fists, bursting her eardrum, then shackled her by wrists and ankles to a table while two other men beat her alternately with a steel flail and a triple-thonged rawhide whip.[170] She was suspended by her wrists for a second beating by fists, then repeatedly immersed in a bath of ice-cold water and held under until she lost consciousness. Locked up alone in a cellar without treatment—for two days without even water—Marguerite feared that she would not be able to resist further torture, and tried unsuccessfully to kill herself by slitting her wrists with a splinter of broken glass.

She was saved by her fellow political prisoners, who had been assured by the Red Cross that there would be no more deaths under interrogation in the prison, and who reacted so violently when word got round that a woman was being tortured to the furthest limits that the prison commander had no alternative but to reprieve Marguerite. After four months she was transported eastwards on the last train to leave Brittany, which was strafed by Allied bombers, held up by impassable bridges over the Loire, and finally halted just before the German border, at Belfort. In the ensuing chaos she was released almost at random, without money or papers, into a town whose inhabitants had locked their doors and windows against an influx of fleeing collaborators who were behaving like wild animals in their frenzy to get out of France. Marguerite was found hiding in the woods by members of the local Resistance, who looked after her until the liberation. The doctor who examined her on her return to Paris said she had survived by a miracle. The surgeon who had operated on her throat in 1919 found her windpipe still in working order.[171] Her experiences had left her without nightmares, able to eat and sleep normally. She was haunted by thoughts of the companions she had left behind, who were now in a

German death camp, but she said that the horrors she had gone through herself had fallen from her as if she had stepped out of a coat she refused to wear. "I always wanted to master my body, and the sufferings it imposed on me...," she told her father. "You have to show yourself in face of everything, and against everything, tough enough to stay upright."[172]

Matisse recognised the philosophy of endurance he had taught his daughter carried to lengths even he had never imagined. Appalled by her account, astounded by the power of her will, he begged her to look after herself, sending long letters of encouragement, advice and admiration, and small packets of luxuries. Christian Zervos, who ran into Marguerite by chance at a concert in Paris, said she glowed with an inner radiance that gave her an almost unearthly beauty.[173] Rouveyre, who saw her briefly when she finally reached Vence, said the same ("How touching she is, and how lovely, after that terrible ordeal. It didn't kill her, but it has ringed her with light").[174] She came, after three months' recuperation, in the middle of January 1945, travelling by plane with priority treatment arranged by her father, who sent a taxi to meet her at the Cannes airport and booked her a room in Rouveyre's small, warm hotel in Vence. For two weeks they spent every afternoon alone together. Matisse said he was literally hypnotised by what she told him: "I saw in reality, materially, the atrocious scenes she described and acted out for me. I couldn't have said if I still belonged to myself.... I was aware several times in her presence of taking part in the greatest of all human dramas—in a side of the existence of others which it is rare to be able to live through with such intensity, to the point where you no longer feel yourself existing separately."[175] For much of the time he was powerless even to draw her.

At the end of the month two neighbours in Vence, the dealer Aimé Maeght and his wife, drove her in their comfortable car through snow and blizzard back to Paris.[176] Matisse was knocked flat for three days when she left. Work was no help to him now. He told Marguerite it was almost a fortnight after their journey to hell and back before he could even begin to function again. People all over France were intent on celebration, levelling old scores and laying foundations for the brave new purged and liberated world of the future. "As for me, I'm caught up in the agonising whirlwind of my daughter's memories of captivity," Matisse wrote to Rouveyre at the end of January. "I've been demolished by it."[177]

CHAPTER TWELVE

∾

1945–1954: *Vence, Paris and Nice*

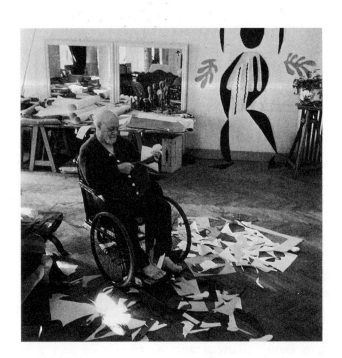

Matisse in the
studio at Cimiez

P eople who visited Matisse in Vence after the war commonly
reported two successive surprises. The first was to find him living in
such a boxlike little house: the Villa le Rêve was so plain and unas-
suming that Picasso initially knocked at the door of a more picturesque
place further up the road, and had to be escorted back by a neighbour to

the right front gate.[1] The second surprise was stepping over the threshold from the sunlit garden into a pitch-black entrance hall. "We entered one room and then another," wrote Françoise Gilot, describing her own first visit to the villa with Picasso. "All shutters were closed, and everything stood in obscurity. As our eyes accommodated to the darkness, the objects gradually emerged from the shadows."[2] In one room light filtered dimly through the tracery of a *moucharabieh,* or Arab screen. White doves flew freely in another. Pots, plants, ornaments and oranges scattered on chairs or tables appeared to come to life, and to be even more alive in the still lifes hanging behind them in the gloaming. "A date tree swinging its palms in the garden outside was framed by the window's colourful Tahitian curtains, and repeated, larger than life, on the wall, as if the strength of this painting allowed reality to become a mere reflection."

Gilot was not the only one who came to think of Matisse in these years as a magician, expanding or contracting space at will ("Space has the boundaries of my imagination," he said simply when asked to define its limitations).[3] Many people felt in his studios at Vence or Cimiez as if they had entered another world, or crossed into a different dimension of the one they knew. Aragon, in a characteristically baroque extended metaphor, compared himself to a hero from Italian romance lost in the enchanter's garden, entranced, disorientated and increasingly aware of being an alien intruder in this strangely ordered universe, "like a man who penetrates the consciousness of another and, without grasping its law, divines its singular coherence."[4] Matisse, who said that every drawing or painting was a morsel of himself, seemed in the closing decade of his life to have turned even his physical environment into an extension of his own way of seeing.[5] It was the final stage of a trick he had first performed in Moscow before the First World War, when the exuberant pinks and greens of Shchukin's drawing room were somehow absorbed into the more powerful reality projected by the twenty or thirty canvases hanging on the walls.

Matisse was operating literally as well as metaphysically on the borders of perception. "I'm out of action because of having flirted for too long, more or less nonstop, with these enchanted colours," he had written to André Rouveyre at the end of 1943, when the paper cut-outs he made for *Jazz* brought his lifelong confrontation with colour to a climax.[6] His Nice oculist (who had treated Monet in his last years in Paris) explained that the eye could not fabricate pigment fast enough to keep up with the speed and intensity of Matisse's response to colour. The painter said he had achieved the same intensity before without being able to sustain it, like a juggler throwing his clubs so high he couldn't catch them ("I was per-

fectly capable of pinning down on canvas the colours that give me relief . . . but I had no way of keeping them at that pitch").[7] Now he cut or carved directly into colour, using scissors and sheets of painted paper, working all day and much of the night, covering his walls with a display of unprecedented brilliance and fluidity. "He lived in and for it," said Lydia. Warnings that this kind of strain might permanently damage his sight could no more stop him than his father's insistence that he would starve had prevented him from becoming a painter in the first place. Matisse lived in darkened rooms, and even took a kind of pride in the fact that his eyes required protection from his latest work.

At the beginning of 1945, he told his daughter he had gone as far as he could with oil painting. From now on he meant to concentrate on larger decorative projects beyond the scope of conventional spatial or conceptual constraints: "Paintings seem to be finished for me now. . . . I'm for decoration—there I give everything I can—I put into it all the acquisitions of my life. In pictures, I can only go back over the same ground . . . but in design and decoration, I have the mastery, I'm sure of it."[8] He felt the same surge of energy he had experienced as a boy when he held his first paint-box in his hands. Now as then he had no time to lose. "I asked my doctors in Lyon for three years' respite in order to bring my work to a conclusion—that was four years ago, and there are still things I haven't said." This was the last great liberation of his life. He plunged headlong—"without thought, especially without afterthought"[9]—into a new world of decoration whose patterns corresponded to the inner movements of his mind. Its infinite possibilities embraced both strength and weakness (or rather, as he said, eliminated conscious distinctions between the two). Its rhythms freed him at last from the inhibitions of the will. Spontaneity was its greatest gift.

"When we arrived we found Matisse armed with a huge pair of scissors, carving boldly into sheets of paper painted in all kinds of bright colours," wrote Gilot, describing another of her visits to the villa with Picasso, when their host sat up in bed holding the paper delicately in his left hand, winding and turning it beneath the blades in his right, which released a steady stream of cut-outs dropping onto the coverlet below.[10] "There is nothing to resist the passage of the scissors," said Annelies Nelck, "nothing to demand the concentrated attention of painting or drawing, there are no juxtapositions or borders to be borne in mind. And the little creatures extracted from their element fall from the scissors in quivering spirals, and subside like those fragile organisms the sea leaves washed up on the sand."[11] Matisse worked without fumbling or hesita-

tion, comparing himself repeatedly in these years to an acrobat or juggler. Mind, hand and eye flowed effortlessly together ("It's like a dance," he said).[12] People who watched him found themselves almost hypnotised by his gliding fingers. Once, Gilot and Picasso brought a real magician to Matisse's bedside as a tribute. Matisse returned the compliment by making abstract portraits of them both, one after the other, cutting out shapes, then sorting, selecting and fitting them together on a coloured ground, "until finally the entire assemblage started to interact and bloom," ready to be pinned in place by Lydia. "We were spellbound, in a state of suspended breathing...," wrote Gilot, describing a performance that reduced Picasso to stunned silence. "We sat there like stones, slowly emerging from a trance."[13]

Every barrier Matisse had broken through in the past had cost him fearful pain and labour. In his seventieth year, he said, he still felt the urge to strangle someone before he could begin to paint, and likened the act itself to slitting an abscess with a penknife.[14] It was only when shape and colour began to interest him to the exclusion of all else that he started experimenting with speedy new techniques—scissors-and-paper, linocuts, children's colouring crayons—all aimed at eliminating friction. "I would say it's the graphic, linear equivalent of the sensation of flight," he said of his cut-paper work, explaining that scissors in his hands became as sensitive as pens, pencils or charcoal sticks ("perhaps even more so").[15] Drawing with scissors effectively abolished the frontiers between thought, feeling and expression. It allowed him to concentrate on overall effect rather than component parts, a knack perfected in more traditional ways of drawing where he no longer worried about inessentials, "any more than a juggler in action thinks about rain or tobacco or beer as his umbrella, his pack of cigarette papers and his beer mug spin through his fingers."[16] The new technique capitalised on the elasticity and confidence acquired initially from etching, and developed in the illustrated books, which came out at intervals after the war: *Les Fleurs du mal* in 1947, the sumptuously simple *Florilèges des amours de Ronsard* in 1948 and *Poèmes de Charles d'Orléans* in 1950. All of them caused misery to editors, printers and their workmen, who learned to dread Matisse's fastidious and exacting supervision as much as they relished the phenomenal boldness and precision of his hand in action. Drawing on highly polished copper plates, swerving and swooping over a surface less resistant than drawing-paper (which swallows the ink and slows the pen), produced a crisp, decisive, calligraphic style that flowed directly into the breathtaking condensations and abbreviations of his large-scale late work in cut-paper.[17]

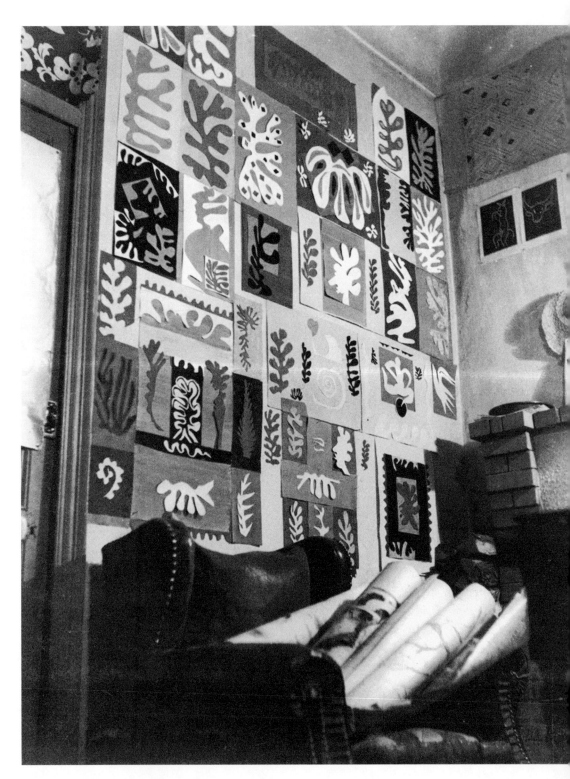

A wall of cut-outs in the studio at Vence

At the time, Matisse said he had no specific aim in mind when he covered the walls of his studio with coloured cut-outs. In retrospect, he came to look back on the years of solitude and wartime privation in Vence as a period of preparation, the equivalent of a musician practising scales and exercises, or an acrobat rehearsing balancing techniques before walking out on the high wire.[18] He said he had been mistaken all his life in measuring the significance of any given work by the struggles that went into it.[19] In his mid-seventies he felt himself approaching the clarity, power and purpose evoked by Paul Valéry in a passage Camoin copied out for Matisse at the end of 1945: "Perhaps what we call perfection in art . . . is no more than the sense of wanting or finding in a human work that certainty of execution, that inner necessity, that indissoluble, reciprocal union between design and matter, which I find in the humblest seashell."[20]

Matisse had come as close as he ever would to dissolving the demarcation lines between art and life. "Everything was for his work," said Lydia. "He ate sparingly so as not to have problems with digestion, he took a siesta in order to be rested for the next work session, he hired a night nurse in hopes of claiming as many hours' sleep as possible." The process of dissolution was simplified by Lydia, who defined her role of secretary in the same generous terms as her compatriot Diaghilev ("A secretary must know how to make himself indispensable," said Diaghilev, outlining the services he required from any youth taken on in this capacity).[21] Matisse's visitors never tired of speculating about Lydia's status—"she gave the impression of a slave, a very beautiful slave"[22]—and the precise functions she performed. But her air of Oriental mystery concealed impressive, if unconventional, administrative talent. She typed, kept records, paid bills and drew up meticulous accounts, organised Matisse's correspondence and coordinated his business affairs with steely efficiency. Her will was indomitable, and her exploits legendary. One summer's day in 1945, Lydia set out to dispatch an urgent package to a publisher in Paris only to find rail services unexpectedly disrupted in Vence, so she raced down the mountain on foot, walking fifteen miles in broiling heat before picking up a local train further along the line in time to reach Nice and deliver her packet to the guard of the Paris express with seconds to spare.[23] Matisse kept up a running joke with Rouveyre about Lydia's real and imagined capacities in all departments, whether it was solving problems of logistics, subduing resistance from unruly editors and dealers, or simply piloting an aeroplane ("It would surprise me if she didn't know how to fly one").[24] He claimed that his entire household came to a standstill in her absence. Lydia for her part never modified or withdrew her allegiance to Matisse,

who had given her life a purpose, and trained her to fulfil it. "Without insisting or explaining anything, he made me useful," she said, "and little by little, I became even more useful than he'd hoped."

Matisse left a graphic record of her progress in two very different portraits. The first—*Young Woman in Blue Blouse*, a tiny canvas gleaming with springlike gaiety and freshness, painted at the outset of their alliance in the autumn of 1939—shows Lydia with straight nose, pink cheeks and yellow hair in a dove-blue dress, looking childishly neat and simple, even prim, but upright and centred like the plumb line. "I was a dimwit in those days," she said long afterwards, "totally ignorant of anything to do with painting." In 1947, Matisse reviewed their partnership again, painting her this time with deep green hair and clearcut, authoritative features sharply divided by geometrical zones of blue and yellow in what he called the *Bicoloured Portrait.* "I had changed during those years," said Lydia. "Responsibility made me like that. I felt my personality completely altered. Before I was shy and inward looking. But it was necessary for me to go into action, to see to everything, to give orders."[25] Lydia had acquired very nearly mythical status by this time in the envious eyes of other painters. She washed Matisse's brushes, cleaned his palette, pinned his flimsy paper

Matisse, *Young Woman in Blue Blouse (Portrait of Lydia Delectorskaya)*, 1939: "I was a dimwit in those days, totally ignorant of anything to do with painting."

shapes in place with a deftness and accuracy even he could not fault. Her prowess in the studio was matched by her reputation as the dragon guarding his privacy against encroachment from the outside world. She kept track of appointments, dealt with workmen and suppliers, engaged and managed models and assistants in the atmosphere of disciplined tranquillity that struck everyone who visited his studio. All these routines were first established on a solid footing in the years of wartime seclusion that she and Matisse spent together at Cimiez and Vence.

The two people who encountered them daily at this time—André Rouveyre and Annelies Nelck—both thought of Matisse and Lydia as a single unit. Rouveyre, who relied implicitly on Lydia's artistic as well as practical judgement, said he found it hard to see them as separate entities.[26] To Nelck, who had turned up in desperation on their doorstep, they showed a concerted front of tolerance, kindness and concern. "I was a child, in a catastrophic state when I came to them, and instead of throwing me

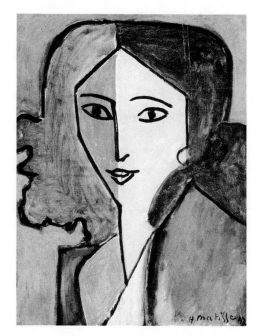

Matisse, *Portrait of Lydia Delectorskaya*, 1947: "I had changed. . . . Before, I was shy and inward-looking. But then I had to go into action, to see to everything, to give orders."

out, they gave me, both in their different ways, the most precious thing they had: their time and their attention."[27] She was by her own account ill, poor, malnourished, unstable, at times almost frantic with misery and foreboding. All she knew about Matisse at that stage was that local people said he was a painter. Between them he and Lydia slowly calmed her perturbed and angry spirit ("What is so marvellous about these two," she told her diary in 1944, "is that they understand everything without ever passing judgement").[28]

Over the next six years Nelck became for all practical purposes an adopted daughter of the house, posing, running errands and helping Lydia in the studio. Matisse took charge of her education as a painter, gave her employment as a model, found buyers for her work ("I told them your usual price was 1,000 francs for a portrait"), and presented her with occasional drawings of his own ("so that, in case you ever need it, you have a little reserve to dip into," Lydia explained). Nelck said he taught her as much about order and balance in her life as in her painting. Her testimony as to how he and Lydia functioned in private as a couple remains unique. Like Aragon, she saw their exclusive absorption in Matisse's work as a form of defiance, a stubborn joint refusal to be outfaced by potentially disastrous odds. "I was a witness of the daily unobtrusive exercise of heroism and virtue, and I could recognise its results," she wrote, describing an

433

ascetic regime stripped of superfluous social or domestic content, permanently attuned only to Matisse's needs as an artist.[29]

He and his doctors knew well enough that in the last resort his life depended on Lydia. He had no illusions about his own chances of survival as he watched his friends claimed one after another in the next few years by infirmity and death. The first to leave was Aristide Maillol. "He ranked senior to us all and now he's gone...," Matisse reported in one of his first letters to Pierre after the liberation. "I hope his lieutenants will have better luck—they're rather shaky, but I hope they'll hold the fort for a bit. You know who I mean by the lieutenants—there's Bonnard, who's seventy-nine and can still get about... then there's me, hoping with minute care to keep going a while longer."[30] Bonnard survived the war, largely thanks to the attentions of Aimé Maeght, who had set up a kind of one-man emergency supply service for artists from an unpretentious picture shop on the Cannes sea front ("Did you notice his canvases?" Matisse asked shrewdly, when Nelck returned from delivering a message to Maeght's house in Vence. "He may well be going to turn into a great picture dealer").[31] The rest of Matisse's little band of companions along the coast—Rouveyre, Bussy, Camoin at St-Tropez—remained intact, if depleted and less mobile than before.

But Berthe Parayre, who had sworn to live long enough to see France liberated, lay dying from cancer at Beauzelle that spring. "Berthe, poor Berthe, ending her life so unjustly after a life entirely given to others," Matisse wrote to Pierre, who reached France just too late to see his aunt alive.[32] She died on 4 June 1945, a month after the German armies surrendered unconditionally in Europe. Amélie spent the final weeks at her sister's side. In the six years since Matisse had last seen his wife, their roles had been dramatically reversed. Whereas he would spend the rest of his life more or less bedridden, she had regained the fighting spirit of her buccaneering Parayre forebears, sailing through the ordeals of arrest, interrogation and incarceration, emerging with aplomb in excellent health to face a prosperous old age surrounded by the pictures which, as she firmly reminded her husband, had been at the core of her life as well as his.[33]

In the spring of 1945, Matisse's oldest friend, Léon Vassaux, came to stay with him in Vence, looking unrecognisably bent, frail and worn. Dr. Vassaux had grown up with the painter and had been his first collector, owning half a dozen luminous little landscapes and still lifes from the 1890s, all of which he had been forced to sell except the last ("It's kept you company all your life," Matisse said encouragingly, proposing to find his

friend a buyer, "and now it can help you through old age").[34] The two reverted to an easy, companionable intimacy, exchanging news, relaxing over good food, wine and music, capping one another's stories of their Bohain boyhood and their student escapades on the Left Bank. They sampled the hearty onion soup and sipped the strangely flavoured nips of neat spirit peculiar to their native North, carefully prepared and served to them by Lydia. She said Vassaux released a side of Matisse—buoyant, jokey, uninhibited—he showed no one else. The doctor gave his host a check-up ("I've never come across an invalid looked after with anything like such understanding").[35] But Matisse was shocked by the dilapidation of the childhood comrade who had sheltered him at intervals for forty years and more, providing a haven of unchanging calm in the painter's long career of turmoil, panic and upheaval. Now it was the other way about. Vassaux remained as perceptive, humorous and kind as ever, but the pressures of his respectable, well-regulated life as a country doctor had crushed his capacity for renewal. Memories of their youth provided temporary refuge from an overwhelming sense of inertia. "I would like to think that energy and courage are contagious," Vassaux wrote sadly to Matisse. "I'm a little younger than you are but of the two of us, it's me that's aged, which is as it should be, because of the two you alone still have a goal in view, an ideal, and what an ideal!"[36]

The second time Vassaux came to stay, he brought with him Matisse's first sculpture, a clay medallion of the girl they had both loved as students more than half a century before.[37] Camille Joblaud, Marguerite's mother, was now also in her seventies, married to a retired schoolmaster in Brittany, and sustained in old age by the golden recollected glow of her short reign as the toast of the artists' quarter in bohemian Paris. Matisse, who sent money and received news of her from time to time through their daughter, hung her plaster portrait on his wall in valediction. His thoughts ran on lives he might have led, prompted by a passage from Gérard de Nerval about the suicide of a beloved friend, which he copied out and decorated.[38] He told Lydia it reminded him of Olga Meerson, another beautiful Russian who had loved him dearly, who had killed herself in Berlin under Nazi rule, and whose death he now commemorated in cyclamen-pink ink with a wreath of blue-ink ribbon.

Over the next few years, the sculpted profile of Camille would appear and reappear in a final astonishing set of variations on a theme first painted in her living presence, the studio interior. These canvases—*Red Interior, Still Life on a Blue Table, Still Life with Pomegranates* and *Still Life with*

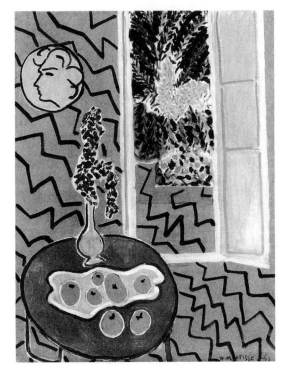

Matisse, *Red Interior, Still Life on a Blue Table*, 1947, showing the clay medallion of Camille Joblaud hanging on the wall of the Vence studio

Pomegranates on a Ground of Venetian Red, all produced in 1947—incorporate the claims of the past without nostalgia or false sentiment in the patterns of the present. They belong to a group of nearly thirty views of the studio at Vence, the last pictures Matisse ever painted, which project light and colour with a vitality so intense it seems almost independent of its physical origins. They look forward to new forms of pictorial abstraction, and at the same time they recapitulate a mood of inner contemplation that goes back to Matisse's earliest work, a Proustian sense of time, telescopic and infinitely adjustable, like space.

On 3 July 1945, Matisse returned to Paris, travelling by sleeper on the train with ambulances laid on at either end, to prepare for the joys and strains of a complicated family reunion. Jean had settled at Issy, working in his father's garden studio and living with his family in the town. Marguerite was installed in her apartment on the rue de Miromesnil that summer, awaiting the return of both her husband and her son from wartime exile in New York. Amélie had moved back into Marguerite's spare room again to lend support. Pierre was the first to reach France, flying in at the end of July to resume in person the extraordinary postal conversation with his father, interrupted in the past six years only by Matisse's operation and the blockade of the Atlantic.

Throughout the public and private dramas of the war, Matisse had articulated his hopes, doubts and fears in weekly letters of up to twenty pages, written on both sides of transparent airmail paper, sometimes with extra lines crammed in at right angles across the top of the original message, as if he could scarcely bear to break contact with Pierre. The letters

convey on both sides a depth and tenderness of feeling neither party could find words for face-to-face. Father and son alternated roles, offering one another sound advice and sensitive consolation, occasionally enlivening their civilised exchange with tirades of Racinean fury or reproach, in a correspondence that combines a diary's scope and freedom with the frankness of the confessional. Like the confessional, it would retain its secrets to the end of both their lifetimes. In public, Matisse's treatment of his son was often wounding or dismissive. Pierre grumbled loud and long about his father. Neither family nor friends suspected the hidden side of a relationship increasingly poisoned on the surface, as postwar prices rose and stocks of paintings dwindled, by Matisse's ingrained mistrust of the dealers' trade.

Terms had to be renegotiated all round in the summer of 1945, as the family slowly adjusted to new positions at the margin of Matisse's life and work. He himself was wary and on edge. This was the first time since the official separation from his wife that he had confronted the outside world with "Madame Lydia" at his side. They settled into the family apartment on the boulevard Montparnasse with a night nurse and the cook from Vence, but although neither studio nor household could function without her, Lydia's position was painfully equivocal. No one knew what to call her, how to treat her, whether or not to take seriously a secretary who combined the role of chief executive with the duties of model, nurse, companion, studio aide and office dogsbody. Male visitors reestablishing official links with Matisse after the war were intrigued by her virtually invisible presence in his apartment. Married couples could not receive her, and her professional credentials would take years to establish with the Paris art world. Lydia set no store by social life, but even business contacts made privacy impossible, since Matisse scheduled appointments at home and ran his affairs through her.

"I'm going to try to isolate myself by behaving as if I were still absent," Matisse had announced before he even reached the capital, but his hopes were dashed by a regular tide of journalists, government envoys, exhibition organisers, dealers and curators washing through the apartment every afternoon.[39] "Paris is hell," he wrote after a fortnight to Rouveyre.[40] Publishers and the dentist took up such time as he had left ("If you knew what I've been through, you'd have toothache yourself"). After a month, he caught bronchitis. Exhaustion was compounded by official attempts to requisition his apartment, and by a failure of the heating system in the vaults of the Banque de France that disastrously affected the work in storage. The ten weeks or so initially set aside for Paris lengthened to a stay of

four months, much of it spent assessing damage, relining canvases and drying out hundreds of waterlogged, often mildewed etchings.[41] Matisse lurked in his room as if it were a hole or cave, rarely leaving the apartment except for visits to the cinema (his first colour film, starring Danny Kaye, was a revelation), or trips to a shooting booth on the boulevard Montparnasse, where he and Lydia hired rifles to relieve their feelings.

Marguerite had warned her father about the campaign of persecution and denunciation raging in liberated Paris against anyone accused, with or without reason, of having collaborated with the German occupiers.[42] Fabiani was arrested, and Albert Skira was refused permission to reenter France. Matisse himself would eventually be forced to drop a scheme to erect a memorial in the Midi to Maillol,[43] whose name had been tainted by the Vichy regime's attempt to rebrand him as France's equivalent to the Nazis' "sculptor of the future," Arno Breker. The mindless virulence of these witch-hunts dismayed Matisse at the time and afterwards. "I don't see what good my protests would do," he said when Mme Marquet urged him to speak out against the infamous wartime delegation headed by Derain and Vlaminck. "You know that those who went to Germany were driven to it by a kind of fright, and they've already suffered for it."[44] Political involvement was not in Matisse's nature, but neither would he criticise Picasso, whose public pronouncements had made him the popular embodiment of the liberty and patriotic pride—la Gloire—in whose name so many excesses were committed. "I don't think like him," Matisse explained to his daughter, who had endured too much real suffering to be impressed by Picasso's posturing, "but it's difficult for me to judge him—he has let himself get caught up in it like Zola before him, and Anatole France. I think an artist has so great a need of solitude, especially at the end of his life, that he should close his doors to everyone, and not waste a single hour."[45]

For all his reservations, Matisse, too, was currently in process of being promoted to the rank of national treasure. Official attitudes changed drastically in this postwar period, when, as Pierre pointed out, the only aspect of France's immediate past in which she could still take unqualified pride was the achievement of her artists.[46] In the first four and a half decades of the twentieth century, the state had bought two paintings from Matisse. In 1945, it bought seven more. This solid nucleus of a collection was earmarked for the new Museum of Modern Art, due to open in 1947 with a room apiece devoted to Matisse and Picasso. Meanwhile a grateful nation acknowledged the debt owed to its allies across the Channel by exporting twin shows of Matisse and Picasso to the Victoria and Albert

Museum in London. A film about Matisse was in the pipeline, and the Autumn Salon put on a special display in his honour. Tériade's resplendent *Verve*—the long-planned *Matisse on Colour*— came out in November, followed by an exhibition of recent paintings to inaugurate Maeght's newly acquired gallery in Paris in December.

Matisse escaped a month before Maeght's opening, to sink back thankfully into the monotony of Vence. "Eight days without seeing anyone, what a treat!" he wrote to Marquet. "Work, books and a radio, that's quite enough for a modern hermit."[47] He painted by day and drew by night with pencils, pens or scissors. Lydia found him two unlikely models.[48] The first was the daughter of a Russian shopkeeper in Nice, Doucia Retinsky, who posed for illustrations to a book of love letters written by a medieval nun, *Les Lettres portugaises.* Recruited as a replacement for Lydia herself ("I was too austere," she said), Doucia at fourteen had a plump, peachy bloom that suited the mix of innocence with passion in this fizzy little text. The second model was a boarder from a local pension, Mme Franz Hift, slender, graceful and part Congolese, a Belgian lawyer's wife more than happy to relieve the boredom of convalescence in Vence by flirting with Matisse. Young Mme Hift had sat for him before without any definitive result, but now—after twelve months of painting virtually nothing—he put her at the centre of some of the richest and most surprising decorative compositions he ever made.

Everything on the canvas in *Young Woman in White Dress*—the floor, the walls, the black doorway, the model in her long skirt and spreading mantle of white tiger skin, the striped chair-back behind her and the potted plant at her side—retains and simultaneously dissolves its own identity in the fabric of the painting. The effect is even more pronounced in *L'Asie,* where the broad, flat, tawny oval of the model's face supplies a template repeated in the sensuously coloured patterns of right shoulder, left arm, and the wrap that appears to float in soft, feathery, mauve-and-blue curves above the anchorage of a geometrical red ground. Early in 1946, Aragon turned up in Vence, seeking refuge from the communist purges and intellectual vendettas of postwar Paris, to find the Villa le Rêve hung with "pictures more beautiful than ever, young, fresh, luminous, full of gaiety, more so than ever before, and more confident in light and life."[49] Matisse's work seemed to breathe a different air from the harsh, drab, materially and spiritually impoverished climate of Europe in the 1940s. "I do it in self-defence," the painter explained bleakly.

He sent Lydia to Le Cannet with *L'Asie* and *Young Woman in White* on extended loan to Bonnard, who had lent him a *Basket of Flowers* in his late

style. Each was mystified by the other's approach to colour ("I'd like to be able to do what he's doing," Matisse told Nelck, "and he'd like to do what I do").[50] What fascinated Matisse was the cloudy opulence of a procedure at the opposite extreme from his own sharply defined structures. "I know he has a colour that doesn't depend on form . . . ," he wrote, trying to analyse it for his daughter, "but still it's with his colour, which is often applied in skeins like lengths of wool, that he constructs his form (you can see this from black-and-white photographs of his work). And then he has an expressive soul."[51] Matisse said Bonnard's canvases gave him the same charge of feeling he got from Goya's, a sense of "being confronted with something passionate and alive." Bonnard for his part admitted defeat, in almost exactly the same words as Renoir had used before him, in front of Matisse's expanses of flat uninflected colour ("How can you just put them down like that, and make them stick?").[52] He hung the borrowed paintings on the ochre walls of his dining room, checking up on them at intervals throughout the day and noting how the evening light brought out the magnificent reds of L'Asie. "By day it's the blue that plays the major role. What an intense and changeable life colours live in different lights!"[53]

Pierre said much the same when he unpacked a consignment of canvases from Paris that spring and watched them respond to the luminous atmosphere of Manhattan. "It's an enchantment," he told his father, reverting to the rhapsodies of his boyhood, when he used to rampage round the sitting room at Issy in uncontrollable excitement over the new work sent up annually from Nice. "Dazzling. A miracle of light and colour . . . a thousand times more vivid, more brilliant than in Paris."[54] Pierre's postwar showing of his father's recent work had a resounding impact, especially on young artists of the newly emerging New York school. The arrival in America of Matisse's 1908 Red Studio had opened up fresh ground for an inventive generation led by Jackson Pollock, already beginning to explore the formal possibilities of abstraction in ways that would in turn feed back into the mainstream of European art in the 1950s and '60s. André Breton, who spent the war years in the United States, said the painters he met never mentioned Bonnard or any other of his contemporaries in France.[55] All they wanted to talk about was Matisse, who used colour in ways no one ever had before.

Very different messages were coming in from a wider public accustomed to look to museums and picture galleries for reassurance, and wholly unprepared for an art that questioned basic principles of vision and perception. In England both Matisse and Picasso looked frankly grotesque to ungrateful Londoners, who climbed on chairs at the Victoria

and Albert waving rolled umbrellas and bellowing disapproval of works that seemed to make a mockery of the civilised values for which the war was fought.[56] There were similar scenes in Nice when the mayor invited Maeght to transfer his Matisse show from Paris to the Palais de la Méditerranée on the promenade. The whole town turned out to pay tribute to an international celebrity whose name few of his neighbours had so much as heard of up till now. Pleasurable anticipation evaporated in incredulity and shock. Students from the art school demonstrated in protest. A "Matisse Scandal" erupted in the local press, which urged its readers not to let themselves be fooled by a blatant conspiracy between international finance and the spiralling ambition of a corrupt art market. The citizens of Nice flocked to see the crude daubs of a madman most people agreed should be locked up, or alternatively elected King of the Carnival and trundled round the streets, pelting the populace "not with the usual banal flowers, but with turnip peel and cabbage stalks."[57] A vibrant red, green and lemon-yellow canvas called *Michaela* caused particular offence among the students, which, as Pierre cheerfully assured his father, only went to show that the young could not keep up with the old when it came to radical innovation ("The dose of vitality in the picture of *Michaela* is phenomenal—as René Clair said, it's a source of energy. One seems to recharge one's batteries in the presence of a painting like that").[58]

A film crew arrived to shoot documentary footage at Vence as well as in Matisse's birthplace, Le Cateau (where, Auguste Matisse told his elder brother, nobody even knew of his existence).[59] Rouveyre sent waspish congratulations on an escapade *"worthy of Hollywold!"*[60] ("Not that they would have dared demand of you the feats they ask of *Douglas Ferblanc!"*) The combination of international stardom with increasingly hermetic isolation irritated Matisse's contemporaries, who saw no call for either. His reserved and forbidding public manner reinforced the reputation for pomposity that always accompanied his bursts of notoriety. Old comrades felt excluded or unwanted. Marquet never forgot paying a surprise visit with his wife to Nice only to find Matisse distant, dazed and blinking as if he hardly knew them, "like an owl dragged brutally from its element of night."[61] The Marquets left immediately, swearing never to return, and were only partly mollified when Matisse rang to apologise, explaining he had been immersed in work and begging them to come back next day. Much the same sequence was repeated with Rouveyre and Jean Puy. However hurt or angry his friends might be, it was difficult to resist Matisse's fond, contrite messages, often accompanied by scatty little drawings showing him peering out from behind pebble glasses with tufts of hair

sprouting from his big bald head and an absurd frill of beard beneath his chin.

Matisse realised there was something monstrous about the consuming passion that took precedence over normal human contact and drove him inexorably into areas where few if any of his friends could follow. "The creators of a new language are always fifty years ahead of their time," he said, when Nelck complained about the constant misrepresentation of his life and work.[62] He told his daughter that any artist who managed to stay sane found himself blundering about in a maze with a concealed exit in the ceiling that never opened except on moonless nights. "The little stump of candle left by the memory of his predecessors casts no light on the way ahead, only on what lies behind. The artist is so made that he can't go back without giving himself up for dead. He must go forward in whatever direction his efforts may carry him—for every generation the ground behind you is a quicksand."[63] The only artist Matisse knew who operated on anything like the same long timescale as himself was Picasso, and the two drew closer than ever before at this point.

They had exchanged paintings more often than usual in the past few years, and emerged united from their joint London showing in spite of initial misgivings, at any rate on Matisse's part. "His relations with Picasso were roughly those of one crowned head with another," said Bussy's daughter.[64] But formalities between them began to loosen up after the war when Picasso started paying regular visits to Vence with Gilot, who had the impression the two were refighting old battles for her benefit, and through her for posterity (she was twenty-five years old at their first meeting, Picasso sixty-five and Matisse seventy-six). Beneath their ritual skirmishing each recognised a tacit understanding and acceptance he found only in the other's company. They discussed their own work and their contemporaries', gossiped about the past and speculated about the future. "What do you think they have incorporated from us?" Matisse asked, producing American catalogues of Pollock and Robert Motherwell: "And in a generation or two, who among the painters will still carry a part of us in his heart, as we do Manet and Cézanne?"[65]

They swapped notes and compared problems. Picasso complained about the effortless, inborn sense of beauty, balance and proportion against which he had fought savagely all his life, Matisse lamented the lack of natural facility that had made his entire career a relentless uphill struggle. Each grumbled freely in private about the other, but Matisse allowed no criticism of his old rival from anyone but himself. He presided with amusement and affection over Picasso's affair with Gilot, welcoming the

birth of their first child with a relaxed indulgence seldom seen by his own grandchildren. "Picasso was very fond of him," said the engraver Fernand Mourlot, who worked closely with both artists; "he looked on him as an elder brother."[66] But Matisse knew perfectly well that what drew Picasso back year after year was not fraternal feeling, but the work emerging slowly as its creator groped his way towards a new and wholly unexpected way out of his apparently unnavigable maze: "He'd seen what he wanted, my paper cut-outs, my new pictures," Matisse reported, unimpressed by Picasso's polite protestations of professional fellowship and neighbourly goodwill, "...all of it will ferment in his mind to his advantage."[67]

To others in Vence and elsewhere, Matisse appeared to be heading for a second childhood, sitting up in bed cutting shapes out of coloured paper, or playing with the heaps of fallen leaves he collected every autumn and brought home to draw. The toothy, softly incised leaves of oak, the serrated fronds of cineraria, the spiky foliage of castor-oil plants and acanthus growing wild along the road outside his gate: all of them had captivated Matisse ever since he moved to Vence. He told an interviewer that he spent the night of his first Christmas at the Villa le Rêve filling a notebook with drawings of a single oak leaf, "transposing it from page to page until it grew into an elegant lacy festoon," explaining that this kind of exercise relieved the torments that destroyed his sleep.[68] At the beginning of 1946, he painted a frieze of oak leaves at top speed to finish off the only decorative commission he had as yet secured, a pair of folding bathroom doors for the apartment of the Argentinian ambassador in Paris, which had occupied him intermittently over the past two years. In drawing a tree, Matisse said, it was essential to follow the pattern of its growth, and pay particular attention to the spaces between the leaves.[69] Now their lines and shapes informed his hand as he drew with scissors in the same airy cumulative rhythms. "At this time of year," wrote Rouveyre in one of his annual birthday letters, "I always see the dried leaves on your table, catching fire as they pass under your fingers from death to life."[70]

Vence gave Matisse the distance and detachment he had always needed—in Ajaccio, Collioure, Tangiers, Nice, Tahiti—at moments of impending crisis in his work. Mortal weakness increased his isolation as each winter laid him low with fever, flu and bronchial congestion. In the spring of 1946, nervous tension brought a return of the old intestinal spasms, this time so acute the patient said grimly that his screams could be heard half a mile down the hillside. He slept at most three or four hours a night. "Luckily I lead two very distinct lives, one by day and one by night. They don't mix. What else can I do at my age, you have to accept what

you've got left, and put up with what upsets you."[71] A nurse was always on hand to massage his legs or make him a tisane, anything to head off the nightmares that contaminated his brief sleep with convulsive cries and movements. He reverted to the strategies of childhood, doing sums in his head, counting aloud in English or German, even reciting paternosters. He wrote letters, filled notebooks, took dictation from the nurse, or talked to her in undertones ("The night was the time for confidences," said a favourite night nurse).[72] More often his attendants read aloud by a dim lamp, murmuring sometimes for hours on end since the slightest pause would rouse the patient from his drowsy state. He drew, and continued drawing in his sleep, groaning and rubbing out invisible mistakes with his left hand.[73] In this half-life, his imagination stirred, stretching out to a space that would release him and his motifs from the narrow confines of the canvas, an expanded pictorial space "beyond me, beyond any subject or motif, beyond the studio, beyond even the house . . . a cosmic space in which I was no more aware of walls than a fish in the sea."[74]

The fish in the sea, the limitless new space and the light it invoked were all associated in Matisse's mind with his voyage to the South Seas. He kept a book of Tahitian photographs beside his bed, and wrote to Pauline Schyle (who still sent him regular supplies of plaited pandanus hats) to say that the woodsmoke from his neighbours' chimneys in Vence, and the cyclists passing on the road outside his window, reminded him of Papeete.[75] Memories he had soaked up like a sponge fifteen years before began to resurface in the twilight zone between sleep and waking. It was in this state, after his return to Paris in June 1946, that he started transforming his bedroom walls with cut-outs quite different from the brightly coloured, separately mounted, largely abstract images that filled the Vence studio. In Paris, he cut white shapes from a block of writing paper, which was the only material available. He began almost at random, producing a paper swallow and handing it to his night nurse to pin over a dirty patch on the wall. Matisse's room at the boulevard Montparnasse had not been redecorated since the family first moved there in 1926, when it was covered with a pale lining material that had darkened over the years to a warm sandy brown. The white swallow was succeeded by a fish. "Then, whenever he suffered from insomnia, he told the nurse to pass him a sheet of paper which he would cut up, telling her 'Put it there!' And so on," said Lydia. "The next night there were another two or three, then four or five, until, little by little, they made a whole ensemble. The wall ended up covered."[76]

By early autumn, all the blemishes and scuffmarks had disappeared under fish from the imaginary lagoon that materialised beneath Matisse's scissors. The design spread across a wall almost four metres wide, eventually spilling along the top of the doorway and round the corner, to flood out over a second wall in a rhythmic tidal swell, bearing in its depths and on its surface, like the sea itself, every kind of marine life: loops and trailing fronds of seaweed, swooping seabirds, dolphins, sharks, jellyfish and starfish, the whole fragile dreamlike pattern punctuated by lines of foam and the tracery of coral. Matisse, who had attempted nothing on this scale since Barnes' *Dance,* had dived without thought or afterthought into an art more concerned with states of consciousness than with any specific visual allusion.

Before he even left Vence, he had turned down the offer of a contract from Paul Rosenberg on the grounds that he was giving up painting for decoration.[77] So far, apart from the ambassador's bathroom doors, his only concrete project was a request for a tapestry cartoon from the state-owned Gobelins workshops, whose envoys remained cautious after an inspection of Matisse's bedroom walls. The pattern was eventually rejected as too tricky for their weavers, and the colour as impossible to match. But Matisse also received a visit that summer from a young Czech manufacturer of fine silks who was starting up a new business in England and hoped to produce silk scarves designed by leading modern artists. Zika Ascher, confident, inventive and resourceful, immediately proposed to translate Matisse's walls into a pair of silk-screen panels printed in white on linen that would exactly match the soft sandy ground.

Matisse finalised both panels—*Oceania, the Sky* and *Oceania, the Sea*—in roughly two months, setting up a second studio in the salon where he used a similar technique to design a parallel pair of tapestries for the Gobelins. Blue was their recommended colour, so he improvised a background from two garish shades of cheap wrapping paper, which was all Lydia could find after scouring every stationer in Paris. He treated it as a test of his ability to transform the most unpromising materials, pinning up alternate sheets of turquoise and verdigris, and explaining afterwards that the first and more formal of his two designs—*Polynesia, the Sky*—was "inspired by the wheeling mass of seagulls above the outlet of the pavilion on the Promenade at Nice."[78] All four designs for *Oceania* and *Polynesia* were completed by the end of the year. Over the same period, work on the illustrated books imposed a punishing schedule at the printers. Tériade brought out *Les Lettres portuguaises* in October. After fearful obstacles, *Les Fleurs du mal* was

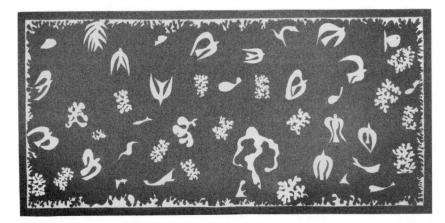

Matisse, *Oceania, the Sea,* 1946

finally approaching publication in 1947, and so was the most prodigious flowering of Matisse's partnership with Tériade, the album *Jazz.* Matisse spent part of the winter compiling a text to accompany these "lively and violent prints," which he described as a kind of pop art, crystallising apparently out of nowhere—"from memories of the circus, folk tales, voyages"—in 1943 to focus a wholly twentieth-century sensibility so sharply that even their creator took time to absorb the shift of viewpoint.[79]

The bitter winter of 1946–47 was the first one Matisse had spent in Paris for ten years or more, and it very nearly killed him. The usual crop of fevers and congestions was compounded by exhaustion, and by his own violent reaction to experimental doses of a new drug called penicillin. Tempests of ice and snow brought Europe to a standstill, with coal stocks exhausted in temperatures lower than ever before in living memory. Bonnard died at Le Cannet at the end of January. Marquet entered hospital for an operation the same month, coming home in a snowstorm, which he promptly painted. Matisse, more than ever convinced that Marquet needed looking after, went round to spell out basic tactics for survival: warmth, bed rest, special diet, unceasing vigilance against cold or drafts, and perpetual surveillance by nurses day and night. "Tell me," Marquet asked his wife, after their guest had gone, "is it really worth living under those conditions?"[80] The two old friends said good-bye on 5 April, just before Matisse's return to Vence. When news came of Marquet's death two months later, Matisse said sadly that he would not have wished to prolong a life made as wretched as his own by sleeplessness and pain.[81]

His greatest human consolation in these years came from his five grandchildren, whose progress he followed closely and whose visits he awaited with the fond, proud impatience of a lover.[82] He drew them

repeatedly, subjecting each in turn to a strange, penetrating, in the final stages almost blind scrutiny that astounded them. "He was listening to form rather than content...," said Pierre's son Paul, describing how his grandfather asked him to tell the story of a recent film at one of their first drawing sessions after the war. "He was looking with an intensity that would have robbed the most brilliant discourse of meaning, and then suddenly I was free. I remember clearly the inner joy of discovering that we were coexisting on a level that was quite new to me. . . . I too was momentarily swept up into an existence in which quality rather than quantity held the master place."[83] These encounters were as nerve-racking as they were exhilarating for the sitters. "His concentration then is terrifying," Paul's sister, Jacqueline, told a friend. "He acts as if he were stone deaf. His talent is a physical thing, which lies in his hand. . . . His hand leads him after he has absorbed the object, and he doesn't look at it any more. He just draws the result of it that is in him, like a film negative."[84]

Even without a pencil in hand, the weight of Matisse's presence and his uncompromising expectations could be alarming. He made no disciplinary concessions, and his affection was not openly expressed. But he watched over his grandchildren with understanding, sometimes with apprehension, describing their separate personalities in perceptive detail for Léon Vassaux, reliving his own problematic adolescence—illness, examinations, love affairs, career prospects—through theirs, and occasionally interceding in favour of mildness and forbearance with their parents. When they were small, he had marked their height on his wall, and pinned their drawings up above his bed where he had once hung his own children's. Now he organised lunch parties and excursions for them in Paris, and invited them to stay with him in the south. He was still deeply attached to Claude, who retained for his grandfather, beneath the veneer of a tall, handsome teenager in stylish American blue jeans, something of the gallantry and vulnerability Matisse had painted in Claude's mother as a child. He was enchanted by Jackie, his only granddaughter, who had inherited his own extreme sensitivity along with his delicate complexion and red-gold hair, and by the exuberantly expressive artworks of Jackie's youngest brother, Peter. But of all his grandchildren it was Jean's son, Gérard, in whom Matisse acknowledged exceptional ability as an artist, discussing his potential with friends like Rouveyre and the founder of Surrealism, André Breton (an unexpected confidant, stranded for two months at Antibes after his postwar return to France). Over the next few years, Matisse arranged for Gérard to attend art school in Montparnasse, giving him regular tuition ("He was a teacher of rare severity," said his

grandson), and sending him at seventeen on a voyage to New York and the Caribbean, which he said would have transformed his own life at that age.

Lonely and more isolated than ever in Vence in the summer of 1947, Matisse found warmth and comfort in the uncomplicated affection of a former model, Monique Bourgeois, who had been by her own account an honorary granddaughter until her defection three years earlier, when she left Nice without warning to enter a convent. Matisse was scandalised, as he would be again, a few years later, when Nelck announced her intention of marrying a fellow artist. Neither marriage nor the veil seemed to him adequate reasons for compromising a serious vocation as an artist, but he could not resist Monique in her new role as Sister Jacques Marie. He was captivated all over again by her combination of unworldly innocence, strength of character and surprisingly flirtatious wit. Sister Jacques was working as a novice at the Foyer Lacordaire a little further up the road, a nursing home run by Dominican nuns who had set up a makeshift chapel in a derelict garage for which she sketched out a little stained-glass window. When she brought her watercolour round to show Matisse, she knew him well enough to be alarmed by his disproportionately enthusiastic response to her perfectly banal madonna.[85]

Matisse painted more pictures in the twelve months after he got back to Vence in April 1947 than in the previous three years put together. "It was a veritable explosion," said Lydia, "a kind of apotheosis." Contemporaries were often mystified by the powerful, even raucous colours and abbreviated forms of these studio interiors, which weave everything within the painter's field of vision into a whole so dazzlingly bold and simple that the canvas itself seems to be part of the inner fabric of his mind. But nothing he painted could appease a growing sense of dissatisfaction and dormant power. Neither *Jazz* (which had a small but striking impact when it was published in September) nor any other of his recent projects led to further decorative commissions. "The fact is, nobody approached Matisse to make anything monumental," said Lydia; "but that is what he dreamed of."[86] By the end of 1947, he was sufficiently frustrated to contemplate asking Aragon if the Communist Party would provide him with a public space or lecture-hall to decorate.[87] Instead, he showed Sister Jacques's watercolour to one of her fellow Dominicans, a young monk convalescing at the nursing home, who insisted that the window should be designed by Matisse himself.

Brother Louis Bertrand Rayssiguier ranked almost as low as it was possible to get in the church hierarchy. He was twenty-seven years old, a diffident, idealistic, inexperienced philosophy graduate from the Sor-

bonne, who had no art-world connections and had never seen a painting by Matisse.[88] But he was also an enthusiast, an instinctive modernist and admirer of Le Corbusier, overwhelmed, like far more sophisticated visitors before him, by what he found at the Villa le Rêve, and by its occupant's magnetic power. Matisse showed him *Jazz*, explaining that the only difference between cut-paper and stained glass was that one reflected while the other transmitted light, and citing the polychromatic brilliance of the Chartres cathedral as a model of true spirituality untainted by the religious gloom of later ages. Rayssiguier readily agreed: "I should be very comfortable saying my prayers in your studio, indeed more comfortable than in many churches."[89] By the end of their first meeting on 4 December 1947, the two had roughed out a basic format not just for a window but for a whole chapel. When Rayssiguier returned after five days with a scale plan, Matisse asked for a working model, which Sister Jacques made and delivered to him two months later. Matisse wrote to Rayssiguier the same day to say he could already see the chapel completed in his head.[90]

The scheme was crazily impractical. Matisse might be a major figure on the international stage, but his fame cut no ice with the lower echelons of the Roman Catholic Church. The Mother Superior at the nursing home, knowing his local reputation for frivolity and nudes or worse, refused even to mention his scheme to any higher authority.[91] The nuns laughed at the model ("You couldn't pray in that, it's going to look like a shoe-shop").[92] Matisse himself talked of an unspecified upheaval about to take place in his work, and complained gloomily to his daughter that all artists were helplessly dependent on random circumstance ("Artists are like plants whose growth in the thickets of the jungle depends on the air they breathe, and the mud or stones among which they grow by chance and without choice").[93] Only Sister Jacques realised with foreboding at this stage that, once started, Matisse could not be stopped. Brother Rayssiguier returned to Vence in April, when he and Matisse planned the entire chapel down to its last detail in four hectic sessions. From now on Rayssiguier was possessed by a transforming vision ("For a year now I feel less and less Gothic, and more and more Matisse," was how he put it twelve months later).[94]

Matisse installed a coloured-paper maquette on the wall opposite his bed so that he could work day and night on the two long windows for the chapel's west wall. He had been impressed in March by Picasso's wildly inventive painted plates and pots, six hundred of them on display at Antibes, where Matisse went twice, alone, to make notes with sketchbook and pencil.[95] Now he consulted Picasso's potter about a weird scheme of

his own for a wall of white ceramic tiles, to be covered with "graffiti-style" drawings in black paint, and placed opposite the chapel windows to reflect their play of coloured light.[96] Rayssiguier had doubts, but for this most ambitious of all his decorative projects, Matisse treated himself as in effect the commissioning agent. This time there would be no question of compromise, and no complaints that what he wanted done was unorthodox or infeasible. Expense was no object. "Of course we're spending money like millionaires," he wrote cheerfully to Rayssiguier before anyone else had seen or approved plans for the chapel, let alone raised a sou to finance it, "even though we're rich only in dreams."[97]

Back in Paris in June, Matisse acquired a powerful champion, Father Marie-Alain Couturier, himself a specialist in stained glass and France's leading moderniser in the controversial battles raging over the future of religious art. A cosmopolitan operator, thoroughly at home in ecclesiastical and secular high society, Couturier was a realist about the Church ("The mission of Catholicism is not only to give but to take everything"), and about the artists who might be induced to serve it ("We must accept them as they are . . . barely Christian at all").[98] Within weeks he had secured approval for the chapel from all the relevant Church authorities. Matisse sent for Skira, announcing airily that the publisher would serve as banker and finance the project by bringing out a book.[99] Rayssiguier wrote sternly to the recalcitrant nuns of Vence ("What has to happen now is for your congregation to accept . . . this gift. And quickly, without giving an impression of indifference which would—without a doubt—wreck everything").[100]

Matisse already spoke of the chapel as the crown of his life's work. He firmly overruled a proposal to seek architectural input from Le Corbusier, producing instead a more biddable consultant of his own, the Parisian architect and academician Auguste Perret ("He'll do as I say," said Matisse).[101] West and south windows rapidly took shape in the apartment on the boulevard Montparnasse. Working conferences assembled two or three times a week beside Matisse's bed. Couturier was constantly at his side, escorting him to the glass-works, or to Notre Dame to check that blue and pink make violet in the southern rose window. They formed a stately pair, Matisse's commanding compact bulk offset by the height of his companion, who was strikingly ascetic and so elegant in his white habit that rumour in New York said he ordered his robes from Balenciaga. The painter asked him to model for Saint Dominic that summer.[102]

The news that Matisse was about to build a chapel, and could be seen

going about town with a priest in tow, caused ribald disbelief in Paris at a time when it was increasingly accepted by the artistic and intellectual community that the best hope for the future, not just of France but of humanity itself, lay with the Communist Party. Picasso came round to inspect the model at the boulevard Montparnasse, and recommended building a fruit-and-vegetable market instead, in a scene reported with gusto by Matisse, who was proud of snapping back that his greens were greener and his oranges more orange than any actual fruit.[103] Family legend preserved an altogether pithier version of this celebrated exchange: "Why not a brothel, Matisse?" "Because nobody asked me, Picasso."

The apartment on the boulevard Montparnasse had now been swallowed up by studios, like the apartment at Cimiez and the house at Vence. The family paid rare and formal visits. Matisse entertained his grandchildren, and relied on Marguerite as go-between in dealings with his wife, who no longer communicated directly with him. Nor did Georges Duthuit, in spite of the fact that his father-in-law had appointed him joint author with Marguerite of a comprehensive catalogue raisonné, a massive undertaking that would outlast both their lifetimes. Marguerite set about compiling records, contacting collectors, becoming the custodian of her father's past, while Matisse himself worked with Duthuit on various current projects, providing illustrations for his text *Une Fête en Cimmérie*, designing a cover for the first number under his editorship of the magazine *transition*, and supplying key material, together with a book-jacket, for his pioneering work on the Fauves. The two collaborated without ever seeing or speaking to one another, negotiating through Marguerite in an atmosphere of simmering, at times explosive, tension.

Jean's marriage had come apart by the summer of 1948, and his wife was dying of cancer. Pierre, who had divided his life between two continents for years, giving the major part of his attention to his artists and working round the clock in his New York gallery, was also heading for divorce, writing to announce his intention at the end of the year, to his father's acute distress. Matisse, who had always been especially close to Teeny, admiring her courage and independence, loving her generosity, gentleness and humour, was torn between sympathy with her and painful fellow-feeling for his son. Images of breakdown and destruction tormented him at night. He told Pierre he dreamed he saw his family lined up like targets at a fairground, ready to be picked off with rifles one by one.[104]

Matisse turned back to his model of the chapel, working on window designs of cut-and-coloured paper with more than usually terrifying con-

centration. "Matisse in Vence drove himself to exhaustion," said Jacqueline Duhême, a young assistant taken on that autumn to help with the endless, intricate adjustment of paper pattern pieces. "His will always got the better of fatigue."[105] He defined the chapel to Rayssiguier as somewhere that would offer hope and respite, a place where people could leave their burdens behind, "as Muslims leave the dust of the streets on the soles of the sandals lined up at the door of a mosque."[106] The model was essentially a machine for making coloured light: a plain rectangular box with long windows on two sides and movable fitments designed for testing experimental effects, like the wooden models constructed for the ballets, *Rossignol* in 1919 and *Le Rouge et le noir* in 1939. All three go back to the earliest of all Matisse's decorative projects, the toy theatre in which he had staged the eruption of Vesuvius with coloured-paper cut-outs and spectacular lighting effects as a fifteen-year-old schoolboy in Bohain.[107] He told Rayssiguier that the sulphuric flame of that volcano was the pure, clear blue light he had looked for all his life, and finally achieved in the chapel windows. "What interests me is to give space and light to a place that is characterless in itself," he said, explaining that the model was like a blank book waiting to be written in. "I don't need to build churches. There are others who can do that.... I'm doing something more like a theatre décor...the point is to create a special atmosphere: to sublimate, to lift people out of their everyday concerns and preoccupations."[108]

Matisse said that, even if he could have done as a boy what he was doing now—"and it is what I dreamed of then"—he would not have dared.[109] Now he had both confidence and courage. All he had to do was fill his empty box (as he had filled the Villa le Rêve) with the contents of his imagination. The only serious problem he anticipated was mortality. "He'd been in a hurry all his life," said Nelck. "Now he had to economise his forces. It was a race, an endurance course, which he was running with death."[110] In this race, the Church supplied skilled backup. Matisse, who had so often said he felt driven by a power beyond his own control, now found himself for the first time in his life among people who spoke naturally and directly the language of dedication, sublimity and submission that he had always used to make sense of his own experience as an artist. Rayssiguier told him he was more genuinely monastic than many real monks.[111] Matisse for his part had no difficulty with religious doctrines of self-immolation, sacrifice and penance, or the ruthless imposition of a divine will that coincided at all points with the will of its interpreters ("We want what God wants," Rayssiguier explained, "and we do what we

believe He wants from us").[112] Both Rayssiguier and Couturier were happy to accept the painter's will as absolute in this sense. When Sister Jacques protested that she had understood Matisse to be directly inspired by God Almighty, he said gently, "Yes, but that god is me."[113]

By the end of 1948, after nine months of intensive planning, the chapel had outgrown the Vence workshop. Matisse decided to transfer operations to the much larger spaces of his old studio at Cimiez, returning with his household to the Regina in the first week of January 1949, the start of his eightieth year. His first move was to strip the big studio, sending away the gigantic philodendron that had served him faithfully for nearly twenty years ("It pains my heart to know that plant must go")[114] to make way for full-sized stained-glass designs: a range of fifteen tall, slender windows in the south wall of the chapel set at right angles to a larger, double west window behind the altar. The apartment became, as Matisse said himself, more like a factory.[115] Scaffolds, steps and platforms built of packing crates held the chair in which he sat with a brush strapped to a bamboo cane to paint the ceramic wall panels laid out beneath him on the floor. He went from one of his three studios to the next in what he called his taxi-bed, a bed on wheels with a specially designed tray to hold drawing materials, and a padded chair-back to support him during working hours.

The high, bare, impersonal spaces of the main studio were animated by a constant traffic of specialist suppliers, deliverymen and porters. Assistants starting work each morning entered a high-energy zone, hazardous but efficient and crackling with emotion. "The atmosphere was always vibrant, stimulating, filled with cries of rage or pleasure," said Paule Martin, another young studio aide who worked on the ladders, pinning papers into place, or helping with her brother to unpack and shift the heavy, fragile, handmade tiles ready to be painted.[116] Matisse reorganised his three studios from top to bottom every few weeks, repositioning his taxi-bed and turning the whole place upside down as he focussed successively on the separate components of his design, abandoning one window maquette to start another, switching from stained-glass to ceramic panels, constantly returning to any completed element to alter or recast it altogether in the light of progress on another. His aim was to give the whole ensemble the fluidity of an oil painting. This provisional approach continued to the end, driving builders, glaziers and roofers to distraction once the chapel started rising from its building site in Vence. Looking back afterwards, Rayssiguier said the ideal solution would have been "to raze

the chapel to the ground at intervals so that Matisse could manipulate walls, windows and ceramic tiles as readily as he did his paintings and cut-paper collages."[117]

Rayssiguier was astonished, even appalled by the way Matisse worked, especially by how calmly he accepted setbacks. He made two entirely different sets of designs for the seventeen windows ("It was like a precious stone in its natural untouched state," he said of the first set, which had cost him four months' work. "The new one is the same stone after it's been cut").[118] It was only on completion of the second version, in February 1949, that Matisse realised he had forgotten to include provision for an armature of black glazing bars, which meant beginning all over again for the third time. "He's not in the least upset at having to redo them," Rayssiguier noted in his diary. Each fresh start enriched and refined the end result. The windows were completed by mid-March in marathon work sessions of up to eleven hours on end. Unlike the previous two, this final version—*The Tree of Life*—contains no red, a change of key that brought an extraordinary clarity, serenity and stillness to the music of the chapel.

By April Matisse was choosing glass samples. Over the next two years, he considered the physical properties and technical possibilities of glass, tiles, stone and metal, undeterred by experts who assured him that what he proposed had never been, nor ever could be, done the way he wanted. He caused mayhem at the highly experienced Parisian firm of Boney, accustomed to producing huge and splendid stained-glass windows by a process of interpretation and approximation based on small gouache sketches supplied by artists like Rouault.[119] Matisse visited Boney's workshop in person, demanding information about every stage of production, paying extreme attention to thickness, translucency and finish, before finally submitting full-scale designs with meticulous specifications (including an impossible lemon yellow that had to be tracked throughout France and beyond).[120] The same relentless precision went into everything from doorknobs and roof tiles to lighting, heating, ventilation, marble samples for the altar and the five different kinds of slate sent specially from the Ardennes for an almost invisible play of colour in the decorative rim edging the altar platform. Georges and Suzanne Ramié, who had turned their pottery at Vallauris into an unofficial studio annexe for Picasso, now enthusiastically embarked on a fresh set of perilous and sometimes catastrophic experiments with Matisse. His ceramic wall tiles were largely spoilt in a first firing in June, and so comprehensively smashed on a second attempt in August that both the Ramiés arrived at Cimiez with Gilot and

Picasso, all four apparently more shocked than Matisse, who felt, like an athlete in training, that failure and distress were part of routine preparation for further trials.[121]

These trials were conducted against a constant groundswell of publicity. The story of the celebrated painter of odalisques enticed by a pure young nun into the embraces of the Catholic Church made headlines in newspapers, newsreels and fashion magazines from New York to Tokyo. The French press reprinted an article from *Vogue* alongside a romantic picture of Sister Jacques looking, as she said herself, like a Hollywood starlet, with long lashes and pert button nose.[122] For her, this was only one of many private miseries in four years of steadily increasing friction. Her fellow nuns at the Foyer Lacordaire, who had stubbornly resisted the chapel from the start, and who believed (like most of their neighbours) that any child could paint better than Matisse, reacted with bewilderment and horror to his successive assaults on everything they held familiar and sacred. To the conservative majority in the Church, his inventions seemed not simply monstrous but blasphemous as well. "I was panic-stricken," said Sister Jacques, describing the day she first saw Matisse's Stations of the Cross, scrawled freehand in thick black paint on shiny white tiles in a violent and disturbing sequence of clotted, caricatural, in places almost unintelligible images. This was the one element of the chapel that Picasso unequivocally approved (later, when he saw the butterfly brilliance of Matisse's chasubles, he admitted that he liked them, too). Sister Jacques now found herself blamed by her entire community for an enterprise that privately appalled her. "How on earth was I to get them to accept these drawings? I stood there, stock-still, utterly crushed."[123]

She appealed at intervals for help, only to be told austerely by her novice mistress that a chapel destined for the sacrificial mass inevitably demands suffering from those involved in its construction ("The builders of churches have never achieved anything good or beautiful without being crucified for it").[124] Rayssiguier, too, came under severe and growing strain. Eager, honest, single-minded and as stubborn as he was undiplomatic, his attempts to mediate between the painter, the nuns and in due course the building site often exasperated all parties. Rayssiguier had tendered his resignation once already to Matisse, who refused it with peremptory and touching frankness: "I am an invalid, even if I do my best to disguise it. I need a second-in-command, I can do nothing without you."[125]

Rayssiguier supplied essential liaison services, but it was Lydia who ran the entire operation from day to day. She organised supply lines, main-

tained relations with the art world and managed the permanent, live-in, female workforce at Cimiez: cook, laundry-maid, two nurses on day and night shifts, at least one model and successive studio aides.[126] Between them they met all studio requirements, apart from posing for Christ (who was modelled by a couple of art students, Paule's brother Jean Martin, and Nelck's boyfriend, Victor Crosals), and the Virgin (whose oval face and slender upright stance came from the fourteen-year-old daughter of Matisse's favourite former model, Henriette Darricarrère, now married to an asthma specialist in Nice).[127] Many of Matisse's assistants were prospective artists themselves: bright, tough, energetic young women, often in their first jobs, eager to see the world and escape from family constraints. They were well paid and generously treated, always included in lunch or tea parties, and introduced to visiting celebrities who came from Paris to inspect the contents of the studio. The work schedule was gruelling, but it was broken up by Lydia with small treats and presents, boxes of chocolates, ballet tickets, trips to Paris. There were frequent festive occasions for opening a bottle of champagne, and at the end of each day's work, everyone gathered in the studio to drink a glass of muscat, look at the latest book from Paris, or play with the four cats who treated Matisse's territory as their own.

All routines revolved around the painter, who exercised dominion—part Oriental pasha, part Victorian martinet—from his bed. Models and assistants were jealously guarded, cut off from outside contact and more or less confined to the premises ("There were no Sundays off with Matisse").[128] Bold spirits who crept out in the evenings or smuggled boyfriends into their rooms at night faced furious inquisitions next morning. Matisse had no patience with their flimsy, frivolous objections to disciplines he had observed himself for years ("Poor things, they don't understand anything," he said indulgently, "but still, I can hardly give up my Sundays for the sake of these young creatures, just because they fancy time out with their lovers").[129] The price required was high but in retrospect worth paying. Even those who most bitterly resented his exactions at the time agreed afterwards that Matisse took much but gave more. He opened doors, changed lives, provided access to unimagined and unimaginable riches. "The work became a passion for me, too," said Paule Martin. Artists like Nelck and Duhême, both of whom learnt to draw from Matisse, were marked indelibly for life. "He had a hard exacting side . . . a sort of absolute rigour," Duhême wrote fifty years later. "For me that was his greatest lesson."[130]

But the pressures of this way of living were punitive in practice. "It was slavery," said Paule, "slavery above all for Lydia."[131] In the enclosed world of Matisse's household Lydia maintained order, humour and proportion, retaining her robust good sense in face of incipient mutiny and sometimes barely suppressed hysteria. In the last resort, everything fell on her. She protected Matisse from intruders—admirers, lobbyists, supplicants, the crowds of Sunday sightseers who strolled up to Cimiez "to see the painter"—and preserved contact with reality for the inmates of his studio. Lydia had no holidays or outside distractions, virtually no evenings off, no escape except for occasional trips to Paris on studio business. Her only time alone was when she shut the door of her room at night, poured herself a stiff drink of neat spirit, and opened a pack of cigarettes. Her authority was cool and unassertive, but under extreme provocation, her face could turn black with rage, according to Matisse. He called her his snow princess, talked constantly about her incomparable qualities in her absence, and could hardly bear to let her out of his sight at home. But he also knew how to tease her until she lost control and swore aloud in French.

He himself kept up a steady flow of curses under his breath as he drew or painted, but it was at night, when he could no longer work, that exhaustion made him vengeful and malignant. He brooded grimly on his own helpless incapacity, venting his frustration on the captive models, or on the night nurses, who rarely lasted more than a few months before they had to be replaced. Lydia herself complained to no one, but there were days when her milk-white pallor intensified and her eyes looked red from weeping. The whole household knew that she kept a small suitcase permanently packed at the back of her wardrobe, and no one doubted that she would leave without warning or appeal if ever Matisse's depredations became unendurable. But younger women like Paule Martin or Anneliese Nelck who took her part, protesting indignantly about his tyranny and her silent subjugation, slowly came to realise that Lydia, who had a will as strong as her employer's, was by her own decision as much a prisoner of Matisse's work as he was.

On 12 December 1949, the first stone of the chapel was laid at Vence in a ceremony Matisse was too frail to attend. He spent his eightieth birthday quietly with his three eldest grandchildren, drawing them with a long-handled brush to keep him company at night on the ceiling above his bed. Cimiez was awash with tributes, flowers and gifts. Advance birthday celebrations had kicked off almost two years earlier with a major retro-

spective at the Philadelphia Museum of Art, followed by a show of the latest canvases and cut-paper compositions at the Pierre Matisse Gallery in New York. The critic Clement Greenberg proclaimed Matisse the greatest of all living painters, and the gallery remained packed so tight throughout the run that Pierre said he only had to open his windows for a mass of art-lovers to fall out onto the street below.[132] French opinion was less enthusiastic about a second showing of recent work at the Museum of Modern Art in Paris in the summer of 1949, when the works in cut-paper were more or less openly dismissed as evidence that Matisse had grown too old and childish to be taken seriously.

Reports of his chapel-building increased art-world disdain. For the rest of Matisse's life rumours that he had abandoned the atheism of a life-time to become a practising Catholic vied with counter-claims that he was about to join the Communist Party. Matisse, who would have been happy to decorate a public space for either institution, accepted overtures from both on his own terms. He provided recent work for an exhibition put on in January 1950 by Nice's pro-Communist town council and heavily patro-nised by the Church ("I have never seen so many curés gathered together in my life," Janie Bussy reported to Vanessa Bell).[133] Five months later he completed his designs for the chapel—"which means that I am free to die now," he told Couturier[134]—and celebrated by displaying them in public for the first time at the Communist-backed Maison de la Pensée Française in Paris. It was a statement of position that exasperated Picasso (who had persuaded Matisse to show there in the first place),[135] embarrassed Aragon (who installed the exhibition) and frankly mystified the public.

Matisse replaced the window maquettes on his walls that summer with cut-paper compositions in the same tall format. *The Thousand and One Nights, The Beasts of the Sea* and *The Creole Dancer* materialised in a wild explo-sion of the colours so rigorously restricted in the chapel. *Dancer*, made in a single day in June, seems to implode and explode simultaneously against a brilliant checkerboard of red, blue, pink, orange, black and yellow, leaving nothing but her head, her green ribbons and two spiky blue-and-white ruffs which might be a corsage and a swirling skirt in rapid motion, like the wings of a bird flashing open in flight. Matisse recognised something exceptional about this *Dancer*, and refused to part with it to Pierre, on the grounds that he could not be sure he would ever produce anything of the same calibre again in any medium.[136]

The manufacture of the windows in Paris precipitated a mass of tech-nical and financial problems. Forced to drop various more unrealistic fundraising schemes (including the notion of making money out of a lux-

ury book from Skira), Matisse had opened a bank account in the chapel's name and invited contributions, giving his own services free, underwriting the account himself, and topping it up whenever funds ran low by producing lithographs or selling a painting.[137] His liability alarmed him, but half-hearted attempts at cutback were overtaken by trouble at the glassworks. Matisse's stay in Paris dragged out in the end to four months, mid-July to mid-November, spent supervising production in a state of simmering frustration at times dangerously close to boiling over ("You know I have given everything to this chapel," he wrote sharply to Couturier, "and it will all have been useless if it isn't *perfect*").[138] Meanwhile tension between builders, nuns and the unfortunate Rayssiguier reached new levels as the chapel roof went on in Vence. The windows were finally installed in time for Christmas. Matisse pronounced the effect better than he had hoped, with the same curiously impersonal satisfaction he had felt twenty years before, when Barnes' *Dance* was finally hoisted into place at Merion in an atmosphere of ferocious strain and barely suppressed violence. "It's very odd, it feels as if the start of my eighty-second year marks a gateway to the unknown, and a sort of detachment of interest in anything around me . . . ," he wrote to Vassaux on 6 January 1951. "I was the one who set the whole thing in motion, and the result is sublime, but I feel almost totally detached from it."[139] For his oldest friend, he summed up his reaction to the chapel in a characteristically prosaic metaphor that goes back to the small-town mentality and rigid social hierarchies of their youth: "Imagine a simple postman confronted with his son, who has become a general."

In February, Gérard Matisse was knocked down by a lorry in Paris, and remained critically ill for three months. He eventually made a full recovery, but the episode left all his relations deeply shaken. Matisse's feelings for his family, always intense and often painful, found free play in his attachment to his grandchildren, who continued to come regularly to stay with him in Nice, bringing news of their parents and their grandmother. Amélie had finally settled in a substantial property of her own at Aix-en-Provence, finding an outlet for her considerable energy in working with Marguerite to establish lost or nonexistent records for the heroic early decades of her husband's work. Matisse's wife and daughter, with no further part to play in the continuing operation of his studio, became in these years joint custodians of his posthumous reputation. Jean had remarried, and rarely saw his father. Pierre—also remarried, to Patricia Matta, the young ex-wife of one of his former artists—was the only one who remained in close, warm, difficult contact with Matisse's life and work at Cimiez.

It was Pierre who represented his father at the consecration of the chapel on 25 June 1951, a ceremony conducted by the Archbishop of Nice, Monsignor Rémond, in the presence of the Socialist city's deputy mayor, the formidable Jean Médecin. The chapel's initial impact, as so often with Matisse's work, was the opposite of what he had intended. Conservative forces within the Church responded to the glare of worldwide publicity with a virulence that echoed the uproar provoked nearly half a century before by *Dance* and *Music*. Charges of sacrilege and scandal brought magisterial rebuke from the Vatican itself.[140] The nuns were the first to succumb to the atmospheric power of their new chapel: within twelve months the entire congregation, led by their Mother Superior, had reversed position, abandoning their attacks on the chapel to rally in unanimous defence of its consoling and contemplative calm. "Mother Gilles and the sisters are content, and stand up courageously to those who come to jeer and mock," Lydia reported to Rayssiguier.[141] From now on, indignant or derisive sightseers demanding to know the meaning of the stations of the cross received a firm response from the nun in charge: "It means modern."[142]

Matisse's own condition after four years of unremitting strain was nicely summed up by his homeopathic doctor: "There is a saying, 'to give yourself to something with all your heart.' You can say more—you have given your heart for the chapel."[143] Cardiac fatigue was compounded by the usual insomnia, breathing difficulties and a deterioration in eyesight so severe that by the end of the year there were times when the painter could hardly see at all.[144] He started work on an immense cut-paper composition, larger in scale than any canvas he had ever painted, working on it with a young night nurse brought back from Paris in the autumn of 1951. Denise Arokas was nineteen years old, slender, dark and supple.[145] Matisse put flowers in her hair and drew her in the pose of the figure on the right of Delacroix's *Femmes d'Alger*, who lent grace and poignancy to the dancing girl on the right of his own *Tristesse du roi* (colour fig. 25). Matisse himself described the three central figures in this work for Couturier: "the sorrowful king, a seductive dancer, and a fellow strumming on some sort of guitar which releases a shower of flying saucers, the colour of gold, to go streaming round the top of composition and end up in a mass around the dancer in action."[146]

In the closing years of his life, whenever Matisse looked back over his career in private conversations or public interviews, he insisted that he had been in search of the same goals ever since he started as a painter. Here for the last time he invokes his alter ego—the musician with a guitar or vio-

lin—in a setting that goes back to the Bible stories of his youth (Saul and David, Herod and Salome) as well as to the northern fairgrounds and cir-cuses, with their exotic gypsy dancers, which had given him his first inkling as a boy of a wider, richer, stranger world of the imagination. *Tristesse du roi* draws on the same popular imagery as *Jazz*. But there is a new grandeur and pathos in this fable of art, life and mortality represented by the guitarist with powerfully expressive hands playing for a lithe young dancer while the aged king, huddled at their feet, stretches out a hand in farewell or salute. Its brilliant elegiac energy was recognised at once by the young artists on the selection committee of the Salon du Mai in 1952, and even before that by Georges Salles, the director general of French muse-ums, who saw it in the studio at Cimiez and immediately arranged to buy it for the nation.[147]

Matisse, intermittently concerned to leave some sort of published record for posterity, had arranged over the past decade for Skira to com-mission successively an account of his life and work from Aragon, the Duthuits' catalogue raisonné, and an album on the chapel.[148] None of these projects came to anything in his lifetime (the first and last would eventually appear decades later; the catalogue, which split into many vol-umes, is still under way). The only thorough and impartial contemporary survey was Alfred Barr's lucid, eloquent and scholarly *Matisse: His Art and His Public*, written to accompany a retrospective exhibition at the Museum of Modern Art in New York at the end of 1951. But this first attempt to establish a basic historical framework dismayed both the painter and his family, reactivating a reticence ingrained ever since the Humbert scandal. In spite of patient prodding from Pierre, who took the American view that knowledge should be free, neither his parents nor his sister responded with anything but suspicion to Barr's written questionnaires, or to the per-sonal envoys who arrived at intervals from New York with increasingly urgent appeals for information.[149] The situation was further complicated by the fact that so many key works had for all practical purposes gone missing. In an impassioned speech at the opening of the MoMA show, Barr outlined the ravages inflicted by half a century of war, revolution and totalitarian dictatorship, highlighting the apparent disappearance of the Moscow paintings, which no one had seen since 1947.[150] Lydia had reopened contact with the Soviet Union after the war by buying a batch of drawings from Matisse and posting them to the director of the Museum of Modern Western Art in Moscow, in token of solidarity with the suf-ferings of her fellow Russians (over the next three decades she would fol-low this first gift with others, donating in the end all the paintings and

drawings given her by Matisse as a provision for her old age).[151] In June 1947, Matisse himself endorsed her gesture by sending a further drawing, but neither his gift nor Barr's efforts to bring pressure through the American ambassador brought news of the pre-1914 pictures, which would remain locked up in Soviet cellars until after Stalin's death.[152]

The paintings in Dr. Barnes' custody at Merion had been inaccessible in practice, if not in theory, for years. Apart from the Sembats' legacy at Grenoble, the only representative collection to have passed intact into public ownership came from Etta Cone, who left more than forty paintings, eighteen sculptures and countless drawings to the Baltimore Museum on her death in 1949. Matisse had treated the Cone Collection as a kind of personal museum or ark, and now he opened a second depository in France. The Matisse Museum in his birthplace, Le Cateau, was initially a dream more symbolic than actual. Founded on the initiative of the mayor and a group of local shopkeepers, launched by a donation of drawings from Matisse himself, and installed in the state room on the first floor of the little Renaissance town hall (where his parents had been married more than eighty years before), it was inaugurated in November 1952 in the presence of the painter's three children, whose future generosity would ensure that it eventually became the safe-house and treasure-store their father had envisaged.

By this time Matisse was apprehensive even about the survival of his chapel. Worries about compulsory closure ("He talked of possible changes of government, of persecutions and expulsions") were exacerbated by Aragon's confident assurance that the building would become a dance hall as soon as the Communists came to power in France.[153] Public perception of Matisse's work as relatively shallow by comparison with Picasso's intensified as the two drew closer in private in these years. Picasso painted violence and devastation; Matisse required from art the serenity and stability life could not give. But the main reason why his reputation would be temporarily eclipsed by Picasso's in the second half of the twentieth century was that whole areas of Matisse's output remained virtually unknown.[154] A series of major acquisitions by MoMA of works from before and during the First World War—the *Red Studio* of 1908, the alternative version of Shchukin's *Dance* of 1909, the *Piano Lesson* of 1914 and the *Moroccans* of 1916—produced a powerful delayed impact on successive generations of American artists after the Second World War. But what Matisse estimated as a time lag of fifty years was still in operation. A single small show of his cut-outs at the Berggruen Gallery in Paris in 1953 was

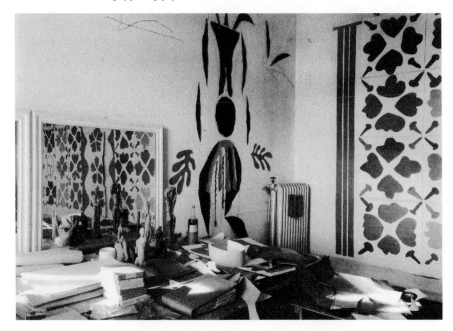

The studio wall
at Cimiez, 1952

followed by a gap of nearly three decades before either the art world or the public started to make sense of the work of his last years.

Visitors in the early 1950s were hard put to find words to describe the studio at Cimiez: "a gigantic white bedroom like no other on earth," said a young English painter sent by the Bussys with a gift of lemons from their garden;[155] "a fantastic laboratory," wrote Georges Salles, who sensed high-tension wires criss-crossing the whole space ("The vibrations are so close in these paintings, the forces are held in such a fragile balance that it seems as though the slightest mistake of calculation would have caused a catastrophe. The retina is pushed to the limit of its potentialities").[156] Matisse explained to newcomers that the whole apartment had once been so filled with greenery and birds that it made him feel he was inside a forest. Now he had got rid of his plants, and given the last of his fancy pigeons to Picasso (who drew its portrait on a famous poster, *Dove of Peace*, sent round the world to advertise a Communist conference in 1949). Instead he filled his white walls with cut-paper leaves, flowers, fronds and fruit from imaginary forests. Blue and white figures—acrobats, dancers, swimmers—looped and plunged into synthetic seas. Diffused and disembodied colour seemed to emanate not so much from any particular motif or composition as from the space itself. "A limpid scattering of colour

463

bathes the whole room, glowing like a rainbow, flaring like lightning, becoming soft and supple, then iridescent again like a rainbow ... blue, orange, violet, almond green, leaf green, orderly, organised, each finding its own shape and place in the ensemble of forms."[157]

As Matisse's race with death accelerated, he feared each work might be his last. He was carving into colour with astonishing speed and mastery, cutting out each motif in minutes and waiting impatiently for it to be pinned into place. His superabundant vitality wore out his young assistants. The gruelling pace of work on four successive *Blue Nudes* left Paule Martin sick and stupefied with exhaustion.[158] Pierre, who produced a flow of American decorative commissions, found himself struggling to keep up with his father's production rate. In 1952, Matisse designed a stained-glass window for Tériade's seaside villa and another for the Christmas issue of *Life* magazine, starting work on a third for Pierre himself as well as producing plans for a mausoleum and three alternative layouts for a tiled patio in California ("Picasso, who never makes any comment, said spontaneously that ... only Matisse could have done anything like that").[159] For himself he made the huge *Swimming Pool*, running right round two sides of his studio, and the even grander *Parakeet and Mermaid*. He told an interviewer that he felt more detached than ever from the moral and physical troubles that threatened to drag him down. "Hell, you know, lies so close to Heaven, and Heaven so close to Hell."[160] He was working now as he had once heard the great violinist Eugène Ysaye play, shortly before he died, barely articulating the separate phrases of a Mozart sonata, caressing the strings of his instrument with gestures so firm and supple "that it seemed as if only the essence of each musical phrase remained. This was how he played at the end of his life. The violinist gave the impression of murmuring with an ease that seemed a little careless. He appeared to be playing for nobody but himself."[161]

Towards the end of 1952, Matisse's handwriting faltered for the first time. He composed a message to Marguerite in elegant, tottery capital letters in September, and often switched to dictation after that. He suffered from intestinal spasms, asthmatic crises and fits of giddiness. Great waves of despondency threatened to engulf him. His doctors tended him "with their fingertips," according to René Leriche, the surgeon who had saved his life in Lyon more than ten years earlier and to whom he still sent a book or drawing every year in gratitude.[162] Marguerite spent the bulk of her time in these years watching over her father in Nice, with occasional side trips to Aix to look after her mother.

Matisse no longer visited Paris, spending the summers of 1953 and

1954 in a villa in the countryside near Vence, resting "in silence and the greatest incognito."[163] It was a return to the isolation and retreat of his first years with Lydia, who could no longer bear to leave him, even for an evening ("It wasn't that he stopped me, but his sorrow and anxiety were so great that I lost all desire to go"). She had learned to sleep intermittently, getting up three or four times to relieve the misery of Matisse's nights, so that he might find strength to work again for a few hours next day. Simon Bussy died early in 1954. Sister Jacques tried unsuccessfully to persuade Matisse to agree to be buried in his own chapel, provoking a rare spurt of anger from Lydia, who pointed out that the offer disturbed his peace while he lived, and would damage his reputation when he died ("The chapel . . . would cease to be a disinterested piece of work and become testimony to an immense vanity").[164] Matisse was justly confident in Marguerite's ability to circumvent any attempt by the Church to take advantage of his physical infirmity.

"I am beginning to take Renoir's place on the Côte d'Azur," Matisse had written after his operation, knowing that his only prospect of survival was to accept the half-life of a permanent invalid.[165] He had drawn courage from Renoir in his first years in Nice, and now he followed the example of their last meet-ings at Cagnes, when he watched life and energy flow back into the dying painter through the brush strapped to his bandaged hands. "I have never seen a man so happy," said Matisse. "And I promised myself then, that when my time came, I would not be a coward either."[166] Alberto Giacometti, one of the few artists of his Paris-based generation who unreservedly admired Matisse's chapel, came to draw his portrait in the spring, and again in the summer of 1954. Gia-cometti drew Matisse in

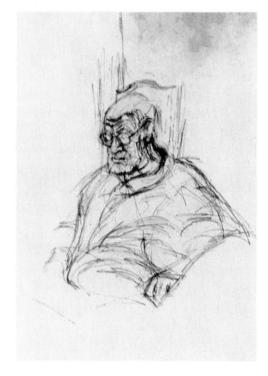

Alberto Giacometti, from *Six Studies of Henri Matisse,* July 5, 1954

465

bed, exploring with delicacy and feeling the skull beneath the skin, the curves and puckers of cheek and neck, the strong lines of browbone, nose and chin. He told Françoise Gilot that what moved him most at these encounters was to see "a great artist still so absorbed in trying to create when death was at his doorstep . . . when there was no longer time."[167]

Matisse's last work was a stained-glass window commissioned by Nelson Rockefeller in memory of his mother, Abby Aldrich Rockefeller, one of the three founders of the Museum of Modern Art in New York. On 1 November, Matisse wrote to Alfred Barr to say that his design of ivy in flower was finished and ready for production. The same day he suffered a ministroke. "He stopped working," wrote his doctor, "and applied himself to dying. His worn-out heart slowly ceased to beat. It took three days."[168] Marguerite never left his side. On the second day Lydia came to his bedside with her hair newly washed and wound in a towel turban, accentuating the classical severity and purity of the profile Matisse had so often drawn and painted. He asked for drawing things, and sketched her with a ballpoint pen on sheets of writing paper, holding the fourth and final sketch out at arm's length to assess its quality before pronouncing gravely, "It will do." "I remember above all its perfect placing on the page," Lydia wrote of this last drawing, "and the impression it gave of lightness and nobility."[169] Matisse died the next day, 3 November 1954, at four o'clock in the afternoon in the studio at Cimiez, with his daughter and Lydia at his side.

Lydia left immediately with the suitcase she had kept packed for fifteen years. Amélie Matisse returned as her husband's widow to resume charge of his work for posterity. Matisse's public position remained even-handed to the end. The family arranged a funeral mass, which was celebrated in the church at Cimiez by the Archbishop and attended by the Socialist mayor, Jean Médecin, who spoke at the church door. The corporation of Nice gave the plot of ground on the hill above the town where the painter lies buried, simply according to his wishes,[170] with no monument except a plain stone slab carved by his son Jean, beneath a fig tree and an olive to which time and chance have added a wild bay tree fifty years after his death.

KEY TO NOTES

~

ABBREVIATIONS

AM Amélie Matisse
AMP Archives Matisse, Paris
AR André Rouveyre
Getty Getty Center for the History of Art,
 Santa Monica, California
GD Georges Duthuit
HM Henri Matisse
HS Hilary Spurling
JC Judith Cousins papers, MoMA, NY
JM Jean Matisse
LD Lydia Delectorskaya
MM Marguerite Duthuit-Matisse
MoMA Museum of Modern Art, New York
Mqt Albert Marquet (Matisse's letters to
 Marquet in Wildenstein archive, Paris,
 with photocopies in Archives Matisse)
OM Olga Meerson
PM Pierre Matisse
PMP Pierre Matisse papers, Pierpont Morgan
 Library, New York
SS Sergei Shchukin

SHORTENED REFERENCES
TO BOOKS, EXHIBITION
CATALOGUES, ARTICLES
AND TAPE RECORDINGS

(The standard author-title short form is used in the
Notes for repeated citations not listed here.)

Aragon 1 and 2 *Henri Matisse: A Novel* by Louis
 Aragon. Vols. 1 and 2. Translated by Jean Stuart,
 London, 1972. (I have made my own translations,
 and taken them from *Henri Matisse, roman*, by
 Louis Aragon, Paris, 1998.)

Barr *Matisse: His Art and His Public* by Alfred H.
 Barr, Jr., New York, 1951.
Bernier tapes "Conversations with Pierre
 Matisse" tape-recorded by Rosamond Bernier in
 1986.
Bonnard *Bonnard/Matisse: Letters between Friends* ed.
 Antoine Terrasse, New York, 1992.
Bussy Matisse's letters to Simon Bussy, Musée du
 Louvre, Paris, with photocopies in Courtauld
 Institute, London.
Bussy 1996 *Simon Bussy (1870–1954): L'esprit du trait,
 du zoo à la gentry* by Philippe Loisel. Ex. cat.,
 Musée départementale de l'Oise, Beauvais, 1996.
Bussy, J. S. "A Great Man" by Jane Simone Bussy,
 Burlington Magazine, vol. 128, February 1986, p. 80.
Camoin *Correspondance entre Charles Camoin et Henri
 Matisse* ed. Claudine Grammont, Paris, 1997.
Collectors 1995 *Morozov and Shchukin—The Russian
 Collectors* ed. George-W. Költzsch. Ex. cat.,
 Museum Folkwang, Essen, 1995.
Courthion "Conversations avec Henri Matisse"
 by Pierre Courthion. Unpublished ts., Getty
 Center.
Couturier *La Chapelle de Vence: Journal d'une création* by
 Henri Matisse, M. A. Couturier and L. B.
 Rayssiguier, ed. Marcel Billot, Paris, 1993.
Delectorskaya 1 *With apparent ease . . . Henri Matisse
 (Paintings from 1935–1939)* by Lydia Delectorskaya,
 Paris, 1988.
Delectorskaya 2 *Henri Matisse: Contre vents et marées.
 Peinture et livres illustrés de 1939 à 1943* by Lydia
 Delectorskaya, Paris, 1996.
Duthuit *Ecrits sur Matisse* by Georges Duthuit, ed.
 Rémi Labrusse, Paris, 1992.
Escholier *Matisse, ce vivant* by Raymond Escholier,
 Paris, 1956.
Finsen *Matisse Rouveyre Correspondance* ed. Hanne
 Finsen, Paris, 2001.

Flam 1 *Matisse: The Man and His Art, 1861–1918* by Jack D. Flam, 1986, New York & London.

Flam 2 *Matisse on Art*, New York, 1995 (1973).

Flam 3 *Matisse: A Retrospective*, New York, 1988.

Flam 4 *Matisse: The Dance*, Washington, 1993.

Flam 5 *Matisse Picasso: The Story of Their Rivalry and Friendship*, New York, 2003.

Fourcade *Henri Matisse: Ecrits et propos sur l'art* ed. Dominique Fourcade, Paris, 1972.

Gilot *Matisse and Picasso: A Friendship in Art* by Françoise Gilot, London, 1990.

Gowing *Matisse* by Lawrence Gowing, London, 1979.

Kean *French Painters, Russian Collectors: The Merchant Patrons of Modern Art in Pre-Revolutionary Russia* by Beverly Whitney Kean, London, 1994.

Kostenevich/Semenova *Collecting Matisse* by Albert Kostenevich and Natalya Semenova, Paris, 1993.

Labrusse 1 *Matisse: La condition de l'image*, Paris, 1999.

Labrusse 2 "L'ami Byzantin: Matthew Stuart Prichard" from "Esthétique décorative et expérience critique: Matisse, Byzance et la notion d'Orient." Ph.D. diss., Univ. of Paris 1, 1996.

Labrusse 3 "Conversations avec Matisse" by Matthew Stuart Prichard, ed. R. Labrusse. Unpublished ts.

Laudon *Matisse in Tahiti* by Paule Laudon, Paris, 2001. (*Matisse à Tahiti*, Paris, 1999.)

Masson "*Conversations avec Henri Matisse*" in *André Masson: Le rebelle du surréalisme. Ecrits* ed. Françoise Levaillant, Paris, 1976.

Matisse Oeuvre gravé *Henri Matisse: Catalogue raisonné de l'oeuvre gravé*. 2 vols. Ed. Marguerite Duthuit-Matisse and Claude Duthuit in collaboration with Françoise Garnaud, Paris, 1983.

Matisse Sculpture *Matisse: Catalogue raisonné de l'oeuvre sculpté* ed. Claude Duthuit with the collaboration of Wanda de Guébriant, Paris, 1997.

Matisse 1986 *Henri Matisse: The Early Years in Nice 1916–30* by Jack Cowart and Dominique Fourcade. Ex. cat., National Gallery of Art, Washington, 1986.

Matisse 1990 *Matisse in Morocco. The Paintings and Drawings, 1912–13* by Jack Cowart, Pierre Schneider, John Elderfield, Albert Kostenevich and Laura Coyle. Ex. cat., National Gallery of Art, Washington, 1990.

Matisse 1992 *Henri Matisse: A Retrospective* by John Elderfield. Ex. cat., MoMA, New York, 1992.

Matisse 1993 *Henri Matisse, 1904–17* by Dominique Fourcade and Isabelle Monod-Fontaine. Ex. cat., Paris, 1993.

Matisse 1998 *Matisse et l'Océanie: Le voyage à Tahiti* by Dominique Szymusiak. Ex. cat., Musée du Cateau-Cambrésis, 1998.

Matisse 1999 *Henri Matisse: Four Great Collectors* ed. Kaspar Monrad, Statens Museum for Kunst, Copenhagen, 1999.

Matisse Paris 1999 *Matisse en Maroc* ed. Brahim Alaoui. Ex. cat., Institut du Monde Arabe, Paris, 1999.

Matisse Picasso 2002 *Matisse Picasso* by Elizabeth Cowling, John Golding, Anne Baldassari, Isabelle Monod-Fontaine, John Elderfield and Kirk Varnedoe. Ex. cat., Tate Gallery, London, 2002, Musée Nationale d'Art Moderne, Paris, & MoMA, New York, 2003.

Nelck *L'Olivier du Rêve: Matisse à Vence. Témoignage* by A. Nelck, Nice, 1999.

Richardson *A Life of Picasso, vol. 2, 1907–1917: The Painter of Modern Life* by John Richardson with the collaboration of Marilyn McCully, London, 1996.

Schneider *Matisse* by Pierre Schneider, Paris, 1984.

Semenova *Collecting Genius: Sergei Shchukin and Early Modern Art* by Natalia Semenova, trans. Andrew Bromfield, Washington, 2004.

Sembat 1913 "Henri Matisse" by Marcel Sembat, *Les Cahiers d'aujourd'hui*, no. 4, April, 1913.

Sembat 1920 *Henri Matisse* by Marcel Sembat, Paris, 1920.

Soeur Jacques *Henri Matisse: La Chapelle de Vence* by Soeur Jacques-Marie, Nice, 1993.

Spurling *The Unknown Matisse. A Life of Henri Matisse: The Early Years 1869–1908* by Hilary Spurling, London and New York, 1998.

Stein *The Autobiography of Alice B. Toklas* by Gertrude Stein, London 1966 [1933].

NOTES

~

CHAPTER ONE

1. Collectors 1995, p. 132; John Hallmark Neff,
 "Matisse and Decoration, 1906–1914" (Harvard,
 1974), ph.d. thesis, chap. 3, kindly shown me by
 John Golding (the commission—for a stained-
 glass window—was ultimately abandoned); and
 see Spurling, pp. 414 and 464, n. 170.
2. Gisela Fiedler-Bender, *Matisse und seine deutsche
 Schuler*, ex. cat. (Pfalzgalerie Kaiserslautern, 1988),
 p. 18.
3. Stein, p. 103 (HM corrected her account in
 "Testimony against Gertrude Stein," *transition*
 [July 1935]: p. 6); Whittemore bought HM's *La
 Terrasse* in 1907 and presented it in 1912 to the
 Isabella Stewart Gardner Museum, Boston.
4. Much argument has centred on the dating of
 Nymph and Satyr, but I am assured by Wanda de
 Guébriant that it was reserved by Bernheim-
 Jeune on 26.11.08.
5. Cezanne's *Abduction* was in the Zola sale at Hotel
 Drouot, Paris, in March 1903, which HM is
 unlikely to have missed.
6. To Edward G. Robinson, PM/HM, 19.11.52,
 PMP.
7. Aragon I, p. 236, n. 3.
8. Information from Shchukin's biographer, Natalia
 Semenova. Authorities from Barr onwards have
 traditionally assigned a later date to this key
 encounter, but in fact HM was away from Paris
 from 7 February (HM/Fénéon, 7.2.09, Matisse
 1993, p. 87–88) until at least 9 March; I am
 grateful to Wanda de Guébriant for pointing out
 that his post was forwarded to him throughout
 this period in Cassis, although he continued to
 use his Paris address for business correspon-
 dence.

9. SS/HM, 27.3 and 30.5.09, in
 Kostenevich/Semenova, pp. 164–65, 107.
10. SS/HM, 30.5.09, Kostenevich/Semenova, p. 165;
 and see Barr, p. 133.
11. HM/Fénéon, 7.2.09.
12. Sembat 1920, p. 7, and *Les Cahiers noirs, 3e partie,
 1906–10* (Paris, 1984), entry for 9.3.09, p. 28.
13. For the Humbert Affair, see Spurling, chaps. 7
 and 8.
14. AM/MM, 28.12.23, AMP.
15. HM/AM, 31.8.28, AMP.
16. Accounts vary because, as numbers rose, HM
 was forced to reduce the amount of time he gave
 his pupils; he seems to have had two studios at
 the Sacré Coeur, one next to his students, the
 other in the family quarters.
17. Sigfried Ullman, *Scandinavian Modernism: Painting in
 Denmark, Finland, Iceland, Norway and Sweden
 1910–1920*, ex. cat. (Göteborgs Kunstmuseum:
 Gothenburg, 1989), p. 62 (I am grateful to Lars
 Erik Sundberg for drawing my attention to this
 informative catalogue); my account of the school
 is based also on John Lyman, "Adieu, Matisse,"
 Canadian Art, vol. 12, no. 2 (winter 1955); Alice
 Keene, *The Two Mr. Smiths: The Life and Work of
 Matthew Smith 1879–1959* (London, 1995); Mal-
 colm Yorke, *Matthew Smith: His Life and Reputa-
 tion* (London, 1997); Billy Klüver and Julie
 Martin, *Kiki's Paris: Artists and Lovers, 1900–1930*
 (New York, 1989); and see Spurling,
 pp. 406–10.
18. H. Purrmann, "From the Workshop of Henri
 Matisse," *The Dial*, vol. 73 (July 1922).
19. P. H. Bruce/HM, n.d. [autumn 1909], AMP.
20. Ullman, *Scandinavian Modernism*, p. 63.
21. Information from LD.
22. Klüver and Martin, *Kiki's Paris*, pp. 40 and 216,
 n. 6.

23. Kostenevich/Semenova, p. 13, n. 22.

24. See Spurling, p. 385, and chap. 2, p. 45.

25. M. Vassilieff, "La Bohème du 20e siècle: Mémoires," 1929, ts. kindly provided by Claude Bernès; my account of her story is based on these memoirs, and on Ada Raev, "Die 'Russische Seite' der Marie Vassilieff," in *Marie Vassilieff 1884–1957: Eine Russische Kunstlerin in Paris*, ex. cat. (Verborgene Museum: Berlin, 1995). I am grateful to Claude Bernès—and to his exhibition, "Marie Vassilieff dans ses murs," Musée du Montparnasse, Paris, 1999—for much help and information.

26. *Toison d'or*, no. 6 (June 1909) (translation credited to the editor, Nikolai Riabushinsky).

27. The surname has often been transliterated as "Merson," but the name she used herself and the signature on her paintings is "Meerson." Her recent arrival in Michael Stein/Gertrude Stein, 1 June, n.d. [1908], Beinecke, and Sarah Stein/Gertrude Stein, n.d. [summer 1908], ibid.; she shared a studio with Vassilieff (Kostenevich/Semenova, p. 13), but is not mentioned in the latter's memoirs (which notoriously elide, telescope or suppress facts and dates). For Mlle Russia, see P. Bruce/Leo and Gertrude Stein, n.d. [summer 1908], Beinecke.

28. This and the next quote from HM/Dr. Paul Dubois, Nov. 1911, Getty Center.

29. Application by OM to Moscow School of Painting, Sculpture and Architecture, 24.1.1891, Russian State Archive for Art and Literature, Moscow; my account of the Meerson family is based on a dossier from the State Archive kindly supplied by Natasha Semenova, including OM's birth certificate (b. 23.11.1878 to Marcus and Maria Amelia Faivushevna Merson of Ponevjev) and police permit, and the birth certificate and art-school application of her brother Feodor; and on information from OM's daughter, Tamara Estermann.

30. Gisela Kleine, *Gabriele Münter und Wassily Kandinsky: Biographie eines Paares* (Frankfurt, 1990), p. 712, n. 16; my account of OM, Kandinsky and the Phalanx Klasse based also on Münter's memoirs in Annegret Hoberg, *Wassily Kandinsky and Gabriele Münter: Letters and Reminiscences 1902–14* (Munich, 1994), p. 31.

31. For *Dame assise sur l'herbe*, or *Fräulein Merson à Kochel*, 1902, see *Kandinsky*, ex. cat. (Paris, 1984), no. 10; see also Hans K. Roethel and Jean K. Benjamin, *Kandinsky: Catalogue raisonné of the Oil Paintings, vol. 1, 1900–1915* (London, 1982), nos. 33 (*Studie zu Schleuse*, 1901, ded. "To Olga Markusovna Meerson from W. Kandinsky, 27 Feb. 1902"), 589 and 594. I am grateful to Peter Kropmanns for first

alerting me to this connection, and for help in sorting it out.

32. Information from Tamara Estermann.

33. OM exhibited Breton subjects in Moscow and Paris in 1908 (her *Breton Peasant Girl*, priv. coll., signed and dated 1905, wears the characteristic coiffe of the Pont Aven region), and her Munich lodging at 16 Gisela Strasse was a few doors from the famously hospitable studio of Werefkin and Jawlensky at no. 23 (see Bernd Fäthke, *Marianne Werefkin: Leben und Werken 1860–1938* [Munich, 1988]).

34. OM's letters to Lilia Efron, in the Russian State Archive of Art and Literature, Moscow, kindly supplied by Natasha Semenova.

35. Jelena Hahl-Koch, *Kandinsky* (London, 1993), p. 177; for this whole episode, see also Magdalena M. Moeller, ed., *Der frühe Kandinsky: 1900–1910*, ex. cat. (Berlin, 1994), p. 34; Kleine, *Gabriele Münter und Wassily Kandinsky*, p. 258; and Spurling, pp. 386 and 462, n. 38.

36. Mann claimed that his character was entirely imaginary (*A Sketch of My Life* [London, 1961], p. 31), but the similarities in name, looks, character and circumstances suggest a strong factual base; for Epstein, see Bernd Fäthke, *Elisabeth Ivanovna Epstein: Eine Künstlerfreundschaft mit Kandinsky und Jawlensky* (Ascona, 1990); her friendship with OM documented in OM/L. Efron, n.d., Russian State Archive for Art and Literature, Moscow.

37. E. Burns, ed., *Staying on Alone: The Letters of Alice B. Toklas* (New York, 1973), p. 92.

38. Frances Spalding, *Roger Fry: Art and Life* (London, 1980), p. 137.

39. M. S. Prichard/Helen Sears, 13.2.10, Labrusse 2.

40. Inez Haynes Irwin, "Adventures of Yesterday," ts. (Radcliffe College, Cambridge, Mass. [JC]), p. 137 (she visited HM's studio on 20.4.08).

41. M. Stein/G. and L. Stein, Sunday, 12 noon, n.d. [1908], Beinecke.

42. Barr, pp. 126–27.

43. Janet Flanner, *Men and Monuments* (London, 1957), p. 88.

44. Stein, p. 56.

45. J. Tugendhold, "Salon d'Automne," *Apollon*, no. 12 (1910) (show put on by the Société Russe artistique et littéraire at 6 Impasse Ronsin in December 1910).

46. *L'Intransigeant*, 31.9.09, in L. C. Breunig, ed., *Chroniques d'Art 1902–18* (Paris, 1960), p. 162.

47. M. Vassilieff/HM, 8.12.11, AMP.

48. HM/P. Dubois, 28.11.11, Getty.

49. Hans Purrmann, "From the Workshop of Henri Matisse," *The Dial*, vol. 73 (July–December 1922), repr. New York, 1966, p. 34.

50. See Flam 1, p. 248, A. Kostenevich in Collectors

1995, p. 418, and Flam 5, p. 74; I am grateful to OM's daughter, Tamara Estermann, for information about the colour of her hair (much has been deduced from the fact that HM abandoned *Nymph and Satyr* with the paint still wet, but in fact he habitually sold or showed works with wet paint, e.g., *Girl with Green Eyes*, bought by Harriet Levy in 1908, and *Pink Studio*, shown at the 1911 Independents' Salon).

51. Vassilieff: "La Bohème du 20e siècle."

52. Aragon 1, p. 236, note (translation HS).

53. The correspondence is in Kostenevich/Semenova, pp. 163–65.

54. Information from Claude Duthuit.

55. Flam 1, p. 223.

56. Alan Bowness et al., *Post-Impressionism: Cross-Currents in European Painting*, ex. cat. (Royal Academy: London, 1979), p. 61; for HM and Cross, see Spurling, pp. 285–91 and 321–32.

57. Three letters from Cross to HM, n.d. [Jan.–Feb. 1909], AMP.

58. M. S. Prichard/Isabella Stewart Gardner, Easter Day [11 Apr.], 1909, in Labrusse 1, p. 276, n. 163; the canvas was *Dance (I)*, MoMA.

59. Flam 2, p. 54.

60. Natasha Udailtsova, entry for 12.4.09 from a journal, published Moscow, 1994, kindly supplied by Natasha Semenova.

61. Information from Claude Duthuit; I am grateful to Dr. Stanley Blaugrund of New York for general information about tracheal malfunction and treatment; for the earlier episode, see Spurling, p. 231.

62. Date in deed of sale, 1912, Archives, Musée Français de la carte à jouer, Issy-les-Moulineaux.

63. Stein, p. 102.

64. Lyman, "Adieu Matisse," and information from Wanda de Guébriant.

65. HM/H. Manguin, 15.7.09, Archives Jean-Pierre Manguin, Avignon; my account of this summer based on HM's letters to Manguin, ibid.; and M. Stein/G. Stein, 7.8.09, Beinecke.

66. Flam 2, p. 54.

67. H-E. Cross/HM, 4.8.09, AMP; and see Spurling, pp. 321–22.

68. Maurice Denis, *Théories* (Paris, 1920 [1913]), p. 164.

69. H-E. Cross/HM, 21.9.06, AMP.

70. Sembat 1913, p. 190 (Sembat noted the date in his journal as 30.10.09, and paid 600 francs for the picture to Bernheim-Jeune on 6.11.09).

71. Sembat 1920, p. 9.

72. Camille Schuwer/M. S. Prichard, 13.10.10, Labrusse 3.

73. Couturier, p. 136.

74. Sembat 1920, p. 9.

75. Spurling, p. 148.

76. George Melly, *Don't Tell Sybil: An Intimate Memoir of E. L. Mesens* (London, 1998).

77. *A Sketch of My Life* (London, 1961), p. 30 (from *Fiorenza*, 1906).

78. Jules Romains, *Amitiés et rencontres* (Paris, 1970), p. 93.

79. Information from Claude Duthuit (pyjama-suits for casual wear at home had been recently introduced to Europe from India and the East; nightshirts were for sleeping).

80. "Tonio Kröger," 1903, in *Death in Venice* (London, 1955), p. 190; the next quote is from p. 191.

CHAPTER TWO

1. HM/PM, 6.6.42, PMP.

2. LD to HS in the course of a series of interviews between 1993 and her death in 1998.

3. Couturier, p. 140.

4. A. Gilot, p. 46.

5. This and all the other quotes in this paragraph are from R. Dorgelès, *Bouquet de Bohême* (Paris, 1989 [1947]), pp. 228–29.

6. HM to P. Courthion, Courthion papers (loose sheet), Getty.

7. C. Lewis Hind, *The Post-Impressionists* (London, 1911), p. 46.

8. My account is based on a visit to the house with Claude Duthuit in May 2000; on the deed of sale of 3.1.12 (referring back to the lease of 18.5.09), the surveyor's 1909 plan and local land registers in the archive of the Musée Français de la carte à jouer, Issy-les-Moulineaux; see also Pierre Beis, *Issy-les-Moulineaux au jour le jour* (Issy, 1994), and Alain Becchia, *Issy-les-Moulineaux: Histoire d'une commune suburbaine de Paris* (Issy, 1977).

9. Georges Flandrin and François Roussier, *Jules Flandrin, 1871–1947* (Paris, 1992), p. 108.

10. S. Bussy/HM, 12.9.10, Bussy.

11. HM/J. Biette, n.d. [spring 1910], AMP, and HM's correspondence with his wife passim.

12. AMP, see Barr, p. 553, and see Joan Halperin, *Félix Fénéon, Aesthete and Anarchist in Fin-de-siècle Paris* (New Haven, 1988).

13. See, e.g., Bussy J. S., p. 81, and Spurling, p. 369.

14. B. Berenson, "Encounters with Matisse," in Flam 3, p. 374.

15. HM/B. Berenson, draft, 6.12.09, and B. Berenson/HM, 12.12.09, AMP; my account of this affair is based on this correspondence, on B. Strachey and J. Samuels, eds., *Mary Berenson: A Self-Portrait from Her Letters and Diaries* (London,

1983), pp. 155, 161; and 163; and on *Bernard Berenson and Isabella Stewart Gardner, 1887–1924* (Boston, 1987), p. 454. Berenson showed HM's designs to Clive Bell (C. Bell/A. Barr, 25.6.50, MoMA), but I am assured by Fiorella Superbi of the Villa I Tatti, Florence, that they are no longer in Berenson's archive.

16. HM/MM, 20.6.26, AMP.

17. Flam 1, p. 264 and n. 34, p. 495.

18. HM/J. Biette, n.d. [Jan. 1910], AMP.

19. HM/AM, Sunday evening, 9 p.m., n.d. [11.12.10], AMP.

20. O. Mirbeau, *Correspondance avec Claude Monet*, ed. Pierre Michel et J-F. Nivet (Paris, 1990), p. 225.

21. Dorgelès, *Bouquet de Bohême*, pp. 229–44; my account also based on A. Salmon, *Souvenirs sans fin*, vol. 2, 1908–20 (Paris, 1956), p. 184; Courthion, p. 141; and "Boronali," in E. Bénézit, *Dictionnaire Critique et documentaire des peintres etc.* (Paris, 1976); for Salmon's 1910 article, see Flam 3, pp. 129–30.

22. R. Dorgelès, "Le Prince des Fauves" *Fantasio*, no. 105, 1.12.10, in Flam 3, pp 124–26.

23. Charles Morice, "A qui la couronne?" *Le Temps*, Flam 1, p. 281, n. 3; see chap. 1, p. 4 above.

24. HM/AM, Saturday afternoon, n.d. [March 1910], AMP; my dates for this trip based on letters written from Collioure (e.g., HM/Mqt, 25.3.10, and G. Sembat/HM, 2.4.10, both AMP).

25. HM/AM, Tuesday, n.d. [March 1910], AMP.

26. E. Terrus/HM, 9.6.10, AMP.

27. HM/AM, Tuesday, n.d. [March 1910], AMP.

28. HM/G. Stein, pc, n.d. [March 1910], Beinecke.

29. G. Apollinaire, *Chroniques d'Art 1902–18*, ed. L. C. Breunig (1960), p. 94 (the canvas was *Girl with Tulips*).

30. "Le dernier état de la peinture," 1910, in *L'Effort des peintres modernes* (Paris, 1933).

31. G. Sembat/HM, 2.4.10, AMP.

32. S. Shchukin/I. Ostraoukhov, 9.11.09, in Semenova; H. Tschudi/HM, 27.6.10., AMP.

33. H. Levy, "Reminiscences," ts., Bancroft Library, University of California, Berkeley.

34. R. Gathorne-Hardy, ed., *Ottoline: The Early Memoirs of Ottoline Morrell* (London, 1963), p. 191.

35. David Sox, *Bachelors of Art: Edward Perry Warren and the Lewes House Brotherhood* (London, 1991), pp. 207–8.

36. M. S. Prichard/I. S. Gardner, 2.1.09, Isabella Stewart Gardner Museum, Boston; the next quote from ibid., 7.7.09.

37. M. S. Prichard/HM, 13.12.12, in Labrusse 3; my account of Prichard is based primarily on this invaluable compilation (kindly supplied by the author), drawn from Prichard's letters and notebooks, and from records of his conversation

made by two of his disciples, Georges Duthuit and William King, in the archives of the Isabella Stewart Gardner Museum, Boston, and the Archives Duthuit, Paris, in Labrusse 1 and 2.

38. M. S. Prichard/HM, 12.3.11, Labrusse 3.

39. Labrusse 2, p. 28.

40. M. Duthuit, "Notes sur Matisse," in Labrusse 2, and Levy, "Reminiscences."

41. M. S. Prichard/Heather Sears, 13.2.10, in Labrusse 2.

42. Charles H. Caffin, "Henri Matisse and Isadora Duncan," *Camera Work*, no. 25 (January 1909), p. 18.

43. See Spurling, p. 210.

44. Labrusse 3.

45. G. Sembat/HM, 2.4.10, AMP.

46. Barr, p. 138, Couturier, p. 131, and H. Purrmann, "From the Workshop of Henri Matisse," *The Dial*, vol. 73 (July–December 1922).

47. Leo Stein, *Appreciations: Painting, Poetry and Prose* (New York, 1947), p. 122.

48. "From the Workshop of Henri Matisse" [Purrmann wrote from memory twelve years later, by which time he had forgotten there were five figures, not four]; the next quote from ibid.

49. Flam 2, pp. 289–90, and G. Duthuit, *Les Fauves* (Geneva, 1949), p. 225.

50. Spurling, p. 46.

51. Charles H. Caffin, *The Story of French Painting* (New York, 1911), pp. 215–16.

52. HM/J. Biette, n.d. [May 1910], AMP (this letter is wrongly dated March in Matisse 1993, p. 93).

53. Stein, *Appreciations*, p. 132; the following quote from ibid., p. 203.

54. H. McBride, letter to Otto, 8.6.10, Archives of American Art, Smithsonian Institution, JC.

55. C. Bell, "The Post-Impressionist Exhibition," *Art News* (1950).

56. R. Fry/Helen Fry, 17.5.09, in Frances Spalding, *Roger Fry: Art and Life* (London, 1980), p. 118; see also p. 147; Fry's review in *The Nation*, 29.10.10.

57. HM/J. Biette, n.d. [May 1910], AMP.

58. E. Terrus/HM, 9.6.10, AMP.

59. HM/J. Biette, n.d. [May 1910], and HM/JM, 18.6.10, AMP, and Mqt/H. Manguin, 2 pc's [end Aug. and Sept.] 1910, Archives J-P. Manguin, Avignon.

60. Stein, p. 102.

61. Information from 1911 census, Archives, Museum of Issy-les-Moulineaux.

62. C. R. W. Nevinson, *Paint and Prejudice* (London, 1937), p. 125.

63. Hind, p. 53.

64. Apollinaire, *Chroniques d'Art*, p. 158; HM/J. Biette, 26.10.10, AMP; and see Spurling, pp. 398–99.

65. G. Fiedler-Bender, *Matisse und seine deutschen Schule*, ex. cat. (Pfalzgalerie Kaiserslautern, 1988), p. 18.

66. Roger Fry, "The Munich Exhibition of Mohammedan Art. I," *Burlington Magazine*, vol. 17 (April–September 1910), p. 284; reprinted in *Vision and Design* (1929 [1920]), London, p. 117.

67. Labrusse 3.

68. Labrusse 1, p. 105; for HM on Islamic art, see Fourcade, p. 203, and Barr, p. 109.

69. Emile Hippolyte Henri Matisse, death certificate, municipal archives, Bohain; for the funeral, see Alice B. Toklas, "Some Memories," *Yale Literary Magazine* (fall 1955), p. 15.

70. Couturier, p. 167.

71. PM, Bernier tapes.

72. Matisse 1993, p. 95.

73. HM/J. Biette, 26.10.10, AMP.

74. Maurice Denis, *Théories* (Paris, 1920 [1913]), pp. 161 and 160 (I have amalgamated Denis's catalogue prefaces to two successive Bernheim exhibitions in 1907 and 1910); Cross died 11.5.10.

75. HM/J. Biette, 26.10.10, AMP.

76. Kostenevich/Semenova, p. 19, and Semenova.

77. MM/PM, 19.4.63, Barr files, MoMA; and Courthion, p. 106.

78. Kean, p. 167.

79. S. Shchukin/HM, telegram, 10.11.10, and letter, 11.11.10, Kostenevich/Semenova, p. 167 (the Puvis was swapped for HM's *Girl with Tulips*).

80. H. Purrmann/A. Barr, 3.3.51, MoMA, and HM/AM, 11.12.10, AMP.

81. HM/AM, 6.12.10, AMP.

82. Couturier, p. 145.

83. MM/PM, 19.4.63, Barr files, MoMA.

84. M. S. Prichard/Isabella Stewart Gardner, 22.11.10, ISG Archives, Boston, JC.

85. HM/J. Biette, 9.1.11, AMP.

86. HM/Mqt, 17.11.10, AMP; next quote ibid., n.d.

87. HM/AM, n.d. [c. 28.11.10]. AMP. My chronology for this Spanish trip is based on HM's correspondence with AM, which is also the source of all information and quotes not otherwise attributed.

88. I am grateful to Martin Brunt for much information about Bréal and his household in Seville.

89. HM/AM, Sunday evening [11.12.10], AMP. (The rug would feature in *Seville Still Life, Spanish Still Life* and *The Pink Studio*.)

90. HM/Camoin, misdated as 3.10.10, in Camoin, p. 20.

91. HM/Manguin, 3.12.10, Archives J-P. Manguin, Avignon.

92. Courthion, pp. 106–7; see also HM/J. Biette, 9.1.11, AMP.

93. Information from LD.

94. HM/AM, 22.12.10, AMP.

95. HM/AM, 8.12.11, AMP.

96. HM/AM, n.d. [10.12.10], AMP; HM spent 11–12 December at the Alhambra, catching the three p.m. train from Malaga to Seville on 13 December.

97. Labrusse 2, record of conversation with HM, 30.6.13, pp. 21–22; see also Claude Duthuit, "La luce nasce sempra dall'Est," Matisse 1998, p. 21; and Spurling, p. 423 (SS's letter of 27.11.10 in Kostenevich/Semenova, pp. 167–68).

98. Roger Fry, "The Munich Exhibition of Mohammedan Art. II," *Burlington Magazine*, vol. 17 (April–September 1910), p. 327; and see John Hallmark Neff, "Matisse, His Cut-Outs and the Ultimate Method," ts. kindly shown me by John Golding, pp. 24–27.

99. Flam 3, p. 152.

100. G. Sembat/HM, 5.12.10, AMP.

101. Barr, p. 151; HM said he painted these canvases in a hired studio, not, as has been previously assumed, in his hotel room, HM/AM, 14.12.10.

102. J. Tugendhold, "Frantsuzkoie sobranie S. I. Shchukina," *Apollon*, vols. 1–2 (Moscow, 1914), pp. 22–28, translation HS.

103. HM's *Joaquina* and Iturrino's *Gitana* are reproduced together with their four still lifes in Kosme M. de Baranano, "Matisse e Iturrino," *Goya*, 205–206 (July–Oct. 1988), pp. 94–95, JC; additional information from Martin Brunt and A. Bréal/HM, 27.3.26, AMP.

104. Extract from HM's 1946 notebook, ts., PMP.

105. HM/AM, Sunday, 9 p.m., n.d. [11.12.10], AMP.

106. This and the next quote from Courthion, p. 107.

107. HM/J. Biette, 9.1.11, AMP.

108. Dorgelès's article in Flam 3, pp. 124–26, and see Spurling, p. 380.

109. Nevinson, p. 19.

110. SS/HM, 20.12.10, Kostenevich/Semenova, p. 168.

CHAPTER THREE

1. HM/AM, 4.12.10; the next quote from HM/AM, 8.12.10, both AMP.

2. SS's letters in Kostenevich/Semenova, pp. 167–69.

3. HM/AM, 2.12.10, AMP.

4. HM/AM, Sunday evening, 9 p.m., n.d. [11.12.10], AMP.

5. HM/AM, 7.12.10, AMP.

6. HM/AM, 5.12.10, AMP.

7. HM/AM, 22.12.10, AMP.

8. HM/AM, 28.11.10, AMP.

9. Terrus/HM, 27.12.10, AMP.

10. HM/AM, 25.12.10, AMP.

11. HM/AM, Armand and Berthe Parayre, 27.12.10, AMP.

12. J. Puy/HM, 11.1.11, AMP.

13. Stein, p. 11.

14. "Storyette HM," 1911, in G. Stein, *Portraits and Prayers* (New York, 1934).

15. My account based on HM/AM, n.d. [1.12.10], and 6.12.10, Seville, AMP; and information from Katharine and Martin Brunt.

16. HM/AM, n.d. [11.12.10], Alhambra, and Kostenevich/Semenova, p. 169, n. 4.

17. E. Terrus/HM, 27.12.10; the stop-off at Cahors in E. Terrus/AM, 25.1.11.

18. A. Bréal, *Cheminements* (Paris, 1928), p. 66.

19. Barr, p. 131.

20. HM/MDM, n.d. [postmark 21.6.26], AMP; and see Spurling, p. 242.

21. See A. Salmon, "Courier des Artistes," *Paris Journal*, 25.4.11.

22. *Le Journal*, 20.4.11.

23. Guillaume Apollinaire, *Chroniques d'Art 1902–18*, ed. L. C. Breunig (Paris, 1960), p. 259.

24. See Gisela Kleine, *Gabriele Münter und Wassily Kandinsky* (Frankfurt, 1990), p. 241, and Helena Jahl-Koch, *Kandinsky* (Stuttgart, 1993), p. 177.

25. HM/AM, Wednesday morning, n.d. [25.10.11], Moscow, AMP. My account of OM's family and her relations with HM is based on his letters to her (Getty Center) and to his wife (AMP); on her letters to Lilia Efron (Russian State Archive of Art and Literature, Moscow, kindly made available by Natasha Semenova); and on information from OM's daughter, Tamara Estermann.

26. HM/Paul Dubois, Nov. 1911, Getty Center.

27. HM/OM, n.d., Getty Center (which holds a second undated note, four postcards and a telegram from HM to OM; AMP has a further telegram, inviting her to lunch at Issy).

28. Information from Wanda de Guébriant, see p. 20.

29. Alice B. Toklas, *What Is Remembered* (New York, 1963), p. 38.

30. Information from LD.

31. See chap. 3, p. 81.

32. Pierre Schneider in Flam 1, pp. 323 and 499, n. 1.

33. OM/L. Efron, n.d. [July 1912], Laningen am Donau.

34. Information from LD, who discussed this affair and its implications with me on several occasions before her death in 1998.

35. HM/P. Dubois, 28.11.11, Getty.

36. HM/P. Dubois, Nov. 1911, Getty.

37. HM/P. Dubois, 28.11.11., Getty.

38. Mqt/HM, 7.1.11; OM's postcard in Getty.

39. Cited in Dominique Fourcade, "Rêver à trois Aubergines," *Critique* (May 1974), p. 484.

40. Fourcade, p. 203, and Flam 2, p. 178.

41. Fourcade, "Rêver à trois Aubergines," p. 480.

42. Flam 2, p. 62.

43. SS/HM, n.d. [26.3.11] and 20.12.10 in Kostenevich/Semenova, pp. 170 and 168.

44. Courthion, p. 104, and Kean, p. 188.

45. The Matisses were planning to leave Paris in late July (M. Stein/G. Stein, July 19 [1911], Beinecke), and had reached Collioure by 30 July (HM/Mqt, 30.7.11).

46. Collioure school register, 1911 and 1912.

47. Louis Codet, *Le Roussillon à l'origine de l'art moderne, 1894–1908*, ex. cat. (Palais des Congrès: Perpignan, 1998), p. 35.

48. E. Terrus/HM, 9.1.11, AMP.

49. O. Traby, preface to *Etienne Terrus*, ex. cat. (Musée Terrus: Elne, 1994), ed. Madeleine Raynal, p. 2.

50. J. Puy/HM, 10.10.11, AMP.

51. Jean-Pierre Barou, *Matisse ou le miracle de Collioure* (Montpellier, 1997), pp. 80–81.

52. S. Bussy/HM, 24.9.11, AMP.

53. M. Stein/C. Cone, 5.1.12, Baltimore Museum.

54. Information from Claude Duthuit, who was present.

55. Information from Wanda de Guébriant.

56. G. Sembat/HM, 1.10.11, AMP.

57. Confusion over the dating of this canvas has arisen because AM's date of 1910 was subsequently amended to 1911 by MM (who was present when it was painted), AMP; I am assured by Wanda de Guébriant that the latter is correct.

58. Barr, p. 131.

59. Both in private collections.

60. Annegret Hoberg and Helmut Friedel, *Gabriele Münter 1877–1962 Retrospektive*, ex. cat. (Prestel, 1992), p. 32.

61. Flam 2, p. 178, Fourcade, p. 204.

62. J. Puy/HM, 10.10.11; see also Mqt/HM, 7.1.11, and E. Terrus/HM, 9.12.11, all AMP.

63. OM/L. Efron, n.d. [1912], Russian State Archive of Art and Literature, Moscow (only the first of these five letters is dated—26.3.12—but the whole sequence evidently belongs to 1912).

64. SS/HM, 3.9.11, Kostenevich/Semenova, p. 170, and G. Sembat/HM, 24.10.11.

65. Courthion, p. 104.

66. Barr notes, 18.11.50, MoMA.

67. HM/AM, n.d. [20.10.11], AMP. All quotes from HM not otherwise attributed in my account of this Moscow visit come from his daily bulletins to his wife; further information from Kean, Kostenevich/Semenova and *Y Shchukina, na*

Zhamenke . . . by Alexandra Demskaya and Natalia Semenova (Moscow, 1993), and from Y. A. Rusakov, "Matisse in Russia in the Autumn of 1911," trans. J. E. Bowlt, *Burlington Magazine*, no. 866 (May 1975) (where I have seen the original Russian text, or other French or English versions of it, I have occasionally adjusted the translation).

68. Kean, p. 188, and HM/A. Romm, Nov. 1934, in Kostenevich/Semenova, p. 32 (restorers finally removed the addition in 1988).

69. See Kostenevich/Semenova, pp. 21–22.

70. SS posted his request for two still lifes before the arrival of *Dance* and *Music* on 4 December, and commissioned three more panels on 20 December, Kostenevich/Semenova, pp. 21 and 168.

71. I. Zhilkin, *Russkoe slovo*, 22.9.11, ibid., p. 22; SS's indoctrination produced strikingly similar ideas and turns of phrase in accounts by others, e.g., A. Benois, B. N. Ternovets, ibid., pp. 20–21 and 23, and Louis Réau, "L'Art Français en Russie," *La Grande Revue*, 10.11.09.

72. Sergei Vinogradov, Kostenevich/Semenova, p. 23.

73. Ibid., p. 42.

74. *Rannieie Utro*, 26.10.11, ibid., pp. 47–48.

75. HM/AM, n.d. [16.11.11], AMP; and see Kean, p. 190, Kostenevich/Semenova, pp. 27 and 31–32.

76. Kean, p. 188.

77. This previously unsuspected deal is documented in HM's first and third letters to AM from Moscow, both undated but datable to 25 and 31.10.11, AMP.

78. HM/AM, 8.12.10, AMP.

79. Kostenevich/Semenova, pp. 22–23.

80. Rusakov, "Matisse in Russia," p. 289.

81. Kostenevich/Semenova, p. 24.

82. Ibid., p. 36.

83. Ibid., p. 24.

84. The play was a comedy by Hamsun called *In Life's Clutches.*

85. Kostenevich/Semenova, p. 36.

86. Kostenevich/Semenova, pp. 50–51, and Matisse 1999, p. 82.

87. See HM/Sophia Markusovna Adel, Thursday, 11 Jan. [1912], Getty (the previously unidentified recipient of this letter was OM's elder sister and guardian, whom the Matisses had met in Paris; "Mlle Lili" is Lilia Efron, "Mlle Tamara" is OM's cousin Tamara Adel, "Mme Curie" is HM's ex-pupil Militsa Nikolaevna Curie); and see Kostenevich/Semenova, n. 1, p. 50.

88. HM's two letters to Dubois in the Getty; I am assured by Paul Dubois' biographer, Dr. Chris-tian Müller, that no trace of this correspondence nor any mention of OM survive in the Dubois archive in Bern, and that his many published case histories are composite, rather than based on individual patients.

89. OM/L. Efron, n.d. [1912].

90. HM/S. Adel, 11 Jan. [1912], Getty; Dr. Kritchevsky was the Steins' and the Matisses' Parisian dentist, pc, S. Stein/G. Stein, June, n.d. [1909–10], Beinecke, and HM/AM, 20.1.19, AMP.

91. Information from Wanda de Guébriant.

92. This and the next three quotes from OM/L. Efron, n.d., 1912.

93. I am grateful to Peter Kropmanns for information about this show at Galerie Alfred Flechtheim, Berlin, 1922.

94. Heinz Pringsheim statement, Munich, 5.11.59, AMP.

CHAPTER FOUR

1. Matisse 1999, p. 79.

2. HM/PM, 3.4.42, PMP.

3. SS/HM, 3.9.11, in Kostenevich/Semenova, p. 170, and HM/AM, Tuesday, n.d. [Nov. 1911], AMP.

4. J. Tugendhold, "Frantsuzkoie sobranie S. I. Shchukina," *Apollon*, vols. 1–2 (Moscow 1914): p. 27, translation HS.

5. Kostenevich/Semenova, p. 36.

6. This and the next two quotes from Tugendhold, "S. I. Shchukina."

7. Utro Rossii, 27 and 28.10.11, Y. A. Rusakov, "Matisse in Russia in the Autumn of 1911," text of 1973 lecture, Hermitage Museum, translation HS from the original unabridged ts. in the Tretiakov Archive, Moscow (see *Burlington Magazine*, no. 866 [May 1975]: p. 288).

8. Kostenevich/Semenova, p. 22.

9. Ibid., p. 171.

10. See below, n. 14.

11. HM/Mqt, 7.2.12, AMP.

12. Courthion, and Gilot, p. 28 (the piece of silk still exists in the family's textile collections).

13. HM/MM, 30.7.43, AMP.

14. HM/Mqt, 11.10.13, AMP (previously identified as no. 35, following Flam, p. 499, n. 14, but HM himself always gives no. 38).

15. Courthion, p. 101.

16. HM/Henri Manguin, 1.3.12, Archives Jean-Pierre Manguin, Avignon.

17. Walter Harris/HM, n.d. [Feb. 1912], AMP; see also Matisse Paris 1999, p. 62.

18. Courthion, pp. 102–3.

19. HM/MM, 31.1.12, AMP.

20. HM/AM, 22.10.19, AMP.

21. HM/MM, 31.1.12, AMP, and AM/Jean Matisse, 31.1.13, AMP.

22. Deed of purchase from the Widow Cocurat 3.1.12, AMP (preliminary agreement V. Cocurat/HM, 23.9.11, ibid.).

23. Michael Stein/HM, 11.3.12.

24. HM/Gertrude Stein, 16.3.12, Beinecke.

25. Pierre Loti, "Au Maroc," in *Voyages* (*1872–1913*) (Paris, 1991), p. 170.

26. John Lavery, *The Life of a Painter* (London, 1940), p. 97; and Walter Harris/HM, n.d. [spring 1912], AMP.

27. PM/HM, 16.11.25, PMP.

28. Walter Harris, *Morocco That Was* (London, 1921), p. 23; see also A. F. Tschiffely, *Don Roberto: Life and Works of R. B. Cunningham Graham* (London, 1937), p. 371.

29. *Camera Work*, no. 38 (April 1912): p. 45.

30. Mqt/HM, n.d. [1912], AMP.

31. HM/AM, 6.4.12, AMP.

32. Lavery, *Life of a Painter*, p. 83.

33. HM/AM, 5.4 and 6.4.12, AMP.

34. Clive Bell, *Old Friends* (London, 1956), p. 66.

35. Lavery, *Life of a Painter*, p. 105, and Walter Shaw-Sparrow, *John Lavery and His Work* (London, 1921), p. 85.

36. Through the proprietress, Mlle Davin; HM/AM, 31.3 and 1.4.12, AMP.

37. HM/AM, 6.4.12, AMP.

38. Harris, *Morocco That Was*, p. 293.

39. HM/G. Stein, 22.2.12, Beinecke.

40. Lavery, *Life of a Painter*, p. 103.

41. Claude Duthuit, "Henri Matisse: Notion du Voyage," Matisse Paris 1999, p. 263 ("*Balek*" means "Look out" or "Clear the way").

42. HM/Mqt, 28.3.12, AMP.

43. This and the next quote from Courthion, p. 102.

44. Information from Claude Duthuit.

45. See John Elderfield, "Matisse in Morocco: An Interpretative Guide," Matisse 1990, p. 215.

46. Pierre Loti, *Roman d'un Spahi* (Paris, 1903), pp. 104–5 and 118 (HM cited both novels on different occasions as his source, see Courthion, p. 102, and Fourcade, p. 117).

47. This episode and its aftermath recounted in HM/AM, 3.4, 5.4 and 6.4.12, AMP.

48. HM/AM, 31.3.12, AMP.

49. *No Thoroughfare*, translated as *L'Abîme*, HM/AM, 10.4.12, AMP.

50. HM/AM, n.d. [postmark Issy 13.4.12], AMP.

51. HM/AM, 31.3.12, n.d. [12.4.12], and HM/MM, 13.6.40, both AMP; and see *The Times*, 8.4.12.

52. *The Times*, 23.4.12; see also Daniel Rivet, *Lyautey et l'Institution du Protectorat français au Maroc: 1912–15* (Paris, 1988), p. 127, n. 520.

53. HM/Mqt, 19.8.11 and 14.8.13, and HM/AM, 27.8.13, AMP, and see Spurling, p. 360.

54. Sembat 1913, p. 192.

55. Georgette Sembat/HM, 28.9.12, AMP.

56. Flam 2, pp. 66 and 69.

57. Marcel Sembat, *Cahiers Noirs 4e partie, 1911–1915* (Paris, 1985), p. 17.

58. HM/AM, 6.4.12, AMP.

59. Courthion, p. 101.

60. Stein, p. 42.

61. This and the next quote from HM/MM, 12 and 23.2.12, AMP.

62. Postscript by AM to HM/MM, 31.1.12, AMP.

63. Flam 1, p. 252, and see Claude Duthuit et al., *Matisse: La Révelation m'est venue de l'Orient*, ex. cat. (Musei Capitolini: Rome, 1997), p. 133.

64. Fourcade, p. 204, and Flam 2, p. 116.

65. Kostenevich/Semenova, p. 43.

66. Tugendhold, "S. I. Shchukina," p. 9.

67. HM/Mgte, 21.11.12, AMP.

68. HM/Jean Matisse, 10.1.13, AMP; and see Matisse 1990, p. 94.

69. HM/MM, 21.11.12, AMP.

70. HM/AM, 25.10.12, AMP.

71. Courthion, p. 103.

72. HM/AM, 25.10 and 2.11.12, AMP.

73. Matisse Paris 1999, p. 230 and p. 235, n. 36.

74. HM/AM, 2.10.12, AMP, and HM/Charles Camoin, 21.10.12, Camoin, p. 34.

75. Camoin, p. 34.

76. Couturier, p. 154.

77. HM/MM, 21.11.12, AMP.

78. See Rémi Labrusse, "L'Epreuve de Tanger," Matisse Paris 1999, p. 50.

79. Sembat 1913, p. 194.

80. Couturier, p. 154.

81. Matisse Paris 1999, p. 50.

82. HM/AM, 25.10.12, AMP.

83. HM/MM, 21.11.12, AMP.

84. G. Sembat/HM, 12.11.12, AMP.

85. Camoin, p. 63, n. 7.

86. G. Sembat/HM, 12.11.12, AMP.

87. Escholier, p. 106.

88. Claude Duthuit.

89. Escholier, p. 105.

90. Camoin, p. 28.

91. HM/Mqt, March 1945, AMP.

92. HM/Mqt, 8.1.13, AMP.

93. Camoin, p. 36.

94. Camoin, p. 36, and HM/Mqt, 28.12.12, AMP.

95. HM/AM, 25.10.12, and HM/MM, 15.11.12, both AMP.

96. Bell, *Old Friends*, p. 168.
97. HM/Armand Dayot, 3.11.25, Getty [JC].
98. HM/Henri Manguin, 11.1.13, Archives J-P. Manguin, Avignon.
99. Camoin, p. 41.
100. Matisse 1990, pp. 115 and 150, n. 9.
101. This and the next quote from Tugendhold, "S. I. Shchukina."
102. HM/AM, 25.10.12, AMP.
103. This and the next quote from HM/AM, 25.10.12, AMP, and see Matisse Paris 1999, pp. 232–33.
104. AM/Jean Matisse, n.d. [11.1.13], AMP.
105. Sembat 1913, p. 192–93.
106. Sembat 1920, pp. 9–10.
107. G. Sembat/HM, 1.10.11, AMP.
108. SS already had *Goldfish, Vase of Irises* and *Amido,* with *Zorah Debout, The Riffian* and two flower paintings due.
109. G. Sembat/HM, 12.11.12, AMP (Pyotr Shchukin died on 25.10.12).
110. SS/HM, 10.10.13, Kostenevich/Semenova, p. 175.
111. Labrusse 3.
112. Georges Flandrin and François Roussier, *Jules Flandrin (1841–1947): Un élève de Gustave Moreau témoin de son temps* (Paris, 1992), p. 161.

CHAPTER FIVE

1. Janet Flanner, *Men and Monuments* (London, 1957), p. 108.
2. Press clippings in the Art Institute of Chicago archives, and Barr, p. 150.
3. Milton W. Brown, *The Story of the Armory Show* (New York, 1988), p. 179.
4. W. Pach/G. Stein, 30.3.13, Beinecke.
5. Sarah MacDougall, *Mark Gertler* (London, 2002), p. 75.
6. Kostenevich/Semenova, p. 49.
7. SS/HM, 10.10.13, ibid., p. 175.
8. Letter from *Neue Kunst* to HM, 3.2.14, AMP.
9. Georges Flandrin and François Roussier, *Jules Flandrin (1841–1947): Un élève de Gustave Moreau témoin de son temps* (Paris, 1992), p. 165.
10. *Charles Angrand, Correspondances, 1883–1926* (Paris, 1992), p. 258.
11. Kean, p. 174.
12. HM/G. Stein, n.d. [3.9.13], Beinecke, and P. Picasso/G. Stein, 29.8.13, Richardson, p. 287; see also ibid., p. 281, and Flam 3, p. 152.
13. Sembat 1920, p. 11.
14. Flam 3, p. 152.
15. Camoin, pp. 22 and 56.
16. Reprinted in *Camera Work*, no. 38 (April 1912): p. 45.
17. Robert Rey, "Une Heure chez Matisse," *L'Opinion*, 10.1.14, and see Flam 2, pp. 71–72.
18. Walter Pach, *Queer Thing Painting: Forty Years in the World of Art* (New York, 1938), p. 120.
19. Daniel Catton Rich, ed., *The Flow of Art: Essays and Criticism of Henry McBride* (New York, 1975), p. 41.
20. All quotes in this paragraph are from Rey, "Une Heure chez Matisse," and see Flam 3, p. 132.
21. HM/Anna Matisse, n.d. [Oct. 1913], AMP.
22. Marcel Sembat, *Les Cahiers noirs 4me partie 1911–15* (Paris, 1985), p. 34.
23. HM/MM, n.d. [Nov. 1913], AMP.
24. HM/Anna Matisse, n.d., AMP.
25. HM/Mqt, 11.10.13, AMP.
26. See Flam 1, p. 371.
27. Camoin, p. 57.
28. HM/AM, 17.11.23, AMP.
29. HM/Anna Matisse, n.d., AMP.
30. HM/MM, n.d. [Nov. 1913], AMP.
31. Guillaume Apollinaire, *Chroniques d'Art 1902–1918,* ed. L. C. Breunig (Paris, 1960), pp. 415 and 419.
32. Pach, *Queer Thing Painting,* p. 219.
33. Aragon 1, p. 23.
34. Courthion, p. 103; HM's abortive plans from family correspondence, Camoin, p. 57, and K. H. Osthaus/HM, 15.11.13, AMP.
35. HM/Anna Matisse, n.d. [March 1914], AMP; see also Spurling, p. 273, and Matisse 1993, p. 112.
36. My account of this affair based on Flandrin and Roussier, *Jules Flandrin,* pp. 165–67, Camoin, pp. 58–59, Escholier, pp. 223–24, and Fernande Olivier, *Picasso et ses amis* (Paris, 1973), pp. 202–4.
37. Entry for 10.2.14, *Cahiers noirs.*
38. M. Prichard/I. Stewart Gardner, 24.4.14, Isabella Stewart Gardner Museum, Boston.
39. Labrusse 3, p. 32.
40. Ibid., p. 23.
41. Dialogue recorded by William King, Isabella Stewart Gardner Museum, in Labrusse 3.
42. HM/AM, 31.3.12, AMP.
43. This and the next quote from a dialogue recorded by W. King, 10.1.14, in Labrusse 3.
44. M. Prichard/G. Duthuit, 4.11.13, AMP.
45. HM/MM, n.d. [Nov. 1913], AMP.
46. M. Prichard/Mabel Warren, 7.11.13, in Flam 1, p. 374, and Labrusse 3; my account of the episode, and quotes from HM and Prichard in this and the next paragraph, based on ibid.
47. Transcript by W. King in Labrusse 3.
48. HM/MM&PM, 15.11.12, AMP; and see Labrusse 1, p. 281, n. 201.
49. Labrusse 3, and see Camoin, p. 57.
50. Transcript by W. King in Labrusse 3.

51. My account based on Albert Landsberg's letter of 30.5.51 to Alfred Barr (text slightly amended in Barr, p. 184) and a memo of February 1981 by Rona Roob, both Barr papers, MoMA.

52. Bernier tapes.

53. A. Landsberg/A. Barr, Barr papers.

54. Labrusse 3.

55. M. Prichard/G. Duthuit, 8.6.14, AMP.

56. Memo by Monroe Wheeler, Barr papers, MoMA.

57. Matisse 1993, p. 114.

58. A. Landsberg/A. Barr, Barr papers.

59. M. Prichard/G. Duthuit, 13.5.14, AMP.

60. This and the next quote from A. Landsberg/ A. Barr, Barr papers.

61. W. Pach/HM, 7.7.16, AMP.

62. Prichard to Francis Burton Smith, printed as an addendum to *Henri Matisse*, ex. cat. (Montross Gallery: New York, 1915), in a copy kindly shown me by J. D. Flam; see also Labrusse 1, pp. 115 and 281, n. 207.

63. John Lukacs, *Philadelphia: Patricians and Philistines* (New York, 1980), p. 288.

64. Kostenevich/Semenova, p. 176.

65. Flandrin and Roussier, *Jules Flandrin*, p. 173.

66. Archives J-P. Manguin, Avignon.

67. Bernier tapes.

68. HM/Anna Matisse, 21.8.14, AMP.

69. André Level, *Souvenirs d'un collectionneur* (Paris, 1959), pp. 37–38 and 49.

70. Yves Flamand, *Fresnoy-le-grand* (St-Quentin, 1992); further information from Elie Fleury, *Sous la Botte: Histoire de la ville de St Quentin pendant l'occupation Allemande, Aout 1914–Fevrier 1917* (St-Quentin, n.d.); Michel Dutoit, ed., *Sur les traces de la Grande Guerre dans la région de St Quentin* (St-Quentin, 2000), and A. Ozenfant, *Mémoires 1886–1962* (Paris, 1968), pp. 81–82.

71. HM/AM, 28.9.14, AMP.

72. HM/AM, 25.9.14, AMP.

73. HM/AM, 7.6.18, AMP.

74. D. Cooper, ed., *The Letters of Juan Gris* (London, 1956), p. 12.

75. Aragon 1, p. 303.

76. This and the next two quotes from HM/AM, n.d. [Oct. 1914], AMP (Adolphe Basler was Polish, Eli Nadelman Russian, Rudolf Levy and Wilhelm Uhde both German).

77. HM/AM, Friday, n.d. [Oct. 1914], AMP.

78. "Testimony against Gertrude Stein," *transition*, vol. 23, no. 1, supp. (February 1935): p. 7; further information from HM's correspondence with his wife, and J. Gris/G. Stein, 19 and 26.10.14 and December 1914, Beinecke.

79. HM/AM, n.d. [autumn 1914], AMP.

80. HM/AM, Tuesday, n.d. [autumn 1914], AMP, and Kostenevich/Semenova, p. 177.

81. W. Pach/HM, 25.8.14, AMP; further information from HM's letters to AM.

82. M. Stein/W. Pach, in John Cauman, "Henri Matisse's letters to Walter Pach," *Archives of American Art Journal*, vol. 31, no. 3 (1991): p. 3.

83. W. Pach/HM, 19.1.15, AMP, and see Barr, p. 186.

84. Pach, *Queer Thing Painting*, pp. 145–46; further information from HM's letters to his wife.

85. HM/AM, Friday, n.d. [27.10.14, placed first in file] and 11.11.14, AMP.

86. HM/AM, 23 and 24–25.10.14, AMP.

87. Camoin, p. 67.

88. Information from Claude Duthuit; my account of this episode based also on Bernier tapes, and HM/PM, 4.11.39, PMP.

89. This and the next quote from HM/AM, n.d. [Oct. 1914], AMP.

90. HM/AM, n.d. [31.10.14], AMP.

91. J. Puy/HM, 18.10.14, AMP.

92. Camoin, p. 67, and see Escholier, p. 112.

93. Flam 1, p. 403.

94. Pach, *Queer Thing Painting*, p. 146.

95. Camoin, p. 67, and see Matisse 1993, p. 115.

96. A. Breton/J. Doucet, 12.4.23, in François Chapon, *Mystères et splendeurs de Jacques Doucet, 1853–1929* (Paris, 1984), p. 293.

97. Camoin, p. 68.

98. J. Puy/HM, 15.1.15, AMP.

99. M. Warren/HM, 10.1.16, AMP.

100. HM/J. Doucet, 7.6.15, Fonds Louis Vauxcelles, Paris [JC].

101. J. Puy/HM, n.d. [1915], AMP.

102. Ibid., 25.10.15, AMP.

103. Camoin, pp. 77–78.

104. Camoin, p. 86.

105. J. Puy/HM, 14.2.15, AMP.

106. Camoin, p. 78, and HM/R. Jean, 1.10.15, JC, MoMA.

107. Camoin, p. 79.

108. Camoin, p. 83.

109. This and the next quote from HM/W. Pach, 20.11.15, in Cauman, "Matisse's Letters to Pach," p. 5.

CHAPTER SIX

1. Gino Severini, *Ecrits sur l'art* (Paris, 1987), p. 276; all other quotes from Severini in this and the next two paragraphs from ibid. unless otherwise attributed.

2. Gowing, p. 128.

3. Gino Severini, *La Vita d'un pittore* (Milan, 1983), p. 193.

4. HM/Camoin, 19.1.16, Camoin, p. 95.

5. HM/René Jean, Jan. 1916, JC.

6. HM/Mqt, Friday, n.d. [Dec. 1916], AMP.

7. HM/Derain, n.d. [Feb. 1916], JC.

8. HM/AR, n.d. [June 1943], Finsen, p. 269.

9. HM/PM, 20.5.41, PMP.

10. PM/HM, 8.2.27, PMP.

11. W. Pach/HM, 22.1.15, AMP; for the acquisition of Cézanne's *Bathers*, see Spurling, pp. 181–82.

12. HM/MM, n.d. [5.11.13], AMP; my account of MM's schooling is based on her correspondence with HM, and on information from LD, and from Wanda de Guébriant.

13. Schneider, pp. 486 and 493, n. 67.

14. Gilot, p. 319.

15. MM/HM, 20.5.43, AMP.

16. HM/A. Derain, n.d. [Feb. 1916], JC; I am grateful to Claude Duthuit, and to Dr. Stanley Blaugrund of New York, for information about the treatment and consequences of tracheal damage.

17. HM/Anna Matisse, n.d. [March 1914], AMP; my account of Jean's career is based on information from Claude Duthuit, and from the late Marie Matisse.

18. Bernier tapes: all PM quotes come from these tapes unless otherwise attributed. (Purchase of violin in PM/HM, n.d., 1921, PMP.)

19. Escholier, p. 119.

20. Information from Claude Duthuit.

21. HM/MM, n.d. [autumn 1912 and Jan. 1914], AMP.

22. Bernier tapes.

23. Information from John Golding and Robert Hughes.

24. Barr, p. 174.

25. W. Churchill, *The World Crisis 1911–1918* (London, 1939), vol. 2, p. 993.

26. Matisse 1993, chronology by Claude Laugier and Isabelle Monod-Fontaine (establishing the recipient of this letter wrongly identified by Barr, p. 181–82, as Purrmann), p. 119; and see Escholier, p. 181.

27. A. Ozenfant, *Mémoires* (Paris, 1931), p. 216.

28. Severini, *Ecrits sur l'art*, p. 278.

29. Frank Trapp, "Form and Symbol in the Art of Matisse," *Arts Magazine*, no. 49 (May 1975): p. 56.

30. L. Rosenberg/P. Picasso, 25.11.15, JC.

31. Catherine C. Bock, "Henri Matisse's *Bathers by a River*," *Art Institute of Chicago Museum Studies*, vol. 16, no. 1 (1990): p. 55.

32. R. Fry/V. Bell, 3.7.16, *Letters of Roger Fry*, ed. D. Sutton (London, 1972).

33. Axel Salto, *Klingen*, vol. 1, no. 7 (April 1918), trans. Scott de Francesco, JC.

34. Schneider, p. 178. HM's term was "Cubistons."

35. G. Duthuit/AM, 1.2.19, AMP.

36. Information from the late Marie Matisse.

37. HM/PM, 1.9.40, PMP.

38. Camoin, p. 87.

39. M. Prichard/HM, 5.7.18, AMP.

40. Aragon 1, p. 23.

41. M. Prichard/HM, 5.6.17, AMP.

42. Michel Dutoit, "Histoire de Bohain: La guerre 1914–18," pp. 8–13, ts.; my account is based on this and other material kindly supplied by G. Bourgeois, including André Lefevre, "Guerre 1914–1918," ms.; and on detailed recollections in Auguste Matisse/HM, 21.6.36, AMP.

43. Severini, *La Vita d'un pittore*, p. 193.

44. W. Halvorsen, "In memoriam," *Dagblad*, Oslo, 4.11.1956, JC.

45. HM/W. Pach, 6.11.16, John Cauman, "Henri Matisse's Letters to Walter Pach," *Archives of American Art Journal*, vol. 31, no. 3 (1991): p. 6.

46. HM/Camoin, 22.11.15, Camoin, p. 91.

47. Matisse 1993, p. 118.

48. Emile Lejeune, "Montparnasse a l'époque heroïque," *Tribune de Genève*, 8–9.2.64, JC; this account based on Lejeune's memoirs, serialised ibid., 25.1–6.2.64.

49. Louise Favre-Favier, *Souvenirs sur Apollinaire* (Paris, 1945), pp. 163–65.

50. Marie Vassilieff, "La Bohème du 20e siècle," 1929, ts. kindly supplied by Claude Bernès, and Couturier, p. 133.

51. Halvorsen, "In memoriam."

52. HM/AM, 20.1 and 11.2.19, and A. Pellerin/HM, 6.2.19, AMP; see also Spurling, p. 230.

53. H. Pearl Adam, *Paris Sees It Through* (London, 1919), p. 175.

54. HM/P. Rosenberg, 12.1.17, Pierpont Morgan Library, New York.

55. G. Prozor/MM, n.d. [1915], AMP.

56. Schneider, p. 339, n. 35.

57. Entry in HM's notebook, AMP.

58. Aragon 1, p. 236, n. 2, see chap. 1, pp. 23–24.

59. J. Puy/HM, Christmas 1916, AMP.

60. HM/P. Rosenberg, 12.1.17, Pierpont Morgan Library, New York.

61. C. Monet/G. Bernheim-Jeune, 28.11.16, Archives Bernheim-Jeune, Paris, and D. Wildenstein, *Monet: Biographie et catalogue raisonné*, vol. 4, 1899–1926 (Paris, 1985), p. 72, n. 643, JC.

62. I am grateful to Wanda de Guébriant for confirming that HM's first purchase of a Courbet from Bernheim-Jeune on 28.11.16 was followed by a *Snowscape* on 15.1.17, *La Demoiselle de la Seine* on 5.3.17, *La Blonde endormie* on 13.8.17 and a seascape on 17.8.17; see also Matisse 1993, pp. 121 and 123; and Walter Pach, *Queer Thing Painting* (New York, 1938), p. 122.

63. HM/W. Pach, 14.12.16, "Matisse's Letters to Walter Pach," p. 8; and see Spurling, p. 96.

64. Spurling, p. 243.

65. Information from LD.

66. HM/Camoin, n.d. [summer 1917], Camoin, p. 105.

67. HM/AM, 21.12.17 and n.d. [Dec. 1917], AMP, and HM/A. Rouveyre, 23.12.17, Finsen, p. 29.

68. Matisse 1999, pp. 142–43.

69. Camoin, p. 105, and Flam, p. 505, n. 23.

70. Schneider, p. 490.

71. HM/Camoin, 2.5.28, Camoin, p. 121.

72. Schneider, p. 493, n. 87.

73. Georges Flandrin and François Roussier, *Jules Flandrin, 1871–1947* (Paris, 1992), pp. 23, n. 20, 189 and 245.

74. HM/AM from Marseilles, 15.12.17, AMP; my account of HM's arrival in the south is based chiefly on letters to his wife.

75. HM/AM, 15.12.17, AMP.

76. HM/AR, 23.12.17, Finsen, p. 29 (AR had introduced HM to the commandant, Capt. Pégat, via Capt. Lassalle, a protégé of the collector Ellissen, HM/AM, 16.12.17, AMP).

77. HM/AM, 21.12.17, AMP.

78. HM/AM, 31.12.17, AMP; HM/AR, Finsen, p. 30. Camoin/HM, 17.1.18, Camoin, p. 109.

79. Previous commentators have confidently cited many different dates for HM's arrival in Nice, but 25 December is the date he himself gave in HM/AR, 23.12.17, Finsen, p. 29.

80. HM/AM, 31.12.17, AMP; and see Spurling, pp. 20 and 170, and Fourcade, p. 123, n. 82.

81. Fourcade, p. 123, n. 82.

82. HM/AM, n.d. [26.1.18], AMP (Joe Janette defeated the French champion Georges Carpentier on 21.3.14); for the fullest account, and identification of pictures in Guillaume's show, see Anne Baldassari, Matisse/Picasso Paris, pp. 361–65.

83. HM/Mqt, Monday evening, n.d. [Feb. 1918], AMP.

84. Fourcade, p. 123.

85. HM/Mqt, Monday evening, n.d. [Feb. 1918], and HM/AM, 13.1.18, AMP; and see Matisse Sculpture, pp. 179 and 258, n. 18.

86. HM/Camoin, 10.4.18, Camoin, p. 115.

87. MM/HM, 19.5.43, AMP.

88. Flam 1, p. 474.

89. Schneider, p. 339, n. 37; and see Copenhagen cat., pp. 300–1, and Flam 2, p. 75.

90. Interview with Ragnar Hoppe in Flam 3, p. 172.

91. Escholier, p. 119.

92. HM/Rouveyre, 3.3.18, Finsen, p. 31.

93. Mqt/HM, n.d. [spring 1918], AMP.

94. Salto, "Henri Matisse."

95. HM/Mqt, 3.4.18, AMP.

96. HM/AM, 7.5.18, AMP.

97. Jean Cassarini, *Matisse à Nice* (Nice, 1984).

98. HM/AM, 1.6.18 and n.d. [7 June] 1918, AMP.

99. HM/AM, Tuesday, n.d. [11 June] 1918, AMP.

100. Bernier tapes.

101. HM/AM, n.d. [June 1918], AMP.

102. HM/MM, 14.6.18, and HM/AM, n.d. [10.6.18], AMP.

103. HM/AM, 13.1.18, and Auguste Matisse/HM, 21.6.36, AMP.

104. HM/AM, n.d. [spring 1918], AMP.

105. HM/AM, 16.7.18, and HM/Mgt, 10.7.18, AMP.

106. HM in Cherbourg to AM, n.d. [13, 16 and 19 Sept. 1918], AMP; and HM/AR, 21.9.18, Finsen, p. 32.

107. Gabriel Hanotaux, *L'Aisne pendant la grande guerre* (Paris, 1919), p. 74.

108. Anna Matisse/HM, n.d. [winter 1918] and Auguste Matisse/HM, 21.6.36, AMP; my account of conditions in Bohain is based on these recollections, and see p. 478, n. 70 above.

109. Anna Matisse/HM, n.d. [winter 1918], AMP; and see Schneider, p. 735.

110. Gilot, p. 319.

111. Escholier, p. 177; Barr and others have claimed that HM was in the south at this point, but his first letter to his wife from Nice (HM/AM, 22.12.18, AMP) makes it clear that he reached Marseilles from Paris on 20 December.

CHAPTER SEVEN

1. Escholier, p. 208; my reconstruction of relations with Renoir is based chiefly on HM's account in letters to AM, and to Courthion, pp. 70–74, which radically modifies the standard view based on Besson's recollections in "Arrivée de Matisse à Nice," *Le Point*, vol. 4, no. 3, 21.7.39, pp. 39–44.

2. This and the next quote from Frank Harris, "Henri Matisse and Renoir," *Contemporary Portraits, 4th Series* (New York, 1923), pp. 140 and 142; and see Jean Renoir, *My Father* (London, 1962), pp. 393–400.

3. Ronald Bergen, *Jean Renoir: Projections of Paradise* (London, 1992), p. 60.

4. G. Besson, "*Matisse et Renoir, il y a 35 ans,*" in *Les Lettres françaises*, Dec. 1952; HM's account in HM/AM, 31.12.17 and 9.5.18, AMP.

5. HM/AM, 9.5.18; see also ibid., 11–12.3 and 5.5.18, AMP.

6. HM/AM, 23.6.18, AMP.

7. HM/W. Halvorsen, 20.4.18, JC, and see ibid., 12.4.18; the lunch took place on 11.3.18.

8. Escholier, p. 208.

9. Barr, p. 196.

10. Courthion, pp. 71—72.

11. HM/AM, 16.12.17, AMP.

12. HM/JM, n.d. [1921], AMP.

13. Francis Carco, *L'Ami des Peintres* (Paris, 1953), p. 227.

14. George Besson, *Artistes et compagnie* (Paris, 1925), p. 389.

15. HM's text on Renoir written for Walter Halvorsen, *Modern French Painting*, ex. cat. (Kunstnerforbundet: Oslo, 1918), p. 290, JC; and see Flam 3, p. 172.

16. W. Halvorsen, "Exposition Braque, Laurens, Matisse, Picasso à Oslo, Stockholm, Copenhague," *Cahiers d'Art*, nos. 6—7 (1937): p. 218, JC.

17. See Kaspar Monrad, "Christian Tetzen-Lund (1852—1936)," Matisse 1999, pp. 142—46 (Tetzen-Lund's principal modern-art contacts were Ludvig Karsten and Halvorsen, both of whom had studied at Matisse's school).

18. HM/AM, 18.1.18, AMP.

19. HM/AM, 12 and 31.4.20, AMP, and information from Natalya Semenova; see also Kean, pp. 232—34, and Barr, p. 180.

20. HM/AM, 13.1.19, AMP.

21. Barr, p. 206.

22. Flam 3, p. 173.

23. HM/AM, 7.1.19, AMP.

24. HM/AM, 5.5.19, AMP.

25. François Chapon, *Mystère et splendeur de Jacques Doucet, 1853—1929* (Paris, 1984), p. 293.

26. Dr. Sébillan/Dr. Vannier, 30.3.19, AMP; family letters and correspondence with doctors (e.g., HM/Dr. Desjardins, 23 and 28.5.19) in AMP; once again, I am grateful to Dr. Stanley Blaugrund for clarifying the surgical background.

27. HM/MM, Friday, n.d. [May 1919], AMP; the operation probably took place on Wednesday, 21.5.19.

28. MM/AM, 27.10.20, AMP.

29. Courthion, p. 73.

30. Flam 3, p. 172.

31. MM/AM, 17.4.23, AMP.

32. Richard Buckle, *Diaghilev* (London, 1979), p. 379.

33. Courthion, p. 87; see also ibid., p. 80, and Michel Georges-Michel, *Ballets Russes: Histoire anecdotique* (Paris, 1923), p. 31.

34. Courthion, p. 82; my reconstruction of this affair is based primarily on HM's own account in daily letters to his wife, slightly modified in his subsequent recollections to Courthion.

35. Courthion, p. 78.

36. HM/AM, Tuesday, n.d. [28.10.19], AMP.

37. HM/AM, 18.10.19, AMP.

38. Harris, *Contemporary Portraits*, p. 138.

39. HM/AM, Friday evening, n.d. [17.10.19], AMP, and Courthion, p. 82.

40. Buckle, *Diaghilev*, p. 360.

41. Courthion, p. 80; I have pieced together the effect of this décor from HM's descriptions to his wife (n.d. [27.10.19], AMP), to the author of "Le Décor au théâtre: une enquête," *Bulletin de la vie artistique*, no. 4, 15.1.20, pp. 99—100, and to Courthion; three of these costumes, in the possession of the National Gallery of Australia, Canberra, reproduced in Matisse 1995, nos. 88—90, pp. 210—11.

42. Georges-Michel, *Ballets Russes*, p. 31.

43. This and the previous quote from HM/AM, 22.10.19, AMP.

44. Courthion, p. 87.

45. Oliver Brown, *Memoirs* (London, 1966), p. 65; this account based on ibid., pp. 65—67; HM/AM, Saturday and Monday, n.d. [15 and 17.11.19], AMP; and Kenneth Clark, *Another Part of the Wood* (London, 1974), p. 77.

46. HM/AM, Friday evening, n.d. [21.11.19], AMP; the story of this curtain told in consecutive letters to AM, 15—21.11.19, and Courthion, pp. 84—85.

47. MM/HM, 22.2.20, AMP.

48. Courthion, p. 89; previous accounts, following Barr, p. 197, state that HM missed the first night at the Opéra, attending the London opening instead, but HM himself said he was present (Courthion, p. 82, and Masson, p. 89) and his contract with Diaghilev (dated 5.11.19, AMP) stipulated a week in Paris leading up to the dress rehearsal (by the time of the London opening on 16 July he was, in any case, in Etretat). Alicia Markova's subsequent claim that HM redesigned her *Rossignol* costume for George Balanchine's revival in Paris in 1925 (Buckle, *Diaghilev*, p. 455) also seems to have been mistaken (when HM eventually saw the revival at Monte Carlo, he was appalled at the mess made of his décor and costumes, HM/AM, n.d. [summer 1928], and Courthion, p. 88).

49. MM/HM, 27.2.20, AMP.

50. HM/AM, 7.3.20, AMP.

51. HM/MM, 25.2.20, AMP.

52. MM/HM, n.d. [Apr. 1920].

53. PM/HM, 12.12.53, PMP, and see Spurling, p. 47 (the two pictures were included in HM's Bernheim-Jeune show, 15.10—6.11.20).

54. HM/J. Romains, 20.7.20, JC.

55. Etta Cone's notes, Cone Archives, Baltimore Museum of Art.

56. 28.9.20, Fry, vol. 2, pp. 491—92.

57. MM/HM, 19.11.20 and 7.1.22, AMP.

58. HM/AM Monday, n.d. [Sept. 1920], AMP (the picture is *Large Cliff: Fish*, Baltimore Museum of Art).

59. MM/HM, n.d. [Nov. 1920], AMP.

60. MM/AM, 27.10.20, AMP.

61. MM/HM, 27.11.20, AMP.

62. JM/HM, 5.12.21, AMP.

63. HM/AM, 11.12.19 and 11.1.20, AMP.

64. Richard J. Wattenmaker et al., *Great French Paintings from the Barnes Collection*, ex. cat. (New York, 1993), p. 264, and Schneider, p. 452; MM's responses in MM/AM, Monday, n.d. [spring 1921], and MM/HM, 21.4.20 and 27.3.23, AMP.

65. Charles Vildrac, *Nice 1921–16 réproductions d'après les tableaux d'Henri Matisse* (Paris, 1922), in Flam 3, p. 202.

66. "Notes of a Painter on His Drawing," Flam 2, p. 132, Fourcade, p. 163.

67. MM/AM, 15.3.21, AMP.

68. HM/AM, Thursday morning, n.d. [spring 1921], AMP.

69. HM/AM, 28.10.23, AMP.

70. HM/Mqt, 22.3.19, AMP.

71. Courthion, p. 125, HM/PM, 19.12.25, PMP, and LD 1, p. 25.

72. MM to Wanda de Guébriant.

73. HM/AM, 29.12.20 and 6.1.21, AMP.

74. MM/AM, 28.1.21, AMP.

75. MM/AM, 16.3.21, AMP.

76. MM/AM, 29.1.21, AMP.

77. HM/AM, 16.2.21, AMP.

78. MM/AM, n.d. [Feb–March 1921], AMP.

79. HM/AM, 1.1.19, AMP.

80. MM/AM, 15.3.21, and n.d. [22 and 29.3.21], AMP.

81. MM/AM, 7.4.21, AMP.

82. MM/AM, n.d. [April 1921]; HM's four notes to AM describing this encounter with Diaghilev are undated, but he drew Prokofiev on 25.4.21, Buckle, p. 381.

83. HM/MM, 14.11.21, AMP.

84. HM/AM, n.d. [Nov. 1921], AMP.

85. HM/W. Pach, 7.9.21, John Cauman, "Henri Matisse's letters to Walter Pach," *Archives of American Art Journal*, vol. 31, no. 3 (1991): p. 10.

86. HM's transformation of this flat documented in daily bulletins to AM in September; see also Jack Cowart's pioneering chronology, 1916–32, in Matisse 86, pp. 15–45 (Cowart's dates are provisional, and his speculative diagram on p. 30 adds substantially to the "two rooms" specified by HM); for further attempts to clarify the successive stages of HM's occupation of this building, see and chap 8, p. 483, n. 32.

87. HM/AM, 31.8.21, AMP.

88. HM/AM, 5.9.21, AMP, and PM/HM, 2.10.21, PMP.

89. In Flam 3, pp. 171–74.

90. HM/AM, n.d. [autumn, ?1921/1923], AMP.

91. Flam 3, p. 230.

92. HM/AM, 7.3.20, AMP (regular visits to Cagnes mentioned in correspondence, e.g., HM/PM, 20.4.25, PMP).

93. HM/AM, Monday evening, 9 p.m., n.d. [1922], AMP.

94. HM/AM, Tuesday, 9 p.m., n.d. [May–June 1922], AMP.

95. Flam 2, p. 131, and Fourcade, p. 162.

96. Information from Wanda de Guébriant.

97. AM/MM, Thursday 22 [Feb. 1923], AMP.

98. AM/MM, n.d. [?Feb. 1923], AMP.

99. HM/AM, 26.12.22, AMP.

100. HM/MM, 28.11.21, AMP.

101. Camoin, p. 114; contrary to the general assumption (see Flam 1, p. 12), abstinence seems to have been HM's rule so far as his models were concerned. I am grateful to J. D. Flam for a detailed discussion of this subject over many years, and for confirming that the only contradictory evidence in his possession came from the American artist Sidney Geist, on the strength of an encounter in Paris in 1949 with a woman whose name he didn't know, who claimed to have modelled for, and slept with, Matisse at an unspecified time (probably the 1920s) and place (possibly Paris). I can find no specific instance involving successive known models to support this anonymous assertion, see, e.g., pp. 240–41; 348 and 486, n. 85; 356–57 and 365–66.

102. LD in conversation with HS.

103. Jules Romains, *Amitiés et rencontres* (Paris, 1970), p. 93.

104. HM/AM, 6.9.21, AMP.

105. HM/MM, 14.11.21, AMP.

106. HM/AM, 14.11.21, AMP.

107. H. Darricarrère/MM, 28.2.23, AMP.

108. PM/HM, 25.1.22, PMP.

109. MM/HM, 30.12.21 and 4.1.22, AMP.

110. MM/HM, 11.1.22, AMP.

111. MM/HM, Lundi de Paques, 1923, AMP.

112. HM/AM, 3.5.18, AMP.

CHAPTER EIGHT

1. J. Sacs, *Enric Matisse i la Critica, II* (pseudonym Felius Elies), *Vell i Nou*, Barcelona, vol. 5, no. 102, 1.11.19, in Flam 2, p. 56.

2. "Protest Against the Present Exhibition of Degenerate 'Modernist' Works in the Metropol-

itan Museum of Art," Sept. 1921, JC, and Barr, p. 198.

3. HM/AM, 31.12.19, AMP.

4. HM/AM, 11.10.25, AMP (of the journalists Jacques Guenne and Florent Fels).

5. Sembat/P. Signac, 20.3.22, Archives Signac, Paris.

6. MM/AM, 16.1.23, AMP, and information from Wanda de Guébriant (MM acted as an executor, helping to sort out and clear up the joint estate).

7. AM/MM, n.d. [Aug. 1924], AMP (Sarah Stein was regularly invited to the annual family picture shows, and her response reported by MM to HM in Nice).

8. See Kasper Monrad, "Christian Tetzen-Lund" and "Johannes Rump," in Matisse 1999.

9. François Chapon, *Mystère et splendeur de Jacques Doucet, 1853–1929* (Paris, 1984), pp. 293–94.

10. J. Quinn/HM, 20.1.21, AMP (for Quinn's dealings with HM, see his correspondence with Walter Pach in the New York Public Library, and with Henri-Pierre Roché in the Harry Ransom Research Center, University of Texas, Austin).

11. HM/AM, 25.11.23, AMP.

12. HM/AM, n.d. [Nov. 23] AMP.

13. MM/AM, 7.2.23, AMP; my account of GD based primarily on information from Claude Duthuit; GD's published works, especially the texts collected by Rémi Labrusse in his invaluable *Ecrits sur Matisse;* supplementary unpublished correspondence with HM and others in AMP; and on the catalogue essays by Claude Duthuit and Rémi Labrusse in *Autour de Georges Duthuit,* ex. cat., Galérie d'Art du Conseil générale des Bouches-du-Rhône: Aix-en-Provence, 2003.

14. Labrusse, *Autour de Georges Duthuit,* p. 61.

15. Georges Duthuit, *Les Fauves* (Geneva, 1949), p. 13.

16. GD/HM, 13.4.26, AMP, see Duthuit, p. 222.

17. M. Prichard/I. Stewart Gardner, 6.6.22, Isabella Stewart Gardner Museum, Boston.

18. GD/JM, Dec. 1923, AMP.

19. Duthuit, *Les Fauves,* p. 222.

20. HM/AM, Sunday, 3 p.m., n.d. [Oct. 1923], AMP.

21. HM/AM, Wednesday evening, n.d. [1923], AMP.

22. My account of this affair is based primarily on family correspondence, on interviews with the late Mme Clorinde Peretti-Landard in Nice in 1993, and with her college contemporary Mme Rosine Gaudiani in Ajaccio in 1992, and on Bernier tapes.

23. HM/AM, 17.11.23; and see R. P. Couturier, *La Vérité Blessée* (Paris, 1984), p. 287.

24. Previous accounts are based on a misunderstanding of a letter from Michael Stein to Etta Cone, 17.12.23, describing the small family lunch party after the civil ceremony and leaving out the subsequent party described at length in family correspondence.

25. AM/MM, 11.12.23, AMP.

26. HM/AM, 27.12.23, AMP, and Man Ray, *Self Portrait* (New York, 1988 [1963]), p. 170.

27. AM/MM, 26.12.23, AMP.

28. AM/MM, 28.12.23, AMP.

29. HM/AM, Wednesday evening, n.d. [end 1923], AMP.

30. The portrait was completed in four afternoon sessions in March described in HM/AM, n.d. [March 1924], AMP; HM's imitations in AM/MM, n.d. [Apr. 24], AMP; see also Matisse 1989, p. 72.

31. AM/MM, n.d. [May 1924], AMP.

32. AM/MM, n.d. [Apr. 1924], AMP. Previous accounts of HM's successive moves in Nice have followed Cowart in Matisse 1986, pp. 15–46, based on deduction and inference from municipal records, but Cowart takes no account of the complex system of sub-letting practised by the tenants of 1 Place Charles Félix. Family correspondence makes it clear that HM rented the third-floor corner flat from Sept. 1921 from Mlle Valentine Bouvanier (subsequently Mme Stella), renting a fourth-floor flat (which he used as living quarters) directly above the first from the journalist Georges Maurvret for 3,500 francs per year from September 1924, and going on to acquire Maurvret's own fourth-floor flat next door three years later. Contrary to the general assumption, he continued working on the third floor until his fourth-floor double studio was done up in 1928; see also p. 482, n. 86, and pp. 293–94.

33. MM/AM, Thursday, n.d. [spring 1924], AMP.

34. GD/HM, 27.6.25, AMP.

35. My account of this affair based on AM/MM, n.d. [28.6.24], HM/AM, n.d. [Dec. 1922], MM/HM, 11.1.25, E. Faure/HM, 7.12.21, all AMP, and information from Wanda de Guébriant; see also Elie Faure/W. Pach, 27.9.21 and 21.3.22, JC.

36. HM/AM, n.d. [Feb. 1924], PMP; my account is based on information from the late Mme Landard, family correspondence and Bernier tapes.

37. John Russell, *Matisse Father and Son* (New York, 1999), p. 25.

38. HM/MM, n.d. [May 1924].

39. B. Parayre/C. Peretti, 28.6.24, kindly given me by the recipient.

40. All previous accounts date this Italian trip to 1925, but I am grateful to Wanda de Guébriant for confirming that family correspondence puts it firmly in the late summer of 1924.

41. Information from Mme Landard (who went on to become a champion tango dancer, and also showed me photos of her backflips).
42. HM/AM, n.d. [Dec. 1924], AMP, and HM/PM, 17.11.48, PMP.
43. MM/HM, 21.3.25, AMP.
44. Mme Landard to HS.
45. MM/HM, 22.12.24, AMP.
46. HM/AM, n.d. [autumn 1924], AMP.
47. This and the next quote from HM/AM, 16.11.24, AMP; see also PM/AM, n.d. [Dec. 1924], and 25.6.25, PMP.
48. This account based on information from Claude Duthuit (half the engravings came from HM, half from MM), and from HM's correspondence.
49. HM/AM, n.d. [Dec. 1924], AMP.
50. PM/HM, 13.12.24, PMP.
51. Information from Paul Matisse.
52. MM/AM, 13.1.23, AMP.
53. MM/PM, 28.12.24, PMP.
54. MM/HM, n.d. [Feb. 1925] and 3.3.25, AMP.
55. MM/HM, 18.11.25, AMP.
56. MM/AM, 1.2.23, AMP.
57. Note inserted by GD in MD/PM, 24.1.25, AMP.
58. MM/HM, 9.4.25, AMP.
59. Dominique Fourcade, "An Uninterrupted Story," Matisse 1986, p. 52.
60. HM/AM, n.d. [Feb. 1924], AMP.
61. I am grateful to Wanda de Guébriant for this insight derived from Marguerite Matisse.
62. HD's concert took place in the Salle des Fêtes de Savoie on 6.5.23; my account of it is based on HM's letters to his wife, hers to Marguerite, and a letter from Henriette to Marguerite, 28.2.23, AMP.
63. HM/AM, n.d. [March 1924]; HM also transferred to Mme Spinelli.
64. Henriette's history as a painter is based on an interview with Claudie Plent, Nice-Matin, 16.11.54, and Matisse family correspondence.
65. Henriette Darricarrère/MM, 28.2.23, AMP.
66. HM/AM, n.d. [autumn 1923–24].
67. Fourcade, "An Uninterrupted Story," p. 57.
68. Flam 5, p. 127; and see Flam 1, p. 480.
69. Catherine C. Bock, "Woman before an Aquarium and Woman on a Rose Divan: Matisse in the Helen Birch Bartlett Memorial Collection," Museum Studies, vol. 12, no. 2, Art Institute of Chicago, 1986, pp. 209 and 211.
70. "Le Surréalisme et la peinture," part 2, La Révolution surréaliste, no. 6, 1.3.26; and see ibid., no. 4, 15.6.25.
71. HM/MM, 24.4.25, AMP.
72. HM/AM, 5.7.25, AMP; see Matisse Sculpture, pp. 261–26, n. 24, for family correspondence which invalidates the chronology generally assigned to this piece; and see pp. 282–84 above.
73. GD/HM, 2.9.25, AMP, in Duthuit, p. 219; see also ibid., 23.9.35, AMP, Duthuit, p. 273.
74. MM/HM, 28.4 and 2.5.25, AMP.
75. Russell, Father and Son, p. 47.
76. Duthuit, pp. 215 and 316, n. 14.
77. My account of this trip is based on JM/GD, n.d. [summer 1925], and HM/AM, 27.11.25, AMP, and Les Confidences de Youki (Paris, 1957), p. 38; and see Spurling, pp. 106–7.
78. MM/HM, n.d. [Apr. 1925], AMP.
79. JM/GD, 27.5.24, AMP.
80. AM/MM, Saturday afternoon, n.d. [Sept. 1925, filed under 1926], AMP.
81. MM/HM, 5 and 21.3.25 and Monday, n.d. [Dec. 1925]; Clorinde, whose pride forbade her to touch the Matisses' allowance, found successive jobs in a couture house in Paris and as a schoolteacher.
82. AM/PM, 12.11.25, PMP.
83. Mme Landard to HS.
84. PM/HM, 27.10.25, PMP.
85. PM/AM, 16.10.25, PMP.
86. HM/AM, n.d. [Oct. 1925], AMP.
87. HM/AM, 18.11.25, AMP.
88. AM/MM, n.d. [autumn 1925], AMP.
89. HM/MM, 4.1 and 13.6.26, AMP.
90. PM/HM, 9.1.26, PMP (PM sold this painting to the President of the Chicago Arts Club, PM/HM, 27.1.26, PMP).
91. Duthuit, Les Fauves, p. 52, and see p. 220.
92. GD/HM, 13.4.26, AMP; see Duthuit, pp. 221–28, for a slightly abbreviated version.
93. HM/MM, 11.5 and 21.6.26, AMP; the introduction was to Mme Jeanne at Worth.
94. Duthuit, p. 289.
95. HM/MM, 20.6.26, AMP; HM's progress reports on this piece 1922–29 in Matisse Sculpture, pp. 261–62, n. 24.
96. HM/AM, Sunday, 5 p.m., n.d. [March 1929], AMP.
97. Leo Stein, Appreciations: Painting, Poetry and Prose (New York, 1947), p. 125.
98. In Matisse 1986, p. 56.
99. Jules Flandrin/Félix Jourdan, 7.6.26, Georges Flandrin and François Roussier, Jules Flandrin (1871–1947): Un élève de Gustave Moreau témoin de son temps (Paris, 1992), p. 228 (the wallpaper was in fact a textile, see Matisse/Picasso, p. 223).
100. JM/MM, n.d. [Apr. 1926], AMP.
101. MM/HM, n.d. [Sept.–Oct. 1926], AMP.
102. HM/MM, 20.6.26, AMP.
103. HM/AM, 14.9.26, AMP (the price of 300,000

francs also included *La Chaise Lorraine aux pêches* and a *Nude*).

104. MM/HM, n.d. [Oct. 1926], AMP.

105. GD/HM, 9.9.26, AMP, in Duthuit, p. 235.

106. For the text of this lecture, "*Les Tableaux qui nous entourent ce soir . . . ,*" see Duthuit, pp. 47–69.

107. Ibid., p. 283.

108. Ibid., p. 50.

109. Matisse Picasso 2002, p. 223; for Guillaume's precautions, see Duthuit, p. 235.

110. PM/HM, n.d. [mid-Nov. 1926], PMP; and see MM/PM, 18.2.27, PMP.

111. HM/AM, 7.10.26, AMP.

112. PM/HM, 20.11.26, PMP.

113. MM/PM, 26.12.26, PMP.

114. HM/AM, 30.12.26, AMP.

115. HM/PM, n.d. [early 1927], PMP.

116. PM/HM, 3.2.27, PMP.

117. PM/HM, 3.1.27, PMP.

118. HM/PM, n.d. [early 1927], PMP.

119. HM/AM, 13.6.26, AMP; Ingram had made his name in Hollywood with *Four Horsemen of the Apocalypse.*

120. Marguerite Matisse insisted that this was why HM stopped working with Henriette (information from Wanda de Guébriant).

121. AM/MM, n.d. [early 1927].

122. HM/AM, 27.11.27, AMP.

123. Duthuit, p. 289.

124. HM/PM, 1.2.27, PMP.

125. GD/HM, 18.12.26, AMP; and see Duthuit, p. 319, n. 33.

126. Duthuit, *Les Fauves*, p. 14; and see Barr, p. 201.

127. *Blue Nude* was bought by Michael Stein for Claribel Cone of Baltimore; *Red Studio* was bought by David Tennant on Prichard's advice for the Gargoyle Club; *Moroccans* and *Bathers by a River* remained unsold until 1952 and 1954 respectively.

128. HM/GD, 2.10.26, AMP in Duthuit, p. 229; see also HM/MM, n.d. [Sept. 1927]; the article, "*Oeuvres récentes d'Henri Matisse,*" *Cahiers d'Art* (Sept. 1926), is in Duthuit, pp. 44–46.

129. This and the next quote from HM/MM, n.d. [Sept. 1927], AMP.

130. HM/AM, 13.10.27, AMP.

131. AM/MM, n.d. [winter 1927–28], AMP.

132. HM/AM, 8.3.28, AMP.

133. AM/MM, n.d. [May 1928], AMP.

134. HM/AM, 31.8.28, AMP.

135. The awning is referred to in HM/AM, 17.7.28, AMP.

136. HM/AM, 7.7.28, AMP; HM's excitement about and hopes for this painting charted in letters to his wife on 6, 7, 8, 14, 15 and 17 July 1928.

137. Georges Duthuit, *Matisse: Fauve Period* (New York, 1956), no pagination.

CHAPTER NINE

1. This and the next quote from HM/AM, 3.3.28, AMP.

2. PM/HM, 14.12.27, and HM/PM, 16.12.27, PMP; for the religious rumour, HM/AM, 1.3.28, AMP; for the Louvre painting, see p. 300, and n. 23 below.

3. Flam 2, p. 83, and Fourcade, p. 92.

4. HM/AM, 4.11.27, AMP; for HM's record as a rower, see Cowart in Matisse 1986, p. 43, n. 21, Schneider, p. 523, Cassarini and "*Club Nautique de Nice Cinquantenaire,*" *Annuaire 1933*, Nice, pp. 69 and 99.

5. Flam 2, p. 84, and Fourcade, p. 94.

6. HM/AM, 18.2.29, AMP.

7. HM/AM, n.d. [Feb. 1929], AMP.

8. Jules Romains, *Amitiés et Rencontres* (Paris, 1970), p. 93.

9. HM/AM, 17.3.29, AMP.

10. PM/HM, 30.5.31, PMP.

11. AM/MM, Friday evening, n.d. [June 1929], AMP.

12. MM/HM, 23.2.29, AMP.

13. My account of this encounter is based on family correspondence, information from LD, Aragon 1, p. 89, and C. de Peslöuan, "Matisse photographe," *Jours de France Madame*, Paris, 27.11.89.

14. AM/MM, Friday, n.d. [spring 1929], and HM/MM, 23.5.29, AMP.

15. HM/MM, n.d. [July 1929], AMP.

16. AM/MM, Friday evening, n.d. [June 1929], AMP.

17. AM/MM, n.d. [May 1929], AMP.

18. MM/HM, 18.6.29, AMP.

19. HM/AM, n.d. [Feb. 1929], and 9.6.30, AMP, and information from Pauline Schyle.

20. Fourcade, p. 102, n. 58, and Flam 3, p. 229.

21. This and the next quote from MM/HM, 6.9.33, AMP.

22. MM/HM, 27.1.29, AMP; the rival authors were Tériade (whose book for Christian Zervos never materialised) and Florent Fels, responsible for the French text of *Henri Matisse* published by *Chroniques du Jour* with English and German editions written by Roger Fry and Gotthard Jedlicka respectively; Henry McBride's *Matisse* came out in New York, and there was a revised edition of Waldemar George's 1925 book of drawings in Paris.

23. HM/MM, 10.3.29, and HM/AM, 24.3.29, AMP; see also Jacques Mauny, "French Museums and French Art," *The Arts*, vol. 15 (May 1929), pp. 314, 318 and 322.

24. HM/AM, 18.2.29, AMP.

25. HM/AM, Sunday, 5 p.m., n.d. [March 1929], AMP.

26. HM/AM, Friday evening, n.d. [March 1929], AMP.

27. MM/HM, 4.12.29, AMP.

28. The plaster *Back I* was shown at the Armory Show in New York in 1913, and again with *Backs II & IV* in Lucerne in 1949; all three were cast in bronze to be shown in Paris in 1950 (*Back III* was never shown in HM's lifetime).

29. Gérard Matisse to HS.

30. HM/MM, 21.11.29, AMP.

31. HM/MM, 16.10.29, AMP.

32. Flam 2, p. 85, and Fourcade, p. 98.

33. Duthuit, p. 288.

34. MM/HM, 19.4.53, AMP.

35. Aragon 1, p. 208.

36. HM/AM, 21.2.30, AMP (The book was Alain Gerbault, *A la Poursuite du Soleil: Journal de bord* [Paris, 1929]); for Lucien Gauthier's photos, see Laudon, pp. 23, 25, 56, 72, 84, 85, 96, 98 and 140, n. 35; for Stevenson, see p. 319; for Chadourne's *Vasco*, HM/MM, 28.4.30, AMP, HM/PM, 6.6.30, PMP, and see p. 313, and n. 77 below.

37. HM/PM, 6.10.29, PMP.

38. HM/AM, 20.9.29, AMP.

39. MM/HM, Saturday evening/Sunday, n.d. [Aug.–Sept. 1933].

40. This account based on family correspondence in AMP, and on three undated letters (1932–33) from MM to PM in PMP.

41. PM/HM, 25.10.29, PMP.

42. MM/HM, 14.10.29, AMP.

43. HM/MM, 10.5.30, AMP.

44. Pesloüan, *Jours de France Madame.*

45. Flam 2, p. 90, and Fourcade, p. 107.

46. HM/AM, 5.3.30, AMP.

47. HM/AM, 6.3.30, AMP.

48. At the Paramount Theatre; details of HM's itinerary from letters to his wife, AMP.

49. HM/AM, 6.3.30, AMP.

50. Flam 2, p. 111.

51. HM/AM, 5.3.30, AMP.

52. HM/AM, 10.3.30, AMP.

53. HM/C. Thorndike, 7.3.30, Getty.

54. HM/AM, 5.3.30, AMP.

55. HM/AM, 10.3.30, AMP.

56. HM/AM, 10.3.30, AMP.

57. This and the next quote from HM/AM, 12.3.30, AMP.

58. HM/AM, 15.3.30, AMP.

59. Aline Kistler, "Matisse Approves," *Art Digest*, vol. 4, no. 14 (April 1930): p. 26.

60. HM/AM, 26.3.30, AMP.

61. HM/AM, 30.3.30, and Laudon, p. 30. My account of HM's experiences on Tahiti is based primarily on his journal-letters to his wife; on conversations with Pauline Schyle on the island of Moorea in November 1994; and on the invaluable Laudon, an account based on first-hand research and intimate knowledge of the island, which is by far the most comprehensive and reliable to date (a first draft of this text and extracts from HM's letters are in Matisse 1998).

62. HM/AM, 30.3.30, AMP.

63. HM/AM, 13.4.30, AMP.

64. HM/AM, 30.3.30, AMP.

65. HM/AM, 30.3.30, AMP.

66. Couturier, p. 205.

67. HM/AM, 1.3.30, AMP.

68. Couturier, p. 289.

69. Flam 2, p. 89, and Fourcade, p. 105.

70. Fourcade, p. 103, n. 58, and p. 109, and Flam 2, pp. 91 and 213.

71. This and any other unattributed quote from Pauline Schyle come from conversations with HS.

72. HM/MM, 10.5.30, HM/AM, 29.4.30, both AMP, and see Camoin, p. 205, and Laudon, pp. 63–64.

73. The best account of the cultural and historico-political context is in John Klein, "Matisse After Tahiti: The Domestication of Exotic Memory," *Zeitschift für Kunstgeschichte* (1997), pp. 44–89 (translated as "Matisse après Tahiti, la maturation d'une expérience exotique" in Matisse 1998), but access to HM's correspondence would have radically modified Klein's conclusions.

74. HM/AM, 30.3.30, AMP, and see Laudon, p. 44.

75. HM/AM, 2.4.30, AMP, and Flam 2, p. 89, and Fourcade, p. 106.

76. HM/AM, 2.4.30, AMP.

77. Marc Chadourne, *Vasco* (Paris, 1994 [1926]), p. 147, and see ibid., pp. 136–37 (Pauline identified herself as the heroine, and HM's drawings of her in this style are in Matisse 1998, pp. 79–80).

78. HM/MM, 28.4.30, and HM/AM, 13.5.30, AMP.

79. HM/AM, 2.4.30, AMP.

80. HM/AM, 30.3.30, AMP; and see Flam 2, p. 89, and Fourcade, p. 106.

81. HM/AM, 24.4.30, and Easter Sunday [20.4.30], AMP.

82. Pauline Schyle to HS.

83. HM/AM, 24.4.30, AMP.

84. HM/AM, 13.4.30, AMP; the next quote from ibid., 13.5.30.

85. Information from Pauline Schyle (who confirmed HM's account of their relations to Laudon, to Klein and to the author); for HM and the sexual context, see Laudon, pp. 63–66.

86. HM/AM, 2.4.30, AMP.

87. HM/AM, 17.4.30, AMP; for Morillot, see Laudon, pp. 68–70 and 141, n. 88.

88. HM/AM, 30.3.30, AMP.

89. HM/Jean Florisson, 20.4.47, in Laudon, pp. 55 and 141, n. 68; see also ibid., pp. 60 and 63, Flam 2, p. 90, and Fourcade, p. 106.

90. HM/MM, 10.5.30, and Laudon, pp. 67 and 81–82; see also Klein, "Matisse After Tahiti," pp. 66–70.

91. HM's sketch is in HM/AM, 4.5.30, AMP, and Murnau's photo in Laudon, p. 88; see also ibid., pp. 84 and 91.

92. This and the next quote from HM/AM, 6.5.30, AMP.

93. HM/AM, 14.5.30, AMP.

94. HM/AM, 22.5.30; for the Hervés, see Patrick O'Reilly and Raoul Tessier, Tahitiens: Répertoire bio-bibliographique de la Polynésie Française (Paris, 1962), and Laudon, pp. 96–99.

95. HM/AM, 22.5.30, AMP (HM's drawing is in ibid., 29.5.30).

96. Robert Louis Stevenson, In the South Seas (London, 1912 [1896]), p. 137; the next quote from ibid., p. 138; HM refers to his copy of the French translation by Théo Varlet in HM/AM, 22.5.30, AMP, and HM/PM, 6.6.30, PMP.

97. HM described the lagoon in HM/AM, 29.5.30, AMP, and HM/PM, 6.6.30, PMP; see also Fourcade, p. 103, n. 58, Flam 2, p. 214, Aragon 1, p. 7, and Courthion, p. 291.

98. HM/AM, 22.5.30, AMP.

99. HM/AM, 29.5.30, AMP; the two drawings are in Laudon, frontispiece and p. 101.

100. Aragon 1, p. 209.

101. Bonnard, p. 41.

102. Couturier, p. 289, and see Flam 2, p. 214, and Matisse 1998, p. 85.

103. HM/Pauline Schyle, 8.4.32, in Matisse 1998, p. 148.

104. Aragon 1, p. 7.

105. HM/PM, 6.6.30, PMP.

106. HM/AM, 9.6.30, AMP.

107. Ibid., and see Courthion, p. 117.

108. Camoin, p. 204.

109. HM/AM, 8.7.30, AMP.

110. Claude Duthuit, "Henri Matisse: Notion du Voyage," Matisse Paris 1999, p. 25.

111. G. Brassaï, Les Artistes de ma vie (Paris, 1982), p. 305.

112. HM/P. Schyle, 29.8.30, Laudon, p. 111; HM/MM, 10.5.30, HM/AM, 13.5 and 19.9.30, all AMP; and see Flam 2, p. 88, and Fourcade, p. 101.

113. Laudon, p. 91.

114. Flam 4, pp. 16 and 79, n. 20.

115. PM/HM, 24.12.27, PMP; and see Boris Ternovets, "Letter from Russia," Formes 3 (1930).

116. HM/AM, 24.9.30, AMP.

117. HM/AM, 24 and 20.9.30, AMP.

118. John Lukacs, Philadelphia: Patricians and Philistines 1900–1950 (New York, 1980), p. 271.

119. I am grateful to Hilton Kramer for this information.

120. This and the next quote from Albert C. Barnes, "How to Judge a Painting," Arts and Decoration (April, 1915), in Howard Greenfield, The Devil and Dr. Barnes: Portrait of an American Art Collector (New York, 1987), p. 54.

121. Greenfield, The Devil and Dr. Barnes, p. 111, and Flam 4, pp. 19 and 79, n. 24; my account of HM's work on Barnes' commission is based primarily on HM's correspondence, on information from LD, and on Flam's definitive account.

122. Time, 20.10.30.

123. HM/AM, 30.12.30, AMP.

124. Claribel Cone/Etta Cone, n.d. [1927], Baltimore Museum of Art, Cone archive.

125. George Boas, "The Cones," Paintings, Sculpture and Drawings in the Cone Collection (Baltimore Museum of Art, 1967), p. 13.

126. E. Cone/MM, n.d. [Jan.–Feb. 1931], draft letter, BMA.

127. HM/AM, 22.12.30, AMP.

128. Peslöuan, Jours de France Madame; my account of HM's behaviour based on this interview, and on information from LD.

129. Flam 4, pp. 26–33 and 81, n. 58.

130. HM/P. Schyle, 29.8.30, in Matisse 1998, p. 108.

131. Flam 2, p. 122, and Fourcade, p. 128.

132. This and the next two quotes from PM/HM, 12.11.31, PMP.

133. GD/HM, n.d. [spring 1933], AMP.

134. Schneider, p. 618.

135. John Russell, Matisse Father and Son (New York, 1999), p. 61.

136. Flam 4, p. 38; and see Spurling, p. 395.

137. I am grateful to Wanda de Guébriant for this account.

138. Masson, p. 93.

139. Jules Romains, Amitiés et Rencontres (Paris, 1970), p. 94.

140. Schneider, p. 616.

141. Georges Charbonnier, "*Entretiens avec André Masson*" ts. of recorded interview, 1933, JC (including material omitted from the published interview in Masson).

142. This and the next quote in Bussy, J. S., p. 83.

143. Flam 4, p. 69.

144. Preface by Jean Guichard-Meili in Claude Duthuit, ed., with Françoise Garnaud, *Matisse: Catalogue raisonné des ouvrages illustrés* (Paris, 1987), pp. xvii–xviii.

145. Flam 2, p. 88, Fourcade, p. 102.

146. HM/P. Schyle, 20.12.31, in Laudon, p. 115.

147. MM/PM, n.d. [Nov. 1931], PMP.

148. Flam 4, pp. 46 and 83, n. 86.

149. The telegrams are in Flam 4, pp. 46–47 and 83, nn. 91 and 92.

150. Escholier, p. 13.

151. My account based on information from Wanda de Guébriant and from LD (known to HM at this stage by her married name of Omeltchenko), who remembered staying for six months, and confirmed that HM was still working on his Mallarmé (see Couturier, p. 149, n. 2), which was published on 25 October.

152. HM/PM, 15.1.33; my account of HM's dealings with Barnes based on his correspondence with PM, who was his father's main confidant throughout.

153. Bussy, J. S., p. 83.

154. Masson, p. 89; the next quote from p. 93.

155. MM/PM, Easter Sunday, 1933, PMP.

156. Masson, p. 88 (*Les Présages* opened on 13 April), and HM/PM, 23.4.33, PMP.

157. Courthion, p. 85.

158. Flam 2, p. 109, and information from LD.

159. HM/MM, n.d. [Apr.–May 1933], AMP.

160. GD/HM, n.d. [Apr. 1933], AMP.

161. HM/MM, 30.5.31, AMP, and Flam 4, p. 62.

162. HM/S. Bussy, 17.5.33, Bussy.

163. HM/AM, 17.5.33, AMP.

164. HM/AM, 18.5.33, AMP.

165. HM/MM, 30.5.33, AMP.

166. Undated letter [June 1933] from Dorothy Dudley to her sister, the painter Katharine Dudley, kindly shown me by the writer's grandson, Steven Harvey; see also Steven Harvey et al., *Ghosts and Live Wires*, ex. cat. (Gallery Schlesinger: New York, 1990).

167. Dorothy Dudley, "Notes on Painting: The Matisse Fresco in Merion, Pennsylvania," *Hound and Horn*, vol. 7 (January–March 1934) (the text is in Flam 2, pp. 108–13, and see pp. 278–81).

168. Greenfield, *The Devil and Dr. Barnes*, p. 251; and E. Haas, "The Appreciation of Quality," unpub. ts., Bancroft Library, University of California, Berkeley, p. 179.

169. Flam 4, p. 74, n. 183.

170. Spurling, p. 17, and see ibid., p. 248, and HM/PM, 9.12.35, PMP.

CHAPTER TEN

1. PM/HM, 10.2.34, PMP (HM had initially turned the proposal down).

2. HM/S. Bussy, 25.6.34, Bussy (in the end HM dropped the Sirens, added Aeolus and subsumed Penelope in an image of her palace at Ithaca); further information in this paragraph from HM/S. Bussy, 17.2.34, S. Bussy/HM, 18.2.34, both Bussy, and HM/MM, 13.3.34, AMP.

3. HM/S. Bussy, 25.6.34, Bussy.

4. HM/S. Bussy, 18.6.33, Bussy.

5. Introduction by Claude Duthuit, *Matisse Oeuvre gravé*.

6. MM/HM, Sunday/Saturday evening, n.d. [Aug.–Sept. 1933], AMP.

7. HM/PM, 22.5.41, PMP; and see Spurling, pp. 60 and 255–56.

8. Pearl Buck, *The Fighting Angel* (London, 1937), p. 58.

9. HM/PM, 5.6.41, PMP; and HM/MM, 15.7.41, AMP.

10. HM/MM, 19.5.33, AMP.

11. HM/S. Bussy, 24.8.33, Bussy.

12. Information from LD.

13. Dossier B. Parayre, F17 24321, Archives Nationales, Paris; and see Spurling, p. 443, n. 105.

14. HM/PM, 11.10.33, PMP.

15. MM/PM, 15 Apr. [1934], PMP.

16. LD married Boris Omeltchenko in Paris on 26.4.30. My account of her history and background is chiefly based on conversations with her in Paris between 1993 and her death in 1998; on her copy of a ts. of an unpublished dialogue with Xavier Girard, modified by her handwritten corrections which she discussed in detail with me; and on her *livret de famille*, kindly shown me by Vincent and Irène Hansma.

17. HM/PM, 28.3.34, and PM/HM, 29.3.34, both PMP.

18. HM/PM, 28.3.34, PMP.

19. HM/PM, 11.10.33, PMP.

20. MM/HM, 6.9.34, AMP.

21. JM/MM, n.d. [1927], AMP.

22. MM/PM, 18.2.27, PMP.

23. PM/HM, 26.1.28, PMP.

24. HM/PM, 16.12.27, PMP.

25. PM/HM, 29.3.34, PMP.

26. Information from Paul Matisse.

27. MM re-hung HM's shows at the Thannhauser

Gallery, Berlin, in February 1930 and the Leicester Galleries, London, in February 1936 (MM/HM, n.d. [Feb. 1930], and 17.2.36, all AMP).

28. This and the next quote from the introduction to *Matisse Oeuvre gravé* by Claude Duthuit.
29. Information from Claude Duthuit.
30. HM/MM, 25.7 and 27.2.35, AMP.
31. Michael Luke, *David Tennant and the Gargoyle Years* (London, 1991), p. 48.
32. Preface by Ruthven Todd, *Fitzrovia and the Road to the York Minster*, ex. cat. (Parkin Gallery: London, 1973).
33. Luke, *David Tennant and the Gargoyle Years*, p. 48; I am grateful to Lady Pauline Rumbold for further information.
34. John Pope-Hennessy, *Learning to Look* (New York and London, 1991), pp. 273–74.
35. AM/MM, 29.1.29, AMP.
36. GD/PM, 23.7.34, PMP.
37. MM/HM&AM, 30.8.34, AMP.
38. Duthuit 1, pp. 271 and 321, n. 61.
39. HM/SB, 8.6, 1.7, and 17.7.34, and MM/AM, 28.6.34, all AMP.
40. HM/S. Bussy, 25.6.34, Bussy.
41. HM/PM, 21.10.34, PMP.
42. The dispute with Macy reported in HM/PM, 10.8, 5.9, and 24.9.34, and 2.2.35 et passim, PMP; and see Claude Duthuit, ed., with François Garnaud, *Henri Matisse: Catalogue raisonné des ouvrages illustrés* (Paris, 1987), pp. 37–38.
43. J. Joyce/T. W. Pugh, 6.8.34, R. Ellmann, ed., *Letters of James Joyce* (New York, 1966), vol. 3, p. 314; HM/MM, 14.8.34, AMP, and HM/S. Bussy, 24.8.34, Bussy.
44. HM/MM, 24.9.34, AMP (Joyce's intermediary was Paul Léon, HM/MM, n.d. [Aug. 1934]).
45. Ellmann, *Letters of James Joyce*, p. 317, and HM/MM, 5.9.34, AMP.
46. See Delectorskaya 1, p. 89 (the painting was *Hercules and Antaeus* in the Uffizi Gallery, Florence); see also Barr, pp. 249 and 474, and Schneider, p. 625.
47. Aragon 1, p. 198.
48. Schneider, p. 582.
49. HM/MM, 5.9.34, AMP; and information from LD.
50. HM/MM, Easter 1935, AMP, and HM/PM, 28.3.34, PMP.
51. AM/MM, 27.1.35 and n.d. [Jan. 1935], and HM/MM, 31.1.35, both AMP, and HM/SB, 26.2.35, Bussy.
52. HM/PM, 2.3.35, PMP.
53. Delectorskaya 1, p. 16; further information from HM/MM, 27.2.35, AMP, and HM/PM, 2.3.35, PMP.

54. HM/SB, 6.3.34, Bussy, and HM/PM, 21.1.35, PMP.
55. HM/PM, 2.7.35, PMP.
56. MM/HM, 16.7.35, AMP.
57. HM/PM, 22.3.35, PMP.
58. HM/S. Bussy, n.d. [28.4.35], Bussy.
59. This and the next quote from Delectorskaya 1, p. 15, and see ibid., pp. 19–21.
60. LD to HS.
61. Delectorskaya 1, pp. 15 and 17.
62. Ibid., p. 22; the next quote on p. 16.
63. HM/MM, 3.3 and 25.2.37, AMP.
64. Delectorskaya 1, p. 22.
65. Ibid., p. 89.
66. Ibid., p. 35.
67. Ibid., pp. 36–37.
68. Tomsk was seized by rebel forces on 4.6.18 (LD was born 23.6.10)
69. Couturier in Delectorskaya 1, p. 200.
70. HM/PM, 2.7.35, PMP (for *Pink Nude* dates, see Delectorskaya 1, p. 29).
71. LD to HS.
72. PM/HM, 20.6.35, PMP.
73. HM/MM, 26.3.35, AMP.
74. Information from Claude Duthuit.
75. AM/MM, 9.7.34, AMP; MM's collection documented in correspondence with HM throughout the spring, summer and autumn of 1935, AMP, and in HM/S. Bussy, 17.8.35.
76. PM/HM, 20.6.35, PMP, and MM/HM and AM, 16.7.35, AMP.
77. HM/PM, 2.7.35, PMP.
78. HM/MM, 21.7.35, AMP.
79. This and the next quote from HM/PM, 2.7.35, PMP.
80. Flam 2, p. 132, and Fourcade, p. 163.
81. MM/HM, 10.10.28, AMP.
82. Information from LD (OM died in 1929 but the news took several years to reach HM).
83. PM/HM, 2.2.35, PMP.
84. HM/PM, 22.3.35, PMP.
85. HM/GD, 23.9.35, AMP, and see Duthuit 1, p. 273.
86. LD to HS.
87. Delectorskaya 1, p. 26.
88. HM/PM, 9.12.35, PMP.
89. Delectorskaya 1, pp. 26–27 (HM's notes are in ibid., pp. 89–138).
90. LD to HS.
91. HM/MM, 7.3.36, AMP.
92. LD to HS.
93. Schneider, p. 582.
94. HM/MM, 25.1.36, AMP.
95. Reports on background and reception of this show in HM/MM, 3, 7, 15, 16 and 17.2.36, AMP.
96. MM/HM, 3.2.36, AMP.

97. Delectorskaya 1, p. 115.

98. HM/S. Bussy, 27.2.36, AMP.

99. HM/MM, 13.4.34 and 19.4.35, AMP.

100. HM/S. Bussy, 31.7.36, Escholier, pp. 131–32, and see p. 373, and n. 128 below; for Gide's studio (which eventually went to another tenant), see S. Bussy/HM, 24.5.39, Bussy.

101. LD to HS; I am grateful to Angelica Garnett for confirming LD's view.

102. Angelica Garnett, *Deceived with Kindness* (London, 1984), p. 169.

103. Alan Sheridan, *André Gide: A Life in the Present* (London, 1998), pp. 464–65.

104. Richard Tedeschi, ed. *Selected Letters of André Gide and Dorothy Bussy* (London, 1983), p. 258.

105. Bussy 1996, p. 131.

106. François de Miomandre in *Simon Bussy et ses amis*, ex. cat. (Musée des Beaux-Arts: Besançon, 1970), p. 129.

107. LD to HS.

108. HM/S. Bussy, 10.2.35, Bussy.

109. S. Bussy/HM, 1.5.41, AMP.

110. Quentin Bell, *Elders and Betters* (London, 1995), p. 157; I am grateful to Angelica Garnett for confirming my interpretation of this passage.

111. Quentin Bell/HS, 1.6.94.

112. Jane Simone Bussy, "A Great Man," *Burlington Magazine*, vol. 128 (February 1986): pp. 801–4 (Bussy, J. S.) (the text is in Flam 3, pp. 320–23). This literary satire has too often been adduced as documentary evidence by scholars who ignore its personal bias and rhetorical exaggerations: my account of its origins based on conversations with LD, and on her annotated version of the French translation (*Bulletin des Amis d'André Gide* [October 1989]).

113. "Testament against Gertrude Stein," *transition*, no. 23 (February 1935).

114. Bell, *Elders and Betters*, p. 158.

115. In Richard Shone, "Matisse in England and Two English Sitters," *Burlington Magazine* (July 1993): p. 483, n. 32.

116. Ibid., p. 481.

117. Ibid., pp. 483–84.

118. Christopher Nevinson, *Paint and Prejudice* (London, 1937), p. 125.

119. Shone, "Matisse in England," p. 482.

120. Matisse Picasso 2002, p. 379.

121. Fry in Flam 3, p. 251, and Barr in cat. preface to Matisse retrospective, MoMA, 1931.

122. This and the next quote from Clive Bell, "Matisse and Picasso," *Europa*, vol. 1, no. 1 (May–July 1933): pp. 30 and 31.

123. "Notes of a Painter on his Drawing," Flam 2, p. 132, and Fourcade, p. 163.

124. HM/PM, 17.12.35, and PM/HM, Feb. 1936,

PMP (Marie Cuttoli commissioned the tapestries, shown at the Bignou Gallery, New York, in February 1936).

125. "Entretiens avec André Masson," taped interviews by Georges Charbonnier, cassette 4, JC (Masson gave a slightly different version in Schneider, p. 616).

126. Schneider, p. 617.

127. HM/S. Bussy, 31.7.36, Bussy; Escholier, pp. 129 and 131–32; and see Matisse Picasso 2002, p. 378.

128. My account of this affair based on Schneider, pp. 137, 152, n. 2, 617 and 621, and Flam 4, pp. 68 and 87, n. 167; HM's view of Dufy (in his correspondence passim) confirmed by Wanda de Guébriant.

129. Dominique Fourcade, "Rêver à trois Aubergines," *Critique* (May 1974): p. 477; and see Escholier, p. 222.

130. Escholier, p. 50; HM's letter accompanying the gift is in Fourcade, pp. 133–34, and Barr, p. 40.

131. HM/MM, 10.3.35, AMP.

132. Kean, pp. 245–46; Barr and Escholier applied unsuccessfully for loans in 1931 and 1937 respectively (Barr, p. 22, and HM/PM, 18.11.36, PMP).

133. HM/MM, 11.1.34 and Easter 1935, AMP; Pierre's schemes in PM/HM, 14.3 and 11.4.32, PMP.

134. Kean, p. 235.

135. Barr, p. 224.

136. HM/S. Stein, 5.8.35, draft, AMP.

137. MM/HM, n.d. [Aug.–Sept. 1933], AMP; my account of the collection based primarily on Brenda Richardson, *Dr. Claribel and Miss Etta: The Cone Collection of the Baltimore Museum of Art* (Baltimore, 1986), extensively updated here in the light of HM's correspondence.

138. MM/HM, n.d. [Sept. 1933], AMP.

139. MM/HM, 8.9.33 and n.d. [Aug.–Sept. 1933], AMP.

140. Claribel Cone, *Aunt Etta and the Personalities* (Phoenix, Arizona, 1986), p. 10; and see Edward T. Cone, "The Miss Etta Cones, the Steins and M'sieu Matisse: A Memoir," *The American Scholar* (summer 1973): pp. 454–55.

141. MM/HM, n.d. [July 1935], AMP.

142. HM/S. Bussy, 10.7.34, Bussy.

143. HM/PM, 28.4.46, and see PM/HM, 10.5.46, PMP.

144. HM/AM, 20.4.30, AMP, and see Spurling, pp. 8 and 15; my account of HM's birds based on information from LD.

145. Shone, "Matisse in England," p. 484.

146. HM/PM, 15.12.37; further information from LD, from PM/HM, 15.12.37 and 10.1.38, and from HM/Marie Dormoy, 25.3.38, Bibliothèque J. Doucet, Paris.

147. B. Parayre/Alexina Matisse, 16.12.37, PMP.

148. PM/HM, 28.9.36, PMP.

149. B. Parayre/PM, 13.1.38, PMP; further information from HM/PM, 22.4.38, PMP.

150. HM/PM, 16.3.38, PMP.

151. Information from LD.

152. Information from LD; and see Delectorskaya 1, p. 277.

153. Information from LD; see also Courthion, pp. 88–89, and HM/PM, 22.4.38, PMP.

154. PM/HM, 25.11.38, and HM/PM, 3.11.38, PMP.

155. Information from LD.

156. HM/G. Besson, 31.10.38, Besson archive.

157. HM/S. Bussy, 29.8.39, Bussy.

158. Information from LD, and HM/PM, 8.1.39, PMP.

159. HM/PM, 26.1.39, PMP.

160. Information from LD.

161. HM/PM, 12.1.39, PMP.

162. J. Bussy/Vanessa Bell, 23 March [1939], Tate Gallery Archive, London.

163. *Correspondence André Gide–Dorothy Bussy*, vol. 3, 1937–1951 (Paris, 1982), p. 126; information from LD, and see Bussy, J. S.

164. J. Bussy/V. Bell, 23 March [1939], Tate Gallery Archive, London.

165. HM/SB, 14.7.39, Bussy.

166. LD to HS; the following account comes from LD.

167. J. Bussy/V. Bell, 23 March [1939], Tate Gallery Archive, London, and B. Parayre/PM, 7.9.39, PMP.

168. HM to an unidentified acquaintance, 2.4.39, Getty.

169. See Delectorskaya 1, p. 33, and HM/PM, 7.5.39, PMP (Rockefeller declined to take this second panel).

170. PM/HM, 5.5.39, PMP.

171. PM/HM, 2.5.39, PMP.

172. See Delectorskaya 1, p. 272 (the ballet was renamed *L'Etrange Farandole* in Paris).

173. HM/S. Bussy, n.d. [June 1939], Bussy (HM seems to have confused Atalanta's marriage with Thetis' wedding to Peleus, which was the one the gods attended).

174. HM/S. Bussy, 1.7.39, Bussy.

175. Information from Claude Duthuit.

176. HM/S. Bussy, 5 and 14.7.39, Bussy.

CHAPTER ELEVEN

1. HM/P. Rosenberg, 9.8.39, Pierpont Morgan Library.

2. HM/SB, 29.8.39, Bussy.

3. HM/SB, 24.9.39, Bussy.

4. Information from LD; see Delectorskaya 1, p. 319 (the painting is also called *Flowers and Figure with Arab Pot* or *Daisies* in Barr, p. 485).

5. This and the next quote LD to HS.

6. HM/SB, 24.9.39, Bussy.

7. HM/PM, 21.10.39, PMP.

8. HM/MM, 20.1.40, AMP (the figure is now in Musée Matisse, Cimiez).

9. HM/PM, 4.11.39, PMP.

10. Barbu Brezianu, "Matisse et Pallady: Leur Amitié et leurs relations artistiques," *Journal Akademiai Kiado* (Budapest, 1973), pp. 436–37.

11. HM/P. Rosenberg, 8.4.40; see also ibid., 30.9 and 7.11.39 (an earlier contract dated 16.7.39 annulled by the war), all in Morgan Library.

12. LD to HS.

13. HM/P. Rosenberg, 10.2.40, Morgan Library.

14. HM/MM, 20.1.40, AMP.

15. HM/PM, 4.11.39, PMP.

16. B. Parayre/PM, 7.9.39, PMP.

17. HM/Mqt, 8.4.41; information about *Noeud de Vipères* from LD, and see HM/AR, 25.10.42, Finsen, p. 116.

18. HM/P. Rosenberg, 7[10].2.40, Pierpont Morgan Library, New York.

19. HM/PM, 10.10.39, PMP.

20. Information from LD, and HM/PM, 7.6.40, PMP.

21. HM/PM, 6.6.40, PMP.

22. Information from LD.

23. HM/SB, 11.5.40, Bussy.

24. Information from LD, HM/PM, 6.6.40, PMP, HM/SB, 7.6.40, Bussy, and Delectorskaya 2, pp. 92–95 and 98.

25. HM/PM, 6 and 7.6.40, PMP.

26. Introduction to *Verve*, no. 8 (June 1940), see Dominique Szymusiak et al., *Matisse et Tériade*, ex. cat. (Musée Matisse, le Cateau-Cambrésis, 1997), p. 62.

27. HM/MM, n.d. [June 1940], AMP.

28. Claude Duthuit, "*Résistantes*," unpub. ts. kindly shown me by the author.

29. HM/PM, 1.9.40, PMP.

30. Delectorskaya 2, p. 100.

31. HM/R. Escholier, 20.4.41, Getty, and see HM/SB, 11.7.40, Bussy, and HM/PM, 30.7.40, PMP.

32. HM/PM, 6.6 and 3.7.40; for the torso's story, see also Escholier, pp. 195–97.

33. HM/SB, 7.8.40, Bussy.

34. Information from LD.

35. HM/PM, 1.9.40, PMP; ibid., 19.8.40, and HM/MM, 27.8.40, AMP.

36. HM/PM, 1.9.40, PMP, et passim.

37. HM/P. Rosenberg, 7[10].2.40, Pierpont Morgan Library, New York.
38. HM/PM, 1.9 and 6.6.40, PMP.
39. HM/MM, 15.10.40, AMP.
40. HM/PM, 10.11 and 11.10.40, PMP.
41. HM/SB, 17.6.40, Bussy.
42. HM/MM, 26.9.40, AMP.
43. HM/MM, 15.8.40, AMP, HM/PM, 27.8.40, and Escholier, pp. 195–96.
44. HM/MM, 15.10.40, AMP.
45. PM/HM, 13.9.40, PMP.
46. Bonnard, pp. 95 and 96.
47. The Beaux-Arts' Villa Medici in Rome was closed down and reopened in Nice in November 1941. HM (who refused to attend the inauguration) broadcast on 21.9.41 and again, after obtaining assurances from the programme's director, Claude Roy, on 28.4.42. Previous commentators, from Barr onwards, have speculated, sometimes unwisely, about this episode, which can be pieced together from HM's letters at the time to André Rouveyre in Finsen, pp. 68–69, 73, 99 and 111; the subsequent confusion is ably cleared up in Finsen's notes, and the respective radio transcripts (excerpted in translation in Barr, pp. 562–63) are on pp. 649–52. See also pp. 407–08, and p. 493, nn. 99–106 below.
48. HM/PM, 18.9.40, PMP.
49. Brezianu, "Matisse et Pallady," pp. 440–41.
50. HM/PM, 1.9.40, PMP.
51. See HM/PM, 18.9.40, and Delectorskaya 2, pp. 67, 114–15 and 117. The successive models were Micheline Payot and Nézy-Hamidé Chawkat.
52. This and the next quote from Brezianu, "Matisse et Pallady," p. 440.
53. HM/PM, 28.11.40, PMP.
54. LD/MM, 25.12.40, AMP.
55. HM/MM, 15.1.41, PMP.
56. My account of the origins, symptoms and treatment of HM's condition is based principally on detailed accounts in LD/MM, 25, 27 and 28.12.40, AMP, supplemented by information from LD; HM's account to Pierre, HM/PM, 20.7.41, PMP; MD's reports in MM/PM, 24 and 31.1.41, PMP, n.d. [Apr. 1945], AMP; and Professor Wertheimer's case notes drawn up for Dr. Augier of Nice, 21.5.41, AMP. I am also grateful to Dr. William Chapman of St. Louis for a general consultation on intestinal disorders with particular reference to hernia. HM has been generally assumed to have suffered from cancer of the colon, which was certainly considered as a possibility by his surgeons before the operation, but not mentioned again afterwards. His condition and its treatment is entirely consistent with bowel trouble caused by the hernia that had incapacitated him in adolescence (see Spurling, pp. 43 and 433, n. 55), and which he himself cited afterwards as the cause (HM/AR, 23.6.41, Finsen, p. 52): he had undergone minor corrective surgery for hernia at the American Hospital in Neuilly on 8.9.37 (HM/Mme Thorndike, 27.8.37, Getty, and information from LD), and a recurrence of the same problem in May 1940 could easily have been put right if correctly diagnosed straight away (see pp. 392 and 394, and p. 491, nn. 22 and 23). Cancer, supposing it had been present, would almost certainly have returned within a matter of months (see p. 409, and p. 493, n. 110). Extra confusion has been caused by the fact that HM generally preferred to describe his troubles with hernia as appendicitis.
57. HM/PM, 10 and 15.1.41, PMP.
58. HM/A. Rouveyre, 2 and 22.4.41, Finsen, pp. 35 and 40.
59. HM/PM, 30.8.41, PMP.
60. HM/MM, 2.4.41, AMP.
61. Information from LD.
62. HM/SB, 14.4.41, PMP.
63. HM/A. Rouveyre, 2.4.41, Finsen, p. 35.
64. HM in conversation with Pierre Courthion, Pierre Courthion papers, Getty.
65. HM/A. Rouveyre, 20.4.41, Finsen, p. 39, and HM/PM, 2.5.41, PMP.
66. HM/PM, 20.5.41, PMP.
67. Note in HM's hand on a cancelled page of his memoirs, Pierre Courthion papers, Getty.
68. My account of HM's proposed memoirs is put together mainly from HM's own blow-by-blow commentary in letters to Rouveyre, June–November 1941, in Finsen; from his account to Pierre in HM/PM, 11.3.42 and 12.5.48; and from Courthion's ts., and supplementary papers (pages corrected or cancelled by HM, miscellaneous notes by both HM and Courthion, correspondence with Courthion and the stenographer Lucien Chachuat, and Courthion's contract with Skira, 9.7.41), Getty.
69. Pierre Courthion, Le Visage de Matisse (Lausanne, 1942), p. 24, and Courthion, p. 140.
70. HM/PM, 20.7 and 8.11.41, PMP.
71. HM/PM, 5.6.41, PMP.
72. Ibid.
73. Bonnard, pp. 93 and 96.
74. Mqt/HM, n.d. [1941], AMP.
75. HM/PM, 11.3.42, PMP, and HM/Mqt, 16.1.42, AMP.
76. Gilot, p. 14.
77. Schneider, pp. 54 and 69, n. 16.

78. Courthion, *Visage de Matisse*, p. 20; the next two quotes from ibid., pp. 39 and 119.

79. Courthion, p. 139.

80. Cancelled passage, pp. 37–38, Courthion ts., Getty (the first was Pierre Janet, consulted in the 1914–18 war; the second was the homeopath Pierre Vannier; the third an unnamed practitioner in Nice).

81. HM/A. Rouveyre, 23.7.41, Finsen, p. 52, and see ibid., p. 55.

82. Courthion, *Visage de Matisse*, p. 33.

83. This and the next quote from HM/PM, 1.10.41, PMP; see also ibid., 8.11.41.

84. Aragon 1, p. 38 (Aragon gives the date as November but it is 20 December in Delectorskaya 2, p. 267).

85. Aragon 1, p. 167 (the text was "Matisse ou la Grandeur," pub. in Pierre Seghers' *Précis* [January 1942]).

86. Aragon 1, p. 42.

87. See Delectorskaya 2, pp. 200–8 and 280–81.

88. HM/PM, 3.4.42, PMP, and HM/MM, 7.4.42, AMP.

89. Aragon 1, pp. 42 and 44; the next quote from ibid., p. 42.

90. "Henri Matisse or the French Painter," in *Henri Matisse: Retrospective Exhibition of Paintings, Drawings and Sculpture*, ex. cat. (Philadelphia Museum of Art, 1948), p. 28.

91. Aragon 1, p. 49.

92. Aragon 2, p. 16.

93. Ibid., pp. 15 and 48–49.

94. Aragon 1, p. 169, and see Aragon 2, p. 16.

95. Aragon 1, p. 170.

96. L. Aragon/HM, 7.6.42, AMP.

97. Aragon 1, p. 173.

98. HM/MM, 28.5.42, AMP.

99. Finsen, L153, p. 99, and see Pierre Daix, *Aragon: Une Vie à changer* (Paris, 1994), pp. 396 and 413; see also Aragon 1, p. 178, and Aragon 2, p. 15.

100. Information from LD.

101. L. Aragon/HM, 11.7.42, AMP, and Aragon 1, p. 17.

102. HM/PM, 26.10.41 and 11.3.42, PMP; and information from LD.

103. Aragon 1, p. 178.

104. HM/MM, 15.2.42, AMP.

105. Couturier, p. 402.

106. Aragon 1, p. 198.

107. Ibid., p. 269.

108. L. Aragon/HM, 3.7.42, AMP.

109. HM/PM, 6.7.42, PMP.

110. My account of this episode based on information from LD, and from Marguerite's subsequent account, n.d. [Apr. 1945], AMP.

111. HM/PM, 6.7[8].42, PMP.

112. Delectorskaya 2, p. 340; and information from Dame Drue Heinz, who was present.

113. Delectorskaya 2, pp. 108–9 and 353.

114. Ibid., p. 400.

115. Ibid., pp. 366–67.

116. HM/L. Aragon, 1.9.42, in ibid., p. 378.

117. Soeur Jacques, p. 24.

118. Ibid., p. 28.

119. This and the next quote from Delectorskaya 2, pp. 414–15.

120. Report on HM's health by MD, n.d. [Apr. 1945], AMP.

121. Aragon 1, p. 136 and n., p. 137, and Aragon 2, p. 15.

122. Information from LD, and see Aragon 1, p. 276.

123. Camoin, p. 187, and see ibid., p. 185, n. 3.

124. HM/MM, 30.3 and 14.6.43, AMP, and see Bonnard, p. 117.

125. HM/PM, 18.6.42, PMP.

126. Carco, p. 224, and HM/A. Rouveyre, 3.7.42, Finsen, p. 119.

127. Aragon 1, p. 181, and Finsen, L235, p. 151.

128. HM/MM, 14.6.43, AMP.

129. HM/A. Rouveyre, 26.7.42, Finsen, p. 120.

130. Ibid, 8–9.12.41, Finsen, p. 83.

131. HM/Mqt, 28.12.44, AMP.

132. HM/A. Rouveyre, 5.3.20, Finsen, p. 33.

133. Finsen, L315, p. 217.

134. Finsen, L302, p. 211.

135. Finsen, L338, p. 226.

136. Finsen, L301, n. 2, p. 211.

137. MM/HM, 20.5.43, AMP.

138. HM/MM, 14.6.43, AMP, and information from LD.

139. This and the following quotes from HM/MM, 26.7.43, AMP.

140. HM/MM, 7.4.42, and information from LD.

141. Aragon 1, p. 186.

142. This and the next quote from ibid., p. 185.

143. HM/MM, 29.11.43, AMP.

144. Aragon 2, p. 35.

145. Information from LD, and HM/MM, 10.22 and 28.9.43, AMP.

146. HM/MM, 7.11.43, AMP, and see HM/PM, 12.2.45, PMP.

147. HM/MM, 1.10.43, AMP.

148. My account of this episode based on "*Résistantes*," see n. 28 above, and HM/MM, 7.8.43, AMP.

149. MM/HM, 23.11.43, AMP.

150. HM/MM, 31.1 and 2.2.44, AMP.

151. HM/MM, 7.3.44, AMP.

152. HM/Mme. Thorndike, 1.2.44, Getty.

153. HM/MM, 28.11.44, AMP.

154. B. Parayre/PM, 20.1.42, PMP.

155. Nelck, p. 35.

156. Ibid., pp. 10 and 13.

157. Ibid., p. 84.

158. Information from LD.

159. Camoin, p. 200.

160. HM/MM, 28.12.45; my account of HM's response to these arrests is based on family correspondence, on conversations with Claude Duthuit and Gérard Matisse, and on "Résistantes," see n. 28 above. Ignorance or misunderstanding of the background to this affair seems to be largely responsible for the widespread assumption that HM supported the Vichy régime, and for the preposterous corollary recently circulated in the United States that he actively collaborated with the Nazis. The only reputable source for these baseless claims seems to be Michèle C. Cone, *Artists under Vichy: A Case of Prejudice and Persecution* (Princeton, 1992), which states accurately enough that HM published two illustrated books with Fabiani in 1943 and 1944 respectively (p. 49), and that he failed to raise political issues in two wartime interviews with Gaston Diehl (pp. 50–51). Cone goes on to speculate (on the evidence of a single remark to a Danish critic in 1924) that HM may have approved of the Vichy régime (p. 52), and concludes that he was the model for a collective escapism among French artists, which she equates with psychological collusion or passive collaboration with the Fascist authorities (p. 180). Cone adduces no documentary or other support for her conclusions, which leave out of account HM's precarious medical condition, his fear of further endangering his daughter, and his responsibility for LD's safety as well as the blanket censorship operated by both Vichy and Nazi rulers. For HM's attempt to make his views publicly known in 1941–42, see pp. 396 and 407, and nn. 47 and 49.

161. HM/MM, 9.11.44, AMP.

162. Nelck, pp. 98 and 111; the next quote from ibid., p. 107.

163. Camoin, p. 205.

164. Nelck, p. 110.

165. HM/C. Camoin, 6.9.44, Camoin, pp. 207–8.

166. See Alain le Grand and G-M. Thomas, *39–45 Finistère* (Brest-Paris, 1987), pp. 306–7; Rennes was liberated on 7 August.

167. Camoin, p. 212.

168. MM/HM, 10.10.44, AMP; and see Camoin, p. 210.

169. HM/MM, 24 and 29.10.44, AMP.

170. This account of Marguerite Duthuit's interrogation in the Jacques Cartier Prison, her deportation and subsequent escape based on "Résistantes," see n. 28 above; MD's letters to her father in the autumn of 1944; Grand and Thomas, *39–45 Finistère*, pp. 307–9; and Roger Faligot and Rémi Kauffer, *Service B* (Paris, 1985), pp. 227–46.

171. Telegram MM/HM, Jan. 1945, AMP.

172. MM/HM, 16.11.44, AMP.

173. HM/PM, 15.1[2].45, PMP.

174. Finsen, L456, p. 301.

175. HM/PM, 12.2.45, PMP.

176. MM/HM, 5.1.45, AMP.

177. Finsen, L457, p. 302.

CHAPTER TWELVE

1. Information from Jean Darquet, interviewed by David Thompson for BBC *Omnibus* in 2002.

2. Gilot, p. 22; the visit took place in March 1946 (HM/PM, 19.3.46, PMP), but the painting was *The Egyptian Curtain* of 1948, so this must be a composite memory.

3. Fourcade, p. 244.

4. Aragon 1, p. 231.

5. André Verdet, *Prestiges de Matisse* (Paris, 1952), p. 48.

6. HM/AR, 16.12.43, Finsen, p. 283, and HM/MM, n.d. [March 1943] and 4.1.44, AMP.

7. Courthion, p. 139.

8. This and the following quote from HM/MM, 11.2.45, AMP.

9. Flam 3, p. 379.

10. Gilot, p. 71.

11. Nelck, p. 82.

12. Couturier, p. 135.

13. Gilot, p. 73.

14. Courthion, p. 134, and see Spurling, p. 24.

15. Verdet, *Prestiges de Matisse*; see also HM/T. Pallady, 7.12.41, Brezianu.

16. HM/AR, 18.8.43, Finsen, p. 281.

17. I am grateful to Aldo Crommelynck for this first-hand account of watching HM at work after the war.

18. Courthion, p. 139.

19. Flam 3, p. 378.

20. Camoin, p. 218, n. 1.

21. Richard Buckle, *Diaghilev* (London, 1979), p. 377.

22. Escholier, p. 207.

23. Information from LD (the packet contained the cover of *Pasiphaë*, printed on the presses of *Nice Matin* for forwarding to Fabiani).

24. HM/AR, 25.1.44, Finsen, p. 287.

25. Information from LD (who subsequently presented both paintings to the Hermitage Museum).

26. AR/HM, Easter and 30.10.42, Finsen, p. 108.

27. Nelck, p. 87.

28. Nelck, p. 98; the next two quotes from ibid., pp. 58 and 56.
29. Ibid., p. 64, and see p. 101.
30. HM/PM, 18.3.45, PMP.
31. Nelck, p. 106.
32. HM/PM, 14.5.45, PMP.
33. AM/HM, 15.10.45, AMP.
34. Information from LD.
35. Vassaux cited in MM/PM, 14.4.45, PMP.
36. L. Vassaux/HM 24 and 30.4.45, AMP.
37. Information from LD, and from Michel Gueguen in Concarneau; and see Spurling, p. 77.
38. HM/AR, 30.1.46, Finsen, p. 356.
39. HM/Georges Salles, ts. draft 1945, AMP.
40. This and the following quote from HM/AR, 19.7.45, Finsen, p. 319.
41. HM/AM, 25.10.45, AMP, and information from LD.
42. MM/HM, 22.3.45, AMP.
43. This episode related in HM's letters to MM, AMP.
44. HM/Marcelle Marquet, 17.4.48, AMP.
45. HM/MM, 21.11.44, AMP.
46. PM/HM, 24.4.46, PMP (France's acquisition of HM's paintings after the war was thanks to the director of the Musée d'Art Moderne, Jean Cassou).
47. HM/Mqt, 3.1.46, AMP.
48. Information from LD.
49. Aragon 1, p. 240.
50. Nelck, p. 93.
51. This and the next quote from HM/MM, 28.12.47, AMP.
52. Information from LD.
53. Bonnard, p. 131.
54. PM/HM, March 1946, PMP.
55. HM/PM, 5.4.48, PMP.
56. I am grateful to the sculptor Bryan Kneale for passing on this eye-witness account from his brother, Nigel Kneale.
57. Jean Cassarini, *Matisse à Nice 1916–54* (Nice, 1984), n.p.
58. PM/HM, 22.3.46, PMP.
59. Auguste Matisse/HM, 27.8.45 and n.d. [summer 1945], AMP.
60. AR/HM, 24.2.46, Finsen, p. 398.
61. Marcelle Marquet, p. 137; and see HM/Mgt, 3.3.41, AMP.
62. Nelck, p. 126.
63. HM/MM, 28.12.47, AMP.
64. Bussy, J. S., p. 83.
65. Gilot, p. 90.
66. Fernand Mourlot, *Gravés dans ma mémoire: Cinquante ans de lithographie avec Picasso, Matisse, Chagall, Braque, Miro* (Paris, 1979), p. 109.
67. HM/PM, 19.3.46, PMP.
68. Gaston Diehl, *La Peinture en France dans les années noires 1935–45* (Paris, 1999), p. 53; further information from LD.
69. HM/AR, n.d. [June 1943], Finsen, p. 270.
70. AR/HM, 30.12.45, Finsen, p. 341 and n. 2.
71. HM/PM, 30.11.45, PMP.
72. Soeur Jacques, p. 16.
73. Ibid., p. 104.
74. Aragon 1, p. 208, n. 1.
75. Laudon, p. 131.
76. My account of this episode based on information from LD; for a fuller version, see Dominique Szymusiak, "Océanie le ciel, Océanie la mer," in Matisse 1998.
77. HM/P. Rosenberg, 2.6.46, Pierpont Morgan Library, New York.
78. HM/MM, 15.10.47, AMP.
79. HM's account from *Jazz*, 1947; see also Olivier Berggruen and Max Hollein, eds., *Henri Matisse: Drawing with Scissors. Masterpieces from the Late Years*, ex. cat. (Berlin, 2003), pp. 50–52.
80. Marcelle Marquet, *Marquet* (Paris, 1951), p. 99.
81. HM/G. Besson, 16.4.47, and HM/MM, 25.5.47, AMP.
82. HM notebook, 1946, ts., PMP.
83. *Henri Matisse: Ten Drawings of Paul Matisse*, ex. cat. (Thomas Gibson Fine Art: London, 1971).
84. Janet Flanner, *Men and Monuments* (London, 1957), p. 130.
85. Soeur Jacques, pp. 66–67.
86. Nelck, p. 148.
87. Aragon 2, p. 222.
88. Couturier, p. 449; see also Frère D. Bonnet, "Le Père Rayssiguier, architecte de Vence et de St Rouin," *L'Art sacré* (November–December 1961).
89. Couturier, p. 36.
90. Ibid., p. 40, and see Soeur Jacques, p. 76.
91. Soeur Jacques, p. 70.
92. Ibid., p. 79.
93. HM/MM, 28.12.47, AMP; see also HM/AR, 25.12.47, Finsen, p. 478.
94. Couturier, p. 206.
95. HM/PM, 9.3 and 28.4.48, PMP.
96. Couturier, p. 47.
97. Ibid., p. 62.
98. Schneider, pp. 739–40.
99. Couturier, p. 73.
100. Soeur Jacques, p. 168.
101. Couturier, p. 71.
102. Ibid., p. 90.
103. Ibid., pp. 78 and 101.
104. HM/PM, 16.11.48, PMP.
105. Jacqueline Duhême, *Passion Couleurs: Entretiens avec Florence Noiville* (Paris, 1998), p. 42.
106. Couturier, p. 86.
107. See Spurling, p. 80.

108. Couturier, p. 101.
109. Ibid., p. 128.
110. Nelck, p. 43.
111. Couturier, p. 129,
112. Ibid., p. 111.
113. Couturier, p. 110.
114. Ibid., p. 128.
115. Ibid., p. 299.
116. Interview with Paule Caen-Martin, Paris, 16.2.94.
117. Bonnet, "Le Père Rayssiguier."
118. This and the following quote from Couturier, p. 141.
119. Ibid., p. 160, and Nelck, p. 143.
120. Couturier, p. 271.
121. Ibid., pp. 226, 229 and 230.
122. Soeur Jacques, p. 96 (for the article by Rosamond Bernier, see *Vogue*, 15.2.49).
123. Ibid., p. 119; and see p. 72.
124. Ibid., p. 132; and see pp. 81–82.
125. Couturier, p. 78.
126. This account based mainly on information from LD, and from Paule Caen-Martin.
127. Interview with Claudie Pleinte, *Nice Matin*, 16.11.54.
128. Paule Caen-Martin.
129. Escholier, p. 206.
130. Duhême, *Passion Couleurs*, p. 41.
131. Paule Caen-Martin.
132. Barr, p. 266, and PM/HM, 25.2.49, PMP.
133. J. Bussy/V. Bell, 28.1.50, Tate Gallery archive, London.
134. Couturier, p. 339.
135. Ibid., p. 298.
136. HM/PM, 28.1.52, PMP.
137. Couturier, pp. 113–14, 355, 384 and 449; Mourlot, *Gravés dans ma mémoire*, p. 116.
138. Couturier, p. 358.
139. HM/L. Vassaux, 6.1.51 (in the possession of Madeleine Vincent).
140. Couturier, p. 455.
141. Ibid., p. 416, and see p. 455.
142. Flanner, *Men and Monuments*, p. 123.
143. Soeur Jacques, p. 144.
144. HM/PM, 15.10.51, PMP.
145. "I Said No to Art Lessons with Matisse," interview with Denise Arokas, *Daily Telegraph*, London, 7.2.2001.
146. Couturier, p. 425, and see Gowing, pp. 190 and 192.
147. HM/PM, 16.5.52, PMP, and Matisse 1989, pp. 381–82.
148. HM/PM, 24.11.46, PMP, and HM/MM, 2.12.46, 7.1.47 and Nov. 1947, all AMP.
149. Barr's seven questionnaires and the relevant correspondence with PM, Monroe Wheeler and John Rewald are among his papers at MoMA.
150. Ts. of Barr's speech, 13.11.51, Barr papers, MoMA; see also Barr, pp. 154; 540, nn. 1, 2 and 3; 262, n. 3; and 263.
151. Information from LD.
152. Draft of HM/B. Ternovets, 27.6.46, AMP; see also Gordon Knox/A. Barr, 12.12.49, and Spencer E. Roberts/A. Barr, 16.4.51, Barr papers, MoMA.
153. Couturier, p. 60, and Escholier, p. 262.
154. For a fuller account of this discrepancy, see HS, "Two for the Road," *Art in America* (January–March 2003).
155. "A Visit to Matisse," ts. by Derek Hill, kindly shown me by the author.
156. G. Salles, "Matisse," *Art News Annual*, no. 21 (1951): p. 37.
157. Verdet, *Prestiges de Matisse*, pp. 16 and 21.
158. Information from Paule Caen-Martin.
159. HM/PM, 12.10.52, PMP.
160. Verdet, *Prestiges de Matisse*.
161. HM, 1946 notebook, ts., PMP.
162. HM/PM, 21.11.52, PMP.
163. HM/Henri Donias, 13.12.53, Getty.
164. Soeur Jacques, p. 153.
165. HM/MM, 28.5.42, AMP.
166. Escholier, p. 208.
167. Gilot, p. 313, and see Couturier, p. 416.
168. Statement by Dr J. L. Bourliachon, 22.8.57, AMP.
169. Delectorskaya 2, p. 546.
170. AM/PM, 18.3.55, PMP.

A

Abduction, The (Cézanne), 5 *and illus.*
Académie Colarossi, 52, 68
Académie Goncourt, 42
Académie Julian, 107, 109
Académie Matisse, 11–14, 16, 27, 36, 39, 42, 50, 73
Académie Russe, 22
Acanthus (Matisse), 113, 123
Adel, Sophia, 75, 76, 93–7
Adel, Tamara, 94
Agutte, Georgette, *see* Sembat, Georgette
Albret, Ernest d', 298
Aldrich, Mildred, 140
Algerian Girl, The (Matisse), 19
Alphonsine (Renoir), 253
Amido (model), 116, 123
Anderson, Hans Christian, 229, 231
Anemones in a Terracotta Pot (Matisse), 270
Angoisse qui s'amasse, L' (Matisse), *illus. 418*
Annette (model), 201
Antoinette with Long Hair (Matisse), *illus. 225*
Apollinaire, Guillaume, 22, 43, 53, 73–4, 109, 137, 144, 158, 192, 206
Arabs, The (Matisse), 243
Aragon, Louis, 23–4, 74, 405–8, 411, 412, 427, 433, 461
 adolescent discovery of Matisse by, 144, 258
 in Communist Party, 406, 408, 439, 448, 458, 462
 on Matisse's paintings, 161, 162, 353, 409, 418–19
 in Resistance, 406, 413
 sketch of, *illus. 406*
 in World War I, 189
Archangel Michael, The (Novgorod school), *illus. 100*
Arensberg, Walter, 170

Armory Show, 135–6, 139, 155, 164
Arnoud, Antoinette, 223–6, 228, 233, 236, 239–41, 243, 248, 251
Arpino, Rosa, 27
Arokas, Denise, 460
Art Institute of Chicago, 136, 187
Art Vivant, L' (magazine), 274, 283
Artist's Model, The (Matisse), *illus. 173*
Ascher, Zika, 445
Asie, L' (Matisse), 439, 440
Astré, Marie, 82
Au Maroc (Loti), 113
Audistère, François, 287, 304
Audra, Paul, 223
Auguste Pellerin (II) (Matisse), *illus. 193*, 193–6
Auric, Georges, 285
Autobiography of Alice B. Toklas, The (Stein), 370–1
Autumn Salon, 7, 15, 22, 36, 51, 53, 56, 62, 73, 82, 85, 87, 97, 121, 144, 147, 424, 439
Avogadro, Carla, 410

B

Bach, Johann Sebastian, 181, 184
Back I (Matisse), 136, 139, 140, 142, 301
Back II (Matisse), *illus. 138*, 139, 140, 142, 301
Back IV (Matisse), 301 *and illus.*
Bakst, Léon, 244
Balanchine, George, 481n48
Balbuena, Carmen, 70, 71
Balbuena, Consuelo, 70
Balenciaga, 450
Baliev, Nikita, 90, 94
Ballet Russe de Monte Carlo, 380, 385
Ballets Russes, 229–32, 243, 244
Baltimore Museum of Art, 377, 462
Banque de France, 387, 396, 437–8
Barbazanges, Hodebert et Cie, 260

Barnes, Albert C., 155, 323–8, 330, 331, 334–8, 341, 343, 347, 352, 373, 374, 382, 445, 459, 462

Barnes Foundation, 233, 323, 338

Barr, Alfred, 62, 72, 80, 86, 168, 184, 219, 330, 372, 375, 396, 461, 462, 466, 490n132

Basket of Flowers (Bonnard), 439

Basket of Oranges (Matisse), 103, 118

Basler, Adolphe, 162

Bathers (Cézanne), 177, 187, 218, 301

Bathers, The (Renoir), 217, 228

Bathers by a River (Matisse), *colour fig. 19, illus. 135,* 138, 140, 142, 174, 184, 185, 187–8, 194, 212, 285, 286, 292, 485n127

 sketch for, *illus. 185*

Bathers with a Turtle (Matisse), 375

Baudelaire, Charles, 423

Bavardages (Matisse), 401–5

Bay of Tangier, The (Matisse), *illus. 103*

Beasts of the Sea, The (Matisse), 458

Beaumarchais, M. and Mme de, 114, 116–17

Beaux-Arts aesthetics, 6, 7, 259

Beethoven, Ludwig van, 181, 286, 417

Bell, Clive, 51, 109, 233, 366, 368, 370–2

Bell, Quentin, 370

Bell, Vanessa, 233, 368, 384, 458

Bennett, Arnold, 233

Benois, Alexander, 89, 374

Berenson, Bernard, 38–9, 44, 45

Berenson, Mary, 39

Berggruen Gallery (Paris), 462

Bergson, Henri, 148–9, 151–2, 423

Berners, Lord, 362

Bernheim-Jeune cousins, 38, 40, 59, 260, 267, 291, 330, 396

 Denis and, 89

 Monet and, 199

 Shchukin and, 56, 57, 91, 134, 163

Bernheim-Jeune gallery, 55, 132, 164, 177, 229, 256, 285, 335, 479n62

 annual exhibitions at, 226, 236, 249, 253, 274, 481n53

 first one-man show at, 40, 45, 47, 50

 Tangier paintings at, 132–4, 137

Besson, George, 204, 207, 217, 221, 226, 382

Bevilacqua (model), 200

Biette, Jean, 50, 51, 55, 56, 58, 63

Bignou, Etienne, 330

Blanchi (violin maker), 271

Blinding of Polyphemus (Matisse), 353

Bloomsbury group, 233, 348, 368–71

Blue Eyes, The (Matisse), 355, *illus. 356*

Blue Nude (Matisse; 1907), 136

Blue Nude (Matisse; 1908), 292, 326, 377, 485n127

Blue Nudes (Matisse; early 1950s), 464

Blue Window, The (Matisse), 176, 375

Bock, Catherine, 187, 273

Bohème du XXe siècle, La (Vassilieff), 15

Bolsheviks, 358

Bolshoi Opera, 93

Boney (stained glass producer), 454

Bongard, Germaine, 191, 224, 242, 243

Bonheur de vivre (Matisse), 25, 325, 329

Bonjour Mlle Levy (Matisse), 28

Bonnard, Pierre, 48, 250, 298, 305, 320, 324, 358, 399, 402, 403, 413, 420, 434, 439–40, 446

Boston Museum of Fine Arts, 45, 150

Boston Public Library, 56

Boucher, François, 96

Bouge, Governor, 316, 321

Bouge, Mme, 321

Bouguereau, William, 107

Bourdelle, Antoine, 22

Bourgeois, Monique (Sister Jacques), 411–12, 448, 449, 453, 455, 465

Boutique fantastique (ballet), 229, 233–4

Brahms, Johannes, 181

Branch of Lilac (Matisse), 285

Braque, Georges, 35, 82, 83, 161, 169, 192 *and illus.,* 274, 371

Braque, Marcelle, *illus. 192*

Braque Banquet, The (Vassilieff), *illus. 192*

Bréal, Auguste, 58, 59, 63, 67, *illus. 70,* 70–72

Bréal, Hermine, 71

Bréal, Louisette, 70–1

Breker, Arno, 438

Breton, André, 144, 168, 189, 226, 256, 258, 274, 292, 440, 447

Breton Peasant Girl (Meerson), 470n31

Brise marine (Matisse), *illus. 296*

British Intelligence, 412, 420

British Museum (London), 230, 367

Brooks, Jack, 104, 113–15

Brouty, Loulou, 27–30

Brown, Oliver, 233

Bruce, Patrick, 14–16

Brummer, Joseph, 163

Buck, Pearl, 342–3, 391

Burgun, Georges, 169

Burliuk, David, 94

Burroughs, Bryson, 51, 164

Bussy, Dorothy, 366–71, 373, 383, 384, 463

Bussy, Janie, 333, 368 *and illus.,* 370, 383–4, 442, 458

 "A Great Man" (essay), 370, 490n112

Bussy, Simon, 83–4, 242, 250, 305, 332–3, 355, 367–9, 373, 413, 420, 434, 463

 and Bloomsbury group, 368, 371

 and breakup of Matisses' marriage, 383, 384, 386

 correspondence with, 37, 337, 343, 385, 388, 394, 399, 400

 death of, 465

illness of, 352

in London, 364, 378

and painting of *The Dance* for Barnes, 332–3, 335–6

Byzance et l'art du XIIe siècle (Duthuit), 279

C

Caffin, Charles H., 49–50

Cahiers d'Art, 292, 350

Calypso (Matisse), 352

Camera Work (magazine), 49

Camoin, Charles, 146 *and illus.*, 147, 156, 413, 420, 431, 434

correspondence with, 59, 166–72, 175, 201, 202, 207, *illus. 210*, 399, 422, 424

at Issy, 40 *and illus.*, 124

marriage of, 260

in Tangier, 125–8, 130

in World War I, 156, 165, 169–71, 189

Capture of Constantinople by the Crusaders, The (Delacroix), 129

Carnegie International Exhibition (Pittsburgh), 297, 322–24

Carpentier, Georges, 480n79

Casbah Gate, The (Matisse), 131

Cassirer, Paul, 6

Cassou, Jean, 495n46

Cendrars, Blaise, 191, *illus. 192*

César, Marc Antonio, 39

Cézanne, Paul, 5 *and illus.*, 13, 31, 33, 35, 80, 136, 187, 190, 194, 300, 417, 442

in Barnes' collection, 325

influence on Matisse of, 176, 177, 218

in Matisse's collection, 99, 186, *illus. 252*, 396

in Pellerin's collection, 193, 199

portrait of wife by, 141–2, 253

Chadbourne, Emily, 45, 52

Chadourne, Marc, 302, 307, 311, 315, 316, 318

Chadourne, Pauline, *see* Schyle, Pauline

Chagall, Marc, 287

Chamber of Deputies, 137

Chamberlain, Neville, 382

Chanson de Roland, 124

Chant du rossignol, Le (ballet), 229–34, *illus. 232*, 380, 452, 481n48

Chaplin, Charlie, 296–7, 339

Chardin, Jean-Baptiste-Siméon, 331

Charles d'Orléans, 414, 418

Charmy, Emilie, 125, 126

Chateaubriand, Vicomte François-Auguste-René de, 77

Chaurand-Nairac, Jeanine, 169, 189

Chawkat, Nézy-Hamidé, 410, 411, 492n51

Chekhov, Anton, 18, 93

Chicago Examiner, 136

Chroniques du Jour, 485n22

Churchill, Winston, 184, 420–1

Cinquante Dessins (Matisse), 225, 242

Circus, The (film), 296–7, 339

Circus Girl and the Manager, The (Roualt), 404

Clair, René, 441

Clark, Kenneth, 233, 362, 367, 371

Clemenceau, Georges, 194, 209, 238

Coburn, Alvin Langdon, *135*

Cochran, Charles B., 229

Cocteau, Jean, 191, 226

Collège de France, 148, 398

Communists, 370, 372, 406, 408, 420, 423–4, 439, 448, 451, 458, 462, 463

Composition No. 1 (Matisse), *illus. 3*

Composition No. 2 (Matisse), *illus. 185*

Concerts de Colonne, 181

Cone, Claribel, 326, 375–7, 485n27

Cone, Etta, 326–7, 375–7, *illus. 376*, 462

Contemporary Arts Society, 371

Conversation, The (Matisse) *colour fig. 12*, 32, 119, 121, 133, 239, 386

Copper Beaches (Matisse), 38

Corner of the Studio (Matisse), 120, 121, 133

Corot, Jean-Baptiste-Camille, 148, *illus. 198*, 199, 203

Corsage Bleu (Matisse), 358

Cortot, Alfred, 191

Courbet, Gustave, *illus. 197*, 199, 203, 212, 218, 274, 392, 396, 479n62

Courtauld, Samuel, 362

Courtauld Institute of Art, 351

Courthion, Pierre, 59, 401–5

Courtyard of the Painter's House in Seville (Bréal), *illus. 70*

Couturier, Rev. Père Marie-Alain, 450, 453, 458–60

Cowling, Elizabeth, 287

Creole Dancer, The (Matisse), 458

Crosals, Victor, 456

Cross, Henri, 25, 27, 29–30, 33, 55–6

Crouching Venus (Matisse), 209

Cubism, 81, 137–8, 175, 188, 190, 196, 220, 298, 332, 355, 402

of ballet designs, 234

competitiveness of, 35–6

of Gris, 160–1, 165

Kahnweiler's philosophical programme for, 274

paintings by Matisse influenced by, 168, 171, 176, 184, 186

in Salon des Indépendants of 1911, 73

Cupid Bearing Psyche Upward (Denis), *illus. 7, 8*, 324

Curie, Melitsa, 94

Cusin, monstre à double aile (Matisse), *illus.*
410

D

Daily Worker, 370
Daladier, Edouard, 382
Dance (I and *II)* (Matisse, 1909), *colour fig. 4*, 3, 8,
23, 25, 26, 29–31, 33, 38, 47, 49–51, 53 *and
illus.*, 56, 60, 77, 88–9, 91, 99, 138, 163, 185,
223, 326, 329, 459, 460, 462
Dance, The (Matisse, 1933), 326, 329–38, *illus.* 329,
336–7, 341, 343, 344, 346, 352, 360, 364, 367,
369, 370, 373–4, 380, 382, 445
Dancer with Arms Raised in a Yellow Armchair
(Matisse), 410–11
Dancer with Tambourine (Matisse), 350
Danjou, Marie, 52
Darricarrère, Henriette, 241–6, 248, 251–3, 261,
262, 270–2, 274, 280, 282, 289–91, 295,
298, 300, 456, 484n62
Davies, Arthur B., 136
Davin, Mlle, 114
Decorative Figure (Matisse), 182
Decorative Figure on an Ornamental Background
(Matisse), *colour fig. 23,* 282–4
Degas, Edgar, 99
Delacroix, Eugène, 104, 108, 128–9, *illus. 130,* 131,
148, 281, 316, 415, 460
Delectorskaya, Lydia (Mme Omeltchenko), 35,
76, 78, 251, *illus. 341,* 345–7, 361, 377, *illus.
388,* 415, 428, 429, 444, 448, 494n25
as Amélie's companion, 345, 354–5
Aragon and, 405, 413
and breakup of Matisses' marriage, 382–4,
390–91
Bussy family and, 368–70
as Claude's nanny, 354, 361, 362, 364
and construction of chapel, 455–57, 460
and Matisse's death, 466
during Matisse's illnesses, 378, 379, 398–400,
409, 413–17
as model, 355–60, *illus. 356, 357, 359, 360,* 366,
382
models hired by, 439
Monique Bourgeois and, 411–12
during Munich crisis, 381, 382
photograph of Matisse by, *illus. 340*
portraits of, 432–3, *illus. 432, 433*
relationship of Matisse and, 388–90, 431–4,
437–8, 465
during Russian Revolution, 358–59
secretarial duties of, 364, 365, 367
and Soviet Museum of Modern Western
Art, 461–2
suicide attempt of, 384

Vassaux and, 435
during World War II, 392, 394, 401, 407, 418,
420–3, 494n60
Delectorski, Dr., 359
Demoiselle Beside the Seine (Courbet), 199, 479n62
Demoiselles d'Avignon (Picasso), 186–7, 256
Denis, Maurice, 7 *and illus.,* 8, 38, 55–7, 89, 109,
324
Derain, Alice, 189
Derain, André, 58, 82, 128, 179, 190, 274, 277
ballet designed by, 229, 233–34
Fauve period of, 35, 175
during Nazi Occupation, 423, 438
Pierre and, 259
during World War I, 162, 169, 184
Desserte (Heem), 170–1
Desvallières, Georges, 332
Detroit Institute of Arts, 255
Diaghilev, Serge, 229–34, 244, 431, 481n48
Diehl, Gaston, 494n60
Divisionism, 41
Donatello, 282
Dorgelès, Roland, 42, 64
Doucet, Jacques, 169, 256
Dove of Peace (Picasso), 463
Dream, The (Matisse), 358, 362, 397 *and illus.,* 399,
411
Drollet, Lucie, 315
Druet, Eugène, 38
du Gard, Roger Martin, 369
Dubois, Paul, 95, 96
Duchamp, Marcel, 155, 165
Duchamp-Villon, Raymond, 165, 168
Dudensing, Valentine, 305
Dudley, Dorothy, 336, 338
Dufy, Raoul, 374
Duhême, Jacqueline, 452, 456
Duncan, Isadora, 63
Duthuit, Claude, 333, 335, 345, 354, 361 *and illus.,*
362, 364, 381, 392–5, 436, 446, 447, 451, 457
Duthuit, Georges, 46, 203, 268, 277, *illus.* 280, 281,
284, 291, 302, 305, 316, 323, 332, 336
catalogue raisonné compiled by, 451, 461
on Fauve paintings, 279, 292, 295
journalistic publications by, 299
lecture on Matisse by, 285–7
Lydia and, 346
marriage of Marguerite and, 257–65, 275,
279–81, 350–2, 363–4
Pierre and, 267, 269
Prichard and, 149, 154, 169, 188, 257, 258
relationship of Matisse and, 265, 274–6,
279–80, 292, 399, 451
sketch of, *illus. 257*
as spokesman for post–World War I genera-
tion, 285, 331

during World War I, 188–9, 257

during World War II, 395, 436

Duthuit, Marguerite Matisse (daughter), 4–5, 9, 31, 75, 122, 141, 166, 175, 201, 238–9, 244, 268, 271, 278, 285, 332–3, 335, 343, 350, 354, 355, 381, 459

at Aix with Amélie, 237, 245, 263

and Amélie's depressions, 298, 303–5

artistic aspirations of, 178–9, 182, 238, *illus.* 252, 348, 349

birth of son of, 333

and breakup of parents' marriage, 383, 386, 390–1

catalogue raisonné compiled by, 451, 461

childhood of, 10, 11, 56

Cone and, 375–7

correspondence with Amélie, 240, 249, 253, 276, 294, 299

correspondence with father, 104, 124, 144, 145, 237, 250, 251, 266, 269, 284, 288, 299–301, 322, 336, 337, 342, 347, 362, 366, 374, 414, 416, 417, 419, 425, 449, 464

couture designs by, 279–80, 361–2

education of, 122, 177–8

and father's death, 464–6

and father's illnesses, 398–400, 409, 412, 415–16, 419

Georgette Sembat and, 118

health problems of, 11, 26–7, 51, 67, 177, 204, 224, 227–8, 234–8, 252

Henriette Darricarrère and, 241–3, 248, 252, 272

at Issy, 39, 52, 67, 68, 106–7, 118–19, 143, *illus.* 157, 179, 287

in London, 366–7

marriage of, 257–65, 275, 279–81, 350–2, 363–4

Olga Meerson and, 76, 84–5 *and illus.*, 96

paintings of, 19–20, *illus.* 20, 71, 167–8, 180, *illus.* 236, 236–7, 243

in postwar Paris, 435, 436, 438

reminiscences of, 46, 57, 121

Renoir and, 219

as studio assistant, 82

in United States, 345, 352

during World War I, 189, 207–9, 212–13, 215

during World War II, 392–5, 420, 422–5, 494n160

Dying Slave (Michelangelo), 248, 271

E

Ecole des Arts et Métiers, 238

Ecole des Beaux-Arts, 104, 149, 150, 395, 396, 407, 492n47

Efron, Lilia, 18, 76, 77, 95, 96

Efron, Sergei, 18

Elderfield, John, 183

Electricity (Dufy), 374

Eliot, T. S., 45, 338

Emergency Rescue Committee, 396

Eminent Victorians (Strachey), 370

Epstein, Elisaveta Ivanovna, 19, 32

Eréna, François, 271

Erzya, Stepan, 22

Escholier, Raymond, 372–3, 394, 399, 401, 490n132

F

Fabiani, Martin, 408, 422, 438, 494nn23, 160

Fall of Icarus, The (Matisse), *colour fig. 24*, 418–19

Family Portrait (Matisse), 141, 259

Farcy, Andry, 256

Farré, Henry, 305, 306

Fascists, 363, 395, 407, 449n160

Fatma (model), 123

Faun Charming a Sleeping Nymph (Matisse), 365 *and illus.*

Faure, Elie, 241

Fauvism, 6, 21, 32, 41, 56, 103, 175, 226, 255, 297, 330, 331

attacks on, 53, 64

at Autumn Salon of 1905, 11, 18

Cubists' competitiveness with, 35–36

Duthuit on, 295, 451

followers of, 35, 137

Impressionism and, 217–18, 221–22

Kandinsky and, 19

of Meerson, 73–74

of portraits of Amélie, 282

Zervos and, 292

Fels, Florent, 485n22

Fénénon, Félix, 38, 163, 164, 256

Fenêtre, Céret, La (Braque), 83

Fête en Cimmérie, Une (Duthuit), 451

Fête espagnole (film), 272

Fighting Angel, The (Buck), 343

Flaherty, Robert, 317, 318

Flam, J. D., 239, 273

Flandrin, Jules, 37, *illus. 53*, 134, 137, 156, 169, 203, 282–4

Flanner, Janet, 135

Fleurs du mal (Baudelaire), 423, 429, 445–6

Fleurs sur la mer (film), 272

Florilège des amours de Ronsard (Matisse), *illus. 410*, 414, 429

Flowers for St. Henry's Day (Matisse), 388

Forest of Fontainebleau (Corot), *illus. 198*, 199

Fort, Paul, 178

Fougstedt, Arvid, *illus. 12*, 191

Fourcade, Dominique, 81, 269–70, 272, 282

Fragonard, Jean-Honoré, 96
Francs-Tireurs et Partisans (FTP), 420, 422
France, Anatole, 438
Free Aesthetics Society, 90
French Window at Collioure (Matisse), *illus. 161*, 161–2
French Window at Nice (Matisse), *colour fig. 20*, 239
Freud, Sigmund, 95
Friends of New Painting, 300
Fry, Roger, 20–1, 51, 54, 57, 61, 136, 143, 164, 187, 237, 372, 485n22
Fry, Varian, 396
Furtwängler, Wilhelm, 96
Futurism, 36, 137, 174, 332

G

Gabrielle in an Open Blouse (Renoir), *illus. 224*
Galanis, Demetrius, 189, 422
Galanis, Fanny, 189
Galitzine, Hélène, 382
Garden of Allah (film), 243
Gardner, Isabella Stewart, 45, 57, 469n3
Gargoyle Club, 350–1, 485n127
Gauguin, Emile, 316
Gauguin, Paul, 88, 121, 136, 177, 277, 308, 316
Gaumont brothers, 241
Gauthier, Lucien, 302
Geist, Sidney, 482n101
George, Waldemar, 485n22
George V, King of England, 107
Georges Duthuit (Matisse), *illus. 257*
Gérard, Emile, 193, 194
Gerbault, Alain, 302
Gertler, Mark, 136
Gestapo, 406, 422, 424
Giacometti, Alberto, 74, *illus. 465*, 465–6
Gide, André, 242, 336, 338, 367–70, 373, 383, 388
Gilles, Mother, 360
Gilot, Françoise, 35, 103, 215, 427–9, 442, 454–5, 466
Giotto, 331
Girl in Green (Matisse), 19
Girl with Black Cat (Marguerite Matisse) (Matisse), 20 and illus.
Girl with Green Eyes (Matisse), *colour fig. 2*, 19–21, 28, 307
Girl with Tulips (Matisse), 19, 20, 139
Glay, Capitaine le, 117
Gleizes, Albert, 188
Gobelins workshops, 445
Goblot, Aicha, 201
Goldberg, Mécislas, 53
Golden Cockerel, The (Rimsky-Korsakov), 153
Golden Fleece (avant garde news sheet), 16
Goldfish (Matisse), *colour fig. 14*, 120, 121

Goldfish and Palette (Matisse), *colour fig. 17*, 168, 186, 226, 256
Goldfish and Sculpture (Matisse), 120
Goncharova, Natalya, 94, 154
Gourgaud, Baron Napoléon, 262
Gourgaud, Baronne, 262, 271
Gowing, Lawrence, 175
Goya, Francisco, 440
Grandes Baigneuses (Cézanne), 194
Grant, Duncan, 233
"Great Man, A" (Bussy, J. S.), 370
Greco, El, 13, 71
Greenberg, Clement, 458
Grey Nude with Bracelet (Matisse), 152
Gris, Josette, 160, 163, 164, 189
Gris, Juan, 160–1, 163–5, 168, 175, 178, 186, 189, *illus. 192*, 203
Grunewald, Isaac, 14
Guernica (Picasso), 373
Guillaume, Louis Joseph, *illus. 159*, 213
Guillaume, Paul, 206, 285–7, 291, 292
Guitry, Lucien, 200
Guitry, Sacha, 422
Gurlitt, Fritz, 136–7, 155
Guthrie, James, 109
Guttman, Dr., 409
Gypsy, The (Matisse), 72, 103

H

Hahnloser, Arthur, 298
Hald, Edward, 13
Halvorsen, Walter, *illus. 188*, 190, *illus. 192*, 193, 195, 218, *illus. 219*, 222, 223, 226, 274
Hanotaux, Gabriel, 214, 367, 373
Harlequin (Picasso), 186
Harmony in Red (Matisse), 3, 6, 16, 153–4, 228, 351
Harris, Frank, 217
Harris, Walter, 104, 107–10, 112, 115–17, 122
Hastings, Beatrice, *illus. 192*
Hautant, Dr., 238
Head, White and Rose (Matisse), 168
Heem, Davidsz de, 170–1
Hélène (model), 295
Helleu, Paul, 152–3
Henriette (Matisse), 274
Henriette II (Matisse), 282
Henriette III (Matisse), 282
Henri and Amélie Matisse in the Studio at Issy-les-Moulineaux with the Unfinished "Bathers by a River" (Coburn), *illus. 135*
Henri Matisse (Delectorskaya), *illus. 340*
Henri Matisse (Fels), 485n22
Henri Matisse (Meerson), *colour fig. 7*, 74, 85
Henri Matisse (Sembat), 255

Henri Matisse Working on "La Serpentine" (Steichen), *illus. 34*
Hercules and Antaeus (Matisse), *illus. 355*
Hercules and Antaeus (Pollaiuolo), *illus. 354, 358, 385*
Hermitage Museum (St. Petersburg), 87, 92
Hervé, Anne, 318–19
Hervé, François, 318–20
Heuschling, Andrée (Dédée; Hessling, Catherine), 217, 241, 242, 289
Hift, Mme Franz, 439
Hind, Louis, 36
History of Psyche (Denis), 89
Hitler, Adolf, 50, 347, 372, 379, 380, 382, 388, 389, 400, 413
Homer, 341
Hoppe, Ragnar, 225, 246
Hound and Horn (magazine), 38
Humbert, Mme, 177
Humbert scandal, 9, 136, 161, 384, 461
Hutchinson, Mary, 371, 372, 378
Hutchinson, St. John, 371
Huyot, Albert, *illus. 84, 85*

I

Ibsen, Henrik, 195
Ile sans amour, L' (film), 272
Impressionism, 17, 41, 171, 193, 198, 217–19, 248, 362, 398
In the South Seas (Stevenson), 302
Ingram, Rex, 243, 289, 290
Ingres, Jean-Auguste-Dominique, 61–2, 136, 194, 411
Institut de France, 107
Interior with a Goldfish Bowl (Matisse), *colour fig. 16*, 149, 223, 262
Interior with Aubergines (Matisse), *colour fig. 11*, 80, 83–5, 56, 331
Interior with a Violin Case (Matisse), *illus. 221*
Interior with Bars of Sunlight (Matisse), 412
Interior with Dog (Matisse), 347, 376 *and illus.*
Interior with Violin (Matisse), 207, 209
Irwin, Inez Haynes, 20–1
Italian Woman, The (Matisse), 196 *and illus.*
Ithaca (Matisse), 354
Iturrino, Francisco, 58, 62–3, 68, 263

J

Jack of Diamonds group, 94
Jacob, Max, *illus. 192*, 195, 226
James, Henry, 19, 20
Janet, Pierre, 493n80
Janette, Joe, 480n79
Jaurès, Jean, 8
Javor, Wilma, 388

Jawlensky, Alexei, 18, 19, 77, 87, 470n33
Jazz (Matisse), 419, 420, 427, 446, 448, 449, 461
Jean, Emile, 259
Jean, René, 170
Jeannette III (Matisse), 139, 142
Jeannette V (Matisse), 139 *and illus.*, 142
Jedlicka, Gotthard, 485n22
Joaquina (Matisse), *illus. 63*, 72
Joblaud, Camille, 266, 435, *illus. 436*
Jolas, Maria, 394
Joyce, James, 340–1, 352–4

K

Kahnweiler, Daniel, 160, 165, 274
Kandinsky, Wassily, 17–19, *illus. 18*, 43, 75, 77, 78, 86, 87, 137
Kas, Marie and Emil, 344
Kaye, Danny, 438
Keynes, John Maynard, 233
King, William, 46, 149, 230
Kipling, Rudyard, 369, 383
Kirstein, Lincoln, 338
Klemperer, Otto, 96
Knipper, Olga, 93
Knot of Vipers (Mauriac), 391
Komisarjevsky, Feodor, 18
Konchalovsky, Pyotr, 94
Kritchevsky, Dr., 96

L

Labrusse, Rémi, 46, 124
La Fresnaye, Roger de, 162
Landsberg, Albert, 149, 152, 154, 203
Landsberg, Yvonne, 45, 152–55, *illus. 154, 155*, 196
Large Horse (Duchamp-Villon), 165
Large Nude in Red Armchair (Picasso), *illus. 286*
Large Reclining Nude (The Pink Nude) (Matisse), 358, *illus. 359, 360 and illus.*, 362
Large Seated Nude (Matisse), 274, 280–2, *illus. 281*, 300
Larionov, Michel, 94
Laurencin, Marie, 96, 287
Lavery, John, 107–11, 115
Lavery, Lady, 107–8
Le Corbusier, 186, 338, 449, 450
Leger, Fernand, *illus. 192*
Leicester Galleries (London), 233, 366–7
Lejeune, Emile, 191
Lenin, V. I., 50, 223
Leriche, René, 398, 409
Lettres portugaises, Les, Matisse's illustrations for, 439, 445
Level, André, 145, 158
Levy, Harriet, 28, 307

Lhote, André, 186

Life magazine, 464

Light That Failed, The (Kipling), 383

Lili (model), 295

Limited Editions Club, 352

Lipschitz, Jacques, 287

Lister, Reginald, 108

London *Times*, 89, 104, 116

Lorette (model), 196, 198–201, 204, 207, 243, 331

Lorette in a Green Robe on a Black Background
 (Matisse), 222

Lorette Reclining (Sleeping Nude) (Matisse), 199 and
 illus.

Loti, Pierre, 104, 107, 108, 111–13, 123

Louis Aragon (Matisse), illus. 406

Louvre (Paris), 47, 139, 248, 259, 275, 285, 297,
 300, 305, 331, 352, 407

Love for Three Oranges, The (ballet), 244

Löwengard, Charles, 298

Löwengard, Lisette, 298, 300, 304–5, 323, 328, 329,
 332, 334, 345, 376

Luce, Maximilien, 40

Luxe, calme et volupté (Matisse), 6, 25, 136

Luxembourg Museum, 139, 300

Lydia (Matisse), illus. 357

Lydia Delectorskaya (Matisse), illus. 341

Lydia Delectorskaya in a Hooded Cape (Matisse), illus.
 388

M

MacChesney, Clara, 118

Macy, George, 341, 352–3

Maeght, Aimé, 425, 434, 439, 441

Maillol, Aristide, 42–3, 297–8, 302, 313, 348, 434, 438

Maison de la Pensée Française (Paris), 458

Maison Worth, 280

Majerzak, Dr., 95

Mallarmé, Stéphane, 296, 323, 328, 333, 334, 339,
 365, 375

Malraux, André, 367

Manet, Edouard, 194, 398, 442

Manguin, Henri, 28, 29, 40, 58, 59, 104, 108, 156

Manila Shawl, The (Spanish Woman) (Matisse), illus.
 72, 72–3

Mann, Katia, 17

Mann, Thomas, 17, 19, 32, 96

Manolo, Manuel, 161

Marchand, André, 250, 288, 290

Marguerite Asleep (Matisse), illus. 236, 236–7

Markova, Alicia, 481n48

Marne, Battle of the, 165

Marquet, Albert, 52, 108–9, 144, 146 and illus., 153,
 161, 215, 251, 288, 441
 correspondence with, 29, 58, 69, 209, 391, 415,
 429

death of, 446

at Issy, 40 *and illus.*, 124

marriage of, 260

in Marseilles, 203–4, 206, 226

Meerson and, 79, 84, 86

in Munich, 54

Renoir and, 218

in Tangier, 102, 112, 126–7

during World War I, 156, 160, 165–7, 209, 213

during World War II, 401

Martin, Jean, 456

Martin, Paule, 453, 456–7, 464

Marval, Jacqueline, 203–4, 209, 283

Massia (violinist), 167

Massine, Léonide, 231–2, 335, 336, 380

Masson, André, 329, 332, 333, 335, 336, 348

Matisse (McBride), 485n22

Matisse, Alexina Satler (Teeny; Pierre's wife), 303,
 349, 378–81, 451

Matisse, Amélie (wife), 4, 9–12, illus. 11, 30, 59,
 161, 177, 178, 201, 218, 242, 271, 291, 301,
 323, 346, 362, 365, 367, 381, 399, 451
 at Aix with Marguerite, 237, 245, 263
 correspondence with Henri, 42, 57, 58, 60–1,
 65–7, 71, 76–7, illus. 91, 119, 122, 124–5,
 204–6, 210–22, 224, 230, 238, 241, illus.
 244, 247, 251, 279, illus. 294, 305–6, 314,
 315, illus. 317, 319 and illus., 322, 339, 374
 correspondence with Marguerite, 240, 249,
 253, 276, 294, 299
 family background of, 9
 and father's death, 249
 Georgette Sembat and, 118
 Gertrude Stein and, 52, 371
 grandchildren of, 333, 345, 361, illus. 381
 Henriette Darricarrère and, 251–2
 and Henri's death, 466
 ill health of, 67, 77, 237, 252–3, 268, 285,
 287–8, 297–8, 302–5, 328–9, 334, 341, 342,
 352, 377
 at Issy, 27, 52–3, 67, 72, 93, 124, illus. 135, 157
 Lydia Delectorskaya and, 345–7, 354, 357, 379,
 382–4
 and Marguerite's marriage, 257, 259–62, 351,
 363–4
 and Marguerite's surgery, 227, 234–5
 marital problems of, 67–9, 72–3, 249, 276,
 344
 marriage of, 9–10, 31, 143
 marriage, breakup of, 382–8, 390–1
 modeling by, 10–11, 75, 120
 in Morocco, 102–9, illus. 105, 111–14, 125–6,
 131, 132
 and mother's death, 16
 move back to Paris of, 144–5, 157
 needlework of, 343

in Nice, 249, 253, 261–2, 277, 289, 290, *illus.*
 293, 294, 298–9, 301–2
old age of, 434, 436, 459, 464
Olga Meerson and, 33, 75, 79, 84–5 *and illus.*,
 94–7
paintings of, 32, 71–3, 141–4, *illus.* 142, 143,
 150–2, *illus.* 238, 282, 290
and Pierre's first marriage, 264, 266, 267
Renoir and, 219
as studio manager, 10
during World War I, 165–7, 188–9, 207–9,
 212, 213, 215
during World War II, 392, 416, 419–20,
 422–4, 424
Matisse, Anna (mother), 10, 67, 122, 132, 144, 146,
 158, 162, 166, 189–90, 205, 213–15, 226, 234,
 235, 288, 351
Matisse, Auguste (brother), 55, 166, 169, 189–90,
 193, 213–15, 226, 235, 392, 393, 441
Matisse, Gérard (grandson), 333, 392, 393, 446–8,
 451, 457, 459
Matisse, Henri:
 Antoinette Arnoud and, 223–6, 228, 235, 240
 Aragon and, 405–9, 412–13, 439
 art collection of, 177, 253, 479*n*62
 attacks on, 42, 56, 63–4, 254–5, 370–2
 in Autumn Salon, 53–4
 ballets designed by, 229–34, 380, 385
 Barnes's commission from, 324–31, 334–8
 Bernheim-Jeune shows of, 40–2, 47, 132–3,
 137, 225–6, 236, 249, 330, 331
 Berlin shows of, 3–4, 136–7, 155–6
 Bernheim-Jeune contract with, 38, 206
 brothels, visits to or otherwise, 125–6, 251
 and Buck's novels, 342–3, 361, 362
 Bussy family and, 367–71
 cars owned by, 202–3, 275, 298
 at Cassis, 8
 at Cavalière, 25, 28–30
 chapel designed by, 448–62
 chastity, attempts at, 32
 and children's artistic aspirations, 178–80,
 182, 275, 347–50
 in Collioure, 82–6, 160–1
 Cones' collection of paintings by, 326–7,
 375–7, 462
 conflicting responses to pre– and
 post–World War I works of, 254–5,
 273–4, 284
 creative process of, 31–3, 48–51, 81, 141,
 148–52, 174–6, 185–6, 197–9, 207–8,
 238–9, 247–9, 295, 333, 372–3, 427–8,
 463–4
 Cubism and, 186–7
 death of, 465–6
 documentary film on, 439, 441

dogs owned by, 276–7, 297, 378
eightieth birthday celebrations for, 457–8
emotional turmoil of, 59, 66, 268–9, 277
family life of, 10, 11, 176–7, 252–3, 276,
 278–9, 292, 294, 342, 436–7
and father's death, 54–6
Fauve period of, 11, 32, 35, 222, 226, 292
favorable reviews of, 43
film-going of, 272, 296–7, 339, 438
final years of, 460–5
in Germany, 3–5, 54
grandchildren and, 333, 354, 380, 446–8, 457,
 459
Guillaume's shows of, 206, 285–7, 291
Henriette Darricarrère and, 242–4, 248,
 251–2, 270, 289–91
illnesses of, 172, 261, 299, 336–7, 341–2,
 378–9, 398–402, 409, 413–17, 446, 460,
 492*n*56
interviews with, 25–6, 29, 47, 49, 118, 297,
 325, 460–1
Lisette Löwengard and, 298, 328, 329, 332
in London, 233
London shows of, 20–1, 51, 136, 366–7
Lorette (model) and, 196, 198–201, 204
Lydia Delectorskaya and, 334–5, 345–7,
 356–60, 364–6, 377, 381–2, 388–92, 416,
 431–4, 461–2, 465, 466
Marguerite's critiques of, 178–9, 238–9, 342,
 362, 367, 417
and Marguerite's health problems, 26–7,
 227–8, 234–8
and Marguerite's marriage, 257–61, 264–5,
 274–5, 279–80, 350–2, 363–4
marital problems of, 67–9, 72–3, 249, 276,
 303, 344
marriage of, 9–10, 31, 143
marriage, breakup of, 382–8, 390–1
memoirs of, 400–5
models, relations with, xvii–xviii, 6, 11, 19,
 23–4, 27, 50, 73–7, 77–8, 115–16, 123–4,
 126, 142–4, 195–6, 198–201, 204, 220,
 223–5, 239–40, 241, 248, 251–2, 270–1,
 271–3, 289–91, 298, 328, 346, 256–7,
 364–6, 382–3, 384, 410, 411–12, 448,
 456–7, 482*n*101
Monique Bourgeois and, 411–12
in Morocco, 97, 101–19, 121–31, 133, 134, 149,
 173–4
and mother's death, 234, 235
move back to Paris of, 144–8, 157
move to Issy of, 27, 34, 36–40
during Munich crisis, 380–2
museum acquisitions of works of, 374–5,
 377, 438–41, 461–2
New York school influenced by, 440

Matisse, Henri (*continued*):
New York shows of, 43, 136, 289, 330–1, 334, 458
in Nice, 220–1, 234–9, 244–53, 255, 256, 261–3, 268, 272–3, 277–9, 294–5, 297–8, 300, 332, 483*n*32
Olga Meerson and, 16–17, 19, 22–3, 32–3, 73–9, 84–7, 93–7
Oriental influences on, 47, 129
painting breakthrough of, 26, 29–31
Picasso's friendship with, 137–8, 140, 399, 426–9, 442–3
and Pierre's first marriage, 263–8
and Pierre's violin studies, 180–3
popular image of, 371–2
portraits of young women by, 20–2, 45, 152–5, 273, 409–12
professional isolation of, 34–6, 256, 372, 373
rejection of Beaux-Arts aesthetics by, 6, 7
Renoir visited by, 216–19, 222–3
in Russia, 87–95, 98–101
in Salon des Indépendants, 25, 26, 43, 73
Sarah Stein's promotion of, 44–6
school of, 11–14, 16, 27, 36, 39, 42, 50, 73
Sembat's writings on, 8, 31, 117, 119, 124, 131–3, 137, 138
Shchukin's collection of paintings by, 6–8, 24, 81, 99–100, 133, 374
Shchukin's commissions from, 24–8, 56–7, 60–1, 63–4, 80, 88, 90–1, 121, 141
sixtieth birthday celebrations for, 299–300
in Spain, 57–63, 65–72, 79–81, 88
Steins' collection of paintings by, 19, 20, 36, 41, 44, 84, 156, 222, 256, 329, 375
student days of, 9, 13
in Tahiti, 289, 302, 305, 307–22, 333
techniques used by, 83, 119, 154, 155, 332, 417–18, 428–9, 431
in United States, 305–7, 322–7, 336–7
in Vence, 420–2, 426–9, 432–5, 439, 441, 443–5, 448
violin playing by, 156–7, 172
visitors shocked by, 139–40
and wife's ill health, 287–8, 302–4, 341, 342, 344–5
works of, *see titles of specific works*
during World War I, 156–71, 184, 188–98, 201–2, 204, 208–15
during World War II, 387, 388, 391–7, 400, 401, 406–9, 412–14, 418–25, 436, 440, 441, 494*n*160
Matisse, Henri, Sr. (father), 9, 10, 54–6, 144, 146, 180, 194, 215, 234, 348
Matisse, Jacqueline (granddaughter), 333, 361, 446, 447, 451, 457
Matisse, Jean (son), 108, 180, 189, 221, 226, 240, 262, 269, 271, 284, 287, 351, 436

adolescence of, 144, 145, *illus. 157*, 158, 166–7, 177, *illus. 179*, 179–80
artistic aspirations of, 238, 275–6, 301, 323, 347–8
birth of son of, 333
and breakup of parents' marriage, 383
childhood of, 10, 11, 67, 82
Duthuit and, 257, 259
education of, 27, 39, 51, 106, 122, 141
family business run by, 277–8
in family portrait, 71
marriages of, 303, 323, 451, 459
and mother's depressions, 253
during Munich crisis, 381–2
prospective brides for, 288–9
tombstone carved by, 466
in World War I, 180, 194, 201, 204, 207, 208, 212, 214, 219
in World War II, 392, 393, 412–13, 419, 422
Matisse, Louise (Jean's wife), 392, 393, 451
Matisse, Marguerite (daughter), *see* Duthuit, Marguerite Matisse
Matisse, Paul (grandson), 361, 446, 447, 451
Matisse, Peter Noel (grandson), 380, 446, 447, 451
Matisse, Pierre (son), 56, 108, 153, 201–2, 227, 230, 248, 252, 269, 285, 294, 302, 323, 326, 339, 342, 347–9, 360, 372, 374, 396, 400
adolescence of, 144, 145, 157 *and illus.*, 158, 166–7, 177–8
artistic aspirations of, 210, 238
and Barr's book on Matisse, 461
and breakup of parents' marriage, 384, 391
childhood of, 10, 11, 67, 82, 106, 122
children of, 333, 361, 380, 447
in Clemenceau's secretariat, 238
Cone and, 377
at consecration of chapel, 460
correspondence of, 240, 298, 333, 335, 343, 355, 362, 364, 373, 397, 399, 401–2, 404–5, 409, 413, 414, 434, 440, 441
Duthuit and, 257
education of, 27, 39, 51, 141
in family portrait, 71
marriages of, 259–60, 262–7, 276, 303, 304, 451, 459
and mother's depressions, 253, 287
painting of, 182–4, *illus. 183*, 201
portrait sittings arranged by, 378
postwar reunion with, 436–8
in United States, 176, 268, 271, 275, 277, 278, 288, 289, 330, 333–4, 336, 337, 345, 349, 351, 352, 363, 380, 381, 395, 458, 464
and *Ulysses* illustrations, 340
violin lessons of, 157, 180–2, *illus. 181*, 201, 207, 210, 212, 226
during World War I, 209, 212, 214

Matisse: His Art and His Public (Barr), 461

Matisse Museum (Le Cateau), 462

Matisse Teaching Scandinavian Artists in His Studio (Fougstedt), *illus. 12*

Matta, Patricia, 459

Matthew Prichard (Matisse), *illus. 44*

Mauriac, François, 391

Maurvret, Georges, 483n32

McBride, Henry, 51, 139–40, 305, 330, 338, 485n22

Médecin, Jean, 460, 466

Meerson, Olga Markusovna, 16–19, *illus. 16, 18,* 22–3, 32–3, 73–9, 84–7, *illus. 84–86,* 93–7, 201, 363, 366, 435, 470nn27, 33

 portrait of Matisse, *colour fig. 7,* 74, 85

Melchers, H. M., 191

Menier family, 203

Metamorphoses (Ovid), 323

Metro-Goldwyn-Mayer, 305

Metropolitan Museum of Art (New York), 255, 305

Metzinger, Jean, 188

Meyer, Marcelle, 285

Michaela (Matisse), 441

Michelangelo, 207, 209, 248, 271, 280, *illus. 281,* 282

Mills College, 396

Ministry of Beaux-Arts, 139, 363

Mirbeau, Octave, 41

Miró, Joan, 363

Moana (film), 318

Modigliani, Amedeo, 192 *and illus.*

Modot, Gaston, 250

Moll, Greta, 19, 22, 96, 153

Monde, Le, 117

Mondrian, Piet, 31–2

Monet, Claude, 41, 198, 199, 218, 417, 427

Monique in a Grey Robe (Matisse), 412

Montherlant, Henri de, 410, 417–18

Montross Gallery (New York), 164

Moorish Harem (Lavery), 110

Moorish Screen, The (Matisse), *colour fig. 21,* 246

Moorish Woman (Matisse), 248

Morand, Paul, 273

Moreau, Gustave, 169, 305, 378, 415

Morillot, Octave, 316

Moroccan Amido, The (Matisse), *illus. 101,* 121

Moroccan Café (Matisse), *colour fig. 15,* 130–1, 134, 255

Moroccans, The (Matisse), *colour fig. 18,* 130, 174–6, 188, 212, 289, 292, 462, 485n127

 sketch for, *illus. 174*

Moroccan in Green (Standing Riffian) (Matisse), *illus. 98,* 300

Morosov, Ivan Abramovich, 7, 87, 105, 114, 121, 133, 323

Morrell, Lady Ottoline, 44, 45, 52

Morrice, James Wilson, 109, 115, 127, 128

Moscow Art Theatre, 18, 93

Moscow *Mirror,* 90

Moscow Museum, 57

Moscow School of Art, 17, 23

Motherwell, Robert, 442

Mourlot, Fernand, 443

Mozart, Wolfgang Amadeus, 181, 464

Mudocci, Eva, 167

Muelle, Marie, 232, 243

Munich crisis, 380–2, 388

Münter, Gabriele, 77, 86, 87

Murnau, F. W., *illus. 317,* 317–18, 322

Musée de la Ville de Paris, 394

Muses Greeting Genius, The (Puvis de Chavannes), 56

Museum of Modern Art (MoMA; New York), 330–1, 461, 462, 466, 495n46

Museum of Modern Art (Paris), 438, 458

Museum of Modern Western Art (Moscow), 323, 363, 461

Music (Matisse, 1910), *colour fig. 5,* 8, 26, 31, 38, 48–51, 53 *and illus.,* 56, 60, 77, 88–9, 99, 138, 163, 185, 223, 326, 460

Music (Matisse, 1939), 385

Music Lesson, The (Matisse), 201, 228

Mussolini, Benito, 389, 394

N

Nadelman, Elie, 22, 162

Nana (film), 289

Nasturtiums with "Dance (I)" (Matisse), 121, 133

National Gallery (London), 233, 362, 367

National Gallery of Art (Washington), 272–3

Nau, Jean, 28

Nazis, 363, 375, 396, 422, 435, 438, 494n160

Nelck, Annelies, 421–3, 428, 433–4, 440, 442, 448, 452, 456, 457

Nerval, Gérard de, 435

Neue Kunst, 137

Neue Staatsgalerie, 43, 54

Nevinson, Christopher, 64, 371–2

New York Evening Post, 139

New York Sun, 305

New York Times, The, 136

Nice Matin, 494n23

"Notes of a Painter" (Matisse), 15

Nouvelle Revue française, 255, 271

Nouvelles, Les (newspaper), 25–6, 29

Novgorod school, *illus. 100*

Nude with Goldfish (Matisse), *colour fig. 22,* 249

Nymph and Faun (Matisse), 366

Nymph & Satyr (Matisse, 1907–8), *illus. 4,* 5

Nymph and Satyr (Matisse, 1908–9), *colour fig. 1*, 5, 8, 23, 24, 76, 78, 366
Nymph in the Forest (Matisse), 365, 372, 373

O

Oceania, the Sea (Matisse), 445, *illus. 446*
Oceania, the Sky (Matisse), 445
Odalisque in Red Culottes (Matisse), *illus. 216*, 255
Odalisque on a Terrace (Matisse), 243
Odalisque with a Bowl of Fruit (Matisse), *illus. 269*
Odalisque with Tambourine (Matisse), 292
Old Believers, 92, 100
Olivares (cellist), 167
Olivia (Bussy), 368
Omeltchenko, Boris, 345
Omeltchenko, Lydia, *see* Delectorskaya, Lydia
On the Terrace (Matisse), 124
Open Window, The (Matisse), 103
Open Window at Tangier (Matisse), 109
Opening of the Lyre and Palette, The (Fougstedt), *illus. 191*
Orientalism, 108, 128
Orpen, William, 152
Osthaus, Karl Ernst, 4
Ostroukhov, Ilya, 87–9, 92, 94
Ovid, 323
Ozenfant, Amédée, 186, 191

P

Pach, Walter, 136, 139, 143, 144, 164, 165, 168, 170, 172, 177, 190, 199, 246, 267
Painter and His Model, The (Matisse), 240 *and illus.*
Painter in His Studio, The (Matisse), 198
Painter's Family, The (Matisse), *colour fig. 9*, 80, 81, 99, 228
Palais de la Méditerranée (Nice), 441
Paley, Mrs. Donald, 378
Pallady, Théodore, 390, 397, 398
Palm Leaf, Tangier (Matisse), *colour fig. 13*, 113, 115
"Papiers découpés" (Matisse), *illus. 430*
Parade (ballet), 234
Parakeet and Mermaid (Matisse), 464
Parayre, Armand (Amélie's father), 9, 10, 42, 68, 69, 72, 82, *illus. 84*, 106, *illus. 157*, 344
Parayre, Berthe (Amélie's sister), 68, 69, 72, 276, 333, 379, 381, 421
 during Amélie's illness, 328–9, 344, 345
 and breakup of Matisses' marriage, 383, 384
 career of, 68, 106, 344
 death of, 434
 estrangement of Amélie and, 391
 at Issy, 157 *and illus.*
 and Marguerite's education, 122, 141, 177
 Pierre and, 10, 106, 122, 259, 264, 266
Parayre, Louise (Amélie's aunt), 209
Parent, Armand, 167, 181
Paris Opéra, 229, 481*n48*
Paris Salon, 16, 107
Paris Soir, 396
Paris-Journal, 42, 73, 74
Pasiphaë (Montherlant), 410, 417–18, *illus. 418*, 494*n23*
Pathé, Charles, 241
Patriot, The (Buck), 343
Pauline Chadourne (Matisse), *illus. 313*
Payot, Micheline, 492*n51*
Peau d'Ours syndicate, 145–6
Pellerin, Auguste, *illus. 193*, 193–6, 199
Peretti, Clorinde, 259–60, *illus. 263*, 263–7, 276, 484*n81*
Periwinkles (Moroccan Garden) (Matisse), 113
Perret, Auguste, 450
Pétain, Marshal Philippe, 393, 394
Petit, Georges, galleries (Paris), 330, 334, 335
Petit Palais (Paris), 373
Phalanx Class, 17, *illus. 18*, 19
Philadelphia Museum of Art, 324, 458
Philip IV, King of Spain, 107
Phillips, Duncan, 324
Pianist and Checker Players (Matisse), *illus. 270*
Piano Lesson, The (Matisse), 182–4, *illus. 183*, 201, 259, 285, 462
Picabia, Francis, 73, 287
Picasso, Pablo, 22, 31, 42, 58, 81, 82, 160–2, 168, 186–7, *illus. 191*, 192, 196, 215, 256, 274, 277, *illus. 286*, 330, 375, 402, 462, 464
 ballets designed by, 229, 234
 in Barnes' collection, 373
 Basket of Oranges purchased by, 103, 118
 Bell and, 372
 Carnegie Prize awarded to, 324, 325
 and chapel project, 451, 454–5, 458
 Cubist followers of, 35, 36, 64, 73
 in Cubist retrospective, 355
 friendship of Matisse and, 137–8, 140, 399, 426–9, 442–3
 in London exhibition, 440
 Metamorphoses illustrated by, 323
 pottery designed by, 449–50, 454
 political involvement of, 423–4, 438, 463
 in Shchukin's collection, 88, 137
 and Spanish civil war, 372
 Stein and, 44, 69
 Surrealists and, 287
 in two-man show with Matisse, 206
 during World War I, 166, 187
 during World War II, 395, 396, 423

Pink Marble Table (Matisse), 229
Pink Shrimp (Matisse), 241
Pink Studio, The (Matisse), *colour fig. 8*, 73, 80, 81, 99
Piot, René, 38–9
Pissarro, Camille, 218
Pitre chatié, Le (Matisse), *illus. 338*, 339
Plato, 149
Plumed Hat, The (Matisse), *illus. 226*
Poèmes de Charles d'Orléans, Matisse's illustrations
 for, 415, 417, 418, 429
Poésies de Stéphane Mallarmé, Matisse's illustrations
 for, *illus. 296*, 323, 328, 333, 334, *illus. 338*,
 339, 349, 375
Poète assasiné, Le (Apollinaire), 192
Poiret, Paul, 147, 186, 190–1, 232, 260
Pollaiuolo, Antonio, 353, *illus. 354*, 358, 385
Pollock, Jackson, 440, 442
Polynesia, the Sky (Matisse), 445
Pope-Hennessy, John, 351
Popular Front, 372
Portrait of Amélie Matisse (Matisse), *illus. 237*
Portrait of Greta Prozer (Matisse), *illus. 195*, 195–6
 Study for, illus. 194
Portrait of Jane Bussy at 20 (Bussy), *illus. 368*
Portrait of Lydia Delectorskaya (Bicoloured Portrait)
 (Matisse), 432, *illus. 433*
Portrait of Madame Matisse (Matisse, 1915), 143 and
 illus.
Portrait of Marguerite (Matisse), 237
Portrait of Mlle Yvonne Landsberg (Matisse), 155 and
 illus., 164, 170, 196, 290
Portrait of Mme Matisse (Matisse, 1913), 141–4, *illus.*
 142, 150–2, 155, 156, 189, 290
Portrait of Mrs. Samuel Dennis Warren (Matisse), *illus.*
 150, 150–1
Portrait of Monsieur Bertin (Ingres), 194
Portrait of Olga Meerson (Matisse), 86 *and illus.*
Portrait of Rapha Maître (Renoir), 199
Portrait of Sergei Shchukin (Matisse), *illus. 99*
Post-Impressionism, 20, 36, 51, 57, 121, 136
Poussin, Nicolas, 18, 31, 33
Prado (Madrid), 58, 92, 387
Présages, Les (ballet), 335
Prichard, Matthew, 44–5, 50, 57, 134, 143, 144, 186,
 220, 279, 485n27
 conversations with Matisse, 47–8, 149–52
 Duthuit and, 149, 154, 169, 188, 257, 258
 Landsbergs and, 152, 153, 155
 in London, 230, 350–51
 in Munich, 54, 61
 portraits of, *illus. 44*, 154
 Sarah Stein and, 25, 143
 during World War I, 166, 189, 222, 250
Pringsheim, Eric, 17
Pringsheim, Heinz, 96, 97

Prix de Rome, 396–7
Prokofiev, Serge, 244
Prozor, Count, 226
Prozor, Greta, *illus. 188*, *194*, *195*, 195–6, 218, *illus.*
 219, 226
Purrmann, Hans, 13, 15, 22–3, 48, 54, 57, 73, 76,
 82, 143, 156, 222
Puvis de Chavannes, Pierre-Cécile, 56–7, 91
Puy, Jean, 43, 69, 82, 83, 86–7, 159, 162, 167, 169,
 170, 196, 400, 441
Puy, Michel, 43

Q

Queen of Spades (Tchaikovsky), 90, 94
Quennell, Peter, 350
Quinn, John, 170, 256, 277, 292, 326

R

Raisouli, 122
Ramié, Georges and Suzanne, 454–5
Rape, The (The Abduction) (Cézanne), 5 *and illus.*
Ravel, Maurice, 181, 392–3
Ray, Man, 261
Raynal, Germaine, 152 *and illus.*
Raynal, Maurice, 148
Rayssiguier, Frère Louis Bertrand, 448–50,
 452–5, 459, 460
Reclining Nude (Matisse), 120, 201, 300–1
Red Interior, Still Life on a Blue Table (Matisse), 435,
 illus. 436
Red Studio, The (Matisse), *colour fig. 10*, 80, 81, 101,
 292, 440, 462, 485n27
Rembrandt van Rijn, 47, 417
Rémond, Monsignor, 460
Renaissance, 23, 62, 207
Renoir, Auguste, 199, *illus. 219*, 224, 226, 256, 289,
 362, 398, 417, 440, 465
 in Barnes's collection, 325
 death of, 233, 248
 in Matisse's collection, 219, 252, 253, 274, 396
 Shchukin introduced to, 223
 visits with, 216–20, 222, 228
Renoir, Claude, 219 *and illus.*
Renoir, Jean, 219 *and illus.*, 242, 250, 289
Renoir, Pierre, 219
Resistance, 412–13, 419–20, 422–4
Retinsky, Doucia, 439
Reverdy, Pierre, 186, 195
Révolution surréaliste, La (Breton), 274
Rey, Robert, 139, 140
Rhys, Jean, 19, 273
Rimsky-Korsakov, Nikolai, 153
Rivera, Diego, 186

Rockefeller, Abby Aldrich, 466
Rockefeller, Nelson, 382, 466
Rodocanachi, Paul, 149
Rolland, Romain, 369
Romains, Jules, 226, 237, 239, 250, 251, 298, 332
Roman d'un Spahi (Loti), 113, 123
Ronsard, Pierre, 404
 Matisse's illustrations for poems of, 407,
 409, 410 *and illus.*, 414, 417
Rosenberg, Léonce, 165, 184
Rosenberg, Paul, 194, 199, 372, 378, 385–7, 390–2,
 396, 399, 408, 445
Rosenshine, Annette, 307
Roualt, Georges, 190, 349, 402–5, 454
Rouge et le Noir, Le (ballet), 380, 385, 452
Rousseau, Henri, 31
Rouveyre, André, 204, 205, 404, 413–16, 420, 425,
 427, 431, 433, 434, 437, 441, 443, 447
Roux, Félix, 250
Roy, Claude, 492n47
Rubinstein, Helena, 371
Russell, John, 275, 331
Russell, Mrs. Gilbert, 371
Russian Revolution, 18, 223, 345, 358

S

Salles, Georges, 461, 463
Salmon, André, 42, 191, 287
Salon d'Automne, *see* Autumn Salon
Salon des Indépendants, 25, 26, 36, 42, 43, 72, 73,
 258, 259, 272
Salon du Mai, 461
Salon of the Champs de Mars, 16–17
Salto, Axel, 188
San Francisco Art Institute, 307
Santy, Louis, 398–400
Sargent, John Singer, 45
Sarraut, Albert, 389
Satie, Erik, 191 *and illus.*, 285
Satler, Alexina, *see* Matisse, Alexina Satler
Saulnier, Raymond, 159–60
Schneider, Pierre, 203, 331, 366
Schumann, Robert, 181
Schuwer, Camille, 31, 46, 149
Schyle, Etienne, *illus. 312*, 312–14, 316
Schyle, Pauline, 307, 309–15, *illus. 312, 313*, 318, 319,
 321, 322, 329, 333, 444
Sears, Mrs. J. Montgomery, 45, 52
Seated Nude (Matisse), *colour fig. 3*, 30, 41
Seated Nude (Olga) (Matisse), *illus. 65*, 73, 85
Seated Odalisque with a Raised Knee (Matisse), 248
Segonzac, André Dunoyer de, 73, 162
Sembat, Georgette, 8, 9, 43, 91, 143, 148, 226
 Amélie and, 124
 collection of, 41, 118, 123, 156, 256, 374, 462

correspondence with, 48, 61–2, 85, 125, 134
death of, 255–56
at Issy, 30, 118
model recommended by, 195
during World War I, 165
Sembat, Marcel, 8–9, 25, 31, 37, 43, 91, 141, 143,
 148, 212, 222, 226, 255–6
 articles on Matisse by, 8, 31, 117, 119, 124,
 131–3, 137, 138
 collection of, 41, 118, 123, 156, 374, 462
 death of, 255
 at Issy, 30, 118
 during World War I, 162, 165, 167
Senate, U.S., Vice Committee of, 136
Serov, Valentin, 89
Seurat, Georges, 277
Severini, Gino, 174, 175, 178, 186, 190, 195
Severini, Jeanne, 178
Seville Still Life (Matisse), *colour fig. 6*, 62
Shadow, The (Picasso), 215
Shchukin, Ivan, 90
Shchukin, Pyotr, 134
Shchukin, Sergei, 6–7, 10, 20, 43, 44, 61, 101, 129,
 134, 136, 143, 163, 168, 223, 256, 325
 correspondence with, 8, 24, 64
 Dance and *Music* commissioned by, *illus. 3*,
 24–7, 30, 38, 56, 60, 63–4, 138, 185, 326,
 329, 462
 death of, 374, 375
 family portrait commissioned by, 66 80, 141
 German museum directors received by, 137
 Goncharova and, 154
 at Issy, 120, 121, 140
 installation of paintings in Moscow palace
 of, 99–100, 427
 in Paris, 10, 81, 88, 144, 156
 portrait of, *illus. 99*
 Puvis painting sold by Bernheims to, 56–7
 and Russian Revolution, 202
 Soviet Museum of Modern Western Art
 and collection of, 323
 still lifes commissioned by, 60, 62, 66, 68,
 69
 submission of works in progress to, 178
 Tangier paintings for, 105, 116, 130, 133
 visited by Matisse, 87–94, 98–9, 105
 young women sent to Matisse's school by, 14
Shéhérezade (film), 243
Shostakovitch, Dmitri, 380
Signac, Paul, 25, 109, 137, 242, 255
Simonsson, Birger, 13
Sister Jacques, *see* Bourgeois, Monique
Six Studies of Henri Matisse, Drawing V (Giacometti),
 illus. 465
Skira, Albert, 323, 333, 400–1, 404, 407, 417, 438,
 450, 459, 461

Sleeping Blonde, The (Courbet), *illus. 197,* 199, 218, 479n62
Smith, Matthew, 50
Socialists, 8, 9, 118, 389, 460, 466
Société des Prisonniers de Guerre, 169
Society of Friends of the Beaux-Arts, 272
Socrates, 149
Somme, Battle of the, 189–90
Song (Matisse), 382, 383, 385
Sorbonne, 148, 149, 186, 345, 449
Soulier, Paul, 82, 85
Soviet Realism, 348
Spanish civil war, 372
Spanish Girl with a Tambourine, The (Matisse), 19
Spinelli, Madame, 271
"Spiritual in Art, The" (Kandinsky), 75
Stalin, Joseph, 50, 462
Steichen, Edward, *illus. 34, 44, 47, 88,* 305
Stein, Allen, 140
Stein, Gertrude, 12, 16, 27, 43, 44, 52, 69, 110, 119, 136, 138, 140, 162, 163, 370–1
Stein, Leo, 12, 48, 50
Stein, Michael, 28, 52, 76, 91, 261, 267, 485n127
 collection of, 36, 41, 44, 84, 156, 222, 329
 horseback riding with, 140
 Marguerite and, 107, 178, 260
 portrait of, 195
Stein, Sarah, 28, 45, 46, 52, 76, 91, 150, 261, 267, 307, 326
 collection of, 19, 20, 36, 41, 44, 84, 156, 222, 256, 329, 375
 Gertrude and, 69, 163
 Marguerite and, 106, 178, 260
 portrait of, 195
 Prichard and, 25, 143
 as pupil, 12, 14, 73
Steinheil, Adolphe, 22
Stevenson, Robert Louis, 302, 316, 319
Stieglitz, Alfred, 43, 108, 136, 139
Still Life after Jan Davidsz de Heem's "La Desserte" (Matisse), 170–1, *illus. 171,* 277
Still Life on a Green Sideboard (Matisse), 295, 300
Still Life with Eggs (Matisse), 146
Still Life with Geraniums (Matisse), 43
Still Life with Magnolia (Matisse), 402
Still Life with Oysters (Matisse), 397, 399
Still Life with Pomegranates (Matisse), 435
Still Life with Pomegranates on a Ground of Venetian Red (Matisse), 435–6
"Storyette HM" (Stein), 69–70
Strachey, Lytton, 368–70
Stravinsky, Igor, 229, 285
Studio, The (magazine), 338
Studio, Quai Saint-Michel, The (Matisse), *illus. 197,* 198, 199, 351
Studio Under the Eaves (Matisse), 146, 161, 164, 198

Studios de la Victorine, 241, 243, 272, 289
Study for "The Studio, Quai Saint-Michel" (Matisse), *illus. 173*
Sudaskaya, Raissa, 93–5, 97
Sultane de l'amour, La (film), 243
Surrealism, 287, 288, 298, 330, 332, 447
Survage, Léopold, 14
Swimming Pool (Matisse), 464

T

Taboo (film), 317
Tahitiennes (Matisse), *illus. 314*
Tanguy, Yves, 167
Tate Gallery (London), 203, 371
Tchaikovsky, Pyotr Ilich, 90
Tea in the Garden (Matisse), *illus. 228,* 228–9, 256
Tennant, David, 350, 371, 485n127
Tériade, Efstratios, 297, 302, 318, 393, 401, 418–19, 439, 445–6, 464, 485n22
Ternovets, Boris, 92
Terorotua, Gustave, 319–20
Terorotua, Madeleine, 319
Terrace, The (Matisse), 243, 469n3
Terrus, Etienne, 42–3, 51, 52, 71, 82–3, 85 *and illus.,* 86, 126
Tetzen-Lund, Christian, 222, 256, 325
Théâtre des Champs-Élysées, 89
Thèmes et variations (Matisse), 405, 408, 413, 417
Theosophical Society, 75
Third Republic, 8
Thorndike, Charles, 250, 251, 280, 288, 296, 306, 420
Thousand and One Nights, The (Matisse), 458
Three Sisters Triptych (Matisse), 201, 325
Three Studies of Zorah (Matisse), *illus. 110*
Time magazine, 325 *and illus.*
Toklas, Alice B., 76
Tomb of Giuliano, Duke of Nemours, detail *(Night)* (Michelangelo), 207, 248, 280, *illus. 281*
Tonio Kröger (Mann), 19, 32
transition (magazine), 451
Tree of Life, The (Matisse), 454
Trees in Tahiti (Matisse), *illus. 308*
Tree near Trivaux Pond (Matisse), 203
Tretiakov Gallery (Moscow), 92
Tricorne (ballet), 229
Triolet, Elsa, 405, 407, 408
Tristesse du roi (Matisse), *colour fig. 25,* 460–1
Trotsky, Leon, 370
Trubetskoy, Prince, 22
Tshudi, Baron Hugo von, 43, 54
Tsvetaeva, Marina, 18
Tugenhold, Jacob, 22, 62, 99–100, 113, 121, 129–30, 133
Tuileries Salon, 282

Turkish Bath (Ingres), 411
291 Gallery (New York), 43

U

Uffizi Gallery (Florence), 107
Ulysses (Joyce), 340–1, 352–4, 409

V

Vaderin, Jeanne, 139
Valéry, Paul, 367, 431
van Dongen, Kees, 73, *illus. 146*, 147
van Gogh, Vincent, 13, 108, 189
Vanity Fair (magazine), 338
Vannier, Pierre, 493n80
Vasco (Chadourne), 302, 313, 316
Vassaux, Léon, 27, 51–2, 181, 434–5, 447, 459
Vassilieff, Marie, *illus. 15*, 15–16, 22, 23, 32, 33, 76,
 191–2, *illus. 192*, 470n27
Velasquez, Diego Rodriguez de Silva, 107
Verdun, Battle of, 184, 190
Verne, Henri, 300
Verve (magazine), 393, 418–19, 439
Victoria and Albert Museum (London) 46, 230,
 362, 367, 438–9, 440–1
View of Collioure (Matisse), 85
View of the Bay of Tangier (Matisse), 118
Vignier, Charles, 189, 260, 275
Vildrac, Charles, 239
Violinist at the Window, The (Matisse), 49, 209, *illus.*
 214, 215, 240
Vivaldi, Antonio, 181
Vlaminck, Maurice de, 73, 162, 169, 423, 438
Vogue magazine, 274, 305, 455
Vollard, Ambroise, 177, 219, 371, 408

W

Waley, Arthur, 230
Warren, Mabel Bayard, 45, *illus. 150*, 150–51, 169
Werefkin, Marianne, 18, 19, 77, 87, 470n33
Werthimer, Dr., 398, 409, 413
Whittemore, Thomas, 4, 45, 469n3

Widener Collection, 325
Window in Tahiti (Matisse), 373
Windshield, on the Road to Villacoublay, The (Matisse),
 illus. 203
Wollkoff, Alexander, 243
Woman in a Madras Hat (Matisse), 300, 323
Woman in a Turban (Lorette) (Matisse), *illus.*
 200
Woman in a Yellow Armchair (Cézanne), 141
Women of Algiers (Delacroix), 129, *illus. 130*, 281,
 460
Woman on a High Stool (Germaine Raynal) (Matisse),
 152 *and illus.*, 156, 183
Woman with a Green Parasol on a Balcony (Matisse),
 224, 226
Woman with a Hat (Matisse), 22, 143, 189
Woman with a Veil (Matisse), 290, *illus. 290*
Woman with Closed Eyes (Matisse), *illus. 11*
Woolf, Leonard, 368
Woolf, Virginia, 368, 371
World War I, 10, 130, 156–71, 175, 184, 187,
 189–96, 201–5, 208–16, 218, 219, 238, 257,
 462
World War II, 321, 391–7, 400, 401, 406–9,
 412–14, 418–25, 436, 440, 441
 events leading to, 380–2, 385, 387–8
 outbreak of, 388, 389

Y

Yellow Dress (Matisse), 322, 323, 376
Young Woman in Blue Blouse (Matisse), 432 *and illus.*
Young Woman in White Dress (Matisse), 439
Ysaye, Eugène, 464
Yvonne Landsberg (Matisse), *illus. 154*

Z

Zervos, Christian, 292, 350, 425, 485n22
Zhilkin, I., 91
Zita (model), 291 *and illus.*, 295
Zola, Emile, 438
Zorah (model), 110, 113, 115–16, 118, 123, 124, 126
Zorah Standing (Matisse), *illus. 116*

A NOTE ON THE TYPE

~

The text of this book was set in Centaur, the only typeface designed by Bruce Rogers (1870–1957), the well-known American book designer. A celebrated penman, Rogers based his design on the roman face cut by Nicolas Jenson in 1470 for his Eusebius. Jenson's roman surpassed all of its forerunners and even today, in modern recuttings, remains one of the most popular and attractive of all typefaces.

The italic used to accompany Centaur is Arrighi, designed by another American, Frederic Warde, and based on the chancery face used by Lodovico degli Arrighi in 1524.

COMPOSED BY NORTH MARKET STREET GRAPHICS,
LANCASTER, PENNSYLVANIA

PRINTED AND BOUND BY R. R. DONNELLEY & SONS
CRAWFORDSVILLE, INDIANA

DESIGNED BY IRIS WEINSTEIN